Ruzhnikov
Fine Art & Antiques

RUSSIA ACCURSED

IVAN VLADIMIROV

RED TERROR
THROUGH THE EYES OF AN ARTIST

UNICORN

Editors
Andre Ruzhnikov, Elena Danielson, Vladimir Ruga

Editorial Contributors
Elena Danielson, John Bowlt, Peter Harrington,
Irina Velikanova, Vladimir Ruga, Andre Ruzhnikov

English Version
Simon Hewitt

Design
Maria Kiseleva

Photography
Andy Johnson, Nikolai Stepanov

Consultants
Edward Kasinec, Yekaterina Yakushkina,
Andrey Barinsky

**Works by Ivan Vladimirov
reproduced by kind permission of:**

Hoover Institution Library & Archives, Stanford
University (Palo Alto, California)

Herbert Hoover Presidential Library & Museum
(West Branch, Iowa)

Anne S.K. Brown Military Collection, Brown
University Library (Providence, Rhode Island)

State Central Museum of Russian Modern History
(Moscow)

State Museum of Russian Political History
(St Petersburg)

Andre Ruzhnikov Collection (London)

Vladimir Ruga Collection (Moscow)

Collection of Sergey & Tatyana Podstanitsky
(Moscow)

Farfor-art Gallery (Moscow)

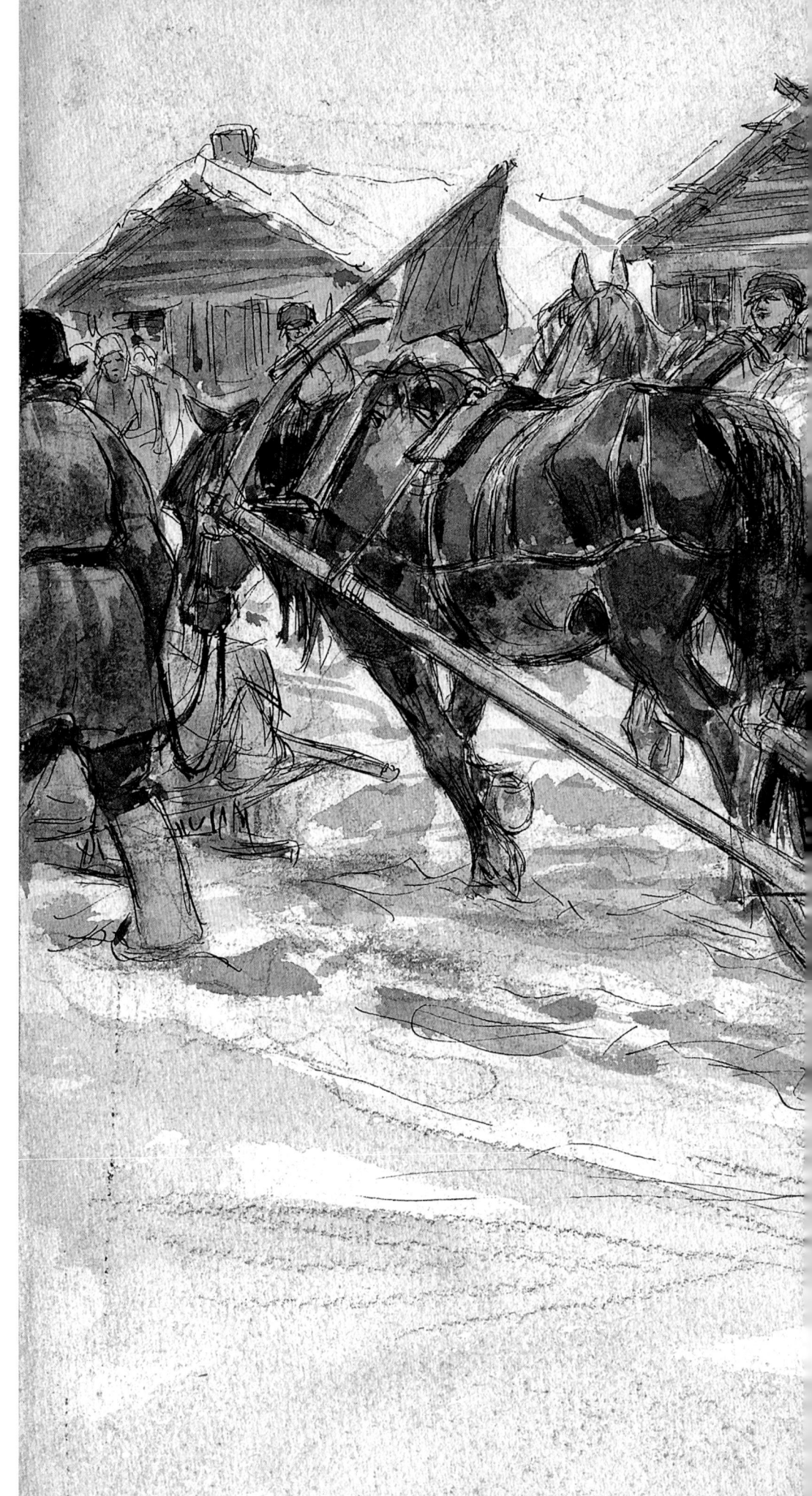

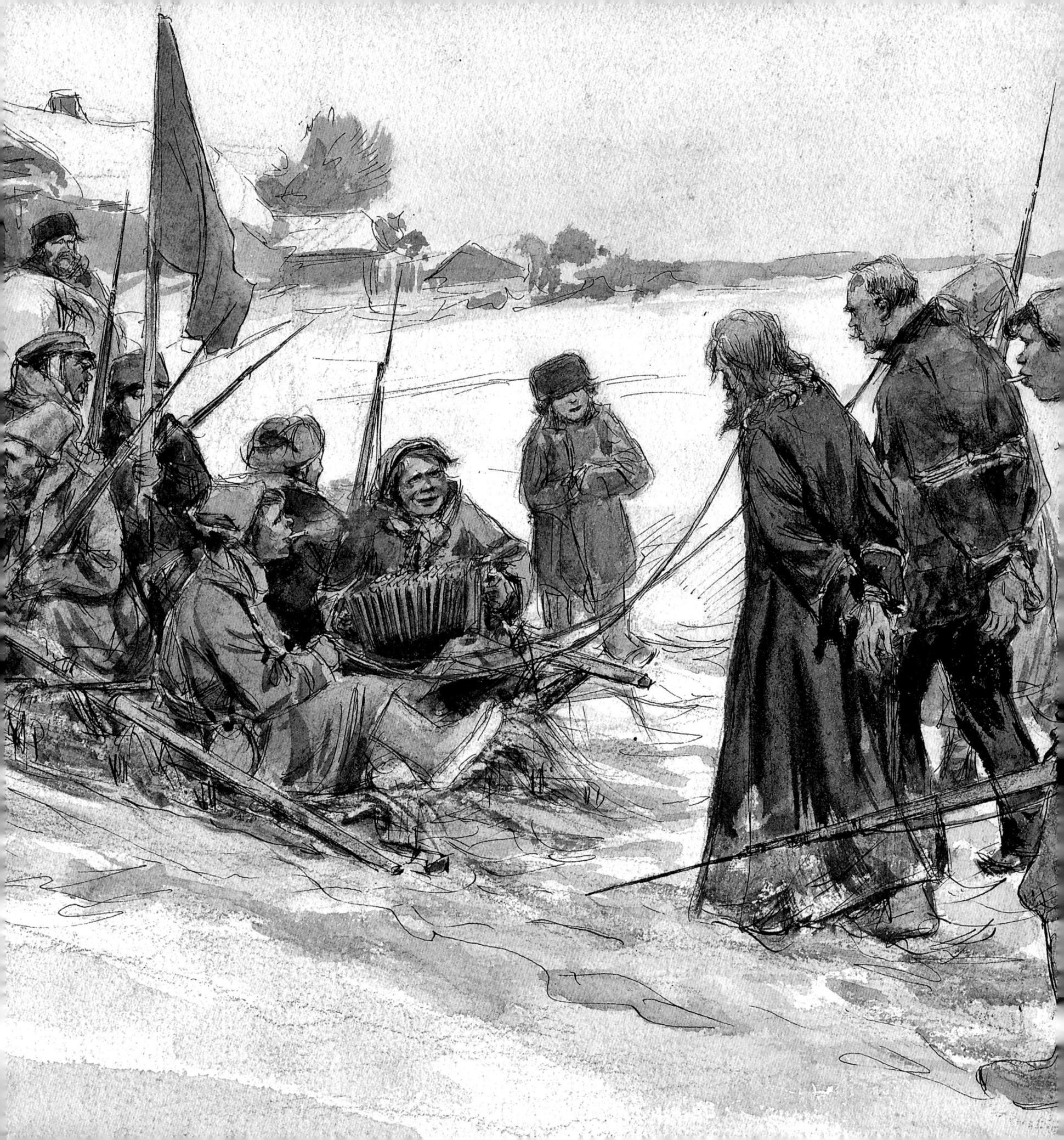

The editors would like to express their sincere gratitude to the following persons and organizations for their generous assistance:

Staff of the Hoover Institution Library & Archives and Stanford University Libraries (Palo Alto, California) for their invaluable help in preparing this book, especially Eric Wakin (Deputy Director of the Hoover Institution and Robert H. Malott Director of Library & Archives); Lisa Nguyen, Vishnu Jani & Fiore Irving (Digital Services Department); Samira Bozorgi and Marissa Rhee (Archivists); Alex Rajeff of Stanford University Libraries; and Mary Munill, formerly Senior Reference Specialist at Stanford University Libraries

Staff of the State Central Museum of Russian Modern History (Moscow), especially Vera Panfilova (Head of the Fine Arts Department, Honoured Cultural Worker of the Russian Federation) and Artur Rosovik (Curator of Art Collection)

Eleonora Zakharzhevskaya (Curator of the exhibition Onset of Revolution – Ivan Vladimirov as a Witness to Troubled Times, Museum of Russian Modern History, 2017)

Staff of the Herbert Hoover Presidential Library (West Branch, Iowa) for their kind and constant support for this project, notably Thomas F. Schwartz, Marcus Eckhardt, Spencer Howard, Melanie Weir, Lynn Smith & Craig Wright

Ryan Hale & Veronique Bowker for their help in preparing the texts

Sergei Volkov for his invaluable advice

Reto Barmettler, Head of Russian Art at Sotheby's London, for assistance in publishing a work by Ivan Vladimirov

Staff of Brown University Library (Providence, Rhode Island), especially Peter Harrington (Curator of the Anne S.K. Brown Military Collection)

Staff of the Russian National Library Manuscripts Department (St Petersburg) for their assistance in providing archival material

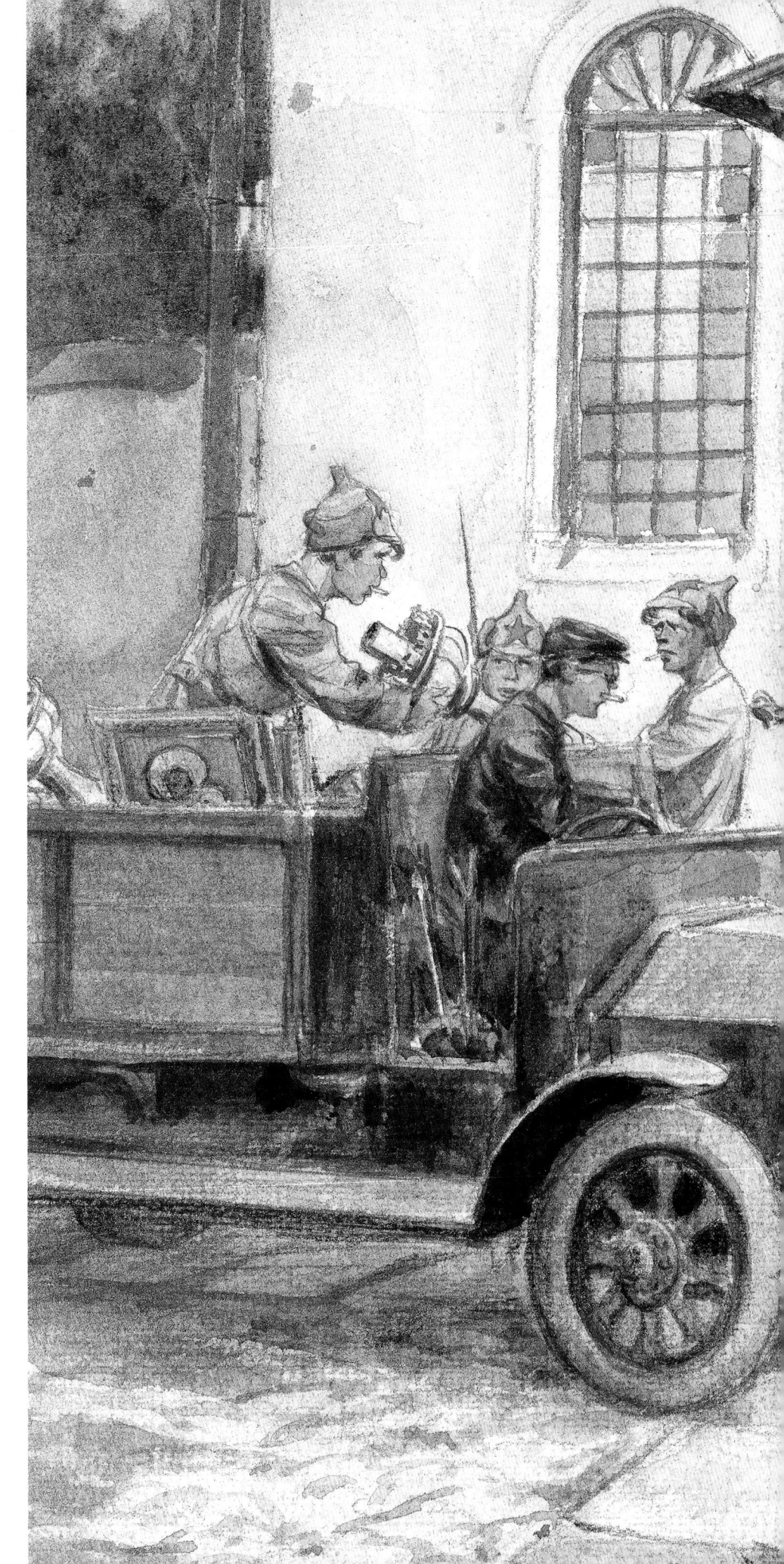

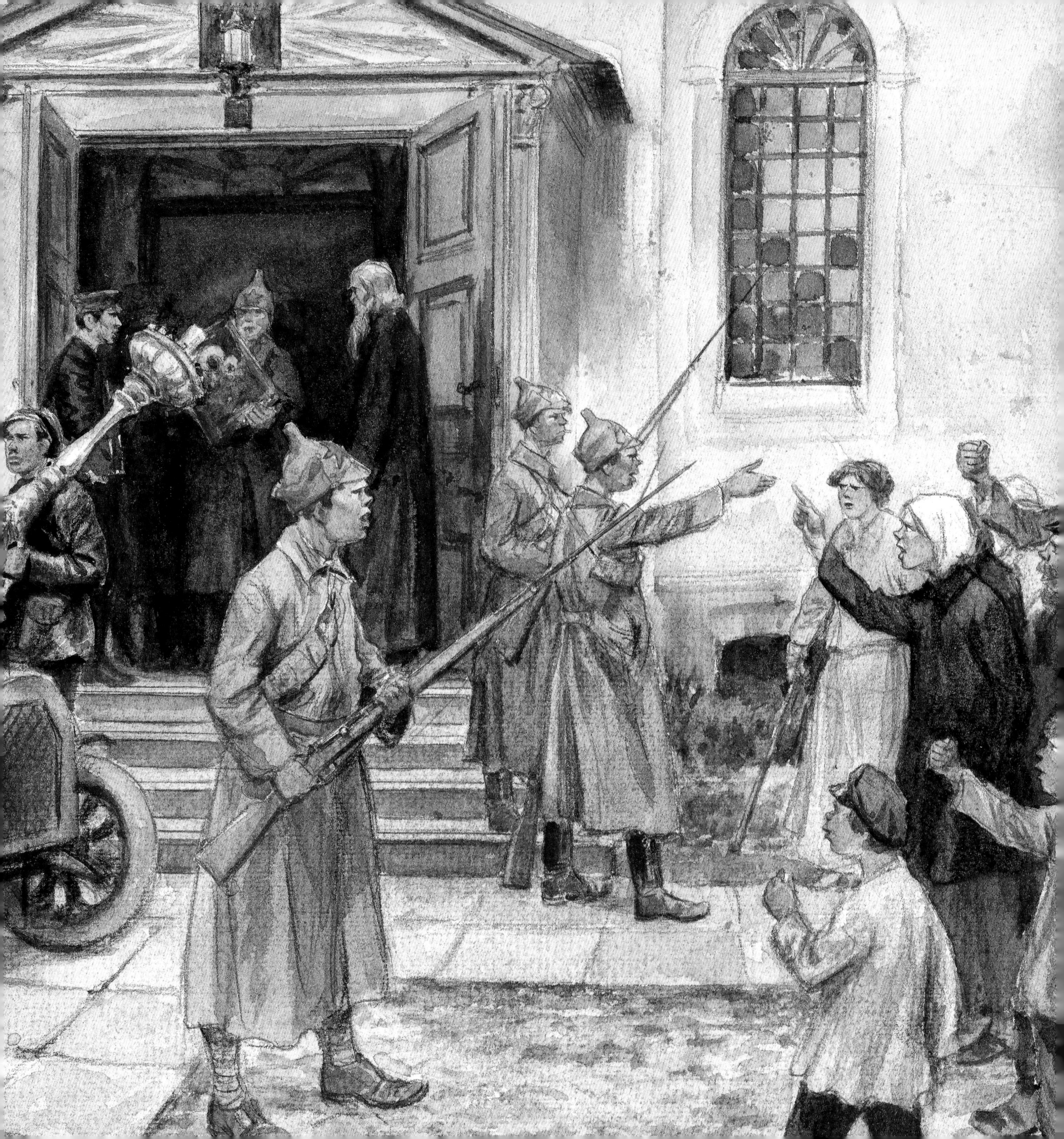

Contents

Chapter 1

8 Elena Danielson
The Dual Vision of War Artist Ivan Vladimirov during Russia's 'Accursed Years' (1917–25)

36 John Bowlt
Ivan Vladimirov – Painter, Draughtsman, Artist-Reporter

46 Peter Harrington
Views of War and Revolution in Russia

54 Irina Velikanova
Works by Ivan Vladimirov in the Museum of Russian Modern History

58 Vladimir Ruga
Works by Ivan Vladimirov in the Vladimir Ruga Collection

64 Andre Ruzhnikov
The Andre Ruzhnikov Collection

Chapter 2 **84** *'Down With The Eagles!'* – The Year 1917

Chapter 3 **112** *'Loot the Looters!'*

Chapter 4 **132** Red Terror

Chapter 5 **150** Bolshevik Propaganda

Chapter 6 **156** Years of Famine 1918–22

Chapter 7 **178** The Bolsheviks and The Church

Chapter 8 **188** Requisitioning in the Countryside

Chapter 9 **198** 'Former People'

Chapter 10 **216** Everyday Life in Petrograd

Chapter 11 **234** The New Bosses

Chapter 12 **260** Annotated List of Illustrations – compiled by Lada Tremsina

Chapter 13 **278** Variants of Vladimirov's Works

The Dual Vision of War Artist Ivan Vladimirov during Russia's 'Accursed Years' 1917-1925

Elena Danielson

Hoover Institution Archivist Emerita
Stanford University

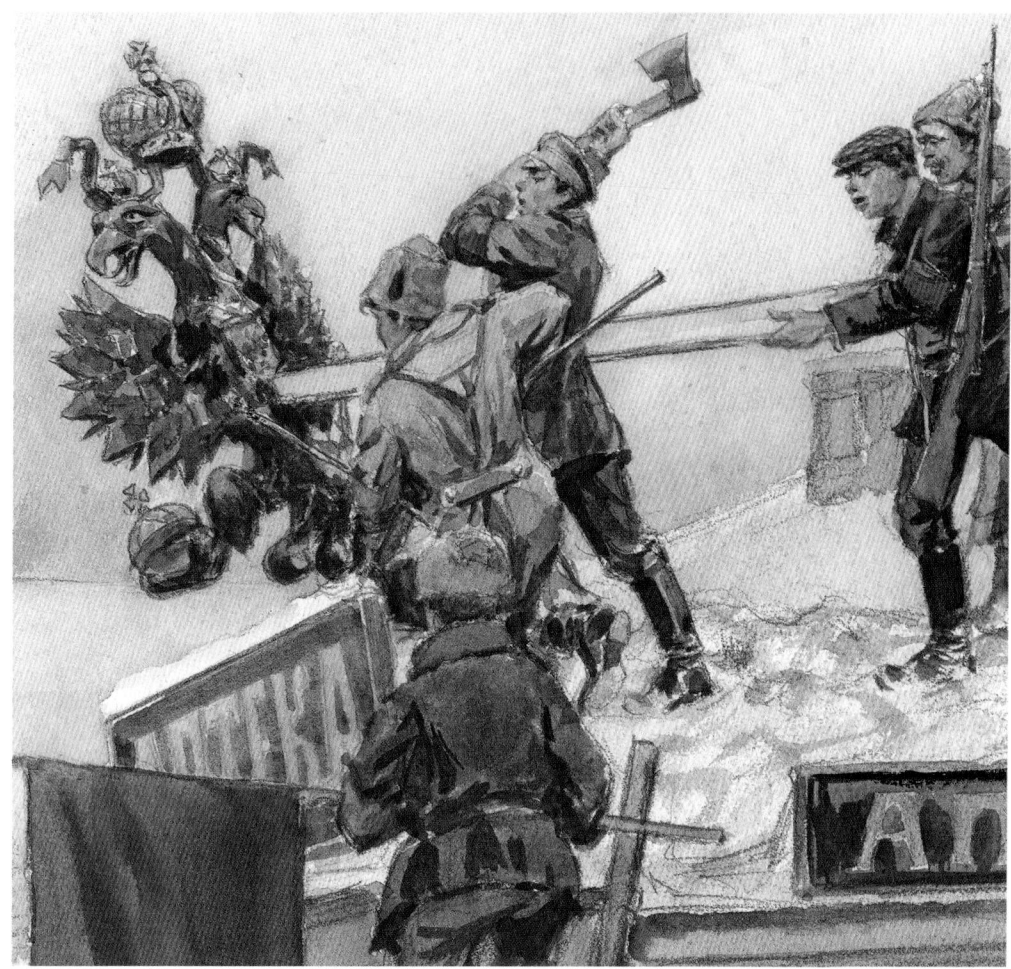

For about a century, the work of the prolific and enigmatic war artist Ivan Alexeyevich Vladimirov (1869 Vilna/Vilnius – 1947 Leningrad/St Petersburg) was far more influential than famous. But who was this artist? And why did he seem to have two different views of the Russian Revolution?

Few Russians in the Soviet Union knew his name, yet a survey of the Soviet history materials in the Hoover Institution Library & Archives at Stanford University turns up many of his historical images. One of the most compelling, Down with the Eagle!, was used to glorify the unstoppable energy of the revolutionary movement. Revolutionaries with red armbands climb a ladder on to the snowy roof of an apothecary, where they smash down the symbolic imperial double-headed eagle with a heavy beam and axe. One version, in oil on canvas, is preserved in the State Museum of Russian Political History in St Petersburg, while a slightly different, more spontaneous version, in watercolour on paper, is now in the private collection of Andre Ruzhnikov [ill. 8]. *Down With The Eagle!* is one of eighteen pictures by Vladimirov that illustrate Maxim Gorky's authoritative and lavishly-produced official *History of the Russian Civil War* (1935), a copy of which is preserved in the

Hoover Institution Library.[1] No expense was spared on this luxury edition. A silk Red Guard armband, similar to those worn by the revolutionaries in Vladimirov's picture, is fixed inside the first volume.

At the other end of the scale, inexpensive museum postcards of Vladimirov's works can also be found in the Hoover collections. Prints of his pictures were also, no doubt, publicly displayed as wall art: Filipp Anulov's 1928 portfolio illustrating the Russian Civil War includes four poster-format Vladimirov works suitable for framing.[2] As much a reporter as an artist, he often gave his pictures titles that read like newspaper headlines. His work was still used in the 1980s to illustrate a Soviet book printed for English-language readers.[3] Because his pictures were often used as informative illustrations rather than as art, they had an impact even on people unaware of the artist's name. Based on the evidence in the Hoover holdings, Vladimirov's imagery seems to have strongly influenced the Soviet perception of historical reality during the turbulent era spanning the First World War, the Revolutions and the Civil War.

In the West, Vladimirov's identity was even less known than in the Soviet Union, but his art still influenced general public perception of the Russian experience for a very different reason: the pictures taken out of the country to Europe and the United States vividly showed the anarchy of modern Russia: destruction and looting followed by suffering from cold and hunger, and the unfolding of Red Terror. On 14 April 1917 his drawing *Down With The Eagles* appeared on the front-page of the widely circulated London news weekly *The Graphic* [ill. 7]. The date of the event is specifically given as 13 March 1917, *New Style* (February 28, *Old Style*), two days prior to the Tsar's abdication. It looks like a preliminary sketch for the painting in the State Museum of Russian Political History, except that there is no red flag and the revolutionaries are not wearing red armbands. Instead of glorifying the Revolution, the caption in *The Graphic* decidedly disapproves of the anarchy unleashed in Russia in 1917, weakening a British ally.[4] Such captions were often based on Vladimirov's notes.

1 M. Gorky, V. Molotov, K. Voroshilov, S. Kirov [died shortly before publication], A. Zhdanov, A. Bubnov, Y. Gamarnik, I. Stalin, eds: History of the Civil War in the USSR (State Publishing House History of the Civil War, 1935-60). Reproductions of works by Vladimirov: Vol. I pp 13, 35, 37, 38, 68, 70, 72-73, 77, 227; Vol. II pp 111, 196, 197, 203, 211; Vol. IV pp 300-1; Vol. V pp 168-9. Hoover Library ref. DK265.I88. The painting *Down with the Eagle!* (1917) is in the State Museum of Russian Political History (St Petersburg). On the importance of visual agitation for the establishment of Soviet power in the revolutionary era, see V. Bonnell: *The Iconography of Power: Soviet Political Posters under Lenin and Stalin* (University of California Press, Berkeley 1997). According to Bonnell, there is something essentially Russian about Soviet political posters that has its roots in traditional Orthodox iconography.

2 F. Anulov: *Pictures of the Civil War* (Community of Artists, Leningrad 1928) – Hoover Library ref. *DK265.15 K37 1928*

3 A. Nenarokov: *An Illustrated History of the Great October Socialist Revolution: 1917 Month by Month* (Progress Publishers, Moscow 1987) – Hoover Library ref. *DK265.15 N43713 1987*

4 *The Graphic: An Illustrated Weekly Newspaper* (London, 14 April 1917). N.B. the English version of the title uses 'eagles' (plural) whereas the Russian version uses 'eagle' (singular)

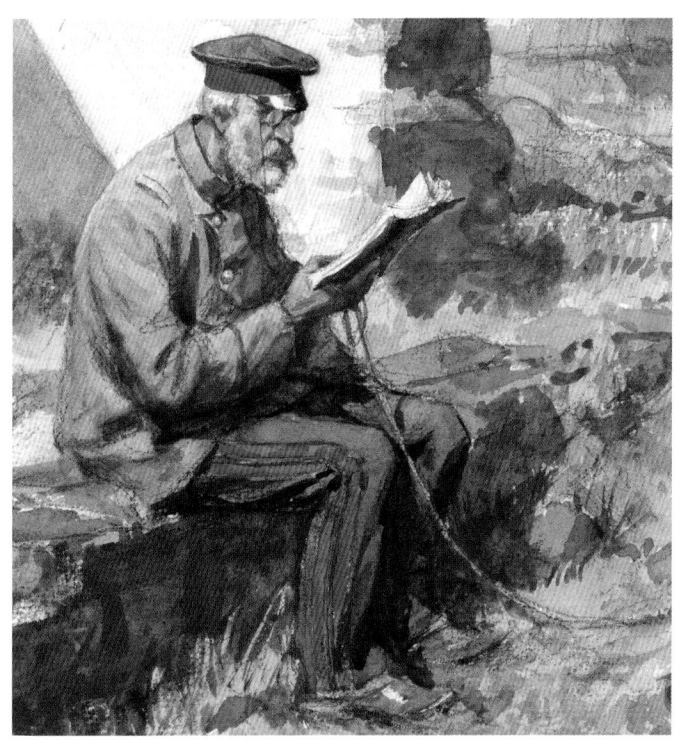

For decades his vision of events continued to have an indirect effect outside of Russia. For the 50th Anniversary of the Russian Revolution, the popular history publisher Horizon illustrated a special commemorative book using pictures by Vladimirov, all from an unmistakably anti-Bolshevik perspective. They came from the Anne S.K. Brown Military Collection at Brown University, and depicted tragic everyday situations such as starving middle-class women rummaging in garbage bins for scraps of food during the years of famine.[5] The artist's work continued to influence major American historians such as W. Bruce Lincoln, who was struck in the 1980s by the original works in the Hoover Archives, especially one labelled *Sic Transit Gloria Mundi* [ill. 66]: 'Perhaps nothing captured the sad spirit of the fallen in those days better than the watercolors of Ivan Vladimirov, one of which portrayed Prince Vasilchikov sitting on a crumbling stone wall in an overgrown courtyard. Vasilchikov's ragged trousers still bore the broad red stripe of a tsarist general, but the goat that stood tethered to his bony wrist spoke amply of the wretched plight of Russia's former lords, who faced poverty and physical danger at every turn.'[6] The general is intently reading a book.

Until 2017 the Hoover paintings, acquired between 1921 and 1925 directly from the artist, formed the largest publicly available collection of his anti-Bolshevik works. There are 37 Vladimirov pictures in the holdings of the Hoover Archives, ten at Brown University, and three in the Herbert Hoover Presidential Library at West Branch, Iowa (Hoover's birthplace). The private collections assembled separately by Andre Ruzhnikov and Vladimir Ruga each have about forty works. Given Vladimirov's prolific output, there could well be many more works in undocumented private holdings.

Some of the works at Hoover still have tinted paper obscuring the artist's signature to protect his identity out of fear of retaliation and retribution during his lifetime.[7] The colour and texture of the

5 E.M. Halliday: *Russia In Revolution* (Harper & Row, New York 1967), published with the support of Horizon magazine. For more information on works by Vladimirov at Brown University, see below P. Harrington, Views of War and Revolution in Russia

6 W.B. Lincoln: *Red Victory: A History of the Russian Civil War* (Simon & Schuster, New York 1989), pp 54, 531 (N.B. Lincoln spells the name 'Vasilshchikov')

7 The diaries of Kornei Chukovsky reveal that Vladimirov was able to mask artists' signatures to mislead tax inspectors – see Chukovsky, *Diary 1901-1969*, edited by V. Erlich and translated by M.H. Heim (Yale University Press, New Haven 2005, p. 134)

cover-ups blend in so well with the paintings that this protective work may have been done in the studio, and with good reason: far from glorifying the revolutionaries, these paintings, which show the dark side of events, would have been politically dangerous. The sketches are sympathetic to the humiliated victims of the Revolution. Using a vocabulary of gestures and symbols, often drenched in irony, Vladimirov depicts the plight of the dispossessed caught up in meaningless chaos, hunger, cold and violence. In one an evicted mother, suffering from exhaustion but still wearing a respectable hat, drags a cart with her family's few remaining possessions through the streets, while in the background triumphant commissars whizz by in an expensive touring car, enjoying the good life. The contrasting postures of victim and victor are unmistakable.

The Hoover Collection has been open to the public for decades. At some point a set of haunting Vladimirov paintings were framed and hung in the reading-room of the Library in Hoover Tower as a reminder of the 1917 events. Various researchers and visitors saw them on the wall, including a then-local art collector and dealer, Andre Ruzhnikov, who was deeply impressed by them in the late 1970s. In the 1990s designer Sandra Jordan inspired staff to take a closer look at the artwork. She supported a major exhibition at the Hoover Institution Archives in 1995/6, using new digital scanning technology to produce six-foot high enlargements that brought out the telling details of the artist's fine, miniature-style brushwork.

Still, although Vladimirov's images informed both academic and popular accounts of Russian history in the West, few Americans knew his name.

Here we have an artist who has made a significant impact in both Russia and the West: an artist with two perspectives, whose work forms a kind of historical diptych. At first glance Vladimirov's two visions seem incompatible and paradoxical at best, or self-serving and opportunistic at worst. Were his pro-Bolshevik pictures merely propaganda to win official approval? Were his anti-Bolshevik pictures merely produced to earn money and food from foreigners during the horrors of the famine years? Somehow it was the human quality of his work that definitively lifted it above the usual banal propaganda, and made it influential in two different spheres.

Until recently it was difficult to evaluate or even properly appreciate his place in Russian art history. In 1974 a well-documented and still valuable biography was published by A.I. Roshchin, long before the duality of the artist's work was understood.[8] In fact, Roshchin emphasised that the strong integrity of his art was bereft of duality. In 1983 Vladimir Lapshin included him in a comprehensive study of art from the year 1917.[9] Since 2009 much more detailed information about the man and his work has surfaced, first in the publication of the diary he kept during the Siege of Leningrad.[10] Of great importance is the scholarly biography by his granddaughter, the architectural historian Natalia Batorevich, with over one

8 A.I. Roshchin: *Ivan Alexeyevich Vladimirov: Life and Work 1869-1947* (Artist of the RSFSR, Leningrad 1974, p. 70)

9 V.P. Lapshin: *The Artistic Life of Moscow & Petrograd in 1917* (Soviet Artist, Moscow 1983)

10 I.A. Vladimirov: *The Great Patriotic War: Blockade Notes 1941–1944* (Dmitry Bulanin, St Petersburg 2009)

hundred illustrations, half in full colour and many published for the first time.[11] She also supplies detailed information on Russian museums which hold his works. Now we also have contributions from two knowledgeable private collectors, Andre Ruzhnikov and Vladimir Ruga. In February 2017 the Museum of Russian Modern History in Moscow exhibited the Ruga Collection together with several Vladimirov pieces from its own holdings.[12] The present volume includes over one hundred colour reproductions, most of them absent from the two biographies. In a sense, this book rescues Vladimirov's works from the 'accursed years' of 1917–25 from oblivion.

With this wealth of material it is finally possible to trace the evolution of this remarkable artist, from a polished but traditional war artist to a dedicated – even obsessive – chronicler of the events overwhelming his native land. There were still two distinct modes of perception in his art during this turbulent era, but the links between them became clearer, along with his formidable narrative talent, empathy and inclusive patriotism.

By comparing various depictions of similar scenes and presenting his pictures in chronological sequence, it is possible to follow Vladimirov's close observation of the unfolding of events. To tell his stories he deploys the same stock characters, each with a distinctive attribute, in different scenes using a range of recurring motifs and gestures. In the course of composing hundreds of sketches he constructed a vocabulary of tropes and signs: a visual language with a set of symbols and a kind of syntax for combining and recombining small details. Take *Down with the Eagle!* The same basic scene is presented in either a positive or negative way by manipulating those symbols. The viewer is rewarded with a sense of the drama of the era, and with a heightened understanding of the people swept up in events they could not comprehend. Assembled together, the sketches can be read like a book, somewhat like the sequential art in a modern graphic novel or 'storyboard.'

Vladimirov made many of these sketches under combat conditions, and took additional chances to ensure that both sides of his work survived. According to his London publisher in 1918, 'Our Russian artist, Mr. John Wladimiroff has seen many of the episodes for himself and has run great risks on several occasions in Petrograd.'[13] Since the 1920s the critical anti-Bolshevik pictures have been dispersed in the West, largely in private collections. Reassessing both visions in his work, even a century later, brings out a coherent and highly empathetic message – as the artist clearly intended. Ivan Vladimirov will hopefully become not just influential, but also better known and better understood.

11 N.I. Batorevich: *I Served Russia All My Life... The Life and Work of I.A. Vladimirov* (Dmitry Bulanin, St. Petersburg 2013)

12 *Onset of Revolution – Ivan Vladimirov as a Witness to Troubled Times,* exhibition at the State Central Museum of Russian Modern History (Moscow, February 2017)

13 *The Graphic,* 17 September 1918 (p. 264)

Where did this talented, decent and astute man come from? From Batorevich's carefully documented and richly illustrated biography, we know that Vladimirov's mother, Catherine Waghorn (died 1872), was English, and a watercolour artist herself. His father, Alexei Porfirievich Vladimirov (1829/30–1905), was a multilingual Russian intellectual who built up a significant museum and library in Vilna (now Vilnius). There were many English-language books in the home when the boy was growing up. His parents called him Johnny. In non-Cyrillic documents, his family used the spelling *Wladimiroff*. He spent time in both England and Russia, and was fluent in both languages. He signed his name as *John Wladimiroff* in an English context and used the usual Cyrillic version in Russia. In a sense, he always lived in two different cultures.

As a teenager he travelled on his maternal uncle's ship as a cabin boy, and saw the world, including pre-skyscraper New York around 1883. In his youth he also had some kind of training for railroad jobs, a skill that would later become important. Batorevich quotes her grandfather on his motivations in life: 'Two passions have possessed my soul throughout my life – a passion for drawing and a passion for travel.'[14] The combination of these two interests led him to a career as a formally-trained war artist, or artist-reporter, who travelled to often distant battles using a sketch-book to capture scenes from life, when cameras were too heavy and too slow to take into the field. First, he studied in his home town of Vilnius. Then he trained as a professional war artist at the Imperial Academy of Arts in St Petersburg, in the battle-painting class of Professor Bogdan Willewalde (1819–1903), who stressed the importance of accuracy and truthful representation. He also studied in Odessa and, in Paris, under Edouard Detaille (1848–1912) who, like Willewalde, was famous for his meticulous realism. The young Vladimirov served in the military, travelled to the front, wore a uniform, shared the dangers of military life, and recorded military history. His early work is constrained by the requirements of the military art genre, but is always of high quality. His profession as battle artist required him to record with precision the different uniforms of various armies and units. Like his mentor Willewalde he paid great attention to depicting horses and cavalry with impeccable detail. As a graphic artist he also made technical drawings of subjects like archeological sites and, given his interest in narrative art, tried out storybook illustration.

According to Batorevich, he first began to work as a special correspondent in 1898, in his late twenties, for the newspaper *Petersburgsky Listok*. He published his eye-witness drawings in this same newspaper for two decades, as well as working for other magazines like *Niva*, *Ogonyok* and *Solntse Rossii*. He perfected the methods he had been taught in the Academy, carrying a small pocket sketch-book and pencil with him to record the action as he saw it unfold, together with written notes. Later, in the studio, he used paint and ink to develop the sketch into a more finished

14 N.I. Batorevich: *I Served Russia...* (p. 22)

depiction, and provide it with a caption. We know he thrived on travel, saw the Caucasus and Crimea, and went as a war artist/correspondent to China during the Boxer Rebellion (1900). He recorded the aftermath of an earthquake in Azerbaijan in 1902, the Russo-Japanese War in Manchuria in 1904, and the revolutionary events of 1905 in St Petersburg, Baku and Moscow.

Then Vladimirov spent time in London, where he made useful contacts and got to know the publishing houses that were producing richly illustrated news weeklies such as *The Graphic*, which presented readers with a polished vision of the world order as though efficiently run by benevolent royalty. The editors bragged about their excellent eye-witness sources around the world. Vladimirov, as one of them, was especially praised, as his paintings were being bought by museums and by members of the Russian aristocracy. A major one-man show in Petrograd in 1915 promoted his work. Over the years *The Graphic* published more than a hundred of his drawings and watercolour sketches, some as early as 1905. Arranged in chronological sequence these drawings compose a pictorial history of the early 20th century. The income from this productive period of his career enabled him to build a large house in St Petersburg, on Bolshaya Grebetskaya, with both a studio and space for his extended family. He later built a charming dacha outside St Petersburg in the artists' colony of Kellomiaki (now Komarovo).

His early painting was not generally considered 'high art' in the European sense of 'art for art's sake.' At a time when French, German, and Russian Avant-Garde artists were experimenting with colourful impressions and the beginnings of abstract art, Vladimirov stayed with the realistic narrative school of the 'Wanderers' (Peredvizhniki). He excelled at documentary paintings that captured a story. The Wanderers' realism, and the closely observed reportage of battle-painting, merged in his work. In 1910 he took part in an exhibition of Russian art in London that was reviewed by The Times.[15] While his form of art was not newly fashionable, viewers liked looking at it and enjoyed decoding the embedded metaphors. And newspapers and magazines needed his reportage from distant and dangerous battlefields.

Vladimirov was trained to work at the front. In 1905 that front came to revolutionary St Petersburg. He may have been a good soldier but, like many educated Russians, he felt sympathy for the demonstrators who were fired on by government forces. Batorevich documents several Vladimirov paintings that were censored and removed from an exhibition in 1906 because they showed tsarist forces in a bad light.[16] There followed a stint covering the Balkan Wars (1912–13), where he was fascinated by the different cultures he encountered. Meanwhile he had a growing family to support, with six children. Fortunately the news journals seem to have paid him well.

..

15 R. Beasley & P.R. Bullock: *Russia in Britain 1880-1940: From Melodrama to Modernism* (Oxford University Press, 2013, p. 153), with reference to The Times, 1 November 1910. The Russian exhibition was staged at the Doré Gallery in New Bond Street. Vladimirov was represented by four works, including a portrait of Tolstoy in his garden at Yasnaya Polyana (reportedly acquired by Liverpool's Walker Art Gallery). Other participants included the artists Konstantin Makovsky and Nikolai Kravchenko, and the sculptors Eugène Lanceray, Konstantin Isenberg and Tolstoy's son Lev.

16 N.I. Batorevich: *I Served Russia...* (p. 156)

According to family descriptions, the roomy house on Bolshaya Grebetskaya became a Silver Age paradise, with lots of dinner parties – a centre for artists, poets and singers, including the great Chaliapin, to meet and exchange ideas. It was no doubt an orderly and ship-shape Silver Age paradise, befitting the nephew of a ship's captain, rather than a Bohemian salon. Vladimirov experimented with portraits and historical themes: Pushkin in a park, thinking poetic thoughts; Napoleon in Russia; Tolstoy on his horse. The one thing he never seriously experimented with was the Avant-Garde style that was becoming so influential in Russian fine art circles. He was above all a Realist. Given the fate of the famous Avant-Garde artists in Soviet Russia, his style would prove much safer in turbulent times.

Fuelled by advances in photography and printing technology, the First World War saw an unprecedented increase in publishing: an outpouring of posters, postcards, and journals, all requiring his style of reportage artwork. Vladimirov was extraordinarily productive, producing war-loan posters, patriotic postcards and newsy vignettes not just for London readers but also for *Niva* in Russia and *L'Illustration* in France. These journals celebrated his art with reproductions and interviews.[17] His Great War images were starting to show the story-telling dimension that later made his work so intriguing. In one First World War loan poster, the wounded Russian soldiers return from a battle swathed in bandages but with noble posture, bloodied but unbowed; one nonchalantly carries a German helmet as a souvenir. Despite his sympathy with the 1905 demonstrators, Vladimirov supported the tsarist army long after many intellectuals became disillusioned with the monarchy.

Although he apparently never felt a need for abstraction, Vladimirov did make a significant transition in style and mood in 1917. Talented illustrators have frequently made a similar shift as their skill develops. In the U.S., Winslow Homer (1836–1910) began as a battle illustrator in the Civil War, working for *Harper's Weekly*, before switching to a more painterly aesthetic. In Russia, Vasily Vereshchagin (1842–1904), whom Vladimirov knew, was also a battle artist whose work over time took on greater significance; with his *Apotheosis of War*, which depicts a pile of human skulls, he became controversial for his anti-war message. Vladimirov gradually made a transition from accurate and direct realism to a more complex style of ironic story-telling. His gesture drawing was able to capture details that occurred over several moments or even hours, and distilled a feeling or story to its essence in a way the camera could not. (At some point he not only changed his style but also his appearance: as a young artist he sported a distinctive bushy moustache; later he posed clean-shaven, with a pipe.)

Batorevich describes how her grandfather elaborated on his spontaneous sketches to create more formal depictions of events using watercolour or oils. As we have seen, the same initial sketch could be interpreted differently in various versions. The sketchbooks from 1904 through 1924 focus on several revolutionary periods; they

17 *With the Russian Army: Sketches by our Special Artist John Wladimiroff* (supplement to *The Graphic*, 18 December 1915) – *The War Artist I.A. Vladimirov* (*Niva* 1915, no 46, pp 841/2), for one of the reproductions, see *Niva* 1914, no 42 (p. 811) – M. Vlagin: *First Exhibition* (*Lukomorye* 1915, no 37, p. 17). See also Hubertus F. Jahn, *Patriotic Culture in Russia during World War I* (Cornell University Press, Ithaca 1995, pp 35, 41, 71, 186)

record the transformation of the country and the suffering of both the ordinary people and the dispossessed upper classes. From the beginning of the February 1917 Revolution through 1918, Vladimirov worked for the Petrograd militia, and went on rounds with his sketch pad. 'During my militia service, I always had with me a little sketchbook and freely sketched everything that presented major interest to me. Upon returning home I would add, according to my impressions, the necessary strokes to the sketches, and sometimes even paint over them with watercolours. Thus, I gathered a wealth of documentary material for future paintings, depicting scenes and episodes of the revolutionary struggle.'[18] While many of the sketches depict scenes he witnessed on the streets of Petrograd, some were drawn in the villages along the Moscow-Vindava-Rybinsk railway where he worked between 1919 and 1921. These four small albums with over 200 drawings have been preserved in the Manuscript Department of the Russian National Library (formerly the Saltykov-Shchedrin State Public Library) in St Petersburg *(Collection 149)*. They were given to the Library by the artist in Summer 1947, just a few months before his death. Many of these sketches were reworked for the paintings that are now in the Brown, Hoover, Ruzhnikov and Ruga collections, including the preliminary sketch for *Down with the Eagle!*[19]

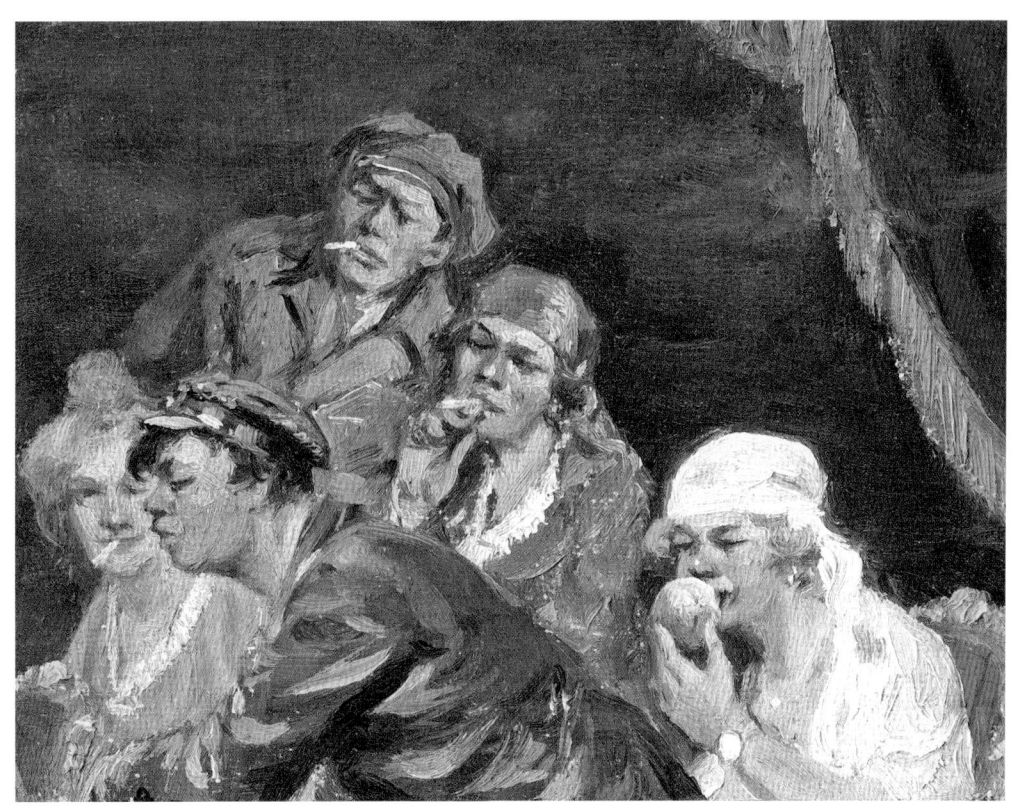

The paintings based on these drawings develop formulaic elements and caricature-like stock characters with identifying attributes: flirtatious factory girls wearing stolen gold watches, the impudent peasant boy with a gaping mouth and misshapen nose, the arrogant commissar, downtrodden priests and despairing mothers. One recurring stock figure, the cheeky Red Guard wearing stolen boots, has been identified in one of his sketchbooks as a real character named

18 N.I. Batorevich: *I Served Russia...* (p. 161); V.P. Lapshin: *Artistic Life...* (p. 106). Both authors cite the artist's memoirs in the Archives of the Russian Academy of Arts (Collection 33)

19 National Library of Russia – Manuscript Department (Collection 149, Units 6–9); *Down With The Eagle* (Unit 7, p. 23). The author is grateful to current and former staff at the Manuscript Department of the National Library of Russia for their professionalism in preserving this valuable collection. Lada Tremsina thanks the staff of the Manuscript Department for their assistance in her study of Ivan Vladimirov.

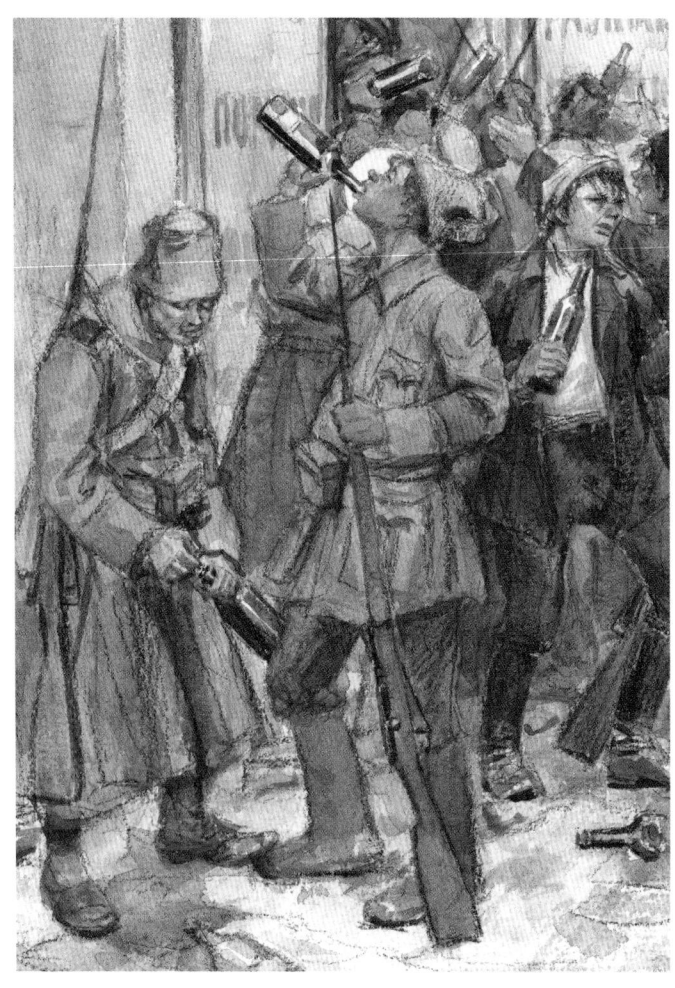

Senka Baldin (or Boldin): 'His distinctive snub-nosed face appears more than once in the artist's drawings and paintings.'[20] The random drunkenness, self-destructive behaviour and gratuitous violence of the 'accursed years', which affected both Reds and Whites, is vividly depicted. Eager looters steal stock certificates for businesses that have been destroyed. Cold, hungry urban dwellers desperately chop down the walls of a bakery for firewood. Peasants loot priceless porcelain that is unlikely to survive unbroken. Starving families cut up a dead horse lying in the street while, in the background, Red Guards blithely wave red flags and celebrate their victory. Priests, officers and landowners are rounded up for execution while the new rulers play the accordion and sing. With these images, all drawn from real life, Vladimirov's artwork takes on an empathetic quality mixed with irony that documented what many Western observers of the day had seen but had difficulty expressing or describing.

In September 1918 Vladimirov abruptly stopped his apparently well-paid but politically hazardous work for the decidedly anti-Bolshevik *The Graphic*. We can only speculate as to his reasons. In its September 7 issue, *The Graphic* openly supported Allied intervention in Russia in an editorial illustrated with one of his drawings, and a note lauding Vladimirov's willingness to take risks in recording these violent street scenes. His last sketch in these pages was published on September 18. He then began rechannelling his native patriotism into pro-Soviet images, sometimes just taking his old sketches and reconfiguring the symbolic gestures – as when *Down with the Eagles* acquired a large, vibrant red flag. He continued to produce critical anti-Bolshevik works for visiting European and American aid workers, but at the same time took part in exhibitions with panoramas glorifying recent street fighting. In 1919 he took part in the First Free State Exhibition of Artworks in Petrograd. In 1923 – the same year he was under contract to produce anti-Bolshevik works for the Hoover Library – he participated in the *Exhibition of Paintings by Petrograd Artists of All Tendencies* and joined the Association of Russian Revolutionary Artists, or *AXPP (Ассоциация Художников Революционной России)*. His paintings *Flight of the Bourgeoisie from Novorossiysk* [ill. 75] and *The First Village Tractor* [ill. 110] both bear the inscription *AXPP* and were exhibited at the *Association's eighth exhibition in 1926, devoted to the Everyday Life of the Peoples of the USSR.*[21]

20 N.I. Batorevich: *I Served Russia...* (p. 172). See: National Library of Russia – Manuscript Department (Collection 149 – Unit 8, p. 37)

21 N.I. Batorevich: *I Served Russia...* (p. 358). Re AXPP, see: N.M. Shchekotov, Art of the USSR: The New Russia in Art (Association of Artists of Revolutionary Russia, Moscow 1926)

How Vladimirov was able to manage both registers simultaneously can perhaps be explained by his Anglo-Russian background. While he was able to modulate his message to please the new authorities – and there was plenty of propagandistic energy in his pro-Bolshevik paintings – his imagery always had an element of truth and a spark of creativity. To support himself and his family during the years of famine he worked for the Petrograd Militia, taught drawing and even worked for the railways. With whatever time he had left he buried himself in his art – producing a stream of sketches and paintings, some commercially viable, others apparently for himself.

Theoretically, he was a member of the vilified bourgeoisie. As such, his house was requisitioned. He told an American aid worker, the YMCA's Ethan T. Colton (1872–1970), that he was happy to live in one corner of the house he had built, as ten other families of strangers had been moved in. His granddaughter, however, reports that the loss weighed heavily on him, and he responded by burying himself in his work.[22] We know from surviving correspondence that, during Russia's 'accursed years', he took risks to convey his critical paintings to the West – selling them, exchanging them for food or trading them for art materials. Others were gifts – souvenirs of hardship, like one at the Hoover dedicated to American Relief Administration worker Donald Renshaw (1889–1961). Renshaw was deeply concerned with the welfare of the Russians he met. In 1921 he wrote to his father about an architect who had sold his last coat for bread and did not expect to survive the Winter.[23]

With his excellent contacts in England Vladimirov could, like many other educated Russians, have emigrated – although whether he could have brought his large family with him is unclear. Instead he made a startlingly evocative painting of emigration: the masses evacuated in chaos from Novorossiysk. People are waving their papers, trying to board. A white-gloved officer tries to keep the mob from swamping the ship. Looking closely at Vladimirov's scene, one can see a former general, one of his stock figures, tightly clutching a now useless silver samovar as he tries to get on the overloaded vessel. The artist painted it in such a way that it could be interpreted either as sympathy for the panicked victims of the Revolution or as ridicule from the new ruling class. It is one of the few paintings in this book not drawn from life (it is unlikely that officers were still wearing impeccable white gloves after their defeat in the devastating Civil War), but the hand gesture conveys finality: there is no turning back, even for those who cannot make it. The artist is the master of the eloquent gesture. Despite the stylized details, the confusion matches the scene described by Nadezhda Lokhvitskaya (1872–1952) in her *Memories from Moscow to the Black Sea*. Lokhvitskaya – writing as *Teffi* – lampooned effete émigrés, such as the women who had to get their hair done before fleeing on the last train or ship out, while making her opposition to both Tsarism and Leninism abundantly

22 Letter from Ethan T. Colton to Bernice Miller, 12 July 1962 (Herbert Hoover Presidential Library 62-6-54, Colton Correspondence). Vladimirov's biography written by his granddaughter adds the missing details to the radiant picture he painted in conversations with foreigners (see Batorevich, *I Served Russia...* pp 59, 61)

23 L. Farrow: *From Jackson Square to Red Square: Donald Renshaw and Famine Relief in Russia 1921–23* (Louisiana History Vol. 43, 2002, no 3, pp 261–79)

clear. Vladimirov's image can also be seen as working both ways – an ambivalent form of criticism.[24]

Vladimirov remained in Leningrad during Soviet reconstruction and industrialization – an era leading on to the great World's Fairs. Soviet Russia was determined to have a strong presence in them, just as Imperial Russia had. The 1900 World's Fair in Paris showcased the Trans-Siberian Railway; the 1937 Paris Exposition bragged about the Dneprostroi Dam. The oversize Soviet Pavilion faced off against the Nazi German Pavilion. Interpreting Soviet ambition required graphic artists and Vladimirov was in demand. Two years later the USSR built another monumental Pavilion at the New York World's Fair. To underline Soviet achievements Vladimirov took his once controversial depiction of the 1905 riots, *Firing on the People at the Winter Palace on 9 January 1905*, and enlarged it into a triptych – one so enormous it had to be rolled up in his studio and lowered out of a window before embarking on its transcontinental journey.[25]

Soviet participation in the 1939 New York World's Fair generated contentious debate among Americans. The red star on top of the Soviet Pavilion's huge tower, designed by Boris Iofan (1891–1976), was initially higher than the American flag, which had to be hoisted even higher. Vladimirov's paintings glorifying the Revolution were key to the Pavilion's message. Batorevich does not make clear whether Vladimirov actually saw his work on display in New York in person. What is clear is that the Soviet presence in New York attracted attention, both positive and negative. It is worth noting that, in 1939, Herbert Hoover (1874–1964) was living in New York, in the Waldorf Astoria Towers, and acquired the carillon from the Belgian Pavilion to top his own Library Tower being built at Stanford at that time. He may have known that his Library owned anti-Bolshevik paintings by the same artist whose work in the Soviet Pavilion celebrated the transformation of Soviet Russia. The irony will have appealed to Vladimorov.

The Soviet Pavilion at the New York World's Fair was dismantled early due to the outbreak of World War II. Vladimirov, a long-term resident of Leningrad, spent the whole war in the blockaded city, losing family members, including his wife, to privation and hunger. Even at his advanced age, he went as an artist-reporter to the frontline which was now close to his home. Throughout it all he kept a diary and made sketches to record the long ordeal – not for propagandistic reasons, certainly not for sale. Some of the same motifs that he used to depict the famine of 1918–21 reappear, but in a different style in the 1940s, such as fetching water from the Neva River in the snow when the municipal water-system broke down, or the duty to bury the dead even in desperate times. These themes re-emerged in his blockade notebooks, in text and images, now without any irony or humour. During the 1940s his habit of

24 Teffi (Nadezhda Lokhvitskaya): *Memories from Moscow to the Black Sea* (Pushkin Press, London 2016, p. 311) – the final chapter describes the chaos among Russian refugees embarking in Novorossiysk for Constantinople

25 N.I. Batorevich: *I Served Russia...* (pl. 15, pp 175, 358); re Vladimirov in New York, see p. 22. See also A. Swift, *The Soviet World of Tomorrow at the New York World's Fair 1939* (The Russian Review, Vol. 57, no 3, pp 364–79) Archival material about the Soviet Pavilion at the World's Fair can be found in New York Public Library.

observation continued as a duty to record what he saw. The journal *Zvezda* honoured him for this in a wartime piece called *Leningradskie Portreti – Gnevnaya Kist*.[26]

Between Batorevich's scholarly research and the newly available collections, it is now possible to reassess the different phases of his career, from conventional illustrator to an intensely dedicated interpreter of the Russian Revolution, including its dark side. The later images from the Blockade add depth and context to the earlier ones, such as the paintings at Hoover. In the drawings of the Siege of Leningrad the humorous touches are gone, the propagandistic flourishes are also gone. The sketches are the perceptions of a close observer: they show the way a woman struggles to balance a bucket of water, the straining required to drag a fallen loved one through the snow to some kind of improvised burial. These smudgy drawings may be his finest work – the documentary eye-witness accounts of Russian suffering that, one way or another, touched every family during the Second World War. They were published for the first time by his granddaughter in 2009, more than sixty years after his death. (The originals were also preserved in the Russian National Library Manuscript Department, *Collection 149*.)

As we have seen, Vladimirov was a man of considerable physical courage. He endured battlefield conditions early in his career in foreign countries, and later in his own city as violence overwhelmed the tsarist regime. He took his skills as a traditional war artist and applied them to document the unprecedented conditions in the streets of Petrograd, including fighting on Bolshaya Grebetskaya near the house he had built. In this transition from foreign wars to revolution at home, his work acquired an enhanced style and a unique empathy. He knew his observations were historically significant. He took chances to record scenes he observed, and he took measures to ensure that these documents would survive both in Russia and in the West. We will probably never know whether he wondered about the fate of his artwork that went abroad. He lived to see the Russian victory after the Second World War and his portraits, from just before his death in 1947, seem to have a sense of coming full circle. He managed to obtain a number of awards and recognition. With his signature pipe in his hand, he posed in 1946, the year before his death, for a portrait photo, proudly wearing his medals.

26 V. Druzhinin: *Leningradskie Portreti – Gnevnaya Kist* (Zvezda no 1, Leningrad 1943, pp 91–97)

The Hoover Library's Frank Golder and the
Acquisition of Vladimirov's Works in the 1920s

As mentioned above, the Hoover Institution Archives still preserve the paintings acquired by the intrepid curator-collector Frank Golder (1877–1929) in Moscow and Petrograd in 1921–25. How these 'counter-revolutionary' artworks got to California from Lenin's Russia is a unique story involving Library founder, curator and artist – all in the complex context of tense international relations.

As revolutionary events in Russia attracted the attention of the rest of the world, including observers in Washington, the breakdown of diplomatic relations made it extremely difficult to assess exactly what was happening. Experts were actively looking for ways to understand the unpredictable turmoil. Herbert Hoover was more knowledgeable about the origins of the Revolution than most Americans. He had travelled extensively in pre-revolutionary Russia several times between 1909 and 1913, to attend to his far-flung mining investments, from Karelia to Eastern Siberia. From these experiences he knew about the political implications of labour unrest. After his triumphs as a humanitarian in the First World War, Hoover worked for President Wilson at the Paris Peace Conference of 1919. Hoover had seen the horrors of the Great War up close, and the quest for peace became a passion with him. From Paris and Washington he sent urgent telegrams to his close confidents at Stanford University, his *alma mater*, and in 1919 authorized a substantial personal donation to fund the innovative enterprise he had in mind: to build a library at Stanford to study the causes of the First World War and the Russian Revolution. He worked in close collaboration with professors in the Stanford History Department, such as Ephraim D. Adams (1865–1930). Then, as Secretary of Commerce in the 1920s, but with a strong interest in the work of the State Department, Hoover wanted to find as much documentation on the new Soviet regime as possible.

Collecting books and documentation in Europe was challenging enough, but documenting the situation in chaotic Soviet Russia seemed hopeless. In 1920 Professor Adams hired the Harvard-trained historian Frank Golder to collect materials on the Russian Revolution and Soviet Russia. Born in Odessa, Golder had come to the United States as a small child and excelled in his studies. He became a history professor specializing in Russian History, and with a particular talent for documentary research, which served him well as a member of Woodrow Wilson's study group – known as the Inquiry – which studied the Great War. Golder had first-hand experience with the drama unfolding in Petrograd. He had been in St Petersburg, working in the archives, when the First World War broke out and had been in Russia again during the February Revolution. He shifted from writing about history to analysing the turbulence in the Russia of his day.

He was finally able to return to Soviet Russia as a representative of the newly founded Hoover War Library under unusual circumstances. For years – actually, since the beginning of the Great War – Herbert Hoover had tried to find a way to stabilize conditions in European Russia. By 1921 post-revolutionary Soviet Russia had become so desperate, and food supplies so dangerously low, that Lenin finally

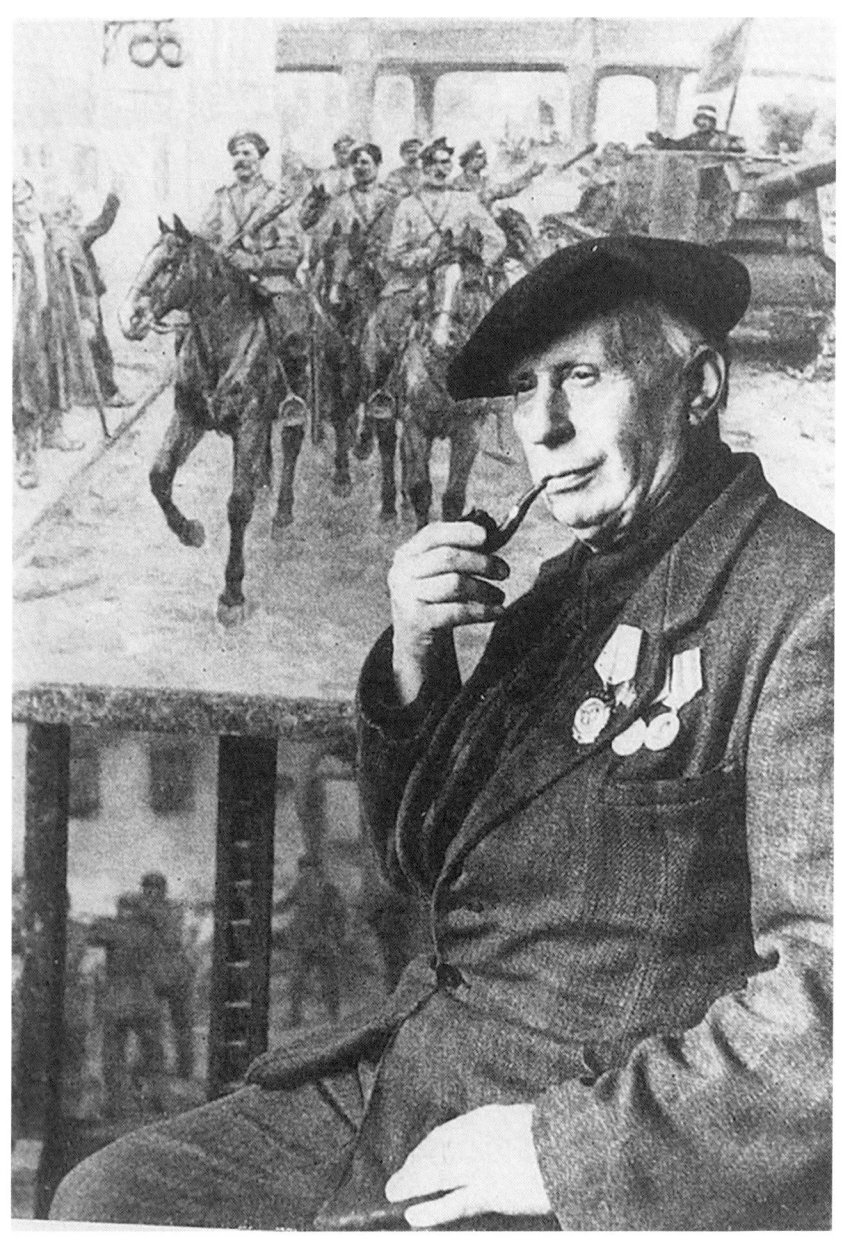

IVAN VLADIMIROV (1946)

permitted Hoover to send huge quantities of food supplies to a population that was literally starving.[27] An extensive network of American-funded food distribution centres was established throughout much of European Russia, all the way to the Urals. A couple of hundred American aid workers organized local feeding-stations and helped stave off starvation for millions of Soviet citizens between 1921 – when the American Relief Administration in Russia (*ARA Russia*) began – and 1923, when

27 B.M. Patenaude: *The Big Show in Bololand: The American Relief Expedition to Soviet Russia in the Famine of 1921* (Stanford University Press, 2002)

it withdrew. Golder entered Soviet Russia along with ARA administrators. He had been assigned the difficult dual role of both assisting with the relief operation and collecting library materials. He also wrote detailed reports on contemporary economics and political developments for Herbert Hoover and Christian Herter (1895–1966) at the Commerce Department. His success is proof of his remarkable character and extraordinary personal gifts.

Golder had friends among historians and artists in Petrograd from his days as a researcher. Once in Soviet Russia he renewed his ties with members of the intelligentsia and, at the same time, developed a cordial working relationship with high-level Bolsheviks such as Karl Radek, Leonid Krassin and Mikhail Pokrovsky, Anatoly Lunacharsky's deputy at the Commissariat of Enlightenment. It is not clear how Golder was able to simultaneously maintain friendships with monarchists, constitutional democrats, bourgeois intellectuals and communists, but he did. A modest, congenial man, he seems not to have been particularly political himself but to have viewed politics from the perspective of an historian. On a personal level, he simply responded to people as individuals. And we know he had a fondness for artists and art. He enjoyed visits to the Hermitage Museum in Petrograd, where he was on good terms with the curator of pictures, the famous painter and art historian Alexandre Benois (1870–1960).

Golder's vivid letters from Petrograd and Moscow were read by Herbert Hoover and shared with Secretary of State Charles Evans Hughes (1862–1948) as the best news analysis available at the time. He also wrote long letters to colleagues at Stanford. As the Russian friends he cherished were increasingly weakened by hunger and beaten down by the regime, he became distraught. While he had never been a supporter of the old tsarist regime, Golder's first-hand account grows very bitter about the plight of the educated classes, now considered bourgeois enemies of the new state: 'To see Russia makes one wish that he were dead. One asks in vain where are the healthy men, the beautiful women, the cultural life. It is all gone and in place of it we have starving, ragged, undersized men and women who are thinking of only one thing, where the next piece of bread is coming from. This is literally true.'[28] Golder's collecting activities gradually became something more than acquiring news or raw historical documentation; it soon became a way for him to honour the sufferings of his Russian colleagues.

One of his close contacts was the then well-known and highly respected historian Yuri Gautier (1873–1943), who carefully recorded the events of these 'accursed years' as objectively as he could: eviction, loss of home and security, humiliation, rumours of arbitrary executions.... Gautier entrusted his dangerously honest handwritten Diary of the Revolution to Golder, who knew to remove any trace of the author's name

28 T. Emmons & B.M. Patenaude, eds.: *War, Revolution and Peace in Russia: The Passages of Frank Golder 1914–1927* (Hoover Institution Press, Stanford 1992); Letter to E.D. Adams (3 October 1921), p. 92

to protect him from retaliation.[29] The file was given a deliberately misleading label, *Diaries of Revolutionaries,* to avoid exposing Gautier's identity, as he was decidedly not a revolutionary. Likewise, Golder believed that Vladimirov's pictures were a front row on history, and preserved them discreetly, making sure the artist's signature was not revealed. Many of the scenes in Vladimirov's paintings reflect similar descriptions in Gautier's diary.

While his charge was to collect books and newspapers, which he accomplished literally by the ton, Golder also commissioned these original pictures by Ivan Vladimirov, whom he visited on several occasions. Golder paid for them out of his own pocket at $5 each – as they were 'out of scope' for the Library collection policy – then presented the works to the Hoover War Library as documentary evidence.

Golder continued commissioning Vladimirov's art for at least two years after the American Relief Administration closed its operations in 1923, by working with Spurgeon M. Keeny (1893–1988) of the YMCA aid organization in Russia. There is some informative surviving correspondence at Hoover: at least seven letters, detailing the transactions for acquiring the pieces.[30] These letters provide clues about the artist's relationship with clients from the West.

In 1923 Golder avoided naming the artist in his letters, although by 1925 that no

..

29 *Time of Troubles: The Diary of Iurii Vladimirovich Got'e,* translated, edited & introduced by T. Emmons (Princeton University Press, 1988). The name of the author of this handwritten diary, covering the period 8 July 1917–23 July 1922, was initially concealed for security reasons. Edward Kasinec, head of the Slavic Collection at Berkeley, identified Gautier as its author after analysing the content and handwriting (which he knew from research in the Russian archives) before informing Stanford historian Terence Emmons.

30 The full texts of the following unpublished letters can be found in the Hoover Institution Records (Box 94B): *26 July 1923:* Spurgeon Keeny, who was working for the YMCA and the American Relief Administration, writes to Golder about obtaining pictures from an unnamed artist. He feels concerned about their content and delivery, and is glad that five have arrived safely, having sent thirty in all. Ten more paintings were in progress, and 'permission will be secured, if possible, to export these. There is nothing objectionable in the pictures; but we shall probably have to pay some export duty. If this is exorbitant I shall not send out the pictures.'
17 October 1923: Golder writes to Keeny urging him to 'get the remaining watercolours, and any other such things' – again without naming the artist or subjects.
15 April 1924: Golder is still prodding Keeny the following Spring: 'Should you be leaving this year, see what you can do about the remaining watercolors. As I have written you before, aside from the thirty you sent us we have no others. Those I bought have been lost.' No mention of how they went astray.
24 April 1924: Keeny reports to Golder that Vladimirov, now mentioned by name, was 'still here and would be glad to do them for you.' He would need a new contract and $5 per picture. Golder could specify the topics: 'If you want some pictures, please state what you are willing to pay and what subjects you are specifically interested in. Only such subjects may be selected as can pass the censor as a matter of routine.' Golder was commissioning paintings, paying for them with his own cash, and being warned to comply with the censors and export provisions.
21 May 1924: Golder supplies a list of the watercolors he already has, as Vladimirov was known to produce duplicates of work in demand. At $5 each, Golder authorizes Keeny to spend $100 on twenty sketches that he will pay for himself, with the hope that the Hoover Library would eventually see the value of the purchase. Golder was not willing to wait. There was some urgency in finalizing all of this. 'Make sure that you can get them out. If possible bring them with you. As to the subjects I am interested in, mostly those dealing with the war and revolution, something along the same line we have already. If it were possible to get all of his it would be worth while, but I am afraid we can't afford it.'
20 June 1924: Keeny promises to negotiate with Vladimirov for more works. 'It will be impossible for me to bring the pictures with me; but I shall make arrangements to have them handled by our office.'
2 October 1925: Golder writes to Hoover Librarian Nina Almond (1882–1964) advising her that he has ordered another 20 watercolours from Vladimirov at $5 apiece, and that they will be brought out from Russia by the ARA's James P. Goodrich (1864–1940), former Governor of Indiana.

longer seems to be a constraint. Golder had some choice as to the subject-matter, but the artist required a contract and persuasion. Over time the price seems to go up, with pictures more expensive by 1925. Getting them out of Soviet Russia was problematical for both political and logistical reasons and some, we do not know how many, were lost in transit, with no reason given. There was concern about the political content of the pictures. Golder was convinced that his mail was being read, and he could not be completely open in what he wrote to others. The 37 works at the Hoover were the result of at least four years' work negotiating with the artist, from 1921 to 1925, with relief workers from the YMCA helping with transport after the ARA left Russia in 1923. He hoped the Hoover Library would accept them and eventually reimburse his personal outlays. Both Vladimirov and his collectors emphasize that the paintings were made 'from nature' and 'eye-witness' accounts of what he saw as an artist and trained observer – every bit as much a primary source as the diaries and newspapers that were 'in scope' for the library. It seems that the collector was just as obsessed with documenting the everyday experience of the Revolution as the artist himself.

In a letter to Professor Ralph Lutz (1886–1968) of the Stanford History Department, a curator of the new Hoover War Library, Frank Golder wrote from Moscow of the joys and frustrations of collecting under the prevailing chaotic conditions. He worried with some justification that the President of Stanford University, Ray Lyman Wilbur (1875–1949), and the University Librarian, George T. Clark (1862–1940), would not understand the unique and unusual opportunities to purchase materials for the Hoover collection. He also worried, with good reason, that his letters were being monitored by the Bolsheviks:

'I have been watching the book market and it makes my intellectual mouth water. Rare editions, beautiful bindings, heirlooms of great value are thrown on the market. I have decided to cast prudence aside and spend a part of the 2,000 dollars on purchases here. Tell Wilbur, Adams, Clark and all the others they might as well begin abusing me now and get done with it for they cannot stop me. In a century from now when I am dead of a broken heart caused by their reproaches the scholar of the year 2000 will thank me.

'Our prospects in the line of collecting are very bright. Indeed Russia is very interesting and I could spend a year here with great profit not only to myself but to Stanford. Each day I make new contacts and revive old ones and each opens up new avenues. Unfortunately I cannot write you many things for so many people between my writing desk and yours have a great desire to read what I say.'[31]

By 1941 a new building on the Stanford campus, the 285-foot-tall Hoover Tower, was completed to house Herbert Hoover's rapidly growing assemblage of documentation on war, revolution and peace.[32] Hoover made the mission of the Library clear in the dedication of Hoover Tower on 20 June 1941, two days prior to

31 ...The Passages of Frank Golder (p. 94, letter to Ralph Lutz on 6 October 1921)

32 For a full description of the Tower opening, including Hoover's speech, see S.L. Bane, The Dedicatory Exercises of the Hoover Library (The American Archivist 1942, Vol. V, no 3, pp 179–84)

the Nazi invasion of the Soviet Union: 'The purpose of this institution is to promote peace.' The Vladimirov collection was preserved in this structure, now one of several buildings that comprise the Hoover Institution. Only after the artist's death in 1947 did the librarians reveal his identity. The paintings have been used as background for numerous books and exhibitions. Golder's prediction came true: nearly a century later, scholars do thank him for preserving this work.

The artist cultivated friendly contacts with other western travellers in Russia, not just Golder. Ethan T. Colton, the YMCA liaison in Russia to the American Relief Administration, also got to know the artist and acquired three of his works in exchange for art supplies. In 1962 Colton in his old age went to visit Herbert Hoover at the Waldorf-Astoria Hotel in New York to present the now feeble former president with his three pictures, which eventually went to the Herbert Hoover Presidential Library in West Branch, Iowa. One shows a priest and a landowner with ropes around their necks being led off to be killed by rollicking Red Guards, one of whom gaily plays an accordion [ill.35]. Colton noted that the artist labelled this 'enemies of the people – to justice' as a protective device to stay beneath the censorship radar of the new regime.[33]

Golder had acquired a panel that shows the next scene in the story sequentially, where an improvised 'court' is sentencing the same two dispirited men to death [ill. 37]. The men's faces show great dignity in the face of adversity. Another of Colton's

33 Letter from Ethan T. Colton to Bernice Miller, 12 July 1962 (Herbert Hoover Presidential Library 62-6-54, Colton Correspondence)

pictures shows a diligent middle-class family leaving an ARA station and loading precious food supplies on a sled [ill. 52]. In the third, slouching hooligans, all leaning to the right, are smoking cigarettes in the Tsar's box in the Mariinsky Theatre in Petrograd. A factory girl, wearing a stolen gold watch, munches an apple [ill. 90]. A similar picture done in oils can be found in the Vladimir Ruga Collection, this time oriented to the left, with one new telling detail: one of the heads of the imperial eagle has been broken off [ill. 91]. Golder's good friend the historian Yuri Gautier describes a nearly identical scene in his diary entry for 30 January 1918, but in Moscow: 'Yesterday we were in the Bolshoi Theatre for one of the last performances in the box that we had reserved for the season, but that it will be impossible to keep in any case. Triumphant louts from among the soldiers' deputies were sitting in the imperial box – it was disgusting and revolting.'[34]

In his correspondence regarding the gift to Hoover in 1962, Colton recalls that 'Old Vladimirov' (the artist was in his mid-fifties at the time) joked about how he criticized an art student for putting his feet up on the desk: 'The ARA director in Petrograd at the time had a notoriety from receiving business callers and talking with them with his feet on his desk. Vladimiroff told one of his students sitting that way was ill-mannered. The boy said *How do you know? I am learning to be an American.* And stayed poised.' The artist was ever alert to gestures and bearing. And found irony and shreds of humour in everyday life, even in tough times. He seems to have had an easy rapport with foreigners. Forty years later these stories from the American Relief Administration were a powerful memory for both Colton and Hoover.[35]

We now know that other foreigners in Petrograd acquired Vladimirov's work. Some 28 pictures in the Ruzhnikov Collection come from the estate of a Swedish businessman named Axel Johansson or, as he was later known in Germany, *Axel Benzler* (1891–1976), who worked in Petrograd during the 1920s.[36] These works are in the anti-Bolshevik mode familiar from the Golder acquisitions, and date from the same period around 1917 to 1922. Several other items in the Ruzhnikov Collection surfaced in Holland and Finland. The ten anti-Bolshevik works at Brown University were acquired after the Second World War from a well-known dealer named Vasily K. Lemmermann (1894–1975), but his source is as yet unclear. Golder's colleague Spurgeon Keeny also acquired a picture for his personal collection, apparently in exchange for art supplies.[37] It seems likely that there were others. A number of mysteries remain – not just how many clients Vladimirov cultivated, but how many paintings he produced in each mode and how many variants he made of important scenes. In any case, the output was prodigious.

..

34 Gautier *Diary* (p. 106); Golder describes a similar scene in Petrograd in 1922 – cf. Frank Golder Papers, Box 2/Folder 2 (1 January 1922), Hoover Institution Archives

35 Letter from Ethan T. Colton to Bernice Miller, 12 July 1962 (Herbert Hoover Presidential Library 62-6-54, Colton Correspondence)

36 Uppsala Auktionskammare: *The Collection of Axel Benzler (www.uppsalaauktion.se/collection-axel-benzler/)*

37 K. Chukovsky: *Diary* (p. 133) – Kornei Chukovsky spoke with employees of American charity organizations (including Keeny, Golder and Renshaw), and helped organize additional assistance for Russian writers in need

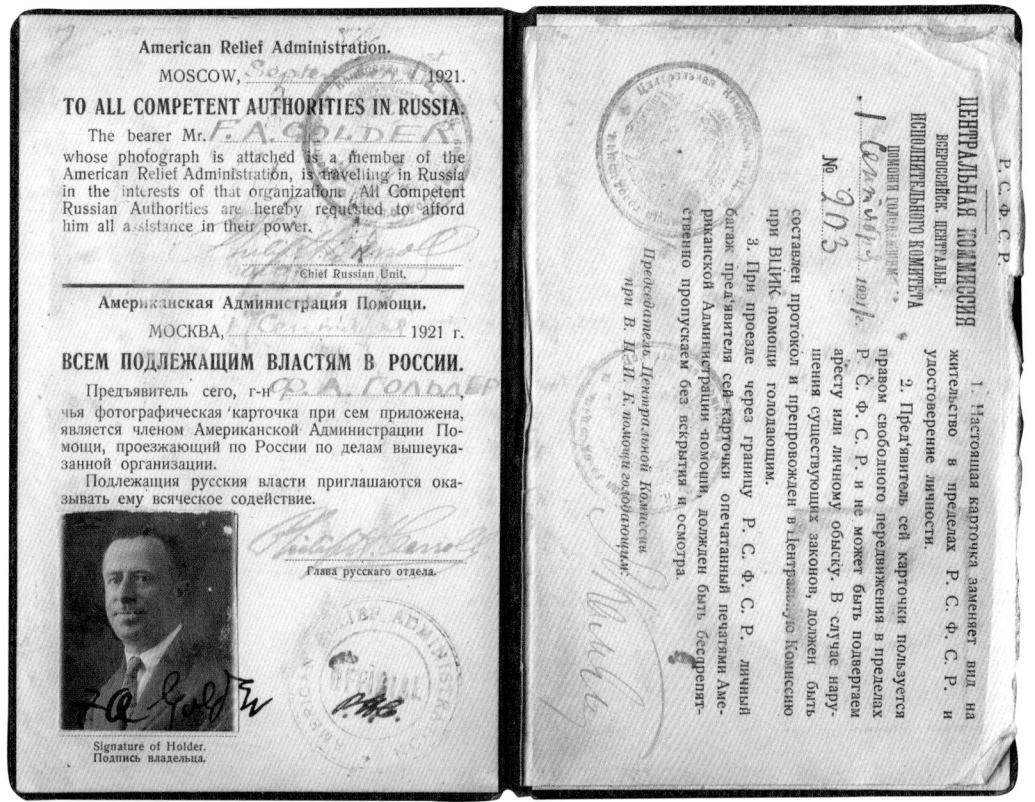

FRANK GOLDER'S ARA CARD (1921) – HOOVER INSTITUTION ACHIVES (GOLDER PAPERS)

Modern collectors such as Ruzhnikov and Ruga built on Golder's magnificent tradition. With their newly available collections, there are now over 130 of the original critical pictures available for research; it is finally possible to reassemble the artist's dual vision. Various themes and variations can now be traced through the interconnected images in different collections. The interpretations may vary, just as different eye-witnesses see different things in the same scene, an effect that the artist himself appreciated very well.

From early in 1917 there are hopeful vignettes in the brief moment before the violence escalated.

At first glance, the work entitled Guards *Regiment joining the Revolutionary Army* from the Ruzhnikov Collection [ill. 1] appears simple enough: soldiers and sailors are waving red flags as a large demonstration approaches along the snowy street. As always, a closer examination of the details brings out a story. The soldiers have far superior fire-power with their rifles and bandoliers, their artillery piece and crates of shells; while the crowds of demonstrators in the distance, with their huge red banner, have far superior numbers. It appears that the confrontation will be peaceful: a sailor waves his cap, a soldier standing on a crate is shouting a greeting with cupped hands, the rifles are not pointed. Here the story-line becomes somewhat dependent on the interpretation of the viewer. The Tsar's military is changing sides, but it seems that the soldiers' loyalty to the red flag is very new. While they have

donned red armbands, they are still wearing their imperial army epaulettes. In an inconspicuous vignette on the far left of the painting, a sweet-faced nurse is talking with a civilian who apparently holds a pad and pencil. Could that be a reporter or a sketch artist, or a combination of the two? Someone is recording the scene.

Two sketches from *The Graphic* for 14 April 1917 provide the tragic spiral of events following this peaceful confrontation preserved in the Ruzhnikov Collection. In one [ill. 4], a lorry carries soldiers who could have come out from behind the crates of shells in the painting *Guards Regiment joining the Revolutionary Army*. The medical nurse who talked with a reporter is now in the truck with the euphoric soldiers turned revolutionaries, heading towards the Astoria Hotel where police loyal to the old regime are holding out. A well-dressed middle-class woman cheers them on, waving her handkerchief, oblivious of the forces that will soon turn against her (she will appear in other paintings in less happy circumstances).

In the next scene [ill. 6] the revolutionaries are storming the Astoria and things rapidly turn ugly. Smashed bottles indicate that the wine-cellar was looted and the soldiers have become drunk and out of control, a scene so common it became a trope in the literature of Alexander Blok and Maxim Gorky.[38]

The destruction of imperial symbols, such as the double-headed eagle and portraits of the Tsars, takes place in an atmosphere of confused loyalties. In Brown University's *Burning Eagles and Romanov Portraits*, the hooligans respectfully doff their hats to the portrait of Nicholas II about to be dumped on the bonfire [ill. 11]. In *All Power To The Soviets!* from the Ruga Collection, revolutionaries on the march are about to trample on a fallen officer [ill. 13]. The signature is in Cyrillic. In a picture obtained by Frank Golder, frenzied soldier-revolutionaries – still in their old uniforms – bayonet, slash and even shoot fine imperial portraits in the Winter Palace during an orgy of violence that leaves shards of marble and picture-frames littering the floor [ill. 14]. Here the signature is in the Latin alphabet, spelt *Wladimiroff*.

The widespread pillaging and destruction are displayed in closely related panels that start to tell a story once they are brought together. A watercolour in the Ruzhnikov Collection, dated 1922, actually shows an event from 1919: a peasant mob pillaging the local manor house, which has been set on fire [ill. 24]. Men, women and children haul off heavy bags of loot. While most wear peasant clothing, some of the young men appear to be wearing stolen military boots – a common occurrence,

38 B. Dralyuk: *1917: Stories and Poems from the Russian Revolution* (Pushkin Press, London 2016, pp 15–16)

as we know from émigré memoirs. A red flag justifies the action. One ancient peasant with a long beard struggles down the steps of the manor carrying a broken grandfather clock, a now useless treasure. The real treasures are ignored: the books and oil paintings, symbols of learning and culture, that litter the grounds in front of the mansion, which the looters trample underfoot. Some of Vladimirov's pictures depict evil; this one depicts ignorance.

A painting in the Museum of Russian Modern History includes a similar image, dated 1926: the same manor house, the same mob, the same trampled books and paintings [ill. 25]. A young man is stealing a fine porcelain plate; an upside-down gilt chair has been pulled out of the parlour. Neither object is likely to survive the raid intact.

The scene in these pictures immediately precedes a scene in one of the Hoover works, where the marauding peasants happily march back to their homes, including the elderly peasant with the broken grandfather clock now strapped on his back [ill. 26]. A very young boy gleefully makes off with the giltwood chair supported upside-down on his head. An impudent young man in stolen boots, looking like Senka Baldin, arrogantly stomps down the road with the fragile plate under his arm.

Background to this story is to be found in *The Graphic*. A sketch entitled *Pillage: Plundering the Country House of Prince Dolgoruky*, published on 17 November 1917 (page 615), depicts a similar event [ill. 23]. From this published sketch it is clear where and when the pillaging occurred. One of his last pictures published in London, dated 20 April 1918, provides a coda to a tragic story: *Civil War in Russia: The Decline Towards Chaos*. In this village scene two groups of peasants face off against each other with pitchforks and rifles as a fire rages in the background. The caption underneath explains that the two sides are fighting over the loot that has been pillaged, with both sides claiming the authority of the red banner. This sketch is not the work of a convinced Communist.

As comic relief, the artist provided scenes of peasant children trying to play the piano looted from the manor house and stashed in a barn. In one version, from the Ruzhnikov Collection, they pound the keys of an upright piano with their fists while their mother looks on smiling [ill. 27]. A pair of old boots is stored on top. In a similar version, from the Ruga Collection, the same children are pounding a grand piano that is used as a table to hold vats of milk while the pigs look on [ill. 28]. The motif of the abused piano recurs in an image of hooligans lounging in a looted apartment. This time a peasant soldier, wearing stolen boots and trousers, uses his fists to play the piano and sing while his raucous friends drink and smoke in the once-refined living quarters [ill.35].

These humorous drawings balance the grim reminders of the Red Terror, the arbitrary mafia-style executions, and the famine. Vladimirov witnessed such brutality up close while working for the municipal militia from Spring 1917 to Summer 1918. He also saw it at stations of the railway where he worked as a senior technician starting in 1919. In the more brutal drawings there are also gestures to follow and interpret. A skinny brown and white dog appears repeatedly. Its significance is unclear but, like most of Vladimirov's symbols, it is based on reality. Herbert

Hoover's American Relief Administration in Russia distributed film footage of the food relief, and a brown and white dog appears on film. Horses also play a role: in one image, an impoverished family trudges home from a soup kitchen past the robust statue of Alexander III on a huge sturdy horse in Znamenskaya Square while, in the distance on the left of the picture, a dead horse lies abandoned on the street [ill. 44]. The picture of a family cutting up the corpse of an abandoned horse for food is especially chilling because of the triumphant demonstration with red flags in the background (Teffi described a similar scene[39]). Another ironic trope is the presence of cheerful posters advertising balls, horse races and cabaret entertainments; these are frequently depicted on the walls behind scenes of desperation.

Another recurring theme is the comfort of philosophy, something we know about from other turbulent periods in history. In the chapter on the dispossessed, there is a scene drawn from life in the room sheltering the humiliated family of General Buturlin [ill. 65]. With grand portraits in gold frames still on the wall, they have had to improvise a cooking and heating brazier in the corner of the room they have been pushed into as others take over the magnificent house. The stove is known as a *burzhuika* or *pechurka*, and the smoke-stack is an improvised pipe suspended haphazardly from the once grand ceiling. A hatchet lies on the floor where the floorboards are being chopped up for firewood to keep the general's family from freezing, not a sustainable practice. Here the grand piano is used as a table for silverware and porcelain, likely to be sold for food. Even in high resolution

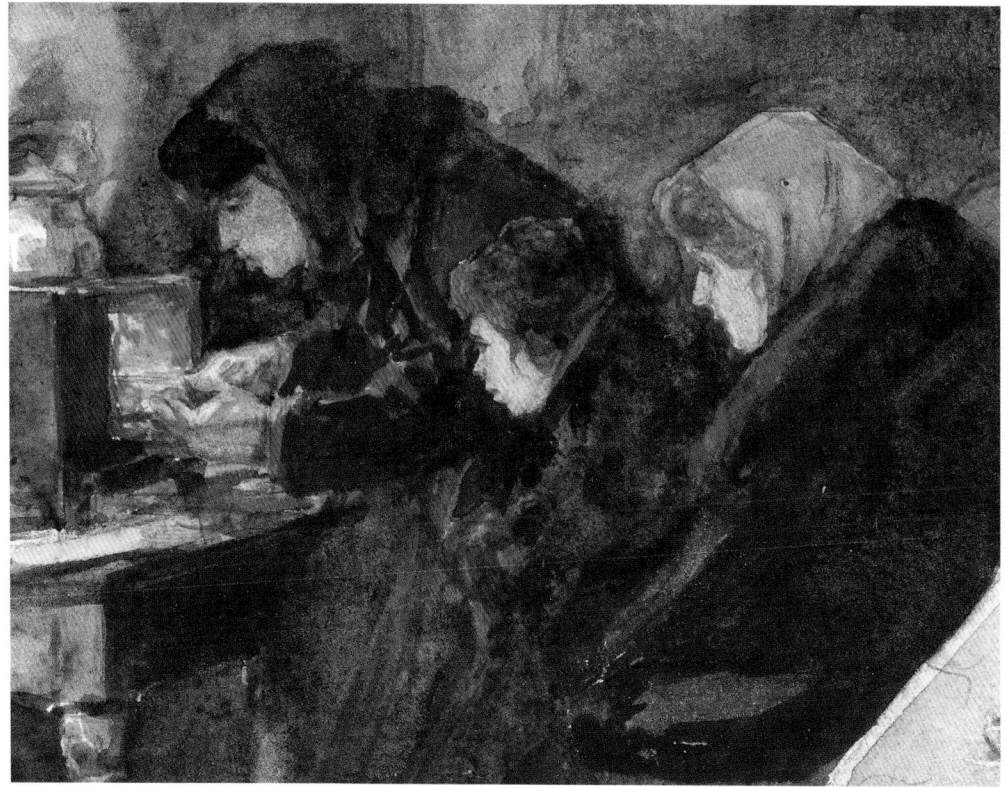

39 Teffi, *op. cit.* (p. 15)

reproductions, it is difficult to see the refined effects of the original: the fire in the small stove reflects in the faces of the three generations of Buturlin women, while the light from the window is reflected in the white pages of the book the General is intently reading. The General is retreating into his own private world. He closely resembles the general identified as Vasilchikov in the painting that impressed historian Bruce Lincoln. Vasilchikov was also absorbed in his reading, while tending a goat. According to Gautier's diary: 'there is pleasure only in study.'[40]

One picture of a militia squad features four men on the outside stair landing of a factory building, three of them in uniform [ill. 77]. The fourth is armed but in civilian clothes, carrying binoculars and smoking a pipe. From Batorevich's biography of her grandfather, we know that he liked to pose for photographs smoking a pipe. It was his own identifying attribute. He is still observing the unfolding scene around him.

To cultural leaders of the 1920s, like Kornei Chukovsky (1882–1969), Vladimirov probably seemed old-fashioned. The newer styles of Impressionism and abstract art both look their best from across the room. Vladimirov's works look best examined up close, even better with a zoom lens on a screen. His gestures, attributes and symbols fit well with the memes of the on-line world, and his pictures work well when assembled in sequence, like a storyboard that unfolds a narrative. In some ways he was actually ahead of his time in terms of visual literacy. In fact, the internet is the ideal medium for picking up his work, and his prolific output has proliferated in cyberspace. Once influential but unrecognized, he is now quite well-represented on-line.

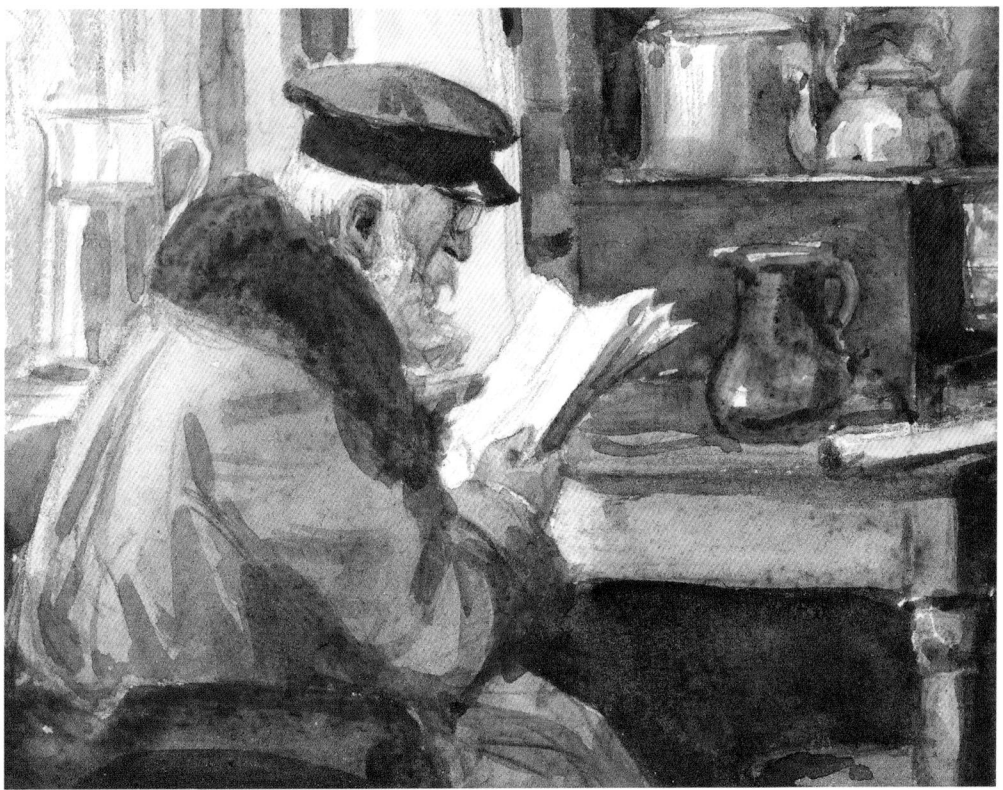

40 Gautier *Diary* (pp 227, 287)

But these on-line images are seldom placed in context. The Hoover images, with their distinctive scraps of paper covering the signature, are usually not provided with provenance, at least not for the moment. Frank Golder's many years of work to preserve this pictorial documentation is not acknowledged. The difference between works intended to take the dark side of the Russian experience abroad for preservation have not been assimilated with those intended to inspire a Soviet audience. Until now, the works circulating on the internet have not just lacked provenance and attribution, they lack meaningful background. The on-line presence has made the influential but unrecognized artist better known, but not yet understood. The Ruzhnikov and Ruga Collections have made it possible to place the pictures from Russia's 'accursed years' in the broader context of the artist's mission to record what he saw around himself. They have opened the door for serious research on a unique observer of a transformative moment in history. And they have raised more questions than answers.

About the author:

Elena Danielson worked at the Hoover Archives at Stanford University from 1978 to 2005. She was Head of the Archives 1996–2005 and Associate Director of the Hoover Institution 2002–05.

Lada Tremsina (Independent Researcher) and Edward Kasinec (Visiting Fellow at the Hoover Institution) assisted in the preparation of this article.

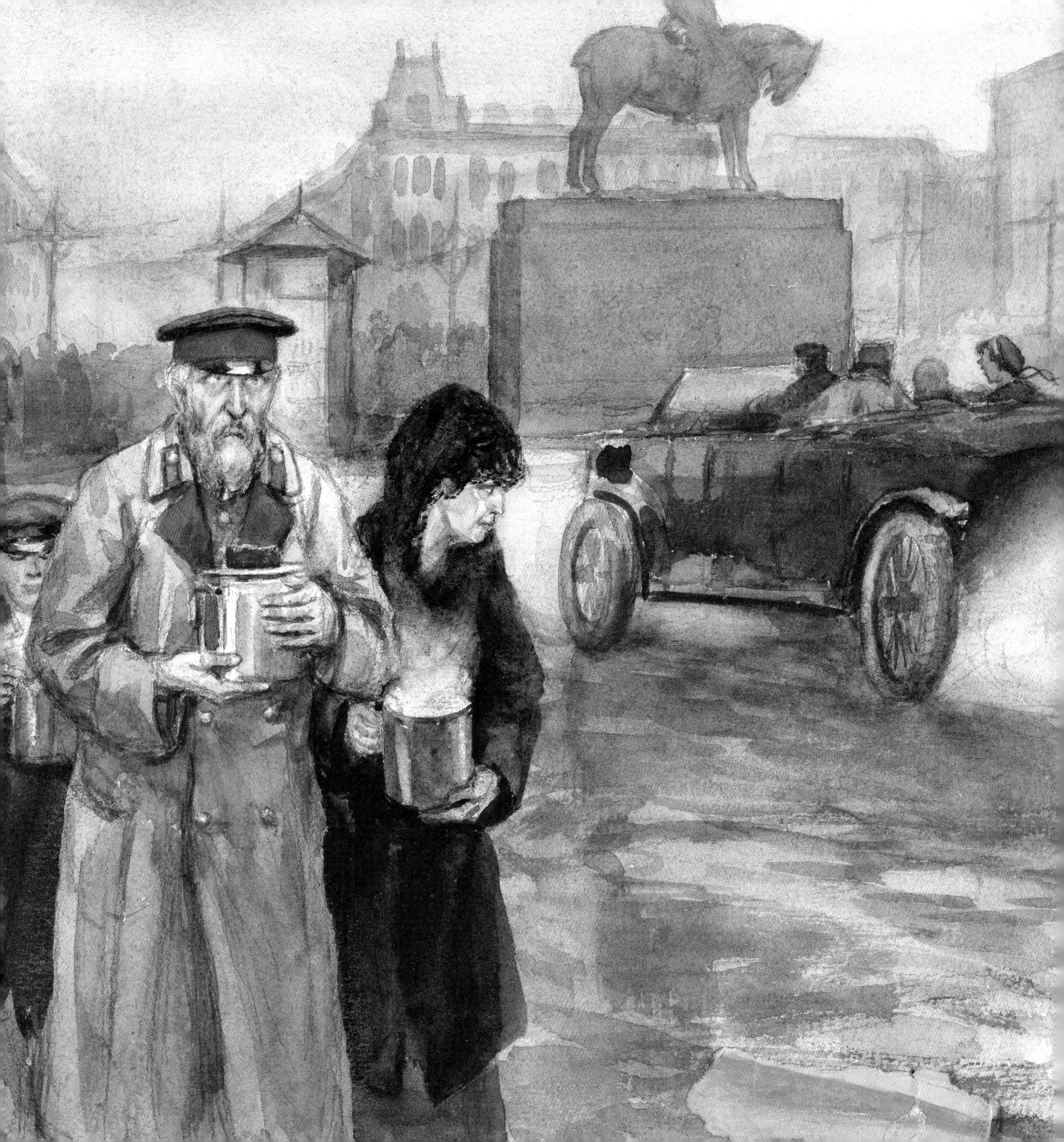

Ivan Vladimirov

Painter
Draughtsman
Artist-Reporter

John Bowlt

Professor Emeritus of Slavic Languages
University of Southern California (Los Angeles)

Founder-Director
The Institute of Russian Modern Culture (IMRC)

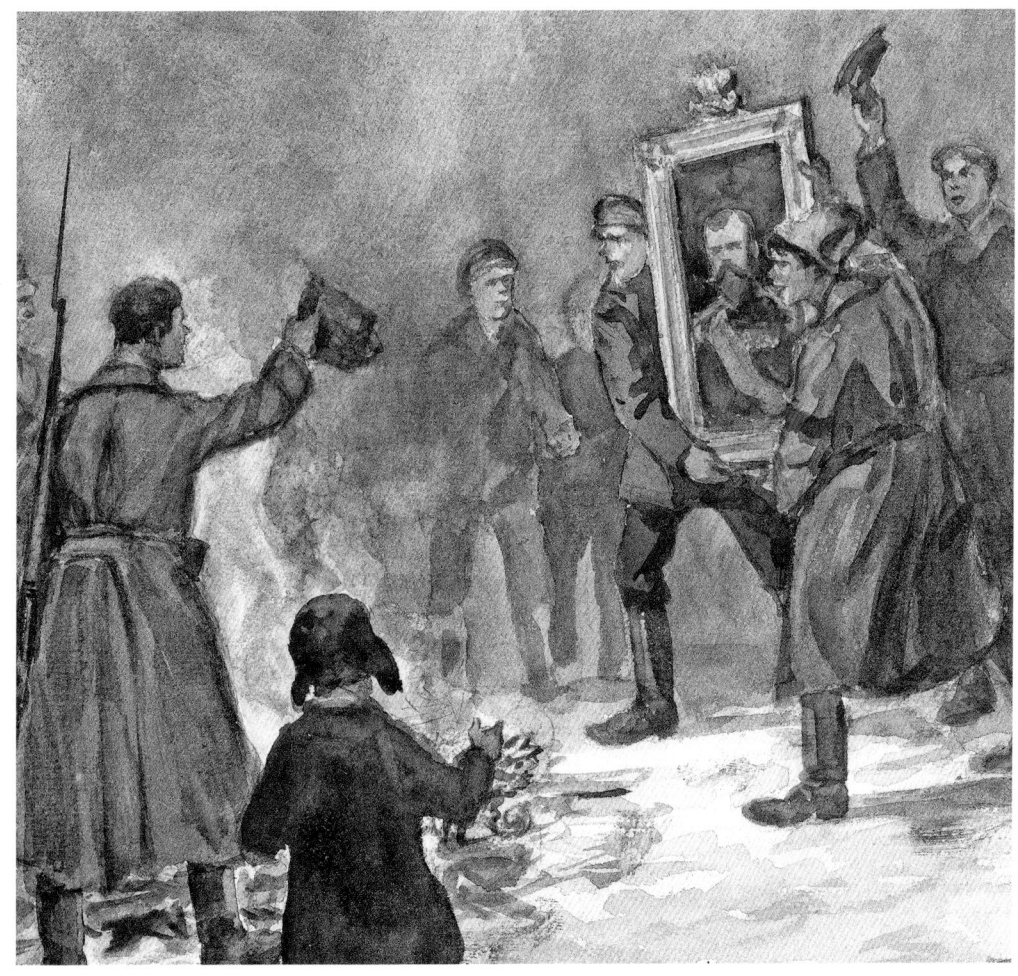

Well before the October Revolution, Vladimirov emerged as a prominent painter and graphic artist, securing a solid reputation as a keen observer of social and political events, even if today his capacity as cartoonist and illustrator has been largely forgotten. Vladimirov's art has not been the subject of copious publications, there is no *catalogue raisonné*, and his last one-man exhibition was in 1915. Nevertheless, in 1904 Vladimirov was sent to the theatre of the Russo-Japanese War as a battle painter and during the 1905 Revolution received high praise as a chronicler and caricaturist. Scenes such as *Arrest of a Student* and *Cossacks 'Cleaning Up' Nevsky Prospekt*, both from 1905 and published as picture postcards, capture the viewer by their lucidity of expression and graphic expertise, sometimes referencing Art Nouveau. True, Vladimirov was distant from the innovative tendencies of the *fin de siècle*, so when the jury of *Mir Iskusstva* [World of Art] turned down his potential contribution to one of their exhibitions, he resubmitted it under a Finnish pseudonym – to be accepted and eulogized by Alexandre Benois. Vladimirov then announced his double-take, much to the chagrin of Benois and his *World of Art* colleagues.

Throughout the 1910s Vladimirov produced posters and placards and illustrated journals and newspapers, producing numerous visual satires, cartoons, and reportorial depictions of social and political episodes. Spring and Summer 1914, for example, were seared by manifestations and strikes as workers expressed their solidarity with comrades on strike in the Baku oil-fields. The St Petersburg police forbade the organization of monetary support for Baku, a stipulation which led to widespread civic disturbance, barricades, and cruel punishments – and Vladimirov was quick to interpret and reproduce such moments of popular unrest. Vladimirov also wrote vivid accounts of his military escapades, publishing them in magazines for family-reading like *Novy Mir* [New World].

After the October Revolution, Vladimirov reoriented his thematic arsenal to praise the new Socialist Republic and condemn the bourgeois West – targeting, not unlike Vladimir Lebedev, the dramatis personae of the Civil War and NEP (New Economic Policy allowing for a partial return to the free enterprise system): White Army soldiers, streetwalkers, private tradesmen, priests, flaccid intellectuals and indolent civil servants. As a foremost member of *AXPP*, Vladimirov produced gripping, if tendentious, scenes such as the celebrated 1926 painting [ill. 75] entitled *Flight of the Bourgeoisie from Novorossiysk on 19 March 1920* (Museum of the Revolution, Moscow; now the Moscow Museum of Russian Modern History) – referring to the desperate effort by the Whites to flee the imminent attack of the Red Army on the Black Sea port of Novorossiysk. Vladimirov also contributed an analogous poster to the eighth *AXPP* exhibition in Moscow on 'Life and Everyday of the Peoples of the USSR.' While the actions and reactions of the 'fleeing Whites' might appear to be histrionic, Vladimir's interpretation showed the bourgeoisie to be powerless in the face of the Bolshevik onslaught which, no doubt, was all too close to actuality. This last stand before tragic emigration was a harsh reality for many Russians, as Baroness Lyudmila Wrangel recalled: 'The human ant-hill had been knocked over, was fussing about, running around, and finally ended up on the deck of a steamship.'[1] Thereafter Vladimirov gained a firm reputation as a fellow-traveller and champion of the Soviet Union and his art, didactic and pungent, secured him a primary position in the pantheon of Socialist Realist artists.

Trained at the Imperial Academy of Arts, Vladimirov believed in the illusionist or documentary function of art and followed this conviction throughout his career. He was not a Modernist and certainly not a supporter of the Avant-Garde even if, as a battle-painter, he was on the frontline of terrible conflicts – witnessing and recording the Russo-Japanese War, the First World War, and the 1905 and October Revolutions. As with other sons of the Academy such as Nikolai Samokish and Leonid Sologub, Vladimirov's pictorial output was surpassed by other, more boisterous styles and yet he interpreted an era of violence, reprisal, and social transfiguration: if only for this reason, his art deserves to be rediscovered, refurbished and re-evaluated.

1 Lyudmila Wrangel: *Vospominaniya i Starodavnie Vremena* ('Memoirs and Bygone Times') – Victor Kamkin Inc., Washington 1964 (p. 98)

Ivan Vladimirov:
With Pencil and Paintbrush amidst Bayonets and Cannons (excerpts)[2]

With the first news about the commencement of military action in the Far East, I had an irresistible urge to go to the war. An obviously natural penchant for battle-painting had awoken within me and, at whatever cost, I decided to depart for the army in the field. In this way I would see for myself and experience the horrors of the bloody tragedy and, as far as possible, sketch the main episodes which would be taking place before my very eyes and, in my album, record the main military types in combat zone.

However, so as to make my cherished dream come true – to join the army in the field in the capacity of artist – was not so easy: first of all, I needed considerable means to cover my expenses at the site of the military action. Moreover, to gain access to the army itself, I also needed patronage. So as to procure the former I sold a few paintings. In addition, a private individual kindly agreed to furnish me with money for the trip. As for patronage, I turned to the Vice-President of the Imperial Academy, Count Tolstoy, who very willingly agreed to help me act upon my decision and issued me the document needed to reach the army in the field, the goal being an artistic one.[3] With this document in hand, it was not hard for me to receive permission to visit the Far East.

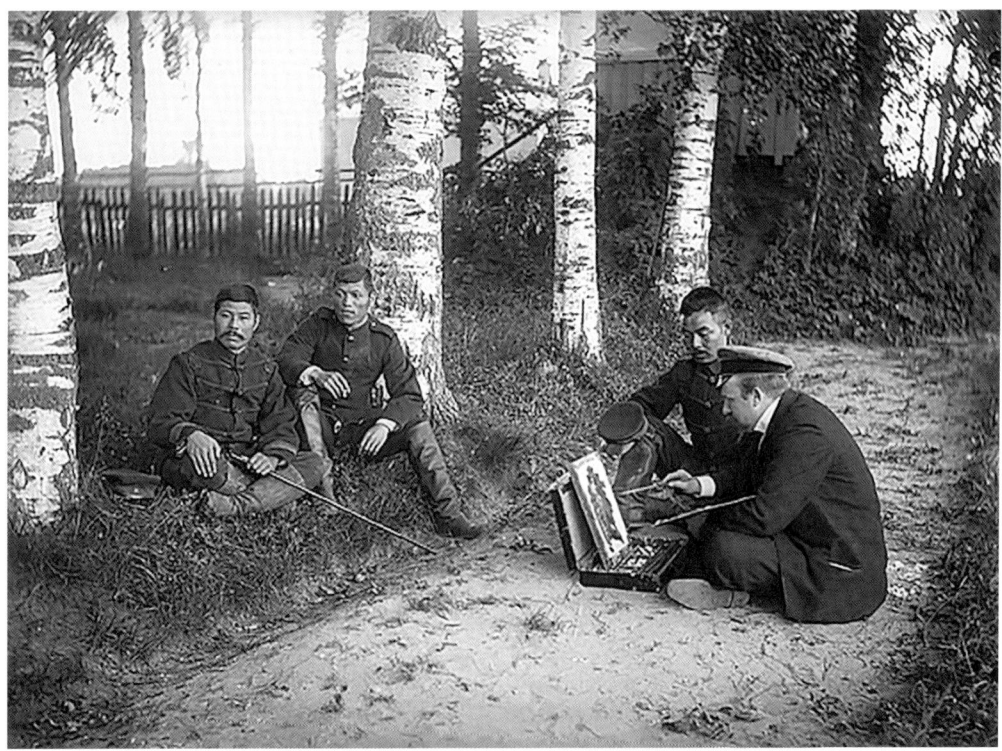

IVAN VLADIMIROV SKETCHING CAPTURED JAPANESE OFFICERS IN MANCHURIA (PHOTOGRAPH, C.1904)

..

2 Ivan Vladimirov: *With Pencil and Paintbrush amongst Bayonets and Cannons – Impressions of the Manchurian Army* (Novy Mir, 1905, no 17, p. 190)

3 Count Ivan Tolstoy (1858–1916) was Vice-President of the Imperial Academy of Arts 1893–1905

In August 1904 I took the fast train from St Petersburg to Moscow and thence, by 'express', on to Siberia and Manchuria...

Before me passed a huge crowd of military types whom you never see in peacetime, far from the roar of cannons. Even the soldiers whom I had known so well from previous times now, on the threshold of the theatre of war, assumed a different appearance.

Taking advantage of each and every opportunity, I sketched the soldiers and painted them in oils. By the way, in Harbin I sketched a 'Tayozhnik' – a typical soldier from the inhabitants of the taiga. These soldiers, drafted from the Siberian settlers who had been criminals in the old days, rendered the army unique service through their steadfastness, endurance, and knowledge of Chinese and Buryat....

Arriving in Mukden towards the end of September, I had the opportunity to witness the Battle of Shakhe River on the 27th and 28th. This battle has been described by correspondents, writers and living witnesses, but none of their descriptions can fully convey the terror of this bloody showdown between two armies..

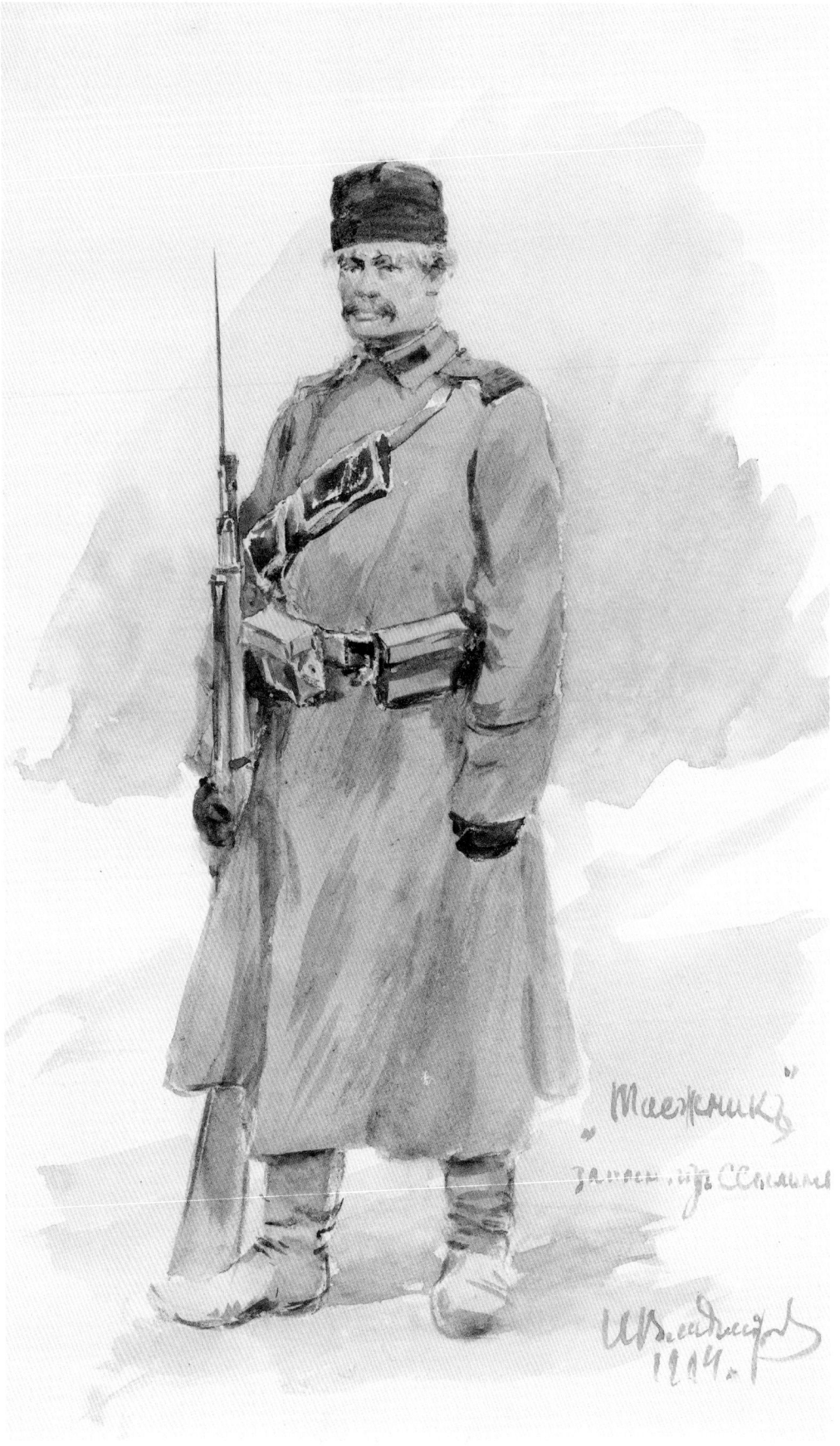

Bibliography

- *The War Artist I.A. Vladimirov – Novy Mir* (St Petersburg 1905) ; № 17, pp 191-193

- Catalogue of the *Exhibition of War Paintings, Watercolours & Sketches by I.A. Vladimirov* at the Imperial Society for Promoting the Arts (Petrograd 1915)

- G. Romm: *In Memory of I.A. Vladimirov (1869-1947)* in Leningrad Fine Art Almanac 1948 (ed. A. Bartoshevich *et al.*) – *Isskustvo* (Leningrad/Moscow 1948), pp 274-276

- I. Vladimirov: *How 'Innovators' Were Ridiculed* – *Khudozhnik* (Moscow 1960) № 12, pp 32-33

- N. Khizhinskaya: *Through the Eyes of the Artist* – *Khudozhnik* (Moscow 1972) № 4, pp 28-30

- A. Roshchin: *Ivan Alexeyevich Vladimirov: His Life and Work 1869-1947* – *Khudozhnik RSFSR* (Leningrad 1974)

- V. Shleyev, ed.: *The Revolution of 1905-07 and the Visual Arts: Petersburg* – *Izobrazitelnoye Isskustvo* (Moscow 1977), pp 106/7

- N.I. Pushkov: *Story of a Painting* – *Iskusstvo* (Moscow 1985), № 10, pp 24-25

- E. Petrova, ed: *State Russian Museum: Painting in the First Half of the 20th Century* – Palace Editions (St Petersburg 1997), Vol. VIII, pp 116-117

- N.I. Batorevich: *I Served Russia All My Life... The Life and Work of Ivan Vladimirov* – Dmitry Bulanin (St Petersburg 2013)

- for reproductions of Vladimirov's drawings and paintings of the October Revolution and Civil War, see A. Rupasov *et al.*: *Agathon Fabergé in Red Petrograd* – Liki Rossii (St Petersburg 2012)

Photographs of Ivan Vladimirov published in the periodicals he worked for as Artist-Reporter

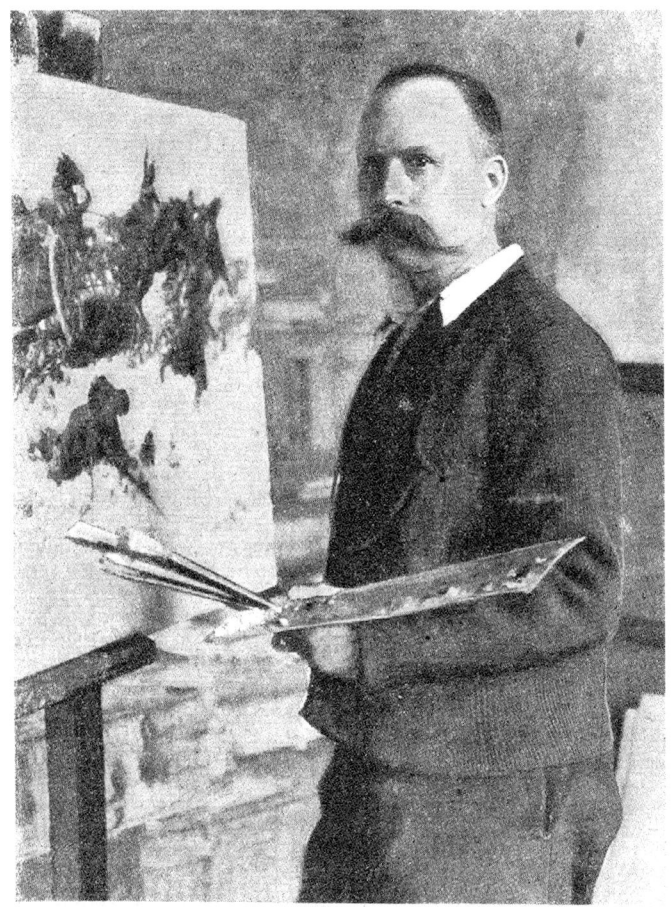

Баталистъ И. А. Владимiровъ.

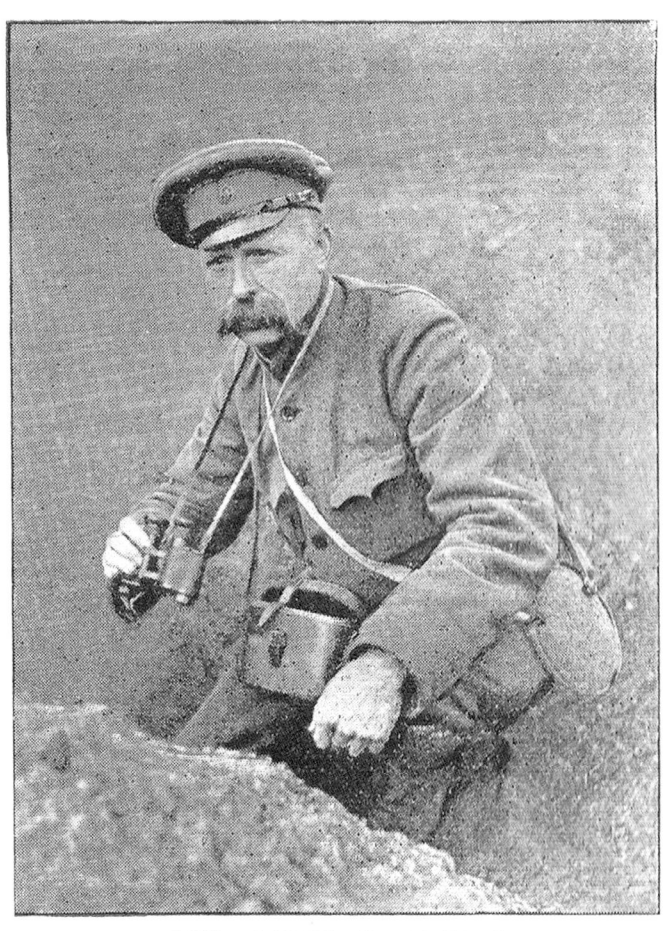

OUR RUSSIAN ARTIST

Mr. John Wladimiroff, the special artist of The Graphic, sitting in a shell-hole at the Riga-Dvinsk front. Mr. Wladimiroff enables The Graphic to be the only paper in the country giving realistic drawings of the revolution.

NIVA (ST PETERSBURG)
14 NOVEMBER 1915

THE GRAPHIC (LONDON)
5 JANUARY 1918

Key Dates in the Life & Work of Ivan Vladimirov

10/23 January 1869*	Born Vilna (now Vilnius, Lithuania)
1883	Enters Vilna Graphic Art School
1891–1897	Attends Imperial Academy of Arts in St Petersburg student of Franz Roubaud, Alexei Kivshenko & Bogdan Willewalde
1890s	Various Prizes for Battle and Ethnographic Paintings
1900s	Takes part in Imperial Academy Spring Exhibitions and other international exhibitions
1904-1905	War Artist: Russo-Japanese War
1905-1907	Depicts unrest during the Revolution of 1905–07
1910s	Summers in Kellomaki (now Komarovo) – Gulf of Finland. Member of Kuindzhi Society of Artists & Society of Russian Watercolourists

* In the dual dating used in this book, the first date corresponds to the Julian Calendar (Old Style) used in Russia until 1 February 1918, the second to the Gregorian Calendar (New Style).

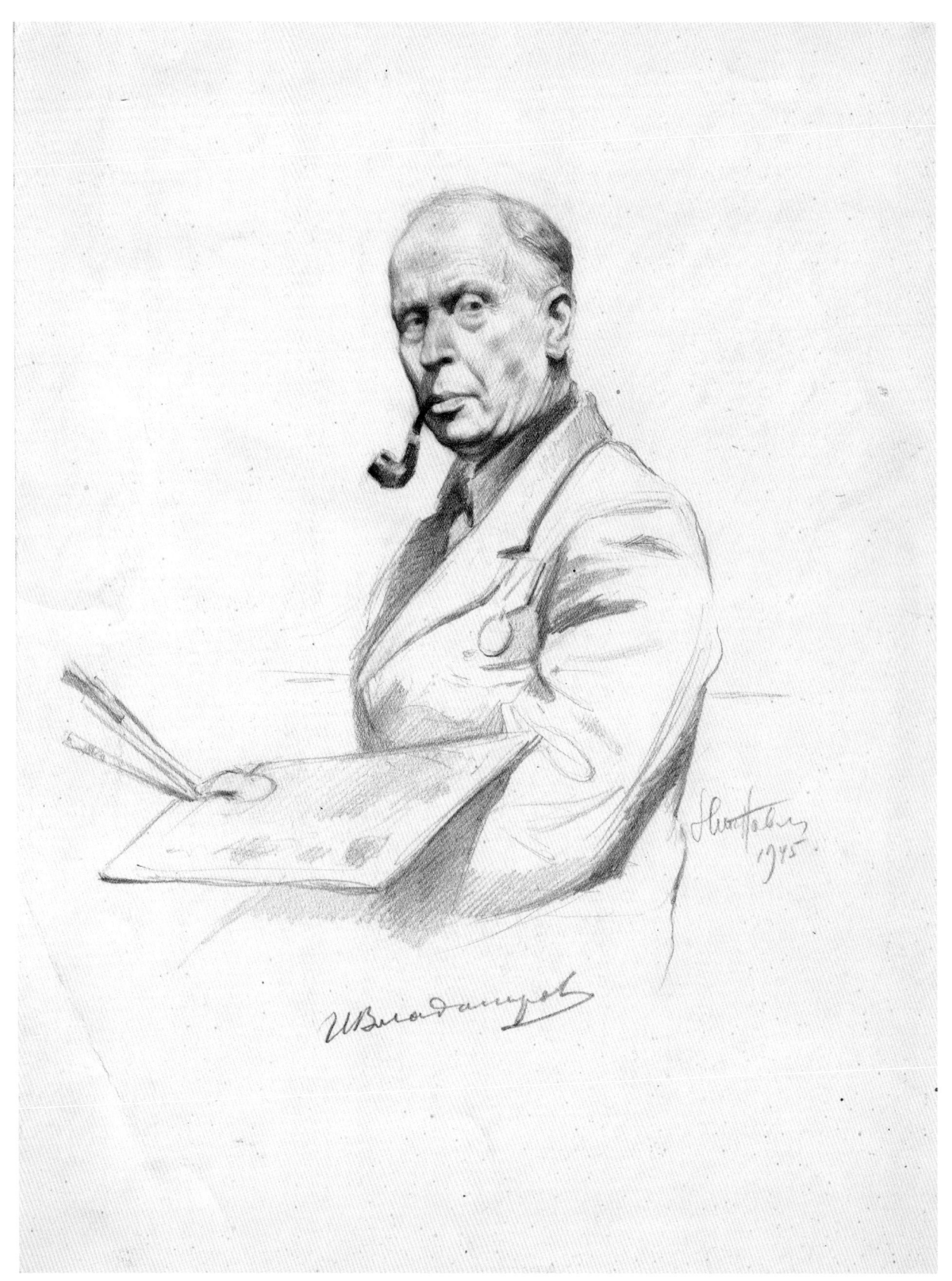

И. Бродатур

1912-1913	War Artist: Balkan Wars
1914-1918	War Artist: World War One
1917-1918	Serves in Petrograd Militia; depicts Russian Revolution
1920s	Member of Association of Artists of Revolutionary Russia
1922	Starts teaching at Art & Industry Technical College, Petrograd
1932	Joins Leningrad Artists' Union
1941-1945	Records Siege of Leningrad
1946	Made an Honoured Artist of the RSFSR Awarded Order of the Red Banner of Labour
14 December 1947	Dies Leningrad

Views
of
War and Revolution
in
Russia

Peter Harrington

Curator
Anne S.K. Brown Military Collection
Brown University Library

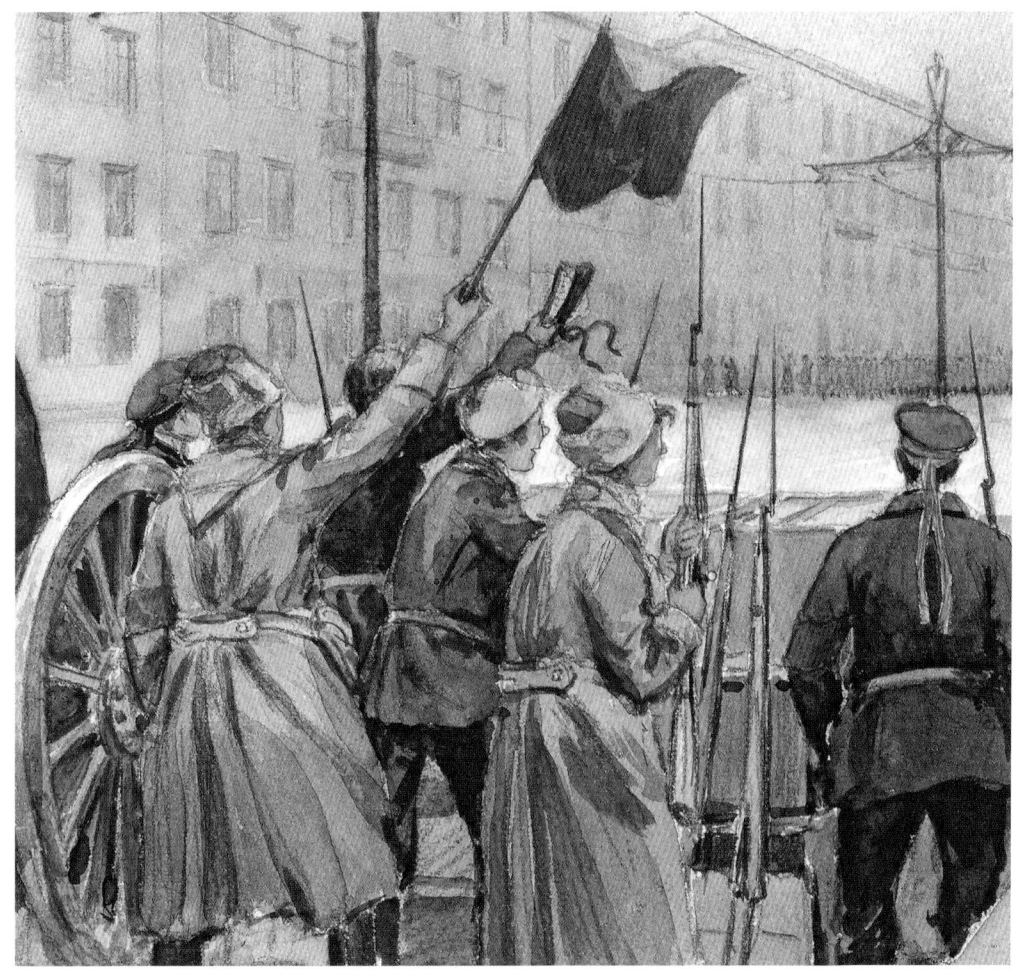

Throughout history, artists have portrayed the military events of their times. We think of images of Napoleon's victories, the hell of the Western Front, and an aerial bombardment of a small Basque town during the Spanish Civil War. The majority of these pictures were painted with conviction and motivation, albeit for different reasons. One can make the case that some of the artists working for Napoleon may not necessarily have approved of his policies but, in order to maintain their careers and secure commissions, they had to produce paintings acceptable to the French emperor.

The official artists of the First World War may have been similarly critical of their governments' handling of the fighting on the Western Front. Rather than producing images for public esteem, they decided to depict the war as they saw it, warts and all, and let their pictures speak for themselves. Hence we see results such as Christopher Nevinson's once-censored *Paths of Glory*, with two dead British soldiers entangled in the wire face down. It is rare, however, to find an artist creating images that on the one hand reflect a particular ideology while at the same time surreptitiously condemning that ideology through discreet pictures intended to show the truth behind the lies. Such an artist was Ivan Vladimirov.

Born in 1869 to a British mother and a Russian father in Vilna [now Vilnius], then part of the Russian Empire, Ivan Vladimirov spent many of his early years travelling. For example, he worked on a coal ship when he was only twelve. Later he joined the Russian Army, serving in the 210th Izhora Battalion as a volunteer, and in 1894 attended the Military Infantry School. His skills as an artist, however, became obvious to many, and he was invited to attend the Imperial Academy of Arts in St Petersburg, where his studies included battle-painting. Vladimirov went on to earn awards in the 1890s for various war pictures, such as scenes from the Russo-Turkish War of 1877, *Capturing a Turkish Fortification and The Defeat of the Kabarda Men on the Malka River*. Around that time he went abroad to hone his skills as a military artist, and spent part of 1897 in Paris studying with the great battle-painter Edouard Detaille. He was schooled in English, and in 1910 he and some friends went to London, where they organized a Russian art exhibition.

At the outbreak of war in 1914 a London weekly pictorial newspaper, *The Graphic*, commissioned Vladimirov to cover the fighting on the Eastern Front as one of its special artists. This was not his first personal experience of battle as a war artist; in August 1904, encouraged by Count Ivan Tolstoy, Vice-President of the Academy of Arts, he had covered the Russo-Japanese War, witnessing several battles. This was the same conflict in which the great Russian military painter Vasily Vereshchagin was killed.

Returning home following the disastrous campaign, Vladimirov witnessed the breakdown of Russian society in the cities, sketching and painting the events. His paintings showed demonstrators near the Winter Palace in 1905, the arrest of students, and revolutionaries manning barricades. These were a portent of things to come. In 1912 he reported on the First Balkan War for the Russian pictorial paper *Niva*.

His initial First World War picture for *The Graphic* appeared on Saturday, 21 November 1914, and depicted Russian infantrymen storming Austrian positions on the outskirts of the town of Yaroslav in Galicia. The artist was identified as *John Wladimiroff*. Thereafter his drawings appeared frequently throughout the war, with the approval of the Russian military censors. More than one hundred of his pictures were published in *The Graphic*. Meanwhile, he also worked for Russian publications, including *Niva*, and several of his watercolours were published as recruiting posters, showing aspects of the Russian Army. *All Must Help Our Glorious Troops* (1916) depicted Russian soldiers in a trench, while *All For Victory*, that same year, showed a convoy of motor vehicles carrying supplies to the front.

In December 1915 *The Graphic* profiled Vladimirov in an article that opened with the statement 'No people have approached war from the point of view in art so poignantly as the Russians.' The piece informed readers that the artist had spent the past year with the Russian Army in Galicia, during which time he had sustained a slight wound.

While convalescing, he finished many watercolours based on the sketches that filled his notebooks. In the late Summer of 1915 he had exhibited 125 war pictures at the Imperial Society for Promoting the Arts in Petrograd. There they were viewed

by members of the royal family, including Dowager Empress Maria, the mother of Tsar Nicholas II, who purchased a painting depicting Siberian infantry and Cossacks capturing a field gun. Another picture, *Our Cossacks Will Catch Them*, was acquired by Grand Duchess Victoria Feodorovna, whose husband was Nicholas' cousin.

The London weekly published pictures of the fighting in Poland and Galicia in 1916, but by 1917 Russia was once again embroiled in revolution. As he was on the spot in Petrograd, Vladimirov took full advantage to document the scenes for *The Graphic* and other publications. When he was not present for the action, he was able to secure first-hand information for his sketches from others. For instance, his sketch of the abdication of Nicholas II that appeared in April was drawn from notes supplied by General Nikolai Ruzsky, who helped to persuade the monarch to step down.

Today Vladimirov is chiefly remembered for his thrilling visual renderings of the October Revolution that brought the Bolsheviks to power, and of the subsequent Russian Civil War. Some of his earliest pictures of the uprising showed rioters shooting down Cossacks on the bridge across the Neva River [ill. 32], and navy rioters capturing a vehicle. That he was sympathetic to the plight of the workers and soldiers in the months leading up to the 1917 revolutions is suggested by his arrest by the tsarist authorities for portraying scenes of workers on strike.

So vivid were his pictures that it prompted the editors of *The Graphic* to boast at the beginning of 1918 that theirs was the only paper in Britain featuring accurate illustrations of the Russian Revolution. It produced a photograph on January 5 with the caption: 'Our Russian Artist. Mr. John Wladimiroff, the special artist of *The Graphic*, sitting in a shell-hole at the Riga-Dvinsk front. Mr. John Wladimiroff enables *The Graphic* to be the only paper in the country giving realistic drawings of the revolution.'

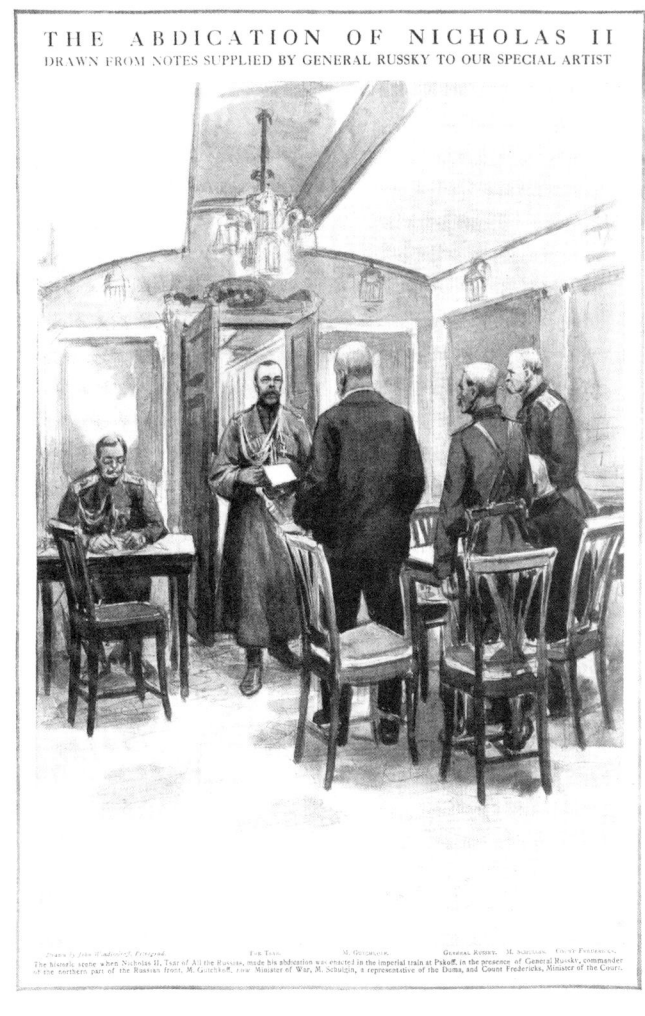

THE ABDICATION OF NICHOLAS II
DRAWN FROM NOTES SUPPLIED BY GENERAL RUSSKY TO OUR SPECIAL ARTIST

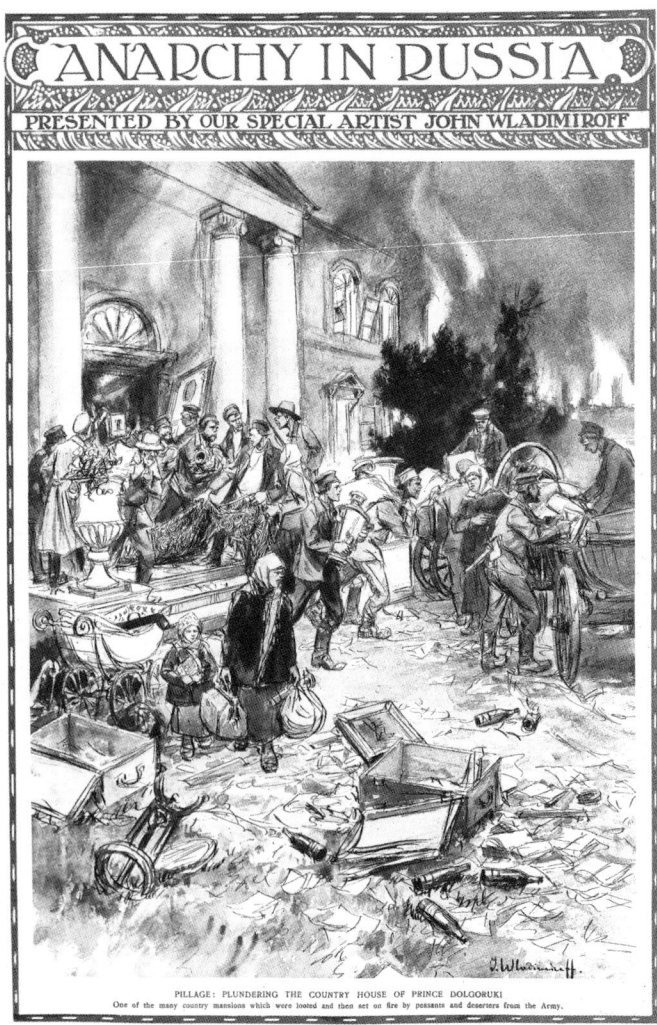

ANARCHY IN RUSSIA

PRESENTED BY OUR SPECIAL ARTIST JOHN WLADIMIROFF

PILLAGE: PLUNDERING THE COUNTRY HOUSE OF PRINCE DOLGORUKI.
One of the many country mansions which were looted and then set on fire by peasants and deserters from the Army.

Vladimirov travelled to Moscow and witnessed the terror of the commune and the barricades near the Kremlin, and back in Petrograd he captured the drama of the street fighting, the breakdown of authority, and the emergence of the Bolsheviks. Throughout the year *The Graphic* brought its readers numerous images of the crisis in Russia from the pencil of Vladimirov, and informed its readers that their artist had run great risks on several occasions in Petrograd. His pictures were captioned to heighten the tension: *Anarchy In Russia* [ill. 23], *Red Revolution in Russia, The Triumph of the Leninists and Revolution, Rapine and Robbery.*

Vladimirov's last picture for the paper appeared on Saturday, 14 September 1918, and was a reconstruction of Red Army troops plundering a train at a station on the Petrograd-Moscow line. Thereafter the products of his labour mysteriously disappeared from the eyes of the British readers, but he was far from finished documenting the revolutionary events.

Vladimirov was about to enter a difficult stage of his career that forced him to lead a double life. In order to be accepted by the new Bolshevik authorities and to gain access to various artistic academies, he began painting stirring scenes of the Revolution that were widely accepted and won for him the Order of the Workers' Red Banner. Later, his role under the Soviet regime was as a *batalist* or painter of battles, and one of his classic canvases from this period, *Down with the [Tsarist] Eagle*, was praised by the authorities. From then on until his death in Leningrad in 1947 he produced paintings extolling the heroics of the Soviet Union that were acquired by various galleries throughout Russia.

In the 1920s and '30s most of his paintings reflected revolutionary themes such as *The Flight of the Bourgeoisie from Novorossiysk in 1920* [ill. 75], *The Shooting at the Factory, The Reds Capture Ufa*, and *Soviet Troops Come to Vyborg*. He portrayed Lenin and Stalin in conference in the summer of 1917, and later made a painting of Lenin walking with Maxim Gorky, the novelist and revolutionary propagandist. Around 1940 he portrayed the events of Bloody Sunday, 22 January 1905, in a large oil painting showing a line of imperial troops firing upon unarmed workers, execution-style, by the Winter Palace in St Petersburg.

Westerners first viewed many of Vladimirov's paintings at the World Exhibition in Paris in 1937, at which Pablo Picasso's *Guernica* was unveiled. Exhibitions of works in his homeland confirmed his reputation as Comrade Vladimirov, a staunch Communist supporter of the Soviet Union. In 1938 some of his pictures were shown in Moscow at a show titled *Twenty Years of the Workers' and Peasants' Red Army*.

The Second World War provided material for similar thematic canvases painted during the war in Leningrad. Pictures from this period include *The Partisans Rout the German Punitive Unit*, painted in 1942; *The Battle for Tikhvin* (1943); and *Combat in the Streets of Berlin*. In 1946 he was awarded the title 'Honoured Artist of the Russian Federation.'

Vladimirov was sympathetic to the plight of the army at the front in 1916, and while he supported in principle the need for reform, he came to despise the Bolsheviks following the 1917 Revolution and particularly during the Civil War. Although he followed the Party line by creating heroic pictures, he was secretly recording the excesses and atrocities committed by Leon Trotsky's Red Army and the regime. The first signs of the artist's disaffection with the Bolsheviks actually began to appear in his sketches in *The Graphic* starting in September 1917. For instance, one of his pictures from August 1918 is headlined *Blight of Bolshevik Barbarism* [ill. 33] and shows three Socialist leaders being 'consigned to the flames by Red Army ruffians.' Another image from the same issue is titled *The Chaos Resulting from Leninite Misrule*.

Many of Vladimirov's anti-Bolshevik pictures were smuggled out by Western collectors. One of them was a native Russian, Frank Golder, who was acquiring material for the Hoover War Library at Stanford University in California, as well as monitoring Herbert Hoover's Russian relief programme. While producing his covert art during the 1920s, Vladimirov was also an active member of the Association of Artists of Revolutionary Russia and was teaching at the State-sponsored Industrial Art Studios.

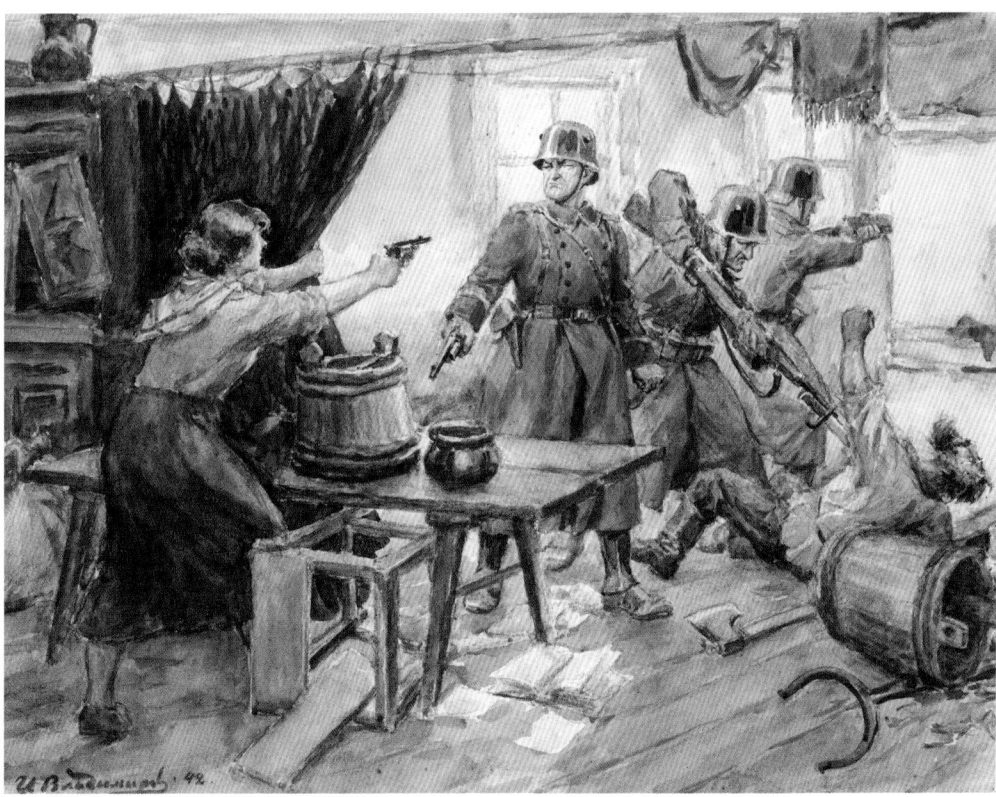

Golder visited the artist on several occasions during this period and purchased as many pictures as he could get, at five dollars each – a significant sum of money in Russia at the time. Apparently some of the pictures were lost in transit, but many arrived safely in the United States, and Hoover himself had three paintings hanging in his Waldorf-Astoria apartment, while librarians at the Hoover War Library pasted over the artist's signature for fear of reprisals against Vladimirov. Had his pictures been discovered by authorities in Russia, the artist would have been shot. For decades many of his anti-Soviet paintings were kept locked away. Others began to emerge in the West, including ten watercolours that were sold in New York in 1953, six years after the artist's death, suggesting that his body of work was far more extensive than originally thought.

In the paintings that reached the West, we see a different face on the events in Russia between 1917 and 1922. Gone are the heroic revolutionaries, replaced by struggling civilians searching for food, ruthless soldiers pillaging a church, the humiliation of former tsarist generals, and priests forced to work in farmyards. We see secret executions and cruelties towards peasants. One painting shows a portrait of Tsar Nicholas II being tossed on to a public bonfire [ill. 11] and, in another, little boys vandalize a statue in Peter the Great's Summer Garden [ill. 94].

In these works Vladimirov displays a humanity that is wholly absent in his 'official' paintings, and shows a real sympathy and affinity for the victims of the repression. Why he painted them at great risk to his survival is unclear, but he may have felt a duty to record the suffering that was suppressed by official Soviet propaganda. Whatever his reasons, his pictures provide a glimpse of the true horror of the Russian Revolution that history sometimes glosses over.

first published as:
Peter Harrington: Views of War and Revolution in Russia
Military History Quarterly, Summer 2005 (pp 80–84)

Works by Ivan Vladimirov in the State Central Museum of Russian Modern History

Irina Velikanova

General Director
State Central Museum
of Russian Modern History

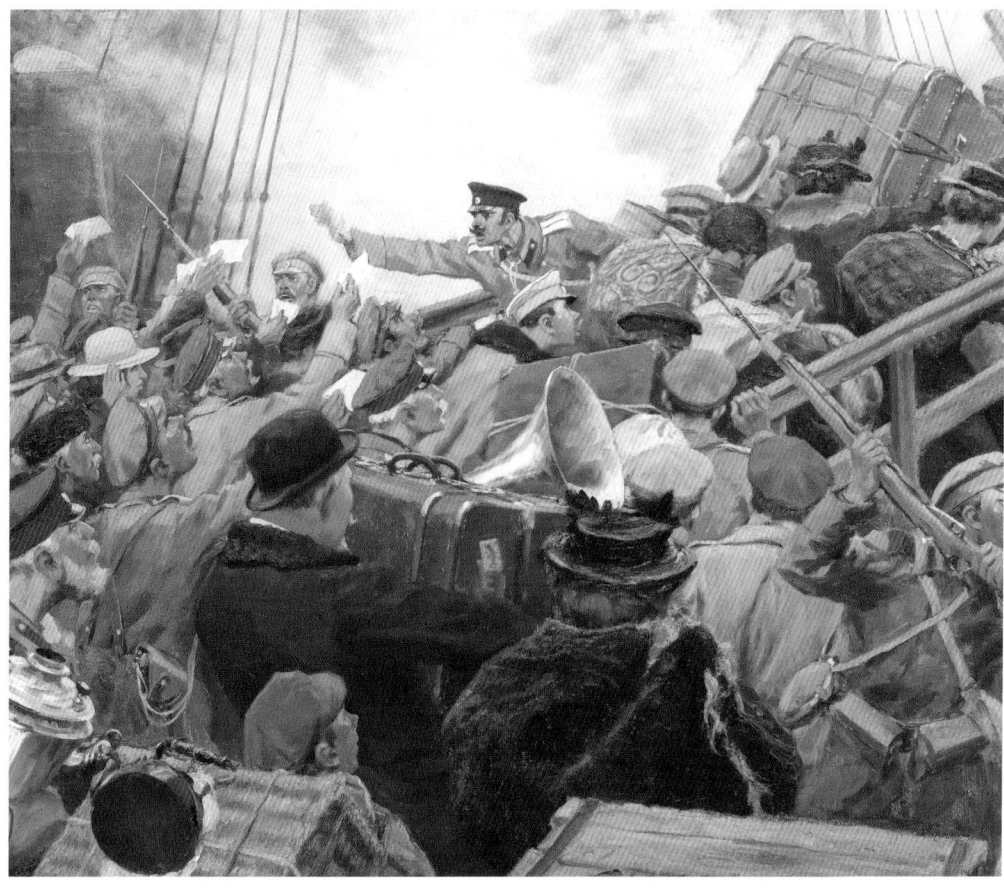

Employees of the State Central Museum of Russian Modern History have always considered, and continue to consider, Ivan Vladimirov as 'their' artist – and not just because most of his works in the museum were acquired from the artist himself. His life and work reflected the turbulence of the early 20th century with its wars and revolutions. He studied under the finest 'battle artists' of the 19th century, Franz Roubaud and Alexei Kivshenko. As a war artist in his own right, Vladimirov chronicled the Russo-Japanese War (1904–05), the Balkan Wars (1912–13) and the First World War I (1914–18), and was an eye-witness of the fighting in Moscow in December 1905.

And, of course, he witnessed the events of 1917 that marked an overwhelming turning-point in the life of Russia and the arts – a time when politicians sought to build a new, progressive world on the ruins of autocracy, as artist-pioneers proclaimed new aesthetic ideals. It was a key year in Vladimirov's life and work. Russia found itself 'in a storm... a perfect thunderstorm' with Vladimirov again 'on the frontline.' As a member of Petrograd's Revolutionary Militia, he saw everything that was going on, from the demonstrations of workers with red banners to the looting of shops and liquor stores and the eviction and arrest of 'former people.'

It takes time for an artist to reflect on events of global historic importance. Many artists do not manage to react in time to the roaring tide of revolution. Ivan Vladimirov did manage – and recorded the events of 1917, the subsequent Civil War and the early years of Soviet power in extremely realistic fashion.

Throughout his career Vladimirov was a staunch adherent of the Russian Realist School with its psychological approach, weighty subject-matter and interest in major events in public life. All his works display the highest professionalism; his compositions, palette and draughtsmanship are impeccable, and invariably convey a very personal reaction to what he sees. While acknowledging the achievements of those newly in power, he angrily, contemptuously and tirelessly – as in *Wrecking a Foodshop in Petrograd in 1917* (1926) [ill. 18] – debunked the vice, cruelty and soulless nature of the sector of the population from which they came. He objectively recorded such manifestations of the new era as *The First Village Tractor* [ill. 110], pioneer detachments or Red Army manœuvres. Remaining true to his preferred genre, he returned again and again to revolutionary events *(Change of Power in the Village,* 1936) and the Civil War *(Frunze at the Battle of Ufa,* 1930), and also evoked the tragedy of the Russian 'exodus' *(Flight of the Bourgeoisie from Novorossiysk,* 1926) [ill. 75].

A work of art is designed to transmit information about events and emotions – capturing events and the artist's attitude towards them. As a result, it is a unique historical source – one not just chronicling history but conveying the 'spirit of the times' as embodied by people's experiences, feelings and moods. Art not only captures past events but also, like a magnifying glass, makes them feel modern and alive – as Ivan Vladimirov's paintings and graphic works in the Museum of Russian Modern History confirm.

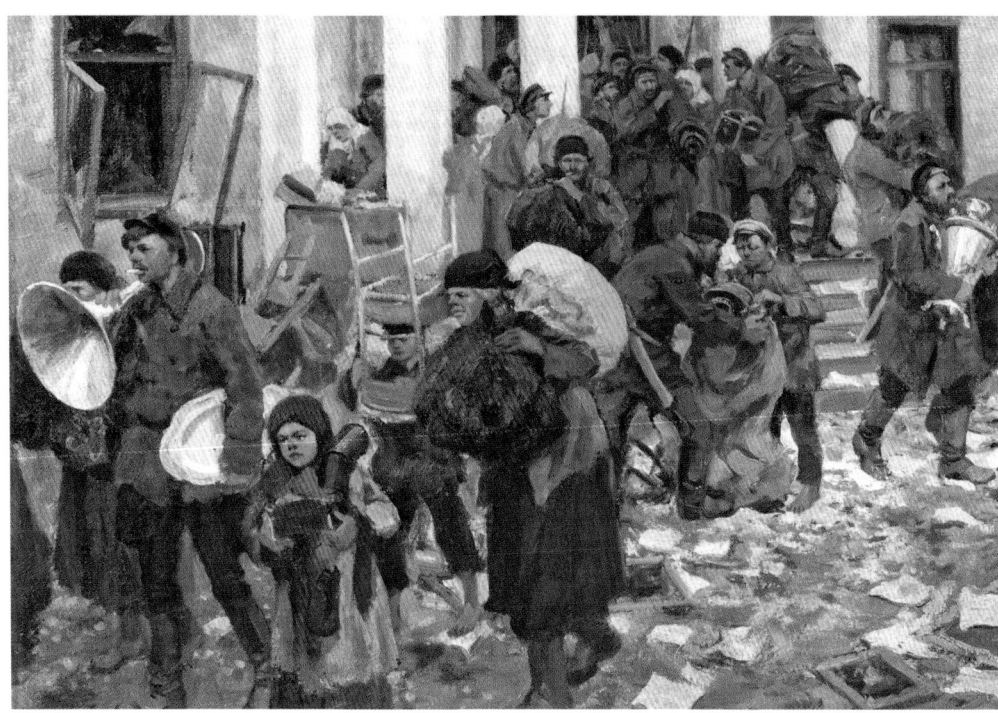

Works by Ivan Vladimirov in the State Central Museum of Russian Modern History (Moscow)

Paintings

1. *February 1917 – Alarming News* (1917). Oil on canvas mounted on board 38.5 x 57cm [GIK 39418/3][1]

2. *February Revolution – Demonstration at the Putilov Factory* (1917). Oil on canvas 58 x 103cm [GIK 4653]

3. *Abdication of Nicholas II* (1920s or, some sources, 1917). Oil on canvas 89 x 72cm [GIK 3171/4]

4. *Strikers Being Dispersed* (1925). Oil on canvas 124 x 180cm [GIK 1480/2]

5. *The First Village Tractor (Testing the Tractor)* (1925). Oil on canvas 98 x 164cm [GIK 6258/34]

6. *Workers Shot in the Yard of the Prokhorov Factory* (1925). Oil on plywood 48 x 62cm [GIK 1128/2]

7. *9 January 1905* (1925). *Oil on canvas 103 x 206cm* [GIK 1569/7]

8. *Flight of the Bourgeoisie from Novorossiysk* (1926). Oil on canvas 138 x 212cm [GIK 3151/7]

9. *Fraternizing at the Front* (1926). Oil on canvas mounted on plywood 47 x 61cm [GIK 3171/6]

10. *The February Revolution* (1926). Oil on canvas 105 x 176cm [GIK 3171/1]

11. *Wrecking a Foodstore in Petrograd in February 1917* (1926). Oil on plywood 48 x 61.5cm [GIK 3171/2]

12. *Arrest of Tsarist Generals* (1926). Oil on canvas 69 x 104cm [GIK 3171/5]

13. *Looting a Landed Estate* (1926). Oil on canvas mounted on plywood 47 x 61cm [GIK 3171/3]

14. *Frunze at the Battle of Ufa* (1930). Oil on plywood 36 x 54cm [GIK 6158/9]

15. *Change of Power in the Village* (1936). Oil on canvas 124 x 190cm [GIK 18972]

16. *The Living Word* (before 1937). Oil on canvas 88 x 151cm [GIK 14500]

17. *9 January 1905* (variant of an earlier work, 1938/9). Oil on canvas 293 x 432cm [GIK 19144]

18. *Lenin Addressing a Meeting* (1938). Oil on canvas 71 x 120cm [GIK 38770/4]

Graphic Art

19. *Escorting a Finnish Revolutionary* (1916). Watercolour on paper 33 x 25cm [GIK 1797/2]

20. *Worker-Militiaman in the February Days of 1917* (1917) Watercolour on paper 34 x 26cm [GIK 1797/1]

21. *Requisitioning Bank Safes – December 1917* (1917) Watercolour on paper mounted on board 33.5 x 51cm [GIK 1051].

22. *Two Communists Shot by Yudenich's Troops at Vyritsa Station on 17 September 1919* (1919). Watercolour & charcoal on paper 34 x 49cm [GIK 18013].

23. *Red Guard Unit in a Village – December 1917/ February 1918.* (1923). Watercolour on paper 33 x 51cm [GIK 1797/3].

24. *Wrangel's Tanks Captured near Kakhovka in August 1920.* (1930). Watercolour on paper 35 x 53cm [GIK 6158 / 23b]

25. *Seizing an Armoured Train* (1930). Watercolour on paper 35 x 53cm [GIK 6158/24]

26. *Execution of Four Communists in Berdyansk – May 1920* (1920). Watercolour on paper 36.5 x 53.5cm [GIK 18012]

27. *White Reprisals on Peasants in Gorki (near Plussa Station) for Helping the Reds* (1920s). Watercolour & pencil on paper 36 x 53cm [GIK 24423]

Poster

28. *War Loan (5½ %) – Your Participation Will Give Our Valiant Troops Fresh Strength* (1916). Chromolithograph on paper 97 x 67cm [GIK 31104/188]

1 Reference Number in the Main Book Inventory of the Museum of Russian Modern History

Works by
Ivan Vladimirov
in the
Vladimir Ruga
Collection

Vladimir Ruga

Collector

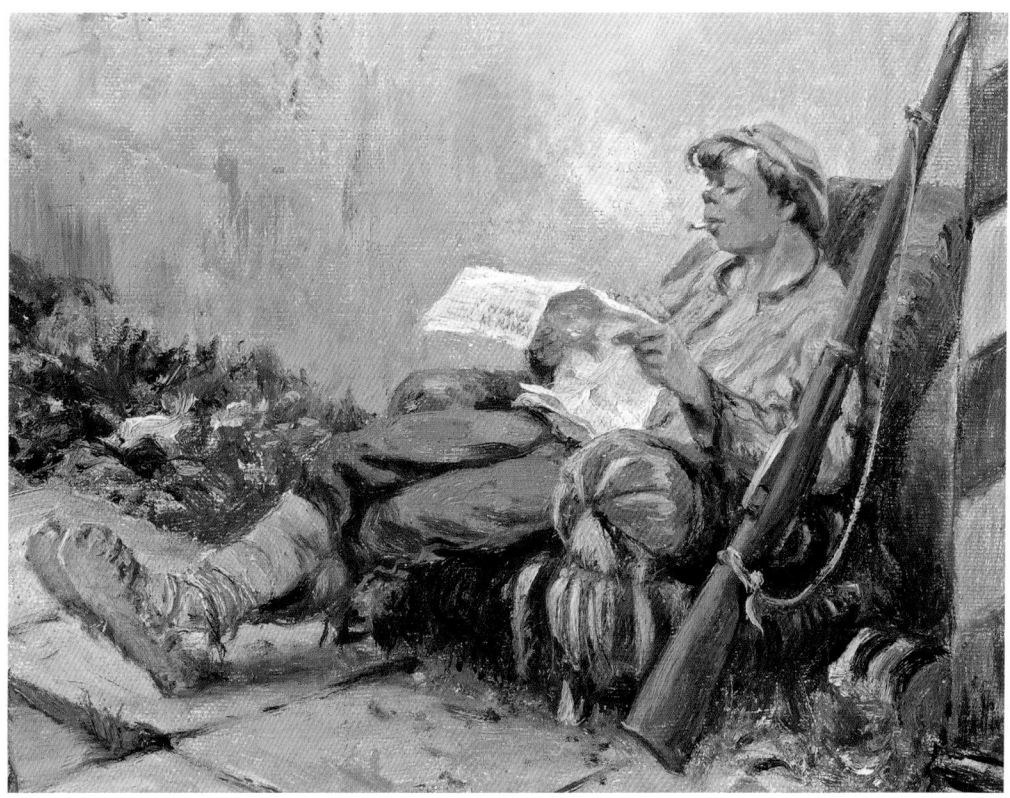

I first became aware of Vladimirov's work a number of years ago, when I was collecting material for a book on the history of everyday life in 1920s Moscow during the New Economic Policy (NEP) and, as a birthday present, I was given a picture of a revolutionary soldier lounging in a fancy armchair. Its realism and biting irony made a deep impression on me. There was something of the Bulgakov about it. From then on I began collecting paintings and watercolours by Ivan Vladimirov. It was as if he had been fated to carry out a special mission – to record for posterity the turbulent, tragic events of Russian history in the first half of the 20th century.

Vladimirov was initally known as a war artist. In 1917 he served in the Petrograd Militia. He was always an excellent draughtsman with a sharp eye and a compassionate heart. I felt close to his artistic approach for personal reasons. As with many Soviet people, my family had lived through their share of exalted and tragic events.

My interest in writing dates from my youth. While studying at the Moscow Pedagogical Institute, I became friends with Andrei Kokorev, who taught in the History Department. We were both curious about the first third of the 20th century. Andrei dug up interesting material from the archives, to which I gave literary embodiment. We wrote two historical detective stories, in the 'alternative history' genre, but soon realized this was not our forte. Instead we decided to write books about the history of Moscow – about the daily lives of Muscovites at the start of the 20th century, how they lived, what they did, where they went, etc. Eight books in the series *Moscow Daily Life* have been published to date.

The era of the New Economic Policy was the period that interested me most. It was a time somewhat reminiscent of the free-for-all 1990s, with some people wanting to get rich quick and 'acquire' aristocratic roots, while others were merely striving to survive. All this against a backcloth of 'devastated minds, souls, homes and lives....' My doctoral thesis discussed *The Creation of a Propaganda Machine in the Soviet Mass Media in the 1920s and 1930s*.

I find it very hard to write about this period, however. I still cannot make up my mind about what attitude to adopt as regards the processes that were taking place. My attitude cannot be unbiased as it is largely influenced by my family's history. One of my grandfathers was a Hero of the Revolution and manager of *Torgsin* – the hard currency store brilliantly evoked by Bulgakov in *The Master and Margarita*. He survived the camps, the war, the harsh years that followed.... I sometimes wonder how anyone could have endured all that without going crazy. When he was imprisoned, my grandmother went after him and lived for several years near the camp where he was held. She ended up getting him out before his time was up! Our own generation is no match for theirs.

My paternal grandfather came from the Altai region. He told us that he took round the collection-plate in church when he was a boy. When I grew up I learnt that he had not told us the whole story: my great-great-grandfather was a priest at the church. He was shot in 1937.

My fascination with the NEP years finds an echo in the work of Ivan Vladimirov. Having (from 1917–22) portrayed the destruction of the old way of life, and the terrifying predicament of swathes of former society (noblemen, officials, priests, officers), he went on to evoke the remodelling of society under the new 'bosses' raised from the gutter by the whirlwind of Revolution.

In our *Moscow Daily Life* books, Kokorev and I touch on these painful topics – and have sometimes been accused of misinterpreting history. Not so: we just collect facts, and do not pretend to do anything artistic. Our books are for everybody. They are an educational *'likbez'* (early Bolshevik campaign to eradicate illiteracy), aiming to give readers an idea of how people once lived.

The same applies to Vladimirov's drawings and watercolours. They record the facts of the reality he saw around him in the city streets, railway stations, theatres and restaurants, then sketched in his reporter's album before working up his drafts into paintings or watercolours. He captured everyday life in Soviet Russia under War Communism at the start of the 1920s – including the seizure of property from 'landowners and capitalists,' the requisitioning of food from the peasants, and the forced labour inflicted on 'alien class elements'... all leading to famine and cultural decline.

The failure of War Communism forced Lenin to announce the transition to a *New Economic Policy* affording some freedom to private enterprise and trade. Ugly economic distortions resulted, reflected in mass speculation by everyone and about everything, and in the overnight riches acquired by an uneducated but devious minority. Meanwhile members of the 'former' or 'alien' class were deprived of their rights – including the right to work – and left to starve. To help save millions of lives,

Western charity organisations such as the ARA (American Relief Administration) were allowed into Russia in 1922. ARA officials knew the English-speaking Vladimirov, and helped dozens if not hundreds of his works to find their way abroad.

Since that birthday present fifteen years ago, I have built up my own Vladimirov collection – acquiring works mostly from auctions or private collectors in Moscow and St Petersburg. As Vladimirov is not a fashionable or 'heavily promoted' artist, his works are generally affordable; I currently own around fifty. Some pre-date the Russian Revolution; others date from the transitional years of 1917–1925 covered in this book.

A Vladimirov exhibition of over fifty works was held in Moscow in early 2017 to mark the 100th anniversary of the Russian Revolution. It was entitled Onset of Revolution – Ivan Vladimirov as *Witness to Troubled Times* and took place at the Museum of Russian Modern History, which was happy to accept my offer to collaborate. The Museum owns about thirty works by Vladimirov – many from his later career and, in terms of style and content, belonging to the world of Socialist Realism. Several (like *9 January 1905* or *Change of Power in the Village)* evoke historical milestones and were painted in the 1930s.

The presence of previously unknown Vladimirovs from a private collection helped the Moscow exhibition provide a fuller overview of his diverse and extensive œuvre. In the exhibition catalogue, Curator Eleanor Zakharzhevskaya wrote of how Ivan Vladimirov's personality was 'expressed through his subtle, aristocratic sense of humour and a talent that enabled him to treat the changes in post-Revolutionary Russia with an irony that was in no way grotesque.'

The exhibition spawned the idea of a book about Vladimirov's work during the revolutionary period, to include works from Russian and American museums and from two private collections – those of Andrei Ruzhnikov and Vladimir Ruga.

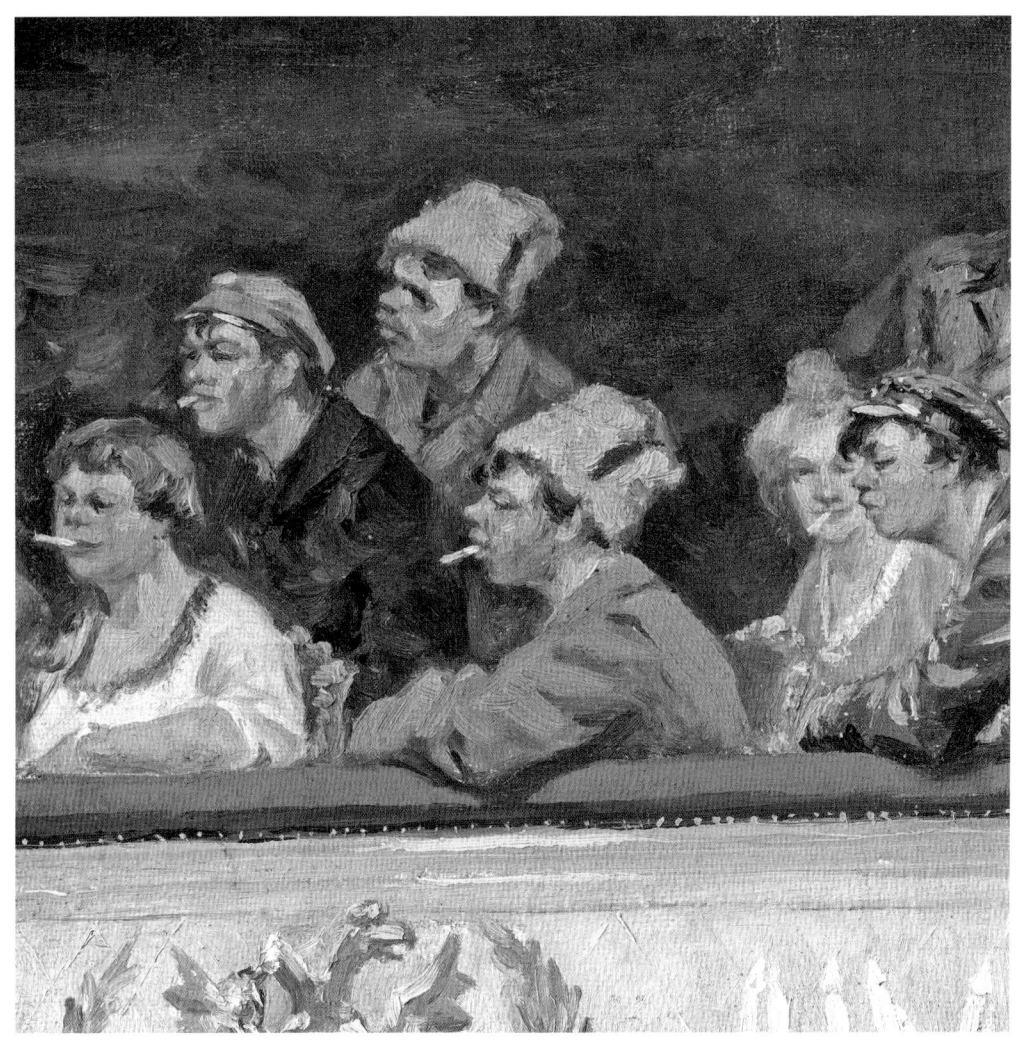

The
Andre Ruzhnikov
Collection

Andre Ruzhnikov

Collector & Art Dealer

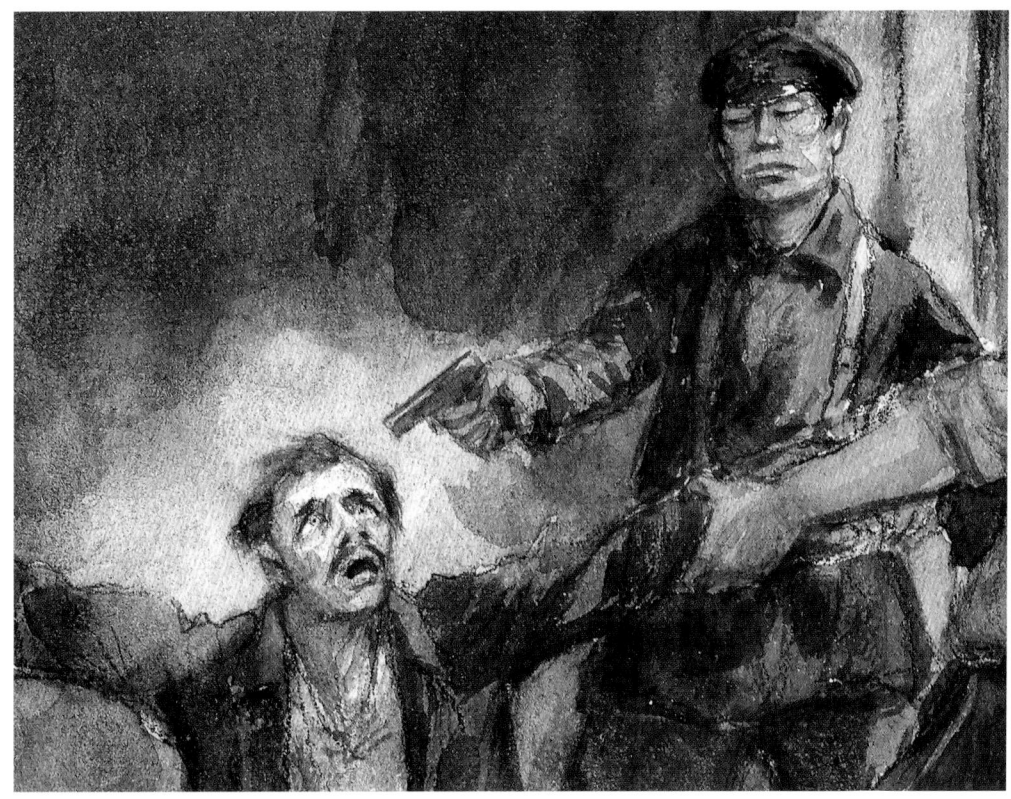

My first encounter with Ivan Vladimirov occurred around forty years ago, in the late 1970s, in the Hoover Tower at Stanford University in California, when I noticed a dozen small watercolours on the wall of the Library reading-room illustrating events from the Russian Civil War (1917–22). Soviet history books grandly referred to this period as *The Great October Socialist Revolution, the Triumphant Progress of Soviet Power, etc.* In Vladimirov's works these events were presented from a completely different perspective, capturing the tragedy of the country's destruction. What grabbed my attention – apart from the skilled draughtsmanship – was his deeply personal approach, reflecting an evident empathy with the scenes and characters he depicted. It needs stressing that he was on the spot: an eye-witness caught up in those turbulent times, with captions specifying that several scenes had been drawn from nature.

I was struck by one bright watercolour featuring brutal soldiers and sailors who had burst into the Winter Palace during the October Revolution, skewering Tsarist portraits with their bayonets [ill. 14]. Another picture showed the unhappy faces of a landowner and priest sentenced to death by a 'revolutionary tribunal' in a recently confiscated country-house [ill. 37]. A third featured a bunch of peasants staggering along a country lane laden with 'booty' from a nearby estate [ill. 26]. Even though I had always been interested in Russian Art, and had visited all the main art museums in the Soviet Union, the name of this artist was completely unknown to me. I had never seen works of art with similar subjects.

During the 27 years I lived in the Soviet Union I never came across works of art that truly reflected Soviet history. As in other countries with totalitarian regimes (including Nazi Germany), art in the USSR was subordinate to the interests of the State. The dominant Communist ideology could be felt in every museum, in every newspaper and in every work of art. The kindly, smiling figure of 'Grandpa Lenin' surrounded by happy children; staunch, invincible Red Army soldiers smashing the enemy; joyful collective farm-workers... these were the staple images from those times. Flags, posters and banners proclaimed *Glory To The Soviet People! Communism Is Our Future! Lenin Is Still Alive!*

Who on earth can have come up with all these stupid slogans festooned around the country? Why has no other country (except Hoxha's Albania and latterday North Korea) seen anything like what the Soviet Union or China under Mao had to put up with?

It's hard to imagine being greeted at an airport in the UK with a portrait of the Queen and a giant slogan glorifying the 'great British people,' or arriving in New York to be told that George Washington is 'still alive' and 'always with us.' What nonsense! To me it was all a farce, and from an early age I understood that the Communist system was built on dust and lies. There was good reason it eventually fell apart and collapsed. Lies make a shaky foundation.

My youth coincided with the 1960s – the time of Khrushchov's so-called 'Thaw.' Few people took his assurances about Communism being achieved within twenty years seriously. The geriatric members of the Politburo were ridiculed for their poor education and general mediocrity. Hundreds of jokes on the subject did the rounds, lampooning the 'beloved' leaders in every way. Brezhnev came in for the most flak – because of his appearance (he was nicknamed *Brovyenosets*, a pun on the title of the famous film *Bronyenosets* – Battleship – *Potemkin)*; because of his provincial, ungrammatical way of speaking; and because of all the awards he was constantly 'bestowing' upon himself. In his Marshal's uniform, with its rows of sparkling medals, he resembled Central Africa's self-proclaimed Emperor Bokassa.

The shortcomings and evils of the Socialist system were obvious not just to the intelligentsia, but to the population at large. Under Khrushchov prices for basic foodstuffs like butter, milk and meat increased by forty per cent in one day – inevitably prompting queues and shortages. They said the measures were supposed to be temporary. I remember, as a youngster, queueing for hours to buy potatoes on the Arbat in the heart of Moscow... and ending up with just a handful of small, dirty spuds (some of them rotten). Sometimes we were told they had run out.

Despite Khrushchov's condemnation of Stalinist repression, the Soviet government continued to clamp down on any expression of dissent or opposition. in June 1962, in Novocherkassk, angry workers protested about a simultaneous hike in food prices and fall in wages. The peaceful demonstration of the workers and their families was suppressed with unjustifiable cruelty. Automatic weapons were fired at

the unarmed crowd. According to official figures alone, 26 people were killed and 87 wounded by police, the military and KGB officers. The corpses were hastily buried in secret. Many demonstrators were arrested. Then came behind-doors trials: seven were sentenced to death and over a hundred jailed. Information about these events was a State secret and not to be mentioned in public (all the grave-diggers had to sign a non-disclosure declaration). In the USSR everything was always hushed up. Censorship reigned supreme.

From 1961 my father, Evgeni Ilyich Ruzhnikov, worked at the Novosti Press Agency as chief editor for English-speaking countries. He was fluent in English and visited the United States and Canada several times. He died in 1971 at the age of fifty-five. He was aware of the Novocherkassk tragedy through his work, and I remember him heatedly discussing it with my mother at home in the evening.

It was not until the 1990s, thirty years later, that the truth about the Novocherkassk massacre finally emerged, and the actions of the authorities ceased to be secret – though to this day some scum still try to justify this Communist atrocity. Take Police Officer Drovalev, one of those who took part in the shooting (and was duly promoted). 'Why keep going on about Novocherkassk?' he asked a journalist. 'What's the point? You ought to write about me – I got a new police station built!' By dividing society from the outset, in its search for 'enemies of the people,' the Soviet government nurtured and promoted this type of murderer.

KHRUSHCHOV VISITING A CONTEMPORARY ART EXHIBITION IN MOSCOW – 1 DECEMBER 1962

In the 1960s and '70s I remember how not just social life, but also art, was controlled by the State. Only trusted members of the USSR's Union of Artists could take part in public exhibitions. Masters like Oskar Rabin, Oleg Tselkov, Vasily Sitnikov, Ilya Kabakov, Vitaly Komar and many others had no opportunity to show their works.

Any exhibition not sanctioned by the authorities was brutally suppressed. The most sensational example was the open-air exhibition held at Belyaevo on the southern outskirts of Moscow in September 1974, when artists encountered not just art-lovers but bulldozers, water cannon and police thugs. The exhibition was broken up, and most of the paintings destroyed. One of the police thugs was Lieutenant Avdeyenko, who felt it 'would have been a pity to waste bullets' on mere artists.

My experiences at school and university gradually opened my eyes to the realities of Soviet life. I went to Moscow School № 69 in the Arbat district. The U.S. Ambassador's residence was nearby, in a beautiful mansion built in 1913 (expropriated in the wake of the Revolution). Americans called it *Spaso House* because it was in Spasopeskovsky Pereulok. In 1962, when I was twelve, several new pupils joined my class – the children of American diplomats. One of them was Jenny Thompson, daughter of Ambassador Llewellyn Thompson. Her younger sister Sherry was also at our school. I can remember the names of others who were class-mates for three or four years: Bruce Fankhauser, John Staples, Carolyn Smith, Susan Houghton.... To us they seemed exotic creatures, from an unfamiliar and utterly different world – their manners, hairstyles, Levi's jeans and bright clothes naturally stood out against our drab Soviet uniforms.

I became friends with Bruce Fankhauser – I helped him with his Russian and practised my rudimentary English with him. A few months later I met his father, a diplomat at the U.S. Embassy. To thank me for helping his son, he invited me to go skiing with the family in Austria during the Christmas holidays.

When I came home and gleefully told my father about this forthcoming trip, he asked me sternly: 'Do you have an exit visa to leave the USSR? Do you have an Austrian entry visa? A passport? Foreign currency?' There was, of course, only one answer to all these questions: *Nyet!*

It was impossible to buy a plane ticket and go skiing in the Alps. Foreign tourism did not exist for Soviet citizens; it was only possible to travel with the permission of the authorities. My heart missed a beat. I felt a tremendous sense of injustice. I could ski and play ice-hockey just as well as my friend, but he was lucky enough to have been born in a free country. I had an overriding desire to see the world. Now I realised I would one day leave Russia.

I always loved reading. Long before I went to university I frequented second-hand bookshops. By the age of seventeen I had already read and acquired lots of books. At university, 'obligatory' foreign literature involved little-known (in fact virtually unknown) authors – usually Communists or Lefties who supported Socialism and 'revealed the ulcers of the Capitalist system.' As I would later learn, few people in the West had ever heard of these wordsmiths.

One author we studied was Jack London. I found his most interesting novels – *White Fang, Call of the Wild* and *The Sea-Wolf* – moving and enthralling. Yet our compulsory programme ignored the books London was best known for, and focused instead on his little-known, anti-Capitalist novel *The Iron Heel*. Dreiser's *An American Tragedy* was meant to show us the vices of American society but, after reading it, I reacted completely differently. Even the authors' title struck me as strange, if not absurd: crime and murder are hardly all-American vices. It was ridiculous to suppose that Americans routinely commit murder to get rich or climb the social ladder.

Given our restricted freedom I was constantly on the look-out for other sources of information. Only thanks to *samizdat*, and to Western radio stations broadcasting in Russian, were we ever able to access something of the truth. At our dacha, 25 miles north of Moscow along Dmitrovskoye Chaussée, I could listen freely in Russian to *The Gulag Archipelago* and other banned 'anti-Soviet' books and novels read on the BBC or The Voice of America. After soaking up the world news from these radio stations I felt sick watching *Vremya* (the daily news programme) on Russian television. Although the BBC, Voice of America and Radio Liberty were violently jammed in Moscow, if you drove out of the city they came through loud and clear.

Albeit with difficulty, so-called 'anti-Soviet literature' and books by dissidents found their way into the USSR despite being banned – and despite the threat of a lengthy prison sentence for distributing them. This was the time when Alexander Solzhenitsyn threw down a daunting intellectual challenge to Soviet totalitarianism. His *Gulag Archipelago*, Boris Pasternak's Doctor Zhivago, Abdurakhman Avtorkhanov's *The Origins of the Partocracy* and *The Technology of Power*, Mikhail Voslensky's *Nomenklatura* and many others were outlawed by the censors. They were distributed by *samizdat*, typed on flimsy tissue paper. Former camp-inmate Varlam Shalamov wrote openly about the horrors of the Gulag in his *Kolyma Tales*. Vladimir Bukovsky experienced the 'humanity' of the Soviet authorities for himself, as related in his book *And The Wind Returns* (published in English as *To Build a Castle: My*

Life as a Dissenter), documenting KGB atrocities against dissidents and freedom-fighters. *Samizdat* was extremely dangerous. Keeping or distributing such material was severely punished: in the Soviet Union – this country of 'justice and prosperity' – it was considered a heinous crime. How could anyone think about disagreeing with the Party line? Any publication not authorized by the State was considered to be anti-Soviet propaganda, and punishable by long sentences in maximum security prisons.

* * *

At 6pm on 15 October 1976 I left the USSR for the first time on a Moscow-London flight with British Airways. I settled with my English wife and her parents not far from the ancient university city of Oxford. I discovered the Russian Department in Oxford Public Library, and began devouring books banned in the Soviet Union one after another, reading day and night. In fact, I spent the whole of my first month in England doing nothing else – leaving home solely to borrow library books. The first was *The Gulag Archipelago*, then came works by Shalamov, Avtorkhanov and other revelations about the Soviet regime.

I learnt from the first wave of Russian émigrés how the February and October Revolutions actually unfolded – the Bolsheviks' brutal murder of the Tsar's family, the bloody consequences of Soviet-decreed Red Terror, how whole villages were left to starve in grain-rich provinces, what actually happened during the Civil War, and much else besides.... Everything I had learnt at school and university turned out to be a complete lie.

After moving to California I often went to look for new 'anti-Soviet' publications at *Szwede Slavic Books* in Palo Alto. I was interested above all in books detailing the true history of the USSR – written by emigrants or authors who had devoted their whole life to studying modern Russia. For many years Vera Shemelis – a highly educated, widely-read little lady known to everyone as *Verochka* – worked at Szwede. It was she who advised me to read Bukovsky's *And The Wind Returns*. I read it straight through without stopping. Vladimir Bukovsky was one of the most famous and unbending of Russian-Soviet dissidents. In 1976 – after being 'embarked' three times and locked up for twelve years in total – he was exchanged for Luis Corvalán, a Communist from Chile imprisoned by the country's dictator Augusto Pinochet.

I knew that Bukovsky lived in Palo Alto during the mid-1980s, and was keen to meet him. In this I was helped by my friend Sasha Borschevsky – a famous academic, authority on crystals, and doctor of sciences since Soviet times. At the time, Volodya Bukovsky was studying 'Sovietology' at Stanford and living alone – a spartan, bachelor existence. We quickly became friends. He liked to come round for dinner, which always turned into an all-night conversation – with me listening to Volodya's accounts of the twelve horrific years he endured in the camps, prisons and notorious Serbsky Psychiatry Institute, where the Asclepius-minded KGB used chemistry to fight dissent. He was a brilliant story-teller. I listened eagerly as he told his tales for hours, in simple, intelligible language.

IN THE OFFICE OF POLITICAL EDUCATION

Like most university students in the USSR, I detested having to study the 'History of the CPSU' (Communist Party of the Soviet Union), for which I always got lousy marks. I was on friendly terms with my other teachers, but found it impossible to establish good relations with the Party's pseudo-historians – who could not think for themselves, and never obliged anyone else to do any thinking either. All they wanted was for you to mindlessly and scrupulously memorise all Lenin's articles and speeches to Soviet congresses and Party meetings. Reading and summarizing all this guff was stultifying and exhausting. My memory could absorb interesting and useful material like a sponge, but stubbornly refused to memorise Leninist theses and the various congresses with all their speeches, decisions and resolutions. I failed to understand why the 'History of the CPSU' had to be studied at every university in the country. Okay, it may have had some vague relevance to History Faculties – but did it really have to be rammed down the throats of everyone reading physics, mathematics, engineering or geology?

When my university torment with Communist Party History was finally over, I cheerfully chucked all my fake history manuals in the bin. If someone had told me that I would be studying the works and words of Lenin and his bloody cohorts again, forty years later, I would never have believed them!

However... Having started work on a book about Ivan Vladimirov, I decided to accompany his works with relevant quotes from Lenin and his accomplices, as well as comments from eye-witnesses and victims of the Bolsheviks' social experiments. With acute vision and accuracy, Vladimirov captured the bloody horror of the Bolshevik regime and its cruelty towards not just individuals but entire social strata who did not fit in with Lenin's schemes for rebuilding the world. I became interested in what Lenin wrote in the fifty-five volumes that form the fifth and final edition of his *Complete Works*, known in Russian as his *Polnoye Sobraniye Sochineny* (PSS). Mind you, on 14 December 1990 Georgiy Smirnov, the final Director of the Institute

of Marxism-Leninism, advised the Communist Party Central Committee that over 3,700 Leninist documents still remained to be published!

Smirnov revealed that these documents covered the following: the policy of terror and repression during the Civil War; the secret work-methods of Communist organs; violence promoted amongst neighbouring states; the expulsion of the intelligentsia from Soviet Russia; and the unseemly conduct of the Red Army (units of the First Cavalry took part in Jewish pogroms, for instance). Since the beginning of Perestroika only a few of these sealed Leninist documents have been published. Even though Soviet power collapsed over a quarter of a century ago, its archives remain locked up and largely inaccessible. Are the Russian people not worthy, even now, a hundred years later, of knowing the whole truth about their own history – however blood-stained and appalling?

A lengthy, in-depth survey of Lenin's post-revolutionary works was carried out by the famous Russian writer Vladimir Soloukhin, and summarized in his *By The Light Of Day*, published in 1992. He discovered much of interest in Lenin's *Complete Works*.

Here's what the Leader Of All Workers – whose first decree had promised to transfer land to the peasants – wrote in Summer 1918 about what the Bolsheviks termed 'prosperous' (in fact ordinary and hardworking) Russian peasants: 'These vampires have stolen the landowners' estates for themselves, enslaving the poorer peasants again and again. Ruthless war on these Kulaks! Death to them!'[1]

In Volume 36 of Lenin's Complete Works, we find what lay behind many of Ivan Vladimirov's Petrograd famine scenes, and the requisitioning of bread and other produce in Russian villages. To quote Lenin again (with Soloukhin's comments):

'The majority – the overwhelming majority – of those working the land are petty commodity producers... The petty bourgeoisie have a small supply of dosh – a few thousand rubles – accumulated 'honestly' and above all 'dishonestly' during the War.'[2]

The population of Russia's two main cities, Petrograd and Moscow, were restricted to survival rations: 100 grams of bread per day. There were unruly queues for these 100 grams.... After forcing workers and other members of the population to go hungry, Lenin announced a campaign for bread – not to feed the cities, but to introduce a grain monopoly: 'We must launch a military campaign against the village bourgeoisie, who are holding back surplus bread and breaking the grain monopoly...[3] and conduct a merciless, terror-based struggle and war against peasants and all members of the bourgeoisie hoarding surplus bread... [and] determine precisely which bread-owners have surplus bread and are not taking it to the collection-points or disposal sites. They are to be declared enemies of the people and imprisoned for at least ten years. Their property will be confiscated and they will be permanently excluded from their communities.'[4]

1 Lenin: *Comrade workers! Let us engage in the last decisive battle!* (6 August 1918 / PSS Vol. 37, p. 41)

2 Lenin: *On the childish and petty-bourgeois nature of 'The Left'* (5 May 1918 / PSS Vol. 36, pp 296/7)

3 Lenin: *Theses on the Current Political Situation* (12 May 1918 / PSS Vol. 36, p. 326)

4 Lenin: *Main Provisions of the Decree on Food Dictatorship* (8 May 1918/ PSS Vol. 36, p. 316)

'We need to convert the War Commissariat into a War Provisions Commissariat... to mobilize the army, pick out its healthiest units and call up 19-year-olds for systematic military action to achieve... the collection and transportation of bread and fuel [with] execution for indiscipline. The units' success is to be measured by the success of their work in procuring bread.'[5]

* * *

But quotes from Lenin were not enough to describe the situation after the Revolution, so I decided to bring in the testimony of people who survived the consequences of Bolshevik 'transformation.' I consulted the memoirs of Count Ivan Tolstoy, Director of the Hermitage; of the artist Alexandre Benois, Hermitage Curator of Paintings; and the diaries of writers Mikhail Prishvin and Zinaida Hippius. Of particular interest, for its plethora of everyday descriptions, was the diary of Yuri Gautier (1873–1943), a professor at Moscow University and Director of the Rumyantsev Museum Library. Interestingly, his Diary for the years 1917–22 was saved by the same Frank Golder who helped salvage Ivan Vladimirov's watercolours for future generations by acquiring them for the Hoover Archives.

YURI GAUTIER

Together with his Harvard University colleague Archibald Coolidge, Golder met Gautier in Moscow several times, attending his public lectures and providing food relief to his family. In July 1922 – due to the difficult living conditions, danger of searches and inability to travel abroad – Gautier decided to give (or sell) Golder the diary he had secretly been keeping since 8 July 1917.

Yuri Gautier's diary is a unique historical document, recording the Bolshevik destruction not only of economic and everyday life (leading to the liquidation of entire estates owned by what the Bolsheviks termed 'former people'), but also the destruction of culture, of national and religious traditions and of the education system. The pages of Gautier's diary capture everyday life in post-revolutionary Moscow, and resonate directly with the subject-matter of Ivan Vladimirov's drawings and watercolours depicting life in Petrograd, the 'city of three revolutions.'

In his first entry, on 8 July 1917, Gautier explains why he is keeping a diary: 'The final fall of Russia as a great and united power... is an episode that has few analogies in world history. Experiencing it, with the utmost grief, shame and humiliation, I, an educated person who had the misfortune to choose the history of my native country as my academic speciality, feel obliged to write down and convey my own impressions as a most imperfect, highly subjective yet nonetheless historical source that may be of some use in future.' By chance, Gautier's historical diary was taken out of Soviet Russia and saved.

5 Lenin: *Theses for the Current Situation* (26 May 1918 / PSS Vol. 36, p. 374)

The story of how Gautier got to know representatives of two American universities –Archibald Coolidge and Frank Golder – is told in his diary. Gautier's story probably has much in common with that of Golder's acquaintance Ivan Vladimirov up in Petrograd. Let me quote a few extracts from Gautier's diary:

26 December 1921. A Christmas present from the Americans Coolidge and Golder: a food packet with a very nice letter, that I enclose. I admit that I was moved, and pleased, and somewhat excited.' The packet contained 22.5kg of grain, 10.2kg of rice, 6.4kg of sugar, 1.2kg of tea, a tub of *salo* (cured lard) and 20 tins of condensed milk.

6 February 1922. Today visited the ARA for talks about food for professors from America… It seems that American universities want to feed Russian scientists: a campaign was launched at the initiative of Russian scientists who have moved to America. I think something may come of it. Overall situation unchanged. They keep waiting for something, I think changes must come. From Simbirsk [Chuvash academic Ivan] *Yakovlev writes that they're eating corpses and rats there.*

16 July 1922. Visit from Golder. He is no less interesting than Coolidge, and more lively. He offered to take out my materials; I think I'll accept. It could boost my future plans and ensure the materials are saved, whatever happens.

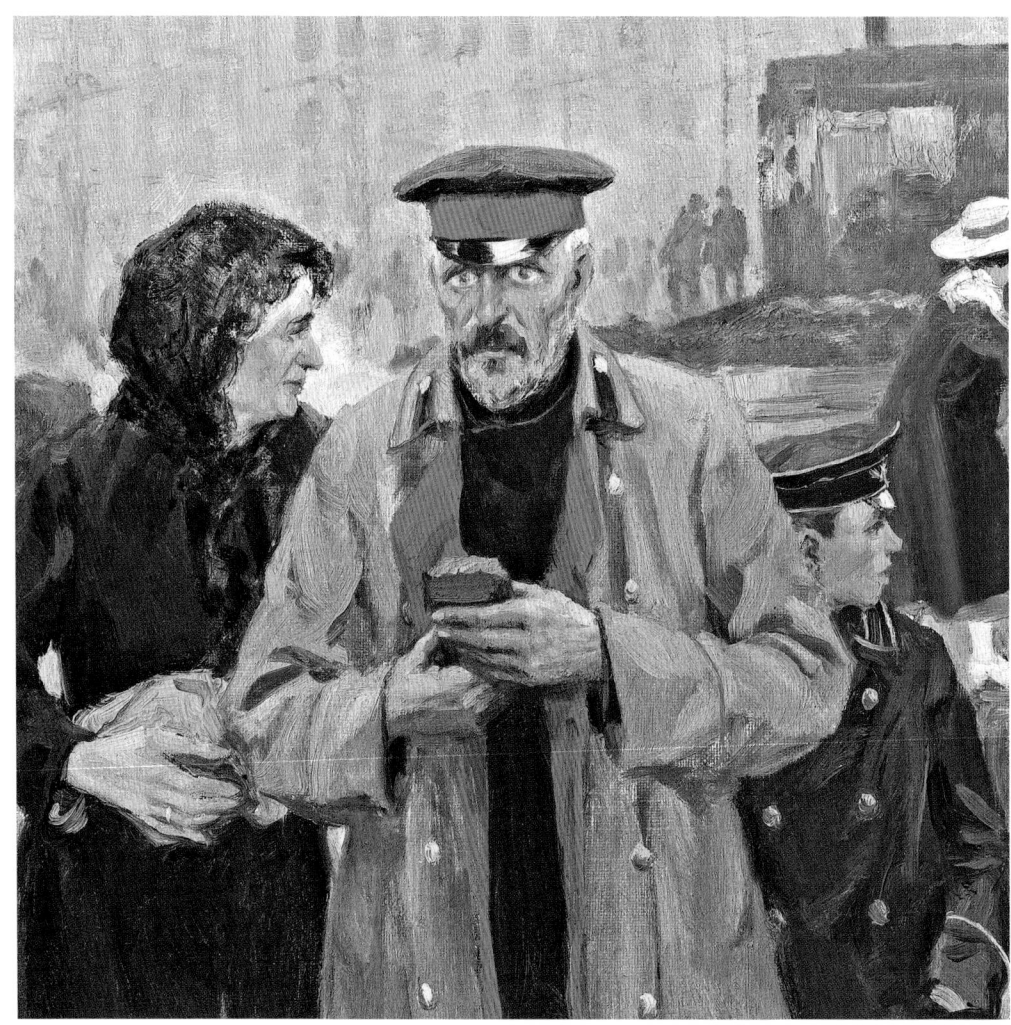

Professor Gautier's final entry is dated 23 July 1922. Saying goodbye to his diary probably saved his life (and his son's) – though Gautier did not escape the usual tragedies of post-revolutionary times: he was arrested in 1930, sent to a labour camp, then exiled for three years to Samara. He returned to Moscow in 1934 to teach, later becoming an Academician. He died in 1943. His diary was not published in Russia until the early 1990s.[6]

* * *

When I first saw Ivan Vladimirov's watercolours at Stanford University I was thunderstruck, and felt an immediate urge to acquire his works. But they rarely appeared on the market. I first saw one for sale at Sotheby's London in the 1980s. It was an oil painting (approximately 60 x 80cm) of a market-scene during the NEP in the early 1920s, and sold for far more than I could afford. A few years later, at a Bukowskis auction in Helsinki, I managed to purchase my first Vladimirov, depicting members of the workers' militia at a Petrograd factory [ill. 77]. Shortly afterwards I bought two more watercolours, although only one of them belonged to the period that interested me (1917–22). My first three acquisitions were fairly moderate in tone, lacking the sarcasm and pointed criticism of the works at the Hoover.

A few years later, at a minor auction-house in the Netherlands, a small ensemble of seven Vladimirov watercolours came up for sale, which I gleefully purchased. All belonged to the period of 'Revolutionary Turmoil' and, in many respects, echoed the works that had impressed me in California. After thirty years of purposeful searching, I had now put together a modest collection of ten watercolours by Ivan Vladimirov.

Then, in the year marking the 100th anniversary of the Russian Revolution, I enjoyed a stroke of good fortune. In June 2017, at an auction in Uppsala, just north of Stockholm, I purchased another 28 Vladimirovs dating from the Revolution and Civil War: the very period that had intrigued me in Stanford almost forty years before. A Swedish entrepreneur called Axel Benzler, who worked in Russia during the NEP, had bought 26 Vladimirov watercolours and two of his oil paintings back in the 1920s. They had remained in a folder, virtually forgotten, until chanced upon by his descendants and offered for sale. So, after many years of active searching, my collection unexpectedly zoomed up to 38 works, and I decided it was time to publish a book about the life and career of Ivan Vladimirov.

I have always been keenly interested in the Russian Revolution and Civil War. In February 2017 a Vladimirov exhibition was held at the State Museum of Russian Modern History in Moscow to mark the centenary of the Revolution. It was held in a grand Neo-Classical mansion which, before the Revolution, had housed a prestigious Gentleman's Club – the English Club, in fact... a cradle of capitalism! Afterwards, ironically, the building hosted the *Museum of the Revolution* which, following the inevitable demise of the USSR, became the *Museum of Russian Modern*

..

6 *Мои заметки* ('My Notes'), *published by Voprosi Istoriy* (1991–93)

History. When I read the exhibition catalogue I discovered that I was not the only person interested in Vladimirov, and soon met up with a Moscow collector called Vladimir Ruga. It turned out that we share not only the same interest and passion, but that our surnames share the same etymology. Ruzhnikov comes from *ruzhnik*, meaning a collector of church taxes. The tax itself was called *ruga*. Both words date back to the 17th century. What a fascinating coincidence!

* * *

Ivan Vladimirov – living in Petrograd and finding himself in the thick of things – left us a living story about the days of the Bolshevik experiment in Russia. He was an acute observer of events – not just in his official role as a member of the People's Militia, but also from a personal desire to understand human behaviour in extreme circumstances. There can be no doubting his humanity, or his sympathy for ordinary Russians who found themselves hostage to new socio-political conditions. The heroes of his works include starving city residents; peasants robbed by food-procurement units; former noblemen, Tsarist generals and priests forced to eke out a miserable existence; 'alien class elements' undertaking forced labour; and gangs of urchins forced on to the streets after the deaths of their parents. We are shown terrible scenes of arrests, 'trials' and executions...

Ivan Vladimirov's watercolours are living sketches of events that took place beneath his eyes. In *Requisitioning Flour from Wealthy Peasants*, Red Army soldiers shamelessly impound the grain these peasants need to survive [ill. 61]. In Requisitioning the *Peasant's Last Cow* [ill. 60], armed Bolsheviks confiscate the final source of a family's livelihood – despite the *babushka's* cries and pleading. In a scene at the *Grand Hotel Europa* [ill. 103], an old-school waiter can barely mask his contempt for two members of the new ruling class whose presence is totally out of keeping with the atmosphere of such an institution.

One of my favourite works depicts a group of village children in a barn, punching away at the keys of a piano [ill. 27] – apparently stolen from the landlord's house, but now surrounded by straw and farmyard animals. Such unspeakable chaos mirrored the Revolution. Ivan Vladimirov was one of the few artists who managed to accurately record such moments in the midst of universal collapse.

Another memorable picture is Reading Pravda [ill. 105]. A country bumpkin in a cap and leather jacket sits at a table laden with vodka and black bread, struggling his way through a Pravda editorial one word at a time. Several gold rings bespangle his fingers, while a gold watch gleams on his wrist – hardly like to have been inherited from his grandmother. Instead, our Pravda reader has been following Lenin's injunction to 'rob and kill' just like he did – not forgetting Number One in the process. A tarted-up village 'Thecla' sits next to him, lapping up every word, her gleaming teeth frozen in a fatuous smile. The fur coat hanging on the wall behind her no doubt used to belong to some hapless bourgeoise.

Vladimirov is a wonderful artist-storyteller. He could tell a tale in a few deft brushstrokes, conveying the nature of his characters and his attitude towards them.

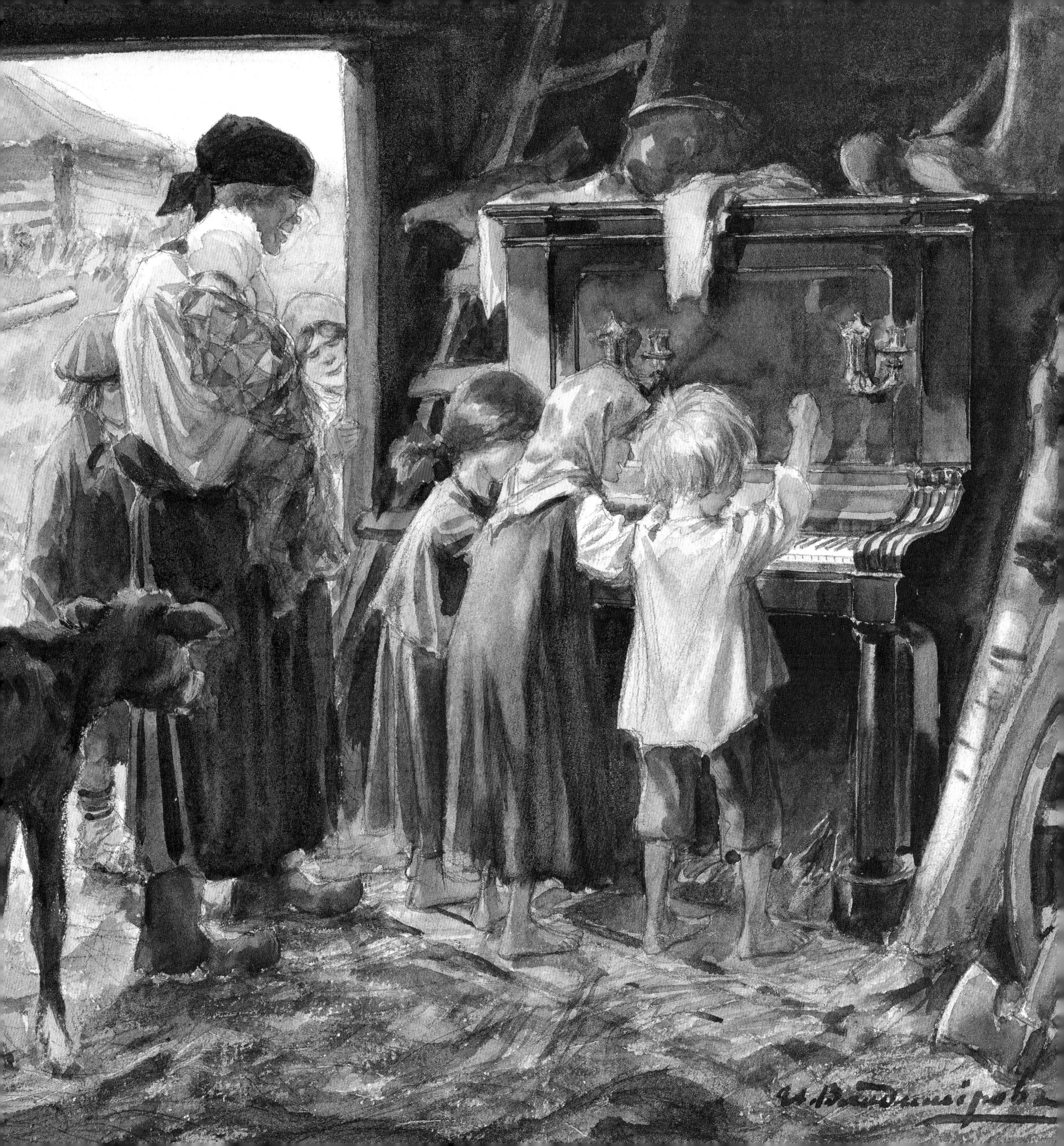

He portrayed with great empathy those for whom the Revolution had proved a catastrophe: the priests scorned by and banished from a society that had hitherto venerated them; the soldiers, government officials and noblemen deprived of their rights and property (officially referred to as *Lishentsi*, 'the disenfranchised'). Vladimirov represents these 'former people' – who are forced to admit there is no place for them in this New Life – with sympathy and understanding. Take *Prince Vasilchikov* shown sitting among the ruins [ill. 66] – a lost soul devoid of hope, a mere shadow of his once glorious self. The persecution of most of these 'former people' was only just beginning. Under the Soviet regime many would be sent to prisons and labour camps; more than ten million would die in the Gulag.

Vladimirov seems to have been fully aware of the true nature of Russia's new rulers. In his works on the Revolution and the Civil War, several recurring types catch the eye. The most common are Red Guards, sailors or armed Bolshevik workers – all looking alike, as if they're from the same family: chubby, shabby, snub-nosed, with smug expressions and a permanent fag in their mouths – whether on sentry duty [ill. 92], in the Tsar's opera box [ill. 90] or shooting someone in a cellar [ill. 36]. Many wear clothes clearly taken from others – either stolen or removed from the bodies of slain Tsarist officers. Members of the Red Army sport officer's boots and riding breeches with piping down the sides; 'expropriated' gold watches and rings adorn their wrists and fingers. The women of this new ruling class are hardly models of shapely beauty, either. And, like the men, they do not look over-burdened with intelligence.

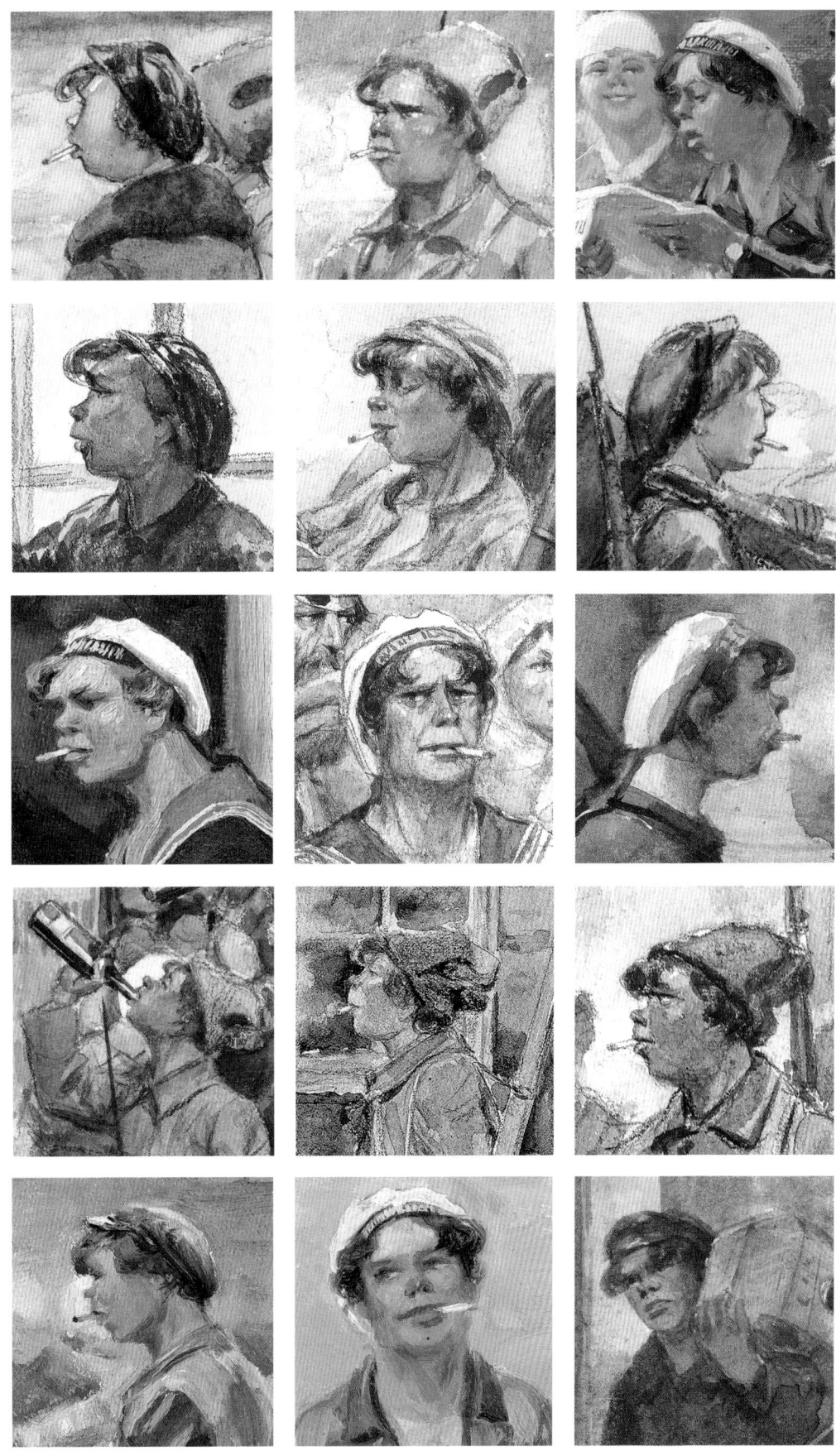

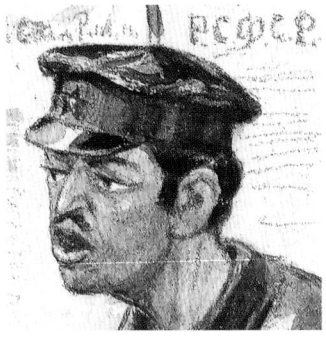

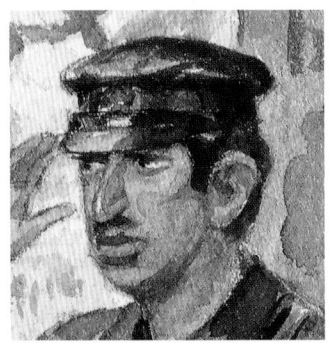

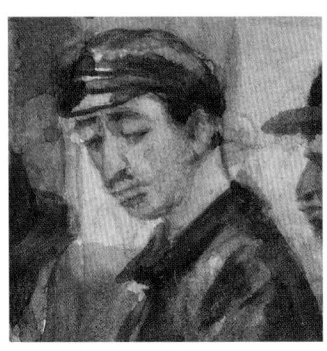

Another figure who recurs in Vladimirov's pictures has a stereotypically Semitic appearance, is always clad in a black cap and leather jacket, and carries a pistol and a brown briefcase under his arm: the Commissar responsible for spreading Bolshevik propaganda.

In contrary to his treatment of 'former people,' Vladimirov portrays the 'new bosses' as primitive and illiterate villains and thugs. Their faces are invariably devoid of human emotion: they are a pack of uneducated savages who feel neither sympathy nor compassion as they exploit their newfound power to carry out lawless and unjustifiable reprisals – robbing homes or liquor stores and grabbing all they want from terrified traders at the market. Vladimirov's pictures debunk these 'victors.'

In the Soviet Union images of revolutionary events were usually given a romantic halo. Vladimirov shows the true face of the 'freedom fighters' – and the true price of society's radical transformation. His vision of reality was too humane and too honest: many of his portrayals of people's lives during Russia's 'accursed years' became dangerous – liable to be viewed by the authorities as 'counter-revolutionary.' Probably the only ones that survived were those Vladimirov managed to hide in some way.

This book marks the first attempt to track down and assemble these works in a single volume – covering the period from the February Revolution to the end of the Civil War and the start of the NEP. It is a collection of the last truthful images from the years of revolutionary turmoil, produced before creative freedom fell victim to the omnipotent State's monopoly on art.

* * *

Ivan Vladimirov was not the only artist whose works from those 'accursed years' escaped the Bolsheviks and somehow found their way to the West. At Sotheby's London I bought a 1920 watercolour by Ivan Simakov (1877–1925) that depicts 'former people' engaged in forced labour, compelled by the new government to clear rubbish from the streets. This sketch is more restrained in nature than those by Vladimirov, and it is not entirely clear on whose side the artist's sympathies lie. Like many of Vladimirov's works, it was also exported to the West at some point.

The story of the very first 'anti-Soviet' work in my collection is worth telling. During a trip to Los Angeles in the early 1980s, I came across a largish (44 x 93 cm) watercolour in a small gallery run by immigrant dealer Misha Kizhner. This masterfully drawn caricature, signed (in Cyrillic) S.Civinsky and dated 1923, satirizes a group of Bolsheviks tramping round Moscow behind a marching band, proudly led by a commander who looks rather like Trotsky. Before us we see a herd of bestial-looking, armed but uneducated riff-raff. I was not the only person taken with this work. Bronislav Dvorsky – then Head of the Russian Department at Christie's New York – introduced me to the famous musician Mstislav Rostropovich, who adored this Civinsky and kept calling me to buy the picture. We could never agree terms. I simply had no wish to sell.

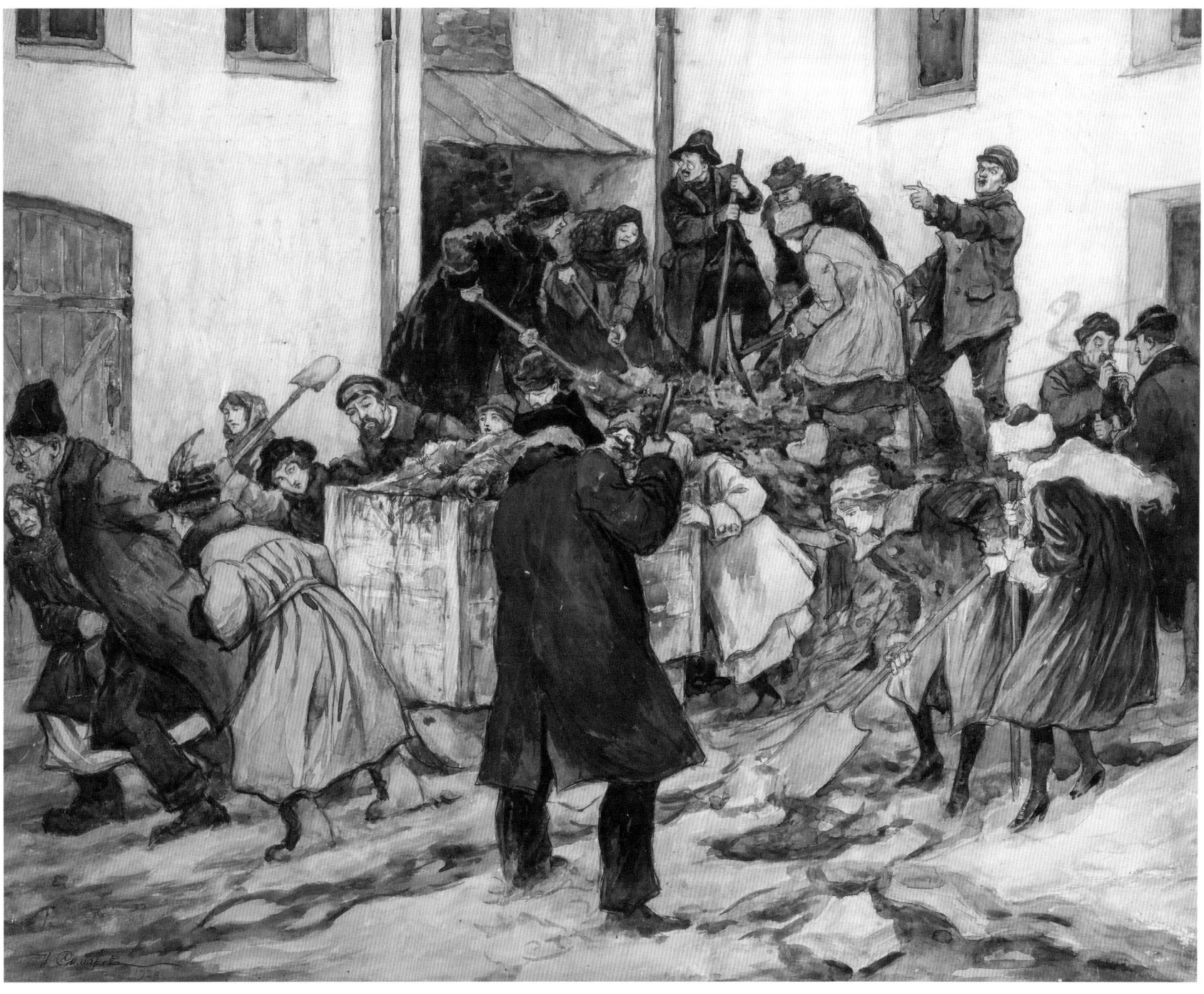

IVAN SIMAKOV (1920)

Volodya Bukovsky also loved Civinsky's watercolour. He never sought to own it but did, however, use it to illustrate a couple of his articles.

It is only recently that I learnt anything about the life of Sergei Antonovich Civinsky (1895–1941). He was born into an officer's family in Dvinsk (now Daugavpils, Latvia); received a military education; became a self-taught artist; fought in World War One; then lived in newly-independent Latvia, publishing political cartoons (primarily about Soviet leaders) under the pseudonym Civis for various newspapers in Riga… an activity that cannot have escaped the attention of ever-vigilant Moscow security officers. In 1934–35 Civinsky worked in America, then returned to Riga. The 'liberation' of Latvia by Soviet troops in 1940 led to mass terror and the annihilation of the Latvian élite and intelligentsia. In October 1940 Civinsky was arrested on charges of espionage and counter-revolutionary propaganda, deported to Moscow and, in July 1941, sentenced to death by the Military Collegium of the Supreme Court of the USSR. He was buried at the Kommunarka shooting ground.

Unlike Ivan Vladimirov, who lived to a ripe old age, Sergei Civinsky paid for his work with his life. Because the Soviet Union sought to destroy the artistic legacy of this 'enemy of the people,' his works rarely appear on the market.

* * *

The final word belongs to the legacy of Ivan Vladimirov. Despite denouncing the Bolsheviks, and his obvious sympathy for the fate of 'former people' during the Revolution, Vladimirov eventually conformed. Like many other artists, he was forced to exploit what few opportunities remained to him after the establishment of Bolshevik power. Some of his works were used to illustrate the official *History of the Civil War in the USSR*, published in 1935 and supposedly authored by Stalin, Gorky, Zhdanov, Molotov, Kirov and Voroshilov. One of them portrays Lenin and Stalin in conversation like two wise, kindly fathers of the nation. Reproductions of Vladimirov's works adorned the offices of Soviet top-brass in the 1930s. It would be naive to suppose that he conformed without good reason – yet his life and career are intriguing and difficult to gauge.

Vladimirov ended up sharing the same fate as many other Russians who lived through one of the cruellest periods in modern history, caught up in a repressive regime with no regard for individuals. Yet, when we look at his images of Lenin from the Soviet era, we can hardly fail to notice their simplified and formalistic nature – as if Vladimirov produced them out of necessity rather than from his own free will. It is no surprise that they are not among the USSR's most famous images of its founding *Vozhd* (leader), or that Vladimirov's Socialist Realist works in general did not garner much of a reputation. By the 1960s his name was little-known in the Soviet Union and had even, I suspect, sunk into oblivion.

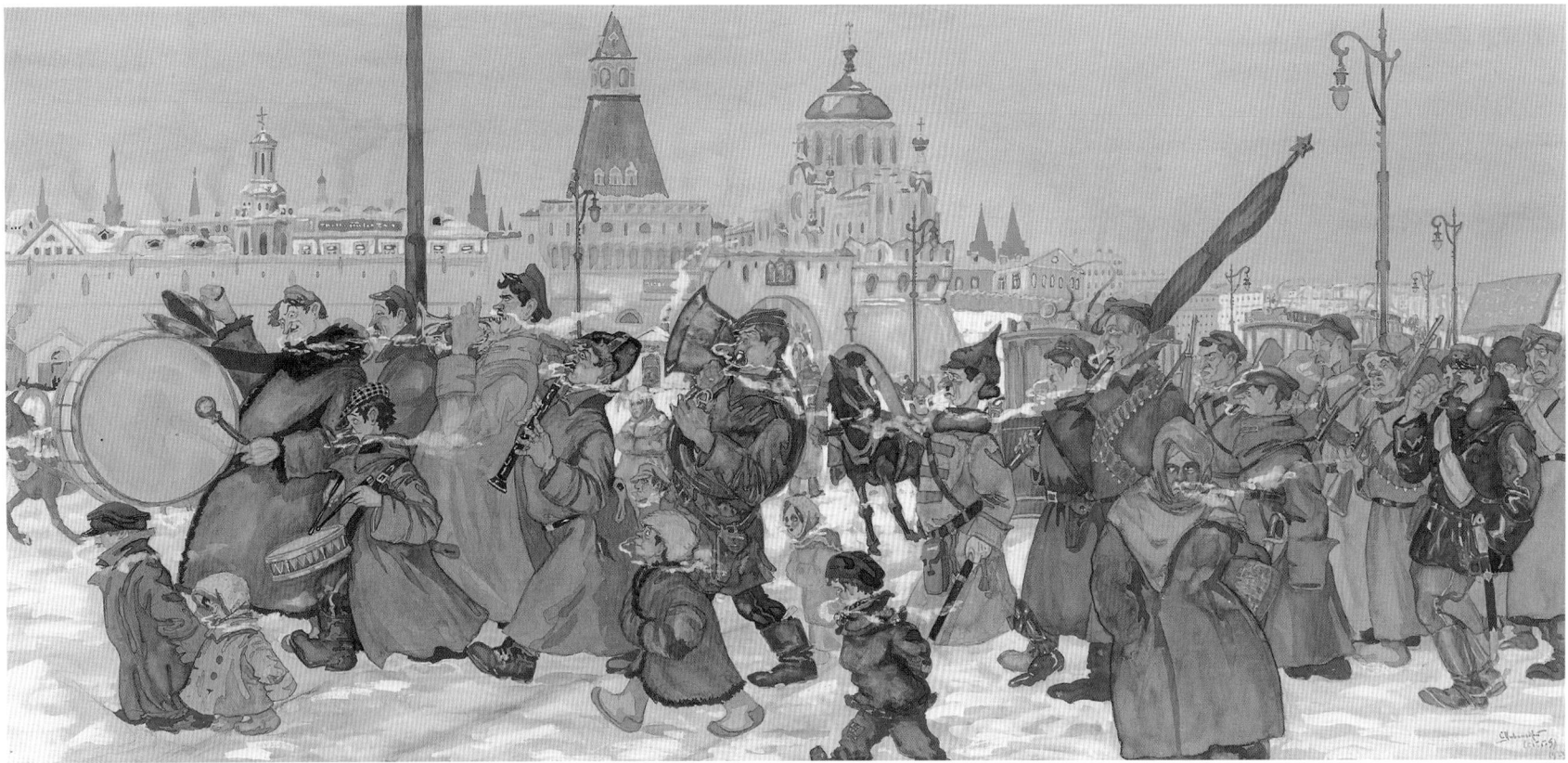

SERGEY CIVINSKY (1923)

His penetrating artistic gaze, illuminating people's lives during the Russian Revolution like a ray of sunlight, was absorbed by the darkness of the regime that followed it. The repressive authorities who plunged the country into totalitarian night had no need for the humanity and powers of observation of this talented Son of Russia. The voices of neither artists nor ordinary people could be heard in the days when State activity resembled the scenes depicted by Ivan Vladimirov.

Chapter 2

'Down with the Eagles!' –
The Year 1917

1917 г.

Дни революцiи.
Баррикады на Литейномъ про

Присоединеніе гвардейскаго полка къ революціонной арміи
1 марта 1917 году на Литейномъ проспектѣ

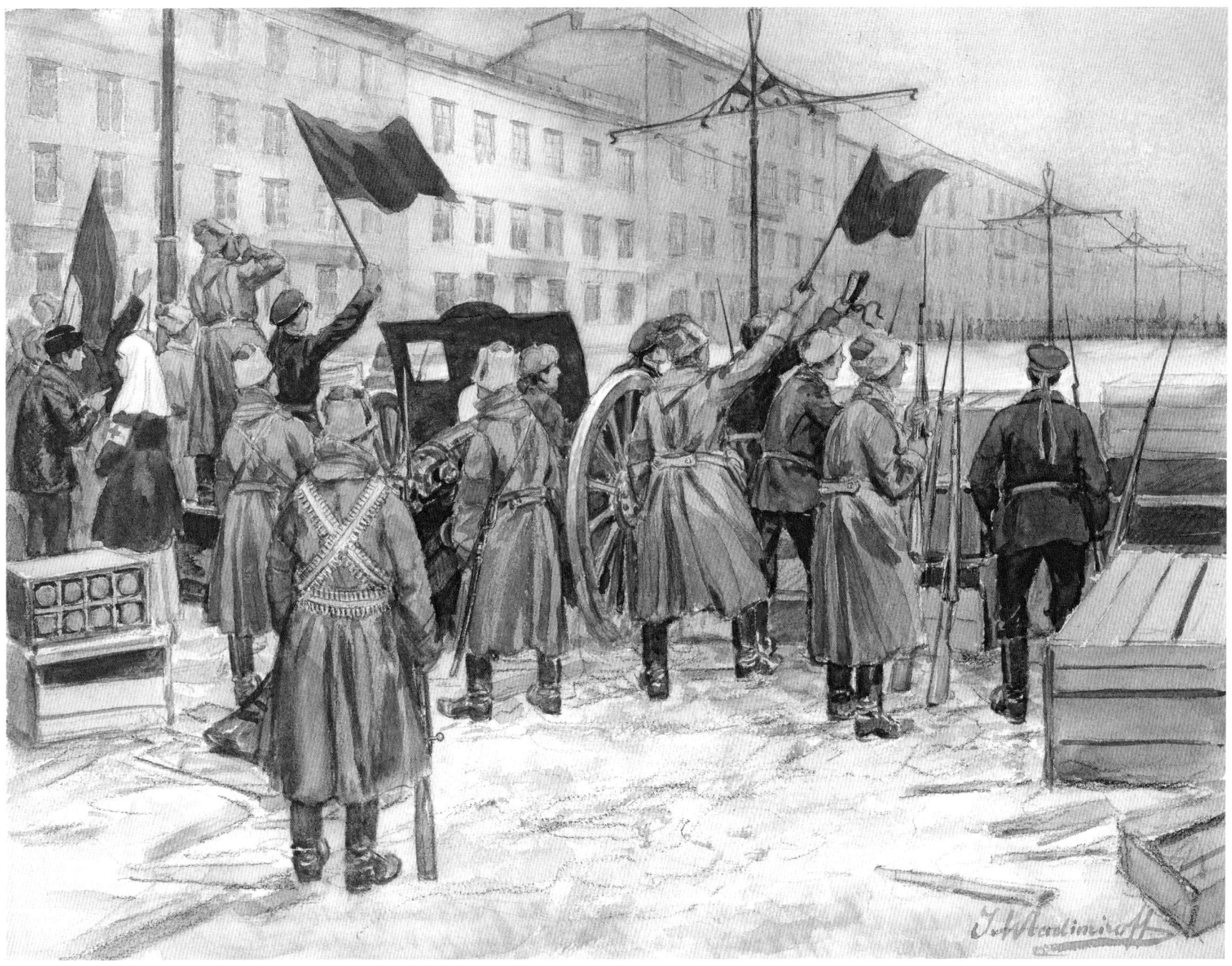

**1. Guards Regiment Joining the Revolutionary Army
on Liteiny Prospekt – 1 March 1917**

ink & watercolour on paper
25.7 x 34.5cm
Andre Ruzhnikov Collection

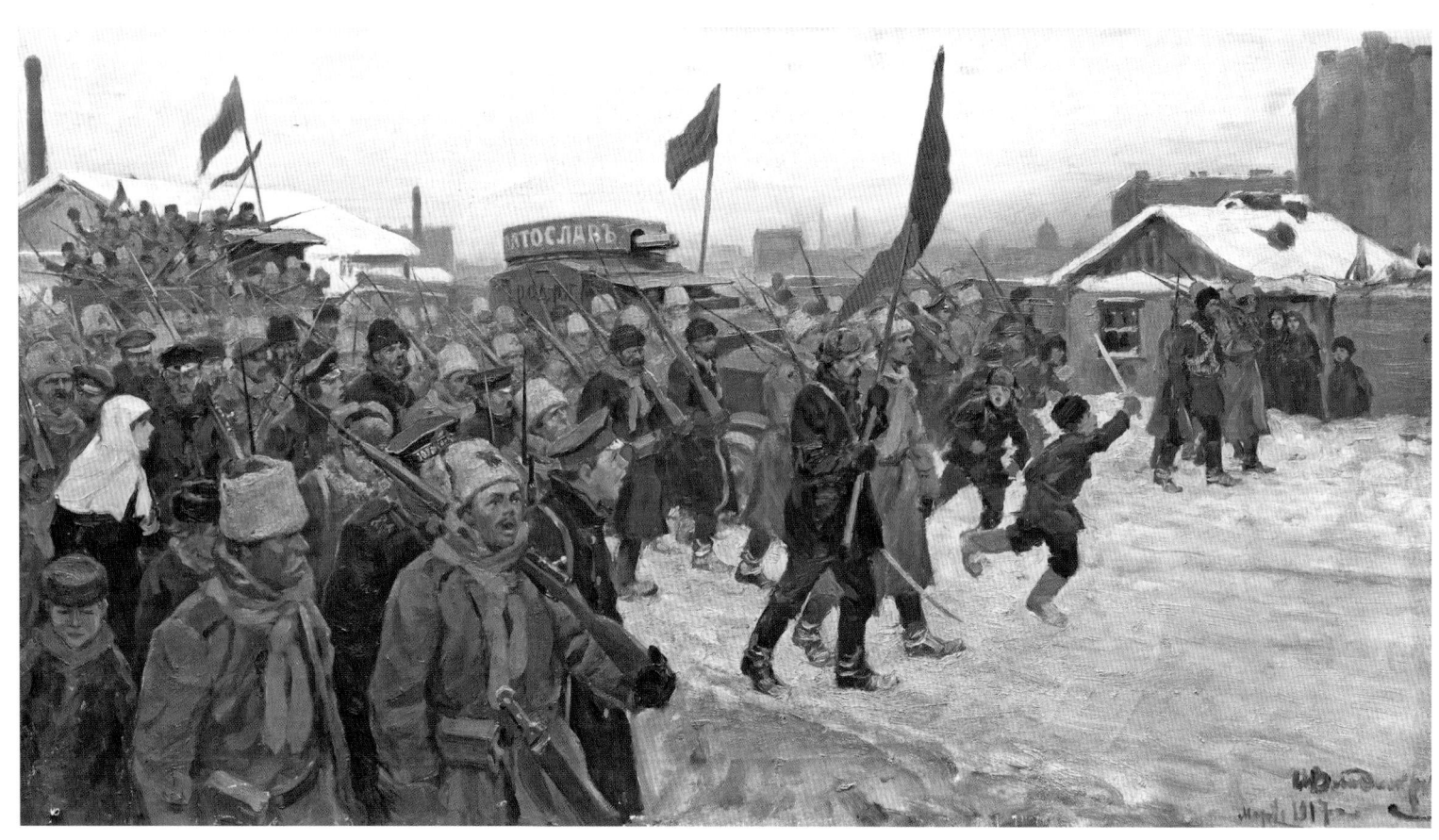

2. The February Days in the Working Suburbs (1917)

oil on canvas
57 x 100cm
State Museum of Russian Political History (St Petersburg)

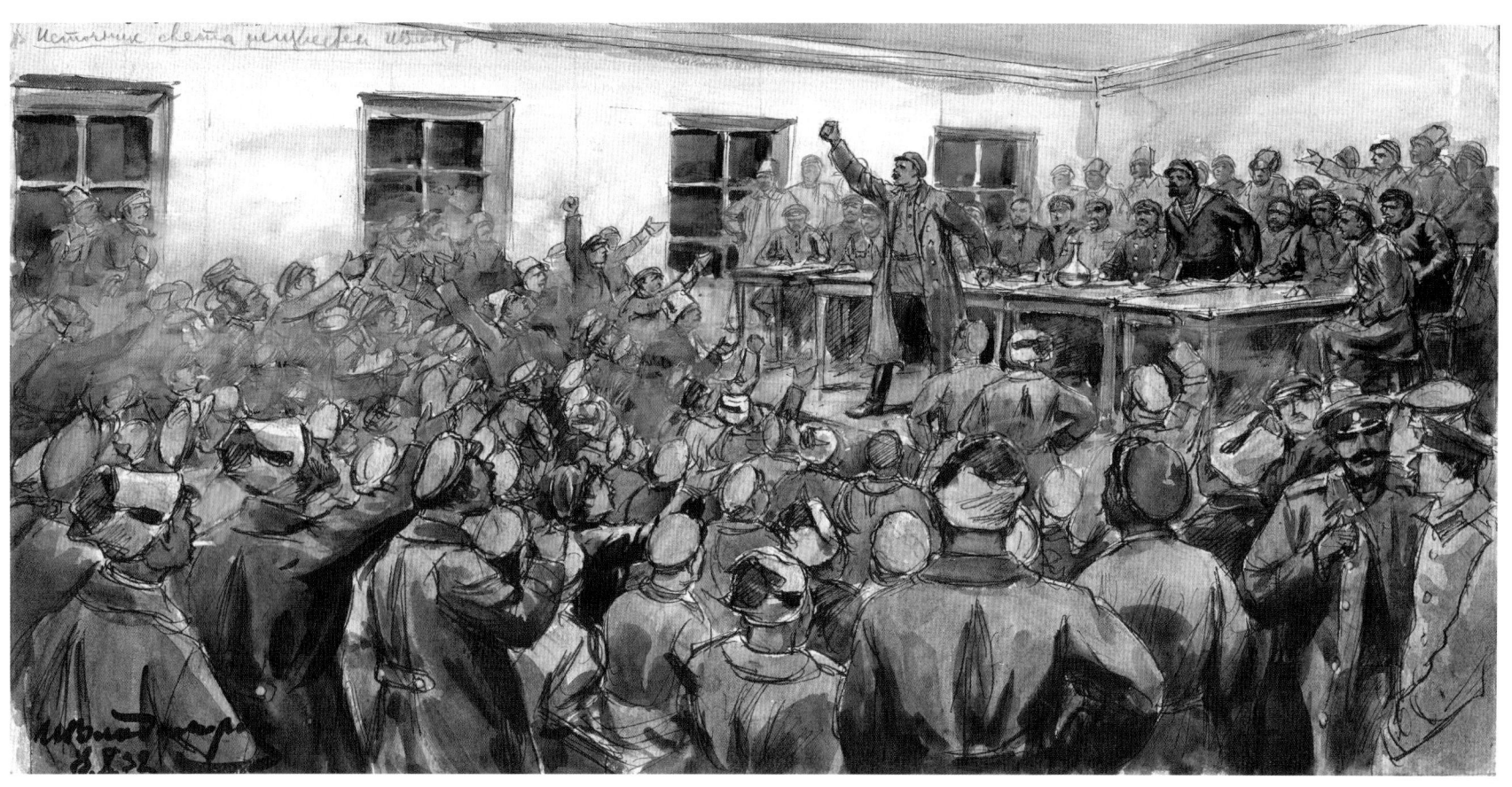

3. Meeting in the Barracks (1932)

watercolour on paper
30 x 49cm
State Museum of Russian Political History (St Petersburg)

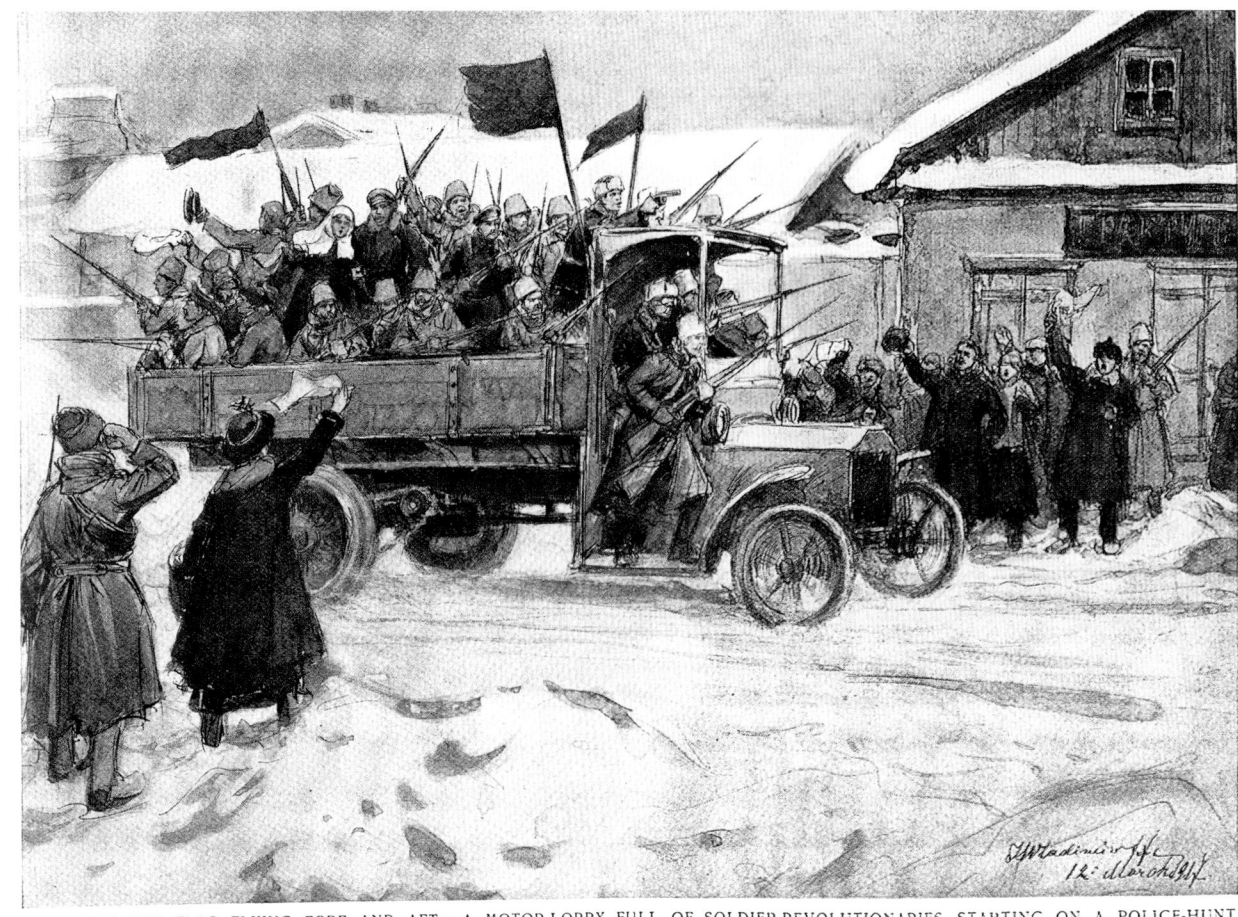

WITH THE RED FLAG FLYING FORE AND AFT: A MOTOR-LORRY FULL OF SOLDIER-REVOLUTIONARIES STARTING ON A POLICE-HUNT
During the fighting numerous motor-lorries filled with soldiers and civilians rushed about the streets hunting down the police, who had occupied a number of roofs and garrets, from which they were eventually driven. One of their strongholds was the roof of the Hotel Astoria, which was in consequence stormed by the mob.

4. With the Red Flag Flying Fore and Aft: Lorry of Soldier-Revolutionaries Setting Off on a Police-Hunt

published in The Graphic (London), 14 April 1917 (p.424)

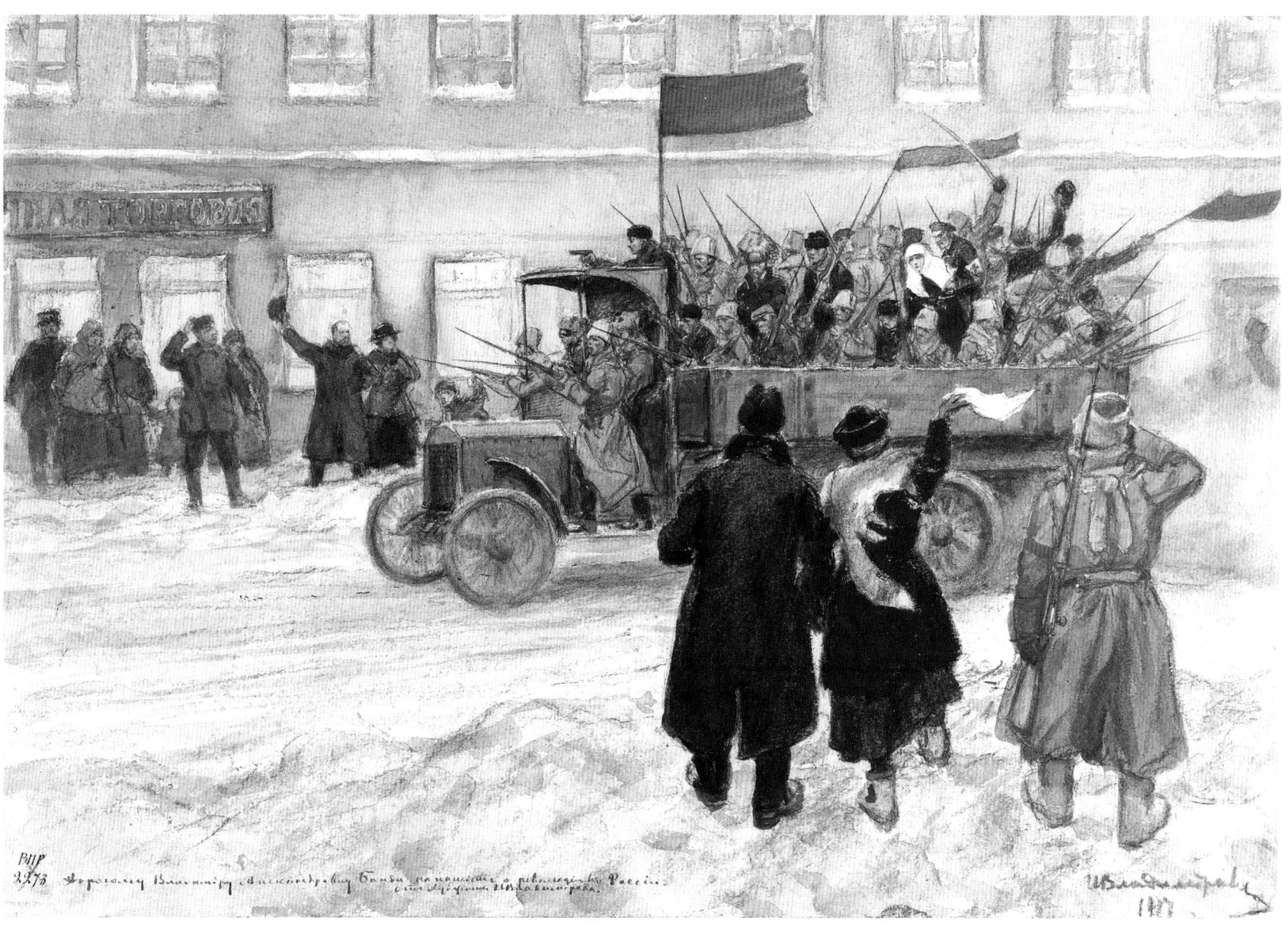

5. Armed Unit on the Streets of Petrograd – 28 February 1917 (1917)

pencil & watercolour on paper
34.5 x 50cm
State Museum of Russian Political History (St Petersburg)

"

We reached the Astoria (on the corner of St Isaac's Square). The ground floor of the hotel was boarded up, though very carelessly, and soldiers climbed in or crawled out by pushing back the boards. In some places you could see inside the restaurant: soldiers were roaming around in search of anything else to take... You could smell wine from a long way off, with broken bottles scattered all over the place. The furniture had been piled up, but the chandeliers were still hanging. The façades were pockmarked by bullets, but curiously the windows were not shattered but neatly perforated with small round holes.

"

Alexandre Benois
Diary (2/15 March 1917)

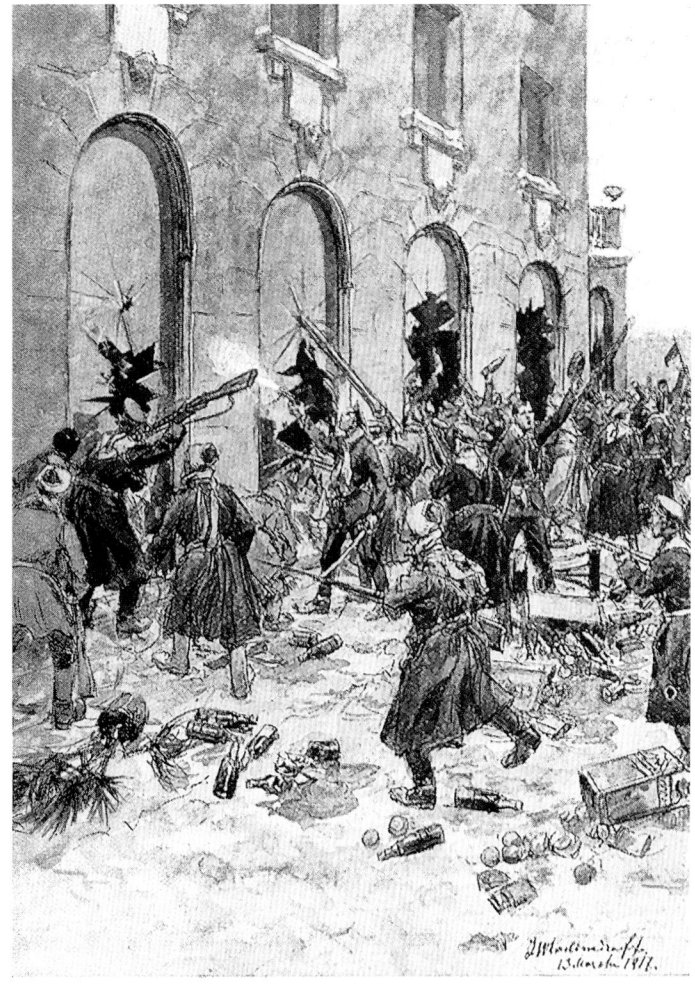

REVOLUTIONISTS STORMING THE HOTEL ASTORIA

6. Revolutionaries Storming the Hotel Astoria

published in The Graphic (London), 14 April 1917 (p. 424)

No. 2472 Vol. XCV.
Registered as a Newspaper.

SATURDAY, APRIL 14, 1917

PRICE SEVENPENCE
By Post, 8d.

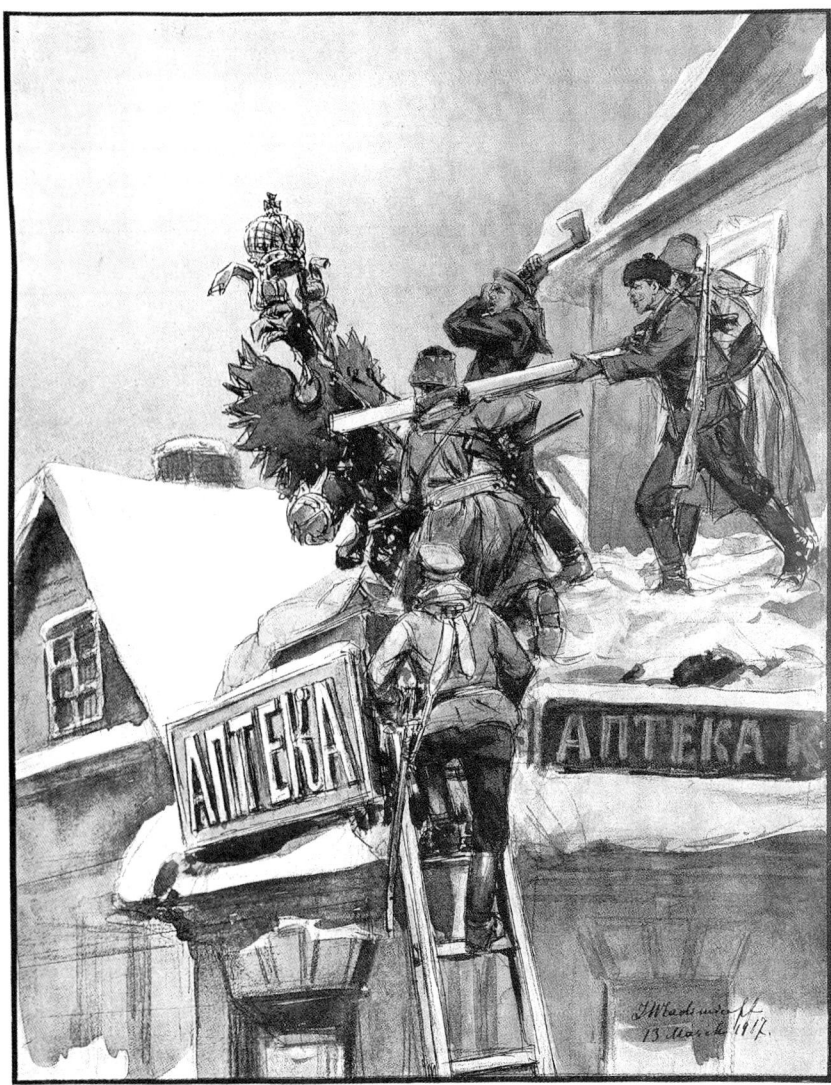

Down with the Eagles !

 One of the first things which the Russian revolutionaries did was to remove all the symbols of Tsardom. The double-headed imperial eagle was torn down from the Government buildings, the imperial standard was everywhere replaced by the red flag, the Emperor's portrait was removed from the Ministries, and the Holy Synod excised from the Liturgy the prayers for the imperial family.

FACSIMILE OF A SKETCH BY JOHN WLADIMIROFF, OUR SPECIAL ARTIST IN RUSSIA

7. Down with the Eagles!

published in The Graphic (London), 14 April 1917 (p. 419)

artist's inscription on back:

"Далой орла"
1917: (2 марта)

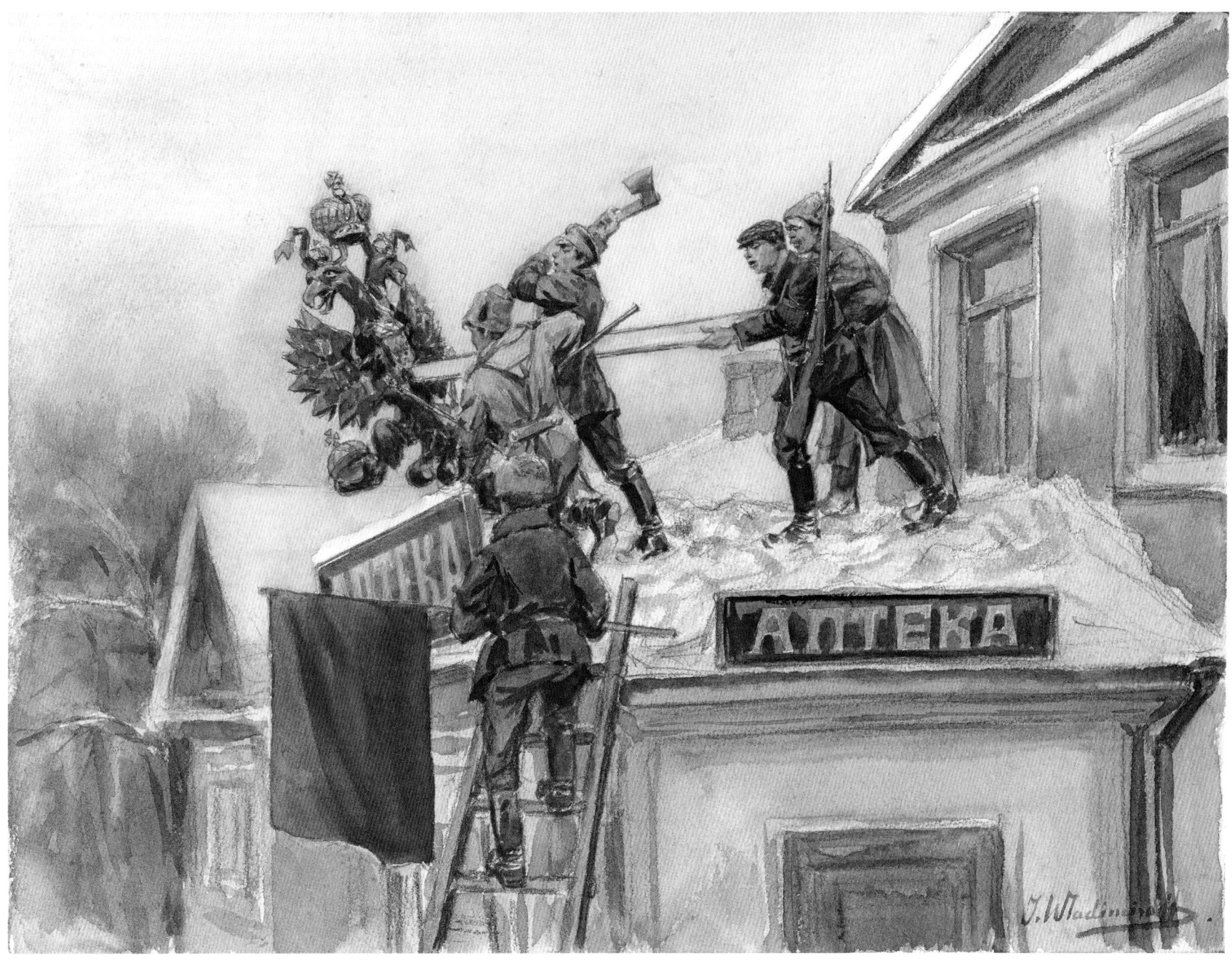

8. Down with the Eagles – 2 March 1917

ink & watercolour on paper
25.5 x 34.5cm
Andre Ruzhnikov Collection

93

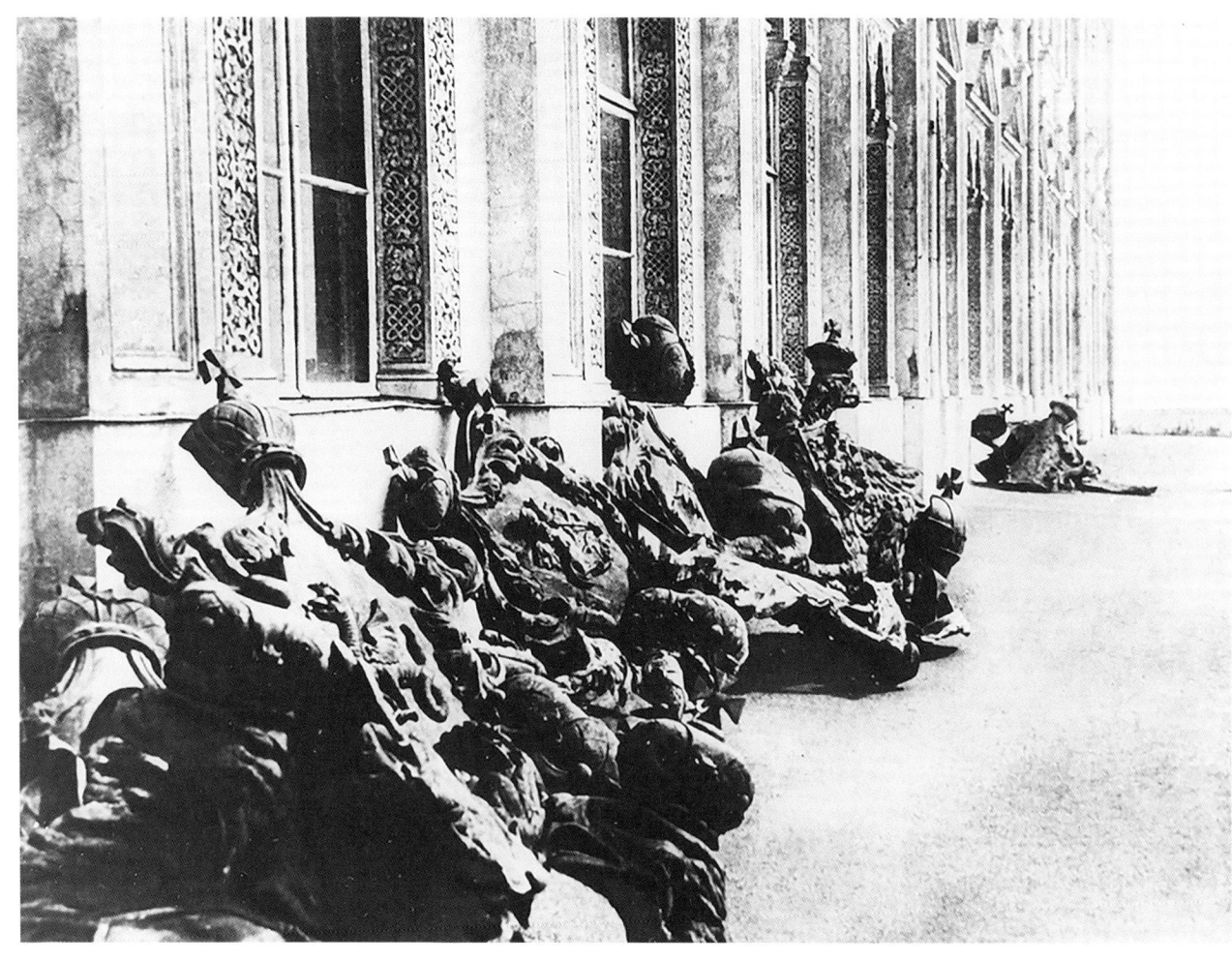

DOUBLE-HEADED EAGLES AFTER REMOVAL (1917)

> A placard had already been placed in the window of *Russkaya Volya* ('Russian Will'): *Nikolai Romanov Has Abdicated The Throne*, etc. Passers-by read it and shrugged. With the same air of placid indifference, some proletarians – mainly young men – were removing the heraldic eagles that adorned the pharmacies and 'Suppliers to the Imperial Court' (and there were quite a few along Nevsky Prospekt), then hurling the symbolic sculptures on bonfires. One soldier was brandishing the gilded claw of an eagle like a mace, while a boy was taking pieces of eagle sawn from the sign above *Coiffeur Molet*, and adding them to the fire. 'Here you go, Nikolashka!' he declared with cheerful good humour.
> 'Here you go!'

Alexandre Benois
Diary (3/16 March 1917)

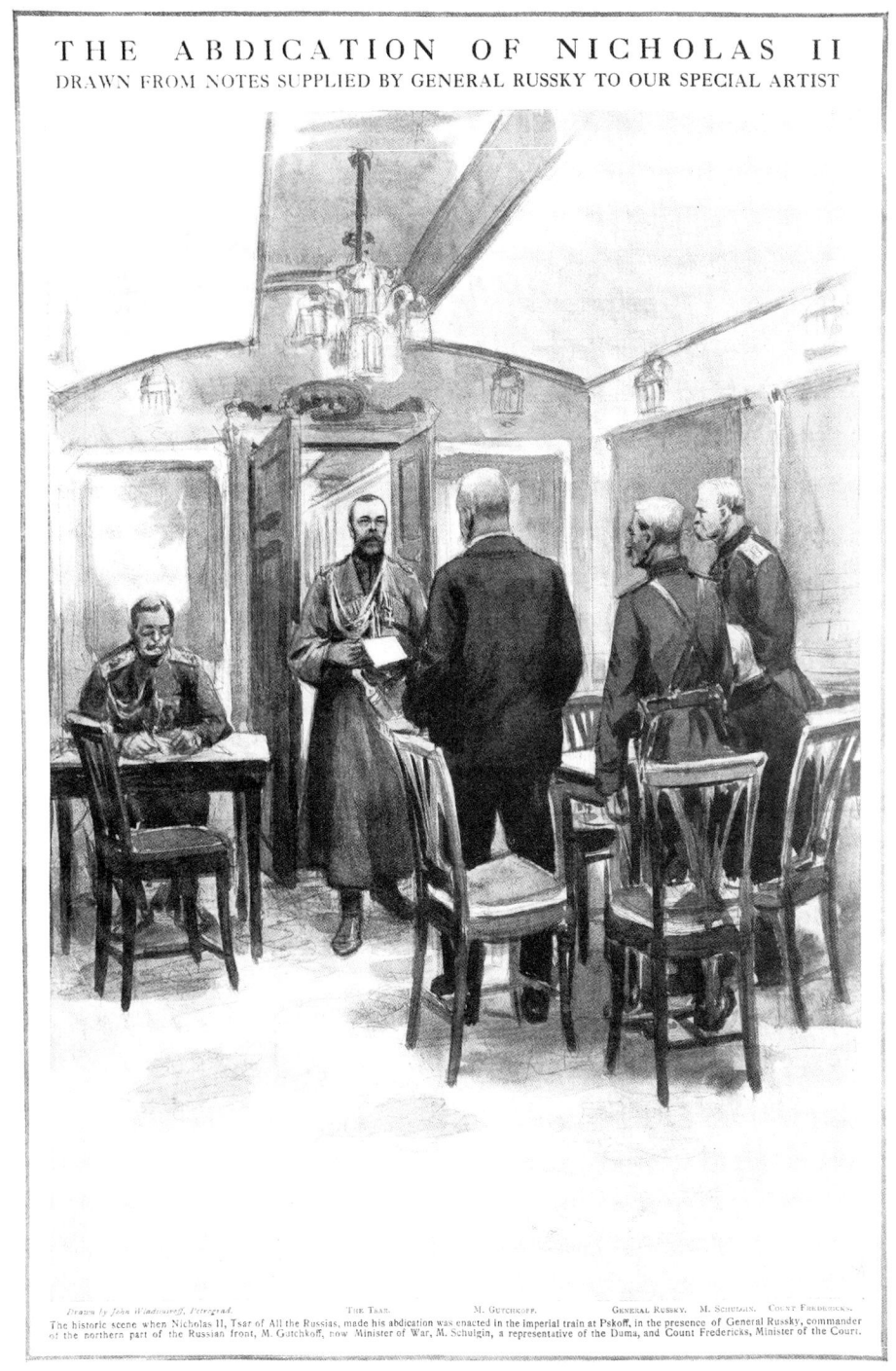

9. Abdication of Nicholas II (drawn from notes supplied by General Ruzsky)

published in The Graphic (London), 14 April 1917 (p. 425)

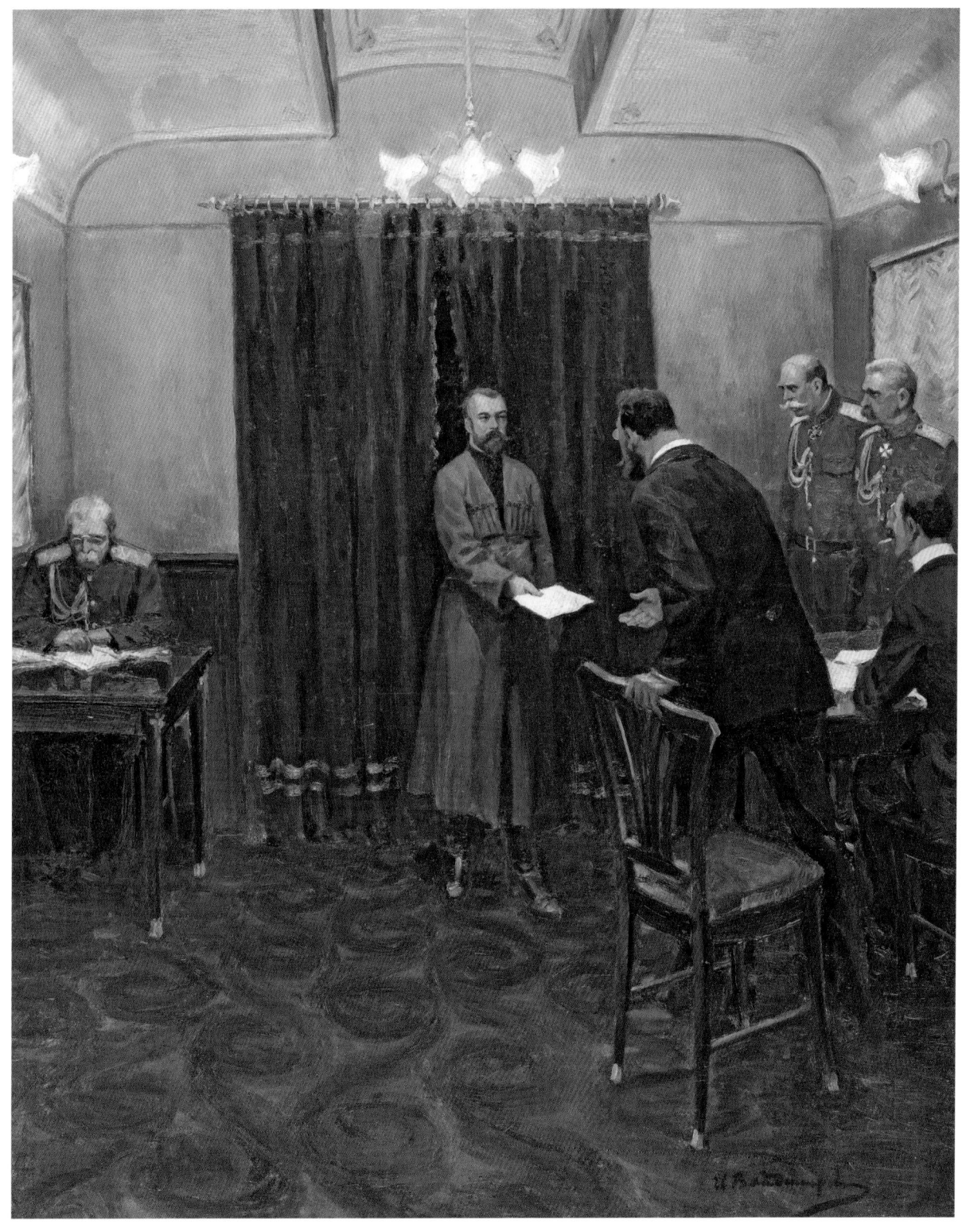

10. Abdication of Nicholas II (1917)

oil on canvas
89 x 72cm
Central State Museum of Russian Modern History
(Moscow)

УТРО
РОССІИ

ЦѢНА НОМЕРА: въ Москвѣ 7 коп. на станціяхъ жел. дор. 8 коп.

№ 61 Суббота, 4-го марта 1917 года. Путинковскій пер., д. 3. Годъ 8-й. № 61

ОТРЕЧЕНІЕ ОТЪ ПРЕСТОЛА.

Манифестъ Николая II.

„Божіею милостію Мы, Николай Вторый, Императоръ Всероссійскій, Царь Польскій, Великій Князь Финляндскій и прочая, и прочая. Объявляемъ всѣмъ Нашимъ вѣрноподданнымъ:

Въ дни великой борьбы съ внѣшнимъ врагомъ, стремящимся почти три года поработить нашу родину, Господу Богу угодно было ниспослать Россіи новое тяжкое испытаніе. Начавшіяся внутреннія народныя волненія грозятъ бѣдственно отразиться на дальнѣйшемъ веденіи упорной войны. Судьба Россіи, честь геройской нашей арміи, благо народа, все будущее дорогого нашего отечества требуютъ доведенія войны во что бы то ни стало до побѣднаго конца.

Жестокій врагъ напрягаетъ послѣднія силы, и уже близокъ часъ, когда доблестная армія наша совмѣстно съ славными нашими союзниками сможетъ окончательно сломить врага. Въ эти рѣшительные дни въ жизни Россіи почли Мы долгомъ совѣсти облегчить народу нашему тѣсное единеніе и сплоченіе всѣхъ силъ народныхъ для скорѣйшаго достиженія побѣды и въ согласіи съ Государственной Думой признали Мы за благо отречься отъ престола Государства Россійскаго и сложить съ себя Верховную власть. Не желая разстаться съ любимымъ сыномъ нашимъ, Мы передаемъ наслѣдіе наше брату нашему Великому Князю Михаилу Александровичу, благословляя его на вступленіе на престолъ Государства Россійскаго.

Заповѣдуемъ брату нашему править дѣлами государственными въ полномъ и ненарушимомъ единеніи съ представителями народа въ законодательныхъ учрежденіяхъ на тѣхъ началахъ, кои будутъ ими установлены, принеся въ томъ ненарушимую присягу во имя горячо любимой родины.

Призываемъ всѣхъ вѣрныхъ сыновъ отечества къ исполненію своего святого долга передъ нимъ повиновеніемъ Царю въ тяжелыя минуты всенародныхъ испытаній и помочь ему вмѣстѣ съ представителями народа вывести Государство Россійское на путь побѣды, благоденствія и славы.

Да поможетъ Господь Богъ Россіи.

2-го марта 1917 года, 15 часовъ. Г. Псковъ.

НИКОЛАЙ.

Скрѣпилъ министръ Императорскаго Двора генералъ-адъютантъ графъ **Фредериксъ.**

Переговоры съ Николаемъ Вторымъ.

Въ Псковъ выѣхали 2 марта военный министръ А. И. Гучковъ и членъ Временнаго Комитета Государственной Думы В. В. Шульгинъ. Они посѣтили царя въ поѣздѣ Съ ними былъ министръ императорскаго двора гр. Фредериксъ и главнокомандующій сѣвернымъ фронтомъ генералъ-адъютантъ Рузскій. Царь вышелъ къ представителямъ народа въ полномъ спокойствіи.

— Я все это обдумалъ, — сказалъ онъ, — и рѣшилъ отречься. Но отрекаюсь не въ пользу своего сына, такъ какъ я долженъ уѣхать изъ Россіи, разъ я оставляю Верховную власть. Покинуть же въ Россіи сына, котораго я очень люблю, оставить его на полную неизвѣстность я ни въ коемъ случаѣ не считаю возможнымъ Вотъ почему я рѣшилъ передать престолъ моему брату, великому князю Михаилу Александровичу.

А. И. Гучковъ и В. В. Шульгинъ просили царя еще разъ обдумать это рѣшеніе и Николай Вторый удалился въ сосѣднее отдѣленіе салонъ-вагона въ которомъ происходила бесѣда. Черезъ 20 минутъ онъ вышелъ оттуда съ текстомъ манифеста въ рукахъ Текстъ былъ написанъ на пишущей машинкѣ и исправленъ карандашемъ.

— Рѣшеніе мое твердо и непреклонно, — сказалъ Царь передавая текстъ манифеста А. И. Гучкову и В. В. Шульгину.

Отреченіе Великаго Князя.

3 марта утромъ А. И. Гучковъ и В. В. Шульгинъ возвратились въ Петроградъ гдѣ на вокзалѣ ихъ ждали члены совѣта министровъ, съ которыми они отправились на квартиру великаго князя Михаила Александровича. Министры ознакомили великаго князя какъ съ волей Николая Втораго, такъ и съ положеніемъ дѣлъ, подчеркнувъ измѣненія въ настроеніяхъ, происшедшія въ извѣстныхъ кругахъ за послѣднія сутки.

Внимательно выслушавъ все сообщенное ему великій князь категорически отказался принять корону.

— Какъ же могу я принять въ такое время и при такихъ условіяхъ Верховную власть, — сказалъ онъ, — когда такой шагъ мой лишь внесетъ еще большую смуту.

Послѣ нѣкотораго обмѣна мнѣніями, великій князь, попросивъ съ собой В. Н. Львова и В. В. Шульгина, удалился съ ними въ сосѣднюю комнату для переговоровъ. Возвратившись оттуда, Михаилъ Александровичъ сказалъ:

— Я рѣшилъ твердо короны не принимать Но если Государственная Дума и народъ пожелаютъ, чтобы я взялъ на себя регентство впредь до созыва и рѣшенія Учредительнаго Собранія, то на это я дамъ свое согласіе.

Присутствовавшій при разговорѣ министръ юстиціи А. Ф. Керенскій подошелъ къ великому князю и сказалъ:

— Вы благородный человѣкъ, я всѣмъ и вездѣ дамъ знать о вашихъ словахъ и вашемъ поведеніи.

FRONT-PAGE OF UTRO ROSSII ('RUSSIAN MORNING') — 4/17 MARCH 1917

"

His Majesty had decided to abdicate that afternoon, and now wished to confirm the act of abdication to the Deputies in person, and hand them the manifesto for publication. The Deputies did not, therefore, have to make any speeches. His Majesty announced calmly and firmly that He would do as his conscience dictated, and renounce the throne for Himself and his Son – from whom He could not be parted due to his painful condition. Guchkov reported that the Deputies' return was fraught with risk, and therefore asked Him to sign an extra copy of the manifesto just in case. The Sovereign agreed.... After midnight the Sovereign retired to his compartment and was left alone. General Ruzsky, Guchkov, Shulgin and the others soon left the Tsar's train and we did not see them again. After one in the morning, the Deputies' train – just a single wagon and a steam locomotive – set off for Petrograd. A handful of people saw it go. The deed was done. Emperor Nicholas II was no more.

"

General Dmitry Dubensky
How Revolution Happened In Russia

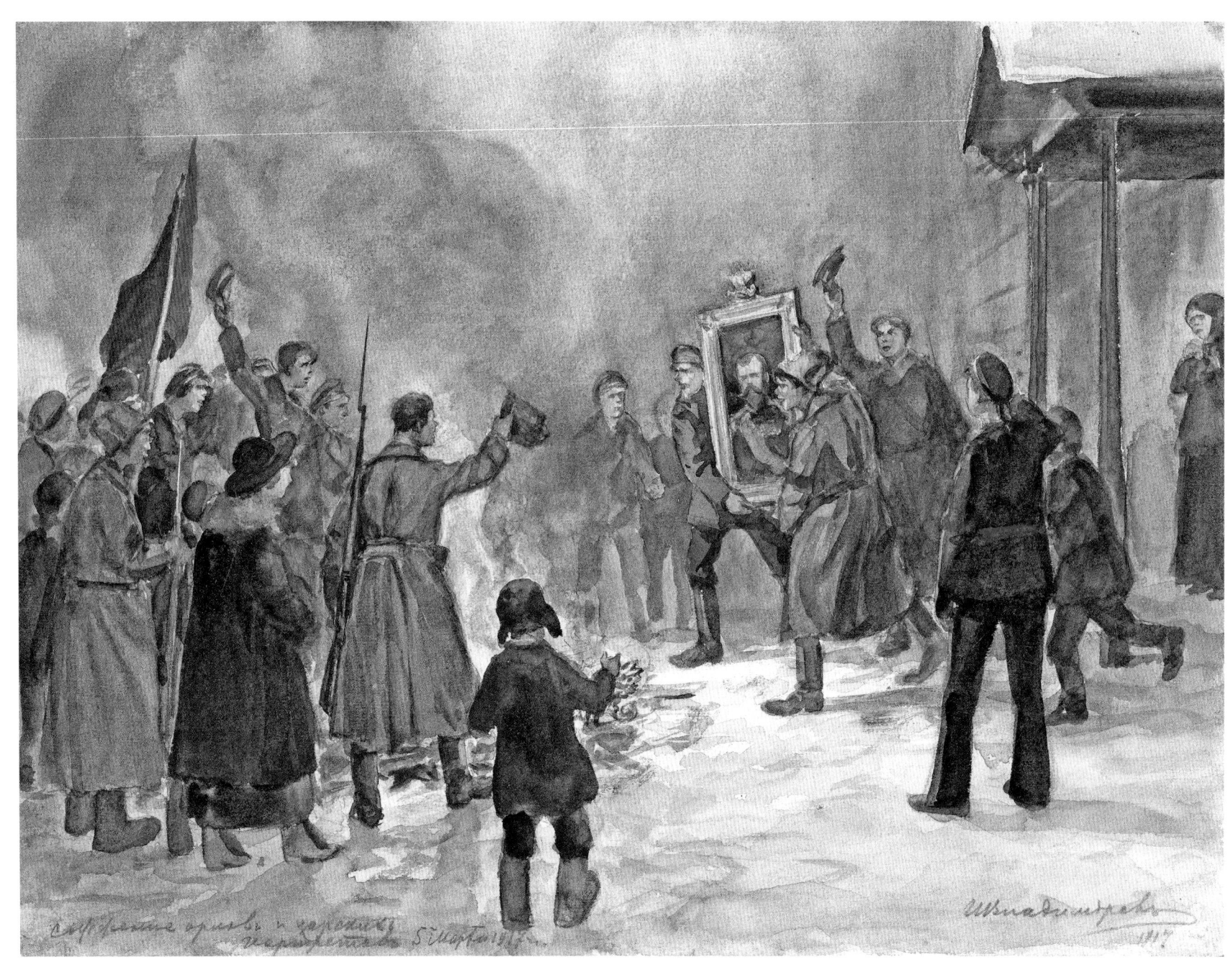

11. Burning Eagles and Romanov Portraits – 5 March 1917 (1917)

ink & watercolour on paper mounted on board

25.7 x 34.5cm

Anne S.K. Brown Military Collection, Brown University Library

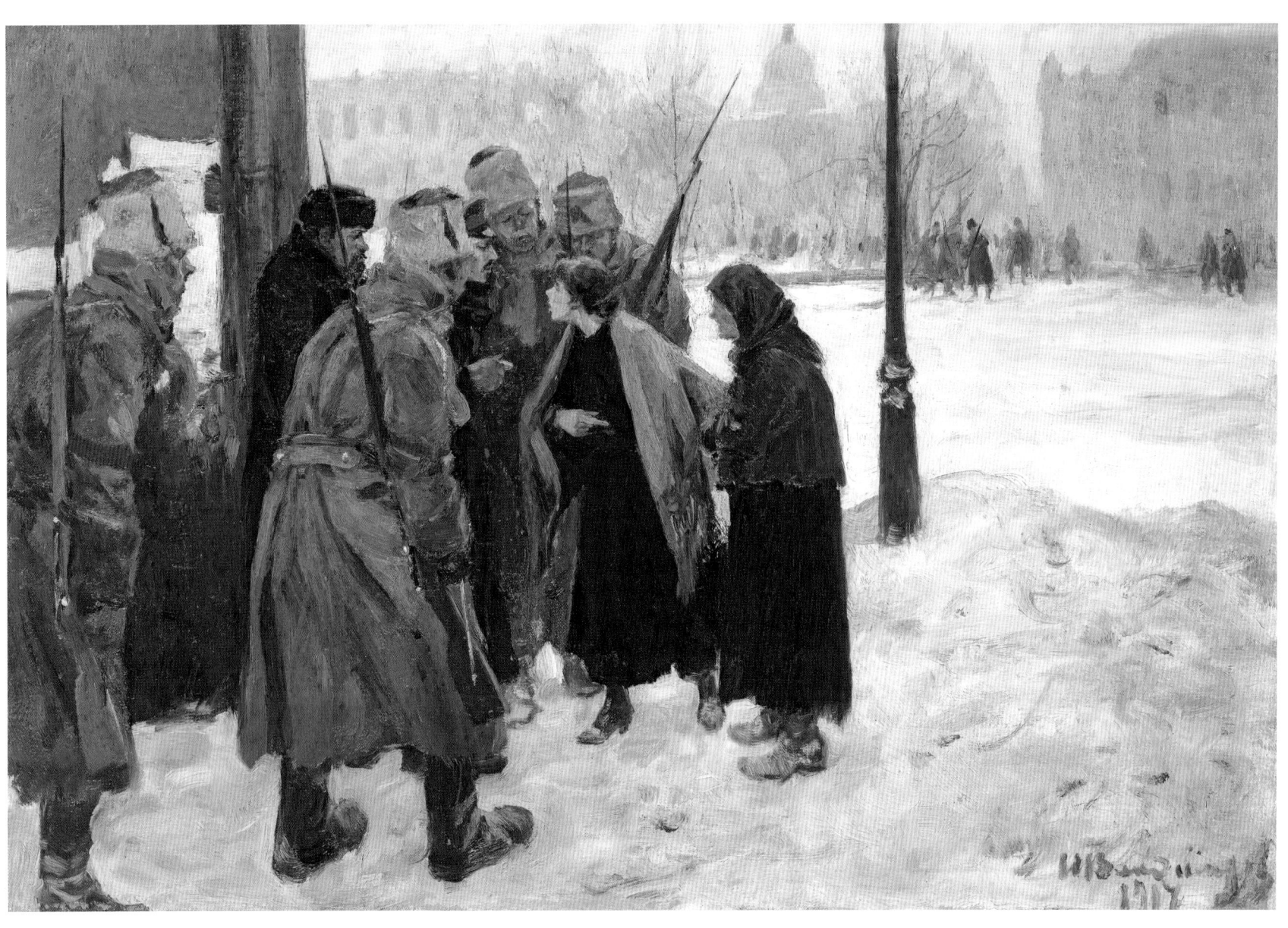

12. February 1917 – Alarming News (1917)

oil on canvas mounted on board
38.5 x 57cm
Central State Museum of Russian Modern History (Moscow)

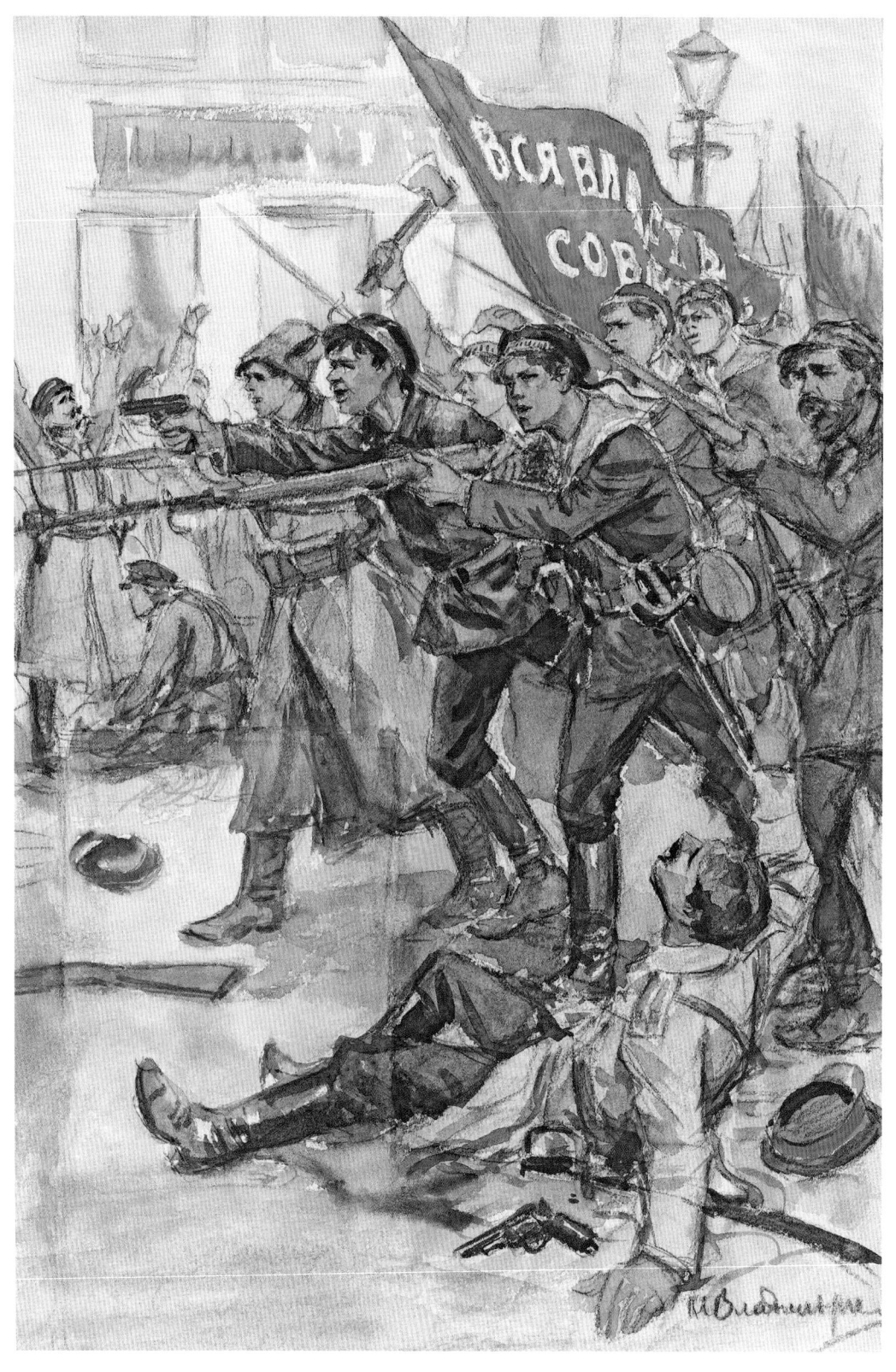

13. All Power to the Soviets! (1917/18)

ink & watercolour on paper on board 36.5 x 26.4cm
Vladimir Ruga Collection

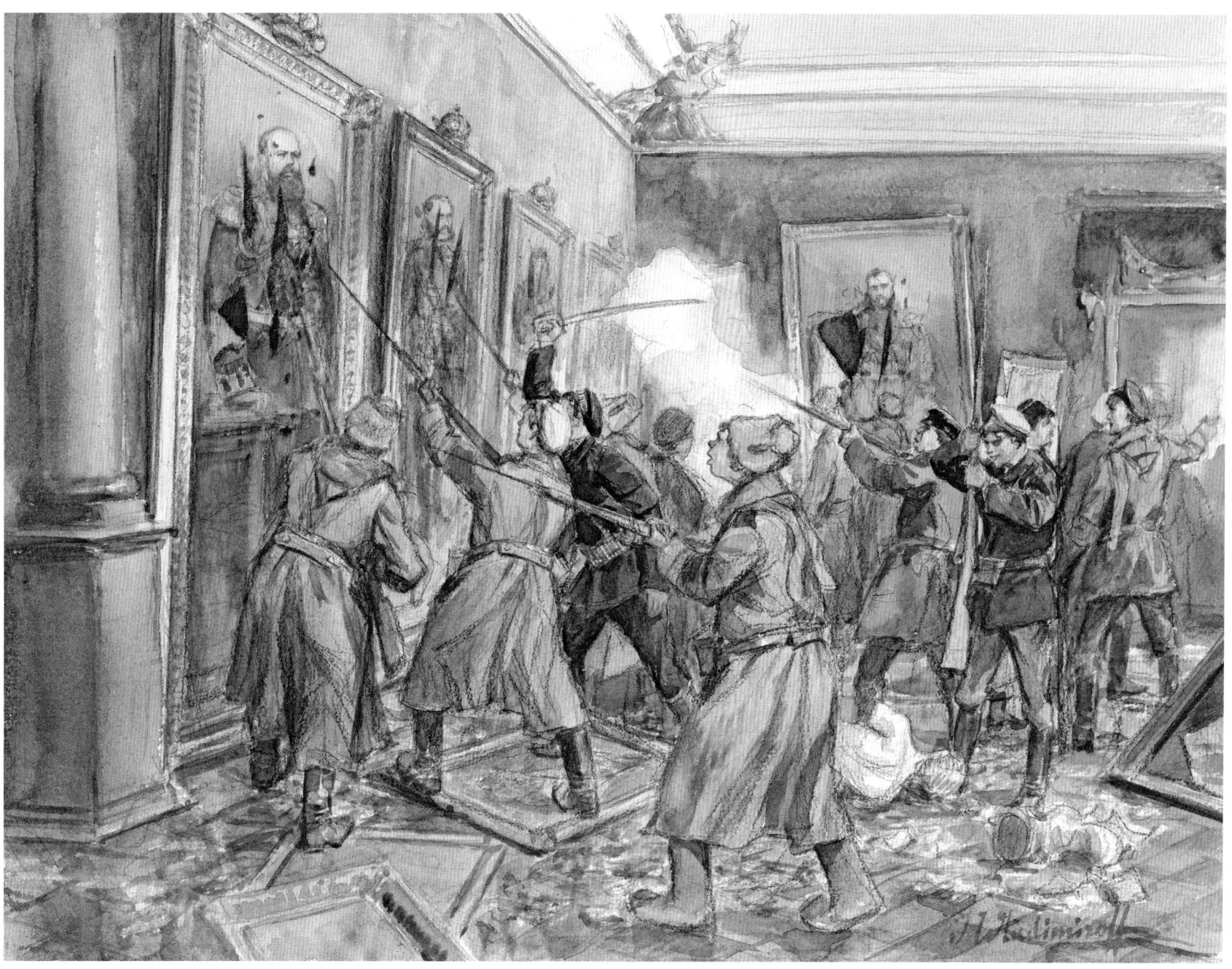

14. Vandalism of the Revolutionaries – Scene in the Winter Palace – 1917

ink, pencil & watercolour on paper
29.2 x 39.4cm
Hoover Institution Library & Archives

"

Although it had been stated that all military units had left the inside rooms, on our first tour of the [Winter] Palace we could still see plenty of armed soldiers roaming around, stealing whatever they could... They used bayonets to pierce the eyes in the large portraits of the Sovereign's parents; the Tsar's portrait by Serov, which used to hang high above a cabinet in the corner, had disappeared. Whoever had taken it must have performed some complicated gymnastics. The portrait was found in the Square outside a day or two later, unrecognizable and ridden with holes. Only a thin layer of paintwork remained, and the facial features could hardly be recognized. They had obviously humiliated it in every possible way – trampling it underfoot, scraping it and scratching it with something sharp!

"

Alexandre Benois
Diary (28 October/10 November 1917)

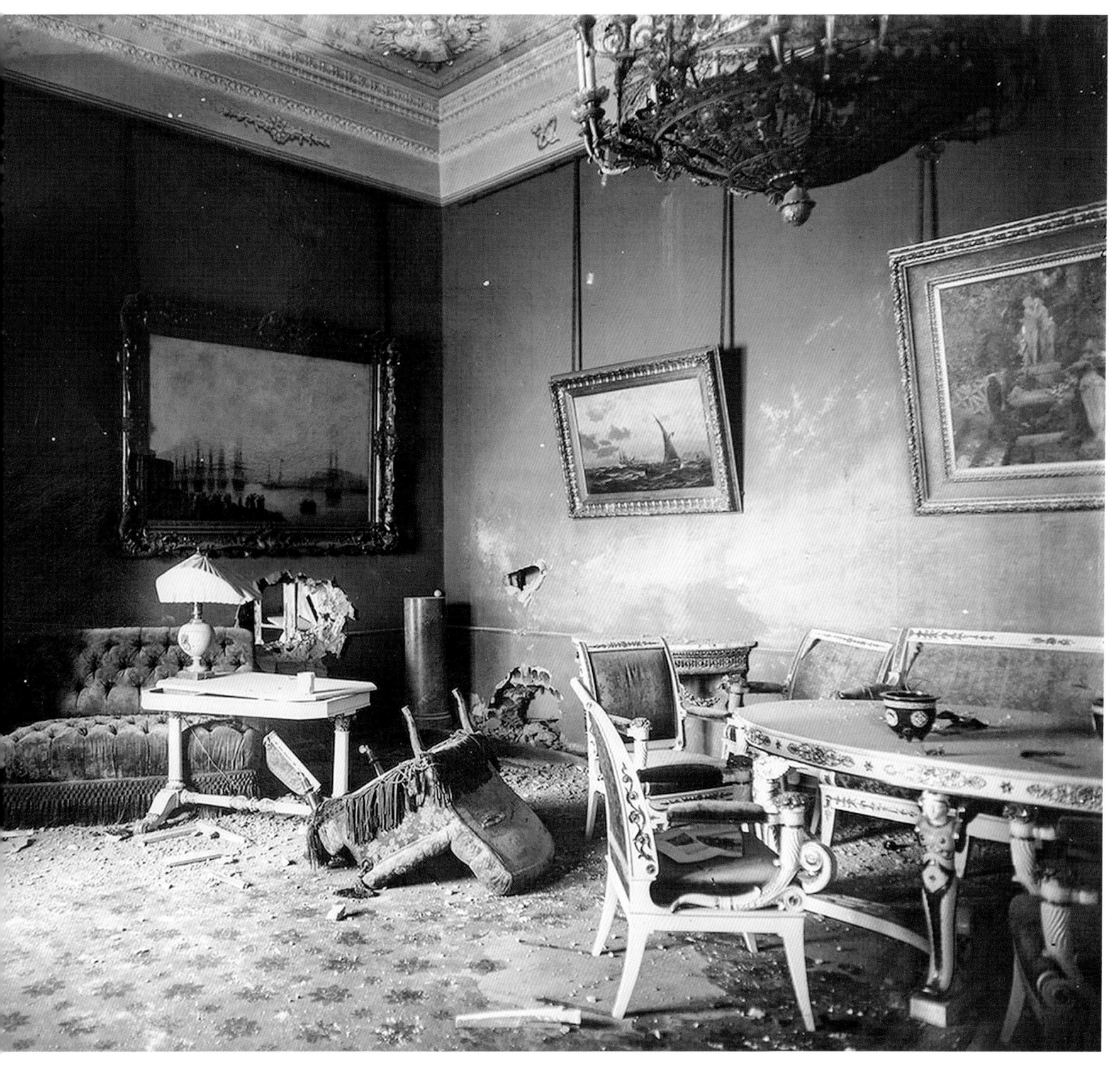

THE WINTER PALACE RANSACKED DURING THE 1917 OCTOBER REVOLUTION –
26 OCTOBER (8 NOVEMBER) 1917

THE BOMBARDMENT OF THE KREMLIN: (1) Artillery firing from the Strastnoy Monastery; (2) The Cathedral of the Twelve Apostles on fire.

15. Bombarding the Kremlin: Artillery Fire from Strastnoy Monastery
Flames Engulfing the Cathedral of the Twelve Apostles

published in *The Graphic* (London), 19 January 1918 (p. 69)

Drawn by our Special Artist, John Wladimiroff
THE RED GUARDS FORCING AN ENTRANCE INTO THE KREMLIN

16. Red Guards Forcing Their Way Into The Kremlin

published in *The Graphic* (London), 19 January 1918 (p. 68)

"

In the morning I went to the museum then on to Kuznetsky Most, driven by over-powering curiosity. The destruction was devastating: the City Duma and the Metropol were particularly affected – the impression was terrifying and indelible; it was even worse at Nikitsky Gate, where we had been the evening before – the Korobkov and former Borgest homes were in ruins; trenches and wire fencing had appeared here and on Arbat Square; tram wires were strewn over the ground, clocks had been knocked down or were leaning helplessly to one side; even more dreadful was the queue for identifying dead bodies outside the University Anatomical Theatre; as I saw on my way home, this queue snaked along the pavement almost as far as the National.

"

Yuri Gautier
My Notes (5/18 November 1917)

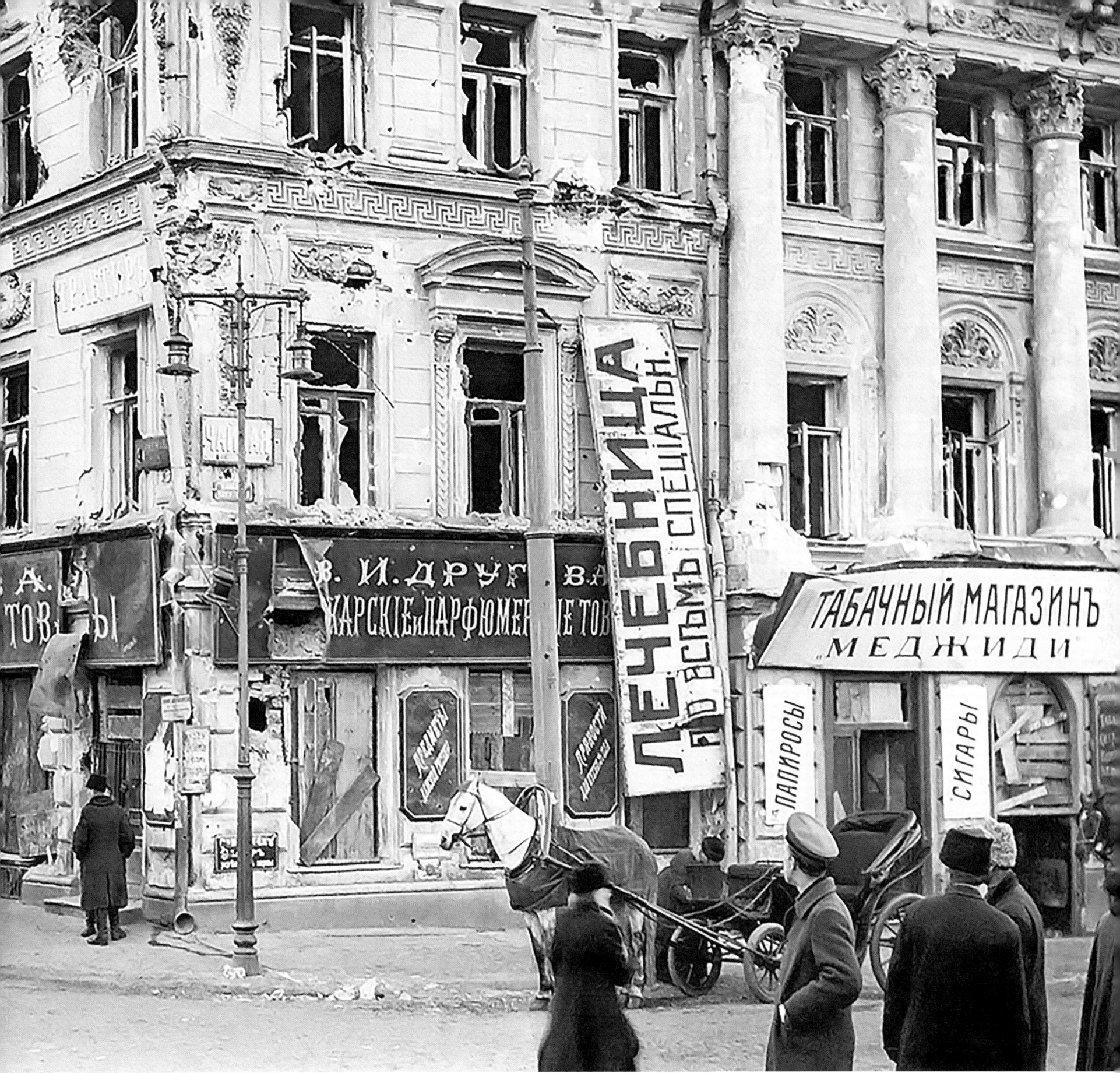

BUILDING AT THE NIKITSKY GATE DAMAGED BY ARTILLERY FIRE – MOSCOW NOVEMBER 1917

109

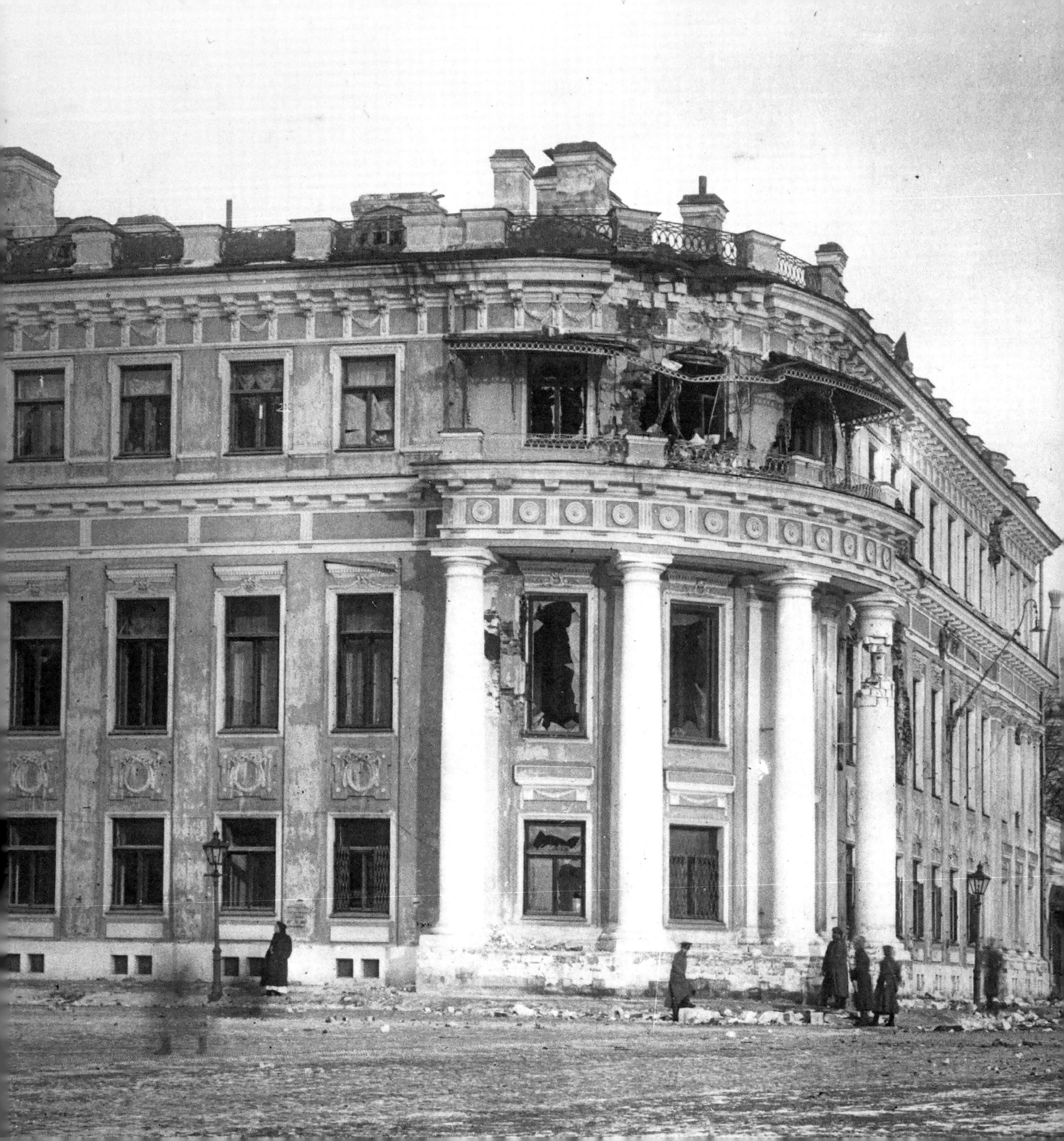

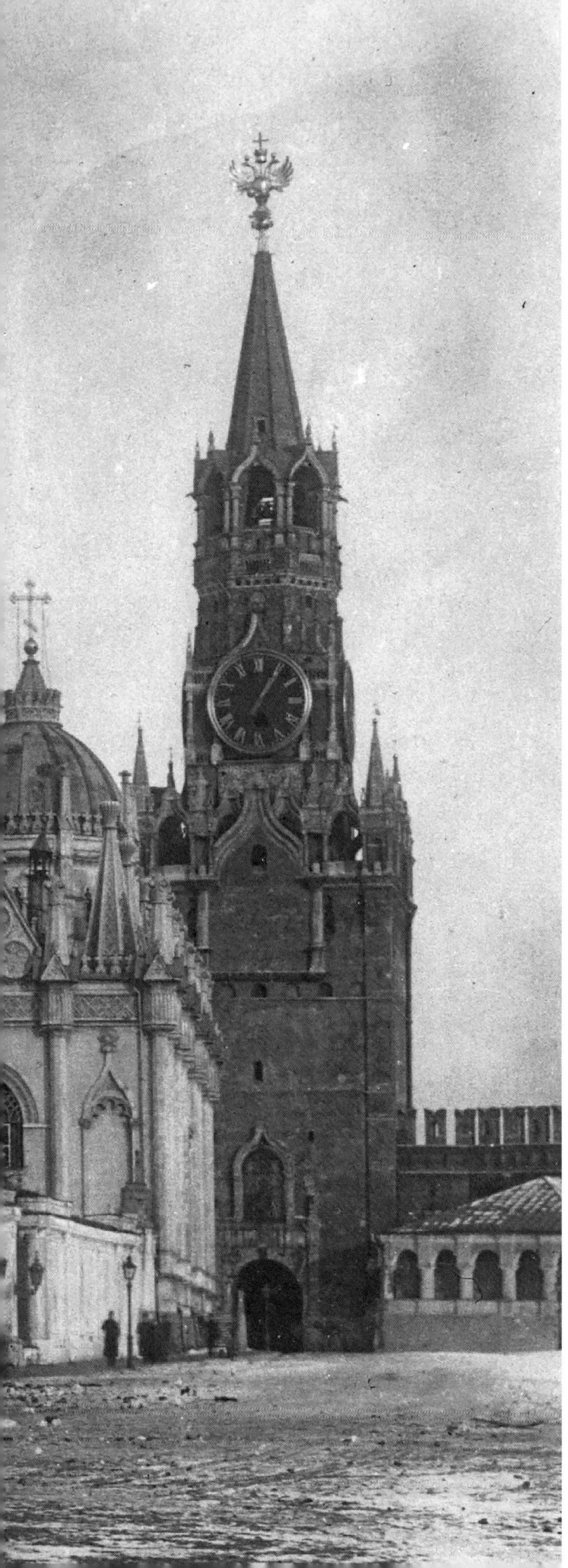

"

It's all the same.
Disgusting to write about it.
The newspapers?
Nothing but lies. Or rather:
the Bolsheviks have shot
Moscow into submission.
The capitals have fallen to
barbaric enemy troops.
Nowhere to run.
No more Motherland.

"

Zinaida Hippius
Diaries (4/17 November 1917)

Chapter 3

'Loot the Looters!'

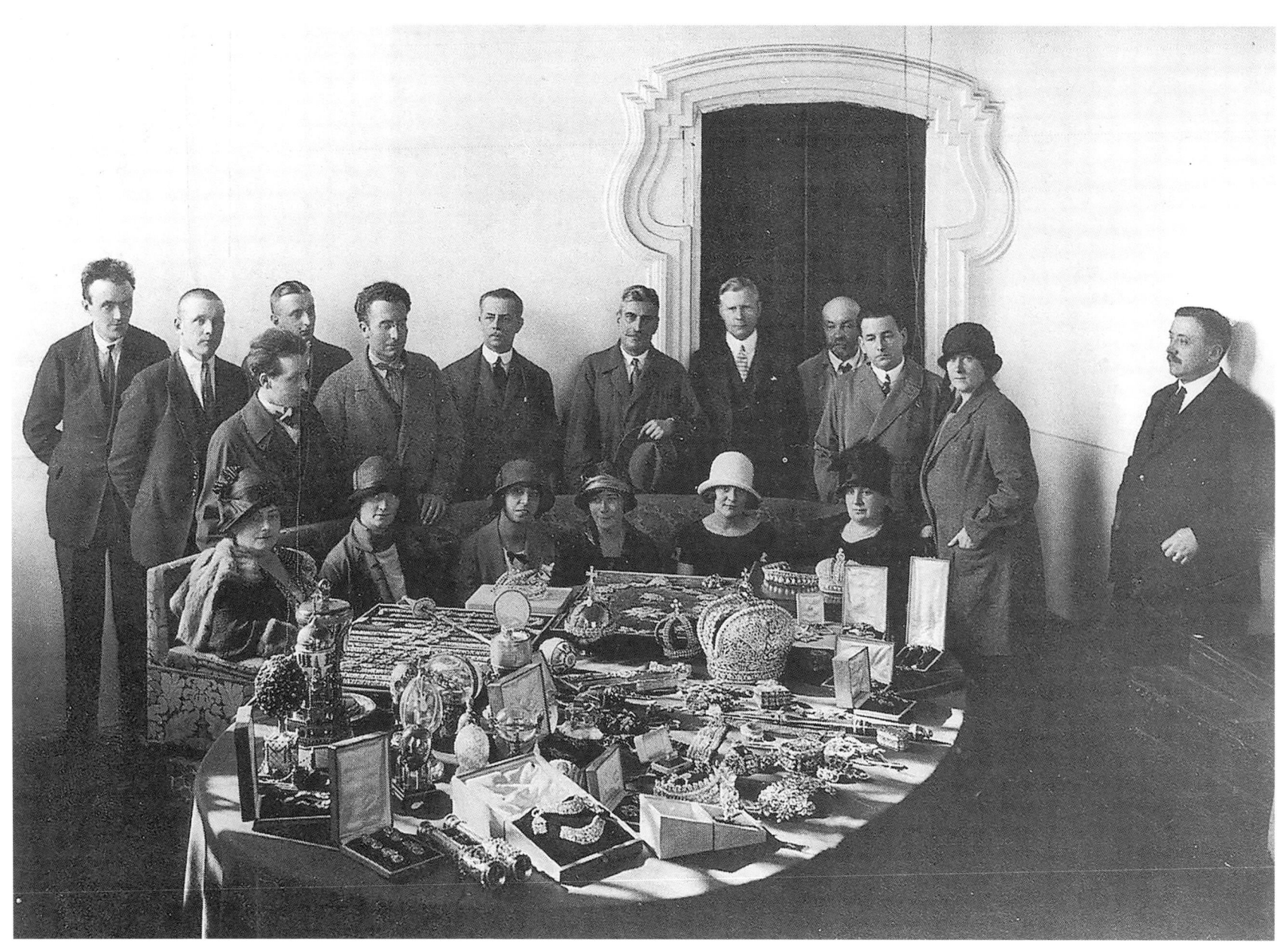

> Tsarist regalia, and the most precious relics of Russia, displayed for sale! We know this photograph, with its circular table encircled by ladies vigilantly guarding Russia's regalia. But there is nothing Russian about these women – they represent the Comintern, with their 'worldly' knowledge of carats, diamonds and pearls. And look what they are allowed to guard: the sceptre, the orb and the crown! We don't just see the 'European Floor' in a trading sense here – we hear the painful question 'What are we doing with Russian glory?'

Ivan Shmelyov
Henri Barbusse and the Crown of Russia

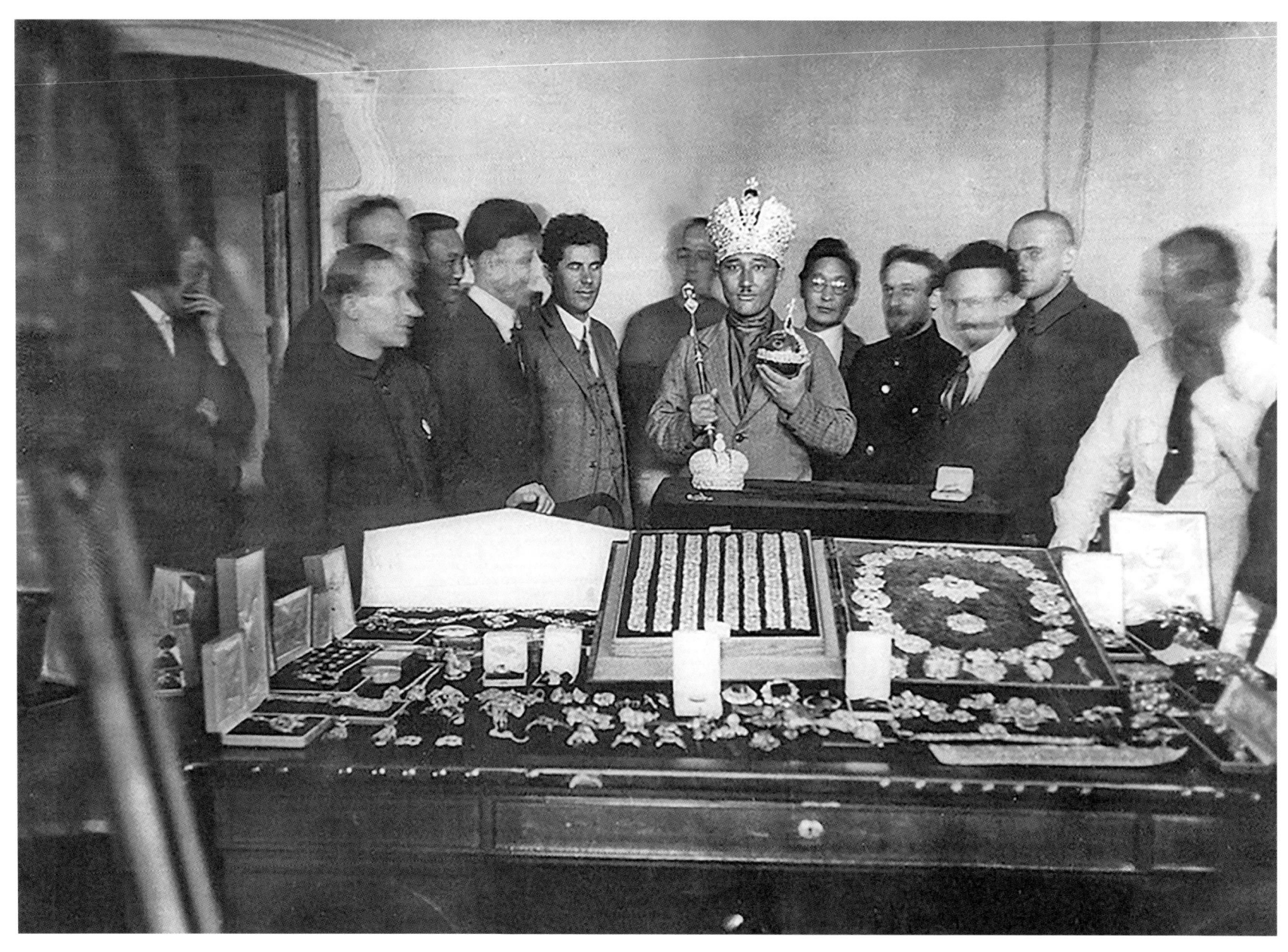

FOREIGN VISITOR TO GOKHRAN TRYING ON THE IMPERIAL CROWN (1923)

"

So what do you reckon this author came up with!? He wanted his photograph taken... with the Tsar's crown in his hands. He was an author with imagination, and his wish came true. Now, with the crown, he has gone down in history. Behind it lie centuries of glory, suffering and heroism. Behind it lie the whole Russian people, a great race, a history of great achievements, of great troubles.... Behind it lies Great Russia.

"

Ivan Shmelyov
Henri Barbusse and the Crown of Russia

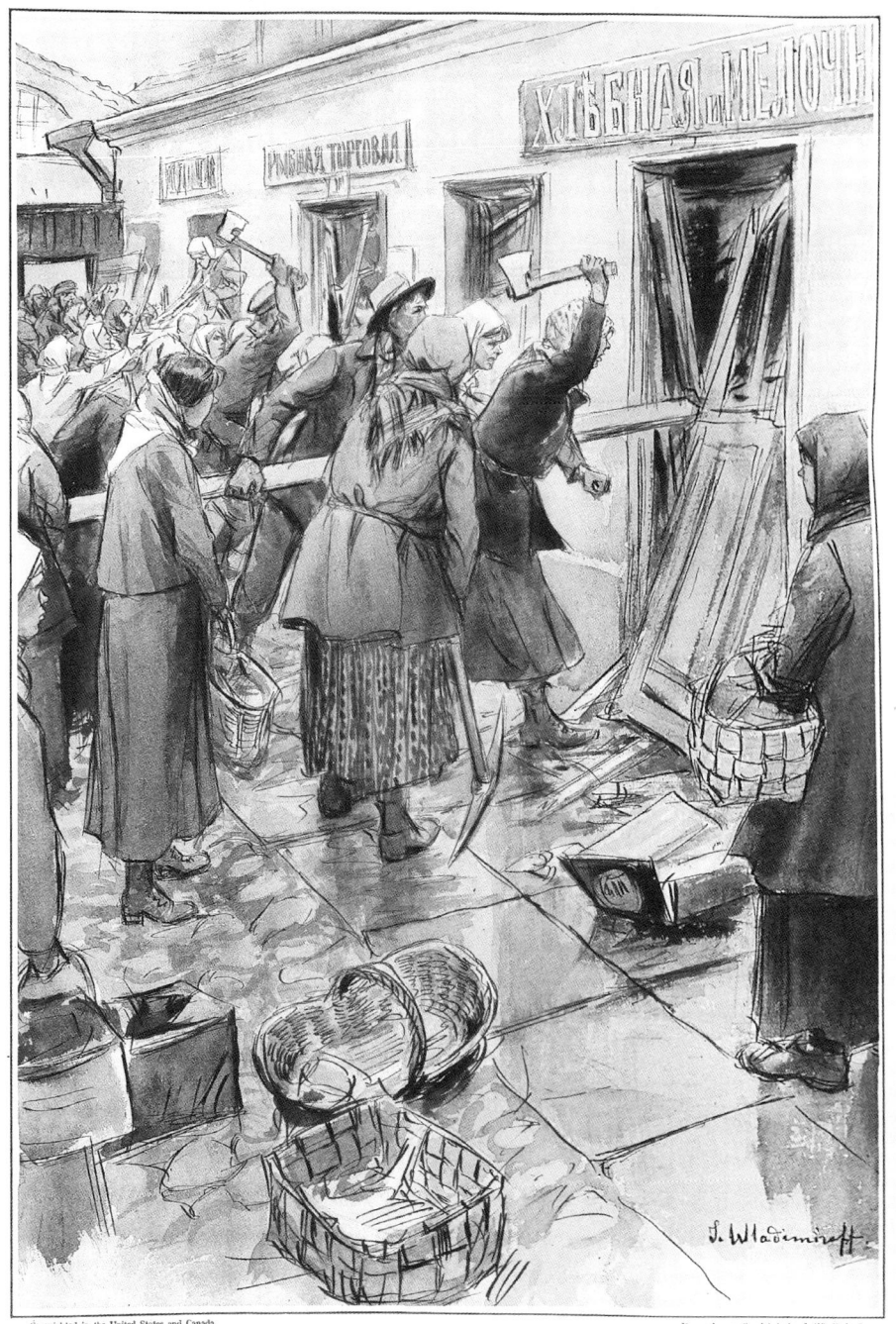

Drawn by our Special Artist, I. Wladimiroff.
WANTON DESTRUCTION: WRECKING SHOPS AT PETROGRAD
The reign of lawlessness was marked by an orgy of senseless destruction, in which women and soldiers were the worst offenders.

17. Wanton Destruction: Wrecking Shops in Petrograd

published in The Graphic (London), 17 November 1917 (p. 616)

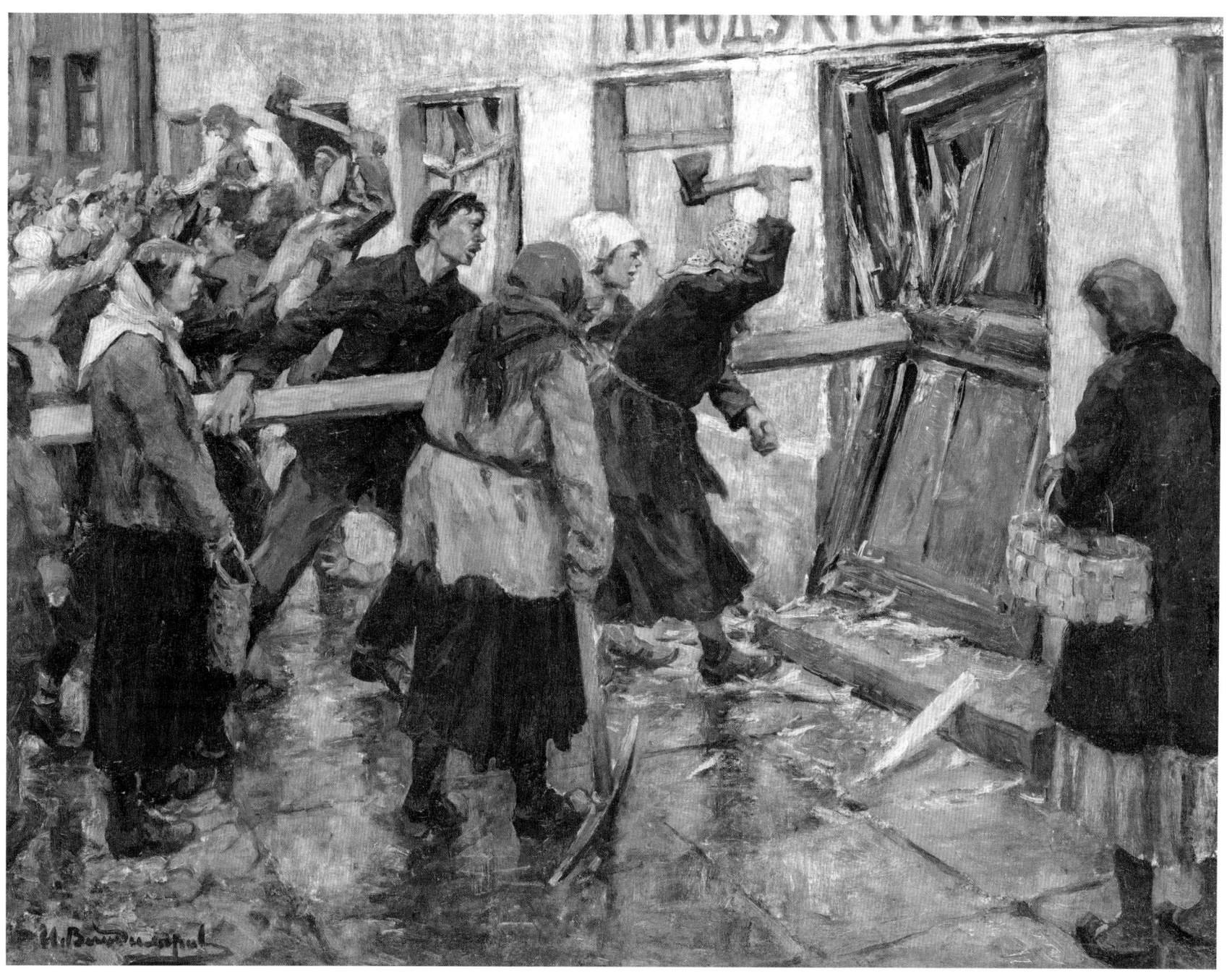

18. Wrecking a Foodshop in Petrograd in February 1917 (1926)

oil on plywood
48 x 61.5cm
Central State Museum of Russian Modern History (Moscow)

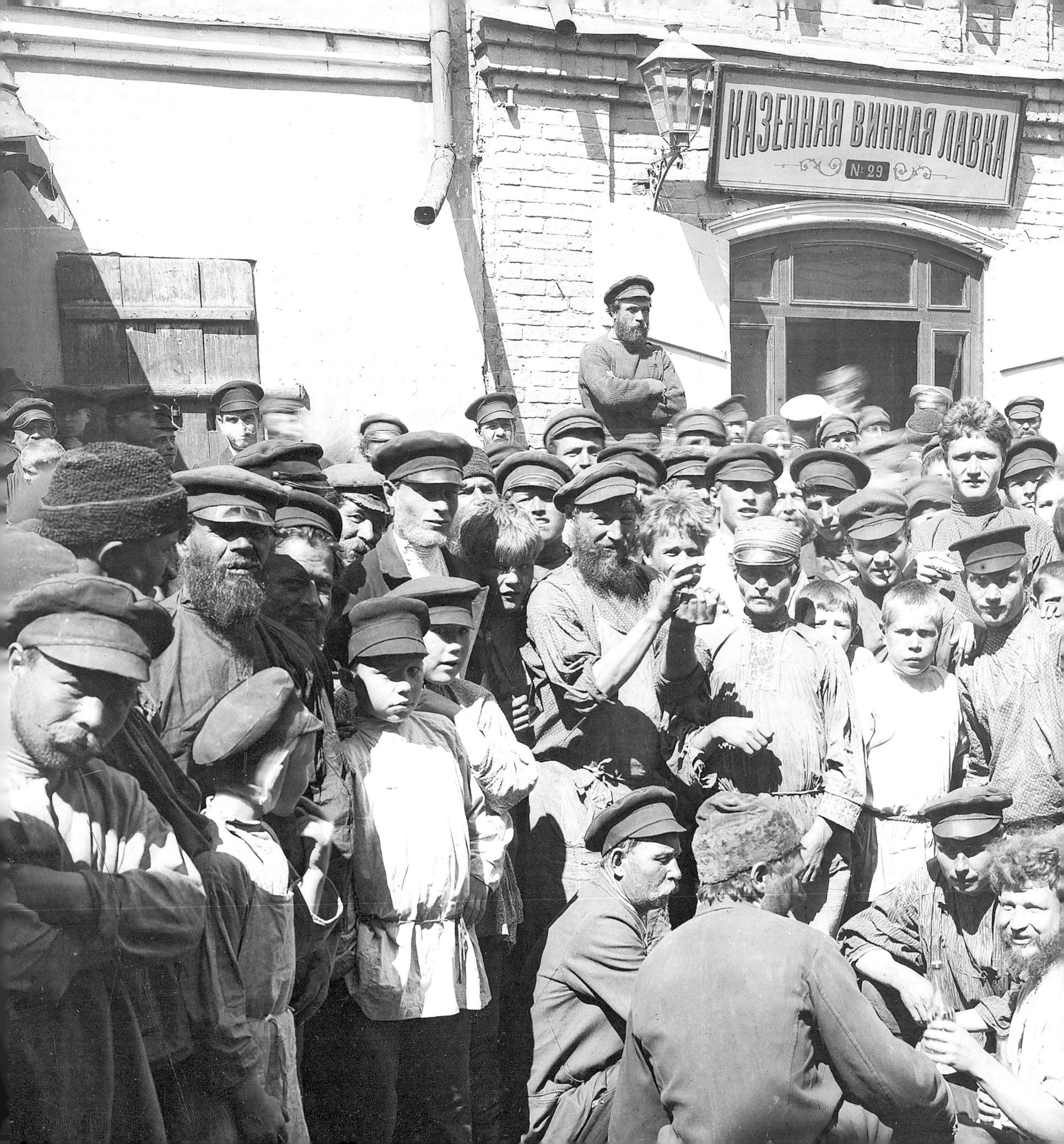

"

After discovering my father's large and valuable wine-cellar, the Soviet sent people round to destroy it. All night long they carried the bottles out and smashed them. The wine flowed in torrents. The air reeked of wine. All the neighbours turned up and, paying no attention to the threats yelled by Soviet officials, scooped up the wine with mugs, collected the wine-soaked snow in buckets, or drank lying on the ground with their lips pressed to the snow. Everyone was drunk: the members of the Soviet who had smashed the bottles, and the people all around the house. The drunken revels lasted all night. Shouting and abuse filled the building, courtyard and neighbouring streets. No one in the house slept a wink. It felt like all this booze could lead to an outbreak of violence at any minute, but on this occasion people were too drunk to kill anyone.

"

Grand Duchess Maria Pavlovna
Memoirs

Revolutionary workmen and soldiers robbing a wine-shop in Petrograd (January 1919)

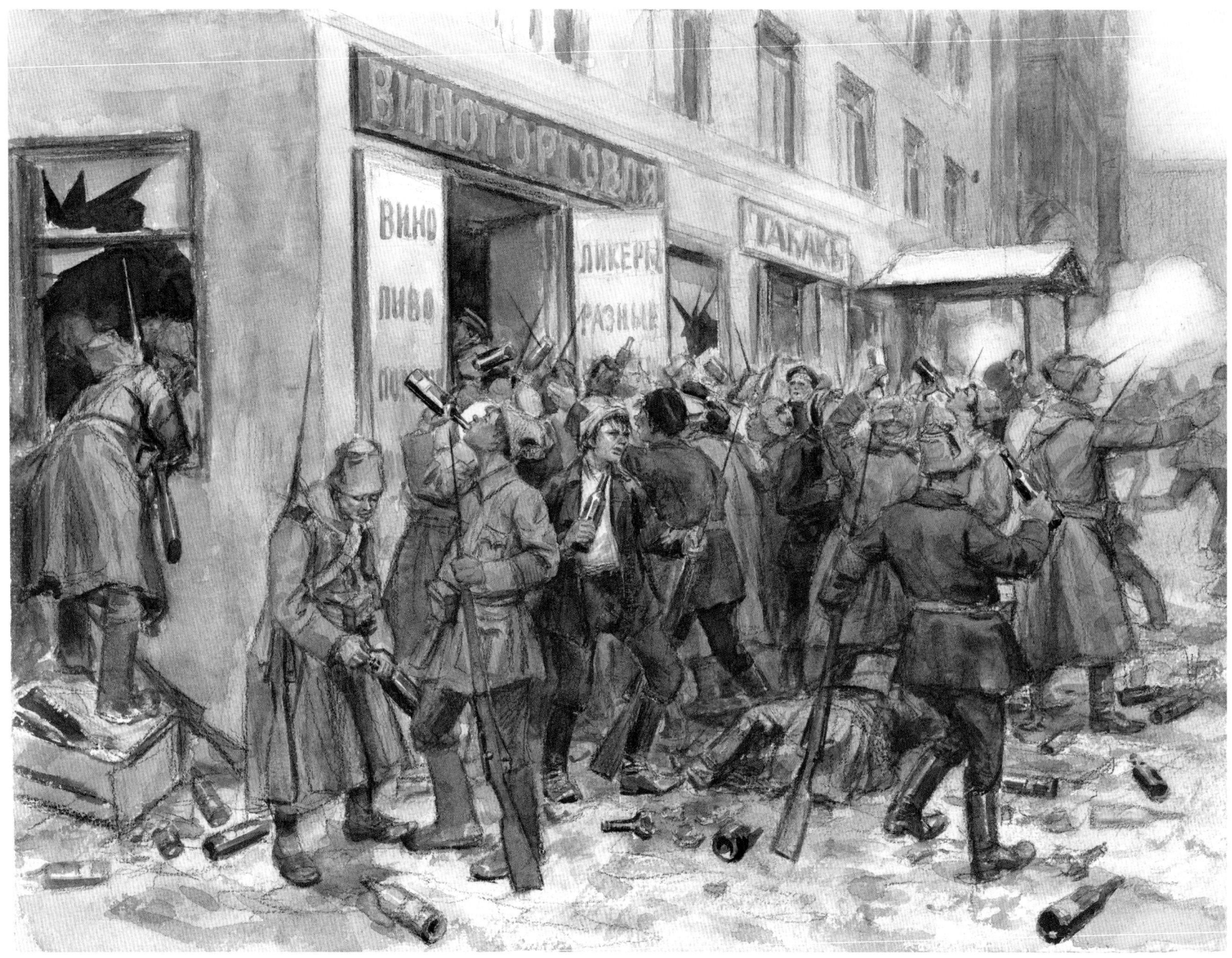

**19. Revolutionary Workmen & Solders Robbing
a Wine-Shop in Petrograd – January 1919**

ink, paper & watercolour on paper
29.2 x 39.4cm
Hoover Institution Library & Archives

> **From the start of November [1917] liquor stores were smashed all over the city, and shooting could be heard day and night. It was hard to make out who was doing the shooting, and why, but much of the fighting was doubtless between rival gangs arguing over the seizure of drink-related goods.**

Dmitry Tolstoy
Revolutionary Times at the Russian Museum and the Hermitage

Requisition of banknotes, obligations etc. from the treasury of Wawelberg-bank in Petrograd. (1919)

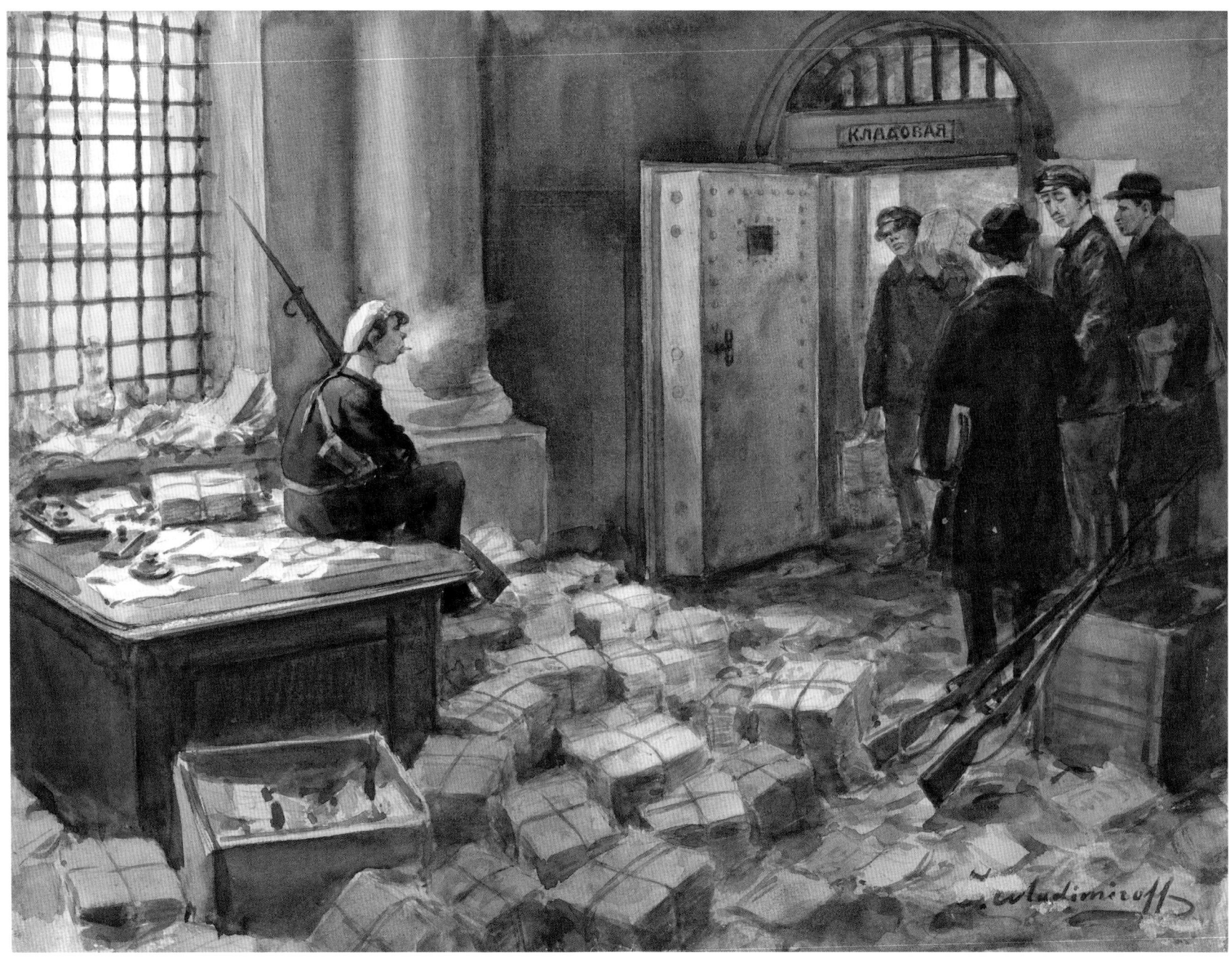

**20. Requisitioning Bank-Notes, Obligations etc.
from Wawelberg Bank – Petrograd 1919**

pencil & watercolour on paper
29.2 x 39.4cm
Hoover Institution Library & Archives

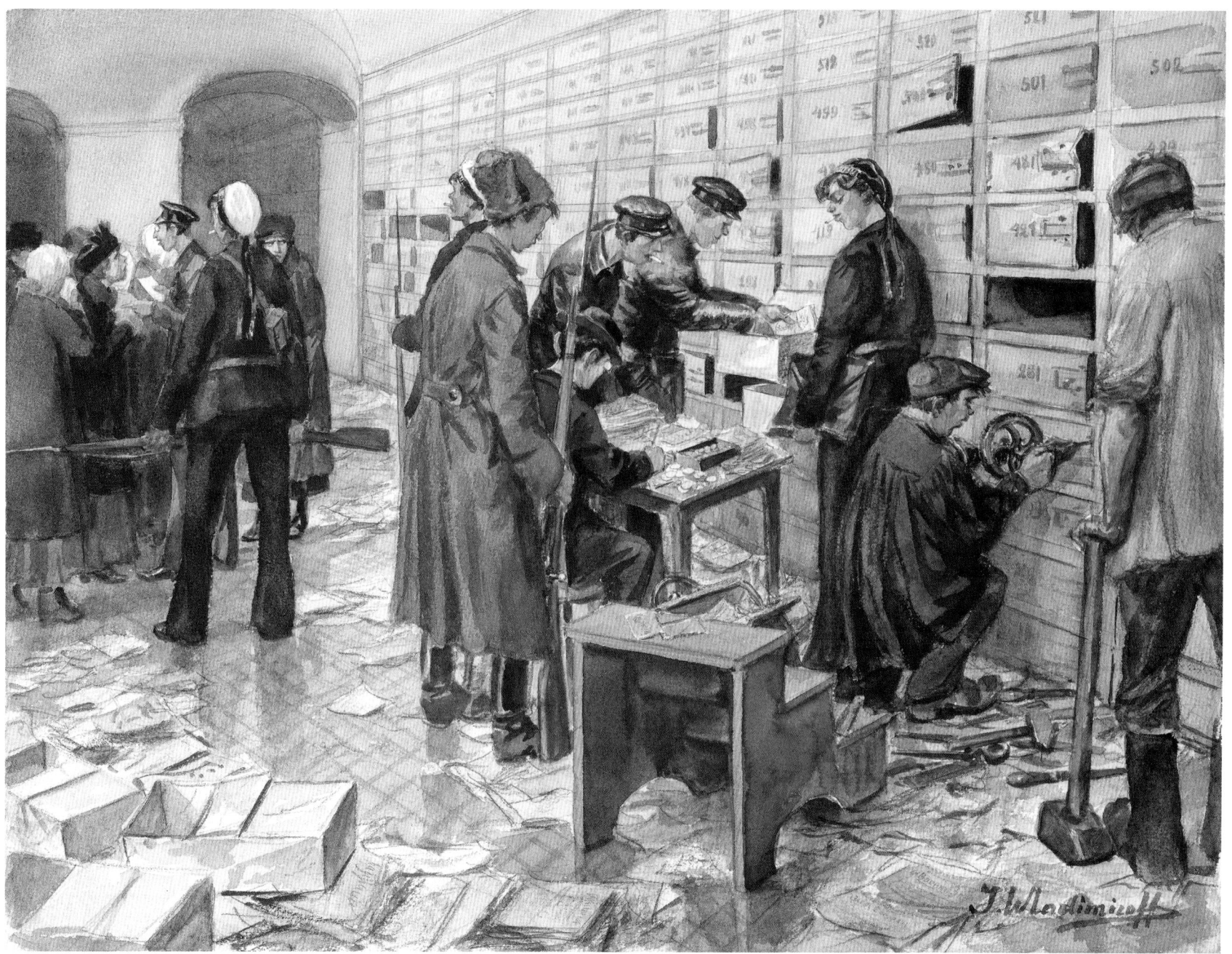

21. Confiscating Valuables – Wawelberg Bank, March 1919

ink & watercolour on paper
25.7 x 34.7cm
Andre Ruzhnikov Collection

"

My brother and I spent the whole of yesterday emptying our safes [at the Junker Bank on Kuznetsky Most]. We had to wait three and a half hours, then they took over forty-eight *zolotniki* from us and all our papers were copied and transferred to the People's Bank of the RSFSR.

"

Yuri Gautier
My Notes (6 October 1918)

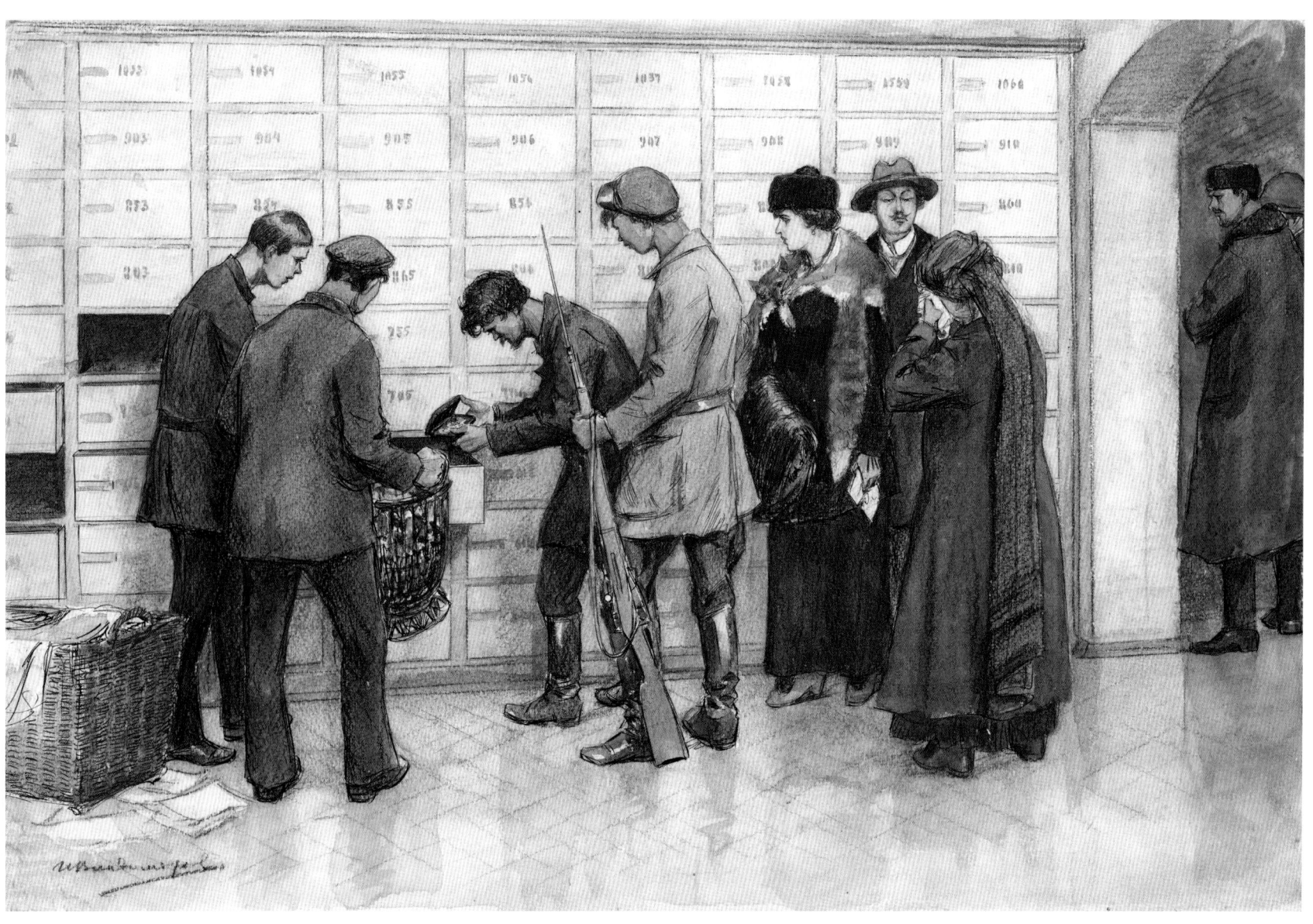

22. Requisitioning Bank Safes – December 1917

watercolour on paper on board
33.5 x 51cm
Central State Museum of Russian Modern History (Moscow)

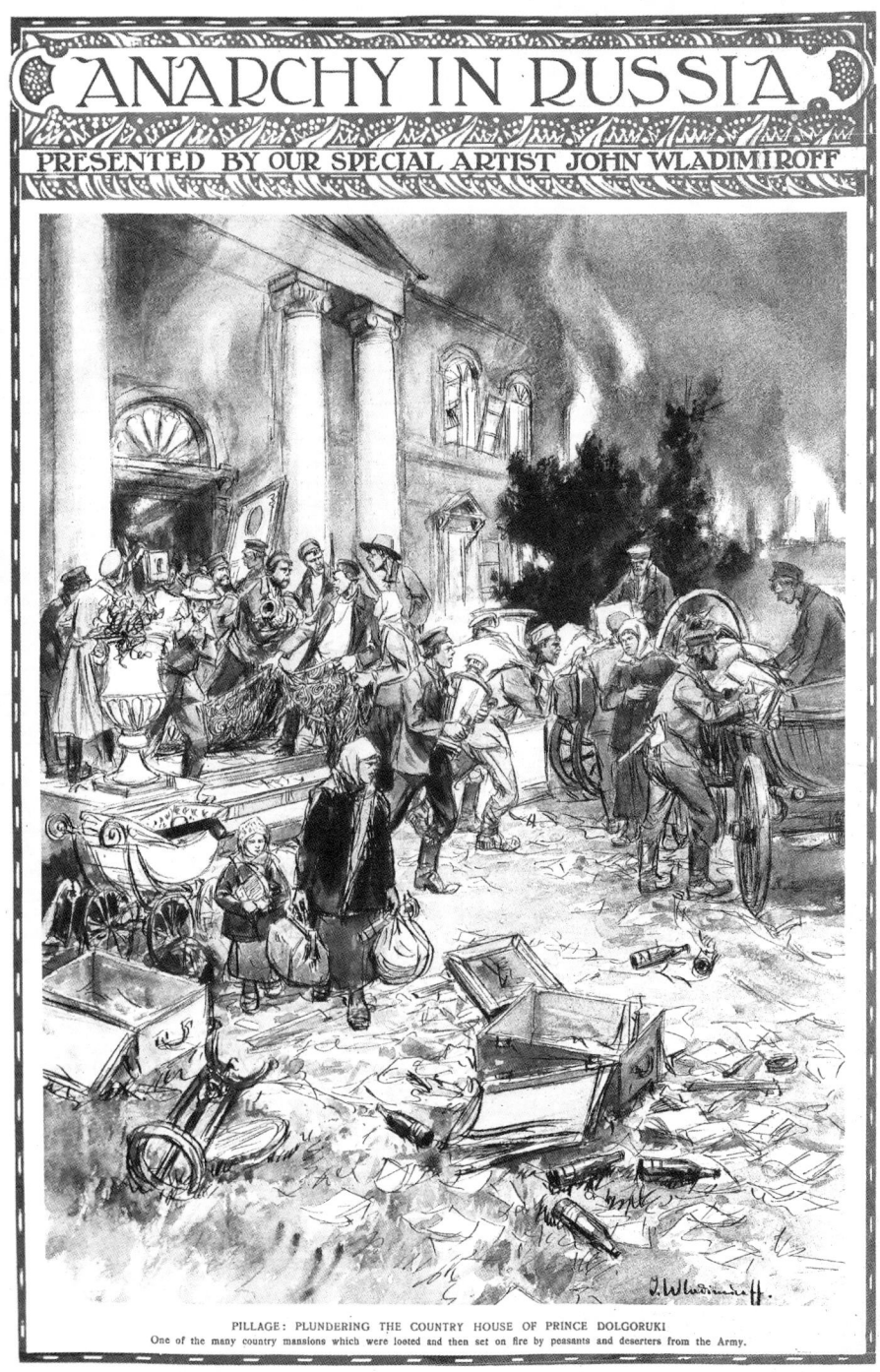

ANARCHY IN RUSSIA

PRESENTED BY OUR SPECIAL ARTIST JOHN WLADIMIROFF

PILLAGE: PLUNDERING THE COUNTRY HOUSE OF PRINCE DOLGORUKI
One of the many country mansions which were looted and then set on fire by peasants and deserters from the Army.

23. Pillage: Plundering the Country House of Prince Dolgoruky

published in *The Graphic* (London), 17 November 1917 (p. 615)

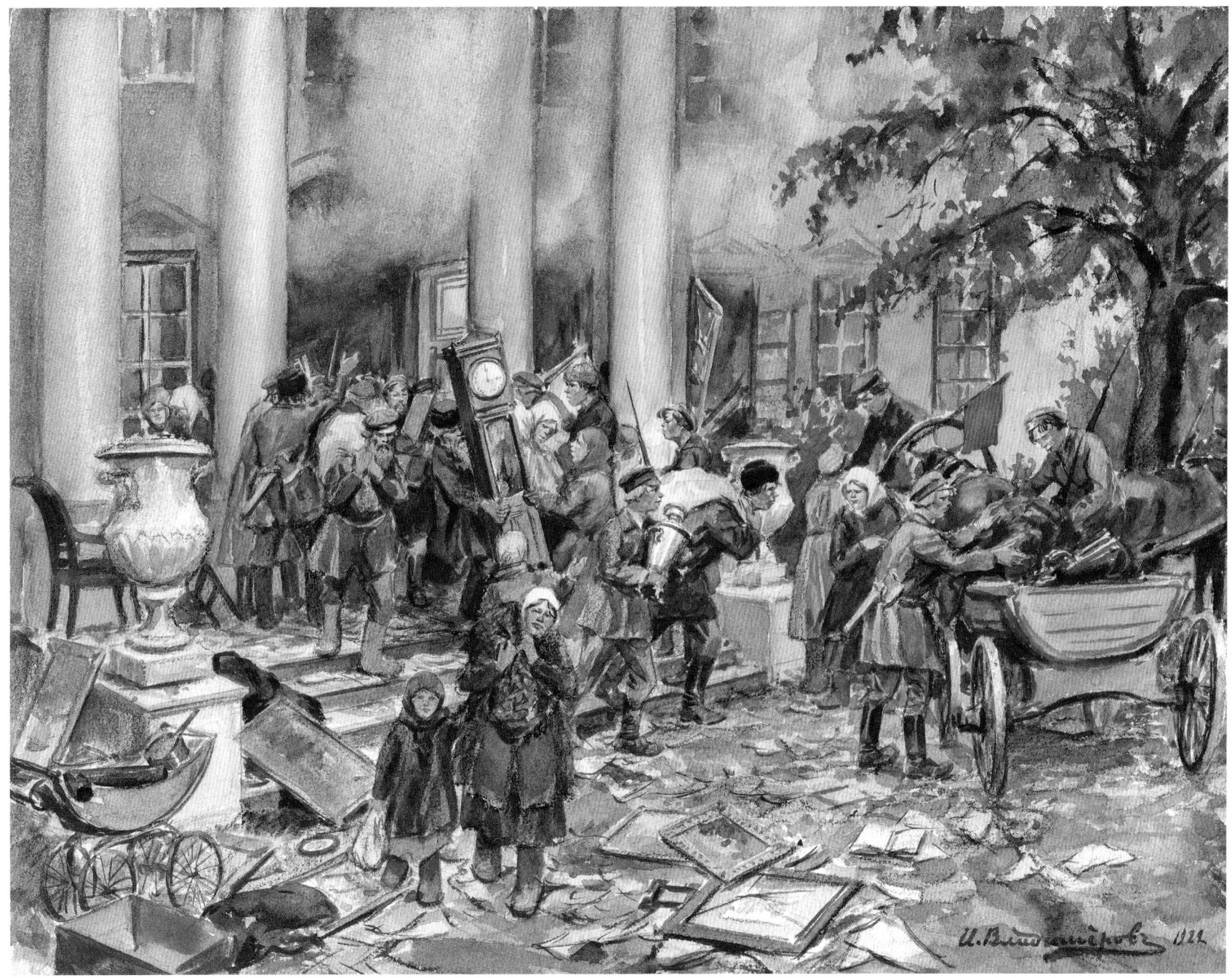

**24. Looting the Estate of an Aristocrat (Prince Vasilchikov)
in Autumn 1919 (1922)**

ink & watercolour on paper
26 x 34.3cm
Andre Ruzhnikov Collection

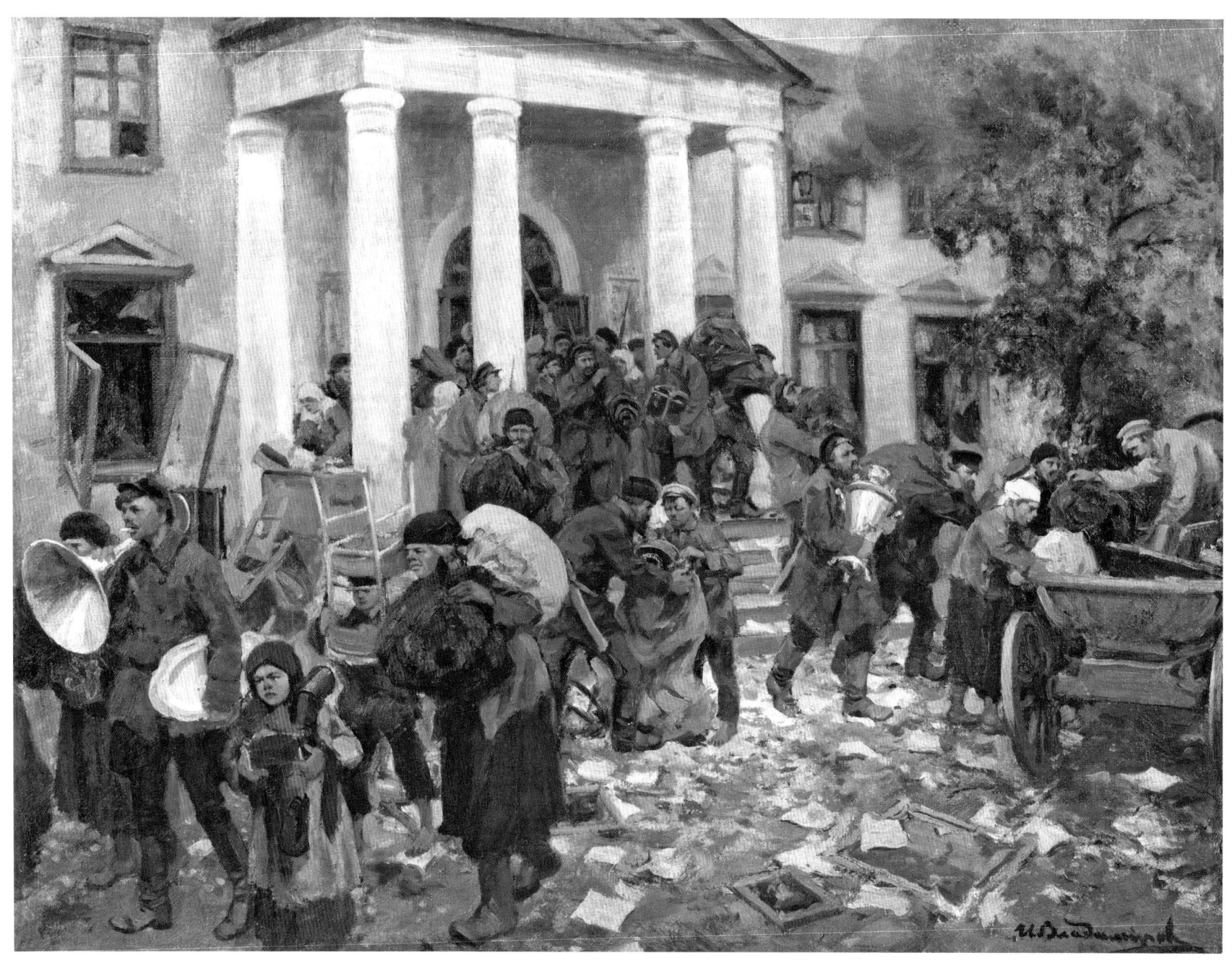

25. Looting a Landed Estate (1926)

oil on canvas mounted on plywood
47 x 61cm
Central State Museum of Russian Modern History (Moscow)

Russian peasants returning home after pillaging a country-house of a rich landlord (near Pskoff 1919)

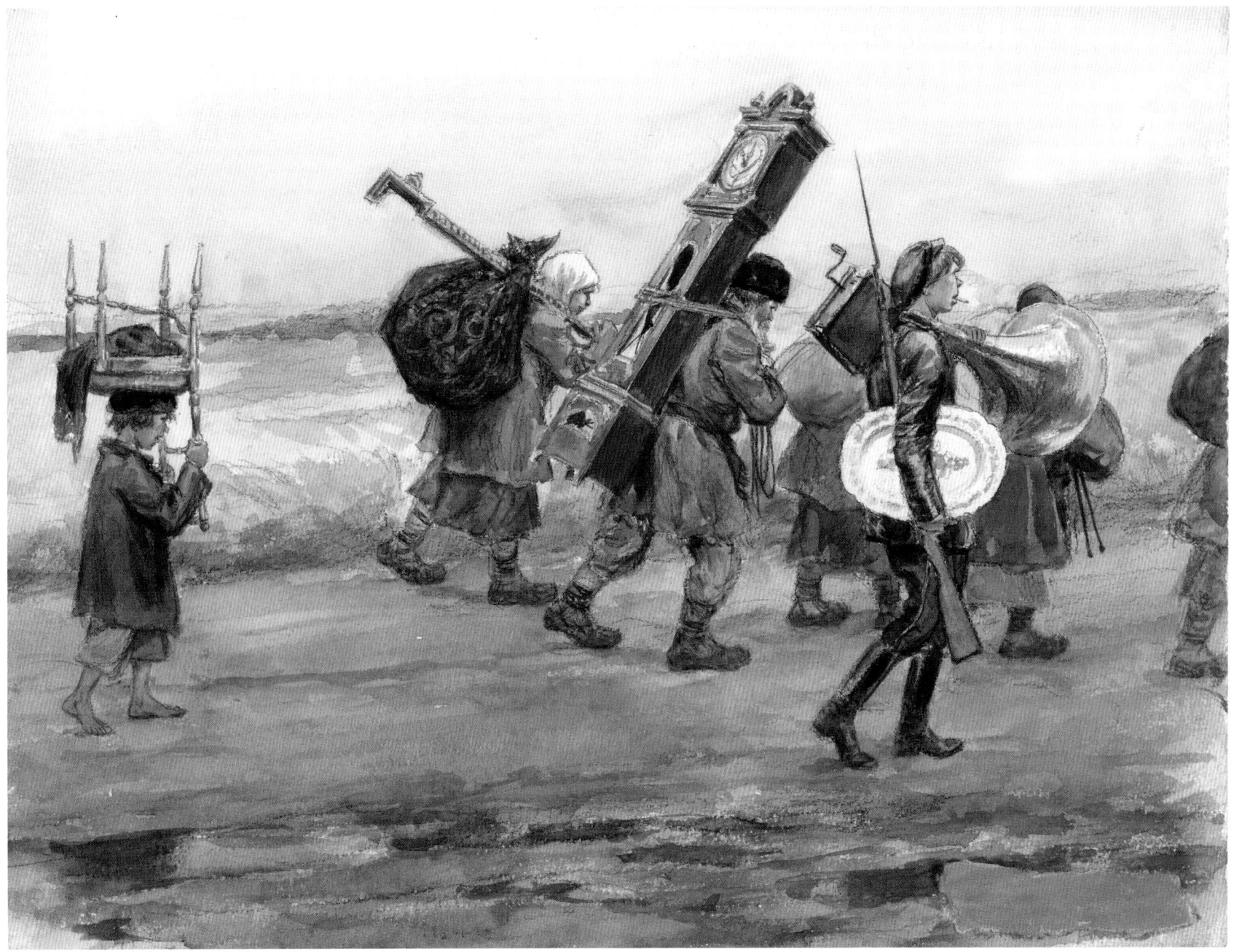

26. Peasants Returning Home after Pillaging
a Nobleman's Estate near Pskov –1919

pencil & watercolour on paper
29.2 x 39.4cm
Hoover Institution Library & Archives

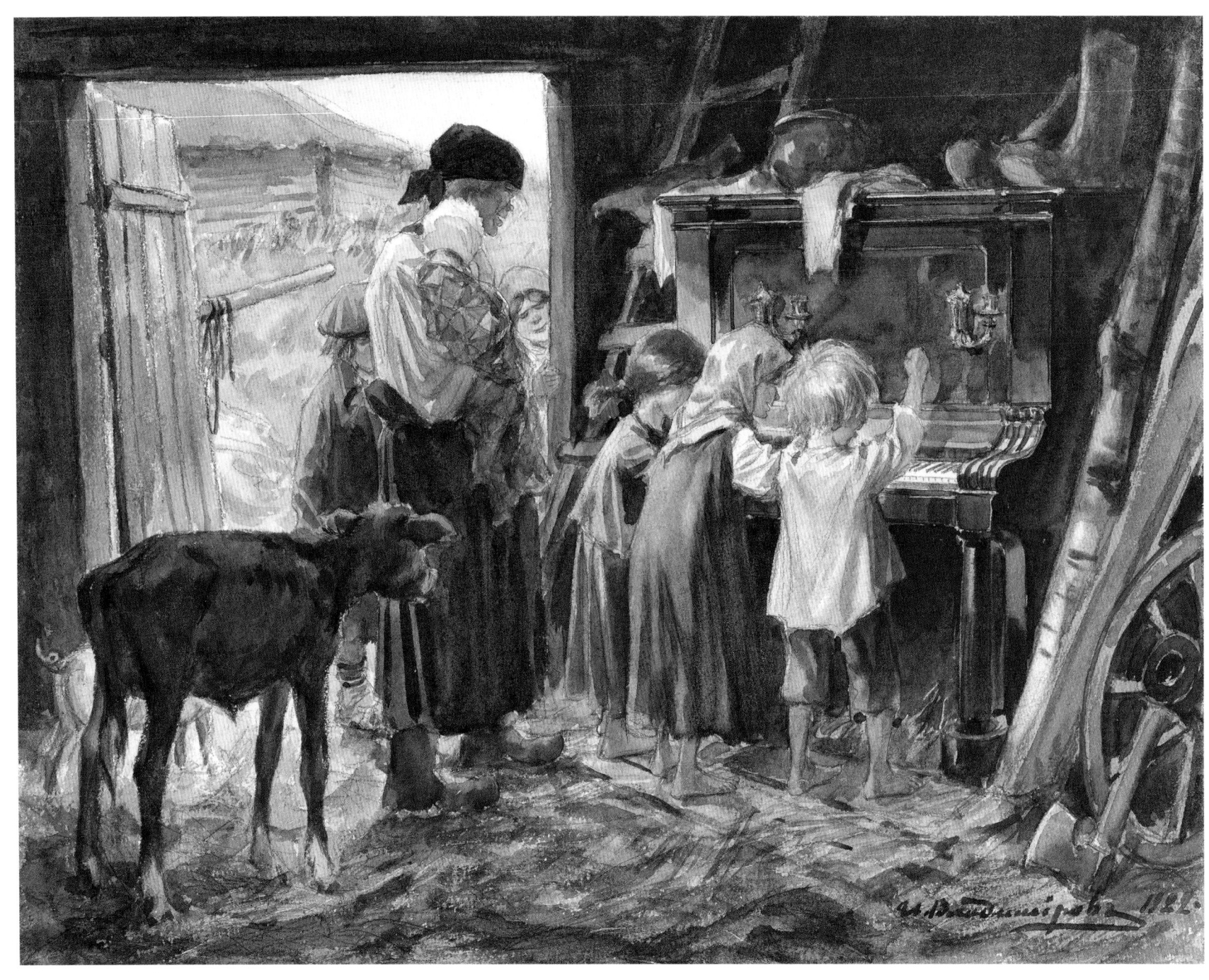

27. In the Village of Gorki near Lychkovo – 12 June 1921 (1922)

ink & watercolour on paper on board
25.5 x 34cm
Andre Ruzhnikov Collection

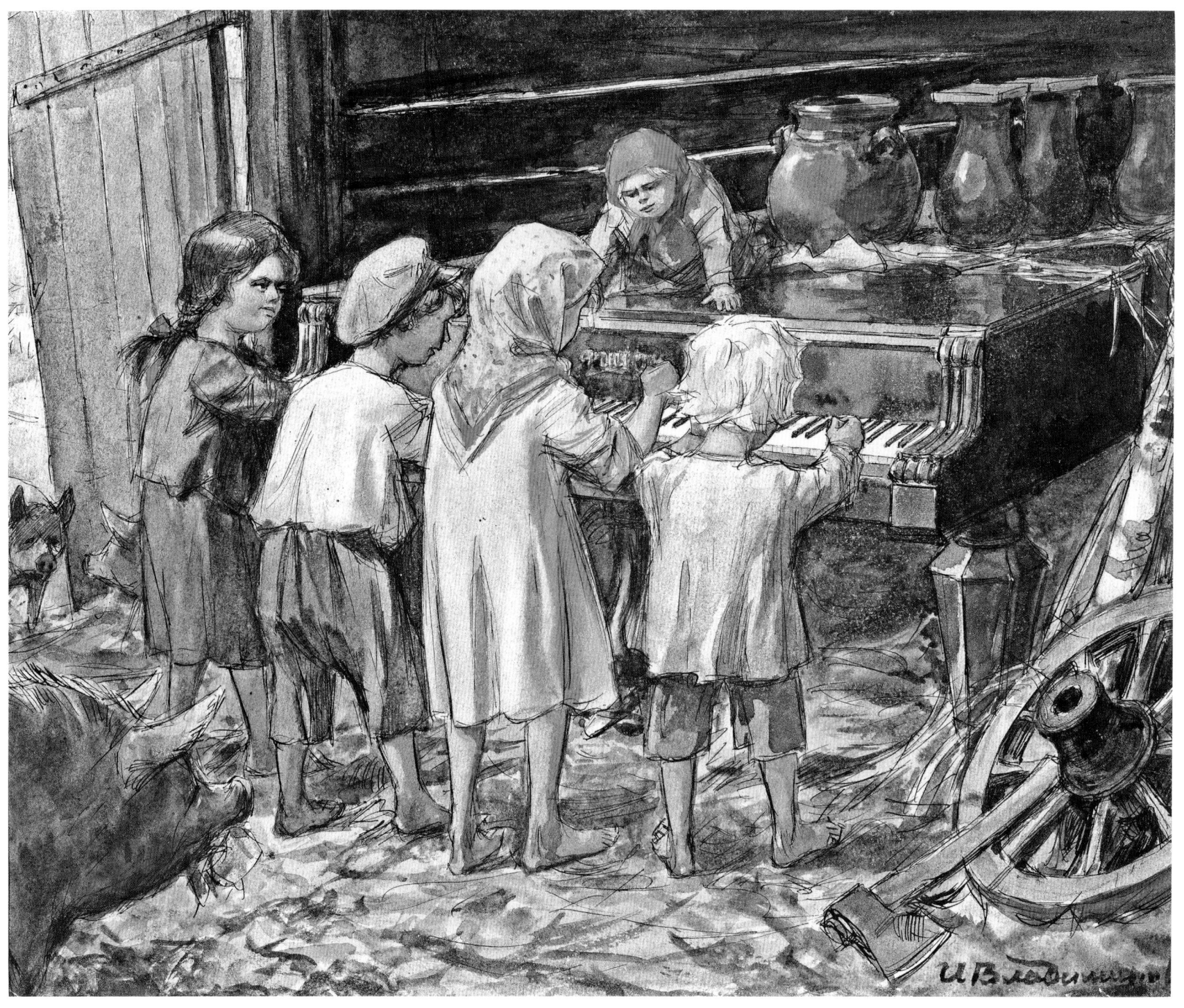

28. At The Piano (1920s)

ink & watercolour on paper mounted on board
23.8 x 29.2cm
Vladimir Ruga Collection

Red Terror

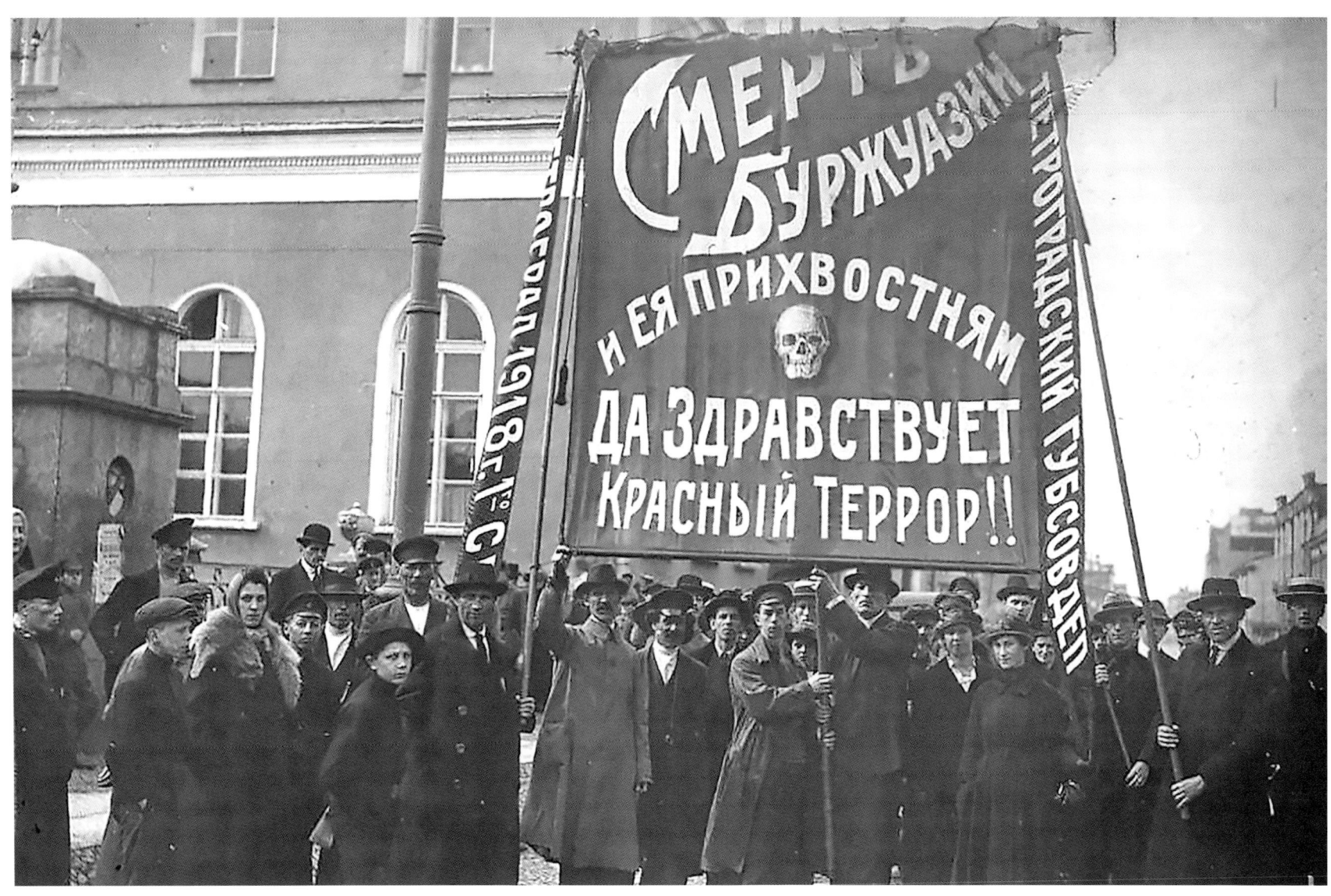

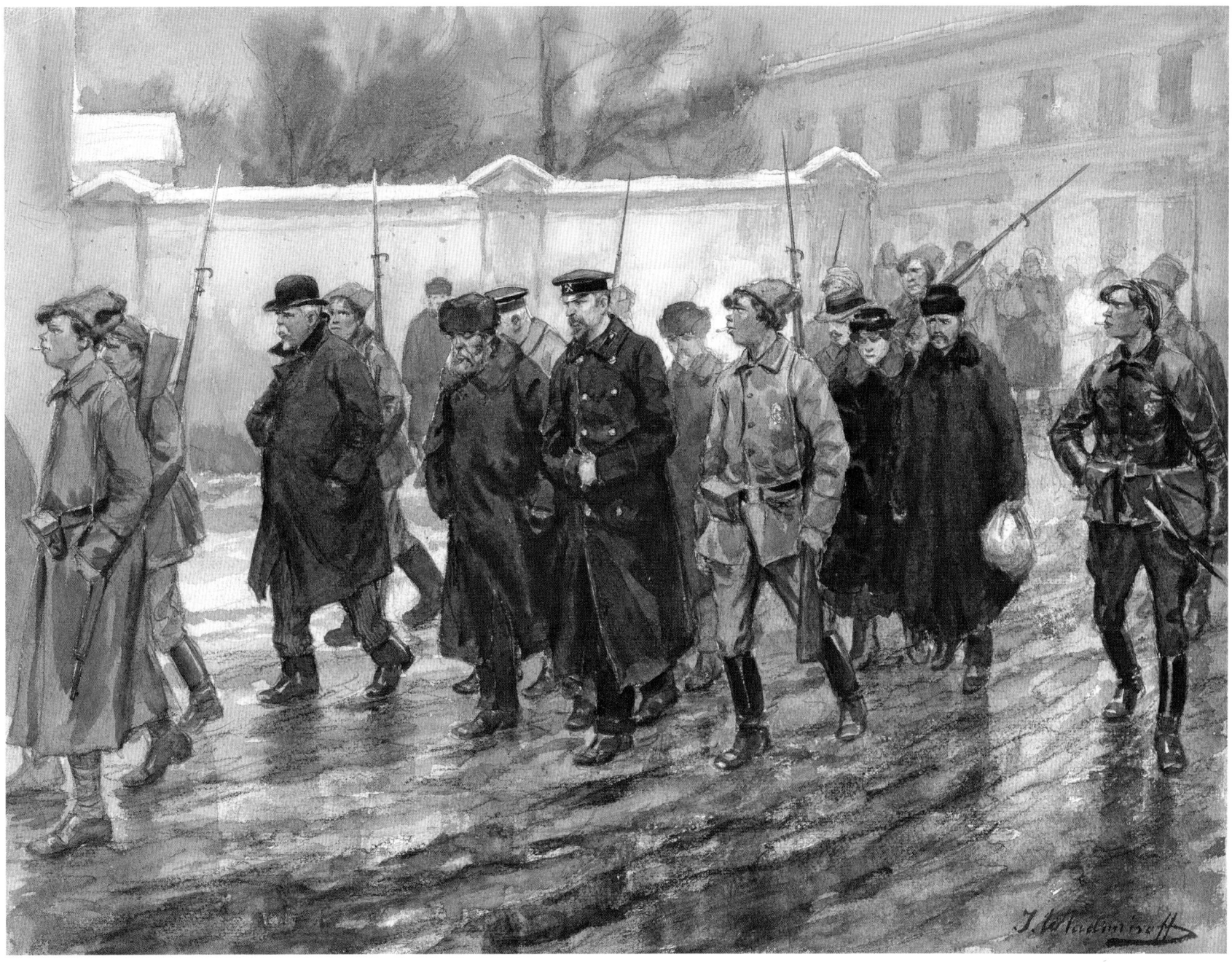

29. Arrested Intellectuals Escorted to Ulitsa Gorokhovaya

pencil & watercolour on paper
25.5 x 34cm
Andre Ruzhnikov Collection

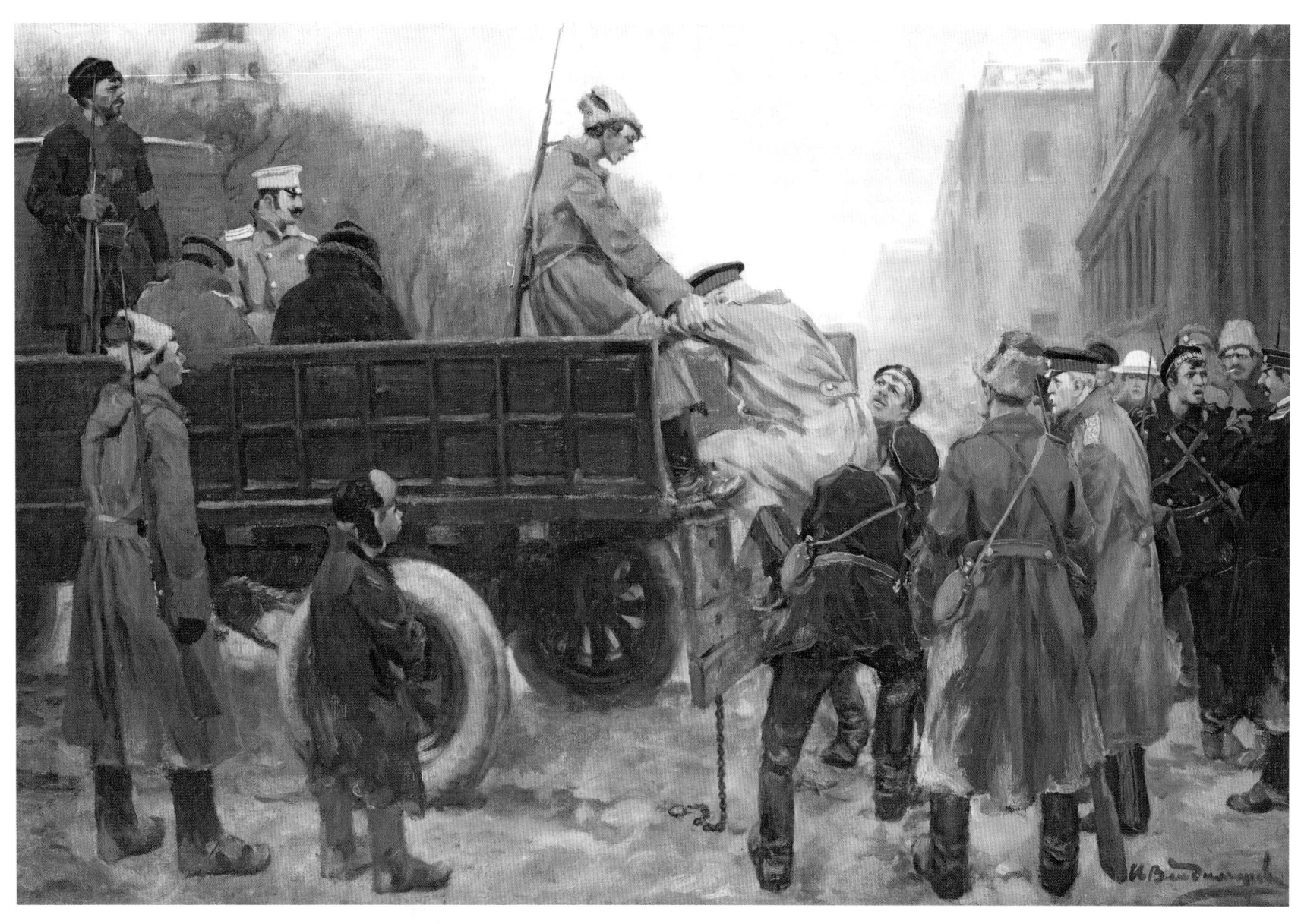

30. Arrest of Tsarist Generals (1926)

oil on canvas
69 x 104cm
Central State Museum of Russian Modern History (Moscow)

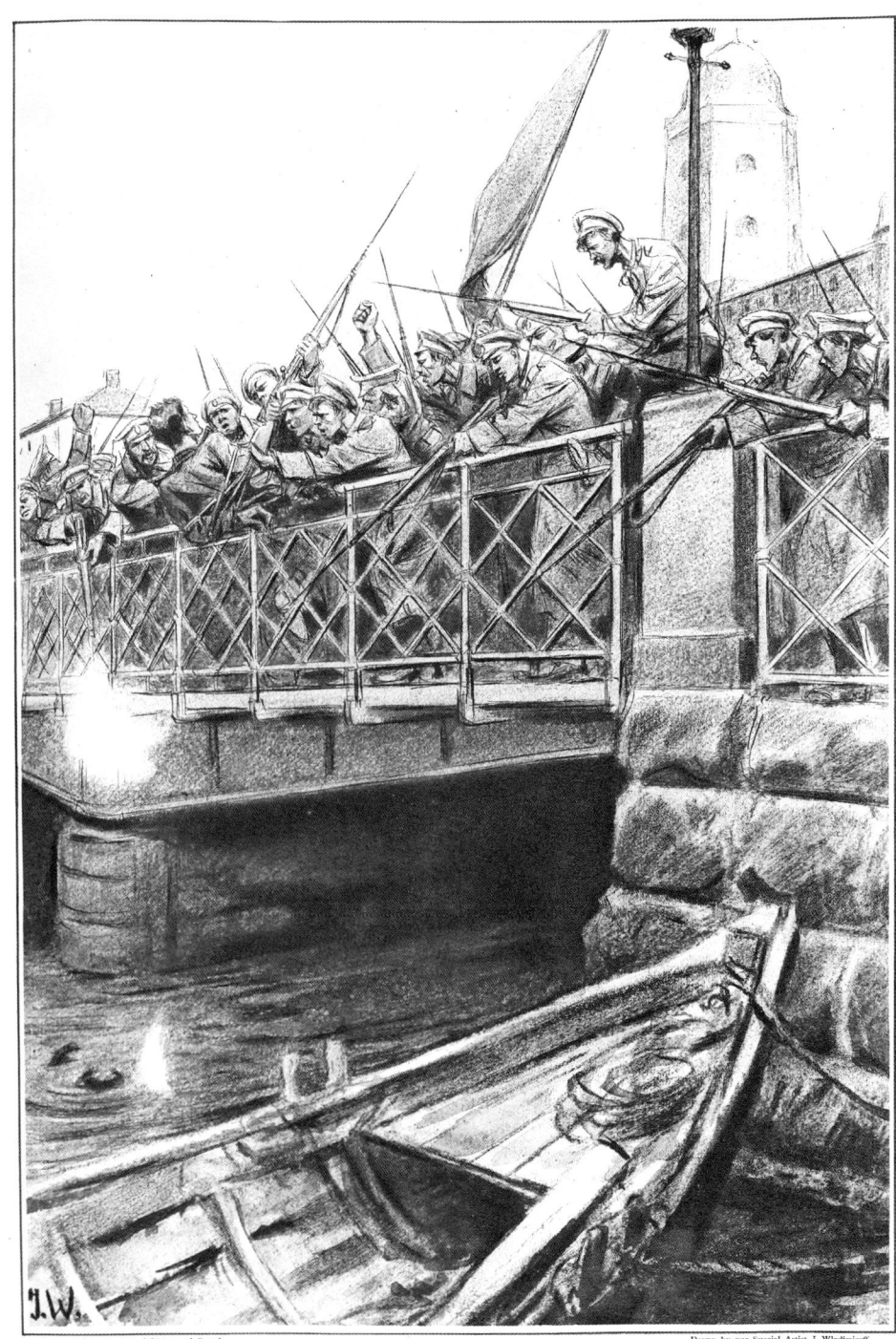

Drawn by our Special Artist, J. Wladimiroff.

MASSACRE : THE MURDER OF OFFICERS OF THE VIBORG GARRISON

In many cases the soldiers ran amok and turned upon their leaders, as happened at Viborg, where a number of unfortunate officers were foully done to death.

31. Massacre: The Murder of Officers from Vyborg Garrison

published in *The Graphic* (London), 17 November 1917 (p. 617)

"

We judge quickly. In most cases, from arresting a criminal to passing judgment takes only a day or two – which does not, of course, mean that our verdicts lack justification. We may of course make mistakes, but so far no mistakes have occurred – as demonstrated by our protocols. In almost all cases the criminals confess when confronted by the evidence – and no argument carries more weight than the confession of the accused.

"

Felix Dzerzhinsky
Izvestia, 3 September 1918

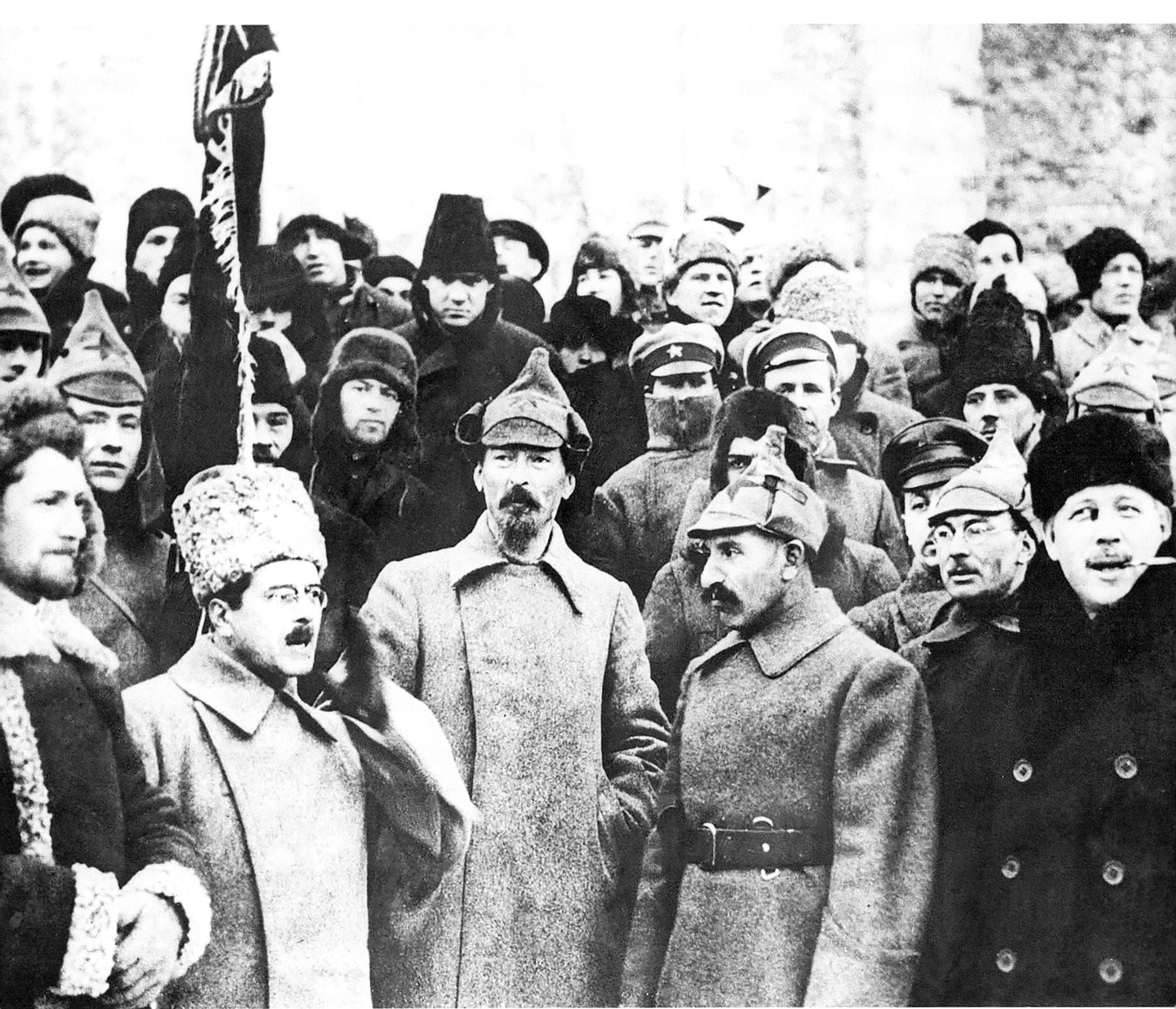

FELIX DZHERZHINSKY (CENTRE) WITH RED ARMY TROOPS ON RED SQUARE (1920)

Разстрѣлъ полицейскихъ на Крестовскомъ мосту 3 Марта 1917 года

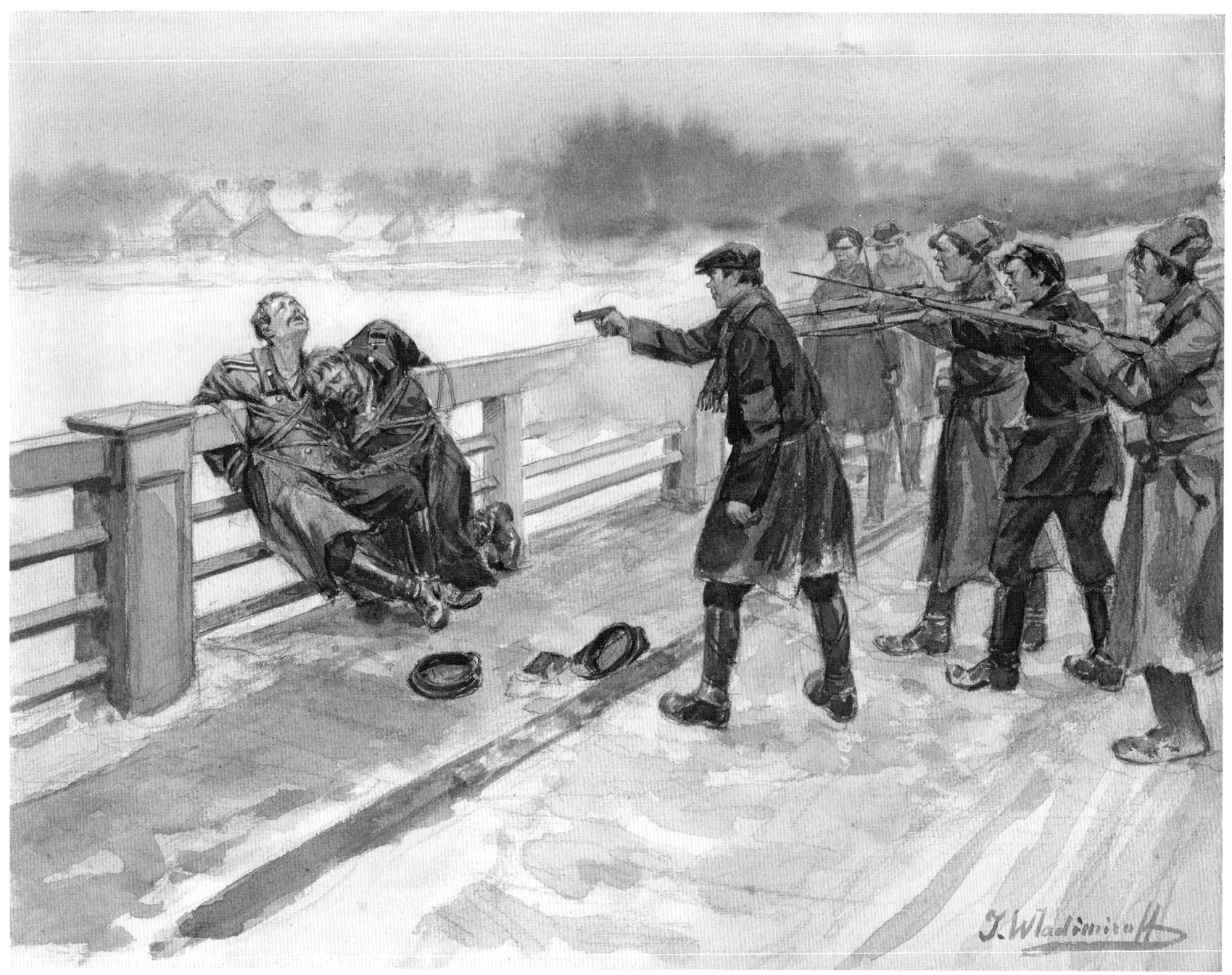

32. Policemen Shot on Krestovsky Bridge – 3 March 1917

ink & watercolour on paper
25.7 x 34.3cm
Andre Ruzhnikov Collection

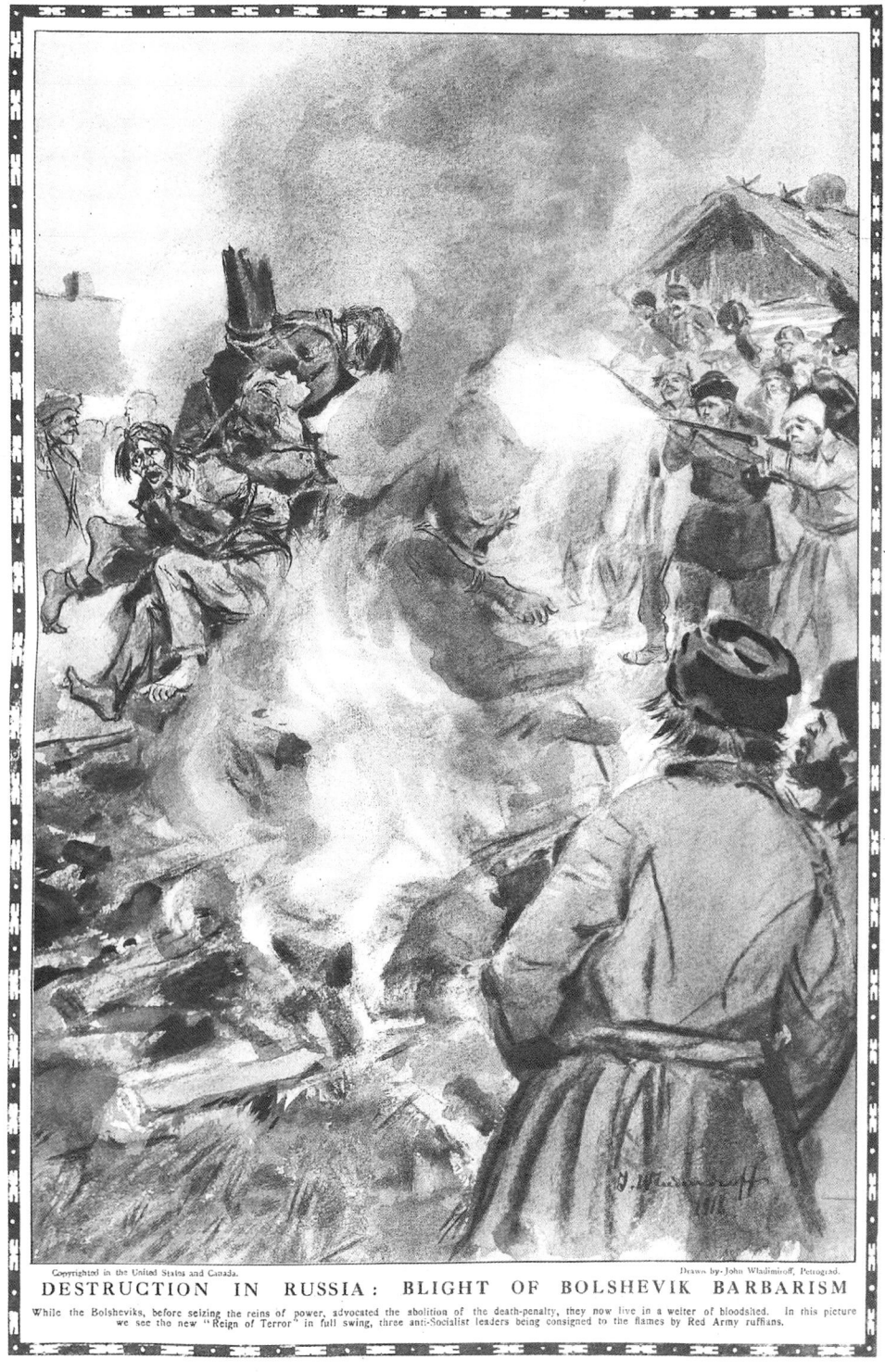

Copyrighted in the United States and Canada.

Drawn by John Wladimiroff, Petrograd.

DESTRUCTION IN RUSSIA : BLIGHT OF BOLSHEVIK BARBARISM

While the Bolsheviks, before seizing the reins of power, advocated the abolition of the death-penalty, they now live in a welter of bloodshed. In this picture we see the new "Reign of Terror" in full swing, three anti-Socialist leaders being consigned to the flames by Red Army ruffians.

33. Blight of Bolshevik Barbarism

published in *The Graphic* (London), 31 August 1918 (p. 235).

CHEKA COMMAND AT LUBYANKA PRISON (1920)

"

We are no longer fighting against individuals – we are exterminating the bourgeoisie as a class. Do not look in the evidence you have gathered for proof that the suspect spoke or acted against Soviet authority. Your first duty is to ask what class he belongs to, what background he comes from, what kind of education he had and what his profession is. These are the questions that should determine his fate. This is what Red Terror is all about.

"

Martin Latsis
Red Terror newspaper, 1 November 1918

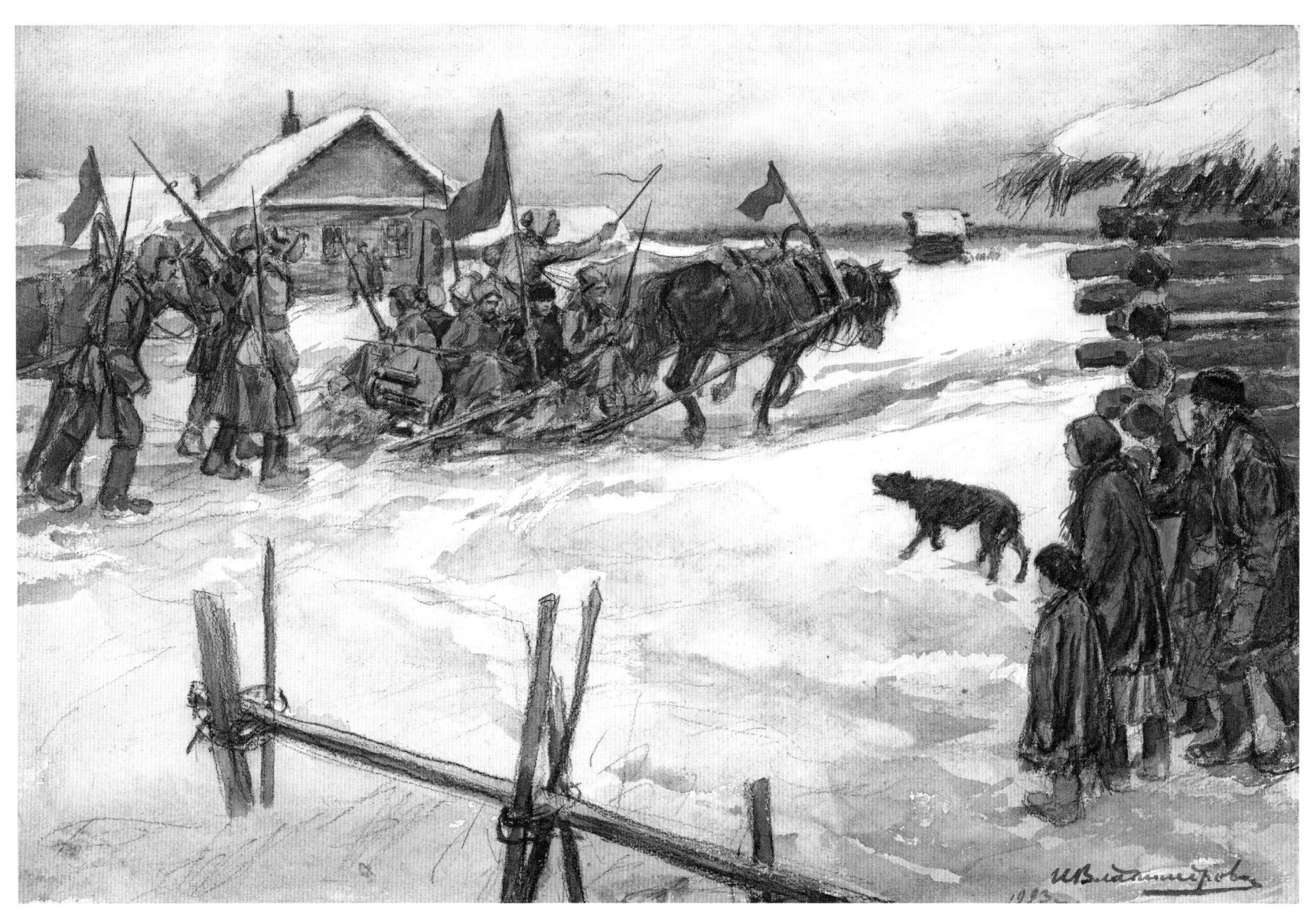

34. Red Guard Unit in a Village – December 1917/ February 1918 (1923)
watercolour on paper
33 x 51cm
Central State Museum of Russian Modern History (Moscow)

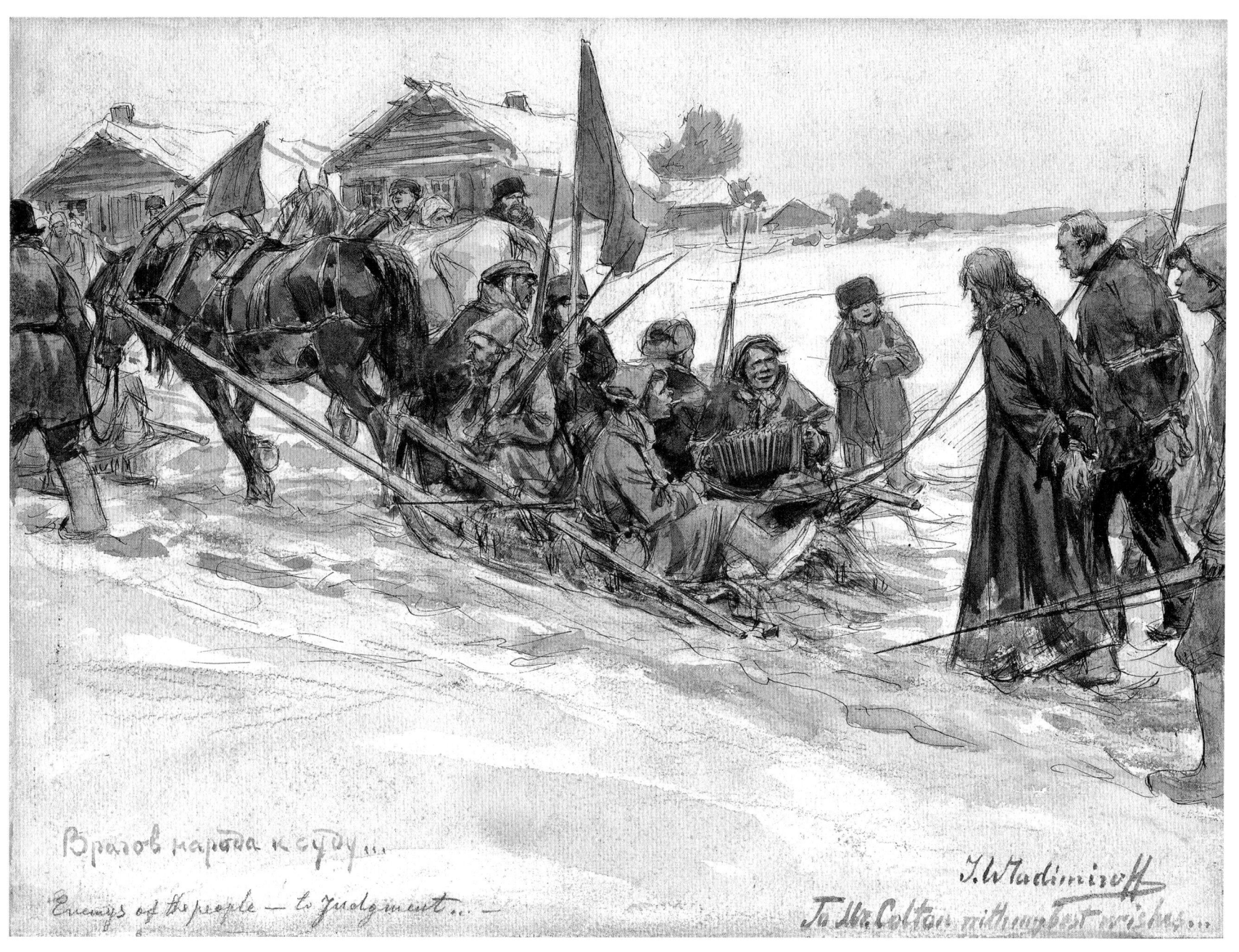

Врагов народа к суду ...

Enemys of the people — to Judgment ... —

J. Wladimiroff

To Mr Colton with my best wishes ...

35. Enemies of the People Taken for Trial

ink & watercolour on paper
24.8 x 34.1cm
Herbert Hoover Presidential Library

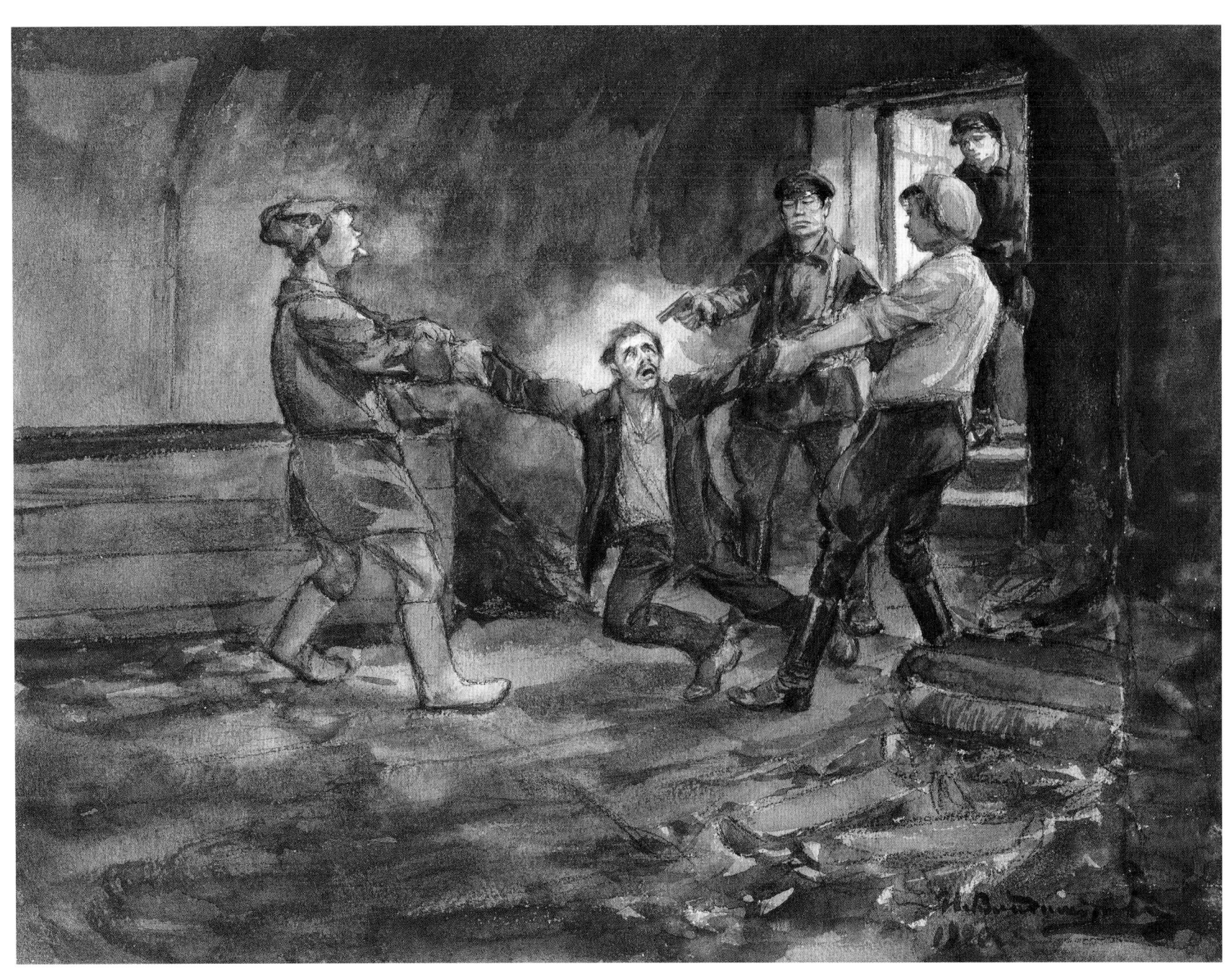

36. Execution at Dno Rail Station in 1919 (1920)

ink & watercolour on paper mounted on board
25 x 34cm
Andre Ruzhnikov Collection

"

Any idea what 'Chinese meat' is?' Here's what:
the Cheka are known to give the corpses of people
they've shot to the animals at the Zoo. Both here
and in Moscow. The Chinese are shooting people.
Both here and in Moscow. But even when they
have killed, and sent off the bodies to the animals,
the Chinese keep stealing. Not all the bodies are
given away – younger ones are hidden, then sold
as veal. Both here and in Moscow. Here, at the
Haymarket. Doctor N. (I know his real name)
bought some meat 'on the bone,' then realized
it was human. He took it to the Cheka. He was
strongly advised not to protest, or he might end
up at the Haymarket himself.

"

Zinaida Hippius
Grey Notebook (1919)

artist's inscription on back:

A landlord and a russian pope condemned to death by a revolutionary Tribunal (at Valdai 1919)

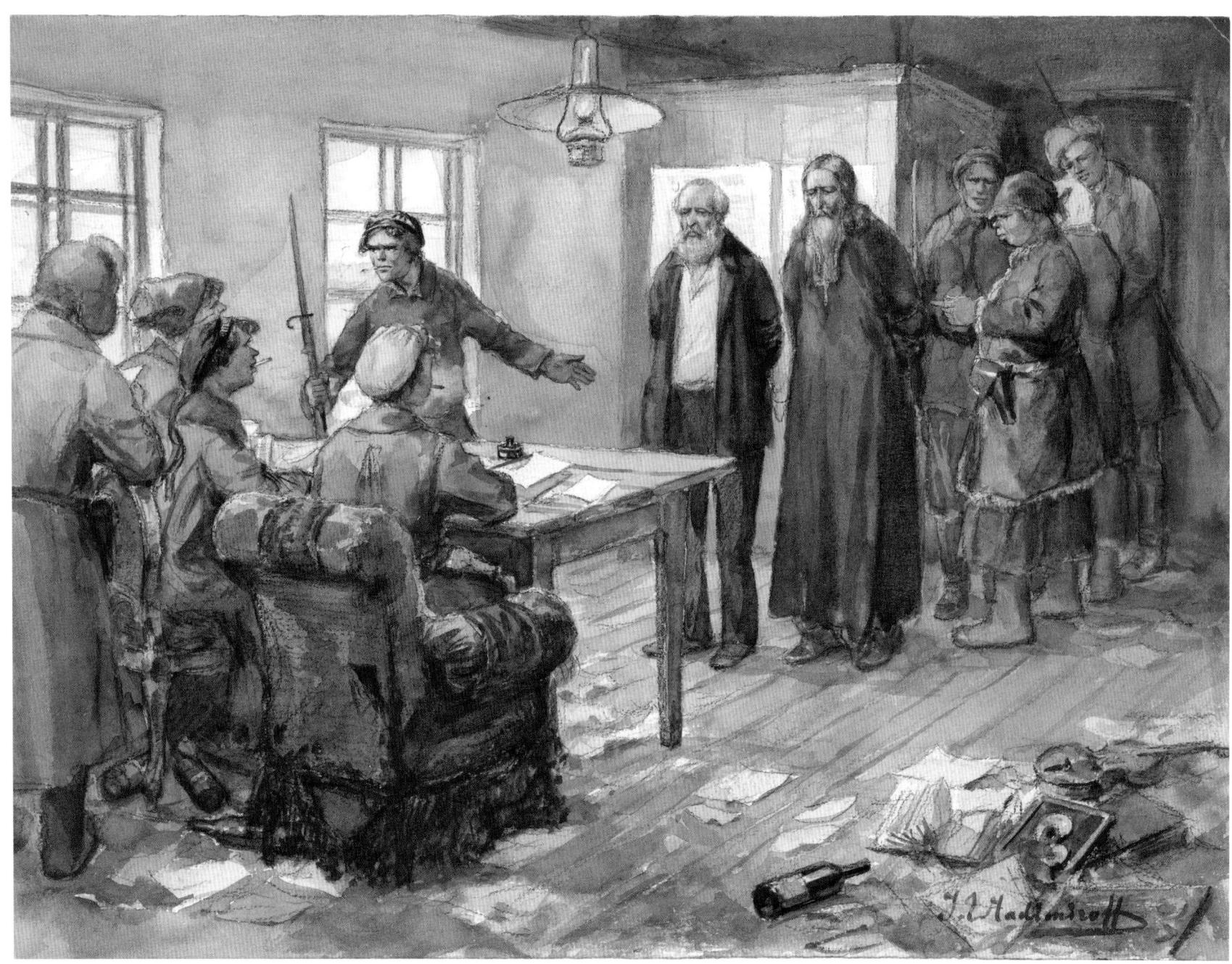

**37. Landowner & Priest Sentenced to Death
by a Revolutionary Tribunal – Valday 1919**

pencil & watercolour on paper
29.2 x 39.4cm
Hoover Institution Library & Archives

Допрос подсудимого в трибунале.
1920 г.

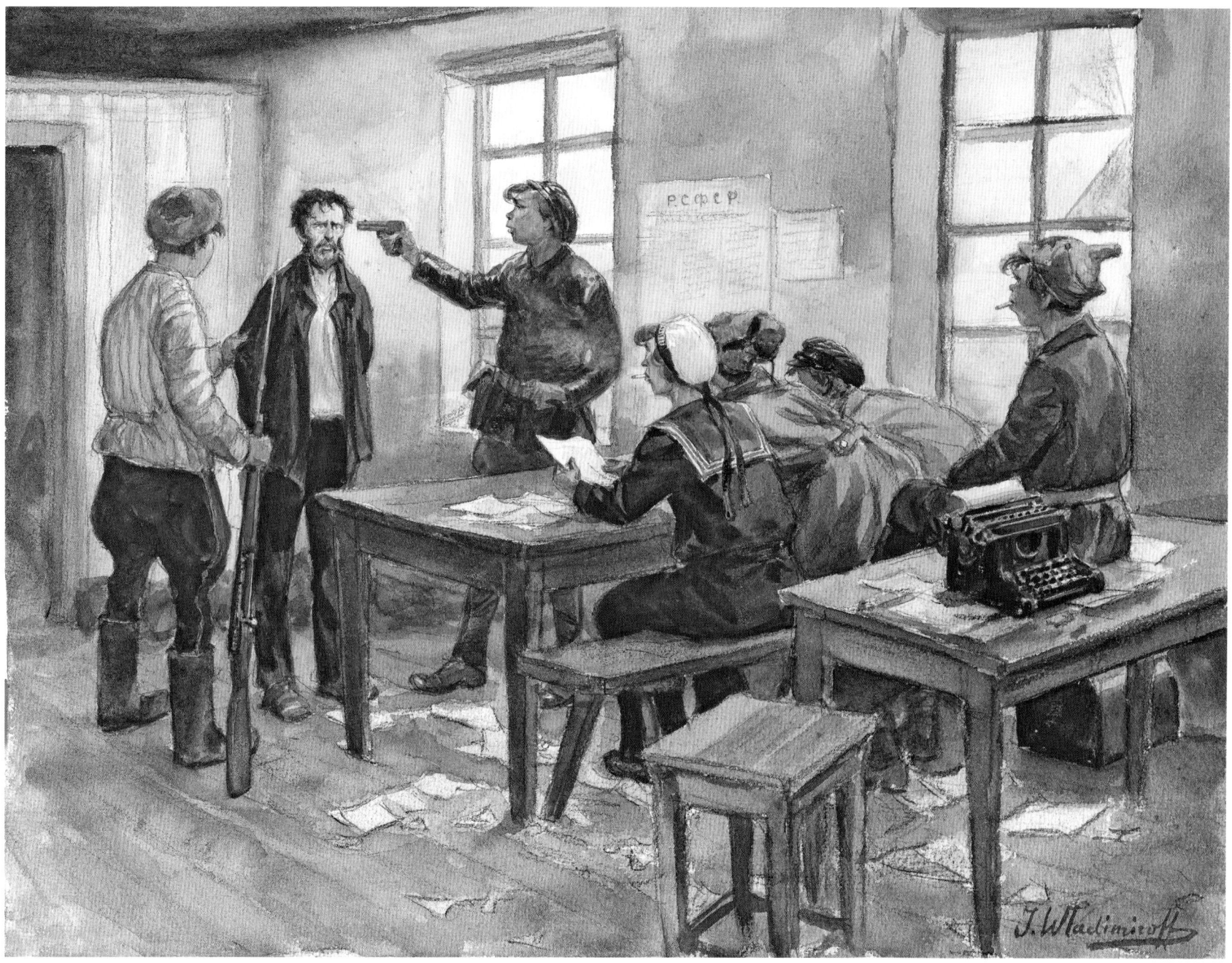

38. Tribunal Interrogating the Accused – 1920

pencil & watercolour on paper
25.7 x 34.3cm
Andre Ruzhnikov Collection

TROOPS FROM BUDYONNY'S FIRST CAVALRY ARMY (JANUARY 1920)

> " We will steel our hearts so they are impervious to pity and do not flinch at the sight of a sea of enemy blood. And we will unleash this sea. Without mercy, without compassion. We will slaughter the enemy by the dozen, by the hundred. Let them gather by the thousand. Let them choke on their own blood. "

Krasnaya Gazeta
31 August 1918

Chapter 5

Bolshevik Propaganda

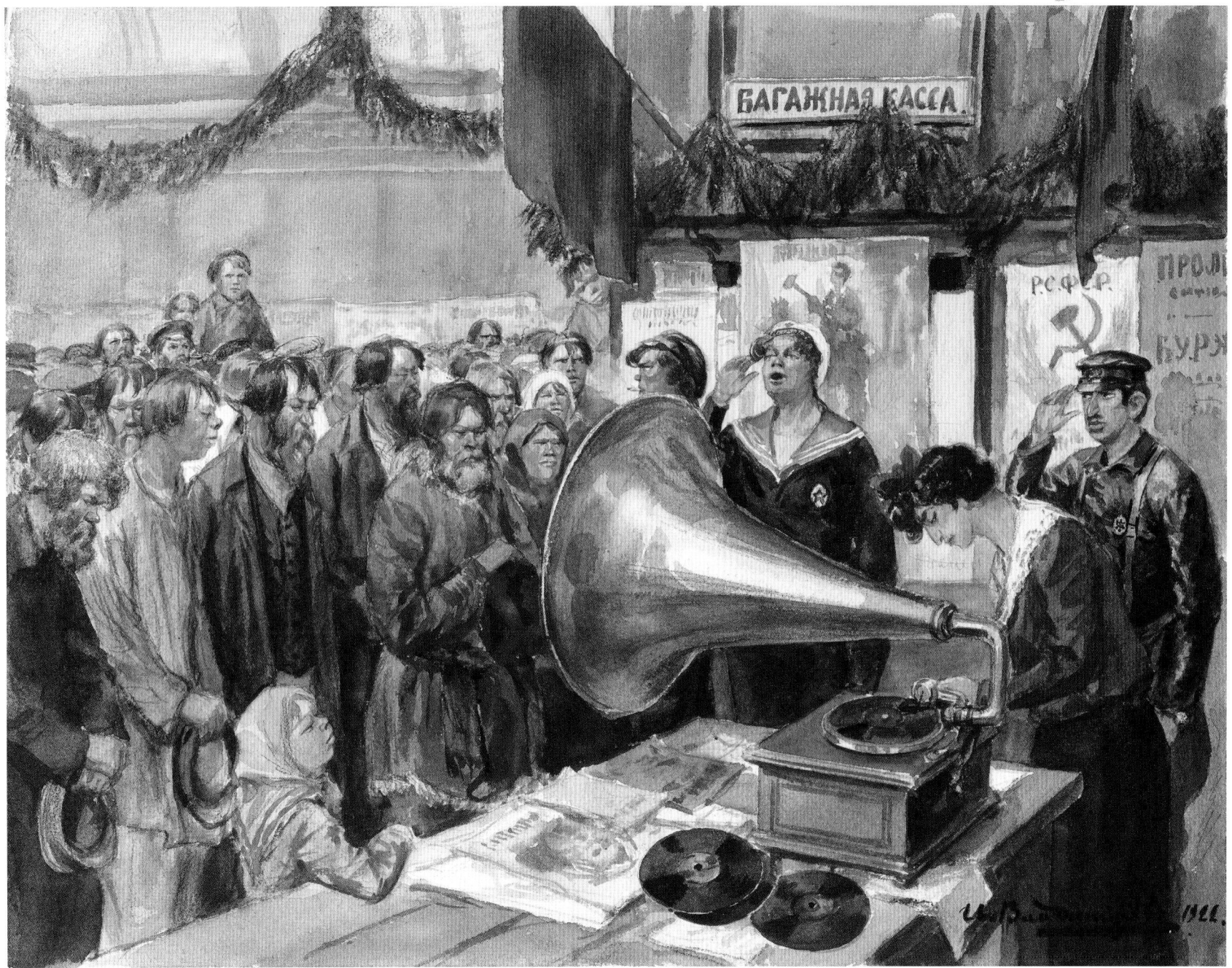

39. The Internationale – Agitpunkt Scene at Dno Rail Station (1922)

ink & watercolour on paper
25.7 x 34.5cm
Andre Ruzhnikov Collection

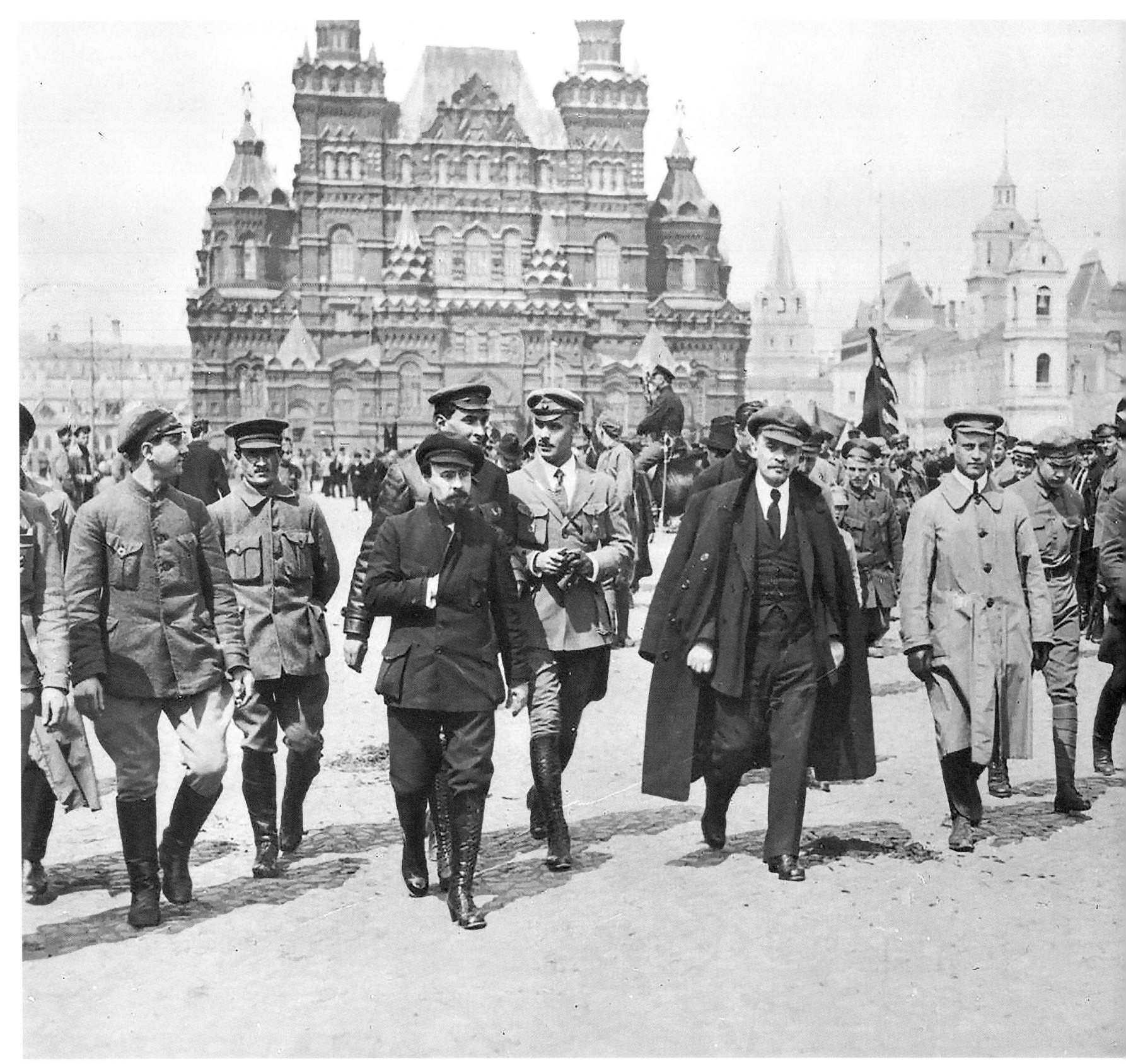

LENIN AT THE VSEVOBUCH PARADE IN MOSCOW ON 25 MAY 1919

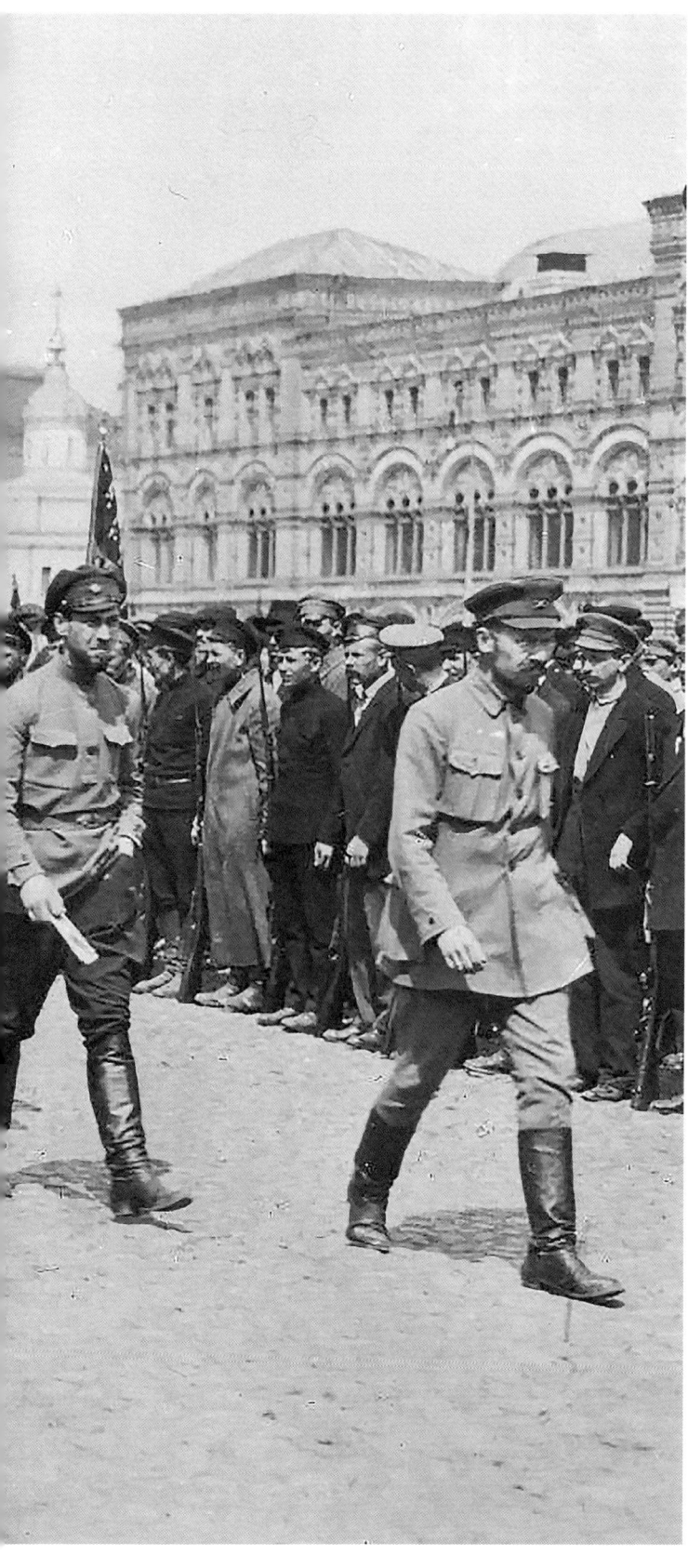

"
To explain to the working masses – by means of literature, posters, gramophone records, cinematography, the living word etc. – the meaning of the continuing struggle, and involve them in building a new life.

"

Workers' & Peasants' Defence Council
Resolution on the Organization of Propaganda Points
at Rail Junctions & Landing Places – 13 May 1919

Лекция о Марксе для крестьян в деревне.

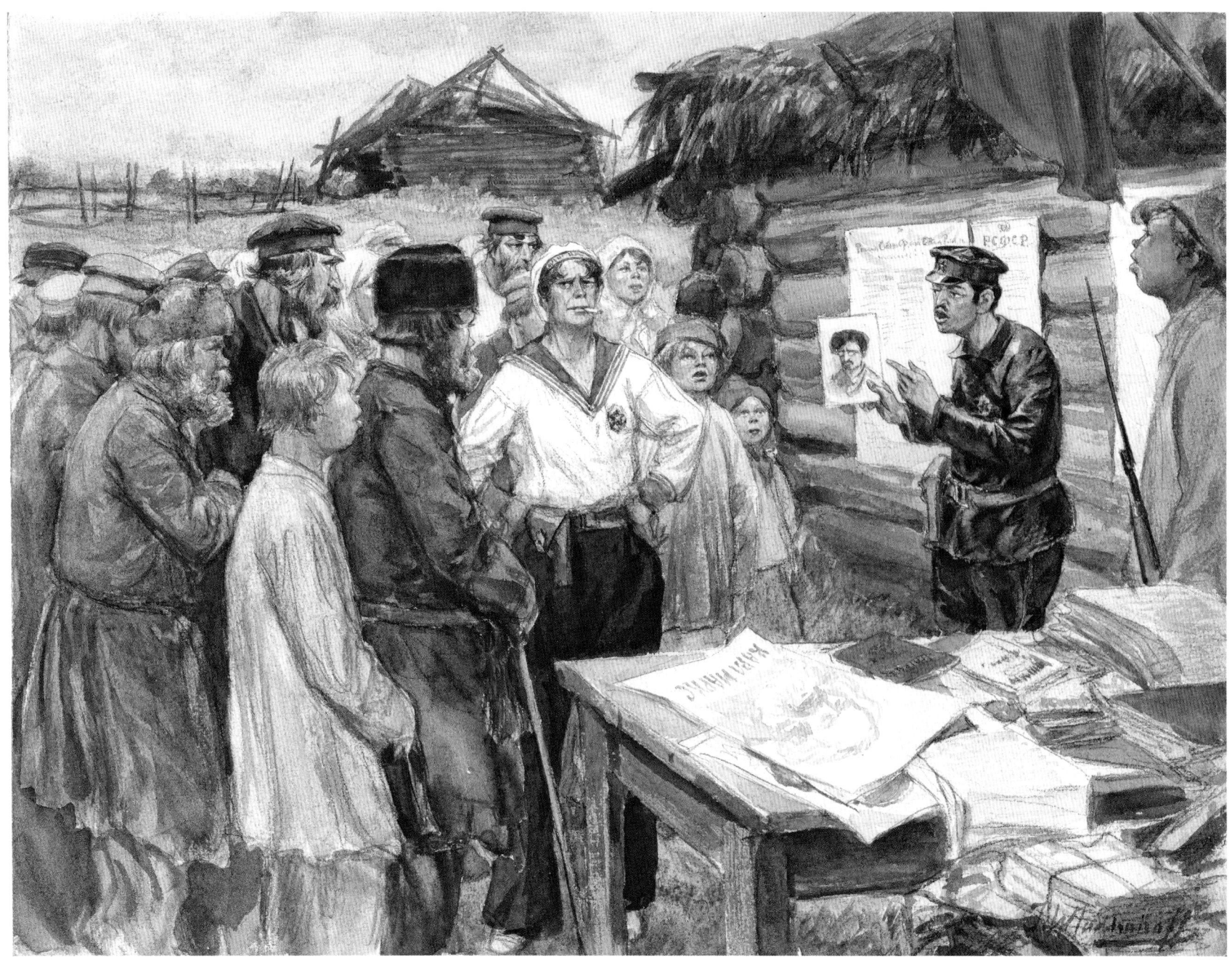

40. Lecturing Peasants About Marx

ink & watercolour on paper
25.7 x 34.5cm
Andre Ruzhnikov Collection

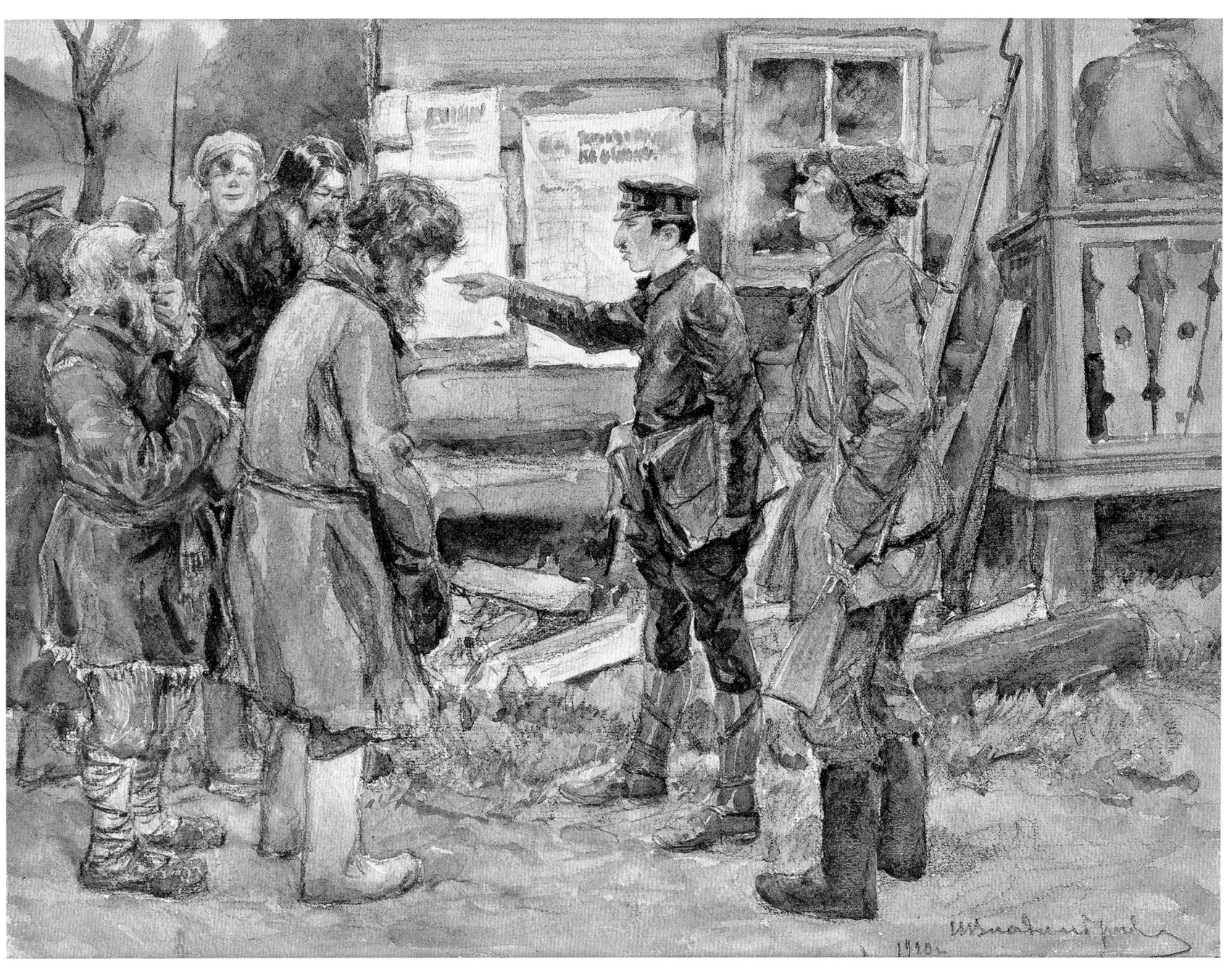

41. Bolsheviks in the Village (1920)

ink & watercolour on paper mounted on board
25.5 x 33.5cm
Andre Ruzhnikov Collection

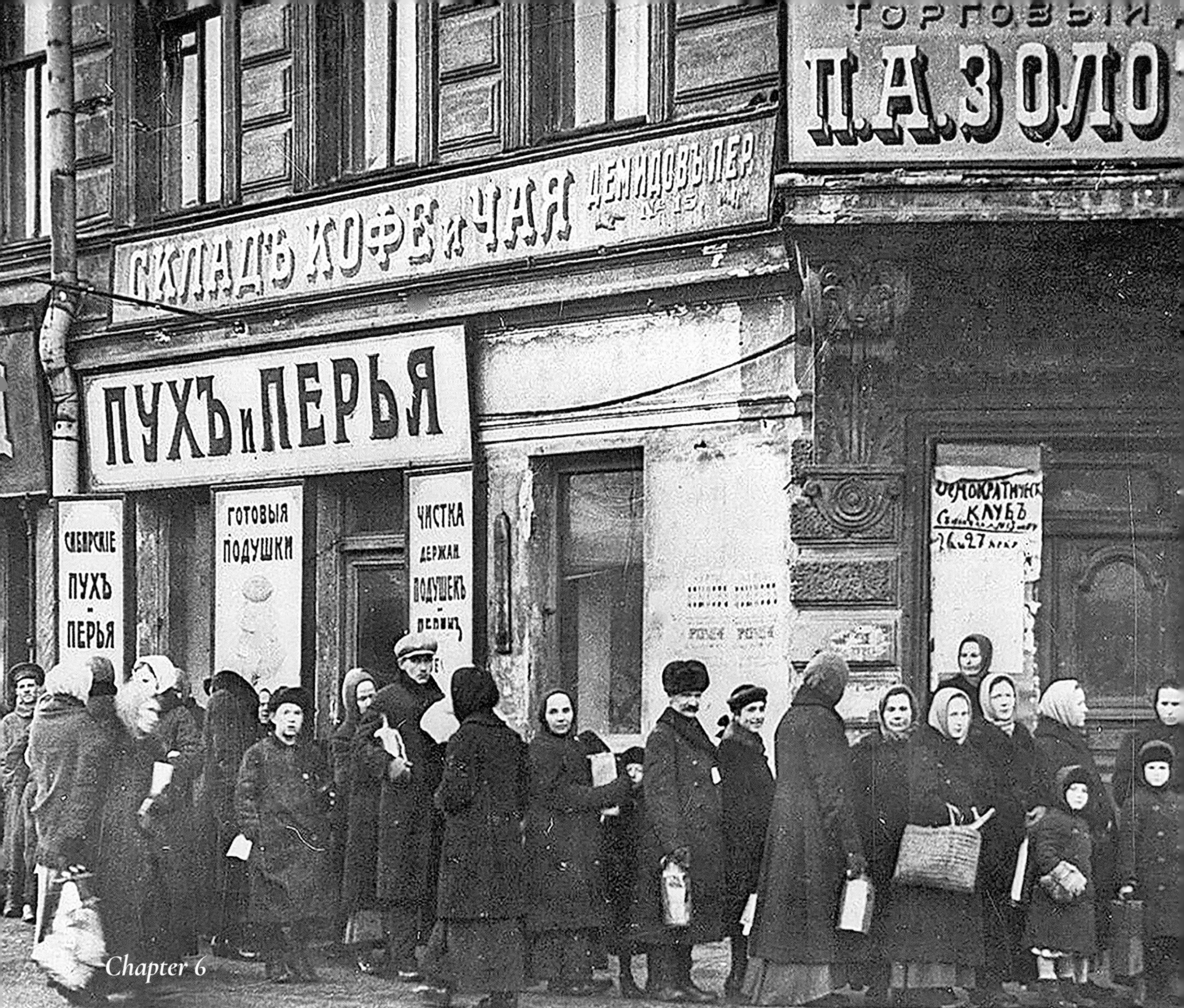

Chapter 6

Years of Famine

1918-22

Hungry days in Petrograd. Hungry people of all classes eating their portions at the doors of a "Communial dining-room" 1919—

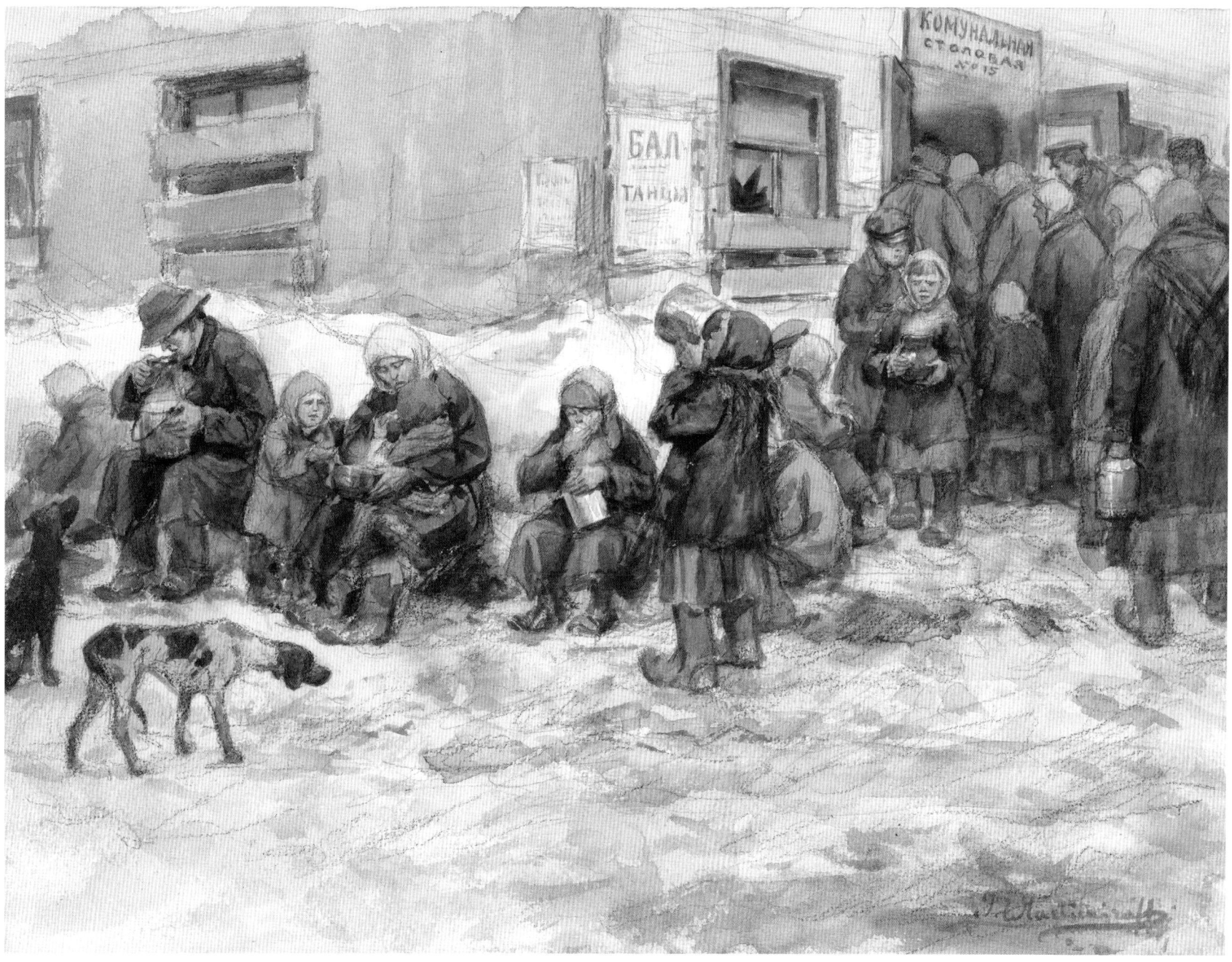

42. Hungry People of All Classes Outside a Communal Soup-Kitchen – Petrograd 1919

pencil & watercolour on paper
29.2 x 39.4cm
Hoover Institution Library & Archives

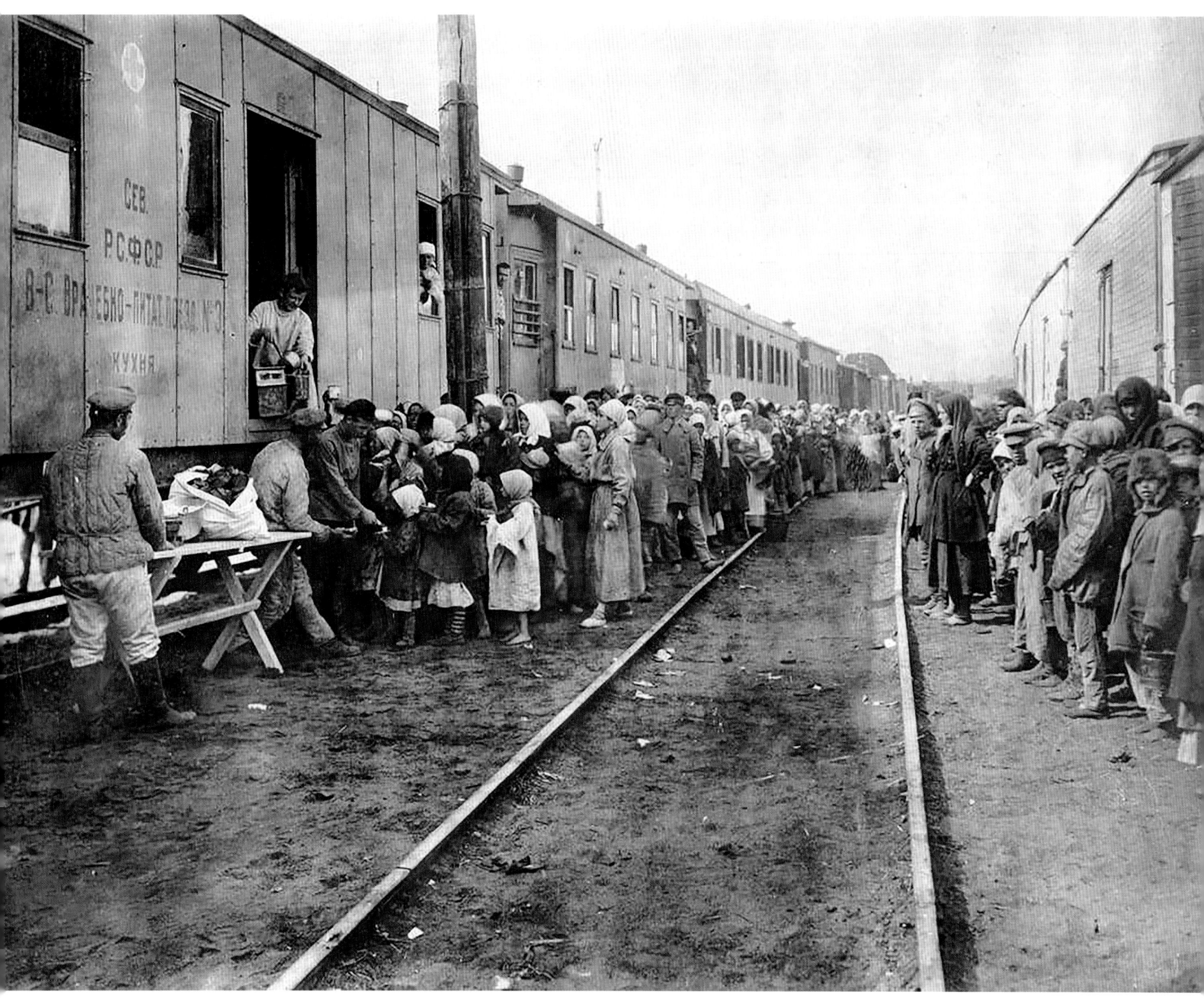

FOREIGN AID FOR FAMINE VICTIMS – VOLGA REGION 1922

"

The city was by now on the brink of famine: we all had the smallest possible rations to live on, and even the black market in illegal goods was highly insufficient and badly organized. People, especially the old and the very young, walked like shadows in the streets and frequently some peasant-woman would stop one, offering some coffee or lard hidden carefully under her apron, illegal goods carried across the border from Finland. All this was bad enough for humans, and few people had thoughts to spare for the half-starved horses who were falling like flies in the snow-covered streets. Not a day passed without my having seen two or three collapsing in their shafts.

"

Edith Sollohub
The Russian Countess – Escaping Revolutionary Russia

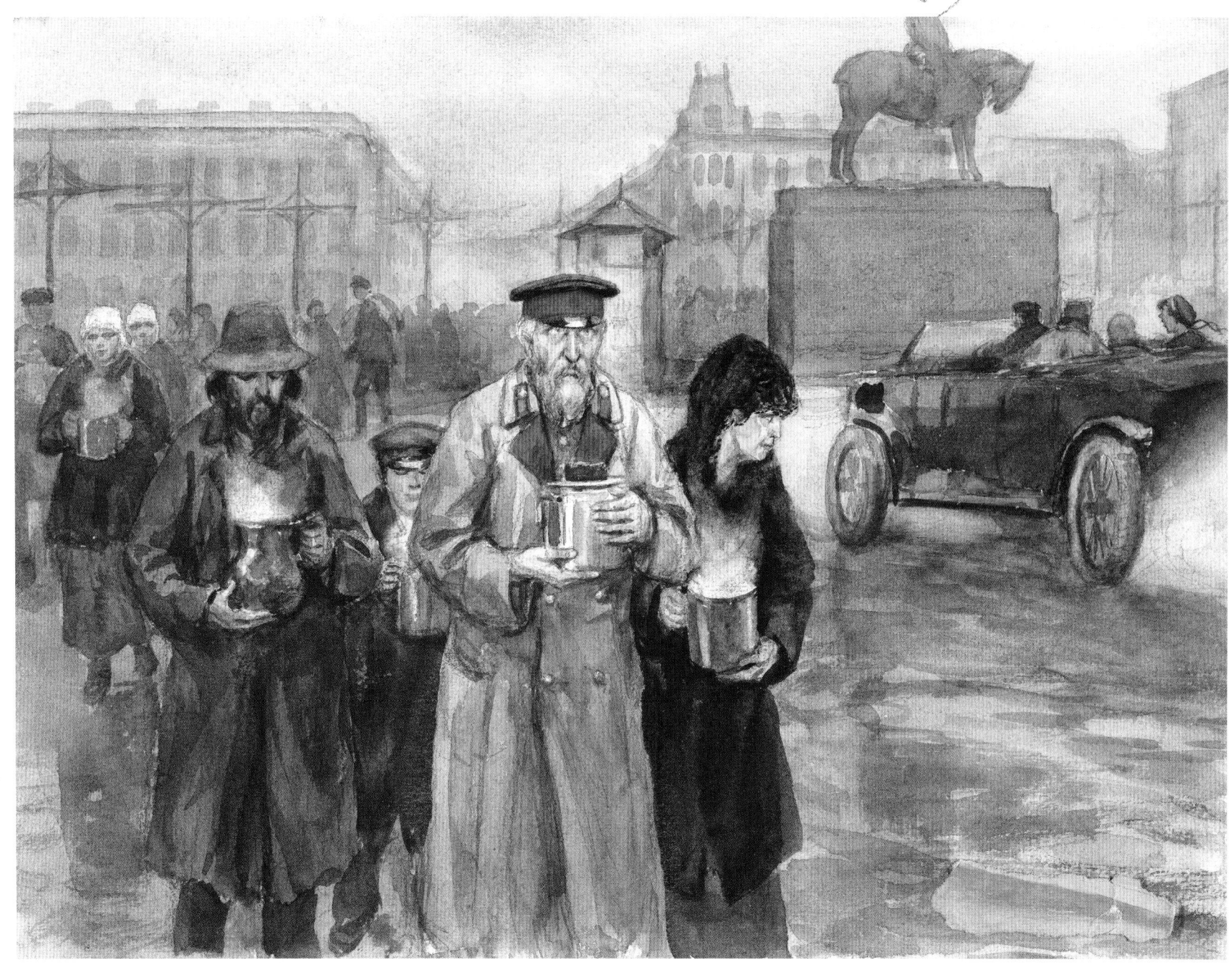

**43. Going Home with a Meal from the Communal Soup-Kitchen
– Petrograd November 1919**

pencil & watercolour on paper
29.2 x 39.4cm
Hoover Institution Library & Archives

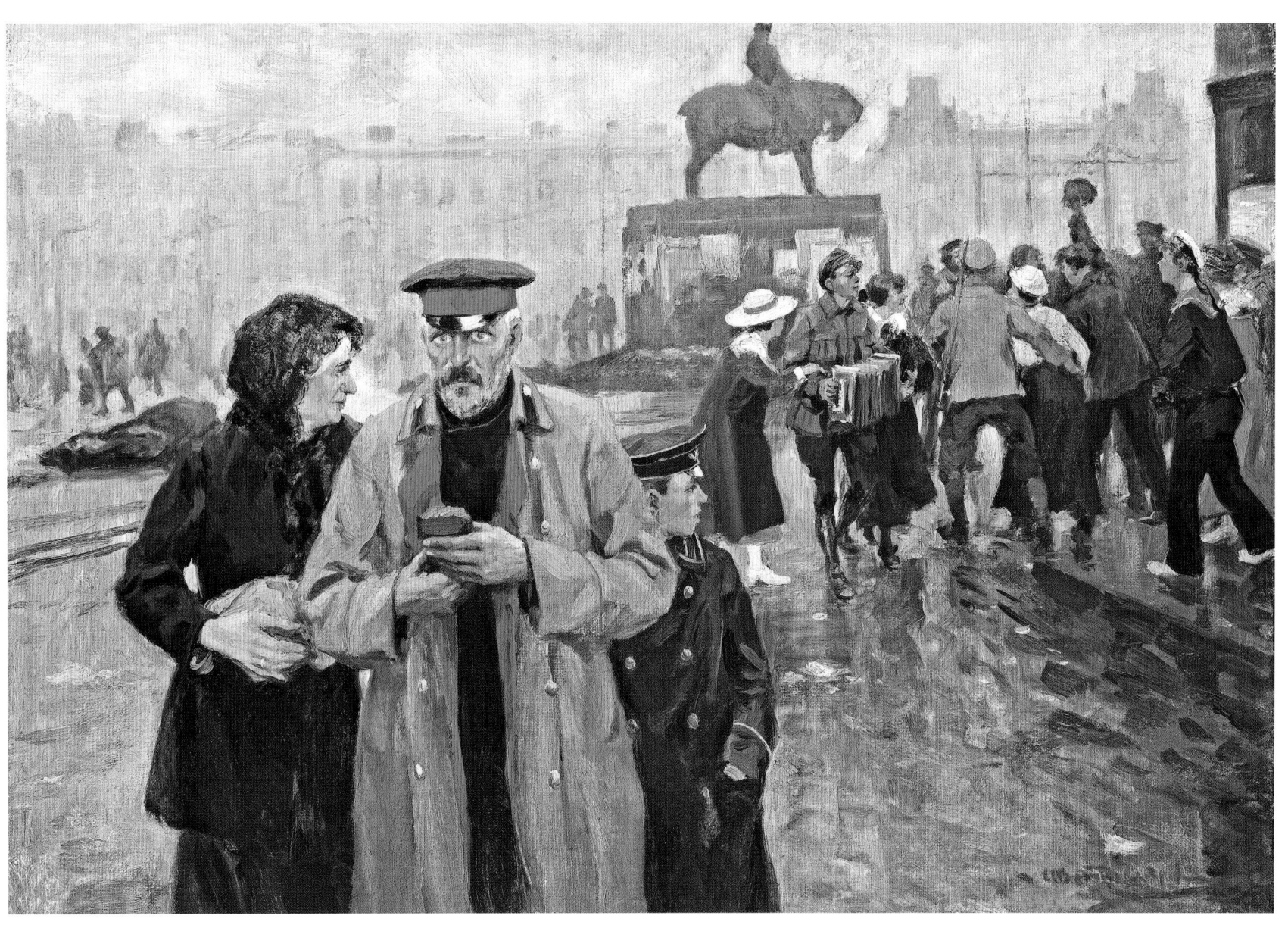

44. On the Streets of Petrograd

oil on canvas mounted on board
42.2 x 66.7cm
Vladimir Ruga Collection

Waiting to recieve 1/8th of a pound of bread. (1919). —

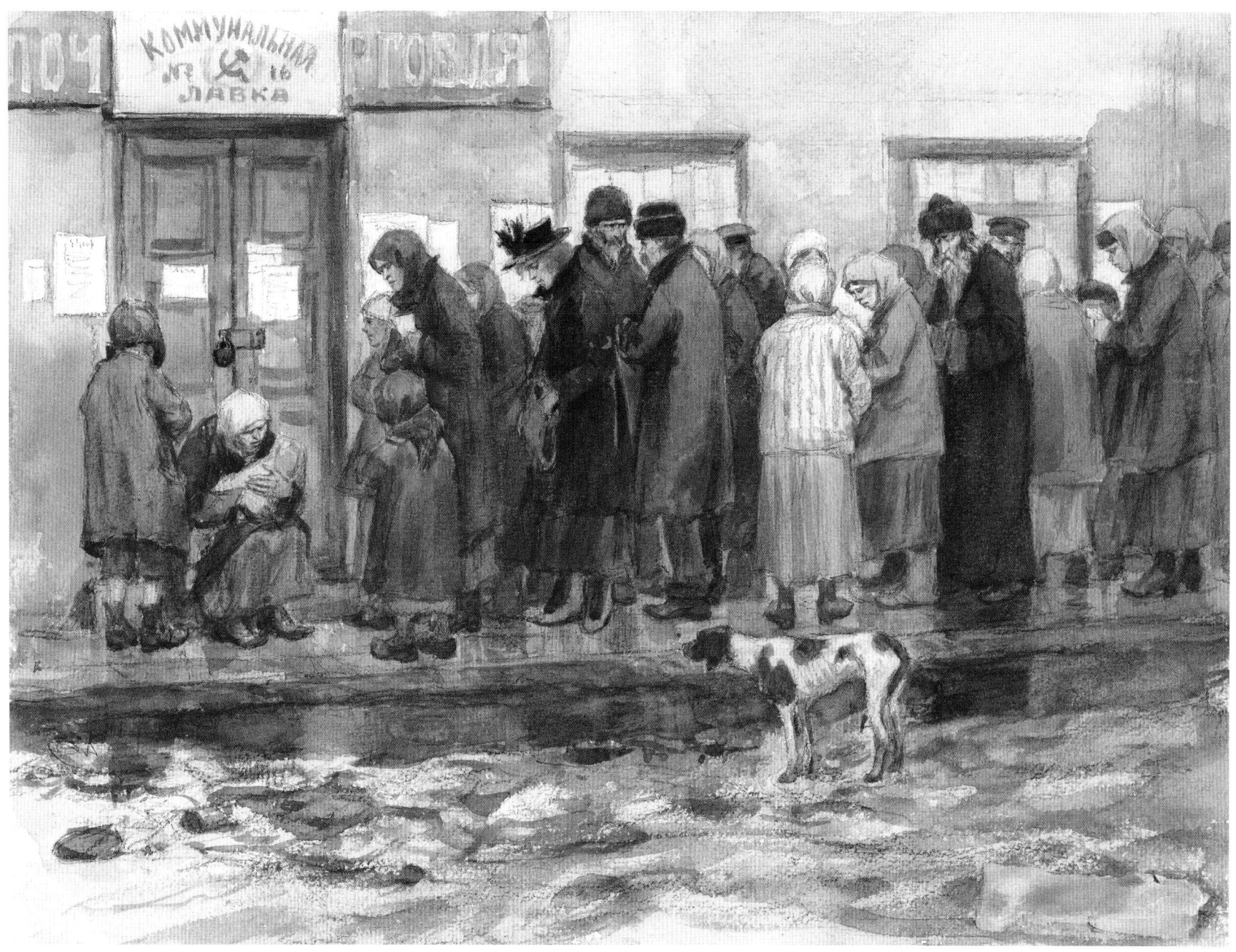

45. Waiting for 1/8th of a Pound of Bread – 1919

pencil & watercolour on paper
29.2 x 39.4cm
Hoover Institution Library & Archives

artist's inscription on back:

Hungry workmen robbing bread from a military lorry-car in Petrograd (1920).

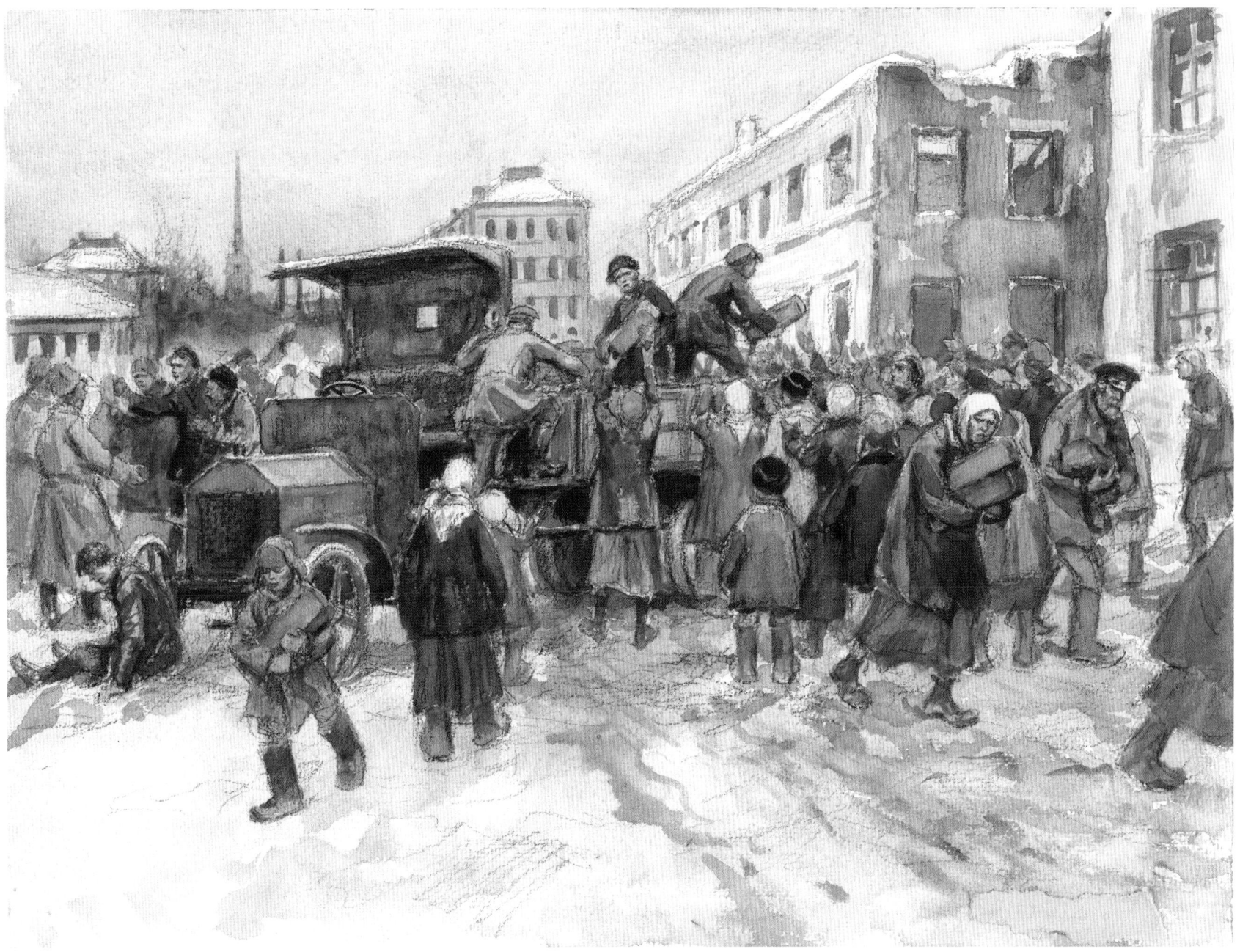

46. Hungry Workers Stealing Bread from an Army Truck – Petrograd 1920

pencil & watercolour on paper
29.2 x 39.4cm
Hoover Institution Library & Archives

Hungry-time in Petrograd. A lady and her daughter searching for potatoe-peel
(drawn from nature) and herring-heads to eat. (January 1919.)

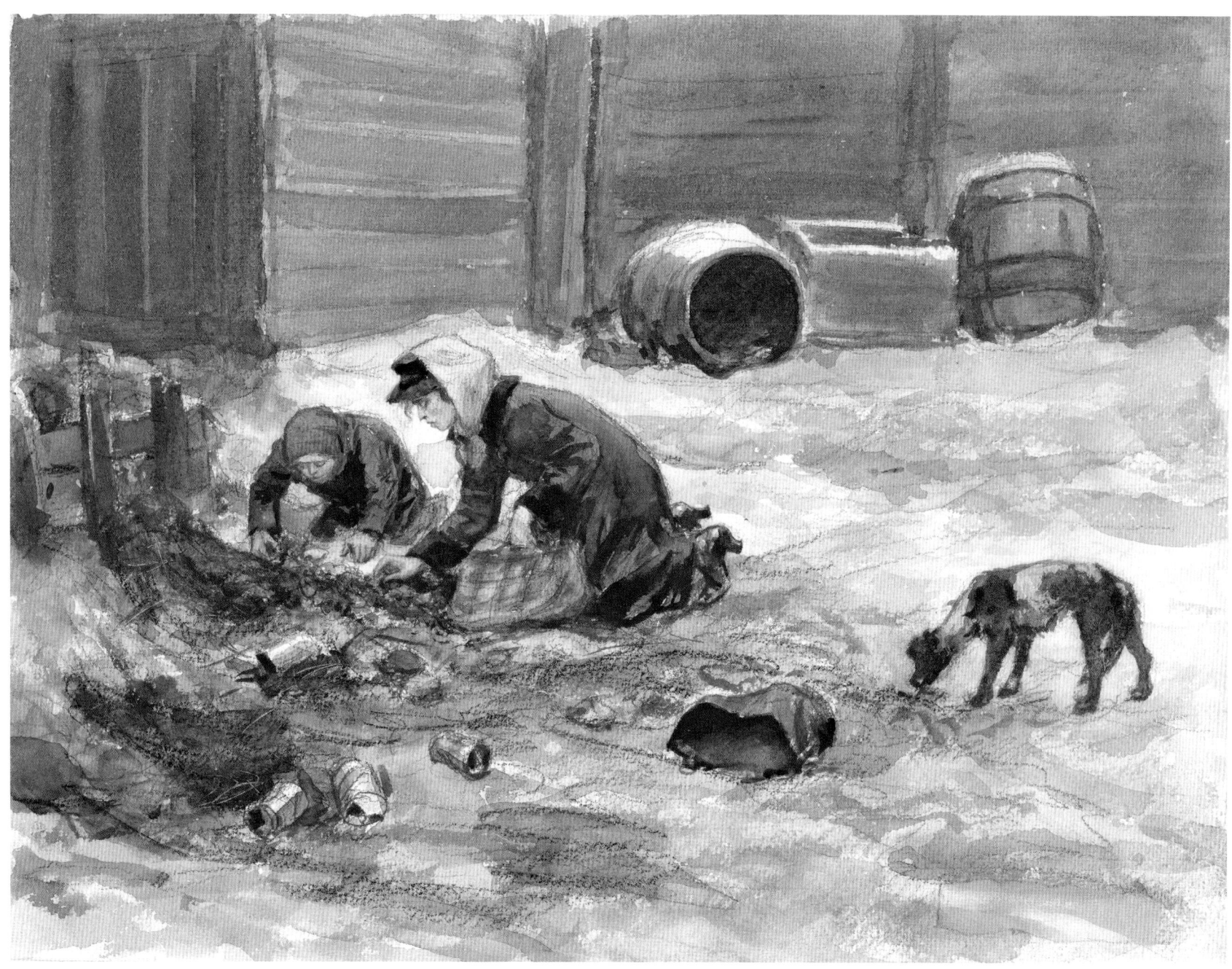

**47. Mother & Daughter Scavenging for Potato-Peel & Herring-Heads
to Eat – Petrograd January 1919**

pencil & watercolour on paper
29.2 x 39.4cm
Hoover Institution Library & Archives

Hungry times in Petrograd

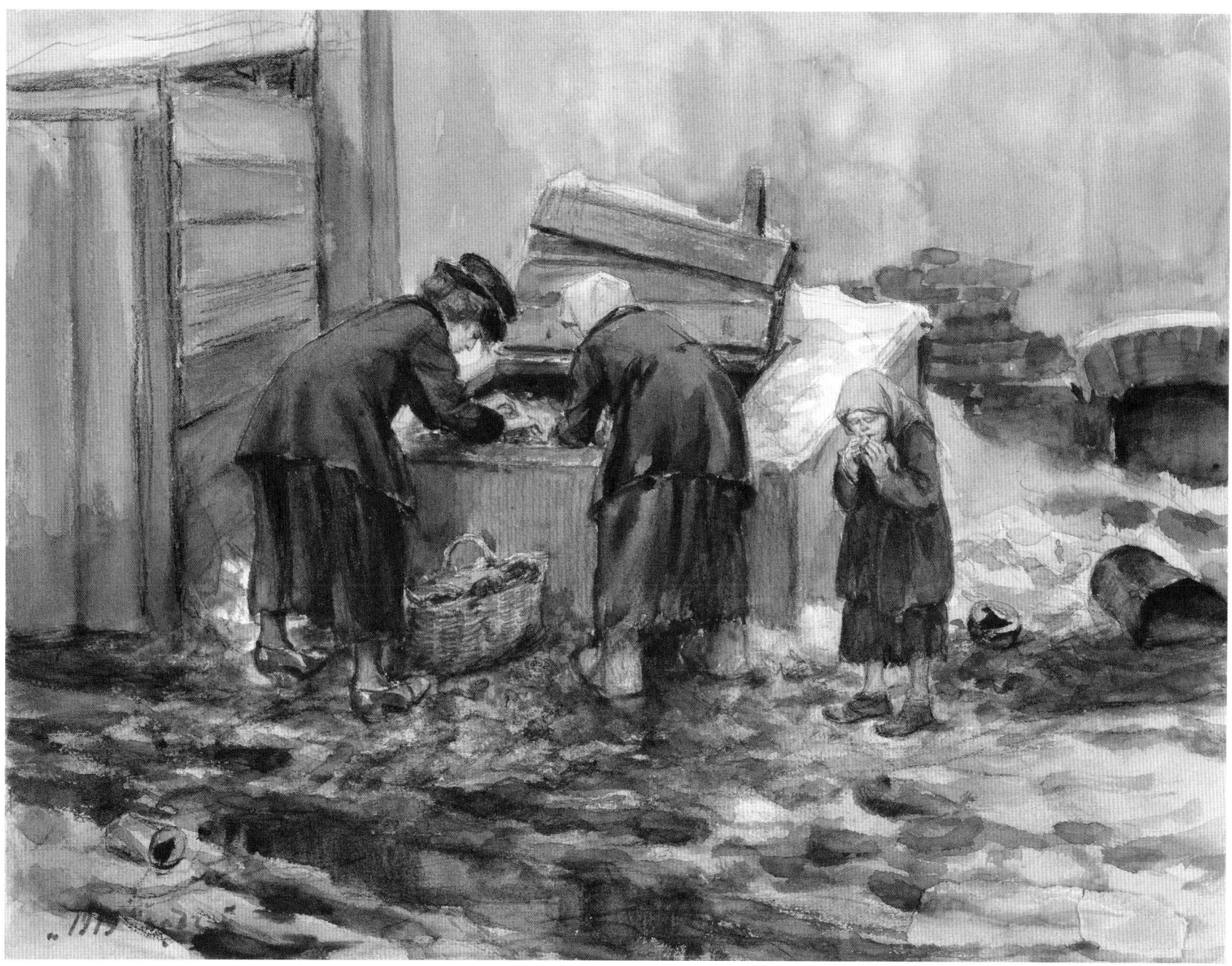

48. Famine in Petrograd (1919)

pencil & watercolour on paper
29.2 x 39.4cm
Hoover Institution Library & Archives

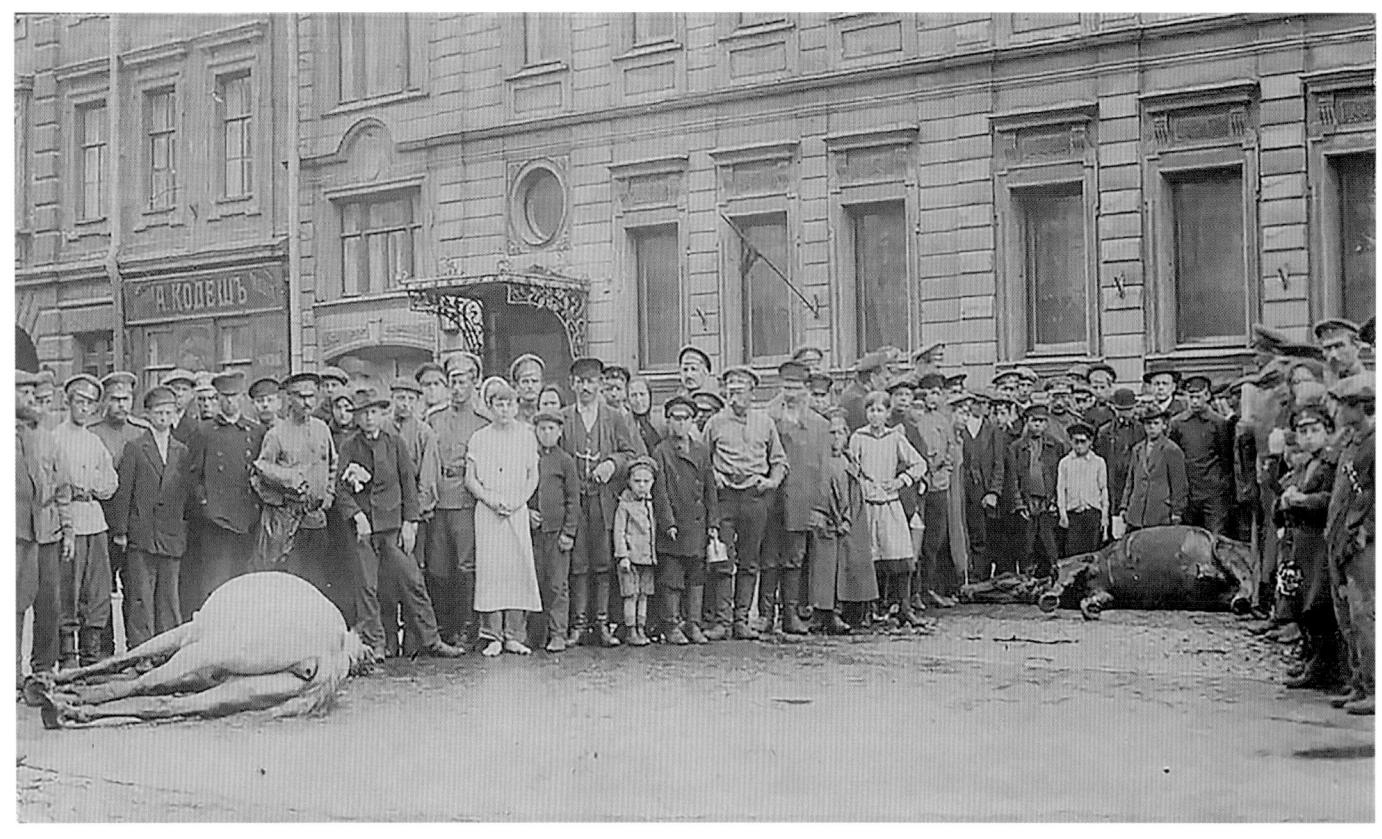

LITEINY PROSPEKT ON THE MORNING OF 3 JULY 1917

"

In Petrograd hunger is widespread.
Whenever a horse collapses on the street,
people dash out to cut off pieces of
meat as soon as the animal has expired.
Eye-witnesses told me they saw a horse
carcass lying on the street with its head
and shoulders cut off for food. Peasants
refuse to sell anything for money but
will exchange food for clothes, shoes
or furniture. All the shops are empty.

"

H.G. Wells

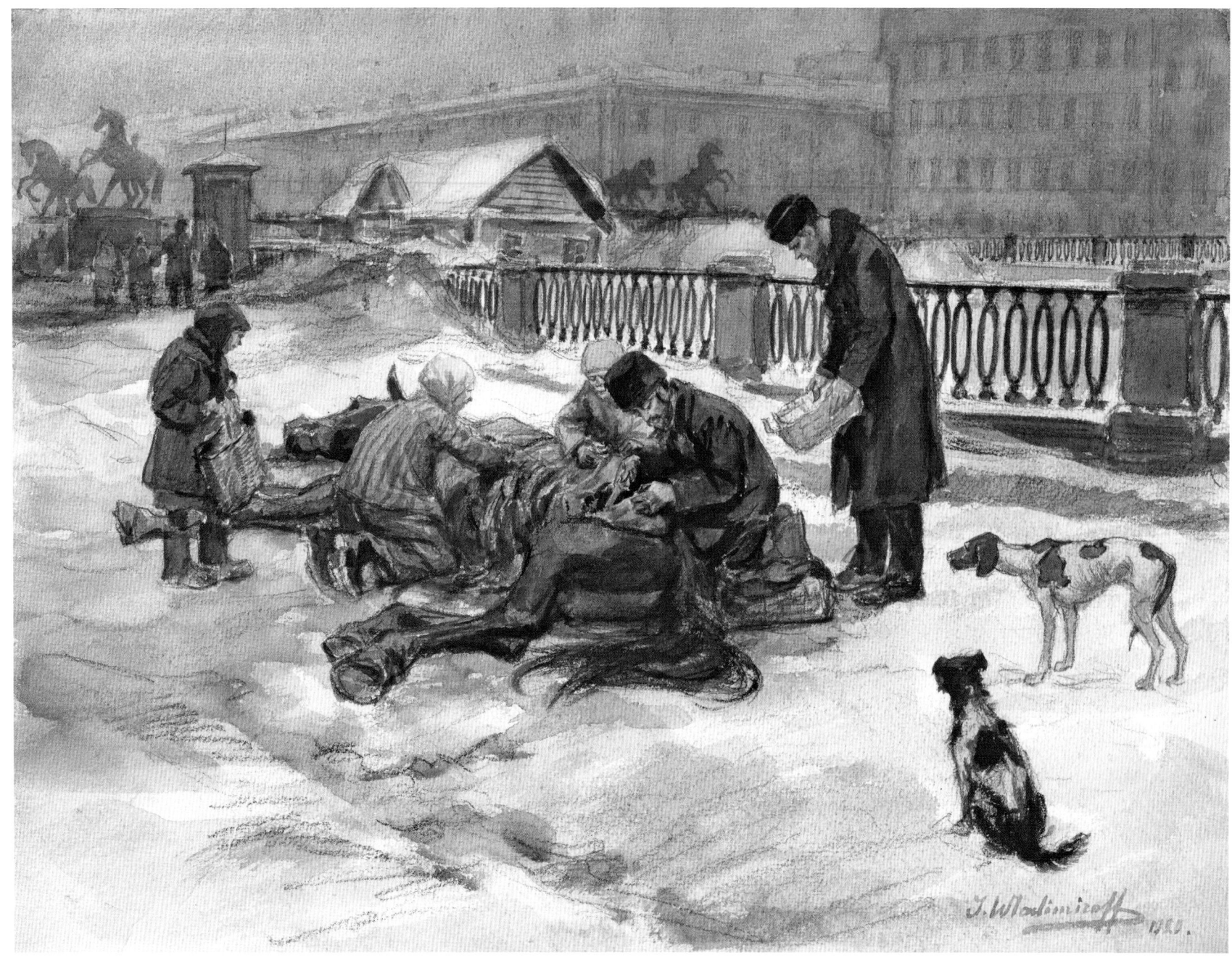

49. Cutting Up a Dead Horse for Food on the Fontanka in 1919 (1920)

pencil & watercolour on paper
25.7 x 34.2cm
Andre Ruzhnikov Collection

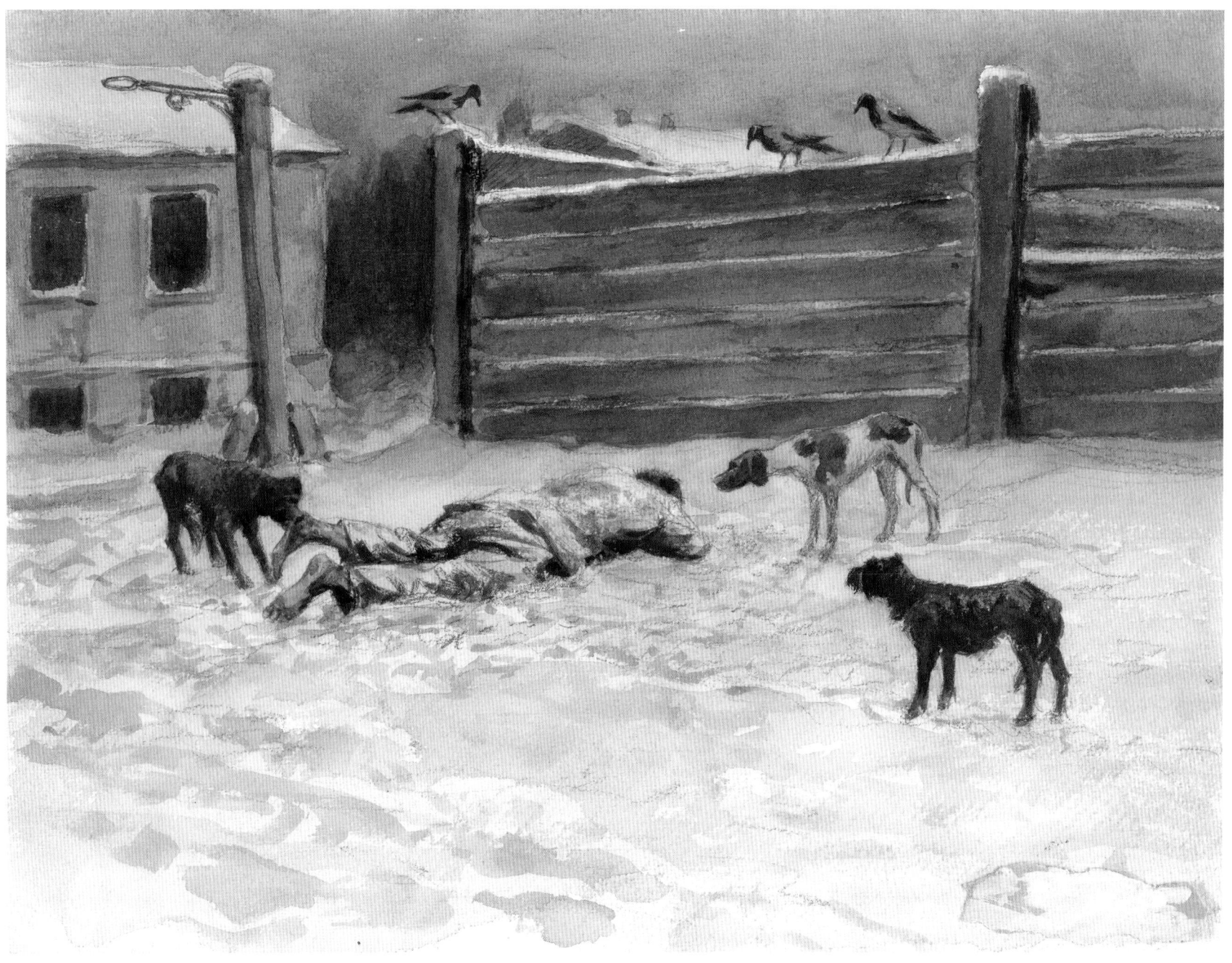

**50. He Who Died from Hunger Falls Prey to Hungry Hounds –
Petrograd January 1919**

pencil & watercolour on paper
29.2 x 39.4cm
Hoover Institution Library & Archives

Ограбленiе товарнаго вагона (12 фебр. 1922 г.)

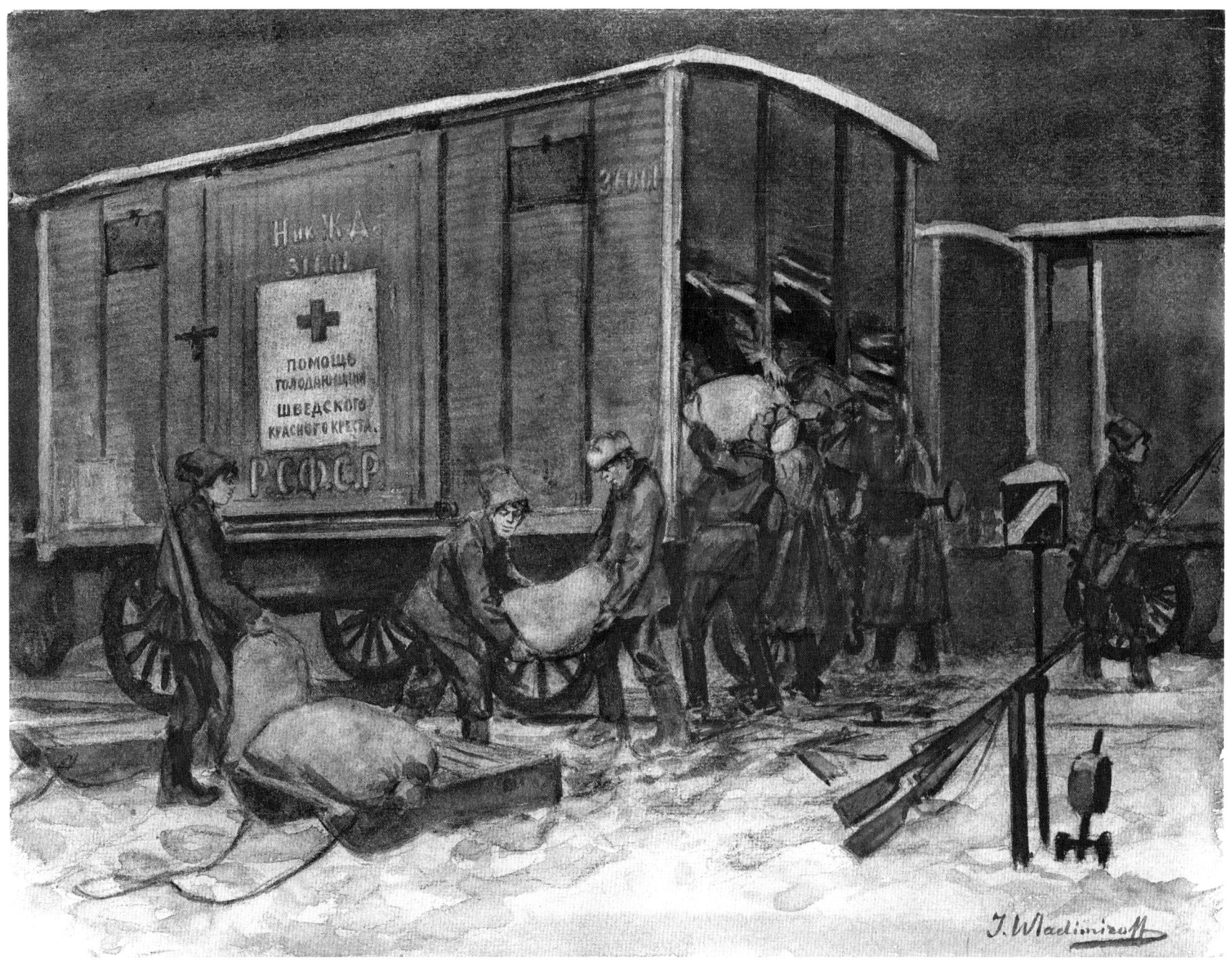

51. Robbing a Goods Truck – 12 February 1922
pencil & watercolour on paper
25.5 x 34.5cm
Andre Ruzhnikov Collection

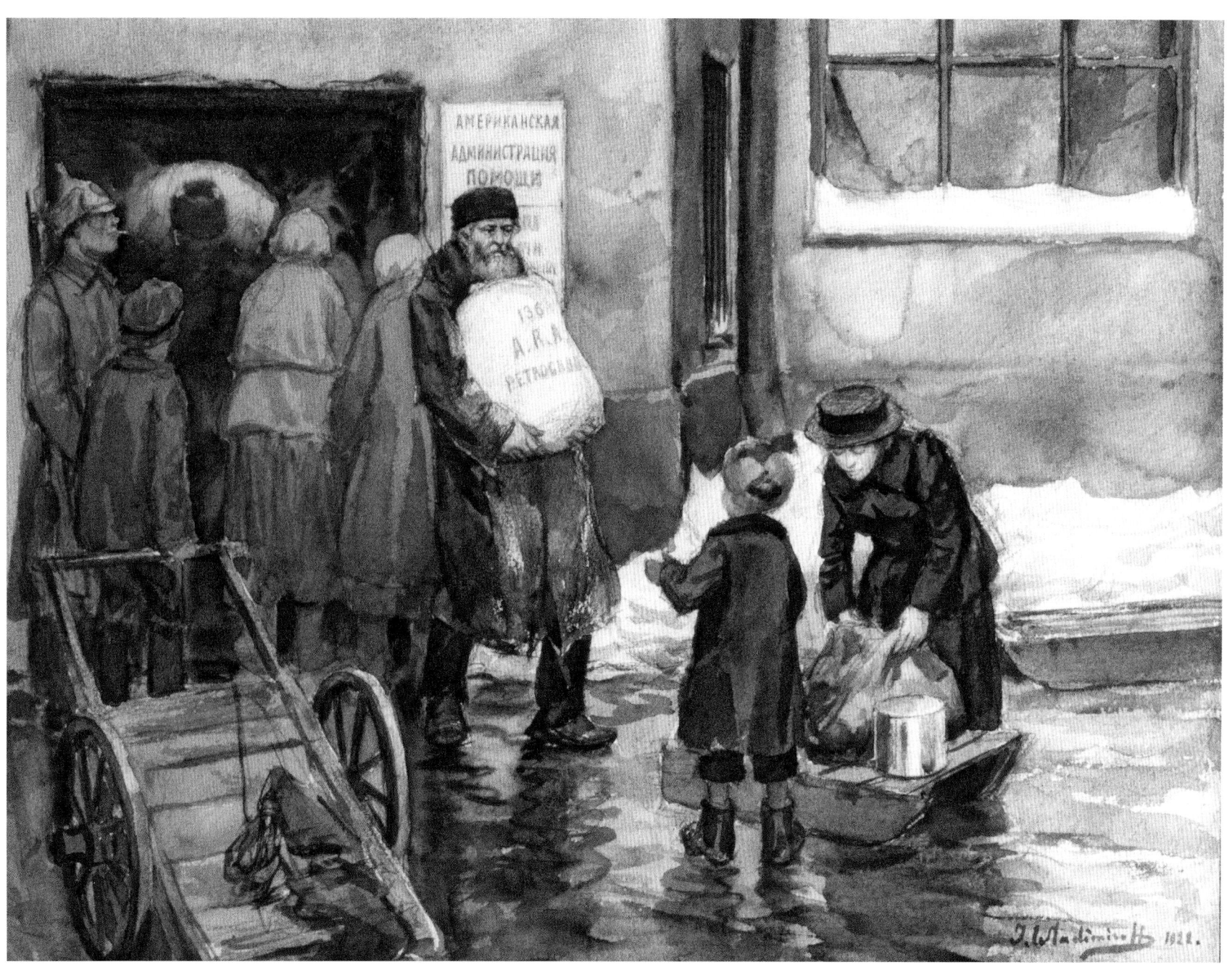

52. American Relief Administration (ARA) Food Distribution Point (1922)

watercolour on paper
30.5 x 38.1cm
Herbert Hoover Presidential Library

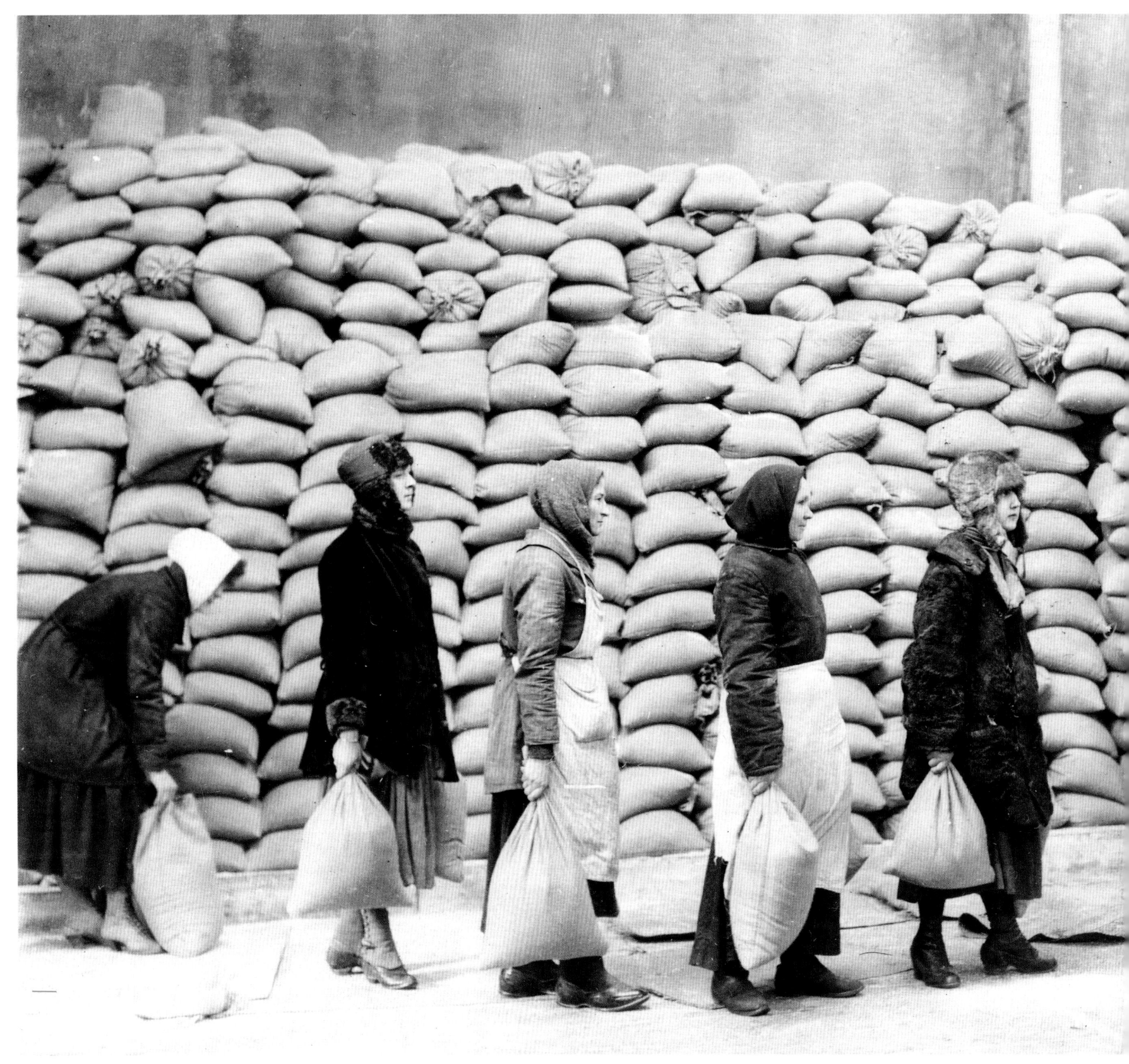

ARA FOOD DEPOT IN MOSCOW (HOOVER INSTITUTION LIBRARY & ARCHIVES)

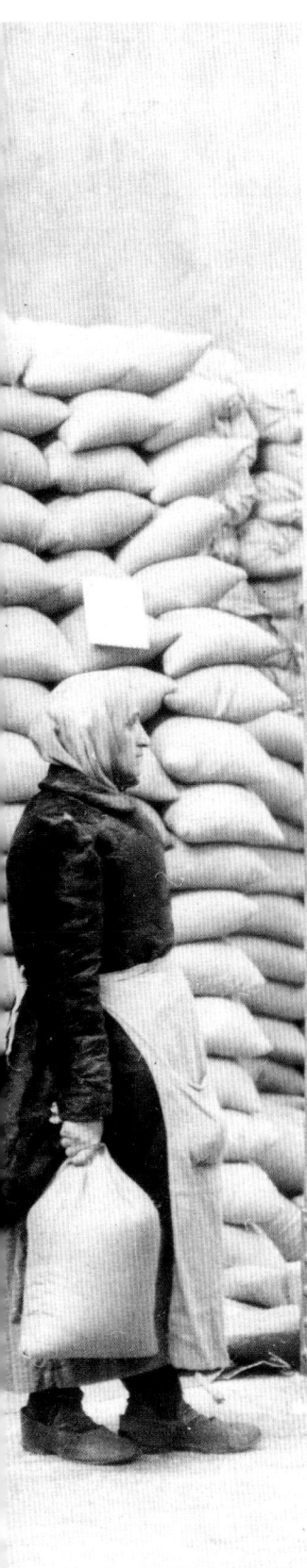

"

I saw on every hand evidences of the greatest care that nothing having any food value be wasted. Cabbage leaves, melon rinds, and articles of this kind ordinarily thrown away are now utilized. In one commune, Baro in Saratov, I did not notice a single dog, a rather unusual condition for Russia, and on inquiry the local secretary of the commune told me that they had butchered about all of them and made them into bologna and sausage for use this Winter.

"

James P. Goodrich
Relief of the Distressed and Starving People of Russia
Hearings before the House of Representatives Committee
on Foreign Affairs – Resolutions 9459 & 9548
(67th U.S. Congress, Second Session, 13-14 December 1921)

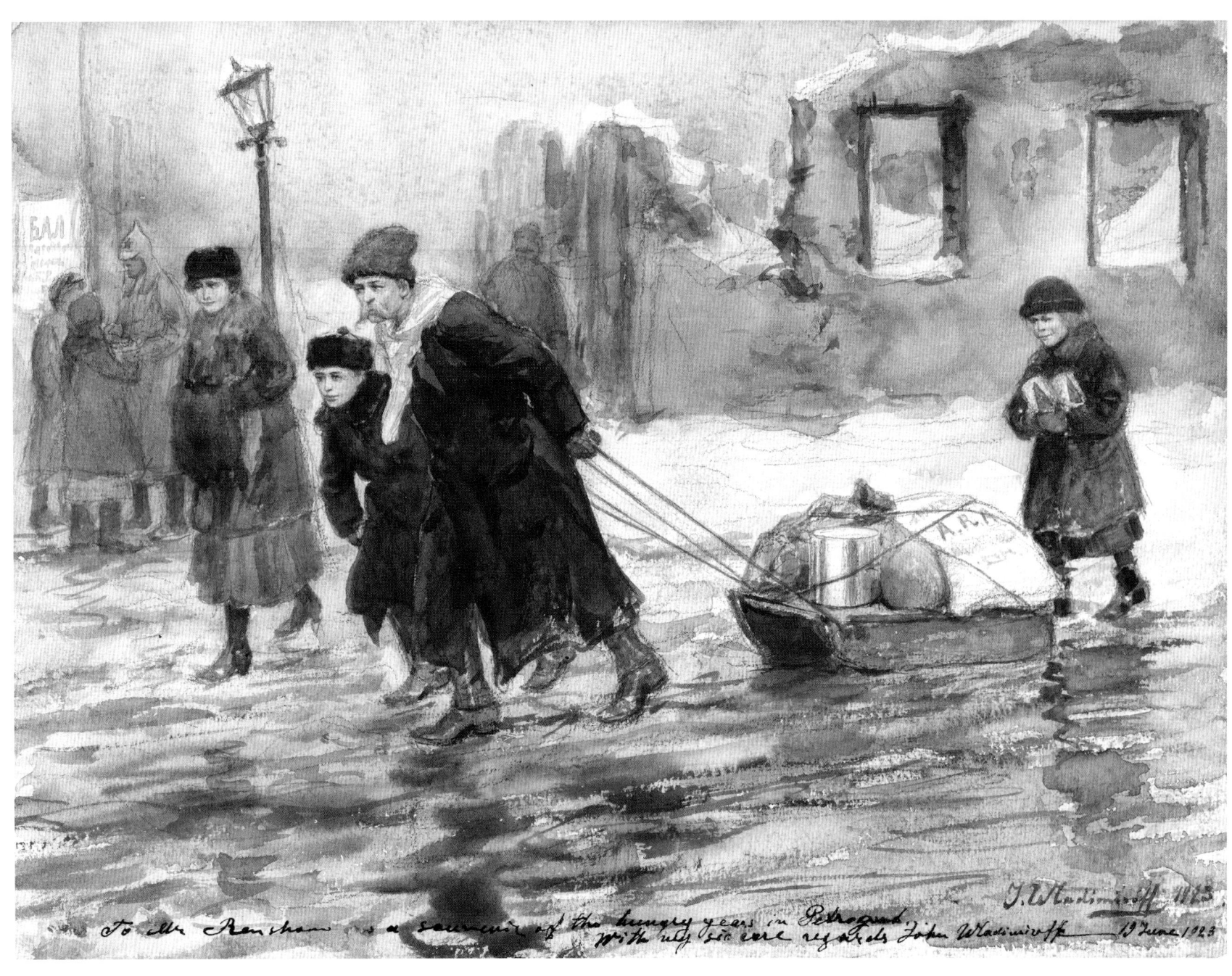

To Mr Renshaw as a souvenir of the hungry years in Petrograd with my sincere regards John Wladimiroff — 19 June 1923

53. A Russian Family in 1923 (1923)

watercolour on paper
29.2 x 39.4cm
Hoover Institution Library & Archives

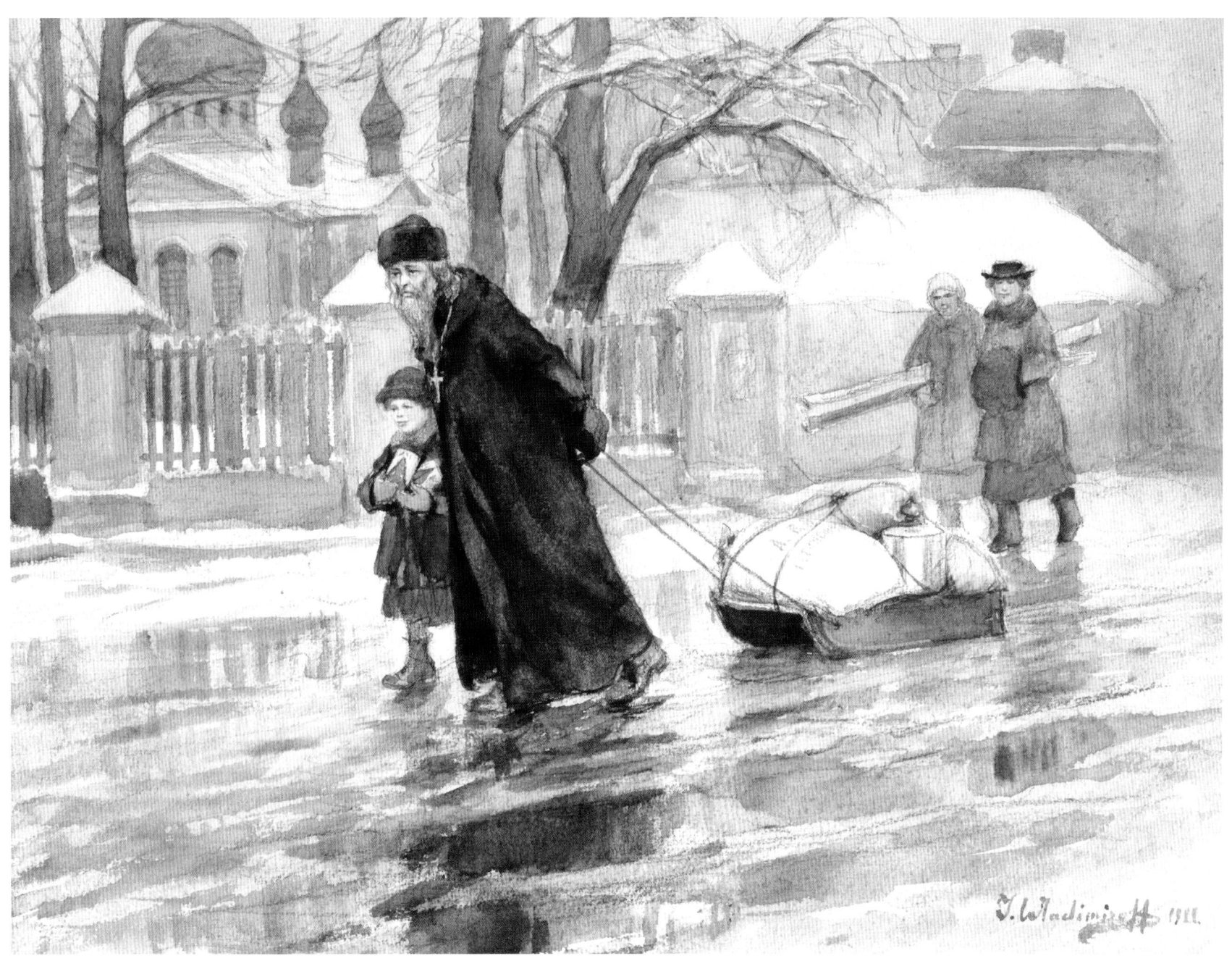

54. A Priest with ARA Provisions (1922)

pencil & watercolour on paper
25 x 33.5cm
Vladimir Ruga Collection

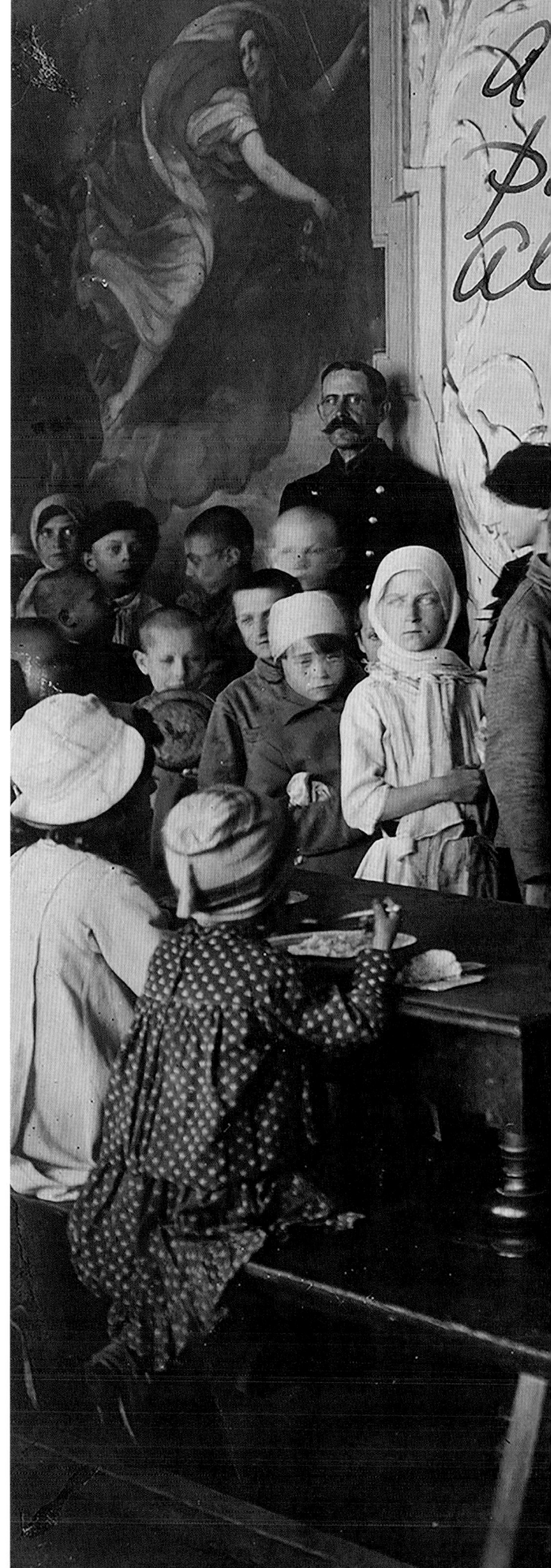

"
A Christmas present from the Americans Coolidge and Golder: a food packet with a very nice letter... grain, rice, sugar, tea, a tub of *salo* and twenty tins of condensed milk.
"

Yuri Gautier
My Notes (26 December 1921)

...eding Station in the one time ...ce of the Grand Duchess Olga ...ndrorska.

ГОЛОДАЮЩИМ РОССИ...

ДАР АМЕРИКАНСКОГО НАРОДА

ARA

Chapter 7

The Bolsheviks and The Church

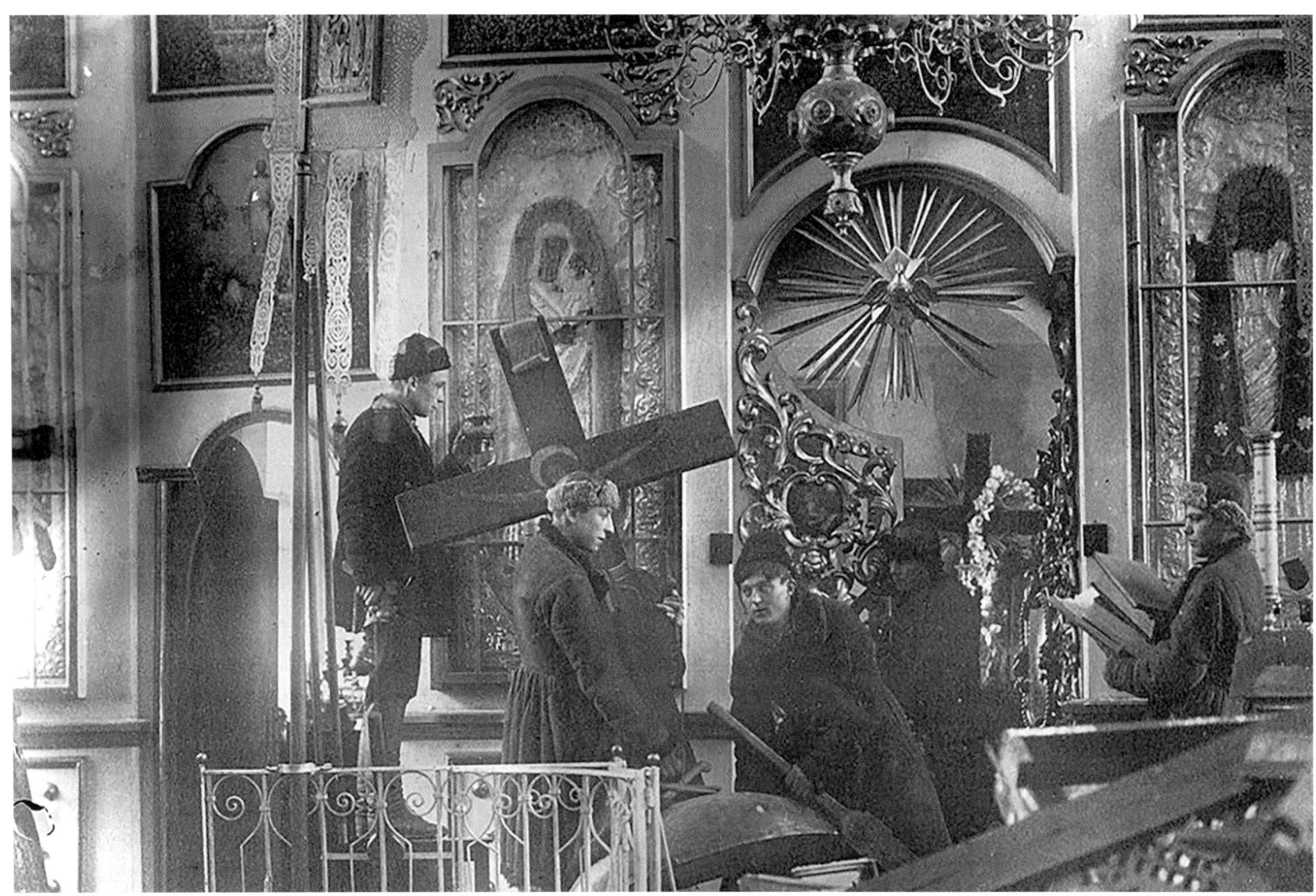

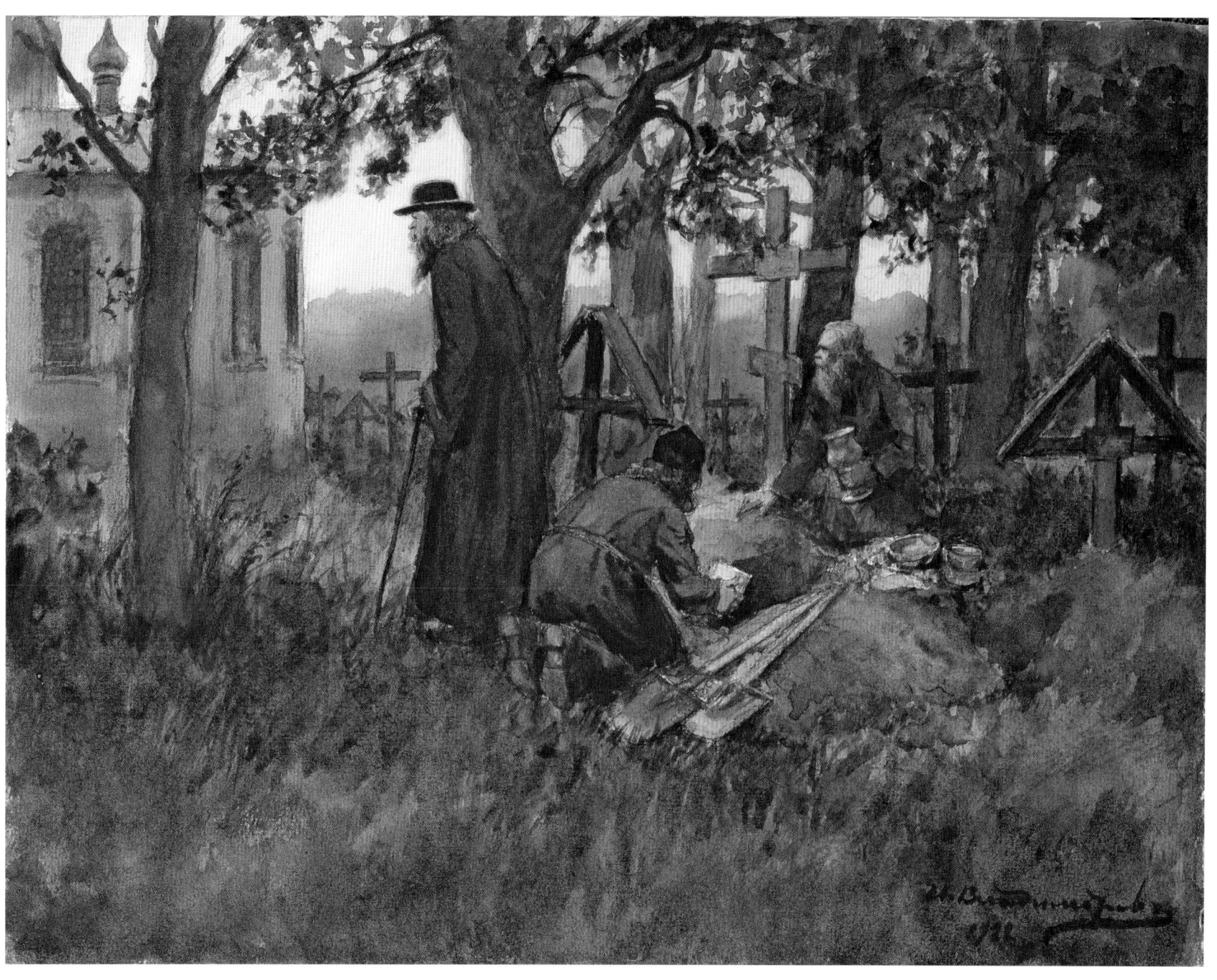

55. Priests Burying Church Valuables in a Cemetery near Luga (1922)

watercolour on paper
25.7 x 34.2cm
Andre Ruzhnikov Collection

artist's inscription on back:

Принудительная очистка конюшен священнослужителями

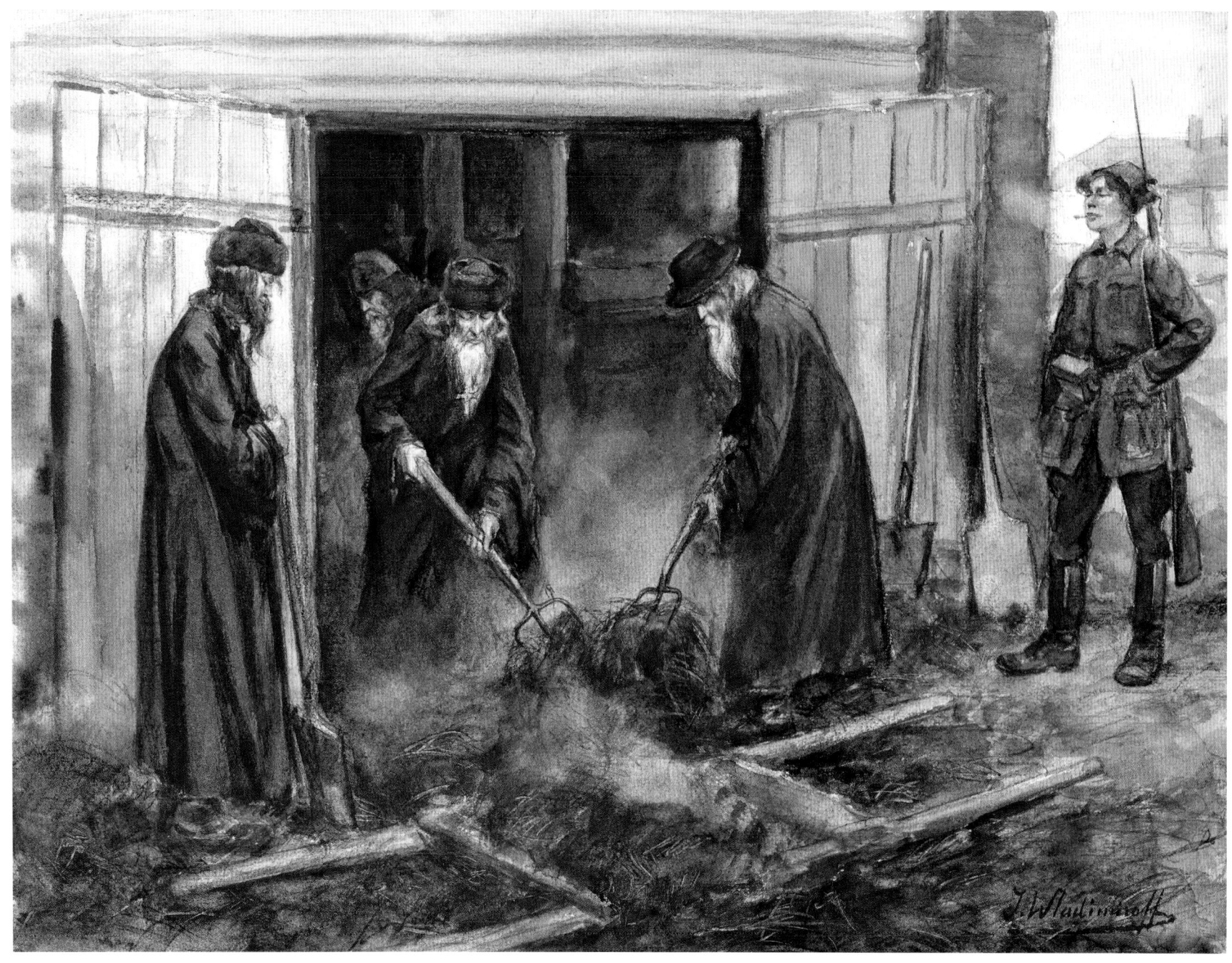

56. Priests Forced to Clean Out the Stables

ink & watercolour on paper
25.7 x 34.5cm
Andre Ruzhnikov Collection

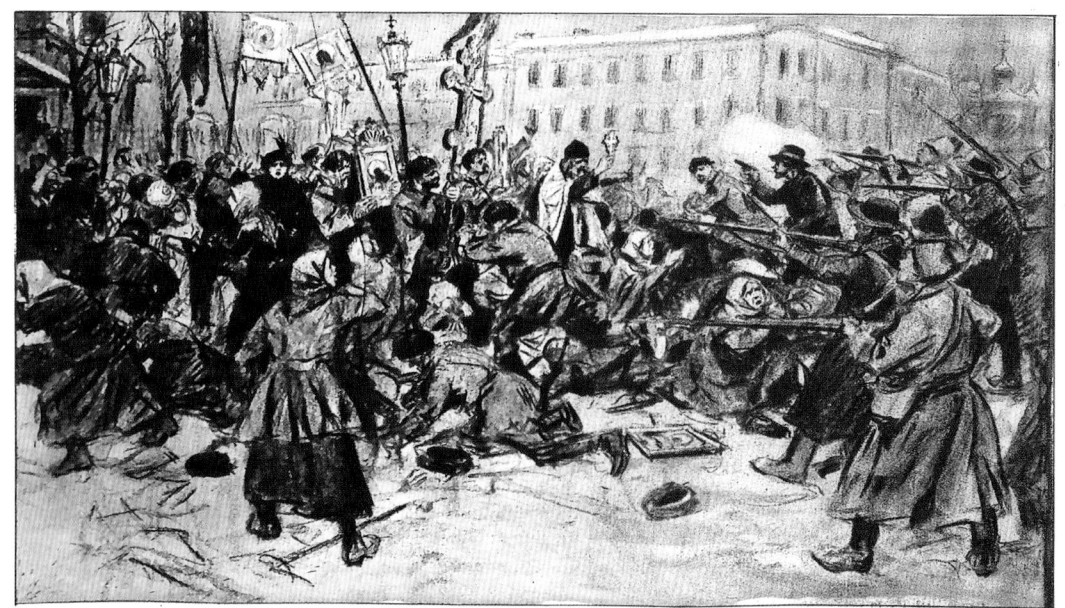

FIRING ON A RELIGIOUS PROCESSION IN THE STREETS OF JOULA : THE RUSSIAN BISHOP CORNELIUS WOUNDED BY THE RED GUARD

**57. Firing on a Religious Procession in Tula: Bishop
Cornelius Wounded by the Red Guard**

published in The Graphic (London), 20 April 1918 (p. 489)

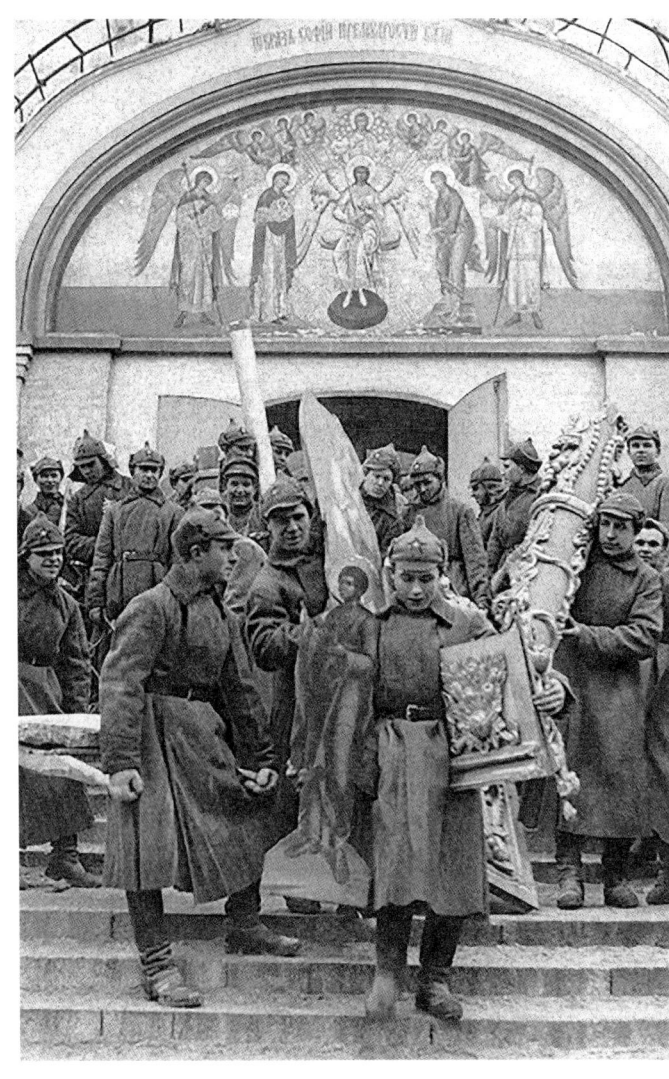

RED ARMY TROOPS REMOVING ICONS & CHURCH
ARTEFACTS FROM SIMONOV MONASTERY (1923)

CONFISCATED MITRES (MOSCOW 1921)

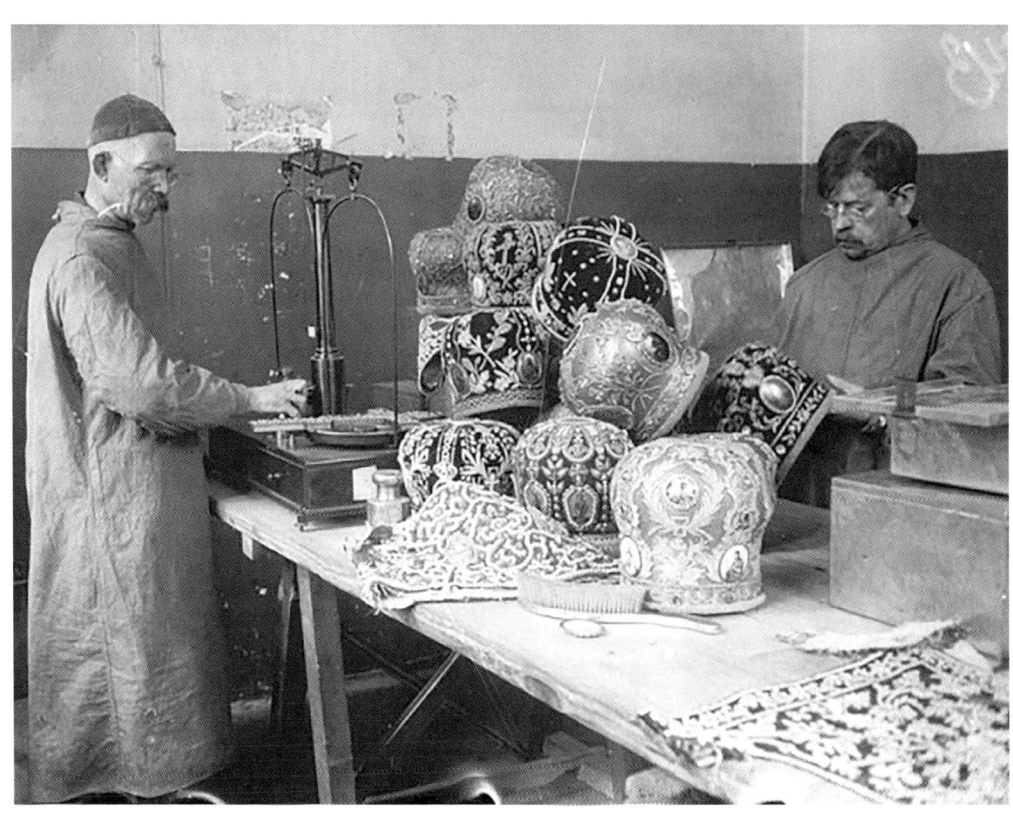

> "The confiscation of valuables, especially those of the wealthiest monasteries and churches, must be carried out with ruthless determination, stopping at nothing, and as quickly as possible. The more members of the reactionary bourgeoisie and the reactionary clergy we manage to shoot while carrying out this task, the better. We need to teach these people such a lesson they won't dare think about resistance for decades."

Lenin
Letter to Molotov (19 March 1922)

Реквизиция церковного имущества в церкви Введения на Пет. Стор.

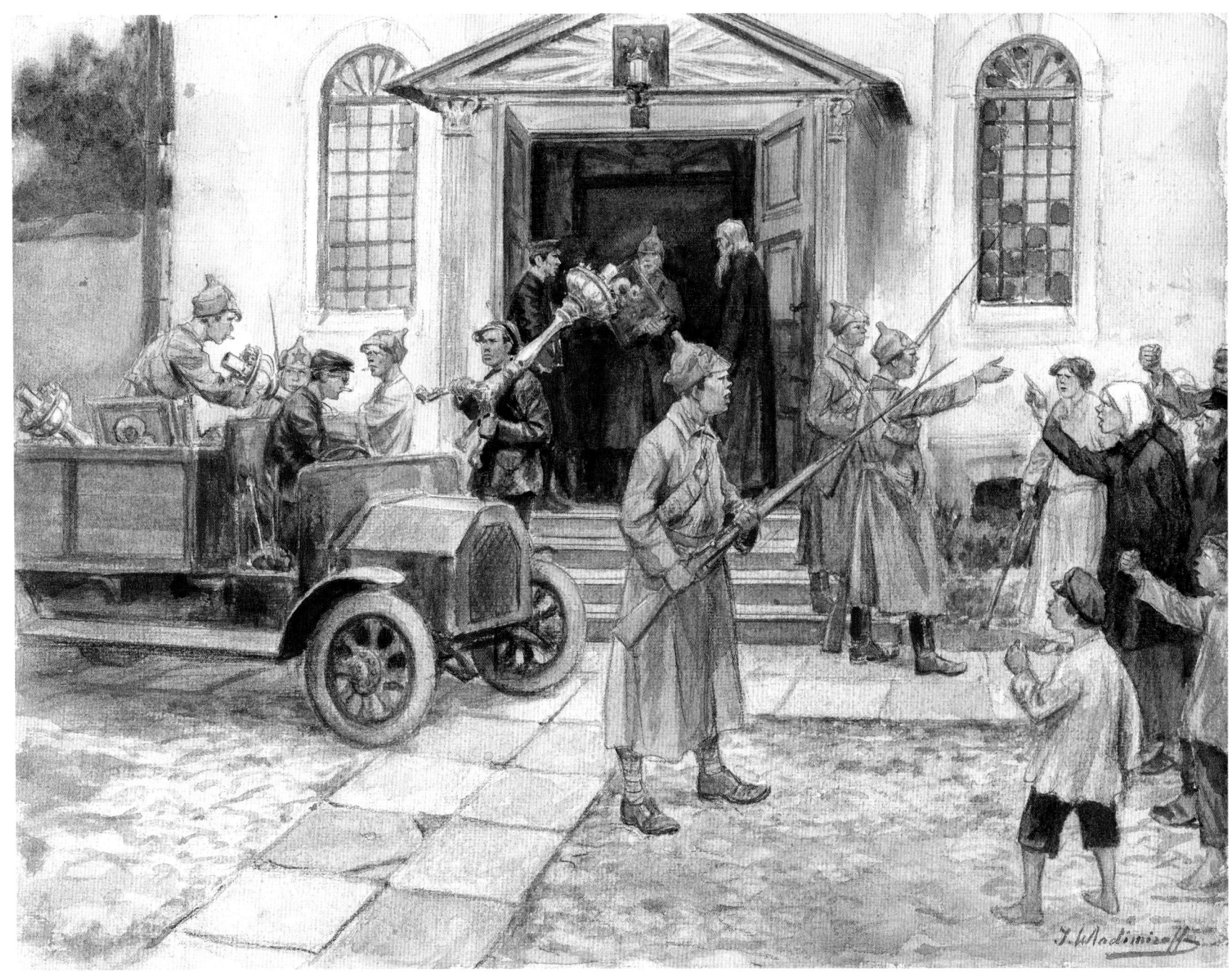

**58. Requisitioning Ecclesiastical Property from
the Church of the Presentation – Petrograd Side**

ink & watercolour on paper
25.7 x 34.2cm
Andre Ruzhnikov Collection

Russian priests conveyed to judgement (1922) (a scene on the Nevsky Prospekt)

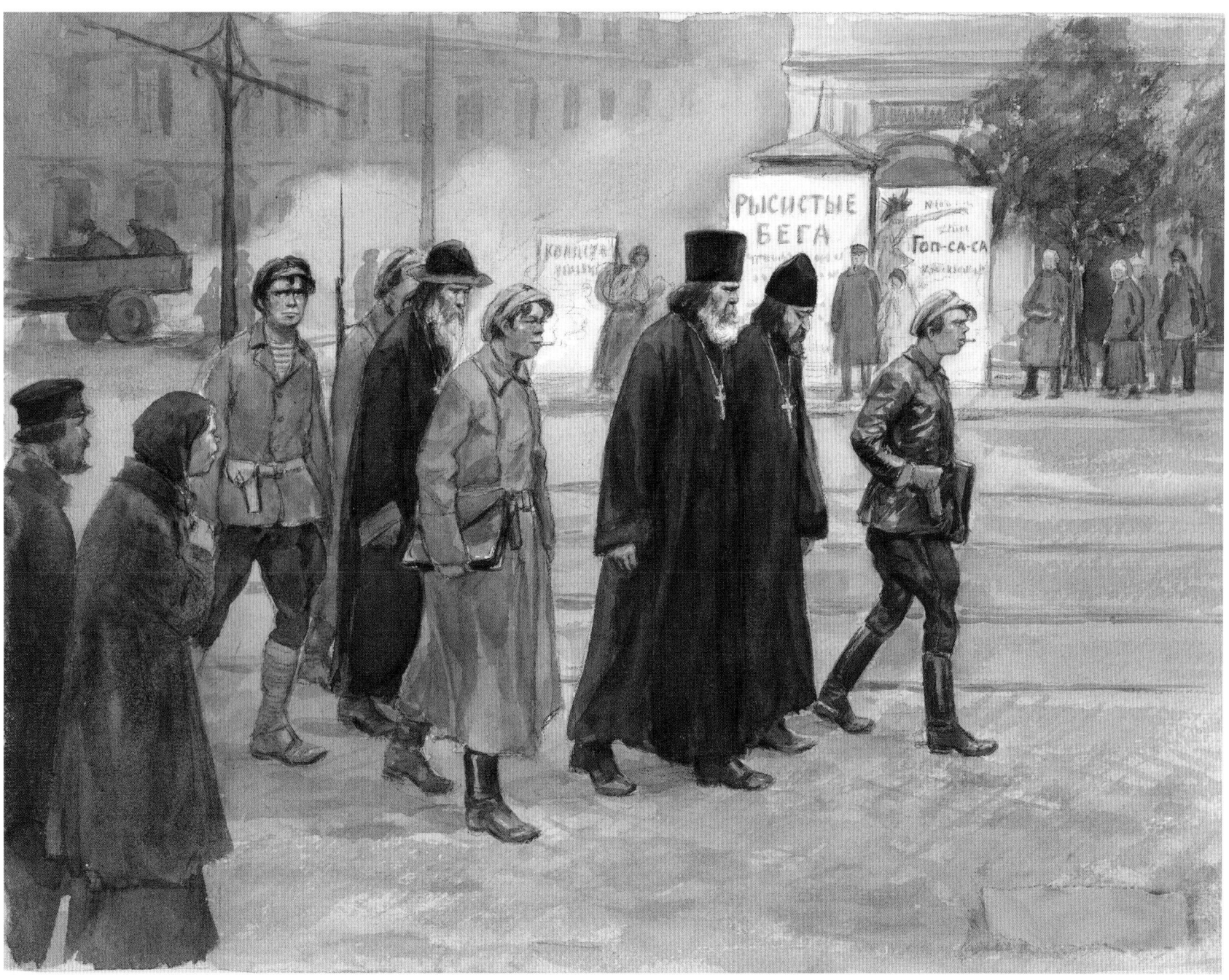

59. Priests Escorted to Trial – Nevsky Prospekt 1922

ink & watercolour on paper
29.2 x 39.4cm
Hoover Institution Library & Archives

"

We succeeded in opposing the religious aspirations of the priests with the needs of the working population. We need to confiscate church valuables, sell them and buy bread. Feelings of hunger and the interests of hunger run counter to the priests' religious aspirations. This was a clever way of putting the question. People did not go against the priests for theoretical reasons, but because of hunger, poor harvests and crop failures. Give us church valuables and we will feed the people. Not even the most profound believer can find anything to say against that.

"

Stalin
Speech at a meeting with correspondents (4 December 1928)

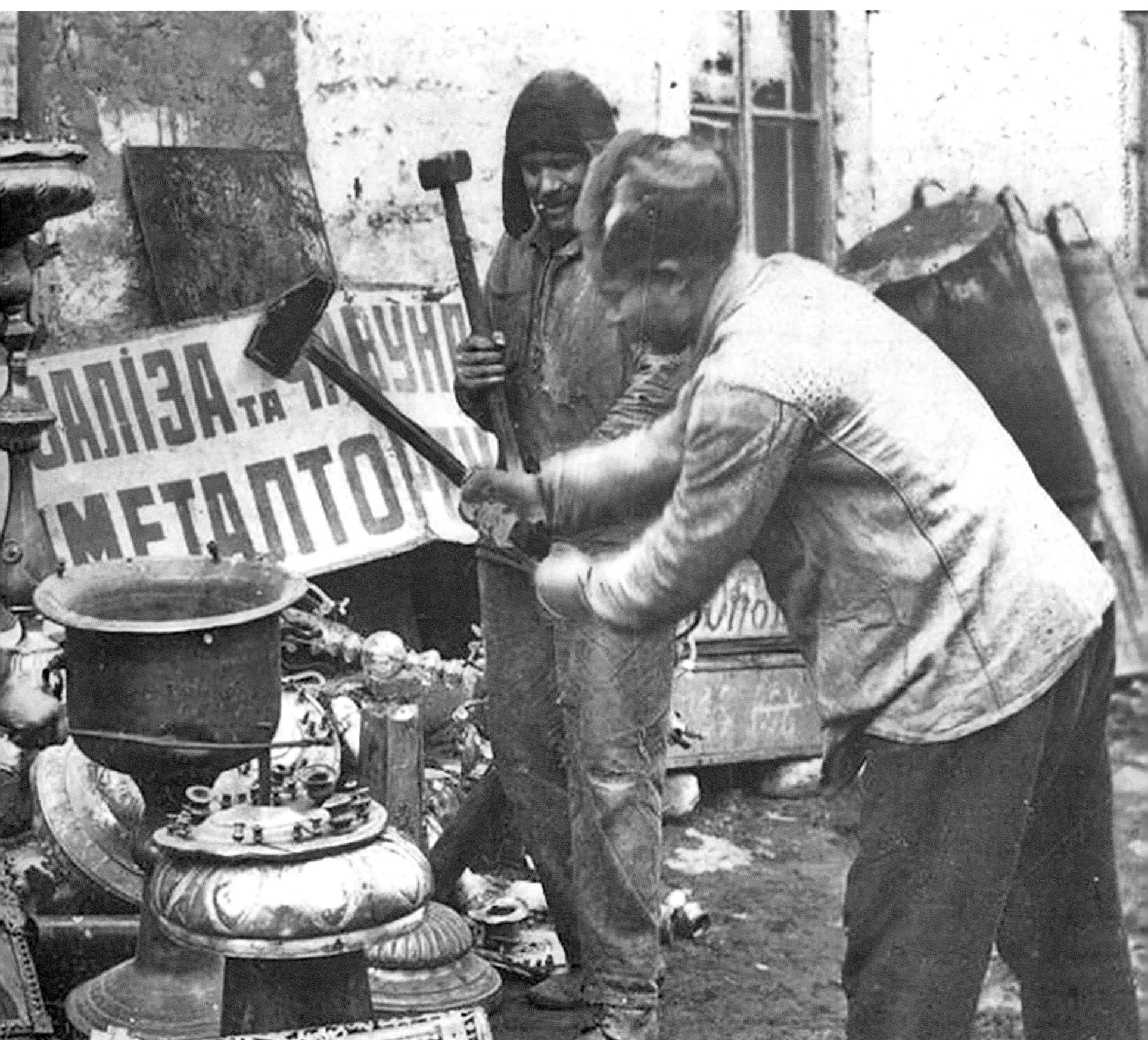

Chapter 8

Requisitioning in the Countryside

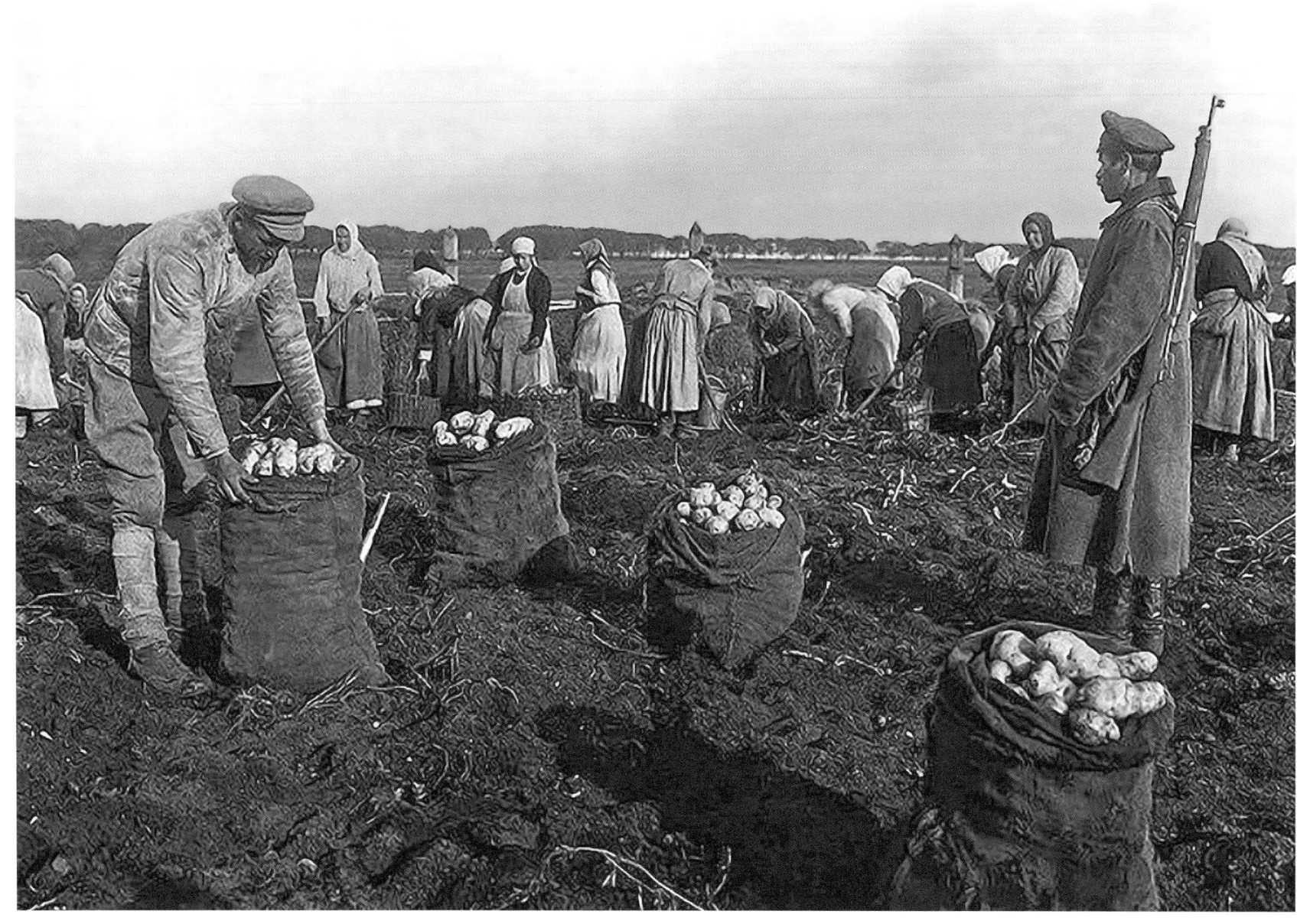

"

Conduct a merciless, terrorist struggle and war on peasants and other members of the bourgeoisie who hold on to surplus bread. Specify that bread-owners having excess bread, but failing to take it to the grain stations or collection-points, shall be declared enemies of the people and imprisoned for at least ten years, with all their property confiscated, and permanently excluded from their community.

"

Lenin
Basic Provisions of Decree on Food Dictatorship, 8 May 1918

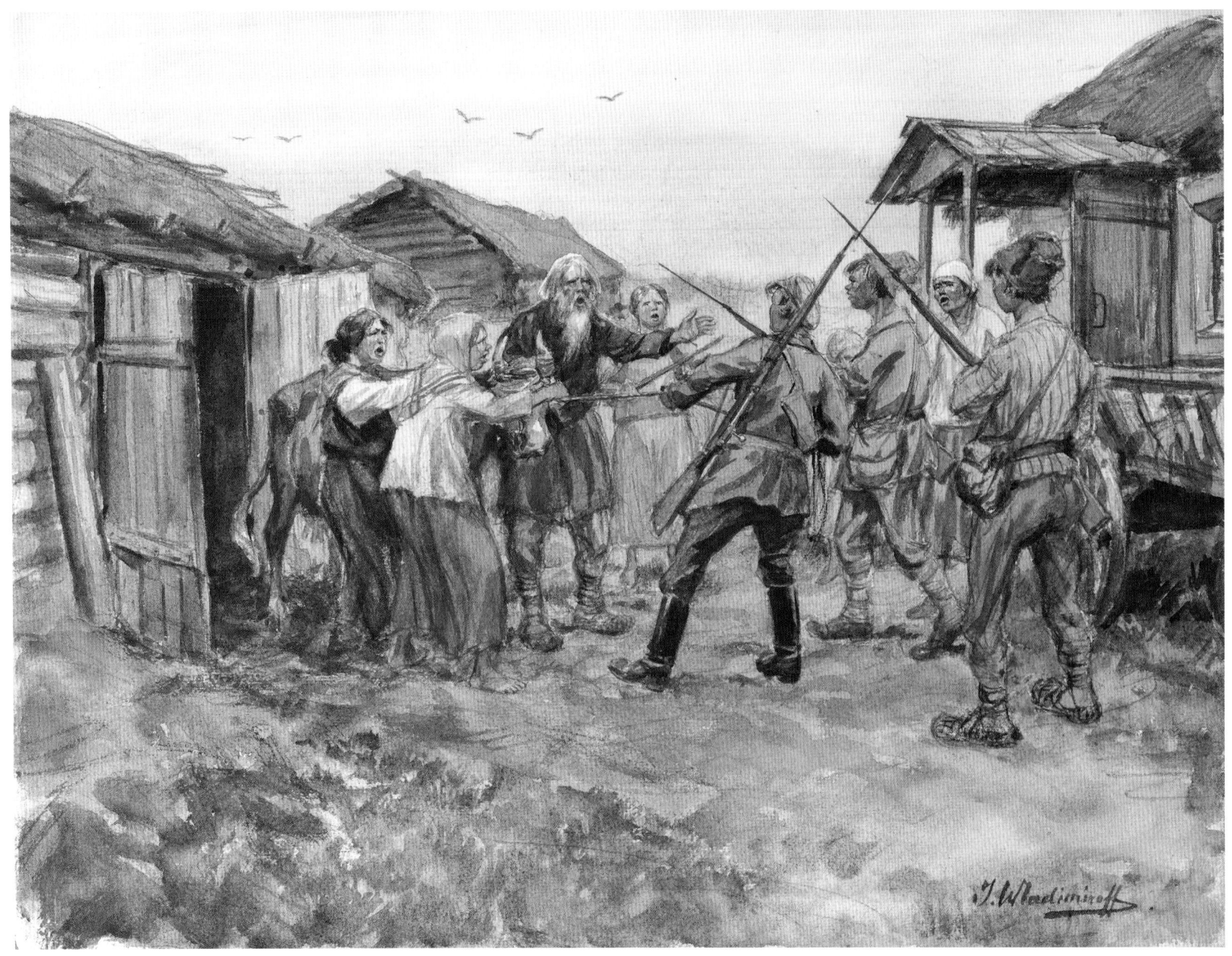

60. Requisitioning the Peasant's Last Cow – 1919
pencil & watercolour on paper
25.5 x 34.5cm
Andre Ruzhnikov Collection

Requisition of flour from rich peasants in a village (a scene near Pskoff) 1922.

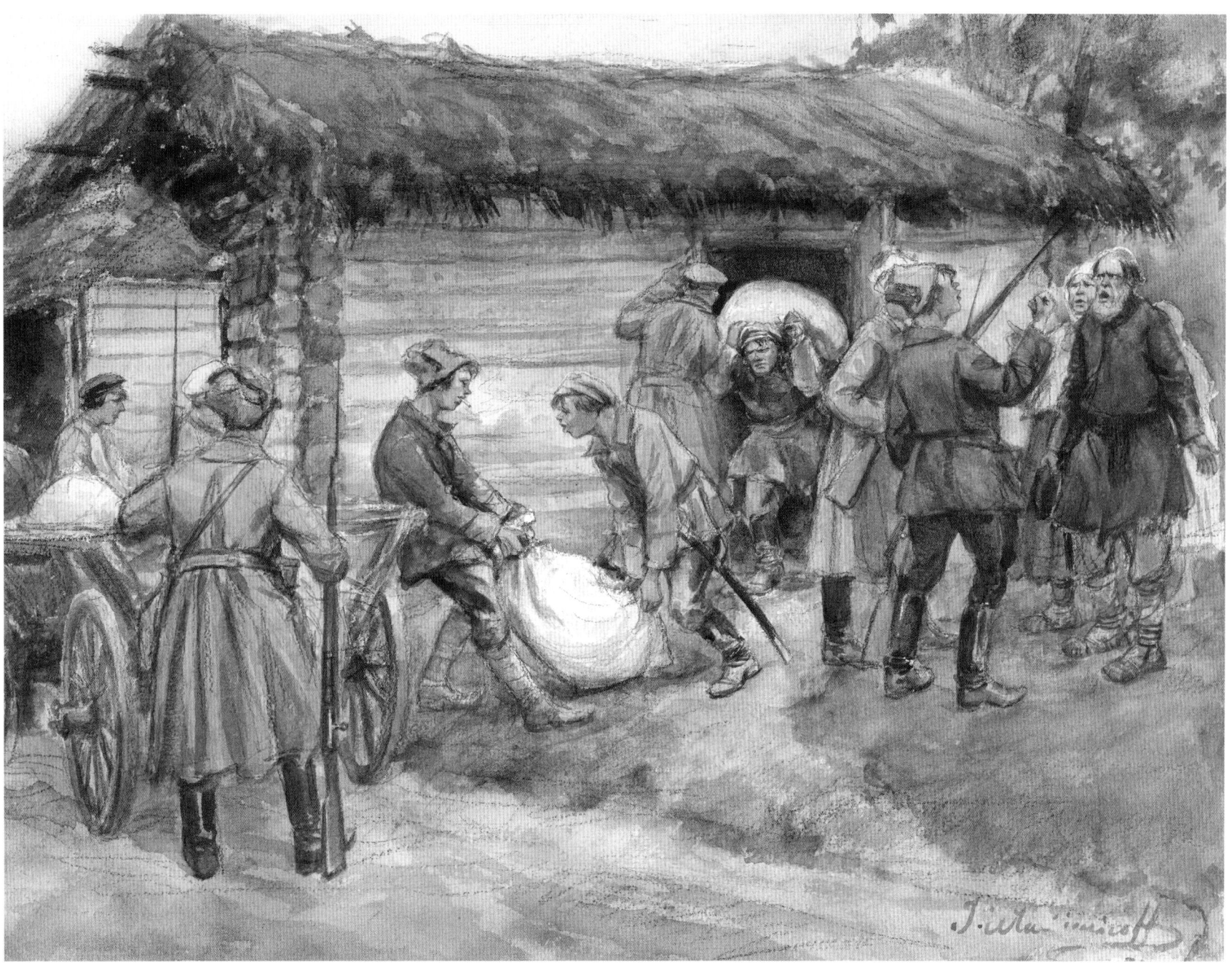

**61. Requisitioning Flour from Wealthy Peasants
in a Village near Pskov – 1922**

pencil & watercolour on paper
29.2 x 39.4cm
Hoover Institution Library & Archives

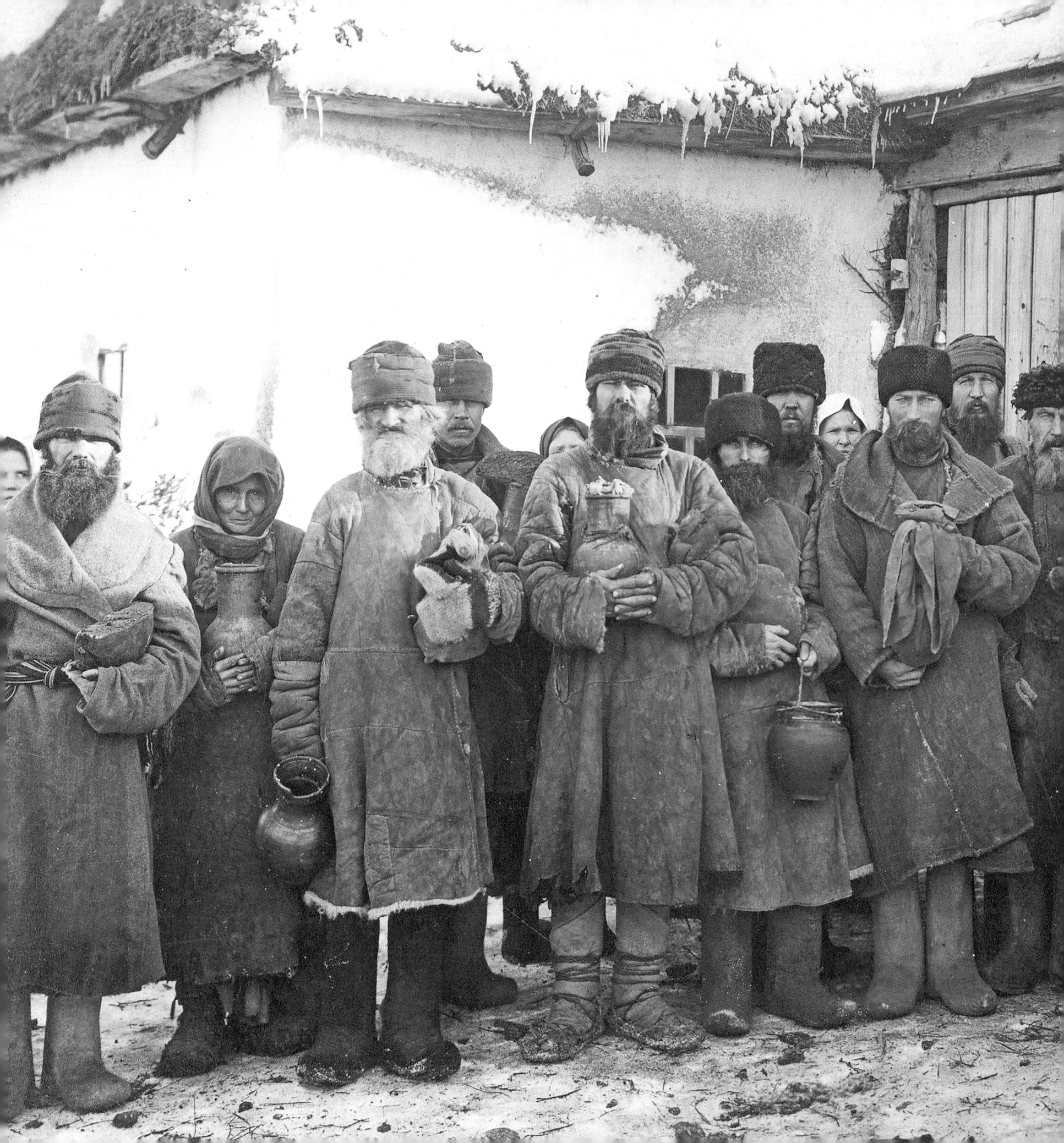

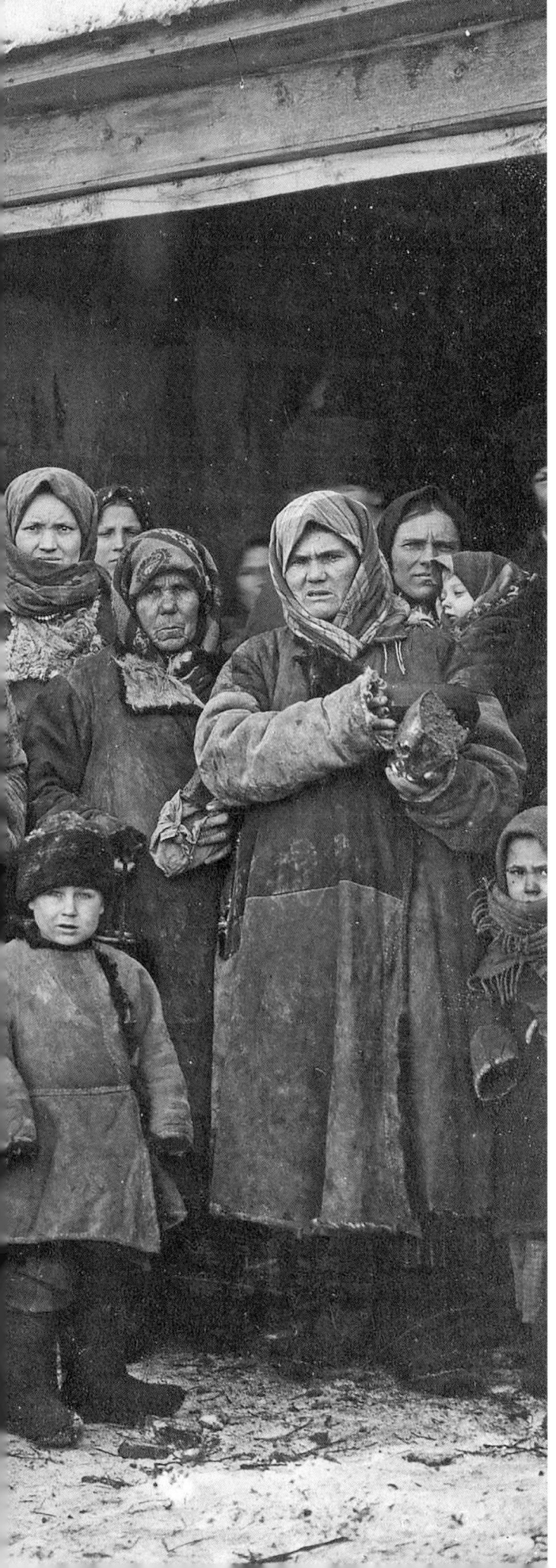

> "
>
> Peasants are far from understanding that freely trading in bread is a crime against the State. 'I made the bread, it's my own produce and I have the right to sell it' says the peasant, out of age-old habit. But we say: This is a crime against the State.
>
> "

Lenin
Speech to First All-Russian Conference on Party Work in the Village (18 November 1919)9 г.

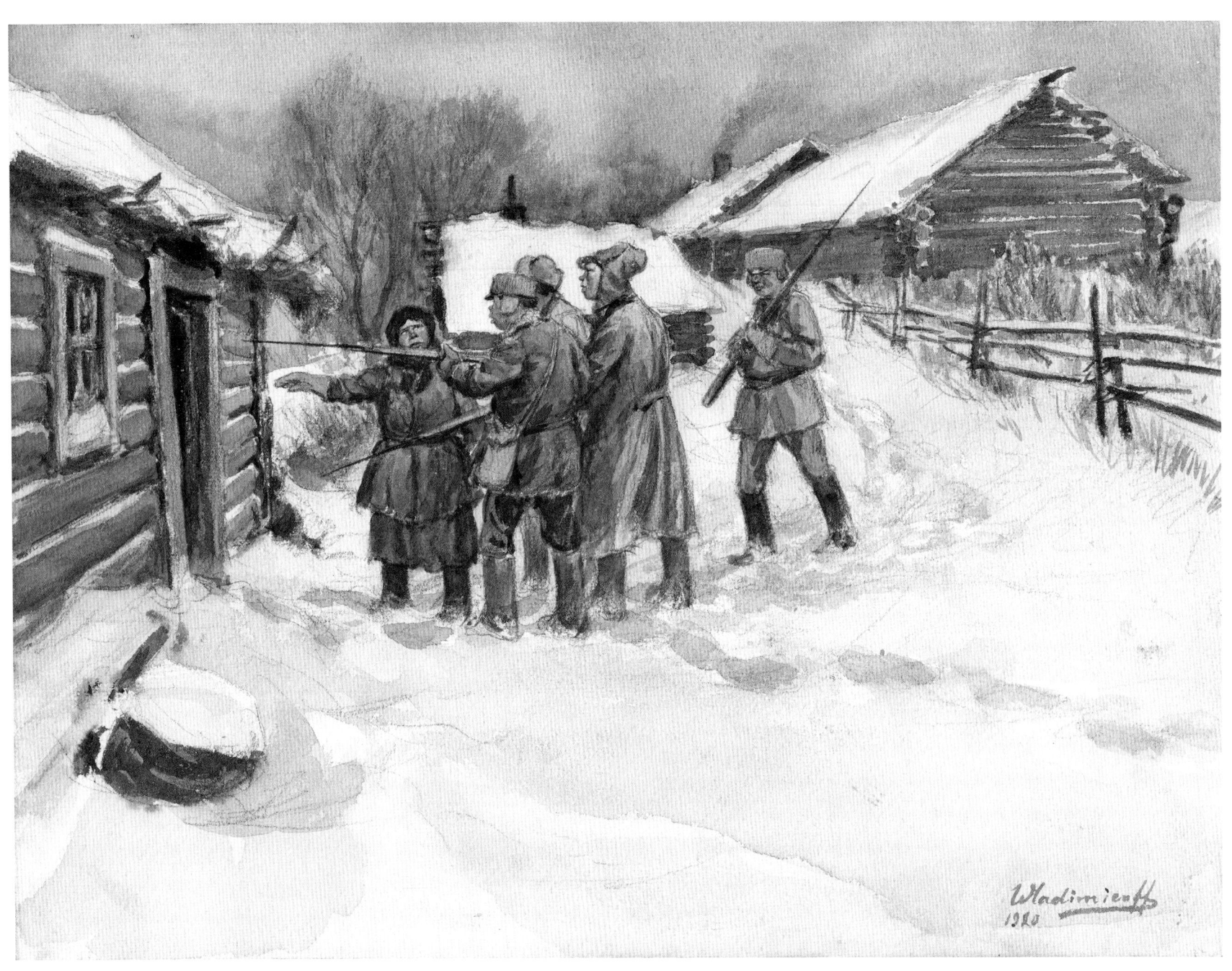

62. Looking for Deserters (1920)

25,6 x 34,3 см
ink, pencil & watercolour on paper
25.6 x 34.3cm
Anne S.K. Brown Military Collection – Brown University Library

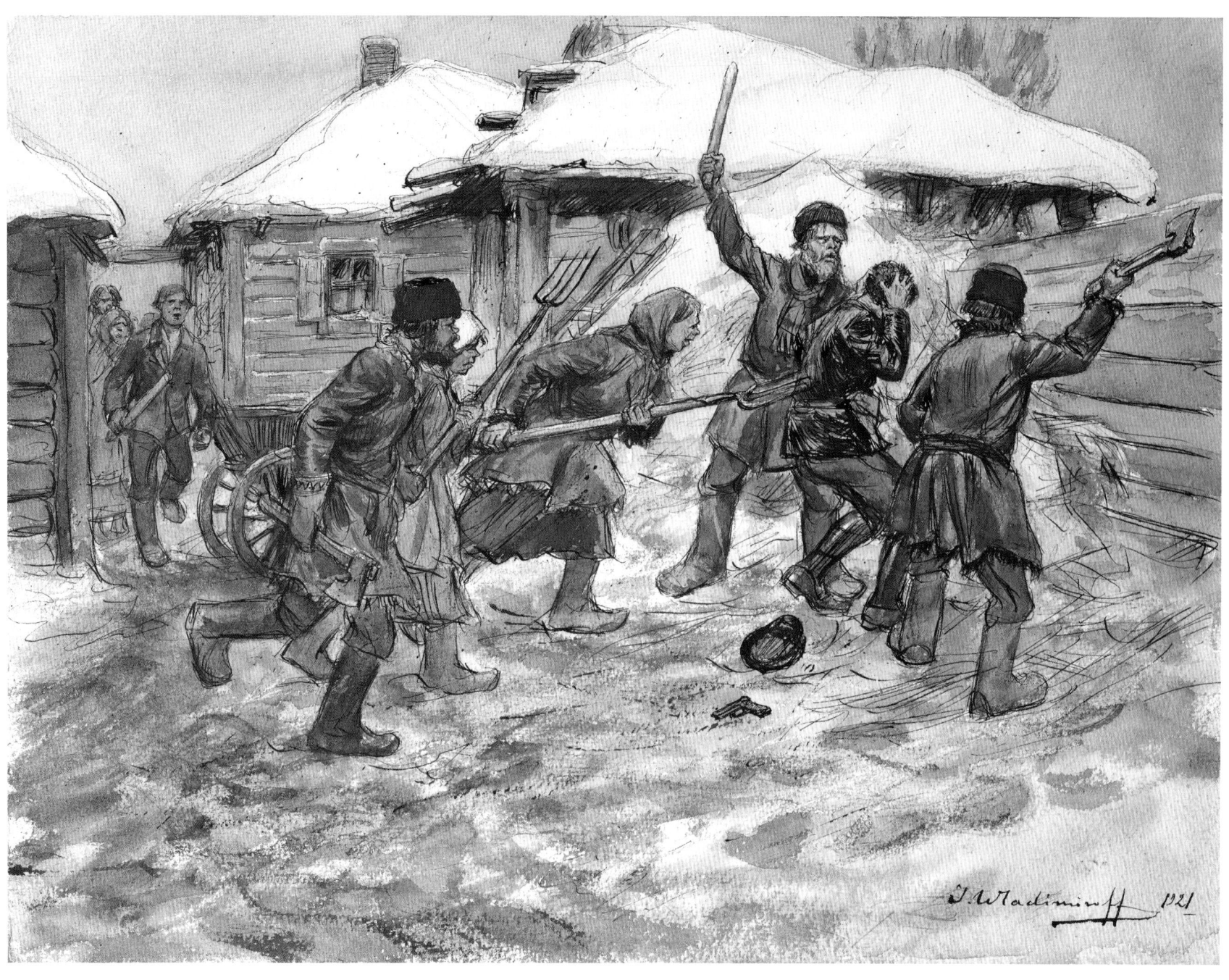

63. Peasants Reprisals on a Bolshevik (1921)

ink & watercolour on paper
25.3 x 33.8cm
Andre Ruzhnikov Collection

DEKULAKIZATION IN THE VILLAGE OF UDACHNOYE (DONETSK REGION)

"

Fighting broke out in one of the villages near Ryazan between peasants and soldiers who had come to requisition bread. Several people were killed. The peasants rushed into the town, disarmed the local police, seized all their weapons and put the soldiers to flight.

"

Novaya Zhizn ('New Life')
16 February 1918 (no 26)

Chapter 9

'Former People'

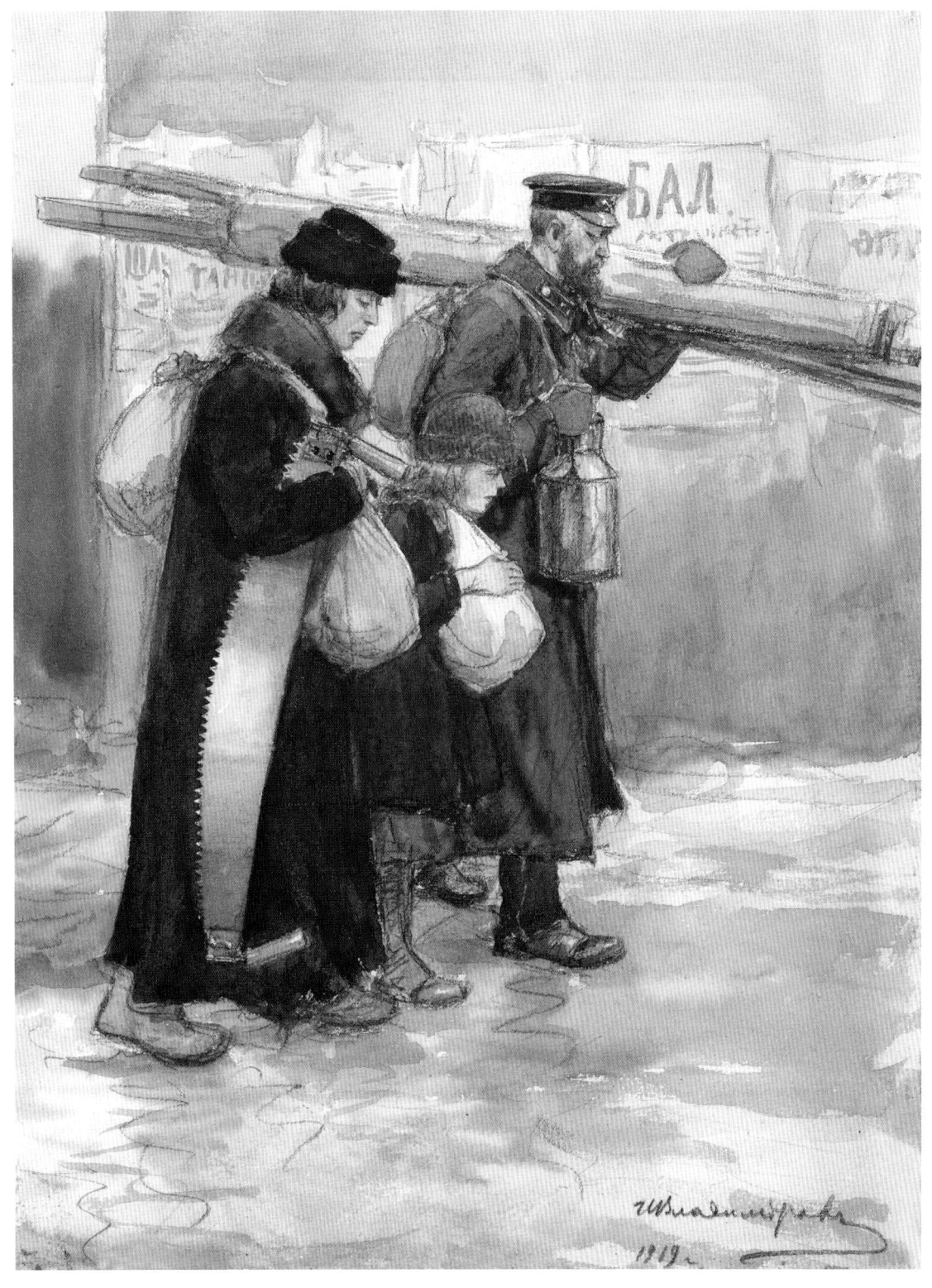

64. An Engineer's Family with their Remaining Possessions (1919)

pencil & watercolour on paper
34 x 25.7cm
Andre Ruzhnikov Collection

Miserable life of russian nobles and persons of high rank during the revolution (drawn from nature in the home of general Buturline) 1919 —

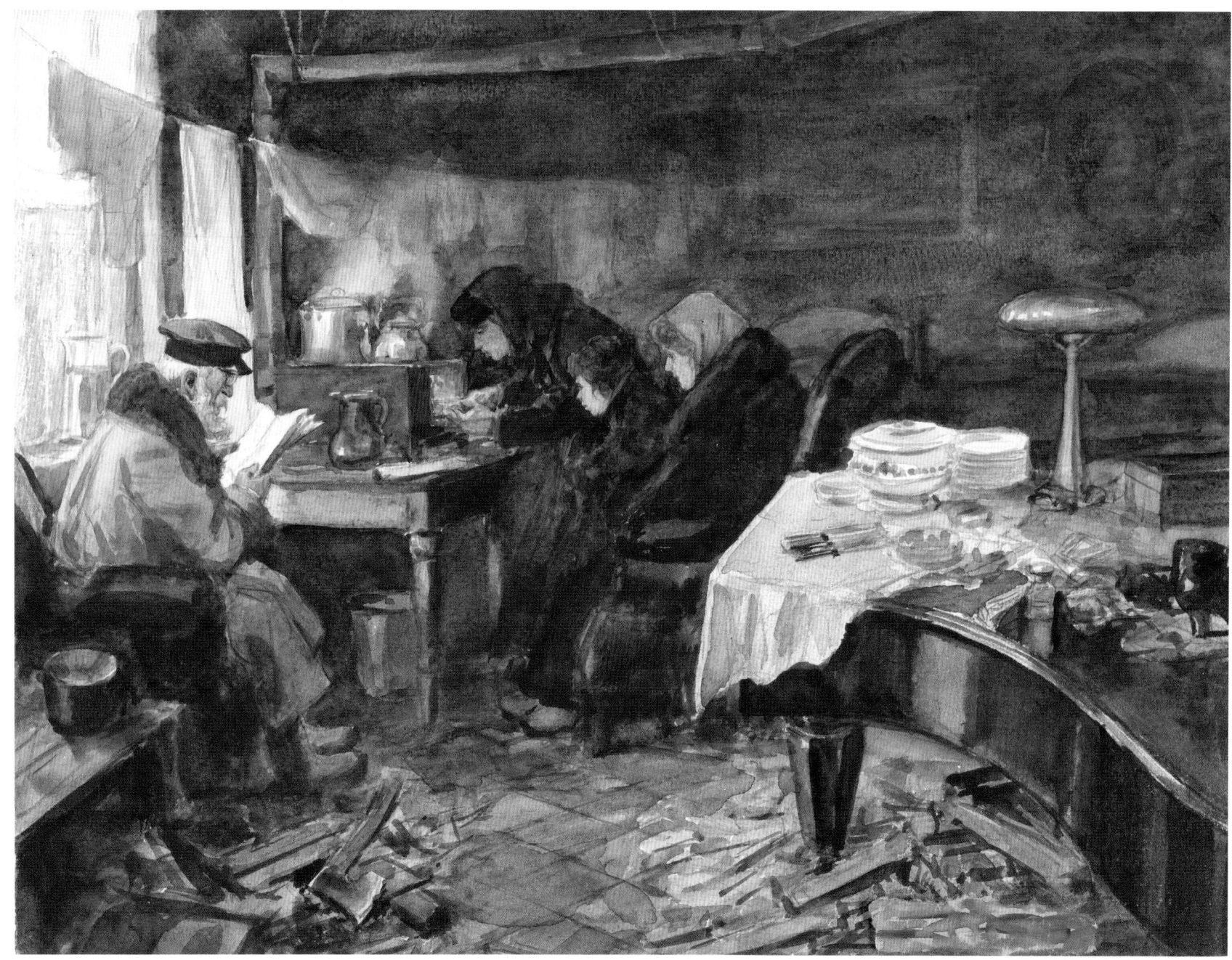

**65. Miserable Life of Russian Nobles & Persons of High Rank – drawn
from nature in the Home of General Buturlin – 1919**

pencil & watercolour on paper
29.2 x 39.4cm
Hoover Institution Library & Archives

A distinguished general (Prince Vasiltchikoff) in his present position.
(June 1922. Petrograd)

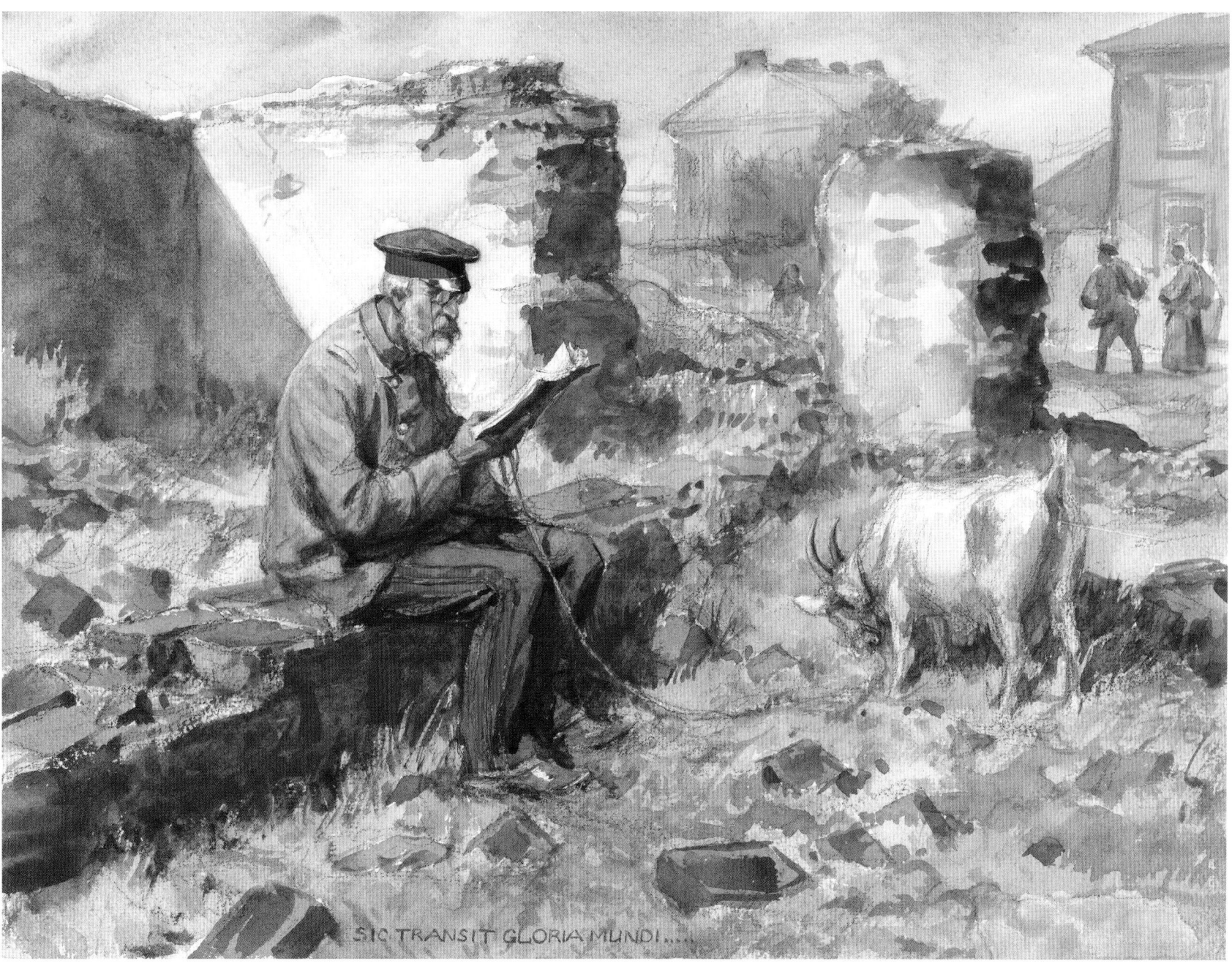

**66. Sic Transit Gloria Mundi: A Distinguished General
(Prince Vasilchikov) in his Present Position – Petrograd June 1922**

pencil & watercolour on paper
29.2 x 39.4cm
Hoover Institution Library & Archives

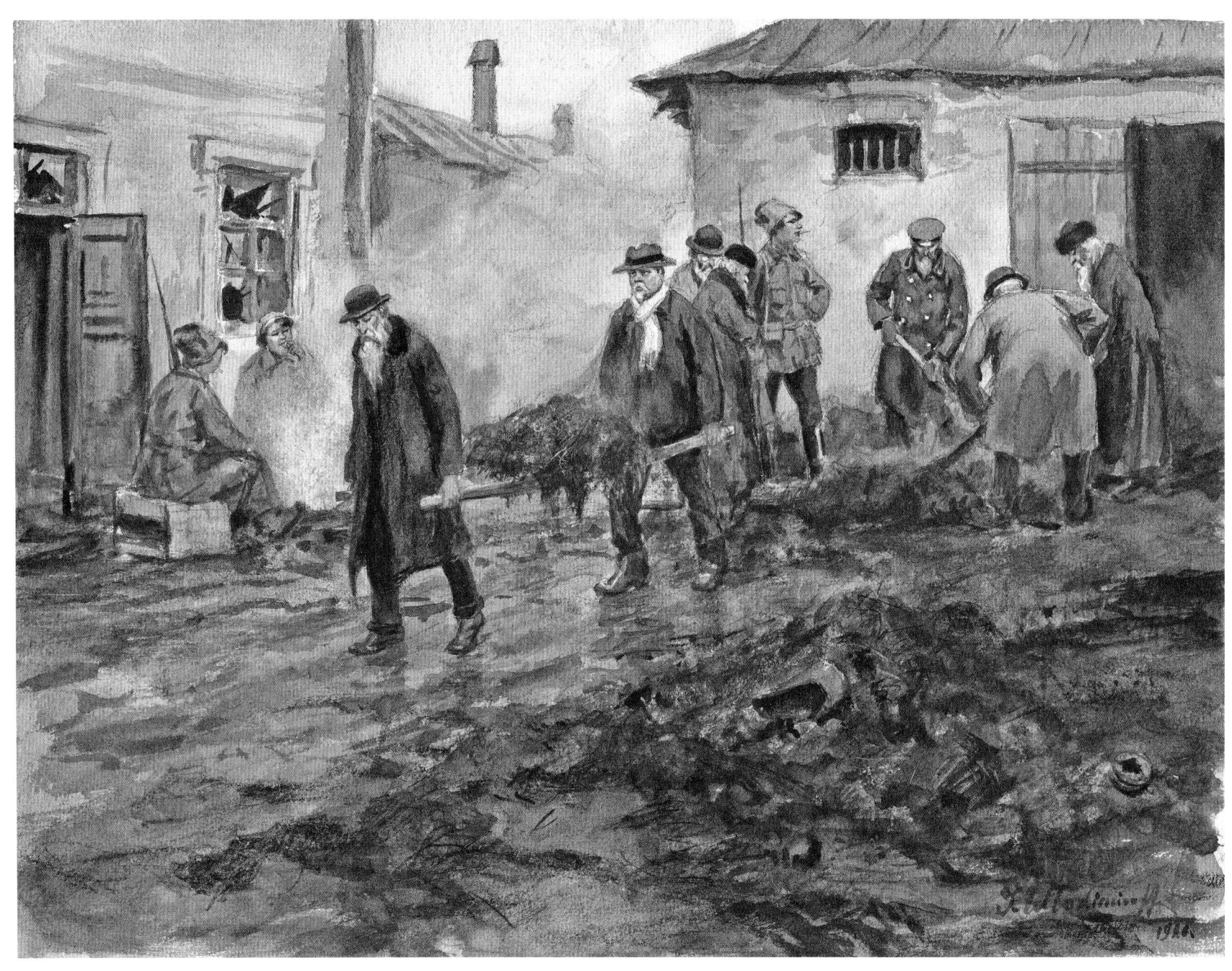

67. Forced Labour for the Bourgeois (1920)

pencil & watercolour on paper
25.8 x 34.4cm
Anne S.K. Brown Military Collection – Brown University Library

hard-labour for rich merchants, nobles and criminals during the years of revolution (1919-1922.)

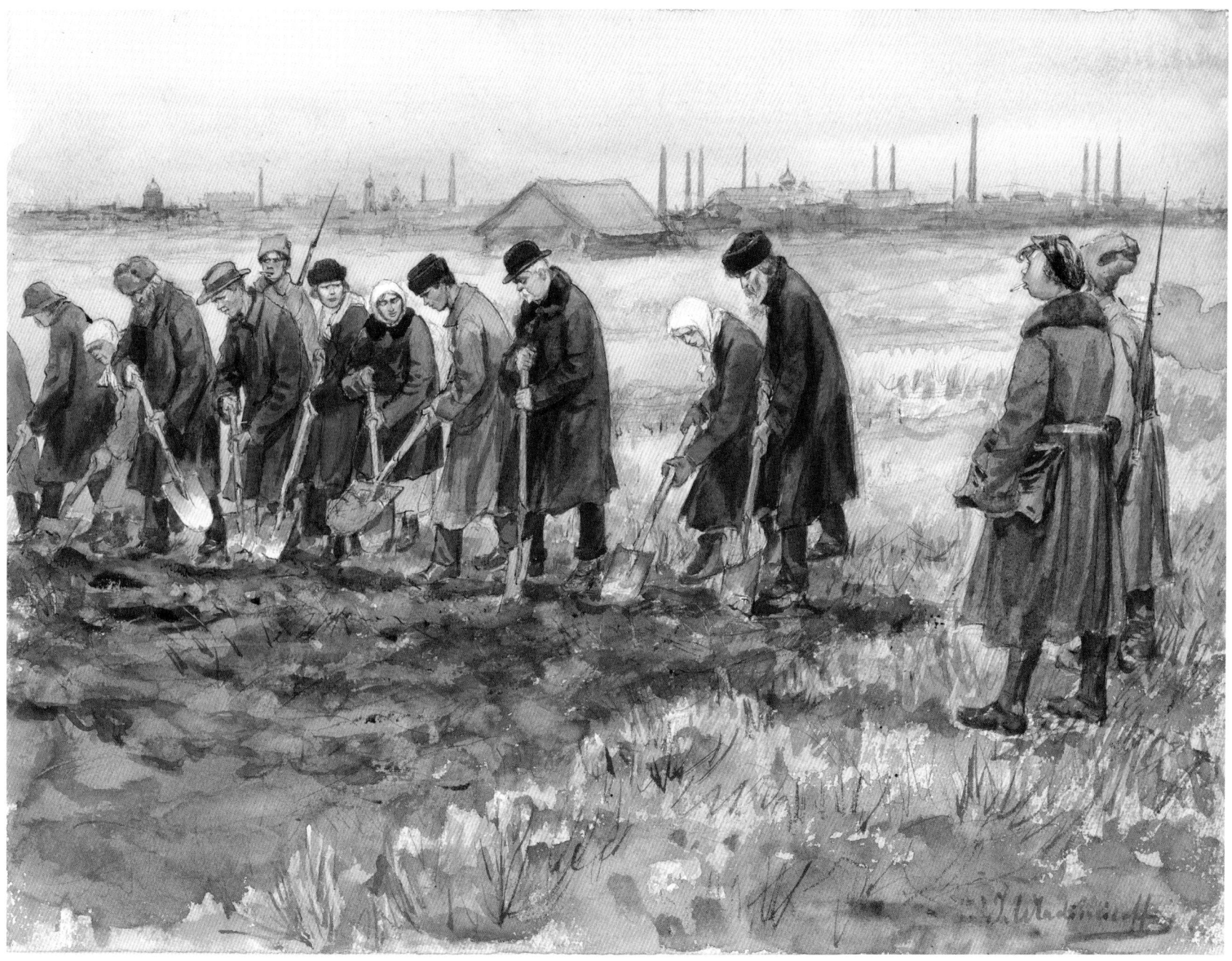

**68. Forced Labour for Wealthy Merchants, Noblemen & Criminals
during the Revolutionary Years of 1919-22**

ink & watercolour on paper
29.2 x 39.4cm
Hoover Institution Library & Archives

"

No mercy for the enemies of the people, the enemies of socialism, the enemies of the working-class! War to the death against the rich and their hangers-on, the bourgeois intellectuals... they must be dealt with, whatever the offence. In one place they will be sent to prison. In another they will be made to clean the toilets. In a third they will be given 'yellow tickets' after serving their time. In a fourth... they will be shot on the spot. The more variety the better!

"

Lenin
How To Organize Competition?

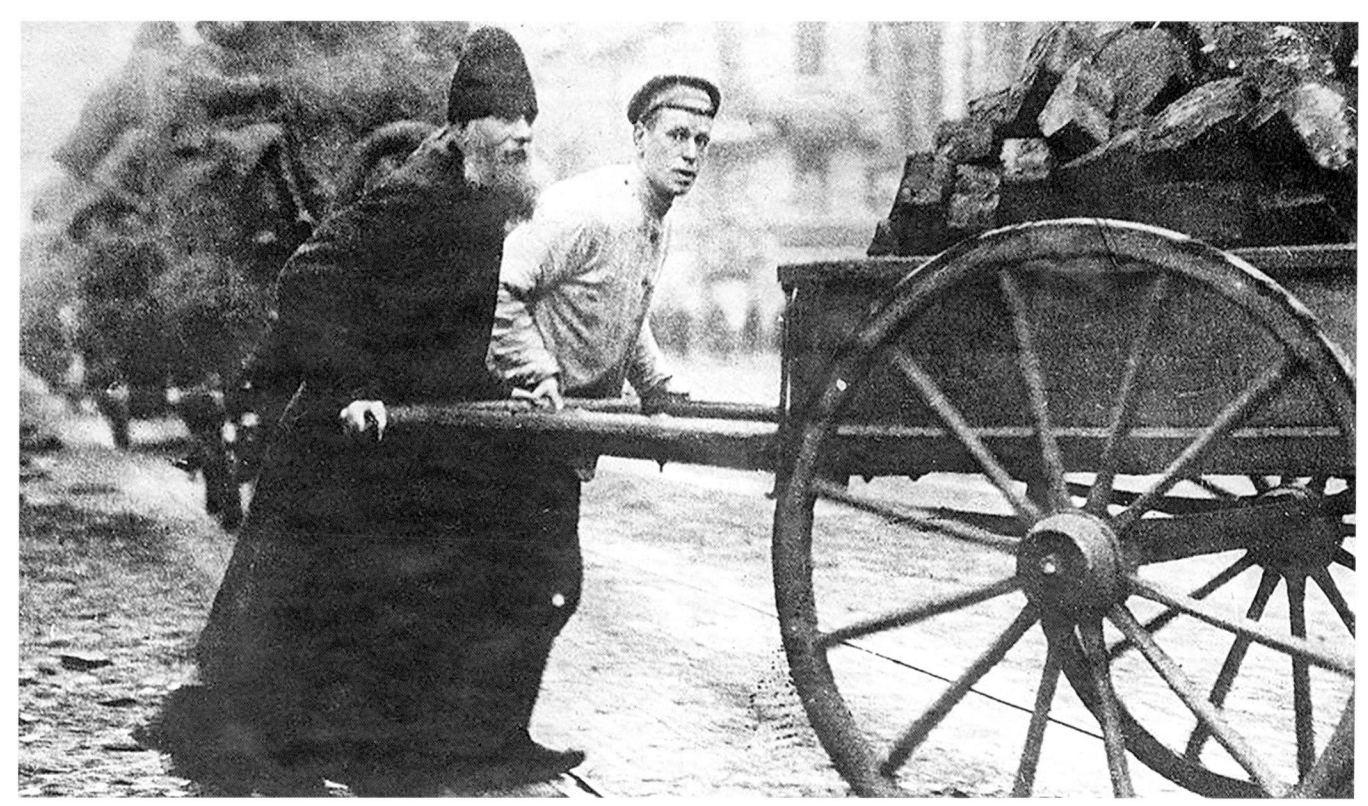

DELIVERING FIREWOOD (1918)

Rich merchants and russian noble-men to pull out rubbish from the yards. —
(1920)

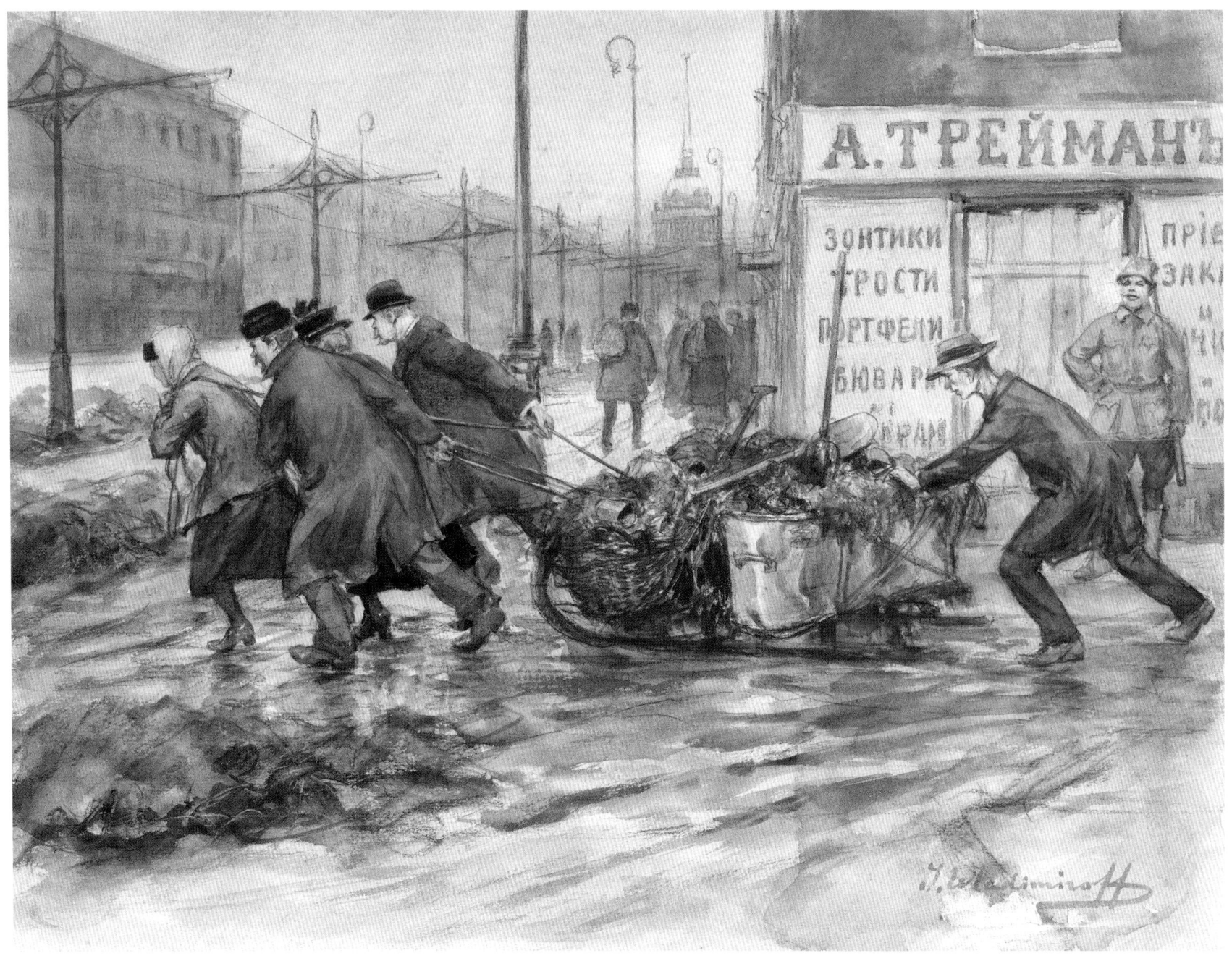

69. Wealthy Merchants & Noblemen Shifting Rubbish – 1920

pencil & watercolour on paper
29.2 x 39.4cm
Hoover Institution Library & Archives

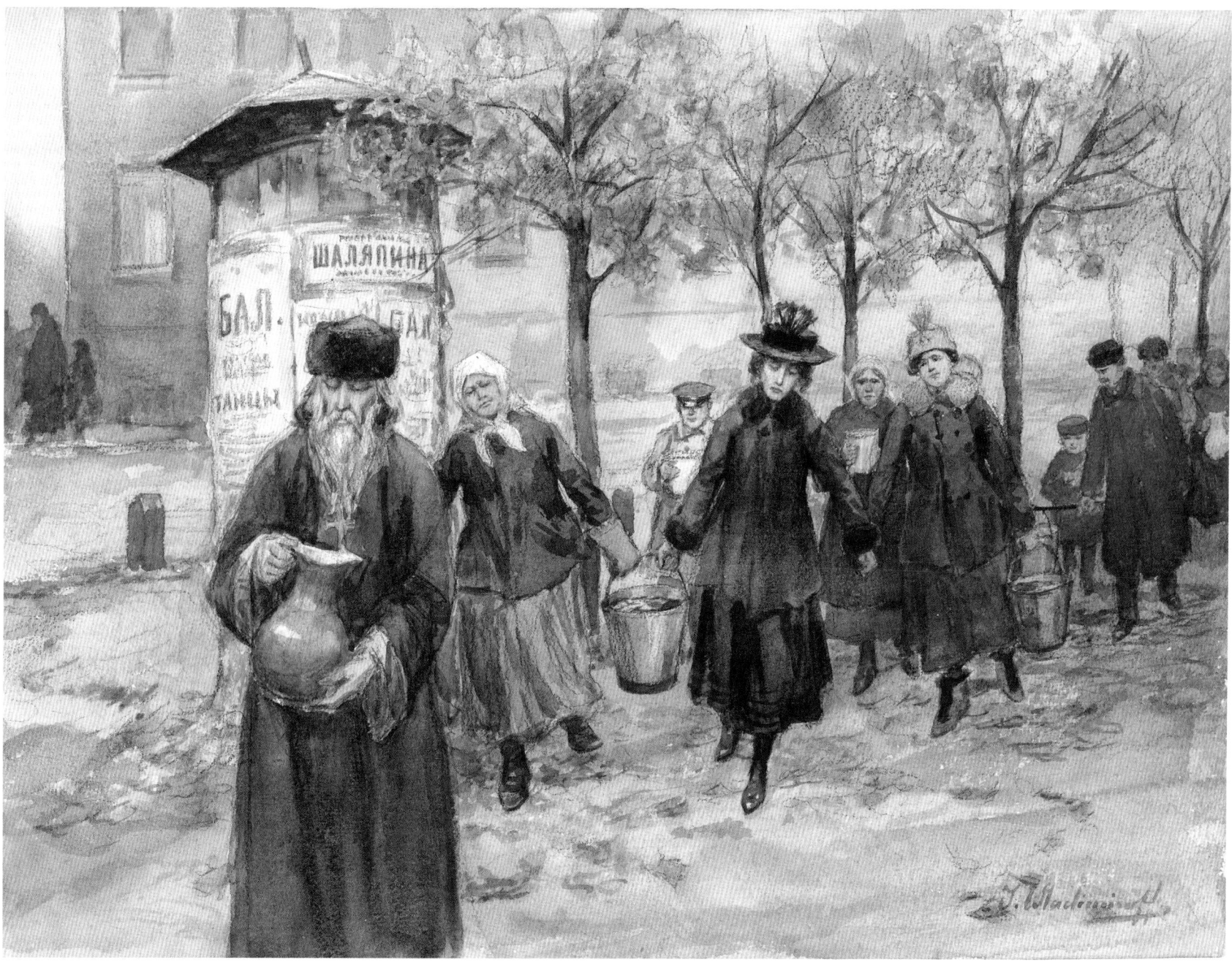

**70. Petrograd Inhabitants Obliged to Carry Water from the Neva –
October 1919**

pencil & watercolour on paper
29.2 x 39.4cm
Hoover Institution Library & Archives

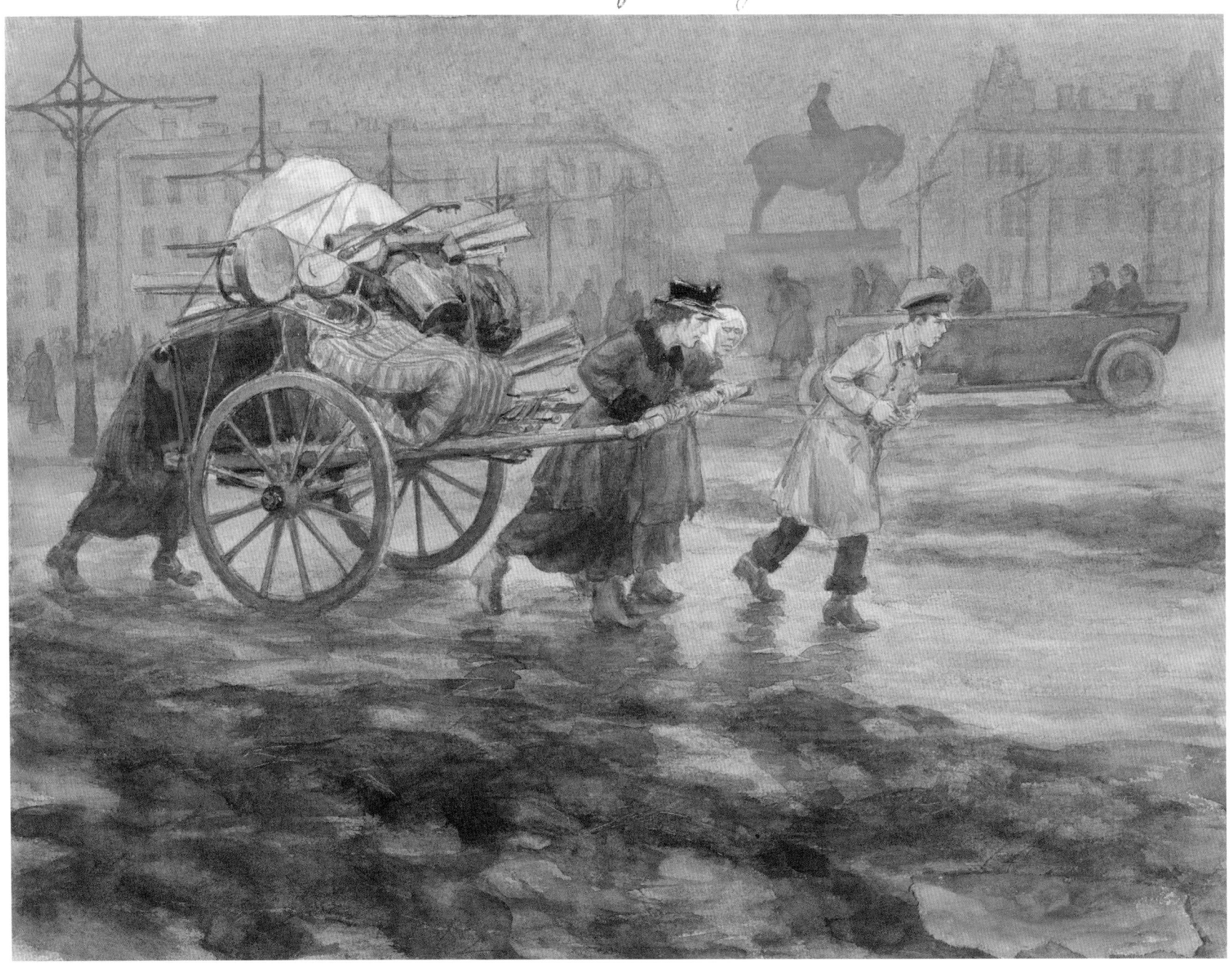

71. Moving Out – Remains of a Wealthy Home – 1919

ink & watercolour on paper
29.2 x 39.4cm
Hoover Institution Library & Archives

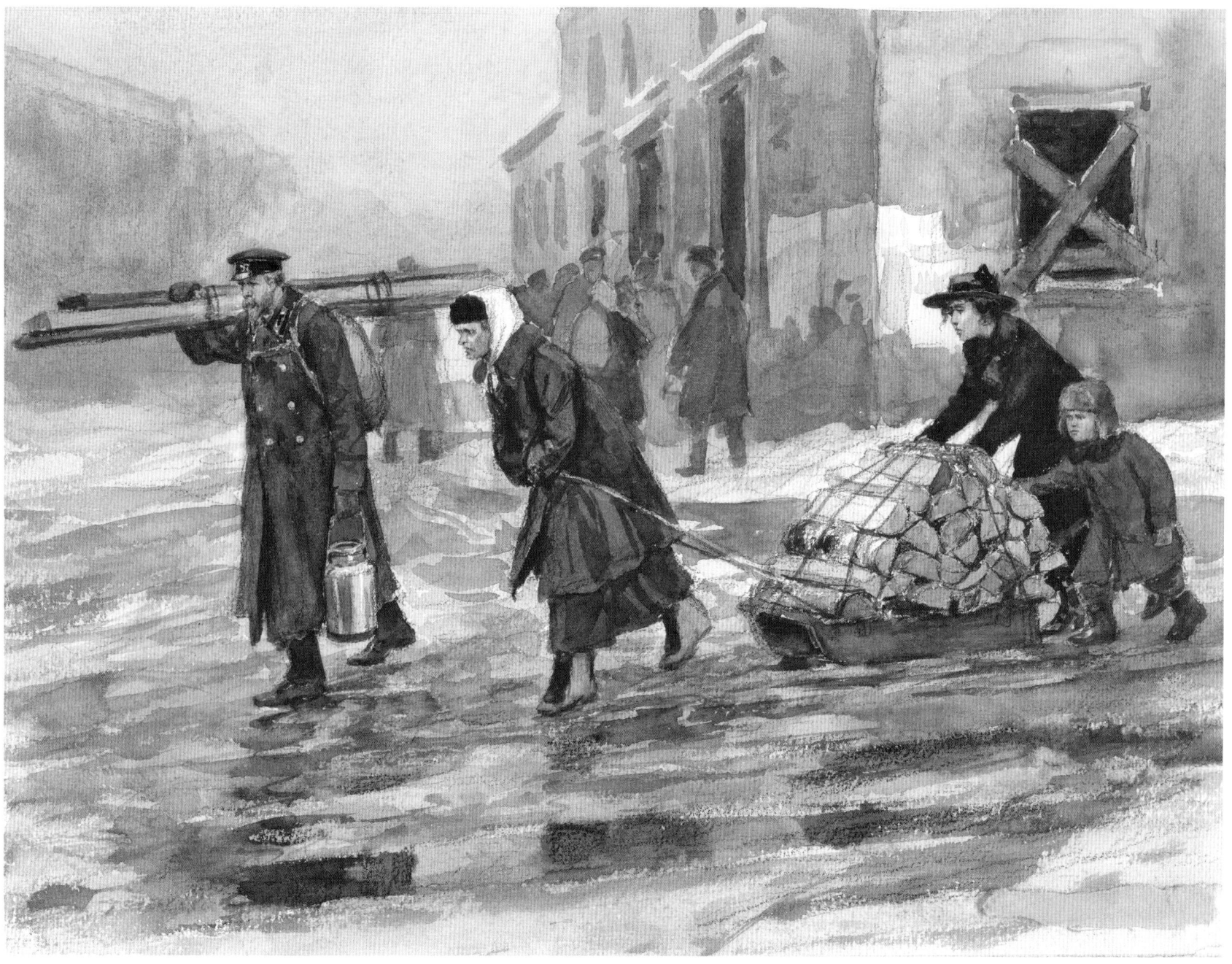

72. Engineer's Family Dragging Home Fuel – Petrograd January 1919
ink & watercolour on paper
29.2 x 39.4cm
Hoover Institution Library & Archives

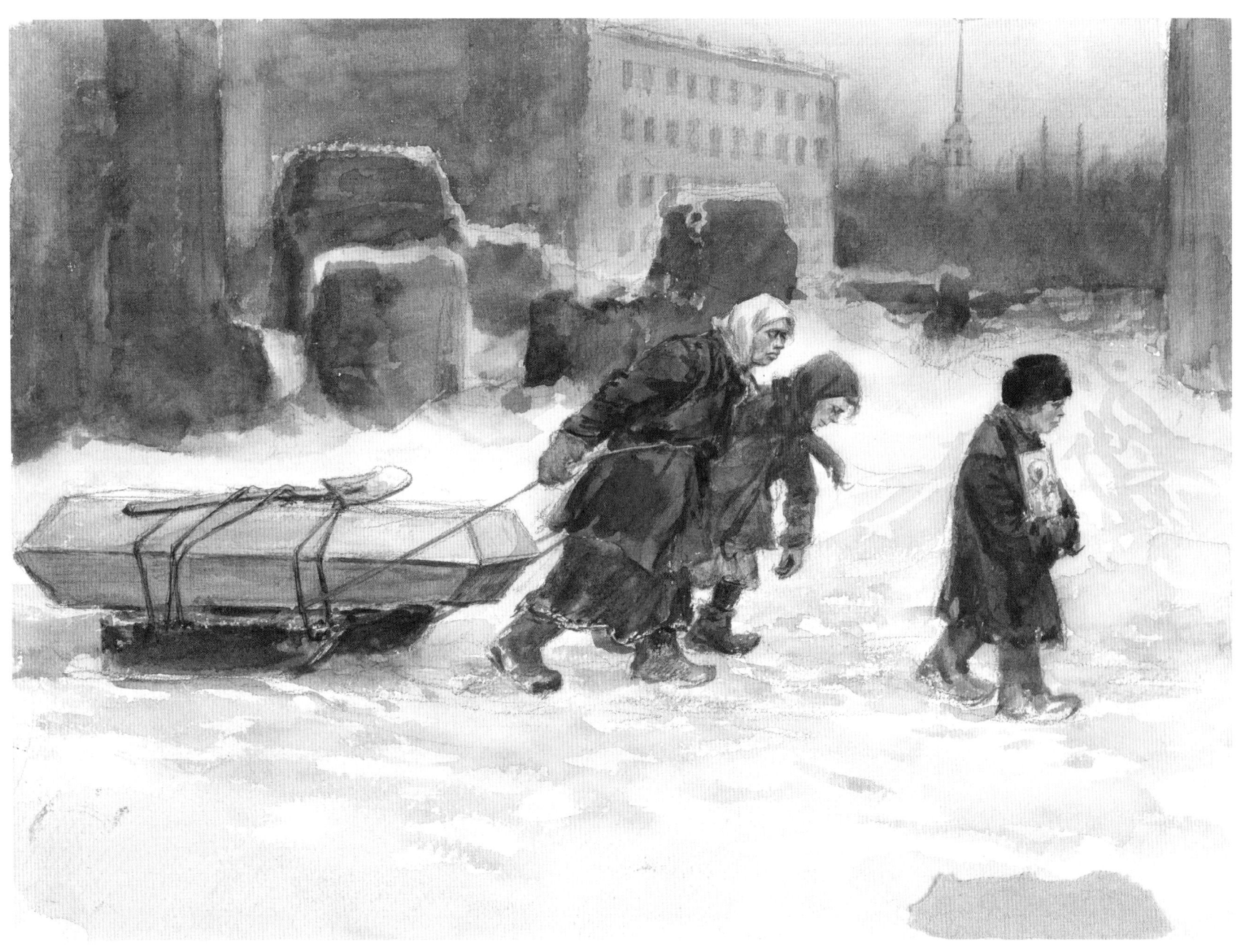

73. Burial of a Non-Communist
(Communists are Buried Magnificently) – January 1920

pencil & watercolour on paper
29.2 x 39.4cm
Hoover Institution Library & Archives

Похароны в 1919 году

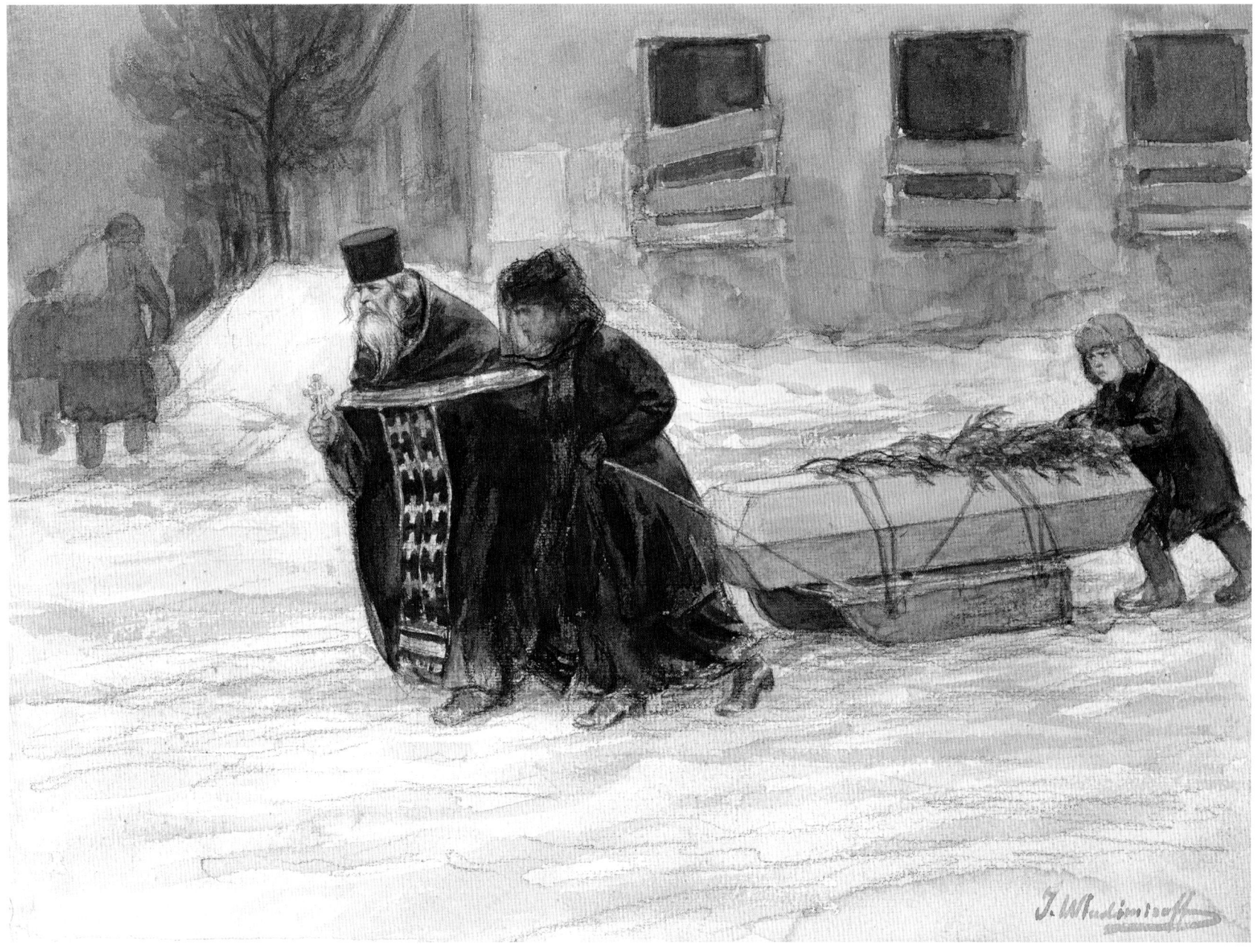

74. A Funeral in 1919
ink & watercolour on paper
26 x 34.2cm
Andre Ruzhnikov Collection

 People may no longer take their furniture with them when they are expelled from their apartments by order of the Bolsheviks. On one occasion blankets were requisitioned: each bourgeois family had to hand in one woollen blanket, supposedly for soldiers of the Red Guard – although everyone knew it was actually so they could be sold to the Germans. Many joined the Red Guard even if they weren't Bolsheviks, to receive a food allowance. Lenin and his comrades live in luxury. "

H.G. Wells

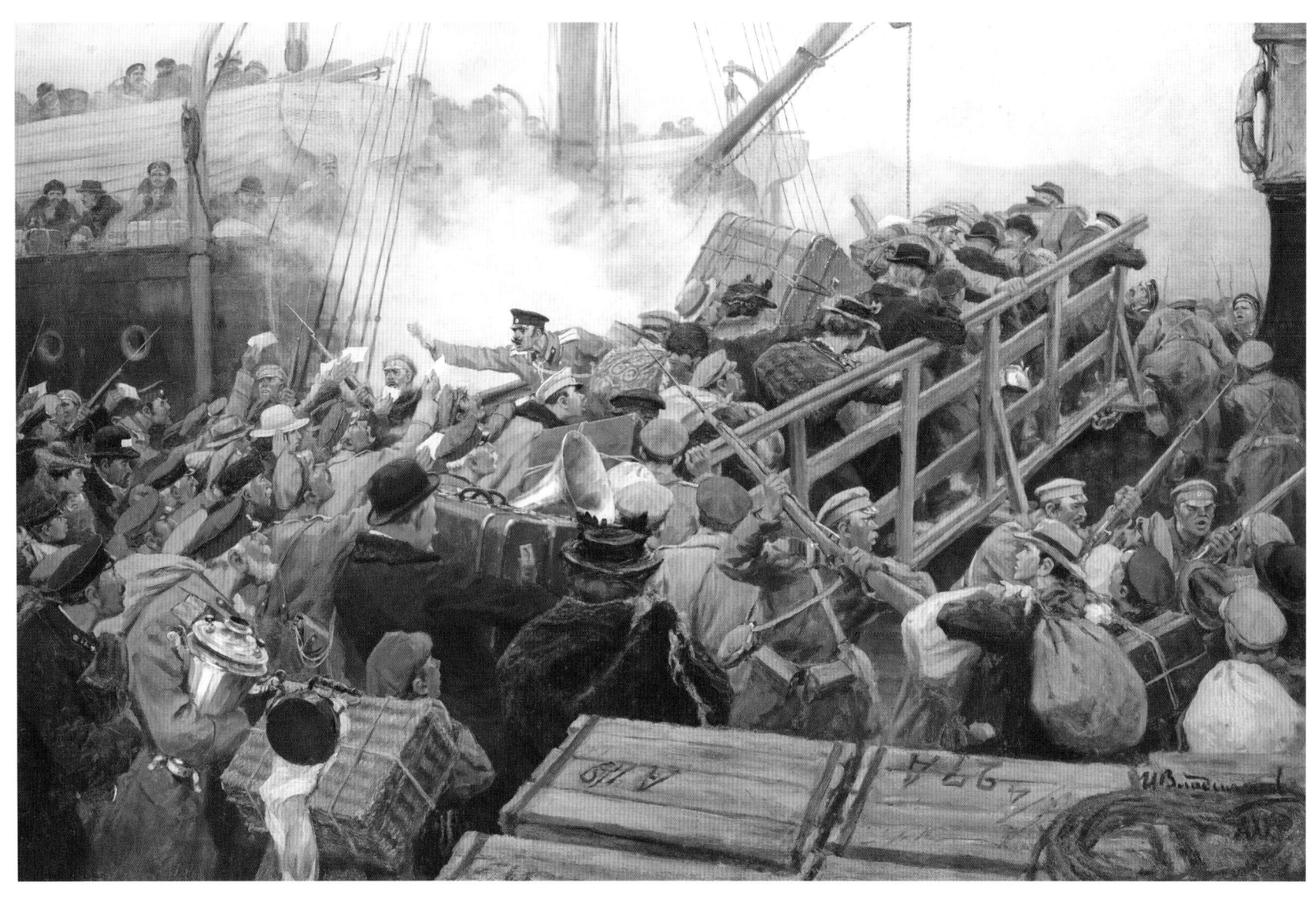

75. Flight of the Bourgeoisie from Novorossiysk (1926)

oil on canvas
138 x 212cm
Central State Museum of Russian
Modern History (Moscow)

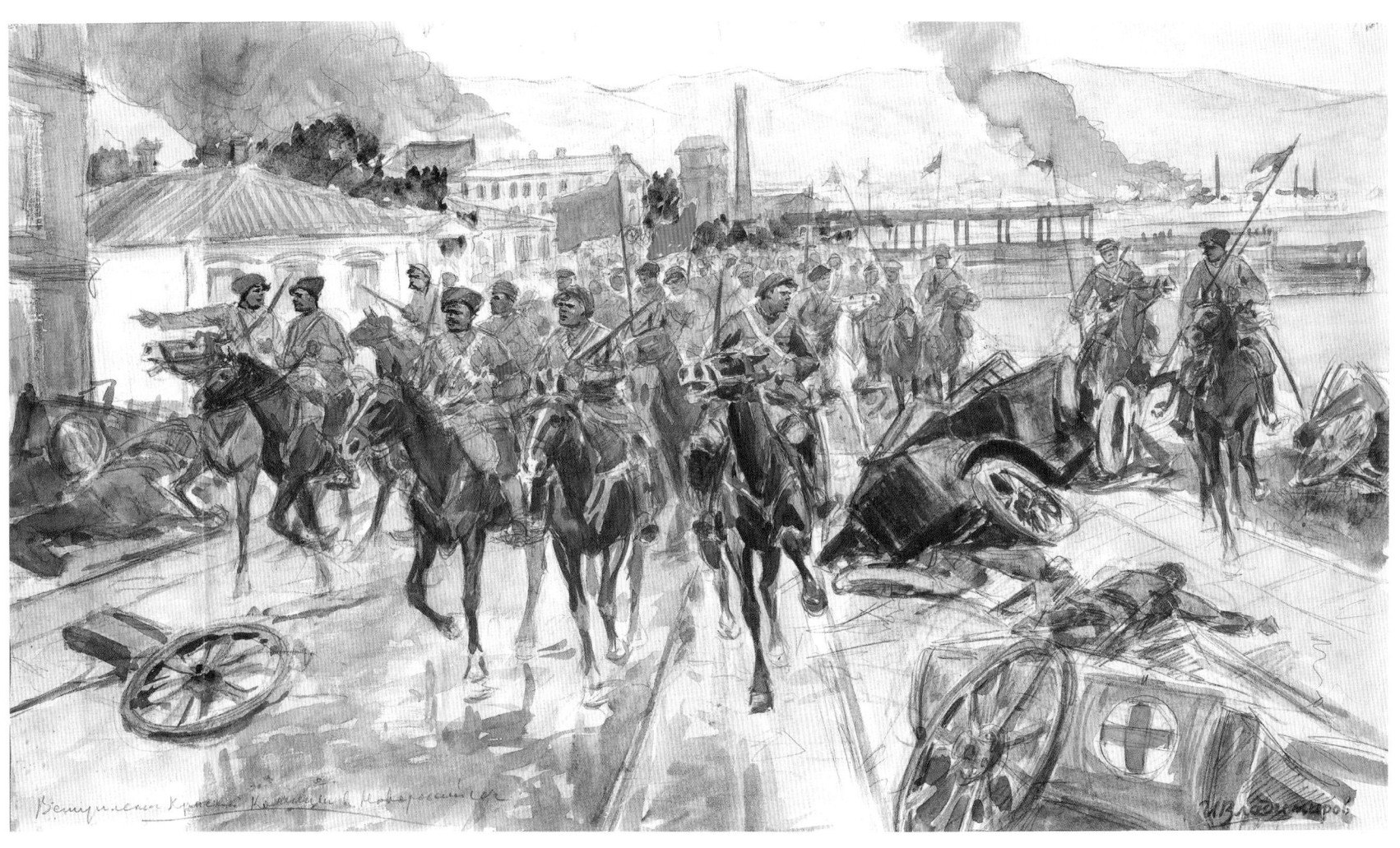

76. Red Cavalry Entering Novorossiysk (1920s)

pencil & watercolour on paper
35.9 x 62.8cm
Vladimir Ruga Collection

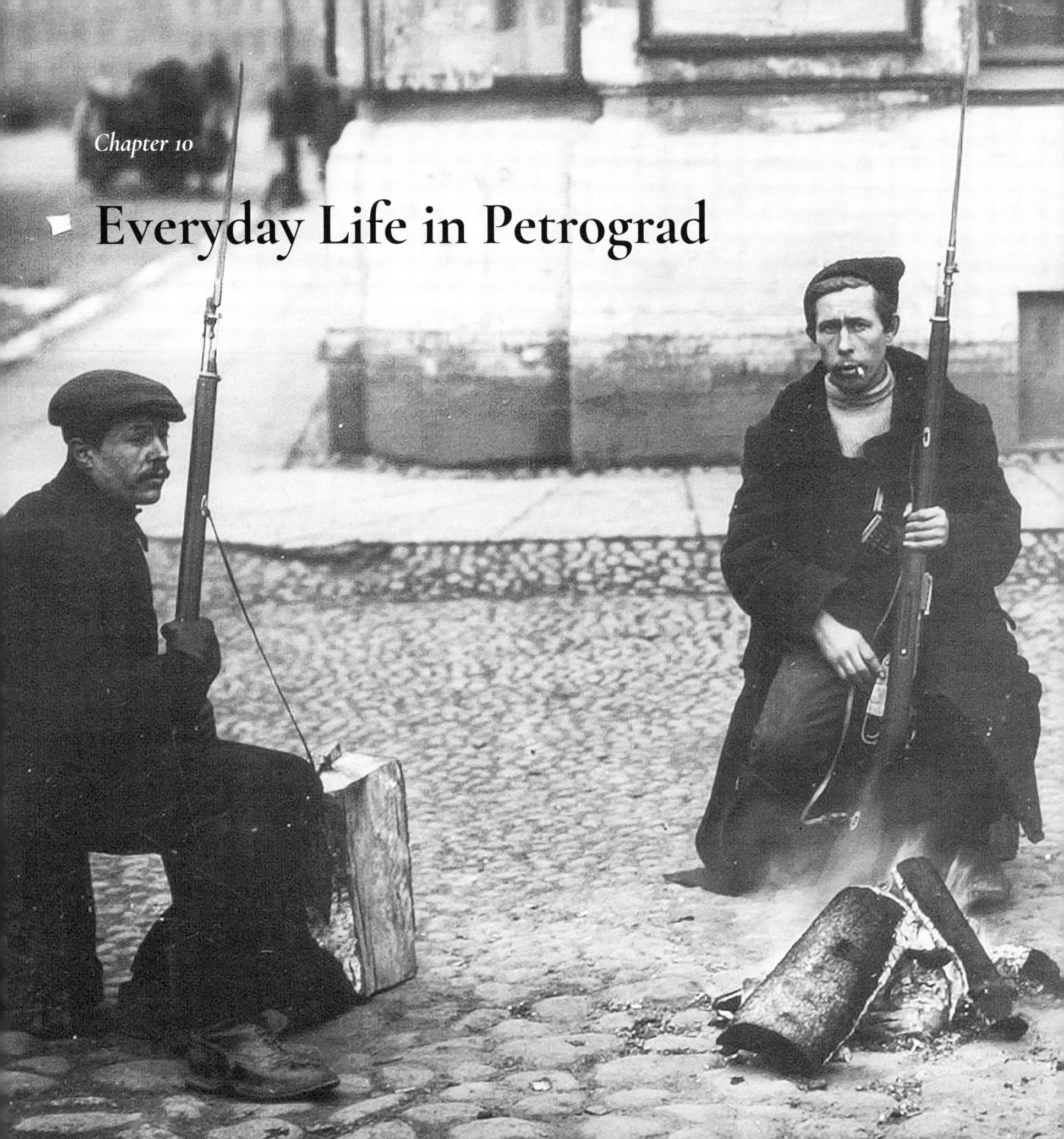

Everyday Life in Petrograd

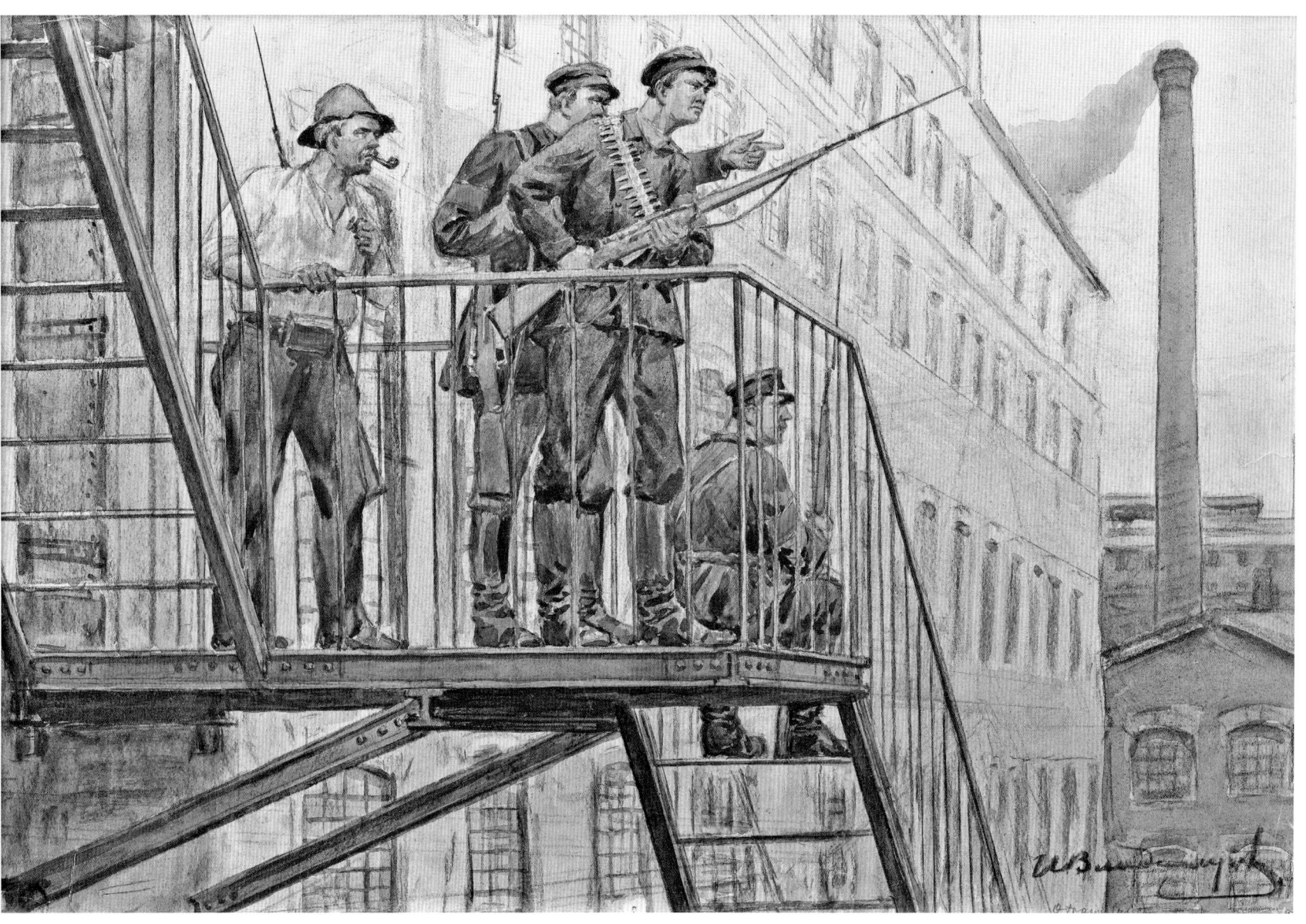

77. Security Forces

pencil & watercolour on paper
48 x 69cm
Andre Ruzhnikov Collection

Workmen breaking down wooden houses for fuel (Petrograd 1920).

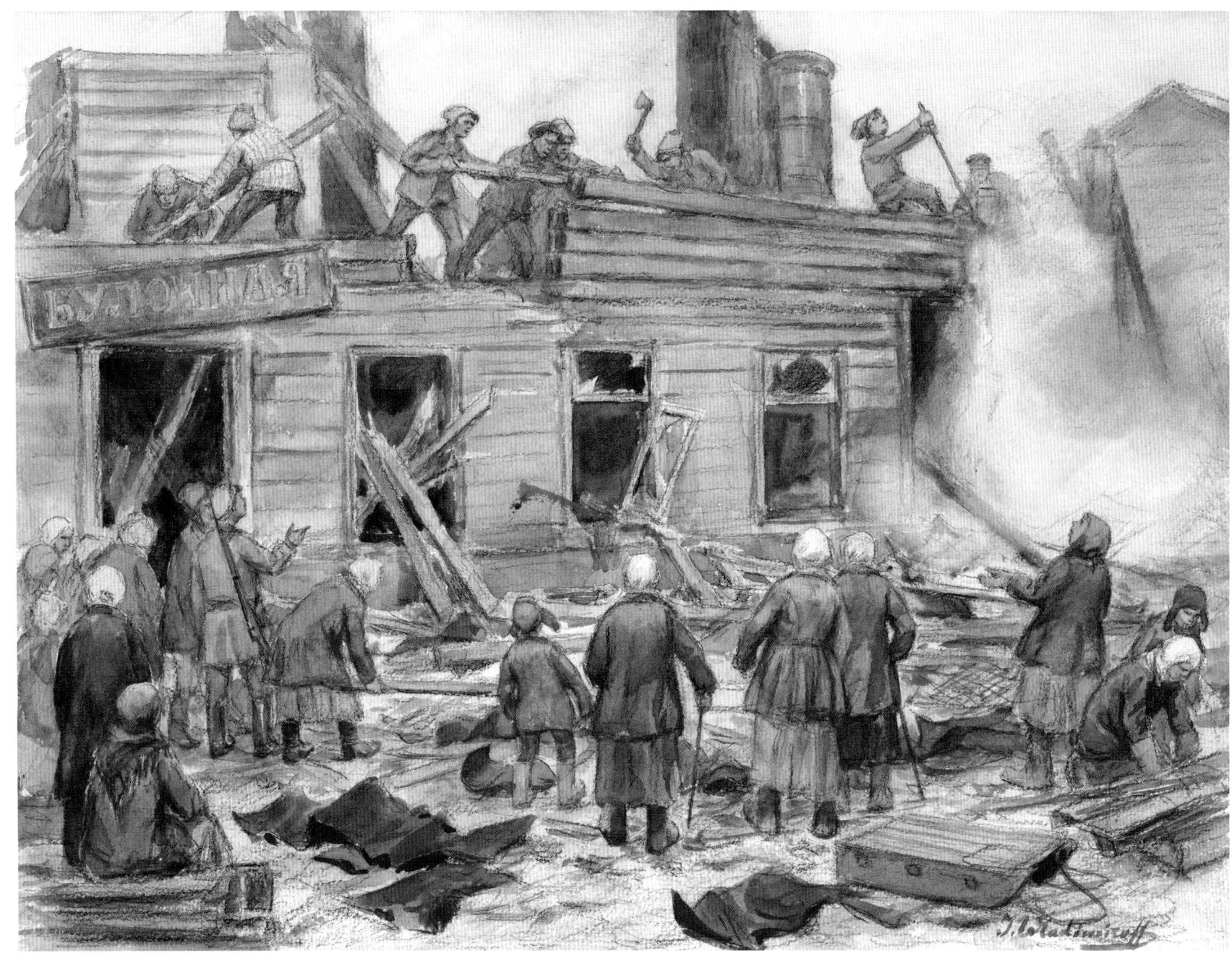

78. Workmen Breaking Up Wooden Houses for Fuel – Petrograd 1920

ink, pencil & watercolour on paper
29.2 x 39.4cm
Hoover Institution Library & Archives

Сломка дома на топливо.
1920-я

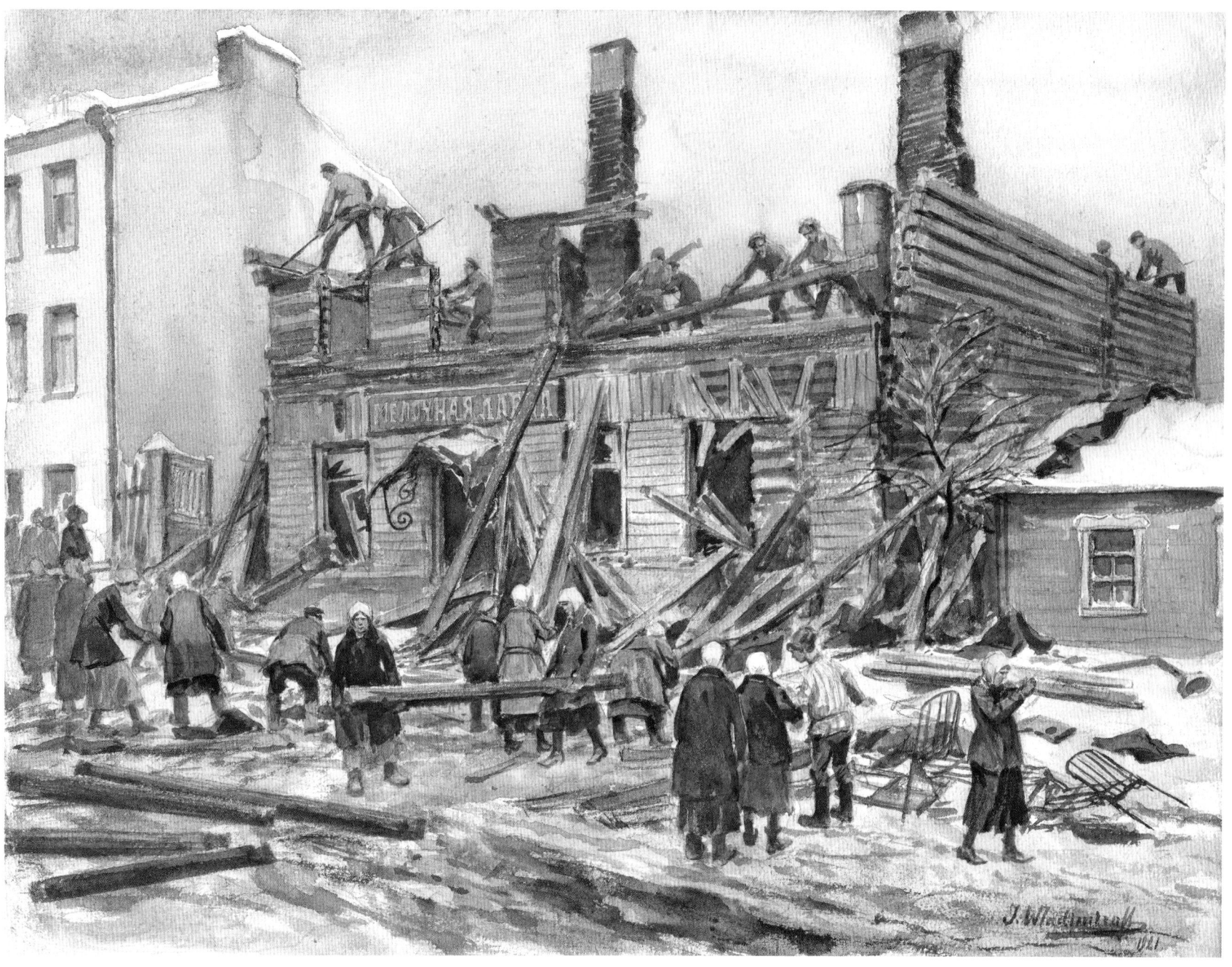

79. House Broken Up for Fuel – 1920 (1921)

watercolour on paper
25.5 x 34cm
Andre Ruzhnikov Collection

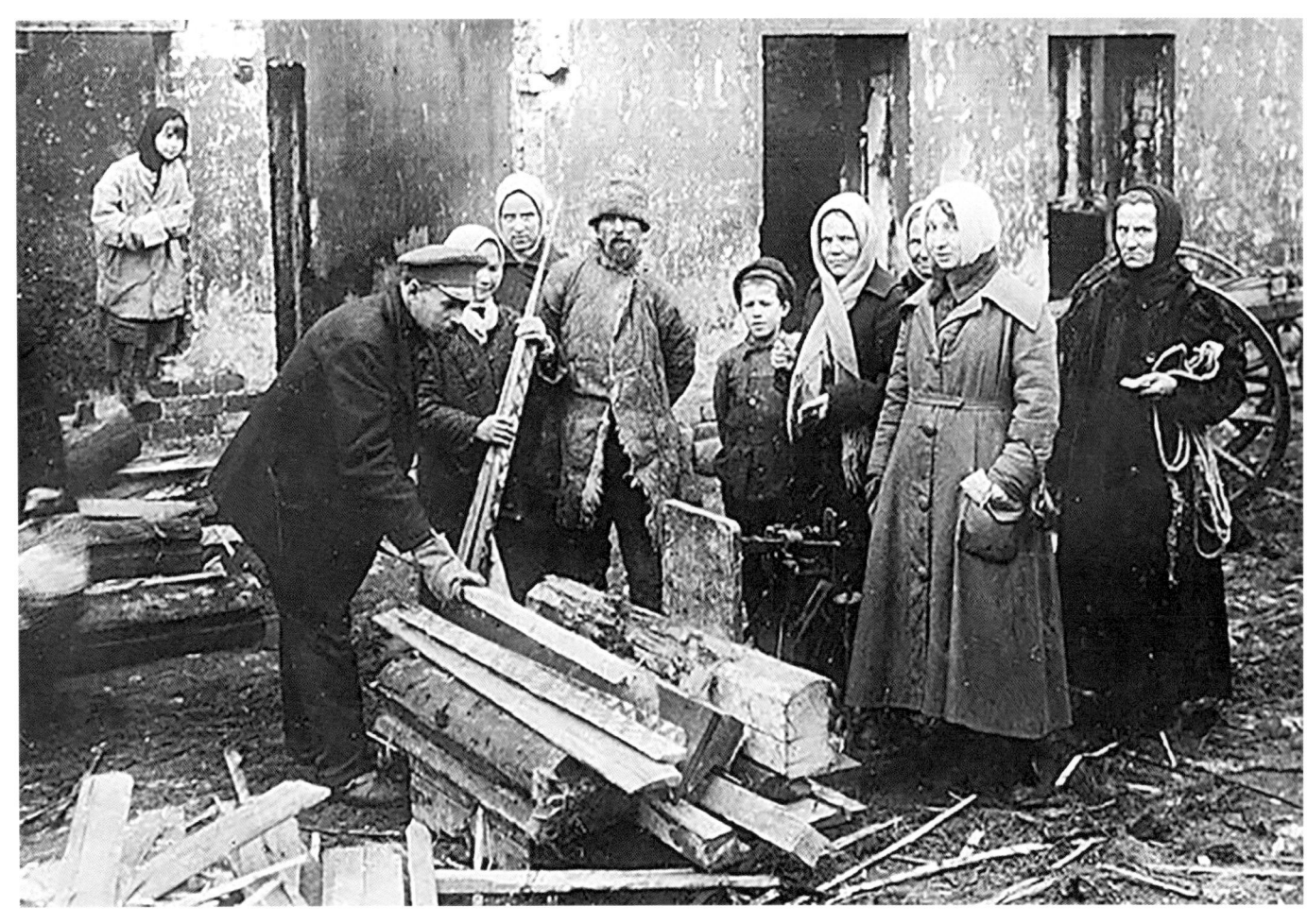

INHABITANTS OF PETROGRAD DISMANTLING HOMES FOR FIREWOOD (1920)

"

Everything in Moscow has changed greatly over the past year. If you walk down the street in the evening, you can hear the sound of chopping in every direction: Moscovites collecting fuel. The boldest of them break up fences, put them on a sledge and cart them home. Some take planks from houses that have been destroyed for firewood. Others tear down a drainpipe or sneak off with a piece of iron from somewhere, to make the sort of small stove almost everyone uses for heating these days.

"

Moscow in November 1919
A Student at Shanyavsky University

Принудительная заготовка дров для фабрики Керстен

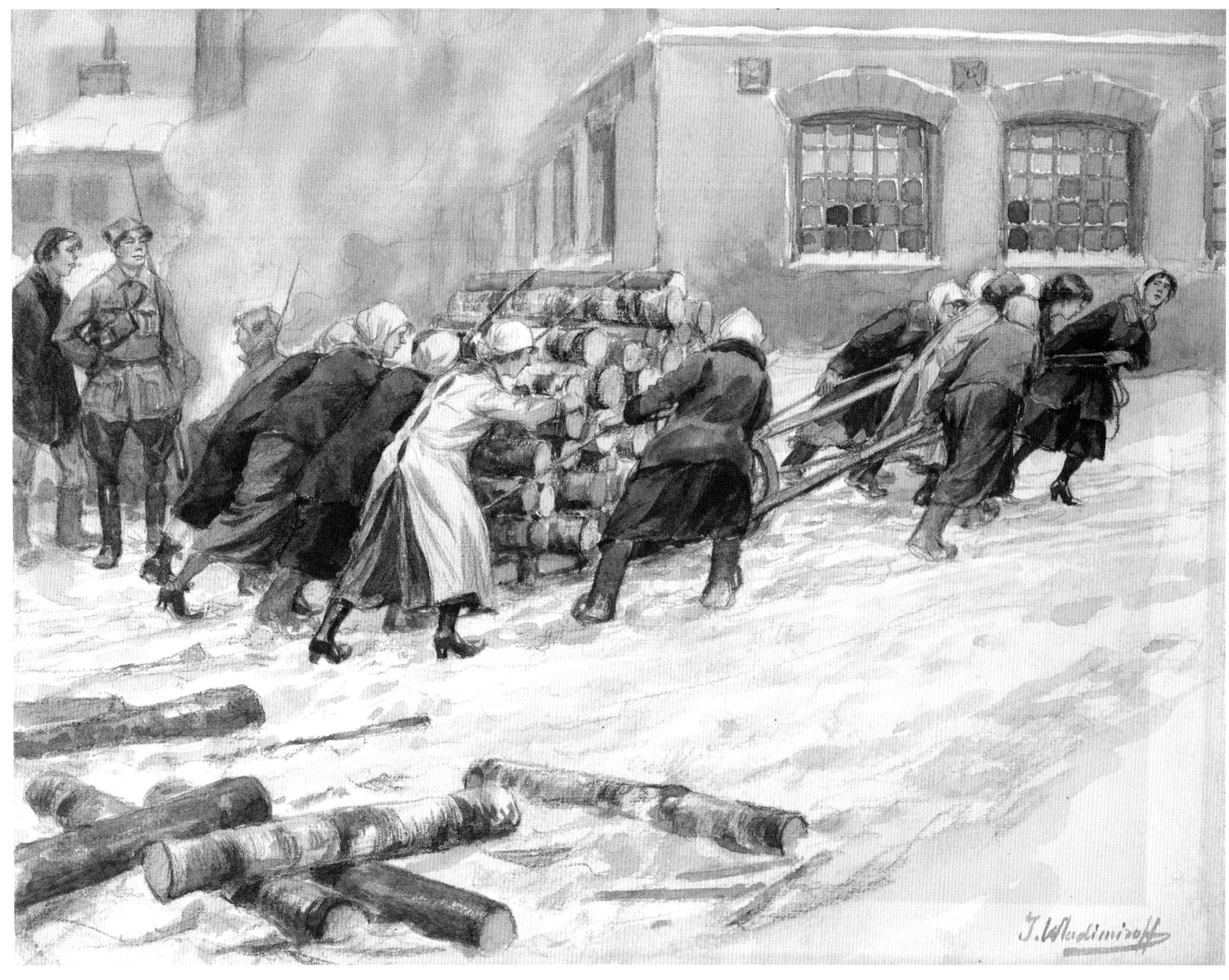

80. Firewood Commandeered for the Kersten Factory
pencil & watercolour on paper
25.3 x 34.5cm
Andre Ruzhnikov Collection

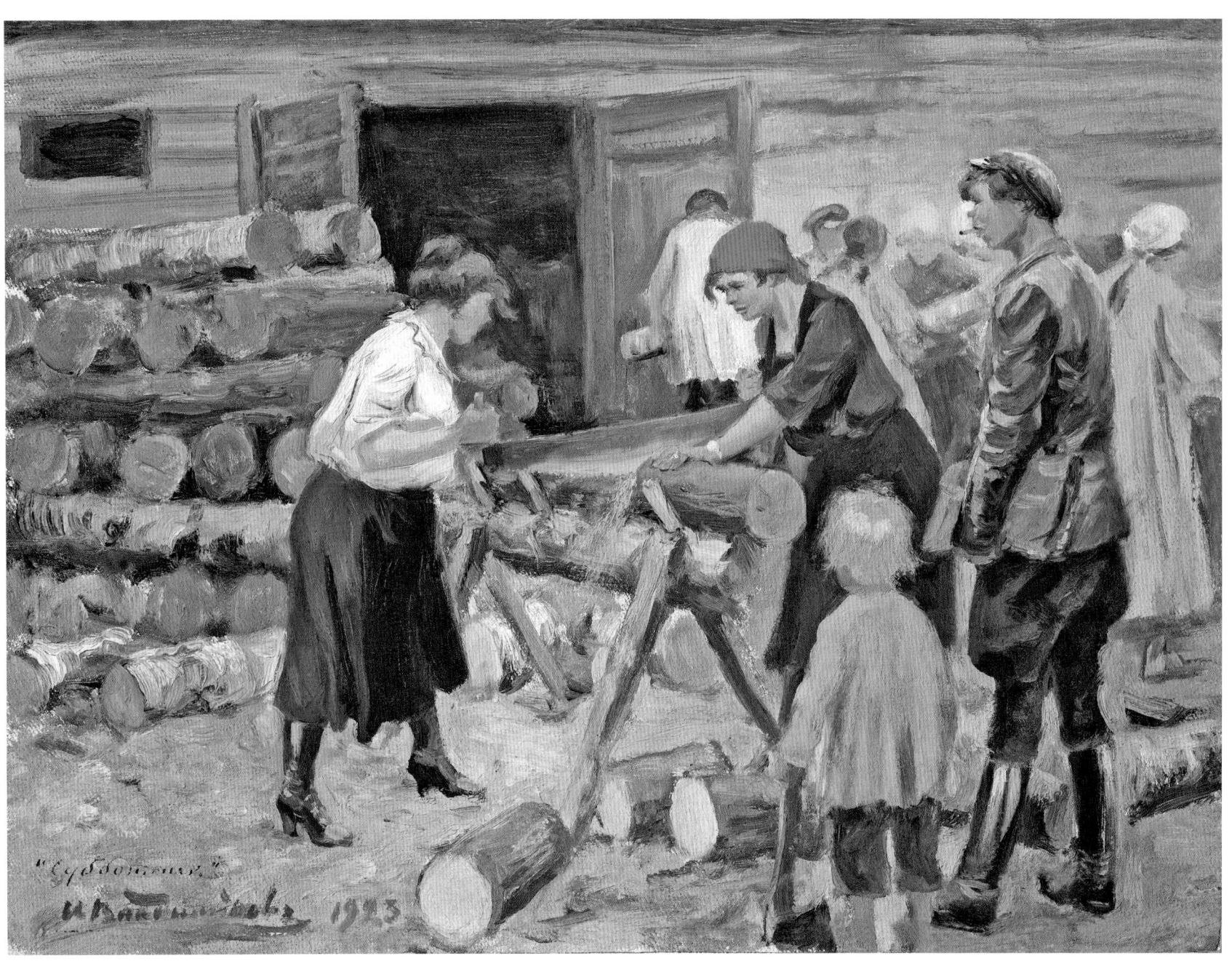

81. Communal Work-Day (1923)

oil on canvas mounted on board
24.9 x 33.7cm
Vladimir Ruga Collection

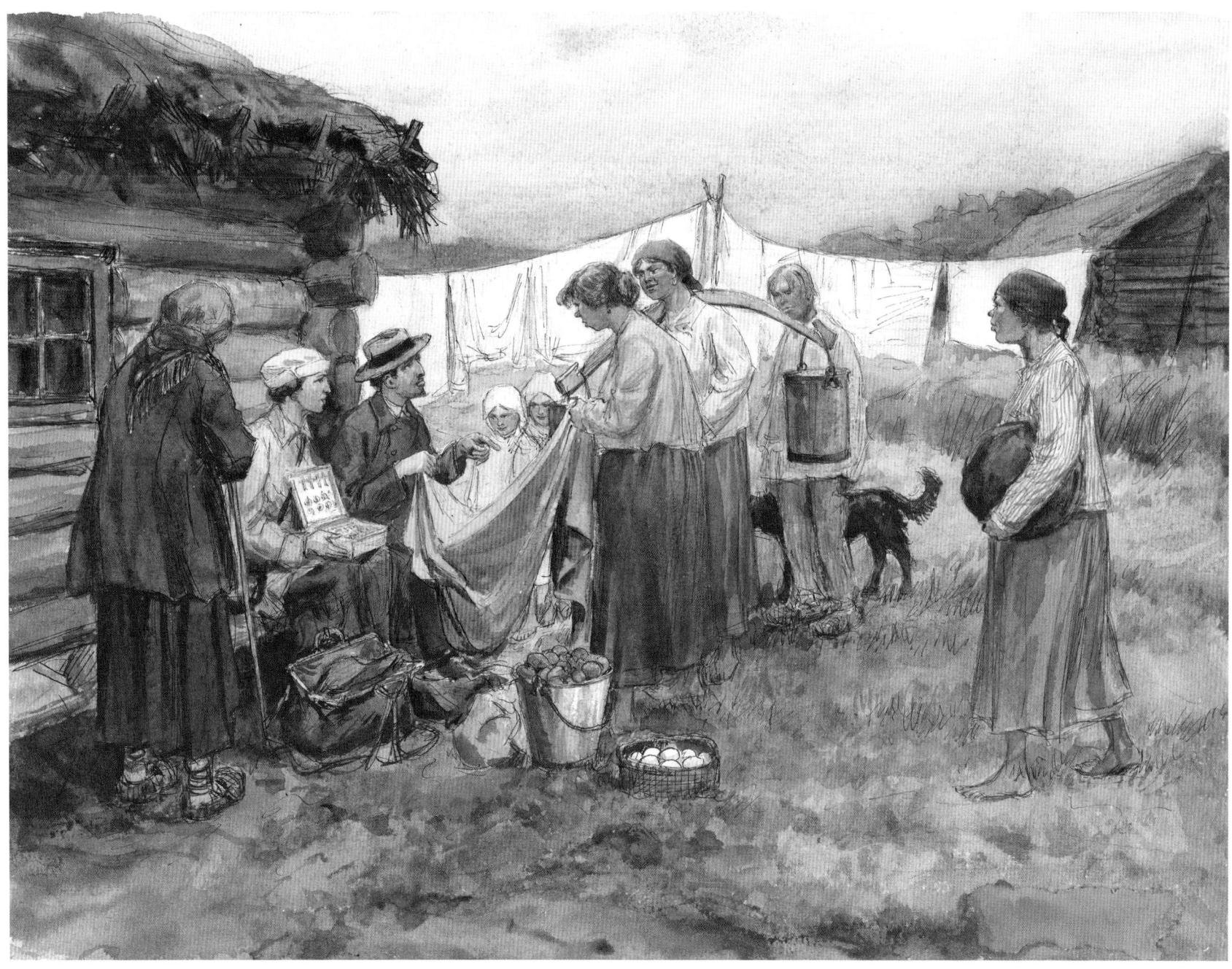

82. Exchanging Goods for Provisions near a Railway Station – June 1919

ink & watercolour on paper
29.2 x 39.4cm
Hoover Institution Library & Archives

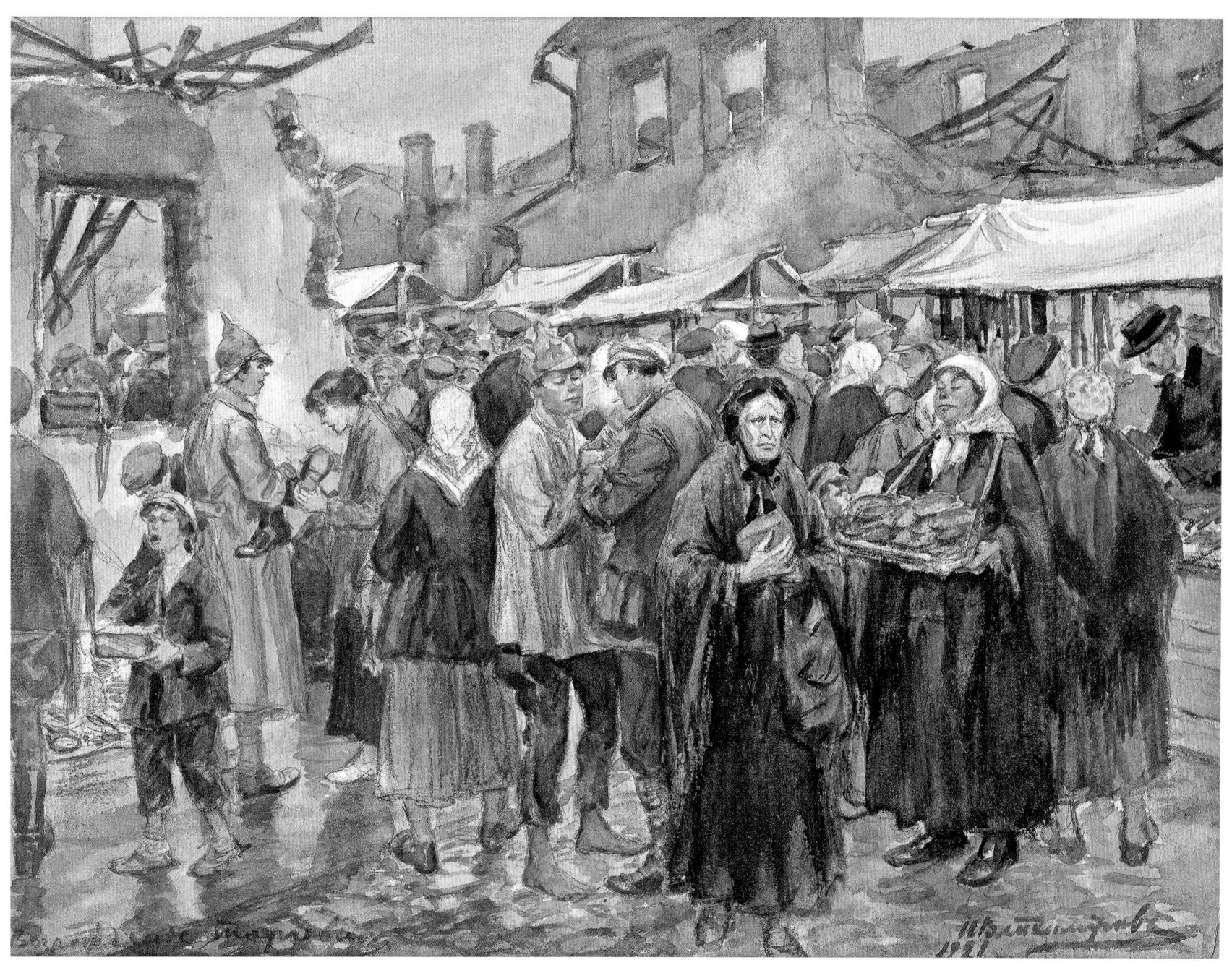

83. Rebirth of Trade (1921)

ink, pencil & watercolour on paper
25.5 x 33.5cm
Andre Ruzhnikov Collection

"

Here was another young lady,
bashfully holding out a small box
containing two little pieces of toilet-
soap. The young lady moved her lips
timidly as people passed by.
I deliberately passed by three times
so I could hear what she was saying.
'*Metamorphosa*' she kept repeating.
Probably the name of the soap.

"

Mikhail Prishvin
Diary (22 March 1918)

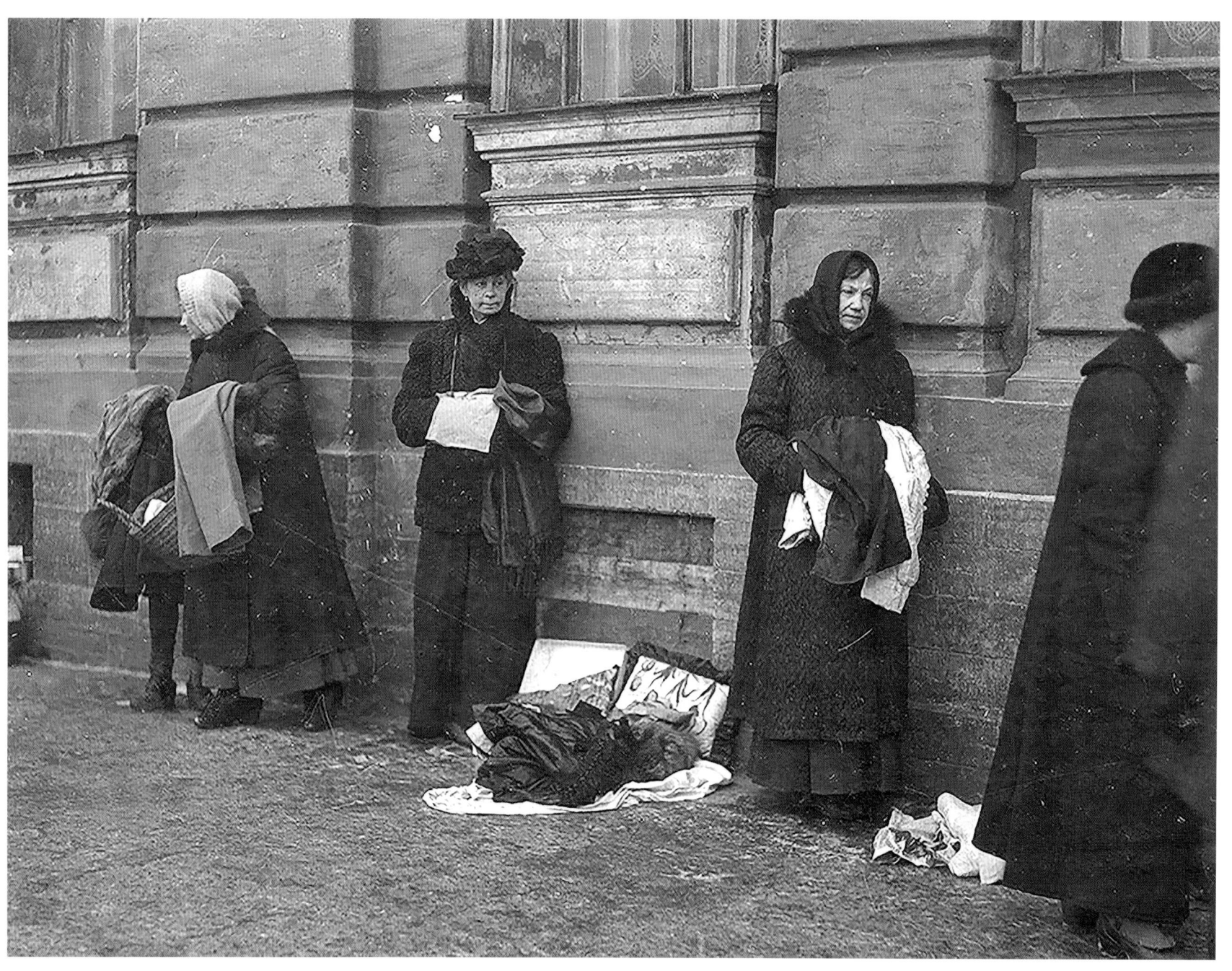

STREET TRADE UNDER WAR COMMUNISM – PETROGRAD 1920

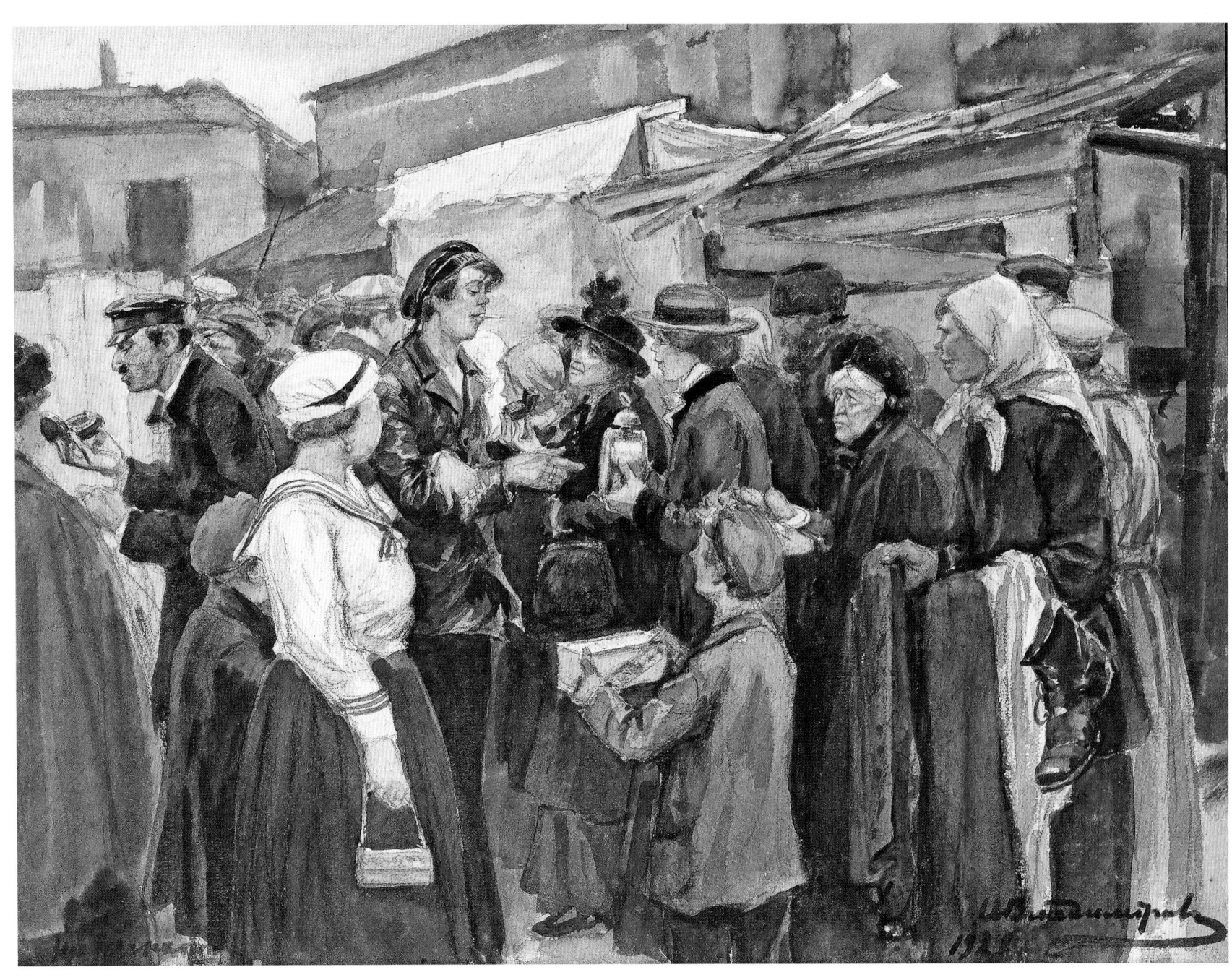

84. At The Market (1921)

pencil & watercolour on paper
25.5 x 33.5cm
Andre Ruzhnikov Collection

"Free trade in Petrograd" Militioners helping themselves
in a market-place (December 1922)

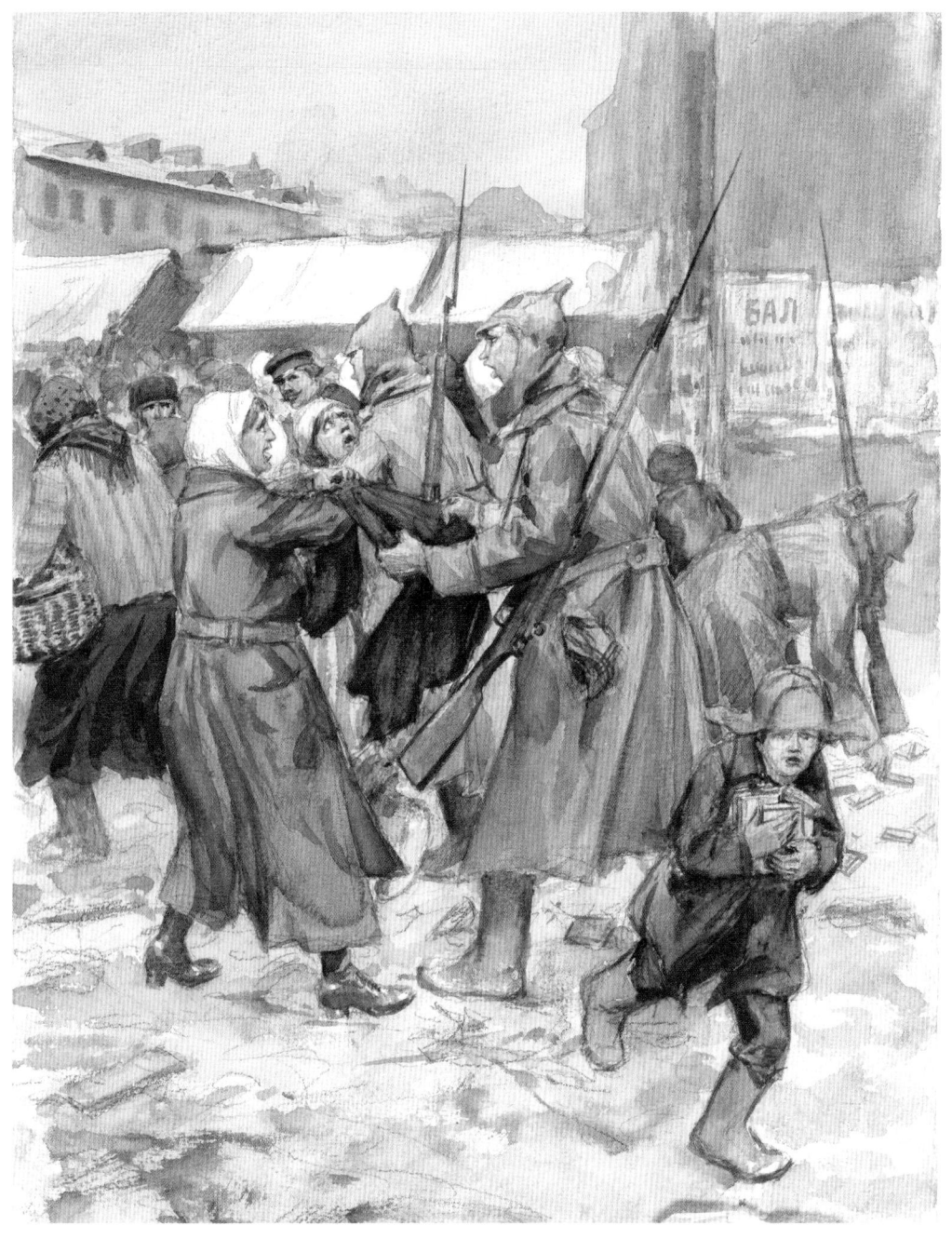

**85. Free Trade in Petrograd: Soldiers Helping Themselves at the Market –
December 1922**

ink, paper & watercolour on paper
29.2 x 39.4cm
Hoover Institution Library & Archives

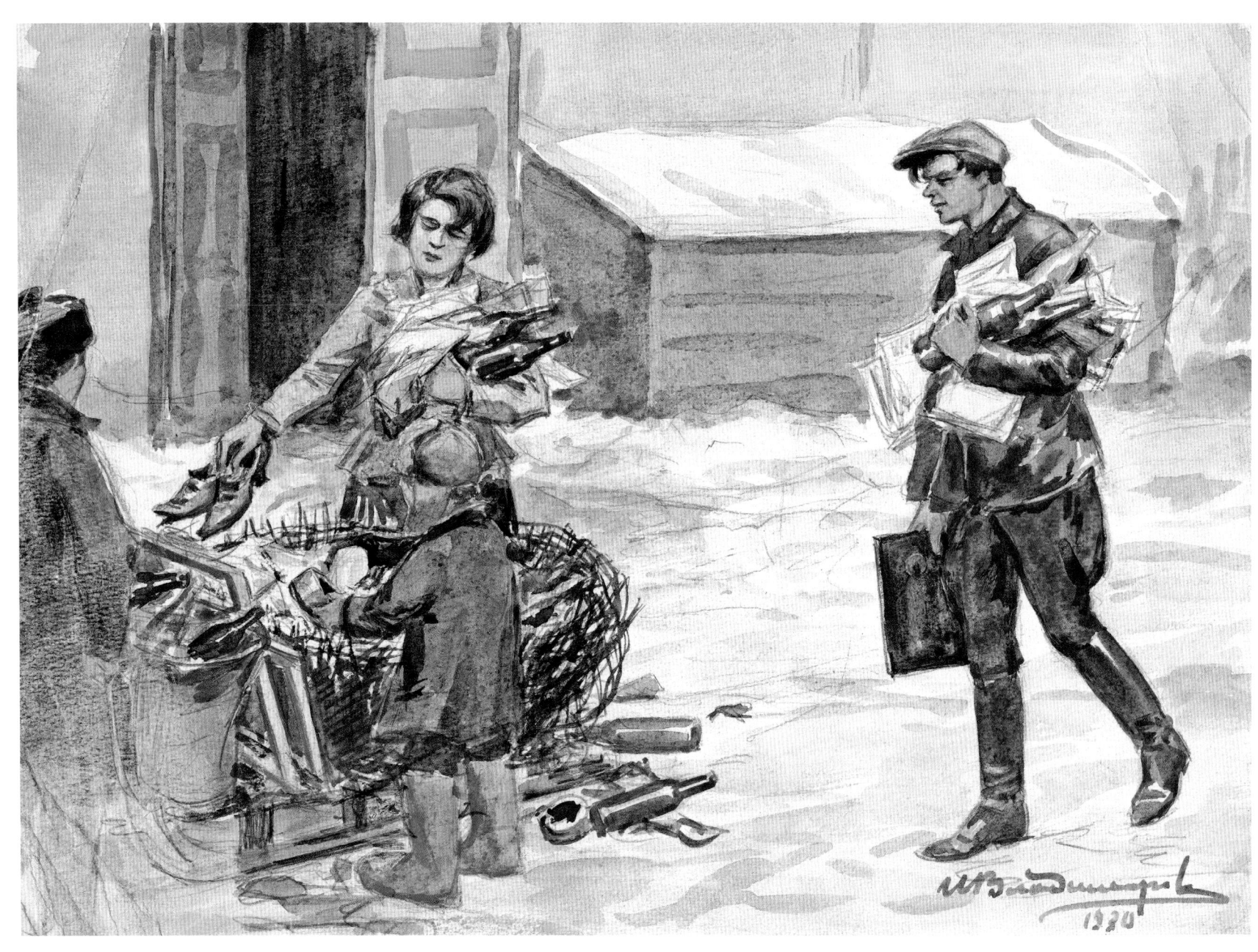

86. Handing over the Past for Scrap (1930)

pencil & watercolour on paper
21.6 x 30.7cm
Vladimir Ruga Collection

artist's inscription on back:

A foreigner attacked by cigarette sellers in Petrograd. (1923)

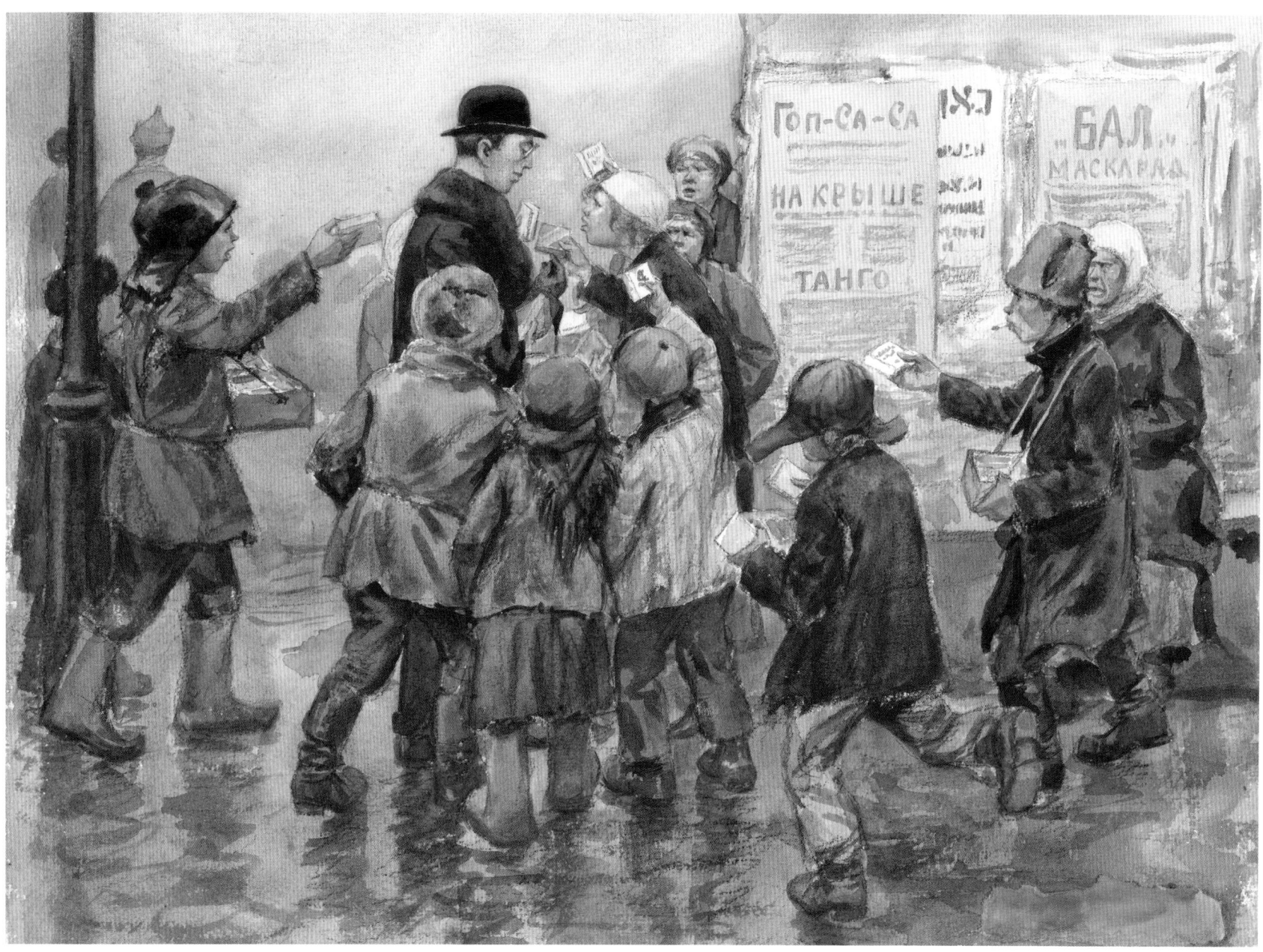

87. Foreigner Assailed by Cigarette-Vendors – Petrograd 1923

pencil & watercolour on paper
29.2 x 39.4cm
Hoover Institution Library & Archives

2 boys arrested for stealing

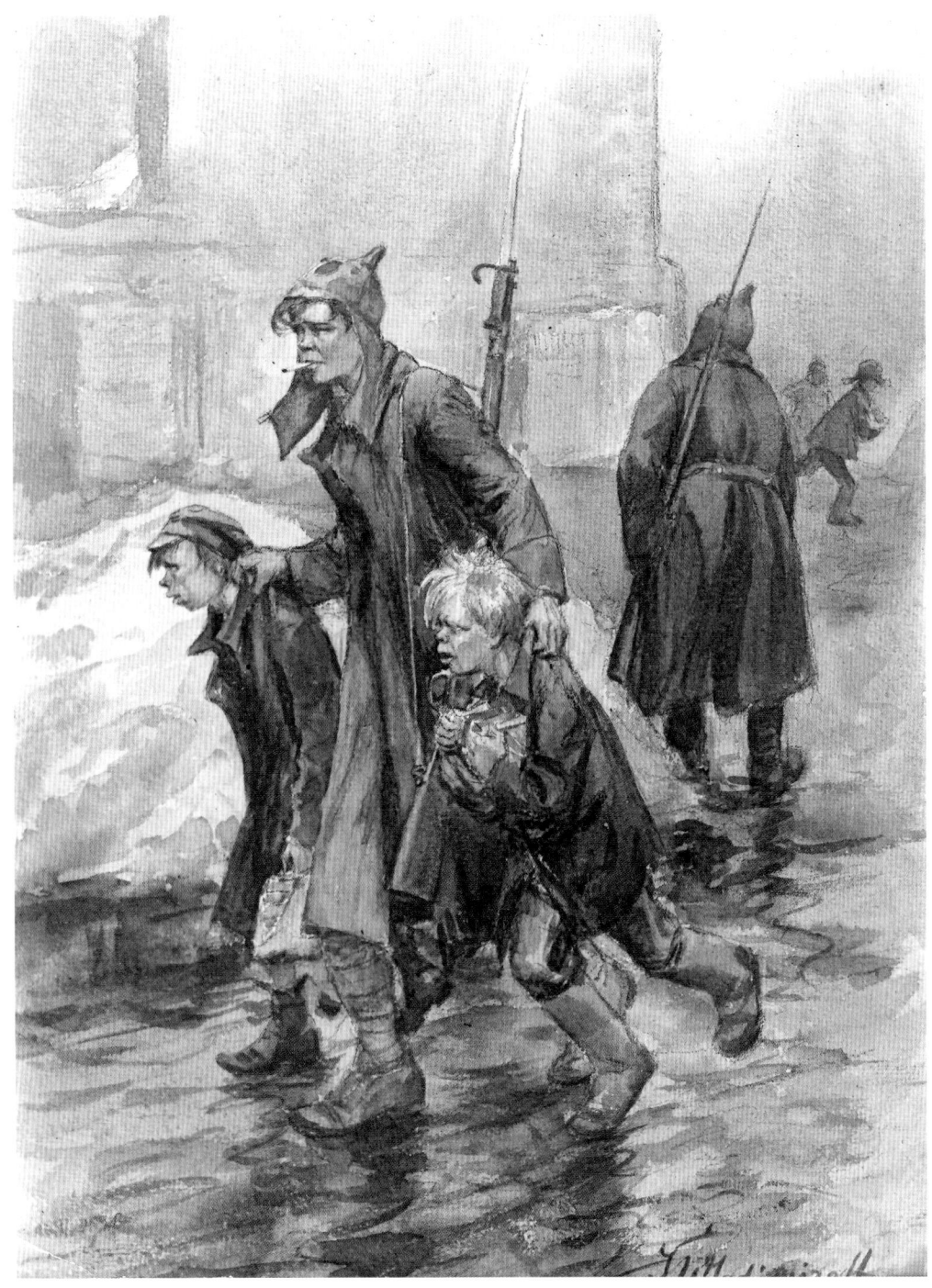

88. Two Boys Arrested for Stealing

watercolour
41.9 x 33cm
(photocopy of original watercolour)
Hoover Institution Library & Archives

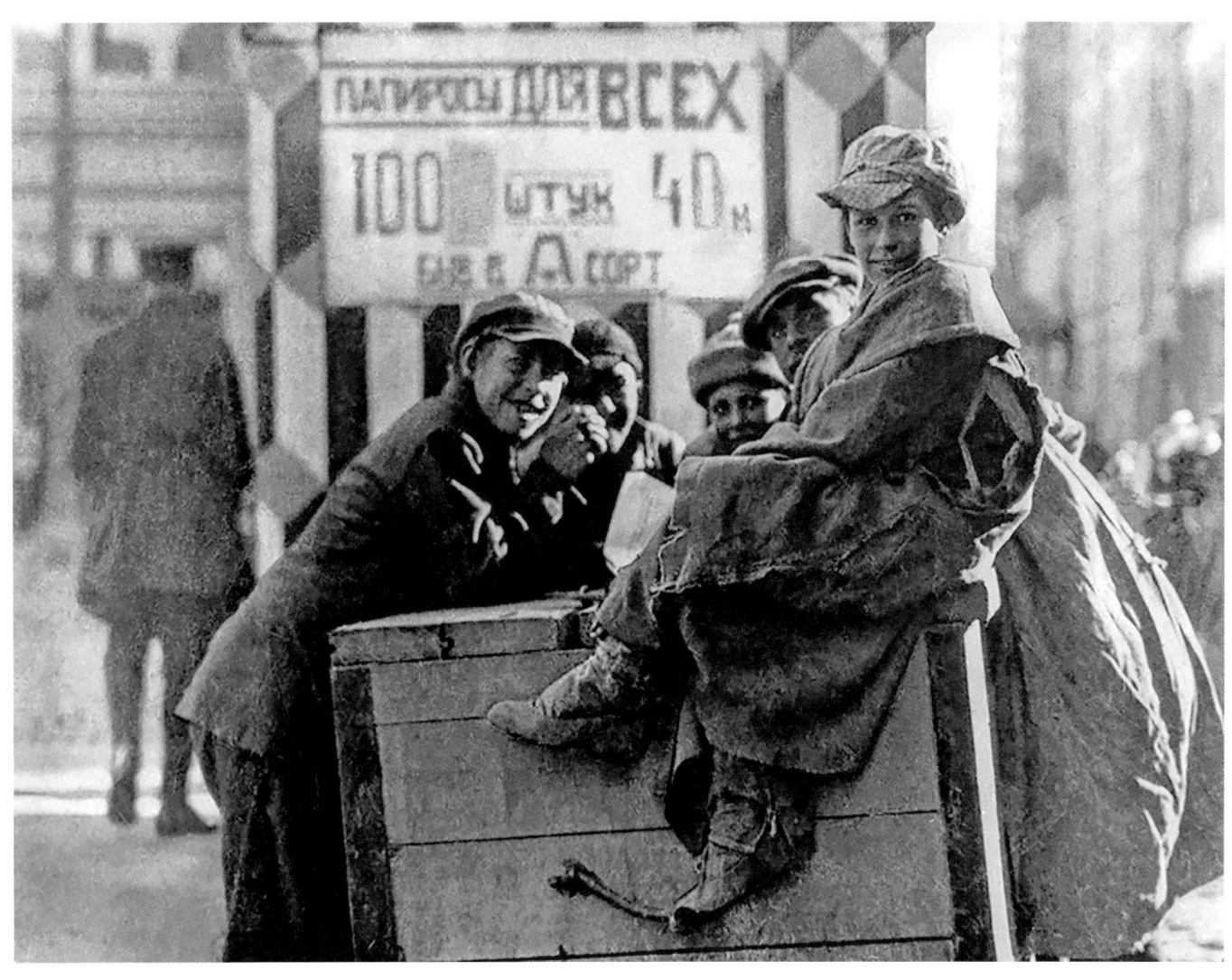

STREET URCHINS ON THE CORNER OF ARBAT/ STAROKONYUSHENNY PEREULOK – MOSCOW 1922

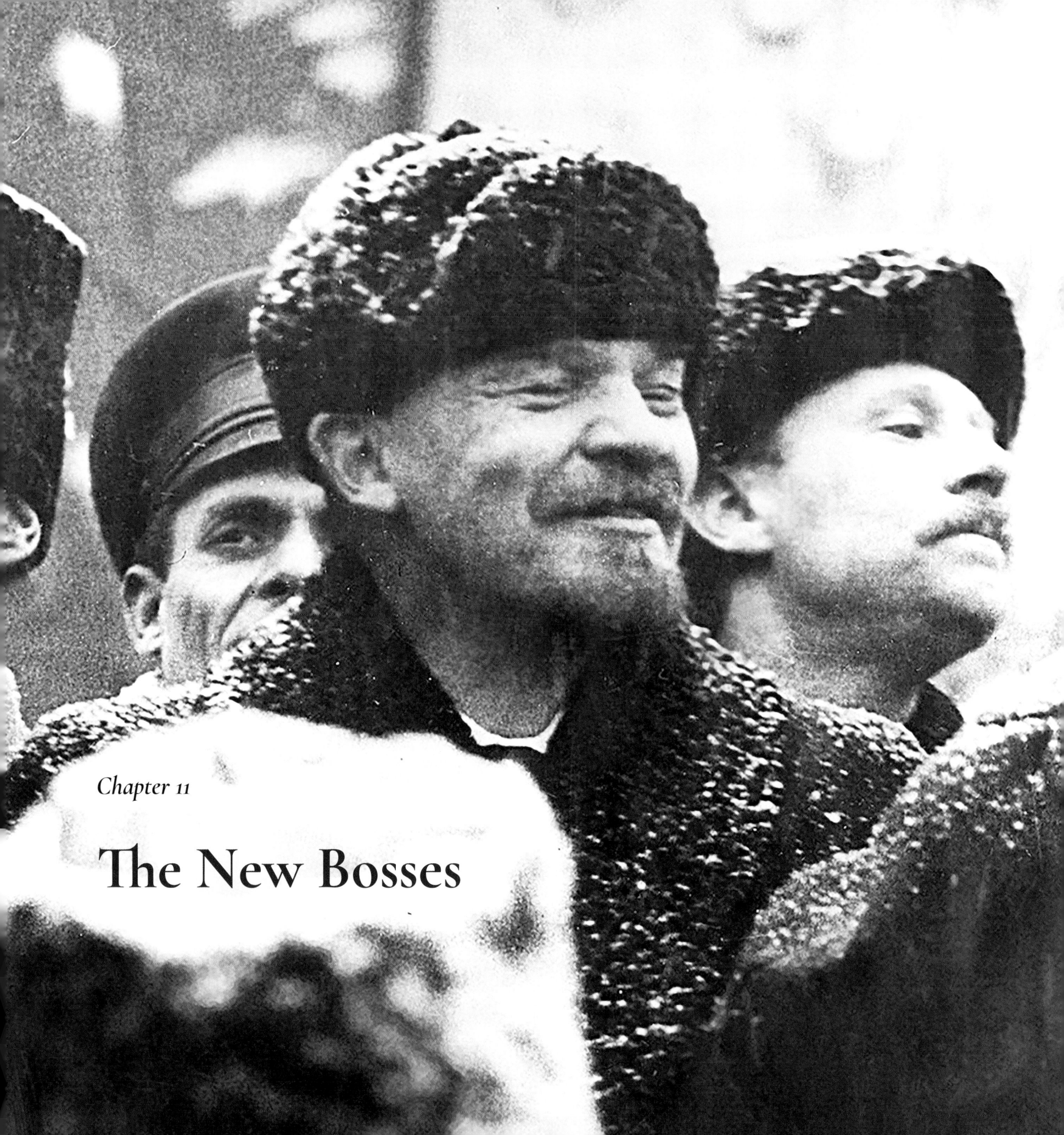

Chapter 11

The New Bosses

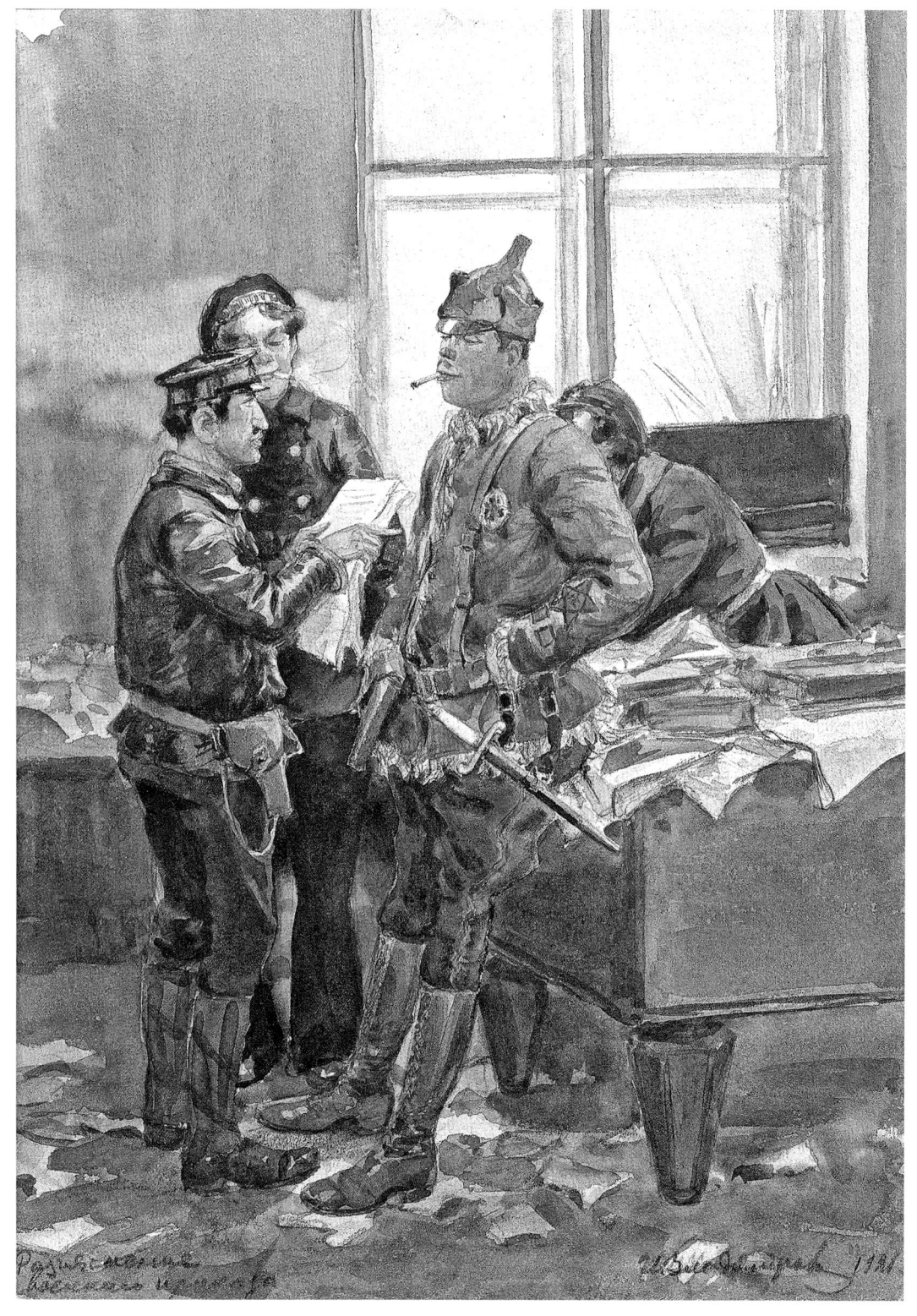

89. Clarifying Military Orders (1921)

pencil & watercolour on paper
33.5 x 24.5cm
Andre Ruzhnikov Collectiona

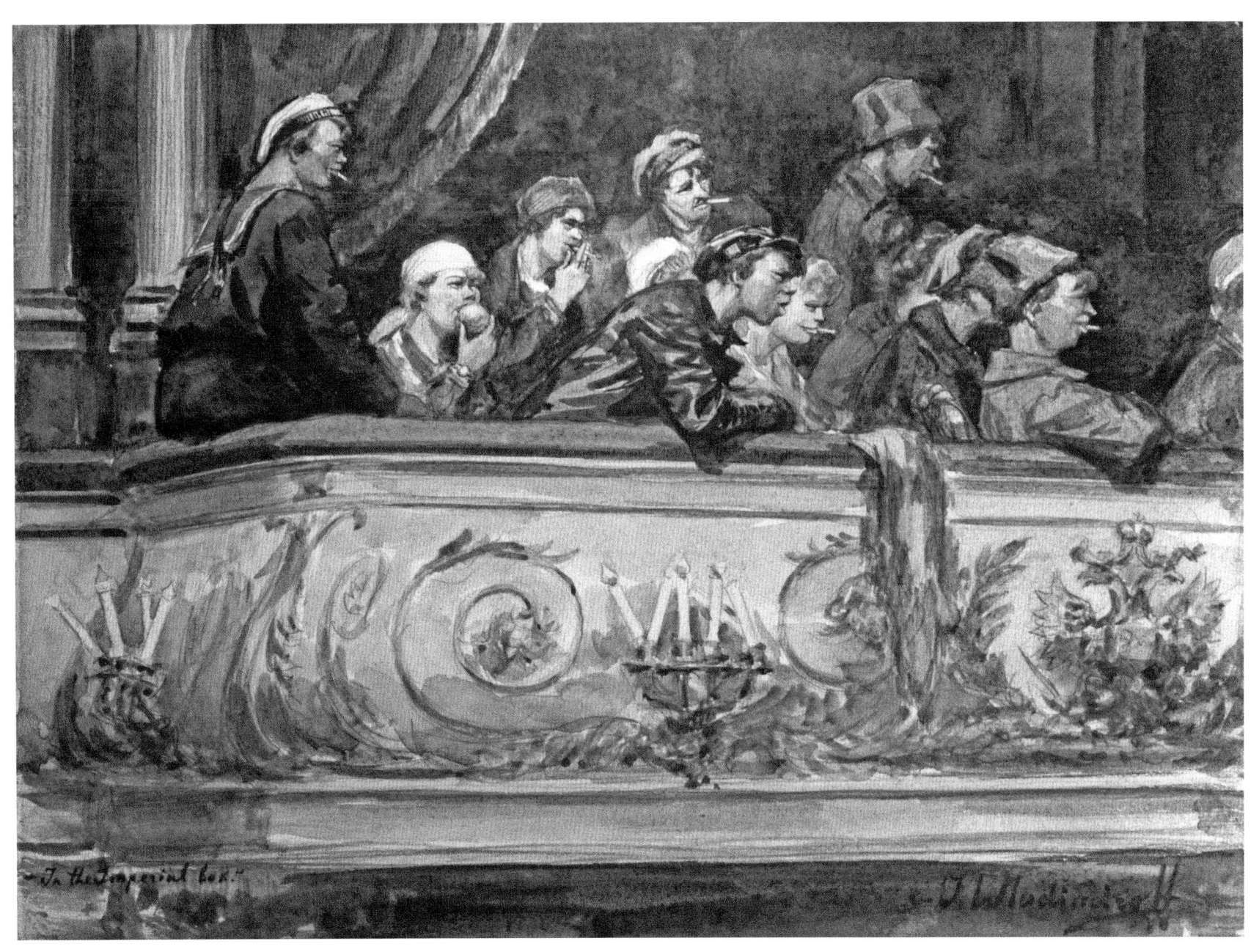

90. In the Imperial Box

pencil & watercolour on paper
40.5 x 48.3cm
Herbert Hoover Presidential Library

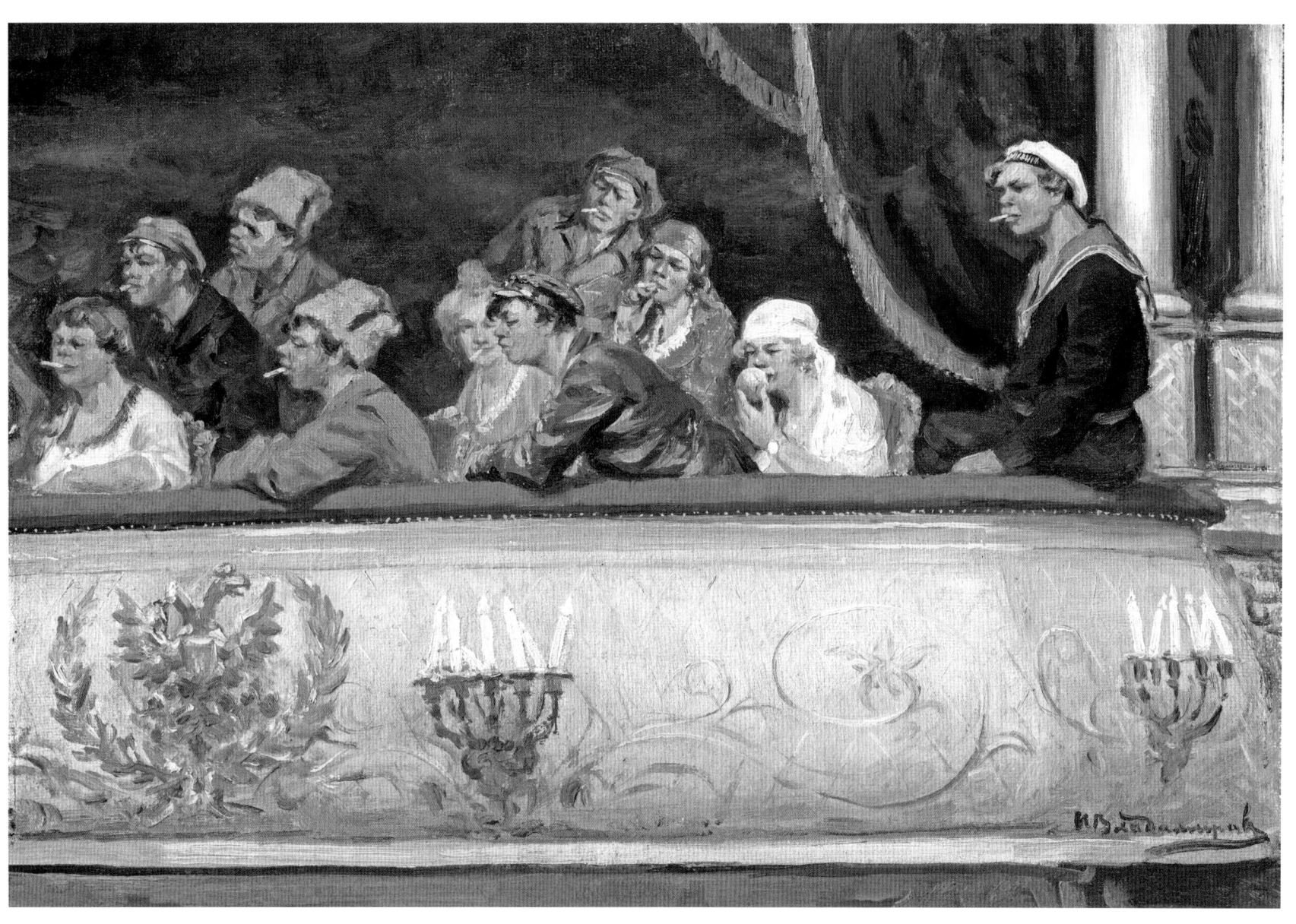

91. At the Theatre – The Tsar's Box

oil on canvas mounted on plywood
28 x 40.5cm
Vladimir Ruga Collection

artist's inscription on back:

"На посту" сцена у ворот казармы.

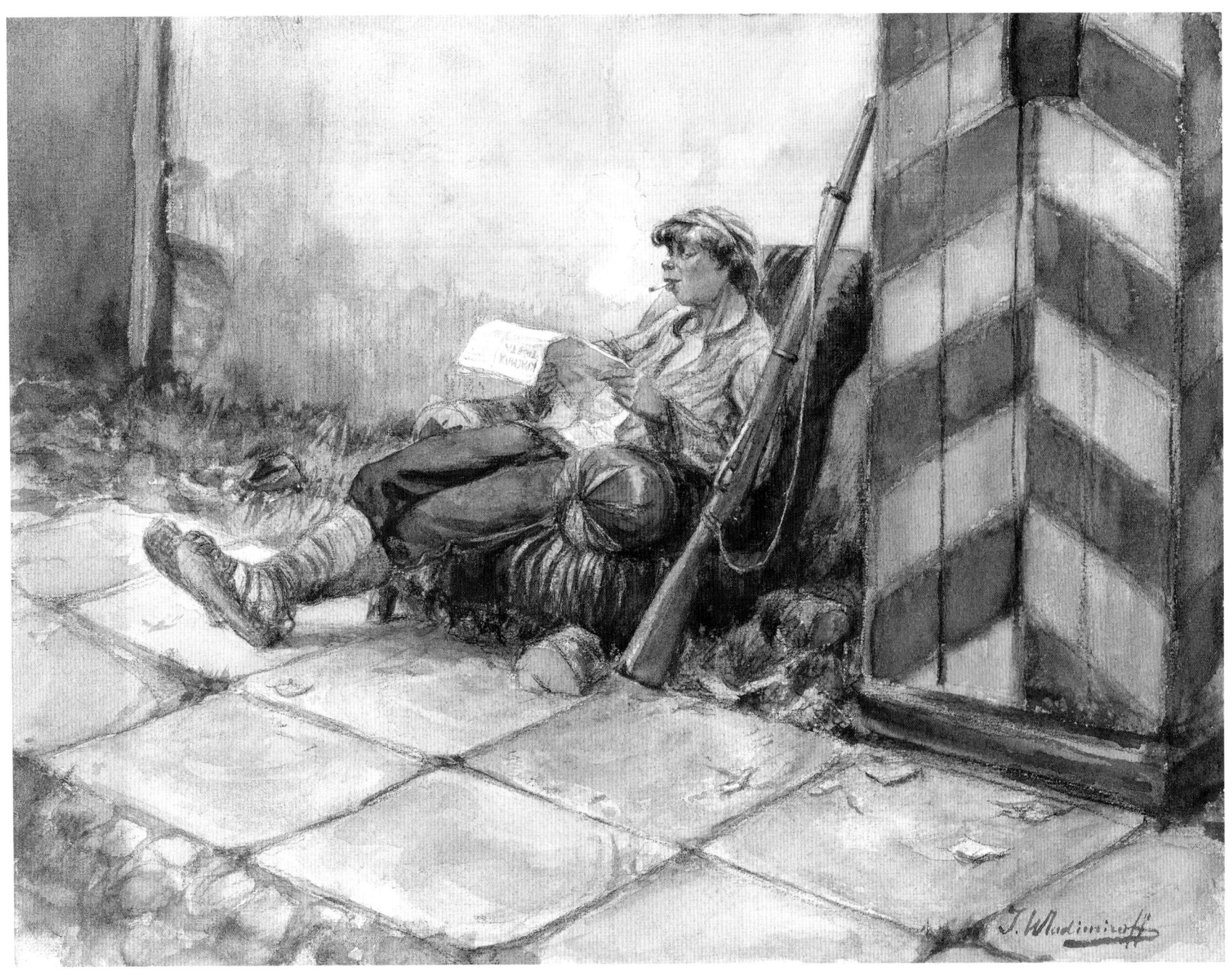

92. 'On Duty' – Scene Outside the Barracks

ink & watercolour on paper
25.7 x 34.2cm
Andre Ruzhnikov Collection

artist's inscription on back:

Милціамерка на посту.
1919 год.)

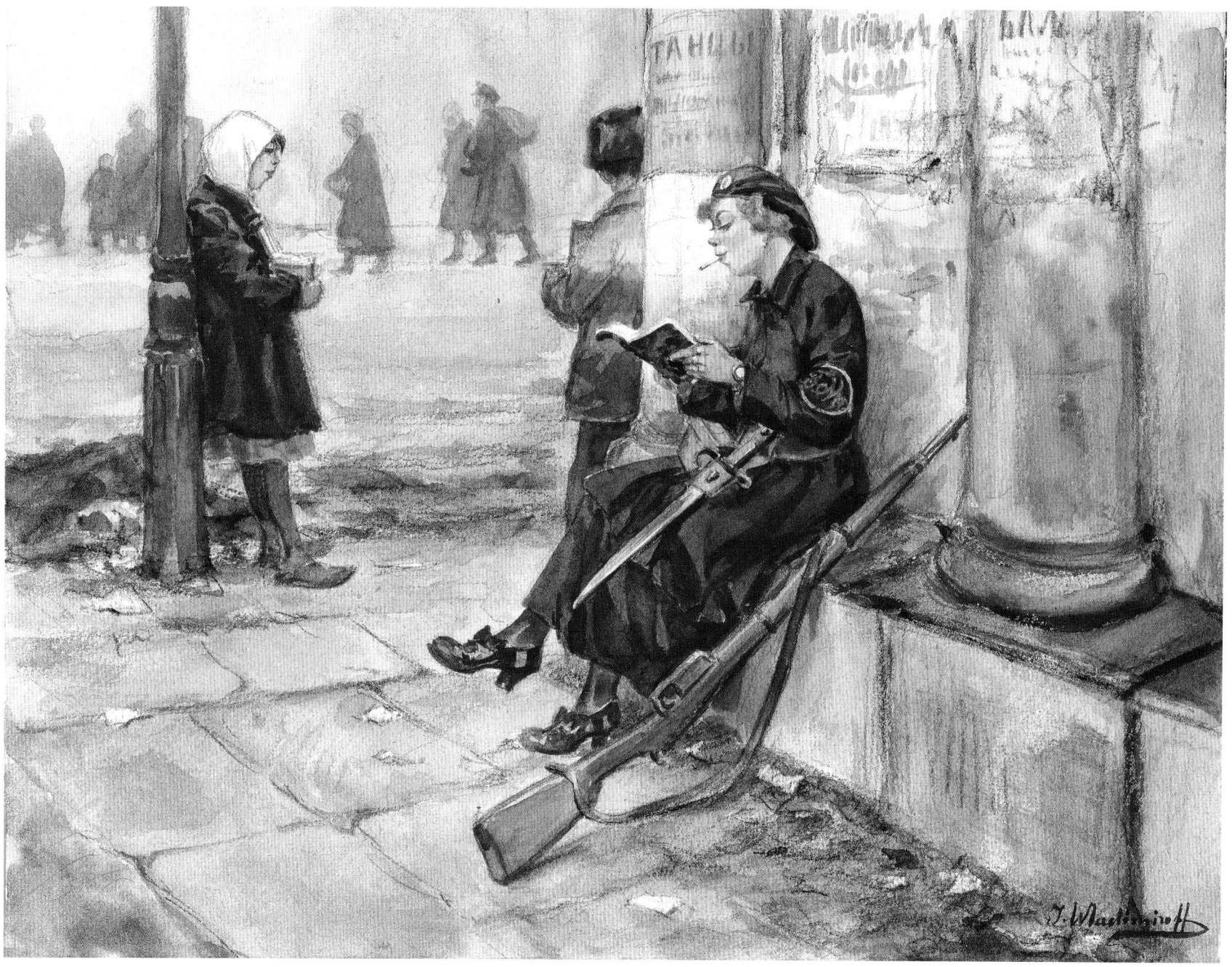

93. Policewoman 'On Duty' – 1919

ink, pencil & watercolour on paper
25.7 x 34.5cm
Andre Ruzhnikov Collection

> "
>
> Petrograd had become more and more like a village – not even a village, but a filthy camp of savage nomads. Grey, hideous-looking vagabonds in flapping greatcoats left a trail of mayhem in their wake. Nevsky Prospekt and the other main streets had become messy, overcrowded market-places. Buildings were covered with tattered advertising posters. People ate and slept on doorsteps amidst the rubbish, buying and selling everything they could. Armed soldiers strolled along in whatever clothes they had left, many in their under-garments. Sentries on duty lolled on chairs with cigarettes in their mouths, chatting to girls. Everyone was cracking sunflower seeds; the shells littered the streets. Shady-looking characters went for rides in court carriages drawn by over-worked, emaciated imperial horses. Their self-satisfied ladyfriends were driven around in the Tsar's already shabby automobiles.
>
> "

Nikolai Wrangel
Memoirs: From Serfdom to Bolshevism (1917)

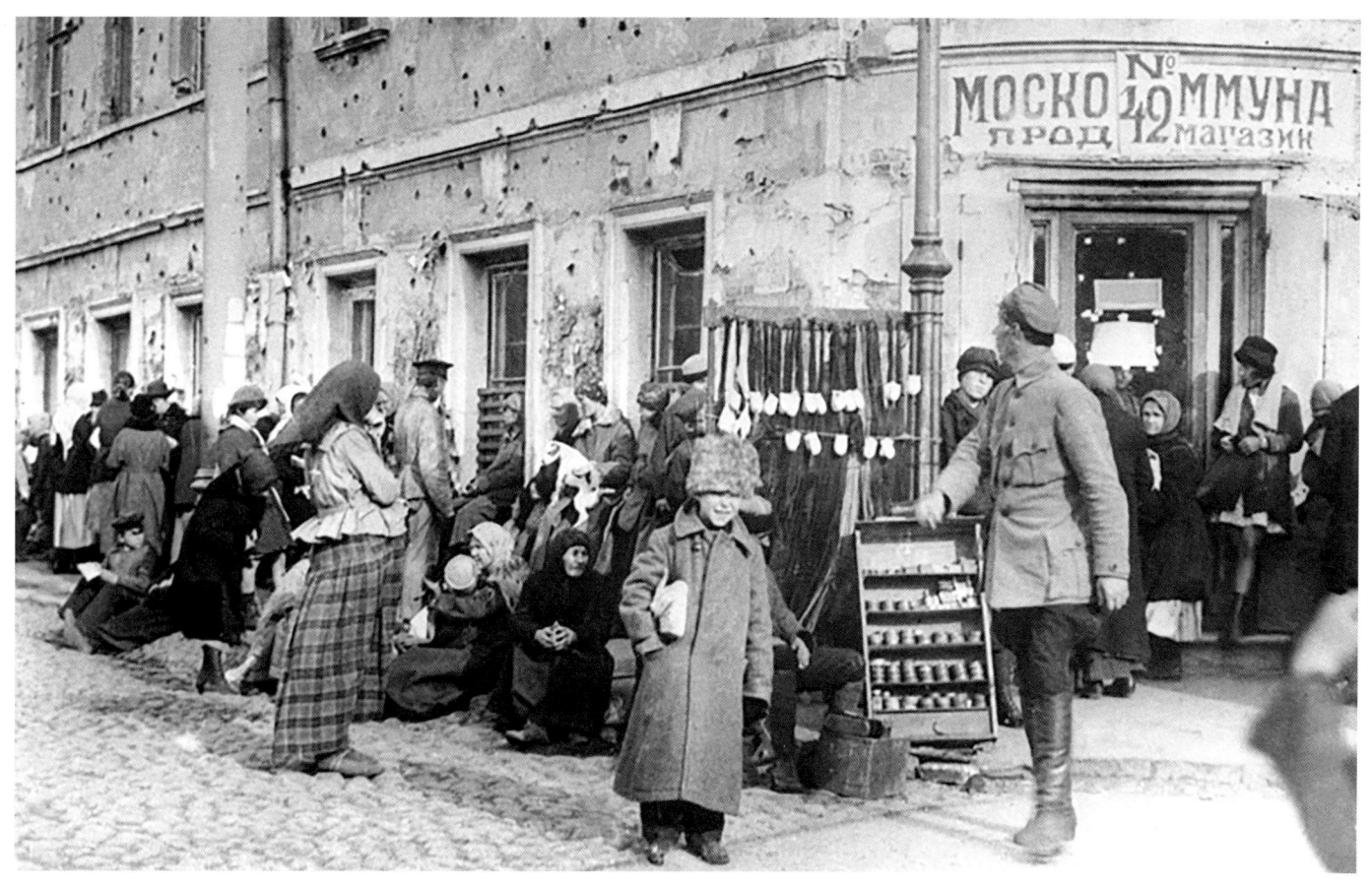

FOOD QUEUE ON THE CORNER OF NIKITSKAYA/ TVERSKOY BOULEVARD (MOSCOW 1920)

94. Sports Contest in the Summer Garden

ink, pencil & watercolour on paper
25.7 x 34.5cm
Andre Ruzhnikov Collectiona

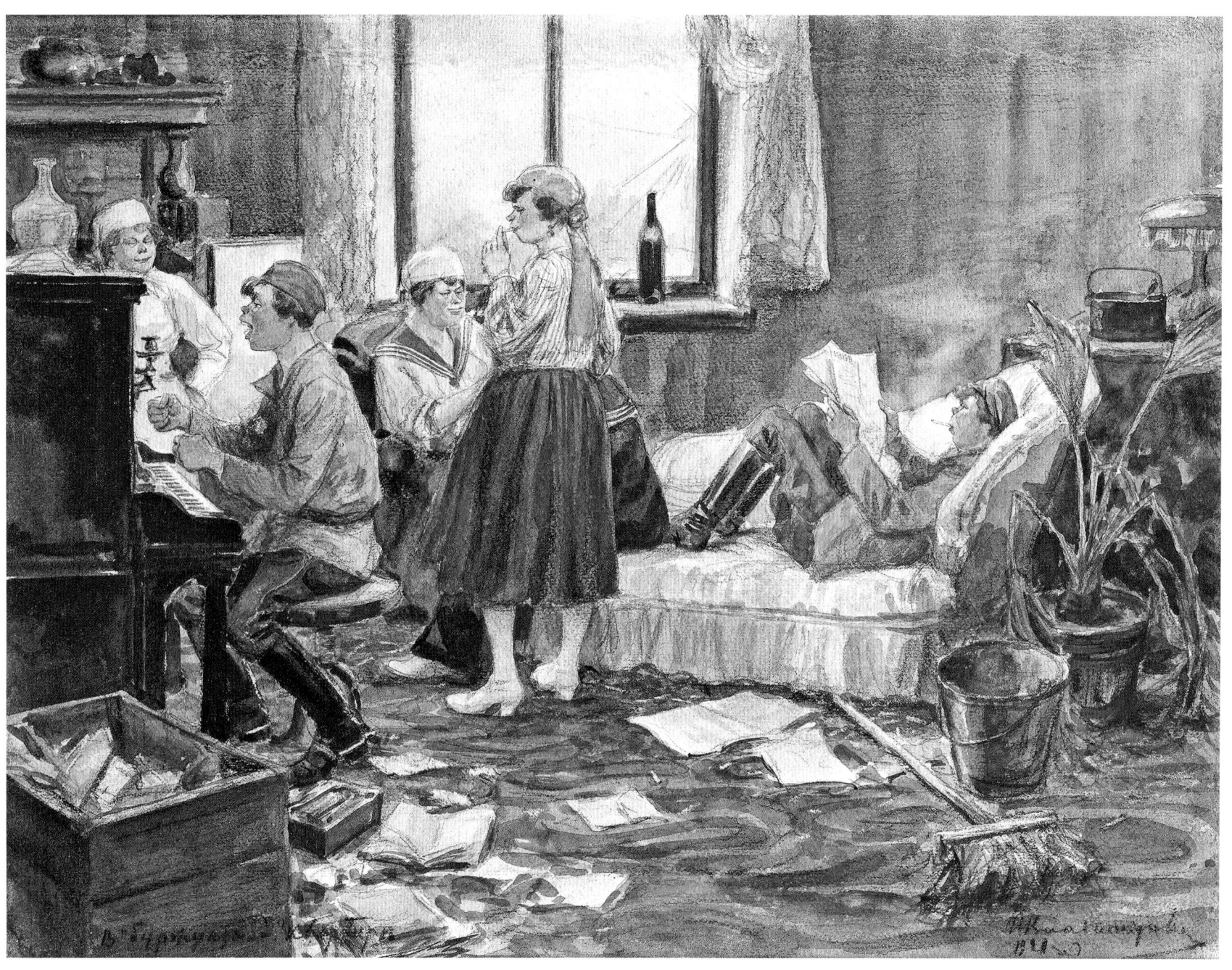

95. Inside a Bourgeois Apartment (1921)

ink, pencil & watercolour on paper
26.4 x 36.5cm
Andre Ruzhnikov Collection

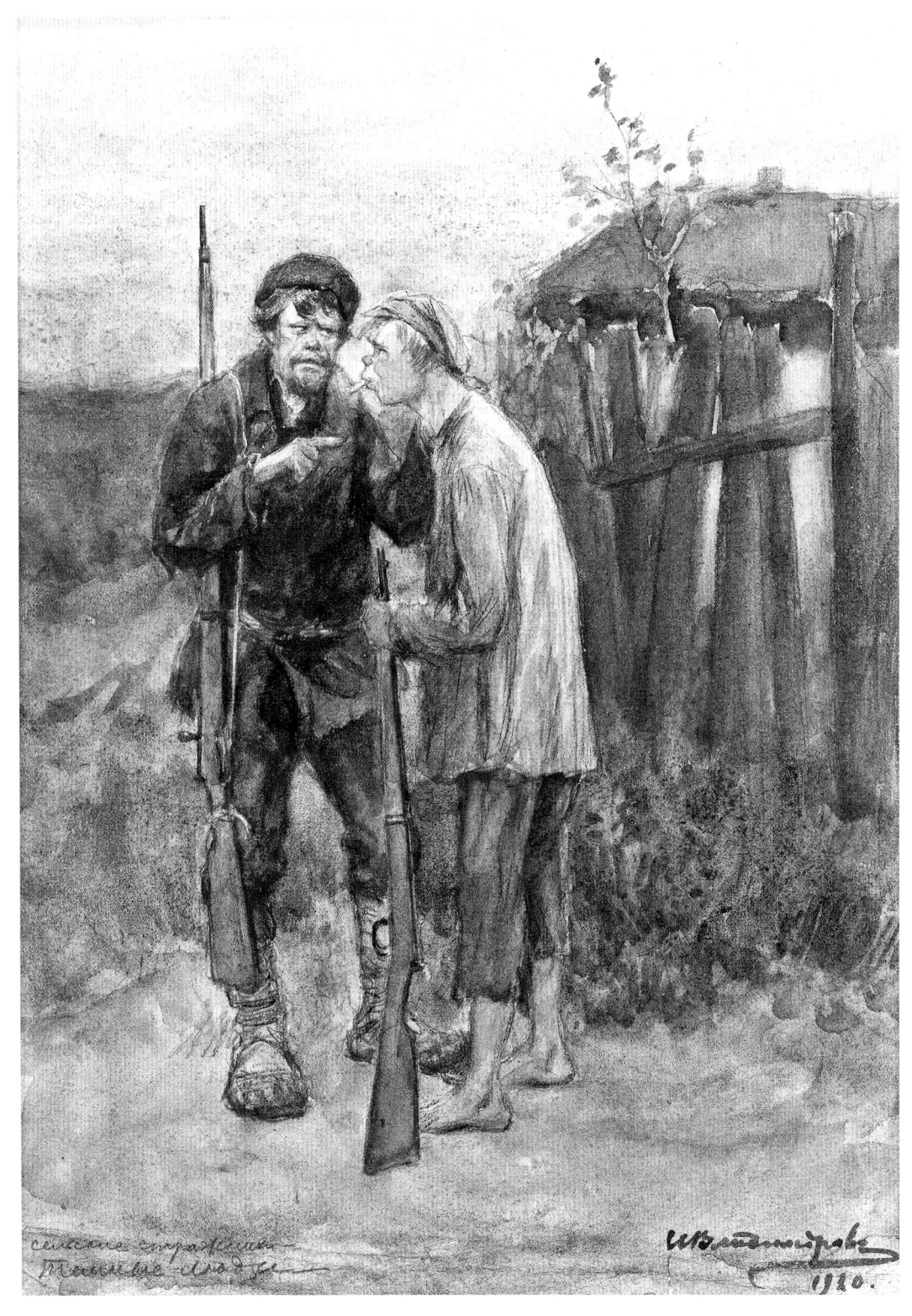

96. Village Guards – Ignorant People (1920)

ink & watercolour on paper
33.5 x 24.5cm
Andre Ruzhnikov Collection

97. No One to Protect Her (1921)

oil on canvas mounted on board
28.7 x 34.2cm
Vladimir Ruga Collection

98. Pleased To Meet You! (1925)

oil on canvas mounted on board
30.5 x 43.5cm
Vladimir Ruga Collection

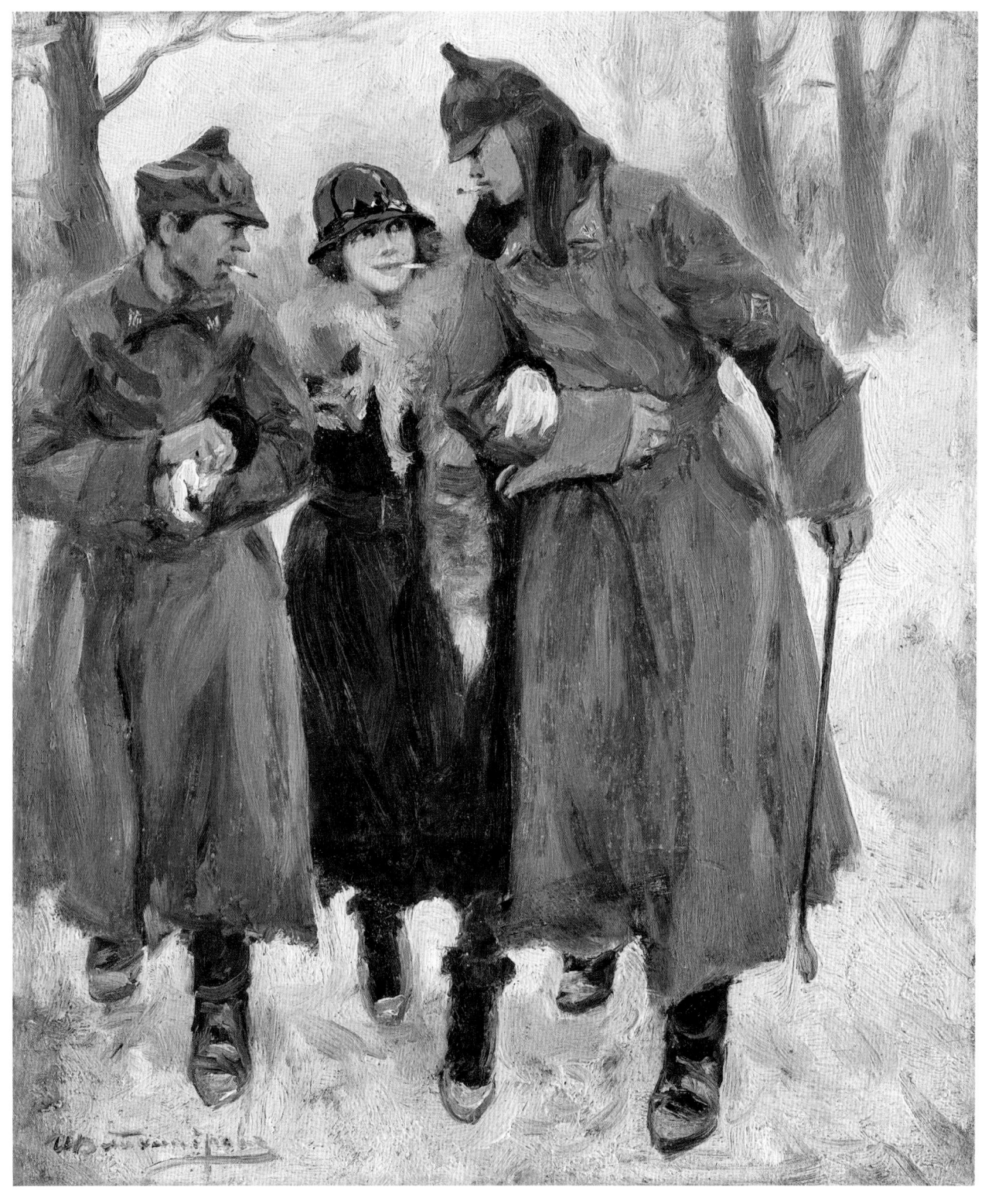

99. Young Lady with Two Red Army Soldiers

oil on canvas mounted on plywood
25.5 x 21.5cm
courtesy Sotheby's (London)

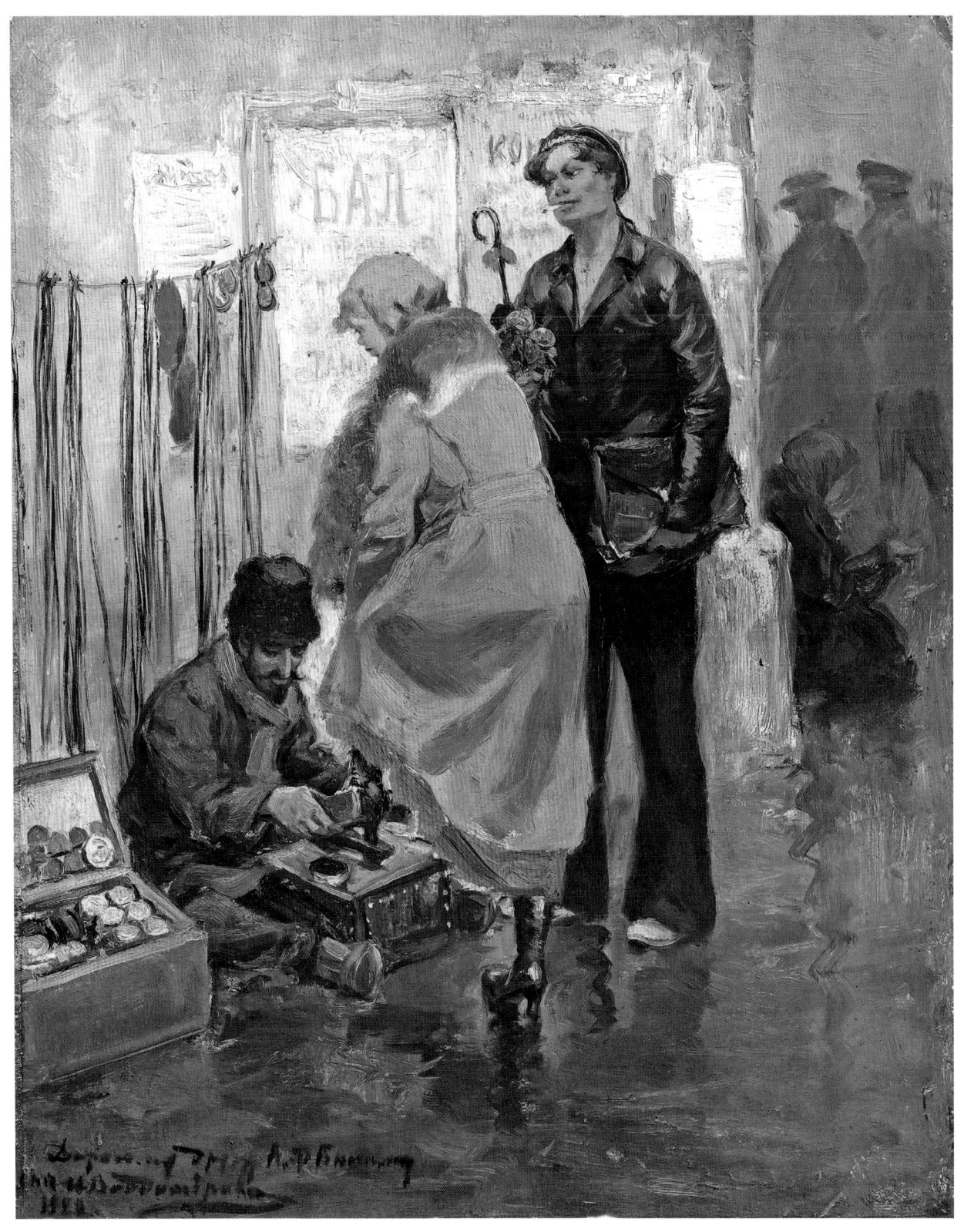

100. The Gallant Boyfriend (1922)

oil on canvas mounted on board
30 x 24.9cm
Vladimir Ruga Collection

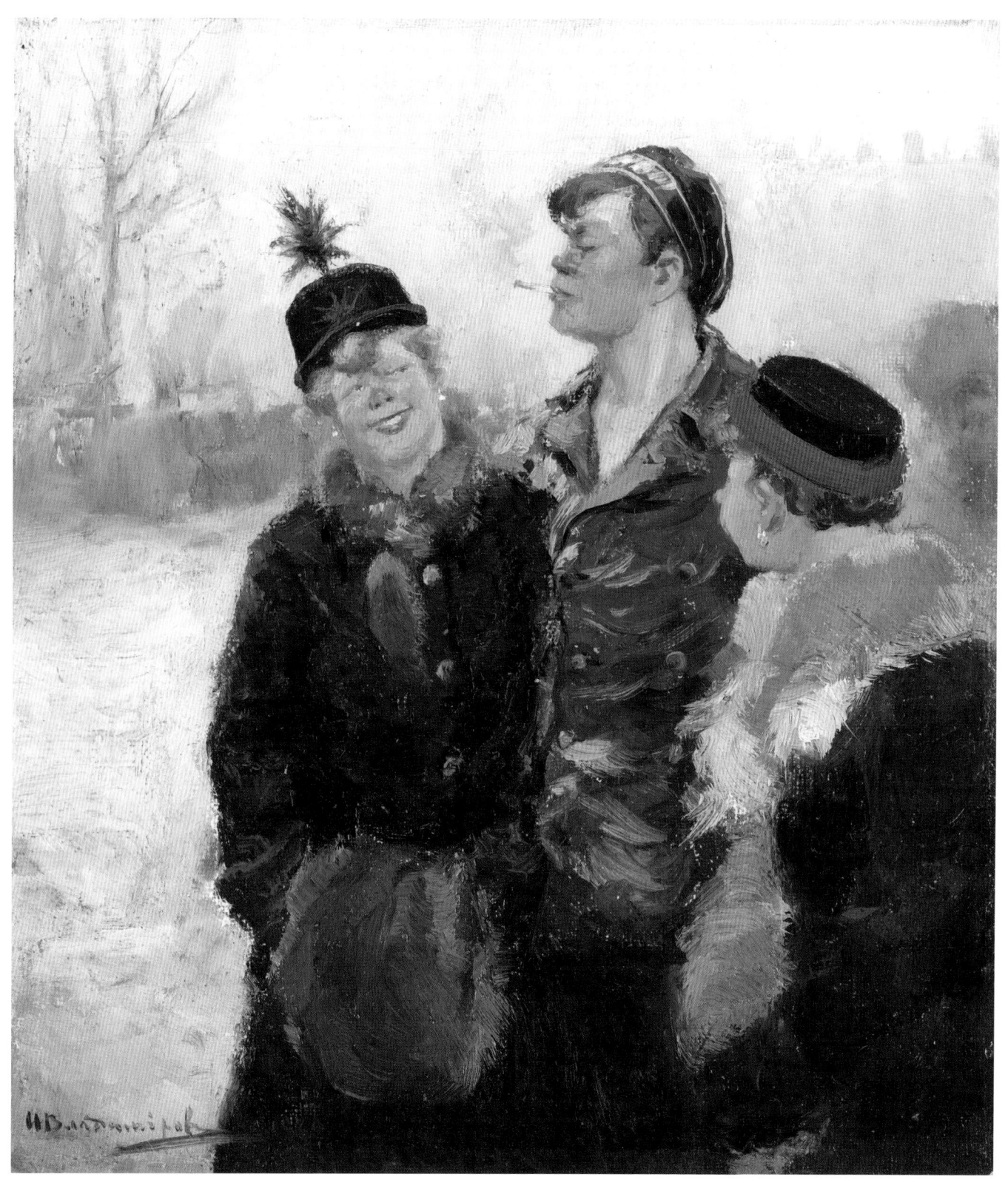

101. The Anarchist

oil on canvas mounted on plywood
21 x 19cm
Farfor-art Gallery (Moscow)

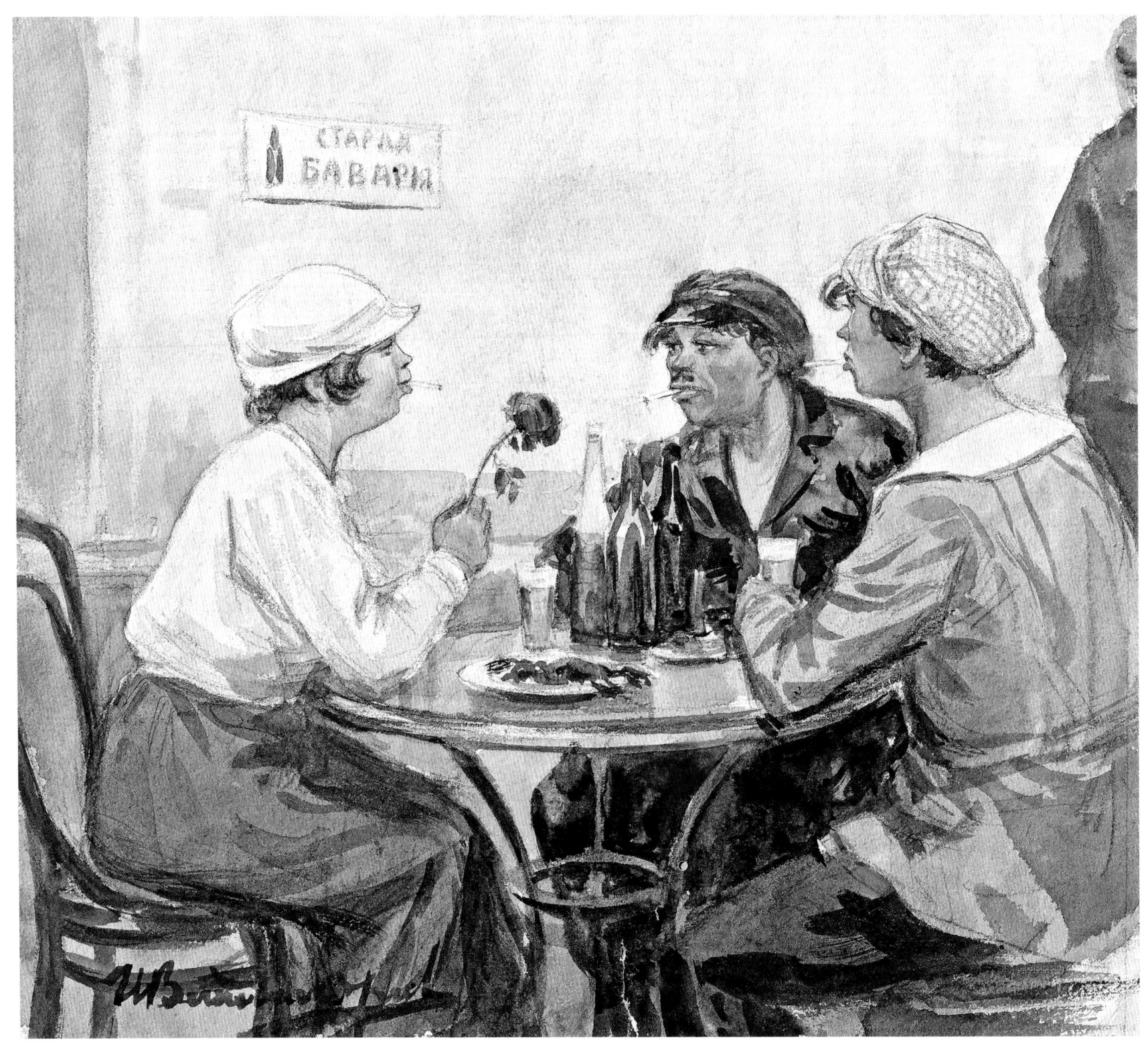

102. Old Bavaria Beer-Hall (1920s)

pencil & watercolour on paper
23 x 26cm
Vladimir Ruga Collection

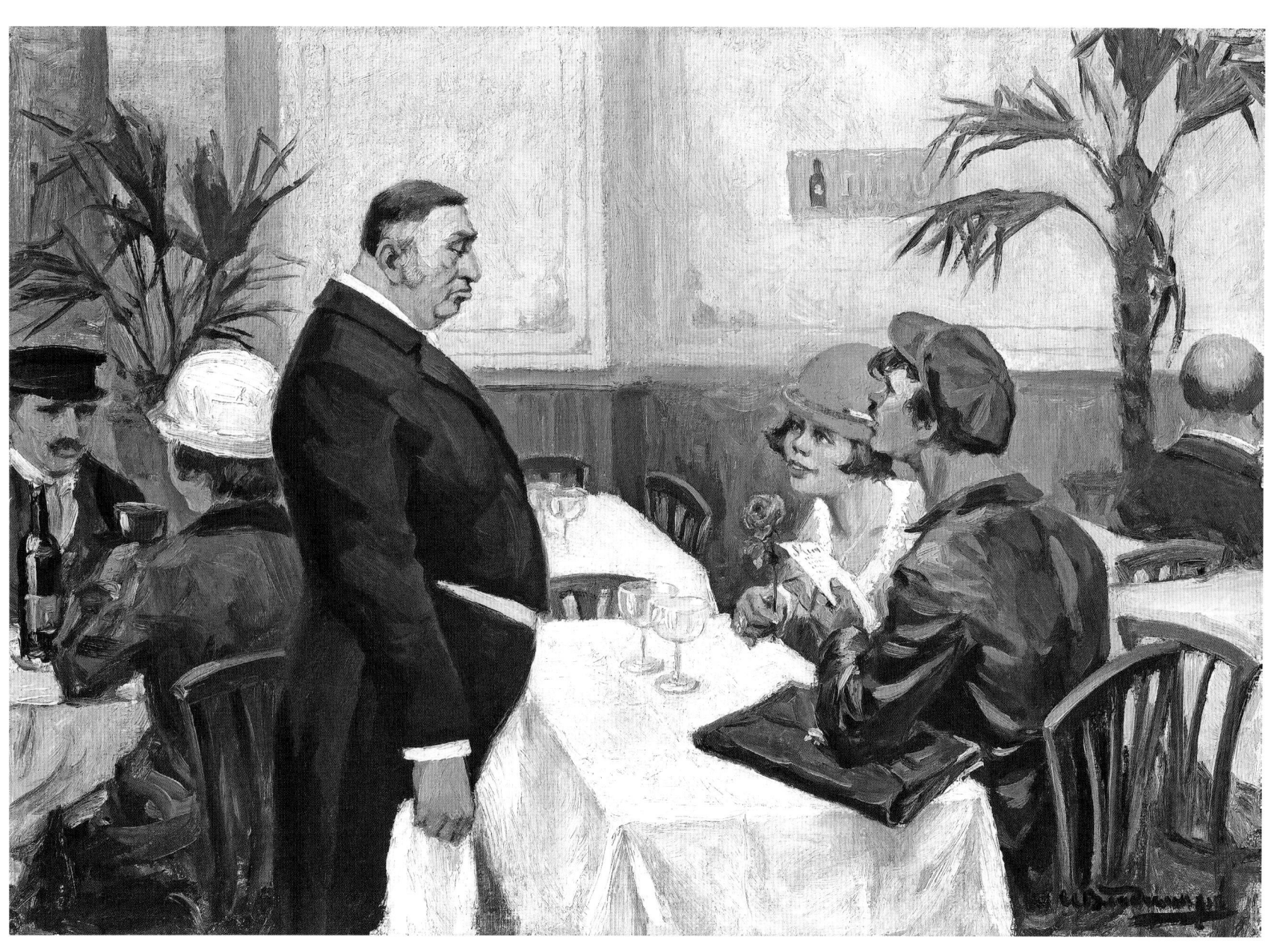

103. Grand Hotel Europa (1923)

oil on canvas mounted on plywood
29 x 41cm
Vladimir Ruga Collection

"

This morning I went for a long walk and had a look at all the various delegates who have turned up in Moscow. They were going around in groups. You could spot them by their curious, mean-looking faces. I was horrified at the thought of such bands of savages deciding the fate of this unhappy country – a filthy rabble guided by demagogues, trampling 'all that is great about this sacred land' into the mud – with not a single civilized person to direct or advise them, or to whom they could listen. These good-for-nothings just do what their Tsar – Ulyanov – tells them to. Then what?

"

Yuri Gautier
My Notes (14 March 1918)

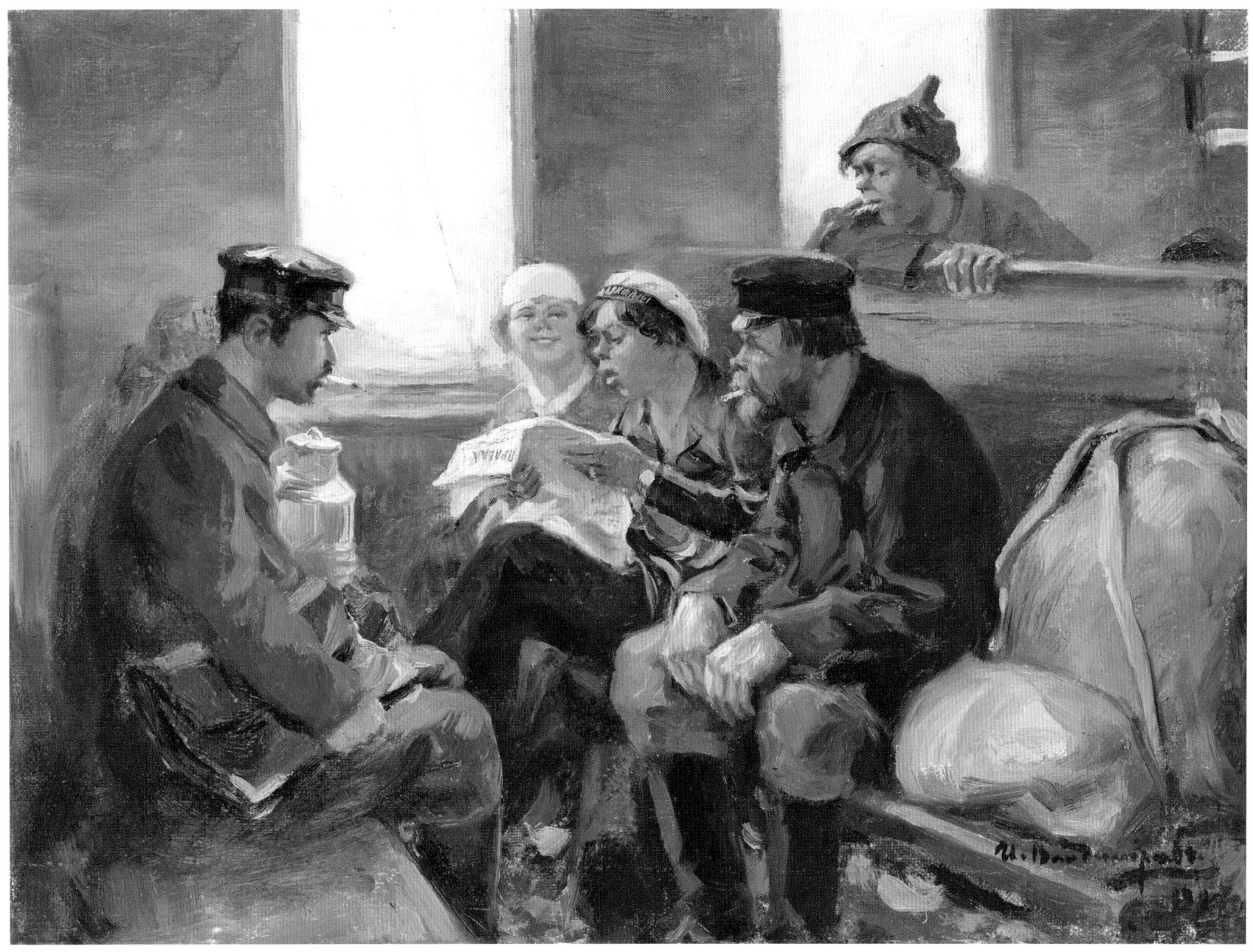

104. Political News (1920)
oil on canvas mounted on board
20.5 x 28cm
Andre Ruzhnikov Collection

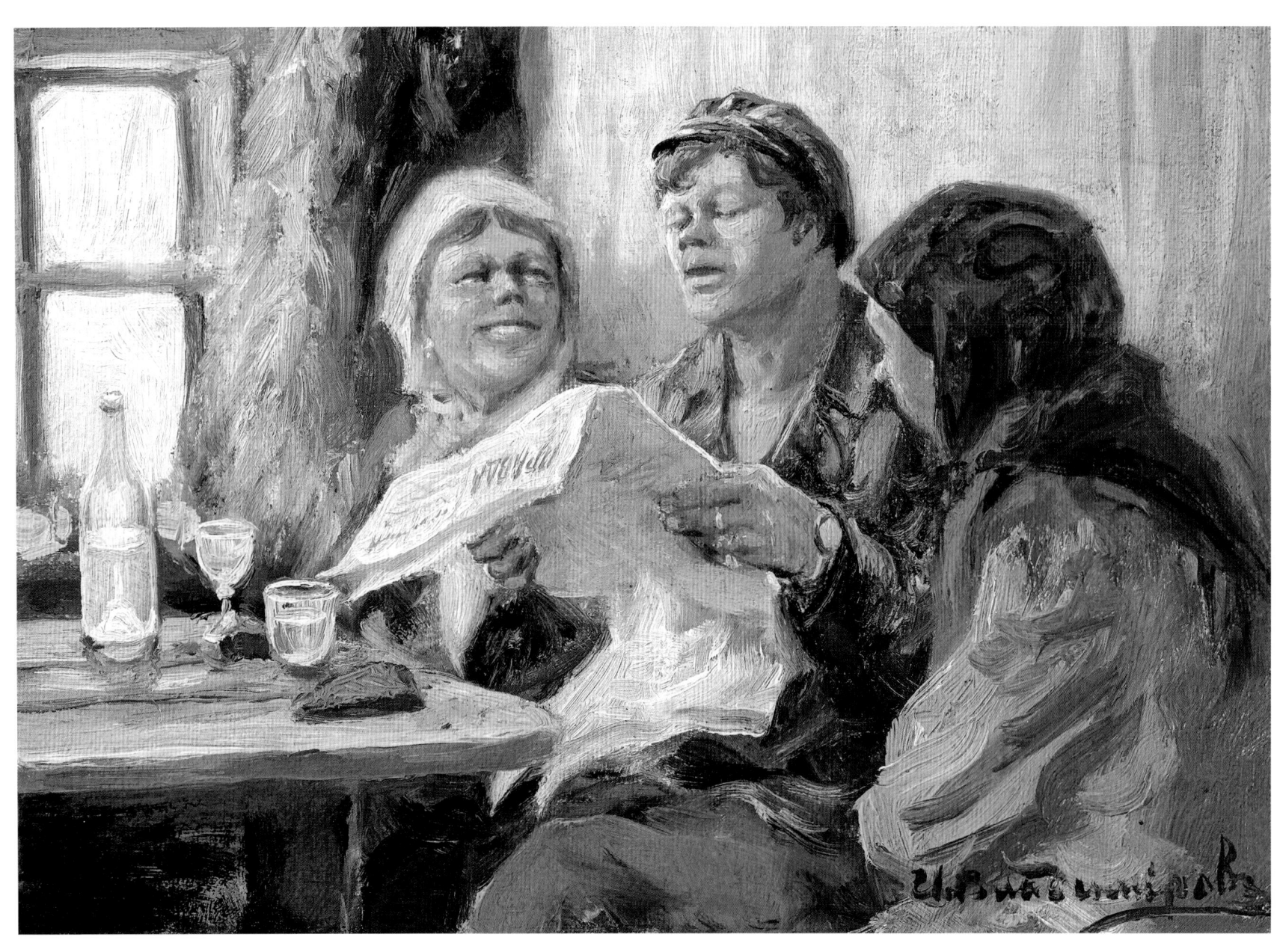

105. Reading Pravda (1923)

oil on canvas mounted on board
17.5 x 23.9cm
Vladimir Ruga Collection

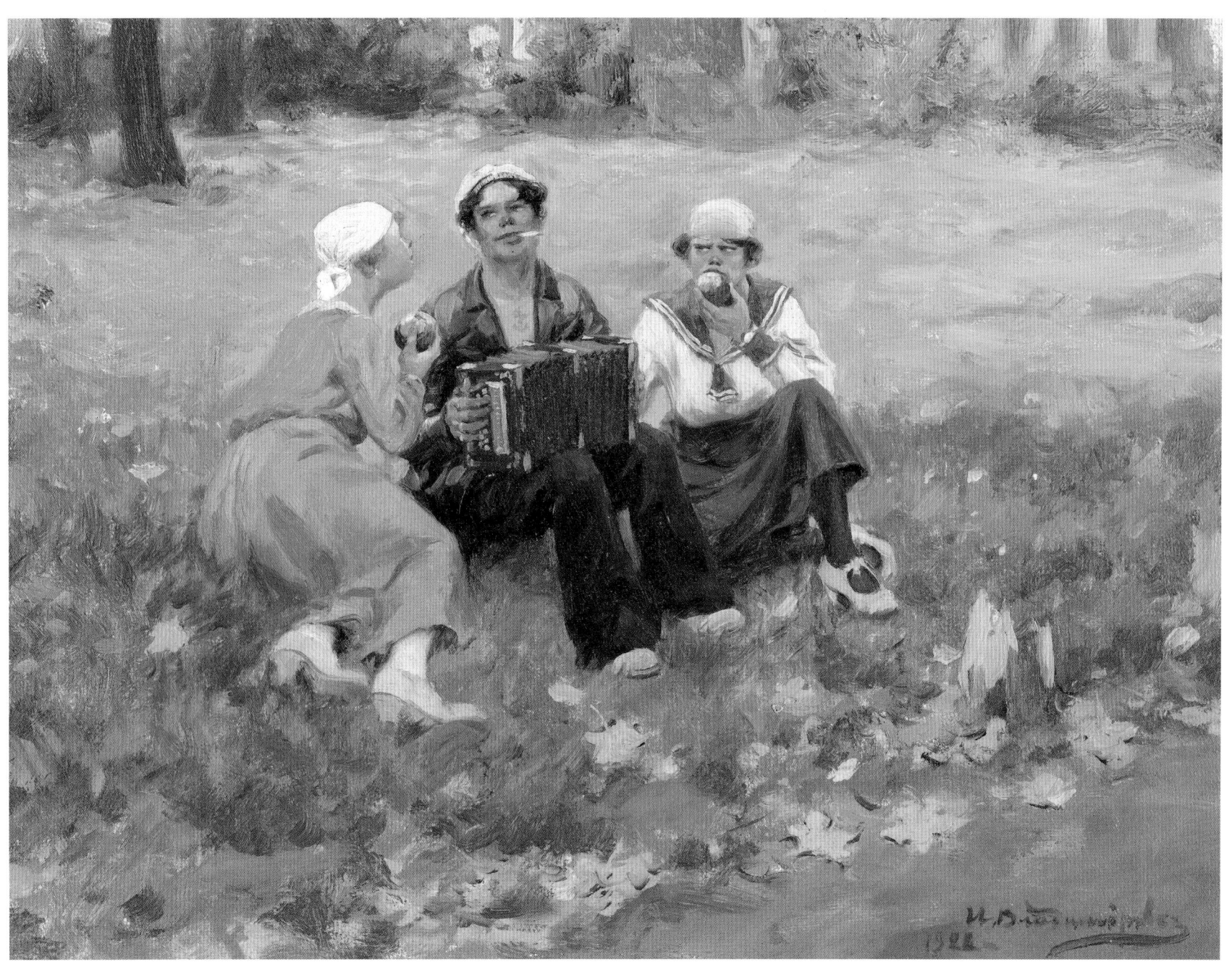

106. Accordionist & Two Girls in a Meadow (1922)

oil on board
30.2 x 41.5cm
Hoover Institution Library & Archives

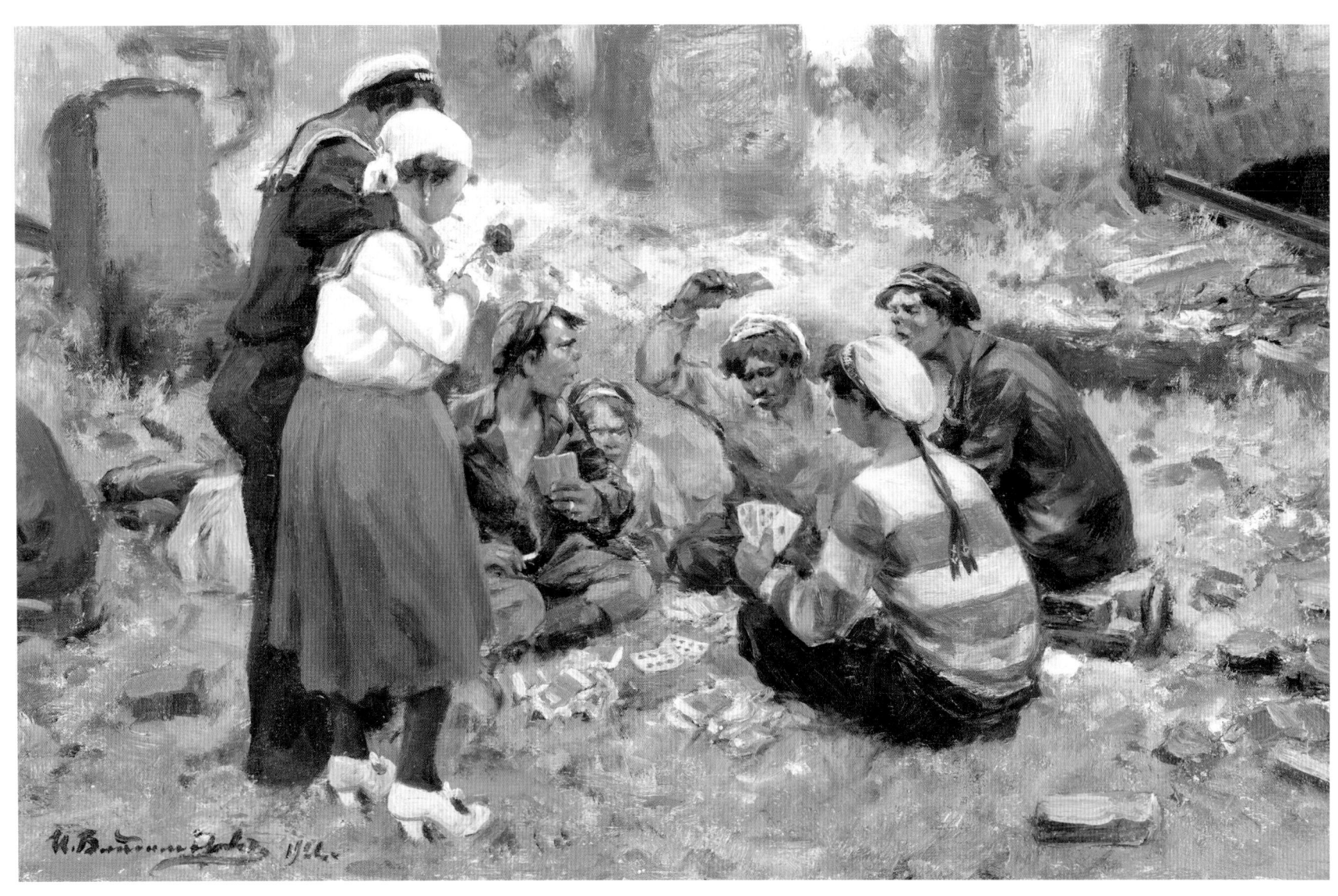

107. Playing Cards Amidst the Ruins (1922)

oil on board
29.2 x 49.7cm
Hoover Institution Library & Archives

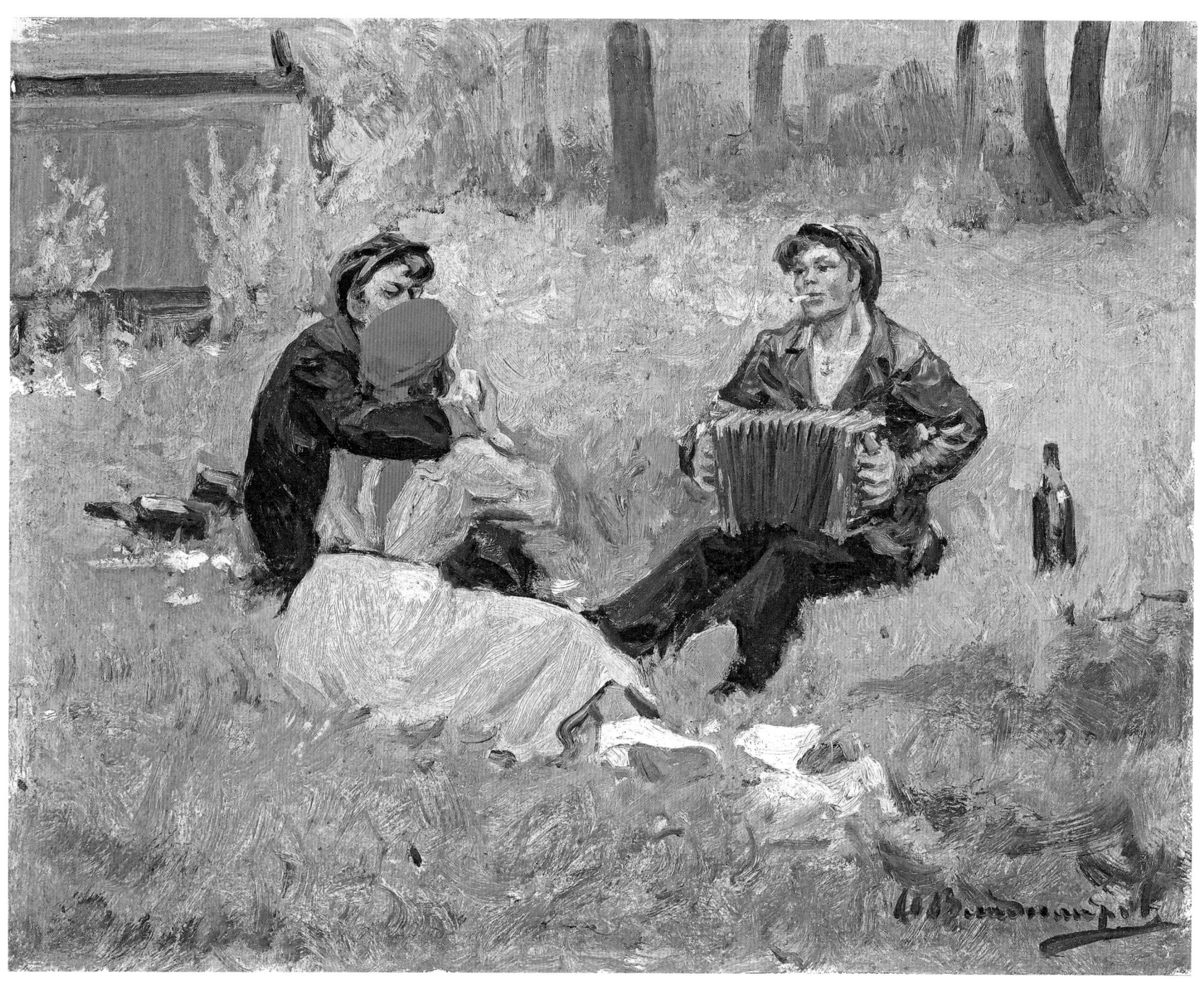

108. Having a Party (1920s)

oil on board
24.5 x 31.5cm
Vladimir Ruga Collection

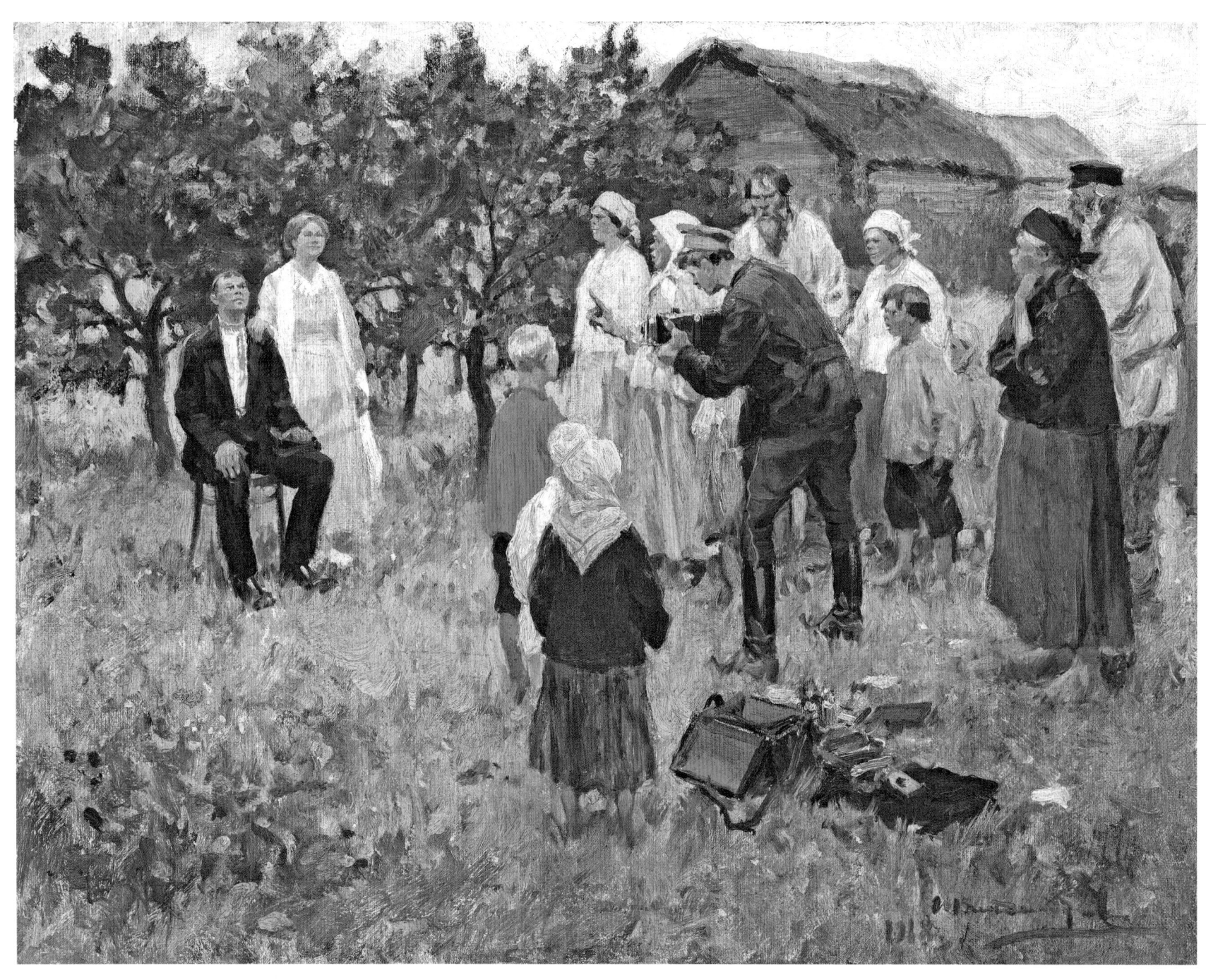

109. Village Photograph (1918)

oil on canvas
42.3 x 52.3cm
Vladimir Ruga Collection

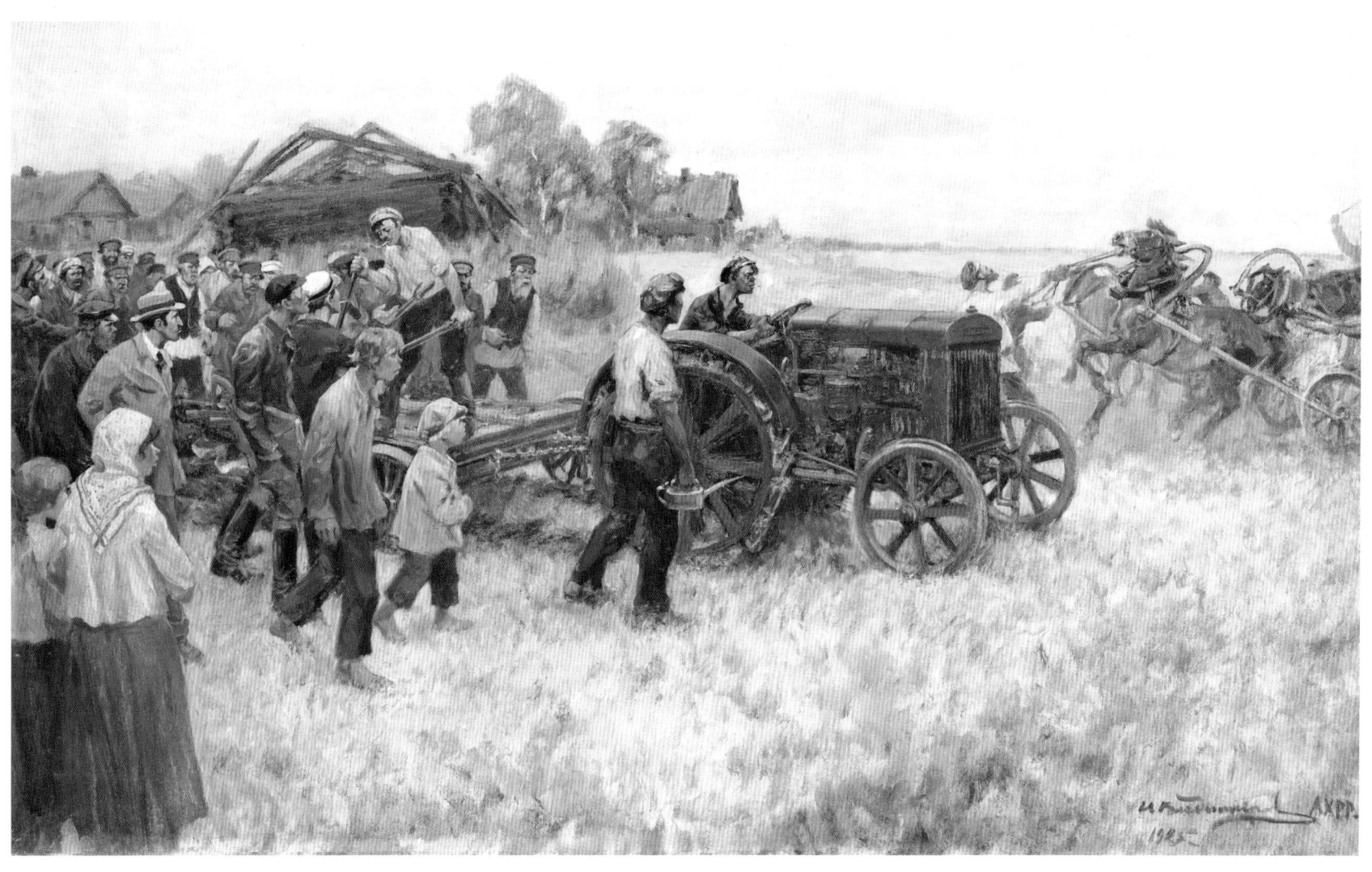

110. The First Village Tractor [Testing the Tractor] (1925)

oil on canvas
98 x 164cm
Central State Museum of Russian Modern History (Moscow)

Chapter 12

Annotated List
of Illustrations

compiled by Lada Tremsina

Abbreviations

AARR Association of Artists
of Revolutionary Russia

BMC Anne S.K. Brown Military
Collection, Brown University Library
(Providence, Rhode Island)

CSMRMH Central State Museum of Russian
Modern History (Moscow)

HHPLM Herbert Hoover Presidential Library
& Museum (West Branch, Iowa)

HILA Hoover Institution Library &
Archives, Stanford University
(Palo Alto, California)

NLR-MD National Library of Russia –
Manuscript Department
(St Petersburg)

***Collection 149**, Ivan Alexeyevich
Vladimorov,* including the following
albums:

Unit 7 February Revolution of 1917
(pencil 15.8 x 25cm)

Unit 8 October Revolution & Civil
War 1917–20 (pencil & watercolour
17 x 25.5cm)

Unit 9 Sketches of the Civil War
1918–24 (pencil, ink & watercolour
17 x 25.5cm)

Ruga Coll. Collection of Vladimir Ruga (Moscow)

Ruzhnikov Coll. Collection of Andre Ruzhnikov (London)

SMRPH State Museum of Russian Political History
(St Petersburg)

N.B.

Vladimirov often dated his pictures immediately after his signature. The dates when works appeared in the London weekly *The Graphic* (1917-January 1918) are given according to the Gregorian calendar (New Style), 13 days ahead of the Julian calendar (Old Style) used in Russia until 1 February 1918. The dates of the events depicted are included in the titles, while the years when the pictures were created are in parentheses after the titles.

Vladimirov's picture titles include references to several stations (and nearby settlements) on the Moscow-Vindava-Rybinsk railway line where he worked from 1919: Luga (now in Leningrad Oblast); Dno (Pskov Oblast); Valday & Lychkovo (Novgorod Oblast); Bologoye & Udomlya (Tver Oblast).

A number of pictures in the Andre Ruzhnikov Collection were formerly owned by the Swedish entrepreneur Axel Johansson (1891–1976), who acquired pictures by Vladimirov while he was living in Petrograd/Leningrad in the 1920s, buying wood. He later lived in Danzig, changing his surname to Benzler [source: Uppsala Auktionskammare].

Article Illustrations

p. 3 Vladimirov: Enemies of the People Taken for Trial (*cf*. n° 35)[1]

p. 5 Vladimirov: Requisitioning Ecclesiastical Property from the Church of the Presentation – Petrograd Side, detail (*cf*. n° 58)

p. 6 Vladimirov: Self-Portrait
oil on canvas mounted on board 40.3 x 30cm, initialled & dated bottom right: I.V. 15 May 1910
Ruga Coll.

p. 9 Vladimirov: Down with the Eagles – 2 March 1917, detail (*cf*. n° 8)

p. 11 Vladimirov: A Distinguished General (Prince Vasilchikov) in his Present Position, detail (*cf*. n° 66)

pp 11, 18 Vladimirov: Revolutionary Workmen & Solders Robbing a Liquor Store in Petrograd, details (*cf*. n° 19)

pp 17, 63 Vladimirov: At the Theatre – The Tsar's Box, detail (*cf*. n° 91)

p. 23 Ivan Vladimirov (1946) in the background: Vladimirov's Our Troops In Berlin (1946)

p. 27 Vladimirov: A Russian Family in 1923, detail (*cf*. n° 53)

p. 29 American Relief Administration Identity Card issued in the name of F.A. Golder 1 September 1921 (Frank Alfred Golder Papers, Box 1, Hoover Institution Archives)

pp 30, 47 Vladimirov: Guards Regiment Joining the Revolutionary Army on Liteiny Prospekt – 1 March 1917, details (*cf*. n° 1)

pp 32–33 Vladimirov: Miserable Life of Russian Nobles & Persons of High Rank – drawn from nature in the Home of General Buturlin, 1919, details (*cf*. n° 65)

p. 35 Vladimirov: Going Home with a Meal from the Communal Soup-Kitchen – Petrograd November 1919, detail (*cf*. n° 43)

p. 37 Vladimirov: Burning Eagles and Romanov Portraits – 5 March 1917, detail (*cf*. n° 11)

p. 39 Ivan Vladimirov Sketching Captured Japanese Officers in Manchuria (photograph, c.1904)

p. 40 Vladimirov: A Tayozhnik Exiles' Reservist, watercolour on board, 34 x 25cm, artist's inscription bottom right: „Таежникъ" запасн изъ ссыльныхъ ИВладиміров 1904 г., Ruga Coll.

p. 42 War Artist Ivan Vladimirov, photograph in *Niva* (St Petersburg), 14 November 1915, no 46 (p. 841), to the left: part of Vladimirov's painting Capture of a German Gun (1915), published in the same issue (p. 849)

Our Russian Artist Mr. John Wladimiroff
photograph in *The Graphic* (London)
5 January 1918 (p. 10)

1 for the numbers of the Vladimirov works reproduced in this book, see pp 65–76

p. 44 Nikolai Pavlov: *Portrait of Ivan Vladimirov* (1945), pencil on paper 36 x 26.5cm, signed & dated *НикПавл 1945* lower right, signed below *ИВладимиров* (Collection of Sergei & Tatiana Podstanitsky)

N.B. Drawing reproduced on the cover of invitations to the ceremony held on 27 February 1945 by the Leningrad Union of Artists to mark Vladimirov's 75th birthday and 50-year career as an artist

p. 49 Vladimirov: War Loan (poster c.1915)

Vladimirov: Abdication of Nicholas II (*The Graphic* 14 April 1917), *cf.* n° 9

p. 50 Vladimirov: Plundering the Country House of Prince Dolgoruky, (*The Graphic* 17 November 1917), *cf.* n° 23

p. 51 Vladimirov: Capturing the Enemy! (1942), pencil, watercolour & gouache on paper, 41.5 x 61.5cm, signed bottom left: *ИВладимиров 42*, Ruga Coll.

p. 53 Vladimirov: Sports Contest in the Summer Garden, detail (*cf.* n° 94)

p. 55 Vladimirov: Flight of the Bourgeoisie from Novorossiysk, detail (*cf.* n° 75)

p. 56 Vladimirov: Looting a Landed Estate, detail (*cf.* n° 25)

p. 59 Vladimirov: On Duty, detail, oil on canvas mounted on board, Ruga Coll.

p. 60 Vladimirov: Old Bavaria Beer-Hall, detail (*cf.* n° 102)

p. 63 Vladimirov: At the Theatre – The Tsar's Box, detail (*cf.* n° 91)

p. 65 Vladimirov: Execution at Dno Rail Station in 1919, detail (*cf.* n° 36)

p. 74 Vladimirov: On the Streets of Petrograd, detail (*cf.* n° 44)

p. 77 Vladimirov: In the Village of Gorki near Lychkovo – 12 June 1921, detail (*cf.* n° 27)

p. 78 Vladimirov: The Gallant Boyfriend, detail (*cf.* n° 100)

pp 79–80 Details from various works by Ivan Vladimirov, 1917–23

p. 81 Ivan Simakov: Forced Labour (1920), watercolour on paper 45 x 50cm, signed bottom left: *И.Симаков*, Ruzhnikov Coll.,

N.B. Ivan Vasilievich Simakov (1877–1925) was a graphic artist, cartoonist and book illustrator who worked in the Petrograd (Leningrad) branch of the State Publishing House from 1919-25

p. 83 Sergei Civinsky: Caricature of Bolsheviks (1923), watercolour on paper 44 x 93cm, signed bottom right: *С.Цивинский 1923*, Ruzhnikov Coll.

N.B. The background shows a section of the Kitay Gorod walls in Moscow, alongside the 16th century Vladimir Gate and 19th century Chapel of St Panteleimon the Healer (all demolished 1934), overlooking Lubyanka Square. Sergey Antonovich Civinsky (1895–1941), also known as Civis, was an officer in the Russian Imperial Army and self-taught artist. He worked as a cartoonist in Riga from 1920– 30, then in New York 1934–35. He was arrested by the NKVD in Riga in 1940, taken to Moscow and shot in 1941.

Reproductions of Works
by Ivan Vladimirov

1. Guards Regiment Joining the Revolutionary Army on Liteiny Prospekt – 1 (14) March 1917
ink & watercolour on paper 25.7 x 34.5cm
signed bottom right: *J.Wladimiroff*
artist's inscription on back: *Присоединеніе гвардейскаго полка къ революціонной арміи 1[?] марта 1917 года на Литейном проспекте*
ex-Benzler Coll.
Ruzhnikov Coll.

2. The February Days in the Working Suburbs (1917)
oil on canvas 57 x 100cm
signed bottom right: *ИВладиміровъ мартъ 1917 г.*
based on sketch from nature: *У бронирован[ного] автомобиля "Святослав". 28 февраля 1917*
('the armoured car *Svyatoslav* 28 February [13 March] 1917')
(NLR-MD Coll. 149, Unit 7, fol. 3)[1]
variants – see pp 278/9
SMRPH

3. Meeting in the Barracks (1932)
watercolour on paper 30 x 49cm
signed bottom left: *ИВладимиров 8.X.32*
based on sketch from nature: *Митинг в казармах. 28 февраля*
('Meeting in the barracks 28 February [13 March]')
(NLR-MD Coll. 149, Unit 7, fol. 6)
N.B. a similar drawing was published in *The Graphic* (London) on 21 April 1917, p. 457, signed: *Rousing the Russian soldier: a meeting in the Petrograd Barracks*
SMRPH

4. With the Red Flag Flying Fore and Aft: Lorry of Soldier-Revolutionaries Setting Off on a Police-Hunt
published in *The Graphic* (London), 14 April 1917 (p. 424), captioned *With the red flag flying fore and aft: A motor-lorry full of soldier-revolutionaries starting on a police-hunt*
signed bottom right: *JWladimiroff 12 March 1917*
based on sketch from nature: *На Большом проспекте* [On Bolshoi Prospekt]
(NLR-MD Coll. 149, Unit 7, fol. 1)

..

1 information on sketches from Vladimirov's work albums that served as the basis for his pictures (NLR-MD Collection 149) provided by Lada Tremsina

5. Armed Unit on the Streets of Petrograd – 28 February (13 March) 1917 (1917)
pencil & watercolour on paper 34.5 x 50cm
signed bottom right: *ИВладиміровъ 1917*
inscribed by artist bottom left: *Дорогому Владиміру Александровичу Бонди на память о революціи въ Россіи от художника ИВладимірова.* [to Dear Vladimir Alexandrovich Bondi in memory of the Revolution in Russia from the artist I. Vladimirov]
N.B. Vladimir Bondi (1868–1934) was a Tsarist-era writer and journalist, who edited the St Petersburg newspaper *Birzhevye Vedomosti* [Stock-Exchange News] and its spin-off Ogonyok (to which Vladimirov contributed). He was arrested in 1931 for transgressing Article 58. His date of death is sometimes given as 1947.
SMRPH

6. Revolutionaries Storming the Hotel Astoria
published in *The Graphic* (London), 14 April 1917 (p. 424), captioned REVOLUTIONISTS STORMING THE HOTEL ASTORIA
signed bottom right: *J Wladimiroff 13 March 1917*
based on sketch from nature: *Разгром Астории* [Storming the Astoria]
(NLR-MD Coll. 149, Unit 7, fol. 22)
N.B. The Hotel Astoria opened on St Isaac's Square in St Petersburg in 1912. During World War One it served as an army hotel and home to officers of the General Staff. During the 1917 February Revolution it was stormed by revolutionary soldiers and sailors.

7. Down with the Eagles!
Published in *The Graphic* magazine (London), 14 April 1917 (p. 419), captioned *Down with the Eagles!*
signed bottom right: *J.Wladimiroff 13 March 1917*
based on sketch from nature: *Долой орловъ!*
(NLR-MD Coll. 149, unit 7, fol. 23)
N.B. The same drawing was subsequently published in the Moscow newspaper *Iskry* (no 18) on 14 (27) May 1917 (pp 140/1), entitled Снятие с вывески двуглавого орла [removing the sign's double-headed eagle], and also published in *The History of the Civil War in the USSR*, Vol. I (1935), p. 70 as Уничтожение царских эмблем [Destruction of Tsarist Emblems]
variants – see pp 280/1

8. Down with the Eagles – 2 (15) March 1917
ink & watercolour on paper 25.5 x 34.5cm
signed bottom right: *J.Wladimiroff*
artist's inscription on the back: *"Долой орла" 1917 г
(2 марта)*
ex-Benzler Coll.
Ruzhnikov Coll.

**9. Abdication of Nicholas II (drawn from notes
supplied by General Ruzsky)**
published in *The Graphic,* 14 April 1917 (p. 425),
captioned *The abdication of Nicholas II drawn
from notes supplied by General Russky to our
special artist* with explanatory note *Drawn by John
Wladimiroff, Petrograd*
N.B. Infantry General Nikolai Ruzsky (1854–1918)
was Commander-in-Chief of the Northern Front in
March 1917, and among those who persuaded Tsar
Nicholas II to abdicate. He accepted his abdication
on 2 March 1917 in the saloon-carriage of the
Imperial train at Pskov station. General Ruzsky was
killed by the Bolsheviks in Pyatigorsk in October
1918.

10. Abdication of Nicholas II (1917)
oil on canvas 89 x 72cm
signed bottom right: *ИВладимировъ 1917*
SCMRCH

**11. Burning Eagles and Romanov Portraits –
5 (18) March 1917 (1917)**
ink & watercolour on paper mounted on board
25.7 x 34.5cm
signed bottom right: *ИВладимировъ 1917*
artist's inscription bottom left: *Сожжение орловъ
и царскихъ портретовъ 5 марта 1917 г.* [Burning
of the eagles and Tsarist portraits 5 *(18)* March 1917]
based on sketch from nature: *Сожжение орлов
на Невском* [Burning Eagles on Nevsky]
(NLR-MD Coll. 149, Unit 7, fol. 25)
BMC

12. February 1917 – Alarming News (1917)
oil on canvas mounted on board 38.5 x 57cm
signed bottom right: *ИВладиміров 1917*
SCMRCH

13. All Power to the Soviets! (1917/18)
ink & watercolour on paper mounted on board

36.5 x 26.4cm
signed bottom right: *ИВладиміров*
Ruga Coll.

**14. Vandalism of the Revolutionaries– Scene
in the Winter Palace – 1917**
ink, pencil & watercolour on paper 29.2 x 39.4cm
signed bottom right: *J Wladimiroff*
artist's inscription on back: *Vandalism of the
revolutionalists, a scene in one of the rooms of
Winter Palace in December 1918.*
N.B. The date of December 1918 is obviously
wrong: according to contemporary reports, acts of
vandalism in the Winter Palace took place after its
seizure by Bolshevik forces on the night of October
25/26 (November 7/8) in the year *1917.* On October
28 (November 10) a commission under Alexandre
Benois started to assess the damage. The Palace
was declared a State Museum soon afterwards.
HILA

**15. Bombarding the Kremlin: (1) Artillery Fire from
Strastnoy Monastery (2) Flames Engulfing the
Cathedral of the Twelve Apostles**
published in *The Graphic* (London), 19 January 1918
(p. 69), captioned *The bombardment of the Kremlin:
(1) Artillery firing from the Strastnoy monastery; (2)
The Cathedral of the Twelve Apostles on fire.*
signed bottom right: *J.Wladimiroff*

16. Red Guards Forcing Their Way Into The Kremlin
published in *The Graphic* (London), 19 January 1918
(p. 68), captioned T*he Red Guards forcing
an entrance into the Kremlin*
signed bottom right: *J.Wladimiroff*

**17. Wanton Destruction: Wrecking Shops
in Petrograd**
published in *The Graphic* (London), 17 November
1917 (p. 616), captioned *Wanton destruction:
wrecking shops at Petrograd*
signed bottom right: *J.Wladimiroff*

**18. Wrecking a Foodshop in Petrograd in February
1917 (1926)**
oil on plywood 48 x 61.5cm
signed bottom left: *И.Владиміровъ*
SCMRCH

19. Revolutionary Workmen & Solders Robbing a Liquor Store in Petrograd – January 1919
ink, pencil & watercolour on paper 29.2 x 39.4cm
artist's signature bottom right masked with paper strip
artist's inscription on back: *Revolutionary workmen and soldiers robbing a wine-shop in Petrograd (January 1919)*
HILA

20. Requisitioning Bank-Notes, Obligations etc. from Wawelberg Bank – Petrograd 1919
pencil & watercolour on paper 29.2 x 39.4cm
signed bottom right: *J.Wladimiroff* (traces of masking-strip)
artist's inscription on back: *Requisition of banknotes, obligations etc. from the treasury of Vavelberg-bank in Petrograd (1919)*
based on sketch from nature: *Реквизиция процентных бумаг из банка Вавельберга*
[Requisition of interest-bearing securities from the Wawelberg Bank]
(NLR-MD Coll. 149, Unit 9, fol. 25)
N.B. Wawelberg Bank (from 1912, the *St Petersburg Commercial Bank*) was located at 7/9 Nevsky Prospekt; owner Mikhail Ippolitovich Wawelberg (1880–after 1936) acquired several pictures by Vladimirov at exhibitions held prior to 1917; he later lived in Poland and France
HILA

21. Confiscating Valuables – Wawelberg Bank, March 1919
ink & watercolour on paper 25.7 x 34.7cm
signed bottom right: *J.Wladimiroff*
artist's inscription on back: *Конфискація ценностей из сейфовъ / банк Вавельберга. март 1919 г.*
based on sketch from nature: *Сцена в банке Вавельберга в ноябре 1919 г.*
[Scene in the Wawelberg Bank November 1919]
(NLR-MD Coll. 149, 9, fol. 43)
ex-Benzler Coll.
Ruzhnikov Coll.

22. Requisitioning Bank Safes – December 1917
watercolour on paper mounted on board 33.5 x 51cm
signed bottom left: *ИВладиміров*
SCMRCH

23. Pillage: Plundering the Country House of Prince Dolgoruky
published in *The Graphic* (London), 17 November 1917 (p. 615), captioned *ANARCHY IN RUSSIA – Pillage: Plundering the country house of Prince Dolgoruki*
signed bottom right: *J.Wladimiroff*
N.B. Prince Dolgorukov's dacha by the Malaya Nevka on Kamenny Island was a neo-Classical mansion built in the 1830s for Prince Vasily Dolgorukov (1786–1858) and subsequently owned by Duke Peter of Oldenburg (1812–81)

24. Looting the Estate of an Aristocrat (Prince Vasilchikov) in Autumn 1919 (1922)
ink & watercolour on paper 26 x 34.3cm
signed bottom right: *И.Владиміровъ 1922*
artist's inscription on back: *Разгромъ барской усадьбы осенью 1919 года (разгромъ дома кн. Васильчикова)*
ex-Benzler Coll.
Ruzhnikov Coll.

25. Looting a Landed Estate (1926)
oil on canvas mounted on plywood 47 x 61cm
signed bottom right: *ИВладиміров*
SCMRCH

26. Peasants Returning Home after Pillaging a Nobleman's Estate near Pskov - 1919
pencil & watercolour on paper 29.2 x 39.4cm
artist's signature bottom right masked by paper strip
artist's inscription on back: *Russian peasants returning home after pillaging a country-house of a rich landlord (near Pskoff 1919)*
based on sketch from nature: *После раздела барского имения. Сентябрь 1919* [After looting a nobleman's estate - September 1919]
(NLR-MD Coll. 149, Unit 9, fol. 35)
HILA

27. In the Village of Gorki near Lychkovo – 12 June 1921 (1922)
ink & watercolour on paper mounted on board 25.5 x 34cm
signed bottom right: *И.Владиміровъ 1922*
based on sketch from nature: *В деревне Горки близ Лычково. 12 июня 1921 г.* [In the village of Gorki near Lychkovo 12 June 1921]

(NLR-MD Coll. 149, Unit 9, ff 36v, 37)
ex-Benzler Coll.
Ruzhnikov Coll.

28. At The Piano (1920s)
ink & watercolour on paper mounted on board
23.8 x 29.2cm
signed bottom right: *ИВладимиров*
Ruga Coll.

29. Arrested Intellectuals Escorted to Ulitsa Gorokhovaya
pencil & watercolour on paper 25.5 x 34cm
signed bottom right: *J.Wladimiroff*
artist's inscription on the back: *Арест интеллигентов и конвоирование на Горохов 2.*
based on sketches from nature: *Саботажники ведут на Гороховую, 2. 18 февраля 1919*
[Saboteurs led to Gorokhovaya 2 –
18 February 1919]
(NLR-MD Coll. 149, Unit 8, ff 18, 47)
N.B. the Petrograd Extraordinary Commission was housed at 2 Ulitsa Gorokhovaya from 1918
ex-Benzler Coll.
Ruzhnikov Coll.

30. Arrest of Tsarist Generals (1926)
oil on canvas 69 x 104cm
signed bottom right: *ИВладиміровъ*
variants – see pp 282/3
SCMRCH

31. Massacre: The Murder of Officers from Vyborg Garrison
published in *The Graphic* (London), 17 November 1917 (p. 617), captioned *MASSACRE: THE MURDER OF OFFICERS OF THE VIBORG GARRISON*
mention bottom right: *Drawn by our Special Artist, J.Wladimiroff*
signed bottom left: *J.W.*

32. Policemen Shot on Krestovsky Bridge – 3 (16) March 1917
ink & watercolour on paper 25.7 x 34.3cm
signed bottom right: *J.Wladimiroff*
artist's inscription on back: *Разстрелъ полицейских на Крестовском мосту 3 марта 1917 года*
N.B. the title probably refers to Bolshoi Krestovsky

Bridge across the Malaya Nevka in St Petersburg
ex-Benzler Coll.
Ruzhnikov Coll.

33. Blight of Bolshevik Barbarism
published in *The Graphic* (London), 31 August 1918 (p. 235), captioned *Destruction in Russia: blight of bolshevik barbarism*
signed bottom right: *J.Wladimiroff 1918*

34. Red Guard Unit in a Village – December 1917/ February 1918 (1923)
watercolour on paper 33 x 51cm
signed bottom right: *И Владиміровъ 1923*
based on sketch from nature: *Проезд революционного отряда через ... в 1918 году (Кирилково)* [Passage of a revolutionary unit through... in 1918 (Kirilkovo)]
(NLR-MD Coll. 149, Unit 9, fol. 40)
SCMRCH

35. Enemies of the People Taken for Trial
ink & watercolour on paper 24.8 x 34.1cm
signed bottom right: *J.Wladimiroff and To Mr. Colton with my best wishes...*
inscribed by artist bottom left: *Врагов народа к суду... Enemys of the people – to judgment...*
based on the following sketches from nature:
– *Удомля 5 декабря 1919 г.*
[Udomlya 5 December 1919]
(NLR-MD Coll. 149, Unit 9, fol. 18v)
– *Врагов народа к суду!*
[Enemies of the people to trial!]
(ibid, fol. 19)
– *На суд. ст. Удомля 1919 г.*
[To the court – Udomlya Station 1919]
(ibid, fol. 26)
N.B. From 1918-24 Ethan T. Colton (1872–1970) administered the Russian Famine aid programme for the European Student Relief, and served as YMCA liaison to the American Relief Administration
variants – see pp 284/5
HHPLM

36. Execution at Dno Rail Station in 1919 (1920)
ink & watercolour on paper mounted on board
25 x 34cm
signed bottom right: *И.Владиміровъ 1920*

based on sketch from nature: *Расстрел грабителя.
Ст. Дно, 12 сентября 1919 г.* [Execution of a Thief –
Dno Station 12 September 1919]
(NLR-MD Coll. 149, Unit 8, fol. 16)
ex-Benzler Coll.
variants – see pp 294/5
Ruzhnikov Coll.

37. Landowner & Priest Sentenced to Death
by a Revolutionary Tribunal – Valday 1919
pencil & watercolour on paper 29.2 x 39.4cm
signed bottom right: *J.Wladimiroff*
inscription on back: A *landlord and a russian pope
condemned to death by a revolutionary tribunal
(at Valdai 1919)*
HILA

38. Tribunal Interrogating the Accused - 1920
pencil & watercolour on paper 25.7 x 34.3cm
signed bottom right: *J.Wladimiroff*
artist's inscription on back: *Допрос подсудимого
в трибунале 1920 год* [Interrogation of defendant
at tribunal 1920]
based on sketch from nature: *Допрос в трибунале*
[Interrogation at the tribunal]
(NLR-MD Coll. 149, Unit 9, fol. 20)
ex-Benzler Coll.
Ruzhnikov Coll.

39. The Internationale – Agitpunkt Scene
at Dno Rail Station (1922)
ink & watercolour on paper 25.7 x 34.5cm
signed bottom right: *И.Владиміровъ 1922*
artist's inscription on the back: *"Интернаціоналъ"
(Сцена въ "Агитпункте" железнодорожн. вокзала
на ст. Дно)* ['The Internationale – scene from
railway Agitpunkt at Dno station']
ex-Benzler Coll.
Ruzhnikov Coll.

40. Lecturing Peasants About Marx
ink & watercolour on paper 25.7 x 34.5cm
signed bottom right: *J.Wladimiroff*
artist's inscription on back: *Лекція о Марксе для
крестьян в деревне* [Lecture on Marx for peasants
in a village]
based on sketch from nature: *Лекция о Марксе
в деревне. В Лычкове. 1920 г.*
[Lecture on Marx in a village – Lychkovo 1920]

(NLR-MD Coll. 149, Unit 9, fol. 24)
ex-Benzler Coll.
variants – 286/7
Ruzhnikov Coll.

41. Bolsheviks in the Village (1920)
ink & watercolour on paper mounted on board
25.5 x 33.5cm
signed bottom right: *ИВладиміровъ 1920 г.*
Ruzhnikov Coll.

42. Hungry People of All Classes Outside
a Communal Soup-Kitchen – Petrograd 1919
pencil & watercolour on paper 29.2 x 39.4cm
signed bottom right *J.Wladimiroff*
inscription on back: *Hungry days in Petrograd.
Hungry people of all classes eating their portions
at the doors of a "Communial dining-room." 1919*
HILA

43. Going Home with a Meal from the Communal
Soup-Kitchen – Petrograd November 1919
pencil & watercolour on paper 29.2 x 39.4cm
artist's signature bottom right masked by paper strip
inscribed on back: *Hungry years in Petrograd. The
inhabitants returning home with their dinners from
a Communal soup-kitchen. November 1919.*
based on sketch from nature: *Голодное время. С
коммунистическими обедами* [Time of Hunger.
With communist meals]
(NLR-MD Coll. 149, Unit 8, fol. 35)
N.B. Illustrations 43, 44 & 71 depict Znamenskaya
Square in Petrograd – heart of the 1917
revolutionary demonstrations and known since
November 1918 as *Площадь Восстания* (Uprising
Square). Trubetskoy's equine monument to Tsar
Alexander III, installed here in 1909 but removed
in 1937, is now located in front of St Petersburg's
Marble Palace.
HILA

44. On the Streets of Petrograd
oil on canvas mounted on board 42.2 x 66.7cm
signed bottom right: *ИВладиміровъ*
Ruga Coll.

45. Waiting for 1/8th of a Pound of Bread - 1919
pencil & watercolour on paper 29.2 x 39.4cm
artist's signature bottom right masked by paper strip

artist's inscription on back: *Waiting to receive 1/8th of a pound of bread (1919)*
HILA

46. Hungry Workers Stealing Bread from an Army Truck – Petrograd 1920

pencil & watercolour on paper 29.2 x 39.4cm
artist's signature bottom right masked by paper strip
artist's inscription on back: *Hungry Workmen robbing bread from a military lorry-car in Petrograd (1920)*
based on sketch from nature: *Разграбление хлеба голодными солдатами и народом на Выборгской стороне.22 февраля 1921 г.* [Looting of bread by hungry soldiers and people on the Vyborg Side – 22 February 1921]
(NLR-MD Coll. 149, Unit 9, fol. 18)
HILA

47. Mother & Daughter Scavenging for Potato-Peel & Herring-Heads to Eat – Petrograd January 1919

pencil & watercolour on paper 29.2 x 39.4cm
artist's signature bottom right masked by paper strip
artist's inscription on back: *Hungry time in Petrograd. A lady and her daughter searching for potatoe-peel and herring-heads to eat. (January 1919.) (drawn from nature)*
based on watercolour from nature: *Поиски картофельной шелухи в помойных кучах* [Searching for potato-peel amidst the rubbish]
(NLR-MD Coll. 149, Unit 8, fol. 25)
HILA

48. Famine in Petrograd – 1919

pencil & watercolour on paper 29.2 x 39.4cm
artist's signature bottom right masked by paper strip
inscribed bottom left: *„1919 годъ"*
artist's inscription on back: *Hungry times in Petrograd*
based on a sketch from nature:
Буржуйки собирают картофельную шелуху и головки воблы и селедки в помойных ямах. 24 декабря 1919 г. [Bourgeois elements scouring the rubbish for potato-peel and herring-heads – 24 December 1919]
(NLR-MD Coll. 149, Unit 8, fol. 28)
variants – see pp 288/9
HILA

49. Cutting Up a Dead Horse for Food on the Fontanka in 1919 (1920)

pencil & watercolour on paper 25.7 x 34.2cm
signed bottom right: *J.Wladimiroff 1920.*
artist's inscription on back: *Разделъ павшей лошади для еды. На Фонтанке / въ 1919 году*
based on sketch from nature: *Раздел палой лошади на углу Б. Разночинной и Геслеровского пер[еулка] 25 октября 1919 г.* [Cutting up a horse on the corner of Bolshaya Raznochinnaya and Geslerovsky Pereulok on 25 October 1919]
(NLR-MD Coll. 149, Unit 8, ff 22, 28v)
ex-Benzler Coll.
variants – see pp 290/1
Ruzhnikov Coll.

50. He Who Died from Hunger Falls Prey to Hungry Hounds – Petrograd January 1919

pencil & watercolour on paper 29.2 x 39.4cm
artist's signature bottom right masked by paper strip
artist's inscription on back: *A man dead of hunger is a prey for hungry dogs. (Petrograd January 1919) (drawn from nature)*
based on watercolour sketch from nature:
Замерзший человек – радость голодных собак [A frozen man brings joy to hungry hounds]
NLR-MD Coll. 149, Unit 8, fol. 51)
HILA

51. Robbing a Goods Truck – 12 February 1922

pencil & watercolour on paper 25.5 x 34.5cm
signed bottom right: *J.Wladimiroff*
artist's inscription on back: *Ограбление товарнаго вагона (12 февр 1922 года)*
based on sketch from nature:
Ограбление товарных вагонов на запасных путях. Ст. Бологое [Robbing a goods truck in a siding at Bologoye station]
(NLR-MD Coll. 149, Unit 8, fol. 55)
N.B. the sign on the goods truck reads *Помощь голодающим Шведского Красного Креста* (Famine Relief – Swedish Red Cross)
ex-Benzler Coll.
variants – see pp 292/3
Ruzhnikov Coll.

52. American Relief Administration (ARA) Food Distribution Point (1922)

watercolour on paper 30.5 x 38.1cm

signed bottom right: *J.Wladimiroff 1922.*
N.B. The American Relief Administration (ARA) was
a charity organization founded in 1919 to provide
famine relief in Europe. It strove to eliminate hunger
in Soviet Russia by opening food distribution points,
soup kitchens and shelters in 38 provinces.
By Summer 1922 up to 10 million people had
received assistance from the ARA, which employed
some 300 Americans and 120,000 Soviet citizens.
HHPLM

53. A Russian Family in 1923 (1923)
watercolour on paper 29.2 x 39.4cm
signed bottom right: *J.Wladimiroff 1923* above
artist's inscription *To Mr Renshaw as a souvenir
of the hungry years in Petrograd. With my sincere
regards John Wladimiroff – 19 June 1923*
N.B. From 1921-23 Donald Renshaw (1889–1961)
worked as head of famine relief for the ARA in
Moscow then Petrograd. The initials ARA can
be seen on the sack of provisions in this picture
(believed to depict Vladimirov and his family).
HILA

54. A Priest with ARA Provisions (1922)
pencil & watercolour on paper 25 x 33.5cm
signed bottom right: *J.Wladimiroff 1922*
N.B. The initials ARA can be discerned on the sack
of provisions
Ruga Coll.

55. Priests Burying Church Valuables in a Cemetery near Luga (1922)
watercolour on paper 25.7 x 34.2cm
signed bottom right: *И.Владиміровъ 1922*
variants – see pp 296/7
Ruzhnikov Coll.

56. Priests Forced to Clean Out the Stables
ink & watercolour on paper 25.7 x 34.5cm
signed bottom right: *J.Wladimiroff*
artist's inscription on back: *Принудительная
очистка конюшен священнослужителями*
based on sketch from nature:
*Старики-священники чистят двор в казармах
Финл полка. Вас ост. 5 окт. 1918 г.*
[Elderly Priests cleaning the courtyard of the Finnish
Regiment Barracks – Vasilevsky Island 5 Oct. 1918]
(NLR-MD Coll. 149, Unit 8, fol. 13)

ex-Benzler Coll.
variants – see pp 300/1
Ruzhnikov Coll.

57. Firing on a Religious Procession in Tula: Bishop Cornelius Wounded by the Red Guard
published in *The Graphic* (London), 20 April 1918
(p. 489) captioned *Firing on a religious procession
in the streets of Joula : the Russian bishop Cornelius
wounded by the Red guard* and *PRESENTED BY OUR
SPECIAL ARTIST JOHN WLADIMIROFF*
N.B. On 15 February 1918 Bishop Cornelius Sobolev
(1880–1933) was wounded by Red Army gunfire
during a religious procession in Tula. His ministry
was terminated in 1927 and he died in 1933 after
being assaulted.

58. Requisitioning Ecclesiastical Property from the Church of the Presentation – Petrograd Side
ink & watercolour on paper 25.7 x 34.2cm
signed bottom right: *J.Wladimiroff*
artist's inscription on back: *Реквизиция
церковнаго имущества церкви Введенія
на Пет стороне*
N.B. The Neo-Classical Church of the Presentation
of the Blessed Virgin, built in 1793–1810
on St Petersburg's Ulitsa Vvedenskaya, was
demolished in 1932. 'Petrograd Side'
(Petersburg Side before 1914) is a district
of St Petersburg north of the Neva.
ex-Benzler Coll.
variants – see pp 298/9
Ruzhnikov Coll.

59. Priests Escorted to Trial – Nevsky Prospekt 1922
ink & watercolour on paper 29.2 x 39.4cm
artist's signature bottom right masked by paper strip
artist's inscription on back: *Russian priests
conveyed to judgement (1922) (a scene
on the Nevsky Prospect)*
HILA

60. Requisitioning the Peasant's Last Cow - 1919
pencil & watercolour on paper 25.5 x 34.5cm
signed bottom right: *J. Wladimiroff*
artist's inscription on back: *Реквизиція последней
коровы у крестьянина 1919 год*
based on sketch from nature: *Реквизиция коровы*

[Requisition of a cow]
(NLR-MD Coll. 149, Unit 9, fol. 2)
ex-Benzler Coll.
variants – see pp 302/3
Ruzhnikov Coll.

61. Requisitioning Flour from Wealthy Peasants in a Village near Pskov 1922
pencil & watercolour on paper 29.2 x 39.4cm
signed bottom right: *J.Wladimiroff*
artist's inscription on back: *Requisition of flour from rich peasants in a village (a scene near Pskoff) 1922.*
based on sketch from nature:
Вывоз собранной развёрстки (зерна и муки)
[Removal of grain and flour]
(NLR-MD Coll. 149, Unit 9, fol. 7)
HILA

62. Looking for Deserters (1920)
ink pencil & watercolour on paper 25.6 x 34.3cm
signed bottom right: *Wladimiroff 1920*
based on sketch from nature: *Поиски дезертиров, спрятавшихся в деревнях. 10 октября 1920 г.*
[Looking for deserters hiding in the villages –
10 October 1920]
(NLR-MD Coll. 149, Unit 8, fol. 43)
BMC

63. Peasant Reprisals on a Bolshevik (1921)
ink & watercolour on paper 25.3 x 33.8cm
signed bottom right: *J.Wladimiroff 1921*
based on sketch from nature:
Дикая расправа в деревне. 18 год [Savage reprisals in a village 1918]
(NLR-MD Coll. 149, Unit 9, fol. 11v)
ex-Benzler Coll.
Ruzhnikov Coll.

64. An Engineer's Family with their Remaining Possessions (1919)
pencil & watercolour on paper 34 x 25.7cm
signed bottom right: *ИВладимировъ 1919 г*
ex-Benzler Coll.
Ruzhnikov Coll.

65. Miserable Life of Russian Nobles & Persons of High Rank – drawn from nature in the Home of General Buturlin – 1919
pencil & watercolour on paper 29.2 x 39.4cm
artist's signature bottom right masked by paper strip
artist's inscription on the back: *Miserable life of Russian nobles and persons of high rank during the revolution (drawn from nature in the home of general Buturline) 1919*
N.B. Vladimirov portrays either Sergei Buturlin (born 1842, died after 1920) or his younger brother Dmitry Buturlin (1850–1920); both were retired Infantry Generals [information kindly provided by military historian Dr Sergei Volkov]
HILA

66. Sic Transit Gloria Mundi: A Distinguished General (Prince Vasilchikov) in his Present Position – Petrograd June 1922
pencil & watercolour on paper 29.2 x 39.4cm
artist's signature bottom right masked by paper strip
artist's inscription along bottom: *SIC TRANSIT GLORIA MUNDI... ('Thus Passes Worldly Glory...')*
artist's inscription on back: *A distinguished general (Prince Vasiltchikoff) in his present position. (June 1922. Petrograd)*
N.B. Prince Sergey Vasilchikov (1849–1926) became a Cavalry General in 1910 [information kindly provided by Dr Sergei Volkov]
HILA

67. Forced Labour for the Bourgeois (1920)
pencil & watercolour on paper 25.8 x 34.4cm
signed bottom right: *J.Wladimiroff 1920*
based on sketch from nature:
Буржуи на принудительных работах. 2 марта 1919 г. [Bourgeois in forced labour – 2 March 1919]
(NLR-MD Coll. 149, Unit 8, fol. 26)
BMC

68. Forced Labour for Wealthy Merchants, Noblemen & Criminals during the Revolutionary Years of 1919-22
ink & watercolour on paper 29.2 x 39.4cm
signed bottom right: *J.Wladimiroff*
artist's inscription on back: *Hard-labour for rich merchands, nobles and criminals during the years of revolution (1919-1922)*
based on sketch from nature: *На принудительных работах. 1919 г.* [Forced labour 1919]
(NLR-MD Coll. 149, Unit 9, fol. 1)
HILA

69. Wealthy Merchants & Noblemen Shifting Rubbish – 1920
pencil & watercolour on paper 29.2 x 39.4cm
signed bottom right: *J.Wladimiroff*
artist's inscription on back: *Rich merchants and russian noble-men to pull out rubbish from the yards. – (1920.)*
based on sketch from nature:
Обыватели вывозят мусор на Невский, где устроена свалка [Inhabitants shifting rubbish to a dump on Nevsky Prospekt]
(NLR-MD Coll. 149, Unit 8, fol. 60v)
HILA

70. Petrograd Inhabitants Obliged to Carry Water from the Neva – October 1919
pencil & watercolour on paper 29.2 x 39.4cm
signed bottom right: *J.Wladimiroff*
artist's inscription on back: *"Petrograd without water." Frequently the water supply was stopped and the inhabitants were obliged to carry water from the Neva. (october 1919.)*
based on sketch from nature: *Без воды!* [No water!]
(NLR-MD Coll. 149, Unit 8, fol. 54)
HILA

71. Moving Out – Remains of a Wealthy Home – 1919
ink & watercolour on paper 29.2 x 39.4cm
artist's signature bottom right masked by paper strip
artist's inscription on back: *Переездъ на новую квартиру въ 1919 году / сценка с натуры / ИВладимировъ / Remains of a wealthy home*
based on sketch from nature: *Переезд "буржуев" на новую квартиру. 25 марта 1919*
['Bourgeois' moving to a new apartment – 25 March 1919]
(NLR-MD Coll. 149, Unit 8, fol. 27)
variants – see pp 304/5
HILA

72. Engineer's Family Dragging Home Fuel – Petrograd January 1919
ink & watercolour on paper 29.2 x 39.4cm
artist's signature bottom right masked by paper strip
artist's inscription on back: *Miserable life of intelligent and noble russian families in Petrograd during the revolution. A family of a engineer dragging home some fuel. (January 1919).*

based on sketch from nature: *Буржуи дрова себе везут* [A bourgeois dragging his own firewood]
(NLR-MD Coll. 149, Unit 8, fol. 40)
HILA

73. Burial of a Non-Communist (Communists are Buried Magnificently) – January 1920
pencil & watercolour on paper 29.2 x 39.4cm
artist's signature bottom right masked by paper strip
artist's inscription on back: *Burial of a workman – who was not a communist. (communists are always buried magnificently). (January 1920.)*
based on sketches from nature: *Похороны отца... С натуры* [Father's funeral ... From nature]
(NLR-MD Coll. 149, Unit 8, ff 24v, 39).
HILA

74. A Funeral in 1919
ink & watercolour on paper 26 x 34.2cm
signed bottom right: *J.Wladimiroff*
artist's inscription on back: *Похороны в 1919 году*
based on sketch from nature: *Похороны в Петрограде* [Funeral in Petrograd]
(NLR-MD Coll. 149, Unit 8, fol. 63)
ex-Benzler Coll.
variants – see pp 306/7
Ruzhnikov Coll.

75. Flight of the Bourgeoisie from Novorossiysk (1926)
oil on canvas 138 x 212cm
signed bottom right: *ИВладимиров АХРР*
N.B. This painting was reproduced in *The History of the Civil War in the U.S.S.R.* (State Political Publishing House 1959), Volume IV (opposite p. 300), and depicts the evacuation of refugees and the Armed Forces of South Russia from Novorossiysk in March 1920. Immediately afterwards the Red Army and the Greens joined up in Novorossiysk and slew thousands who had been left behind.
variants – see pp 314/5
SCMRCH

76. Red Cavalry Entering Novorossiysk (1920s)
pencil & watercolour on paper 35.9 x 62.8cm
signed bottom right: *ИВладимиров*
inscribed in pencil bottom left: *Вступление красной конницы в Новороссийск*
Ruga Coll.

77. Security Forces
pencil & watercolour on paper 48 x 69cm
signed bottom right: *ИВладимиров*
Ruzhnikov Coll.

78. Workmen Breaking Up Wooden Houses for Fuel – Petrograd 1920
ink, pencil & watercolour on paper 29.2 x 39.4cm
signed bottom right: *J.Wladimiroff*
artist's inscription on the back: *Workmen breaking down wooden houses for fuel (Petrograd 1920)*
based on sketch from nature: *Разломка дома на Теряевой улице* [Breaking up a house on Teryaeva Ulitsa]
(NLR-MD Coll. 149, Unit 8, fol. 45v)
HILA

79. House Broken Up for Fuel – 1920 (1921)
watercolour on paper 25.5 x 34cm
signed bottom right: *J.Wladimiroff 1921*
artist's inscription on back: *Сломка дома на топливо. 1920 год*
based on sketches from nature:
Разборка деревянных домов в Петрограде на топливо
[Dismantling wooden houses in Petrograd for fuel]
(NLR-MD Coll. 149, Unit 8, ff 17, 41)
ex-Benzler Coll.
Ruzhnikov Coll.

80. Firewood Commandeered for the Kersten Factory
pencil & watercolour on paper 25.3 x 34.5cm
signed bottom right: *J.Wladimiroff*
artist's inscription on back: *Принудительная заготовка дровъ для фабрики Керстен*
based on sketch from nature:
"Советские кобылы". Фабричные работницы в роли лошадей. 27 февраля 1920
['Soviet Mares' – Factory workers in the role of horses 27 February 1920]
(NLR-MD Coll. 149, Unit 8, fol. 58v)
N.B. Vasily Kersten's Hosiery & Knitwear Factory on Bolshya Spasskaya (now *Ulitsa Krasnovo Kursanta*), close to Vladimirov's home on Bolshaya Grebetskaya, was nationalized after the Revolution as the Red Banner Knitwear Factory
ex-Benzler Coll.
variants – see pp 308/9
Ruzhnikov Coll.

81. Communal Work-Day (1923)
oil on canvas mounted on board 24.9 x 33.7cm
signed bottom left: *ИВладимировъ 1923* beneath inscription *"Субботник"* ['Subbotnik']
Ruga Coll.

82. Exchanging Goods for Provisions near a Railway Station – June 1919
ink & watercolour on paper 29.2 x 39.4cm
artist's signature bottom right masked by paper strip
artist's inscription on back: *Hungry years in Petrograd. Changing merchandise for provisions in a village near a railway station. June 1919.*
based on sketch from nature: *Товарообмен. 1919 г.*
[Bartering – 1919]
(NLR-MD Coll. 149, Unit 9, fol. 21)
HILA

83. Rebirth of Trade (1921)
ink, pencil & watercolour on paper 25.5 x 33.5cm
signed bottom right: *ИВладиміровъ 1921*
artist's inscription bottom left: *Возрождение торговли*
Ruzhnikov Coll.

84. At The Market (1921)
pencil & watercolour on paper 25.5 x 33.5cm
signed bottom right: *ИВладиміровъ 1921*
artist's inscription bottom left: *на рынке*
based on sketch from nature:
Типичная сцена на рынке. Буржуи распродают свое имущество [Typical market scene – the bourgeois selling their possessions]
(NLR-MD Coll. 149, Unit 8, fol. 32)
Ruzhnikov Coll.

85. Free Trade in Petrograd: Soldiers Helping Themselves at the Market – December 1922
ink paper & watercolour on paper 29.2 x 39.4cm
artist's signature bottom right masked by paper strip
artist's inscription on back: *"Free trade in Petrograd" Militioners helping themselves in a market-place (December 1922)*
HILA

86. Handing over the Past for Scrap (1930)
pencil & watercolour on paper 21.6 x 30.7cm
signed bottom right: *ИВладимиров 1930*
Ruga Coll.

87. Foreigner Assailed by Cigarette-Vendors – Petrograd 1923
pencil & watercolour on paper 29.2 x 39.4cm
artist's signature bottom right masked by paper strip
artist's inscription on back: *A foreigner attacked by cigarette sellers in Petrograd. (1923)*
HILA

88. Two Boys Arrested for Stealing
watercolour 41.9 x 33cm
photocopy of original watercolour
signed bottom right: *J.Wladimiroff*
inscription on back: *2 boys arrested for stealing*
based on sketch from nature: *Свобода торговли. 15 марта 1922 г.* [Free trade – 15 March 1922]
(NLR-MD Coll. 149, Unit 9, fol. 22)
HILA

89. Clarifying Military Orders (1921)
pencil & watercolour on paper 33.5 x 24.5cm
signed bottom right: *ИВладиміровъ 1921*
inscription bottom left: *Разъяснение военнаго приказа*
Ruzhnikov Coll.

90. In the Imperial Box
pencil & watercolour on paper 40.5 x 48.3cm
signed bottom right: *J.Wladimiroff*
artist's inscription bottom left: *In the Imperial box*
HHPLM

91. At the Theatre – The Tsar's Box
oil on canvas mounted on plywood 28 x 40.5cm
signed bottom right: *ИВладимиров*
based on sketch from nature: *Сцена в бывшей царской ложе в театре. 1919 г.* [Scene in the former Tsar's box at the theatre – 1919]
(NLR-MD Coll. 149, Unit 9, fol. 38)
Ruga Coll.

92. 'On Duty' – Scene Outside the Barracks
ink & watercolour on paper 25.7 x 34.2cm
signed bottom right: *J.Wladimiroff*
artist's inscription on the back: *"На посту" сцена у ворот казармы*
ex-Benzler Coll.
variants – see pp 310/1
Ruzhnikov Coll.

93. Policewoman 'On Duty' – 1919
ink, pencil & watercolour on paper 25.7 x 34.5cm
signed bottom right: *J.Wladimiroff*
artist's inscription on the back: *Милиціонерка на посту. 1919 год*
based on watercolour sketch from nature: *Милиционерка "на посту". Июнь 1919 г.* [Policewoman 'On Duty' June 1919]
(NLR-MD Coll. 149, Unit 8, fol. 33v)
ex-Benzler Coll.
Ruzhnikov Coll.

94. Sports Contest in the Summer Garden
ink, pencil & watercolour on paper 25.7 x 34.5cm
signed bottom right: *J.Wladimiroff*
artist's inscription on the back: *Спортивныя состязанія в Летнем Саду*
ex-Benzler Coll.
variants – see pp 312/3
Ruzhnikov Coll.

95. Inside a Bourgeois Apartment (1921)
ink, pencil & watercolour on paper 26.4 x 36.5cm
signed bottom right: *ИВладиміровъ 1921 год*
artist's inscription bottom left: *В "буржуазной" квартире*
Ruzhnikov Coll.

96. Village Guards – Ignorant People (1920)
ink & watercolour on paper 33.5 x 24.5cm
signed bottom right: *ИВладиміровъ 1920*
artist's inscription bottom left: *сельские стражники – темные люди*
Ruzhnikov Coll.

97. No One to Protect Her (1921)
oil on canvas mounted on board 28.7 x 34.2cm
signed bottom right: *ИВладиміров*
Ruga Coll.

98. Pleased To Meet You! (1925)
oil on canvas mounted on board 30.5 x 43.5cm
signed bottom right: *И.Владиміровъ*
Ruga Coll.

99. Young Lady with Two Red Army Soldiers
oil on canvas mounted on plywood 25.5 x 21.5cm
signed bottom left: *И.Владиміровъ*
courtesy *Sotheby's London*

100. The Gallant Boyfriend (1922)
oil on canvas mounted on board 30 x 24.9cm
artist's inscription bottom left: *Дорогому другу
А.Ф.Б...у от И.Владимірова 1922*
('to my dear friend A.F.B.... from I. Vladimirov 1922')
Ruga Coll.

101. The Anarchist
oil on canvas mounted on plywood 21 x 19cm
signed bottom left: *ИВладиміровъ*
artist's inscription on the back: *И.Владимиров /
"Анархист"*
Farfor-art Gallery, Moscow

102. Old Bavaria Beer-Hall (1920s)
pencil & watercolour on paper 23 x 26cm
signed bottom left: *ИВладимиров*
Ruga Coll.

103. Grand Hotel Europa (1923)
oil on canvas mounted on plywood 29 x 41cm
signed bottom right: *ИВладимиров*
variants – see pp 320/1
Ruga Coll.

104. Political News (1920)
oil on canvas mounted on board 20.5 x 28cm
signed bottom right: *ИВладиміровъ 1920*
artist's inscription on back: *"Политическія новости"
ИВладиміровъ*
ex-Benzler Coll.
variants – see pp 316/7
Ruzhnikov Coll.

105. Reading Pravda (1923)
oil on canvas mounted on board 17.5 x 23.9cm
signed bottom right: *И.Владиміровъ*
Ruga Coll.

106. Accordionist & Two Girls in a Meadow (1922)
oil on board 30.2 x 41.5cm
signed bottom right: *И.Владиміровъ 1922*
HILA

107. Playing Cards Amidst the Ruins (1922)
oil on board 29.2 x 49.7cm
signed bottom left: *И.Владиміровъ 1922 г.*
variants – see pp 318/9
HILA

108. Having a Party (1920s)
oil on board 24.5 x 31.5cm
signed bottom right: *ИВладиміровъ*
Ruga Coll.

109. Village Photograph (1918)
oil on canvas 42.3 x 52.3cm
signed bottom right: *ИВладиміровъ 1918*
Ruga Coll.

**110. The First Village Tractor [Testing the Tractor]
(1925)**
oil on canvas 98 x 164cm
signed bottom right: *И.Владимиров АХРР 1925*
SCMRCH

Variants of Vladimirov's Works

I.

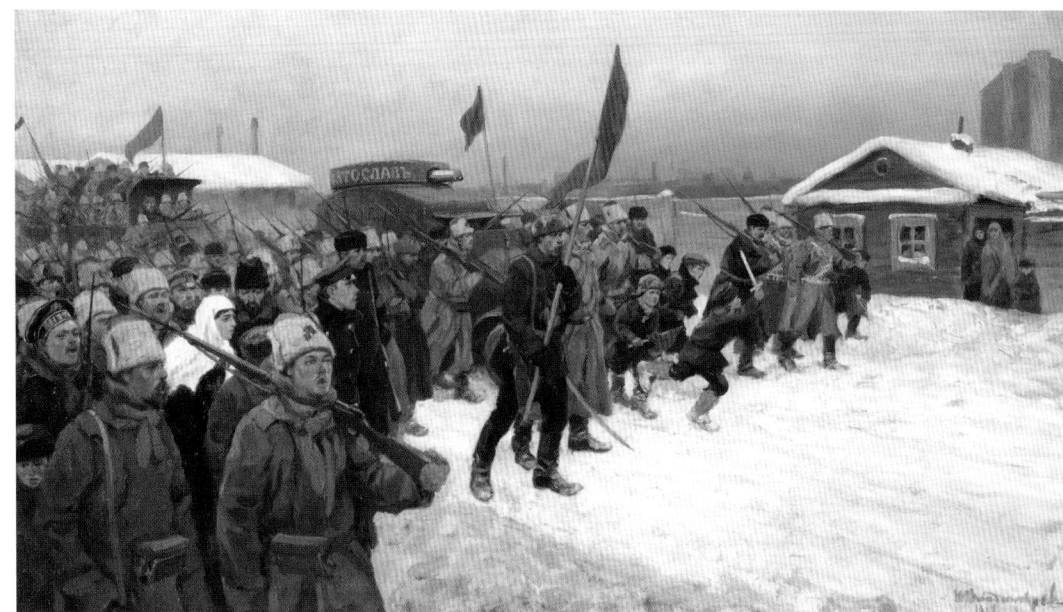

February Revolution – Demonstration at the Putilov Factory (1917)

oil on canvas 58 x 103cm
signed bottom right: *ИВладиміровъ 1917 год*
CSMRMH

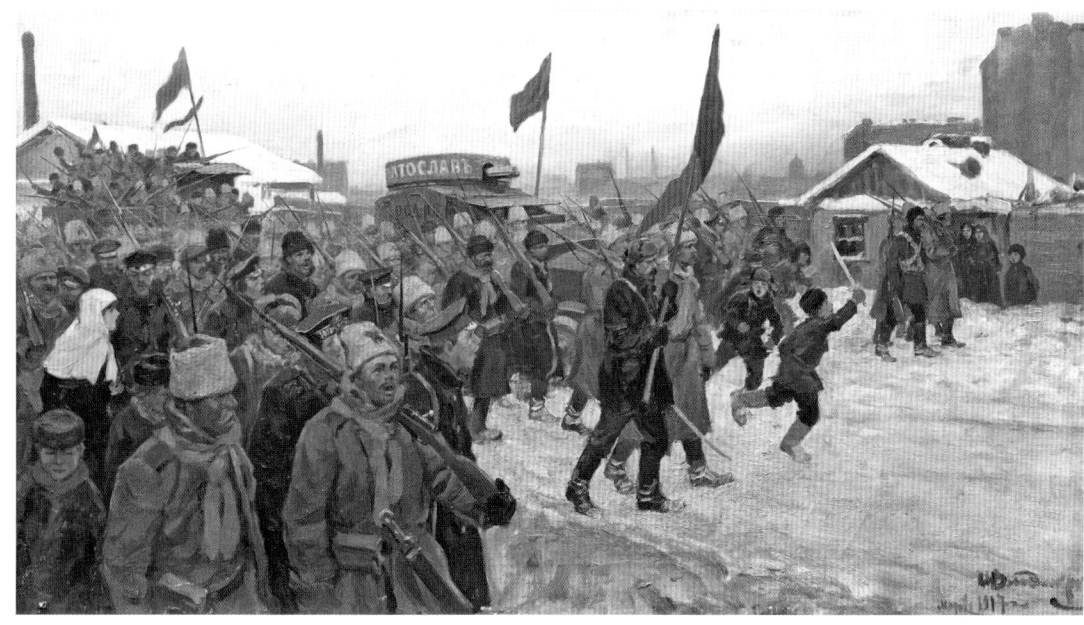

The February Days in the Working Suburbs (1917)

oil on canvas 57 x 100cm
signed bottom right: *ИВладиміров мартъ 1917 г.*
SMRPH

2.

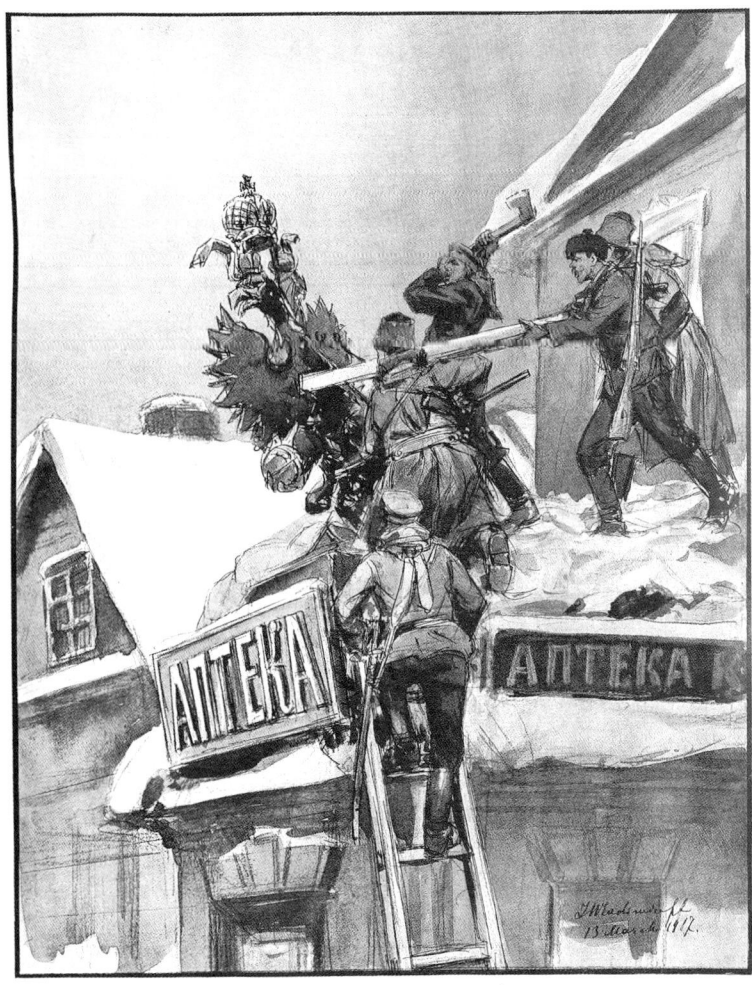

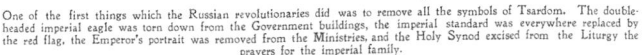

Down with the Eagles!

One of the first things which the Russian revolutionaries did was to remove all the symbols of Tsardom. The double-headed imperial eagle was torn down from the Government buildings, the imperial standard was everywhere replaced by the red flag, the Emperor's portrait was removed from the Ministries, and the Holy Synod excised from the Liturgy the prayers for the imperial family.

FACSIMILE OF A SKETCH BY JOHN WLADIMIROFF, OUR SPECIAL ARTIST IN RUSSIA

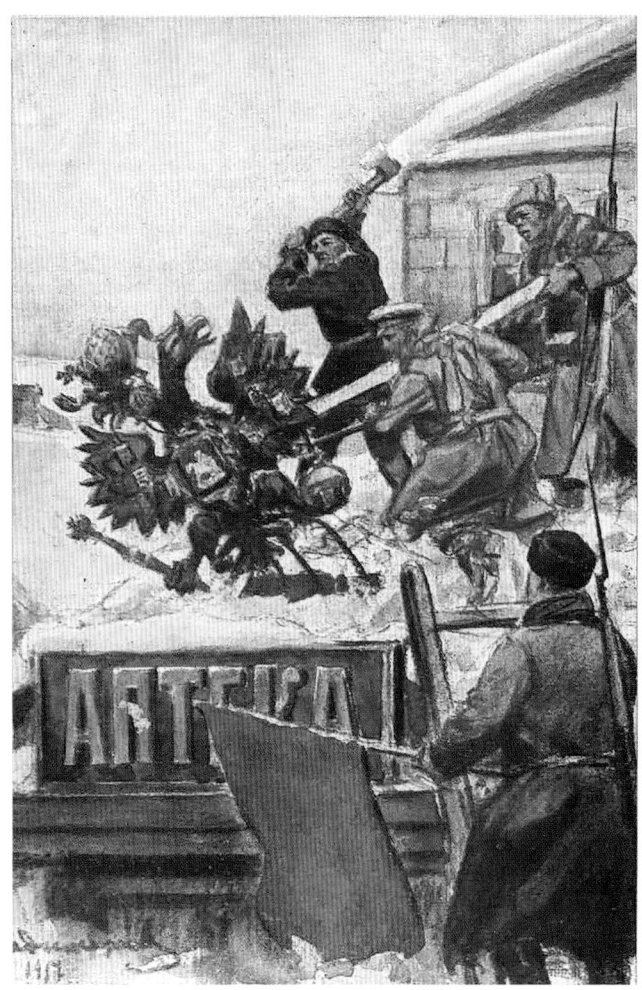

Down with the Eagles!

published in *The Graphic (London)*, 14 April 1917 (p. 419),
captioned *Down with the Eagles!*
signed bottom right: *J. Wladimiroff 13 March 1917*

Down with the Eagle!

published in *Velikaya Voyna v Obrazakh i Kartinakh*
(The Great War in Images & Pictures) no 14 (Moscow 1917)
signed bottom left: *ИВладиміровъ 1917*

"Долой орла"
1917: (2 марта)

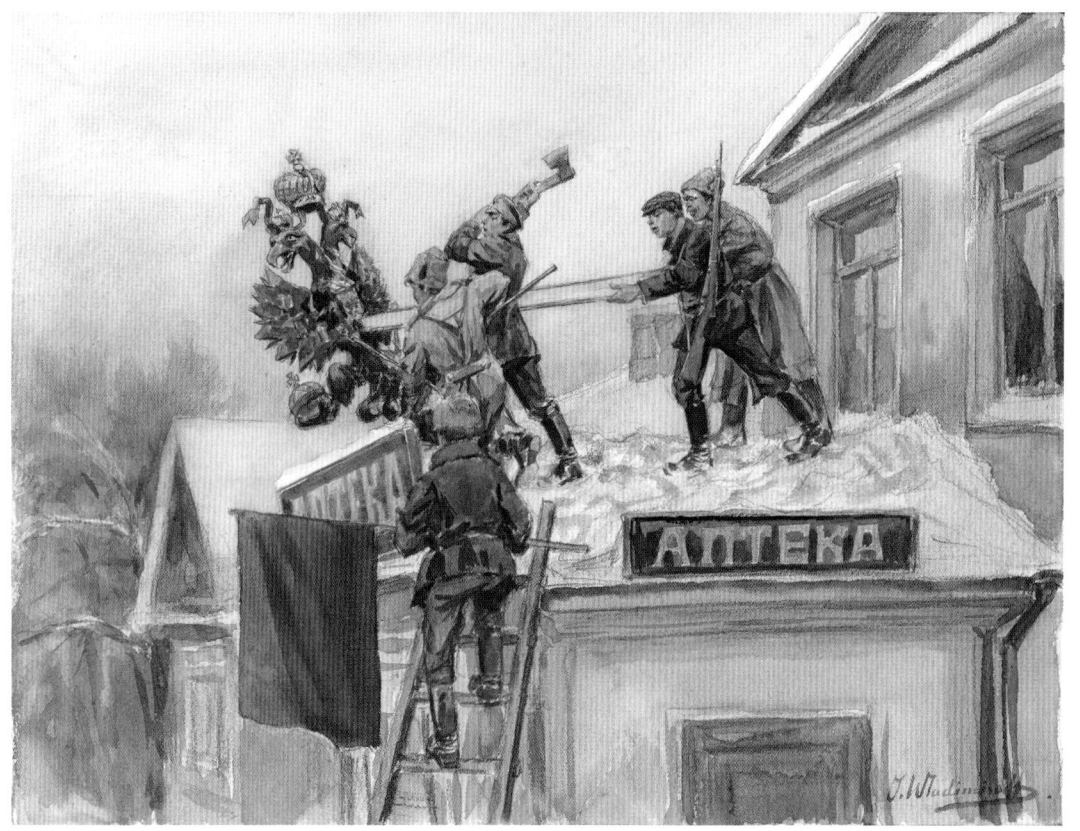

Down with the Eagle – 2 (15) March 1917

watercolour, ink on paper 25.5 x 34.5cm
signed bottom right: *J.Wladimiroff*
artist's inscription on back: *"Долой орла" 1917 г. (2 марта)*
Ruzhnikov Coll.

3.

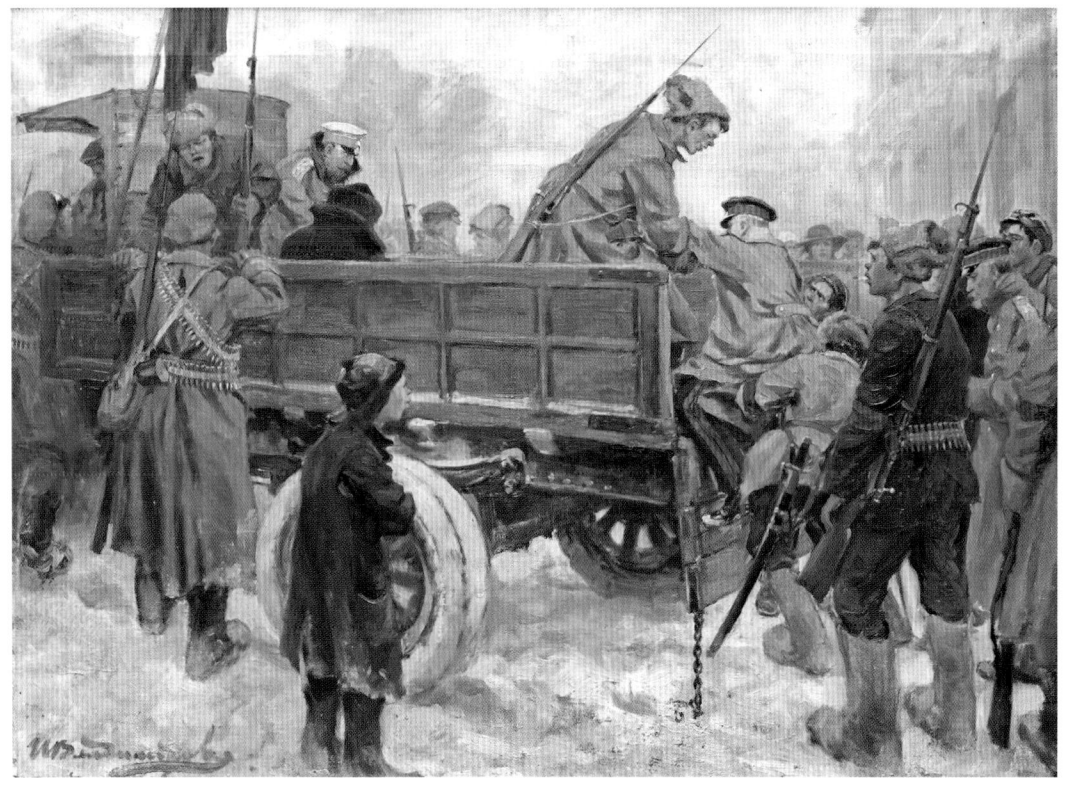

Arrest of the Generals (1918)

oil on canvas 70 x 98cm
signed bottom left: *ИВладимiровъ*
SMRPH

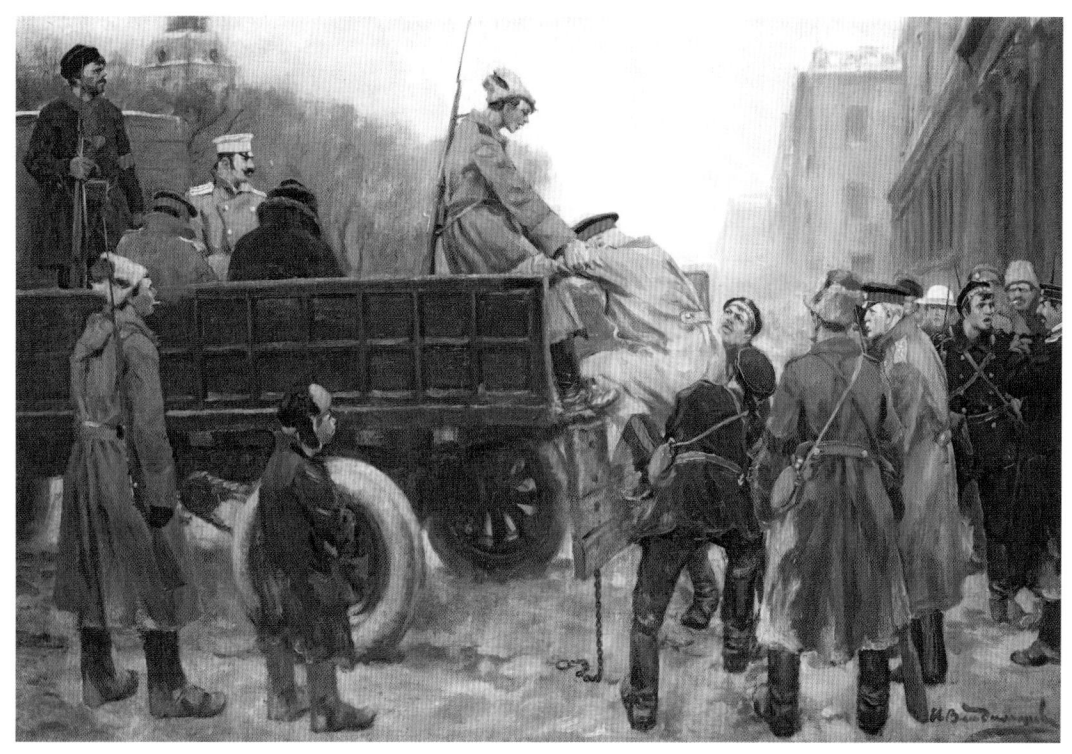

Arrest of Tsarist Generals (1926)

oil on canvas 69 x 104cm
signed bottom right: *ИВладиміровъ*
CSMRMH

4.

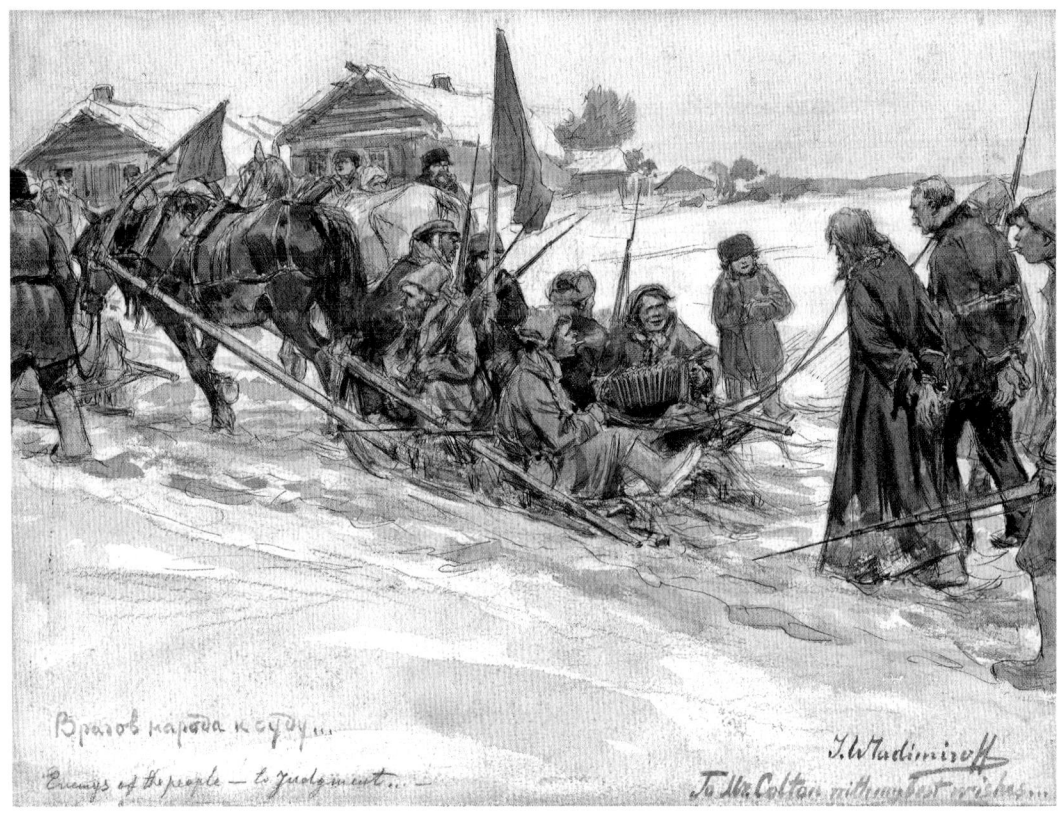

Enemies of the People Taken for Trial

ink & watercolour on paper 24.8 x 34.1cm
signed bottom right: *J.Wladimiroff above To Mr. Colton with my best wishes....*
inscription bottom left: *Врагов народа к суду... Enemys of the people –*
to judgment...
HHPLM

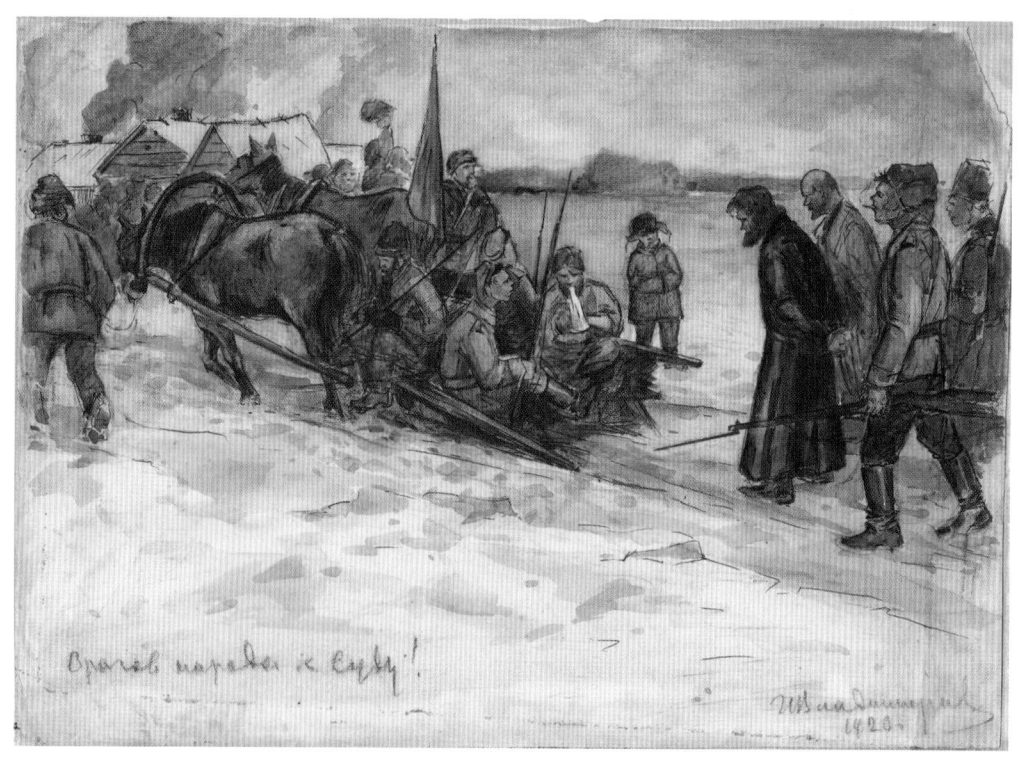

Enemies of the People To Judgment! (1920)

ink & watercolour on paper 26.3 x 36.8cm
signed bottom left: *Врагов народа к суду!*
signed bottom right: *ИВладимиров 1920 г.*
SMRPH

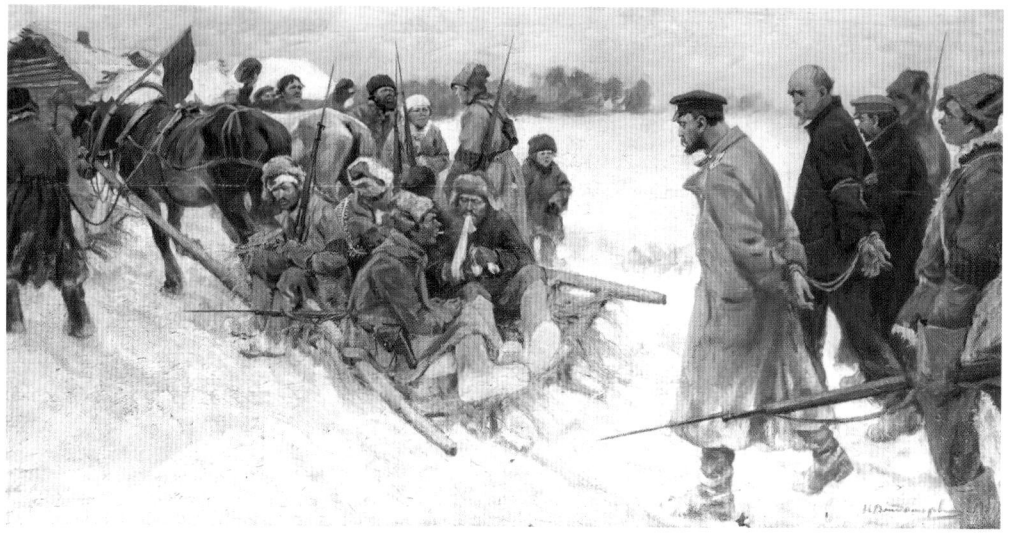

Red October in the Village (1926)

oil on canvas 106 x 210cm
signed bottom right: *ИВладимиров*
SMRPH

5.

Lecturing Peasants About Marx

ink & watercolour on paper 25.7 x 34.5cm
signed bottom right: *J.Wladimiroff*
artist's inscription on back: *Лекція о Марксе для крестьян в деревне*
Ruzhnikov Coll.

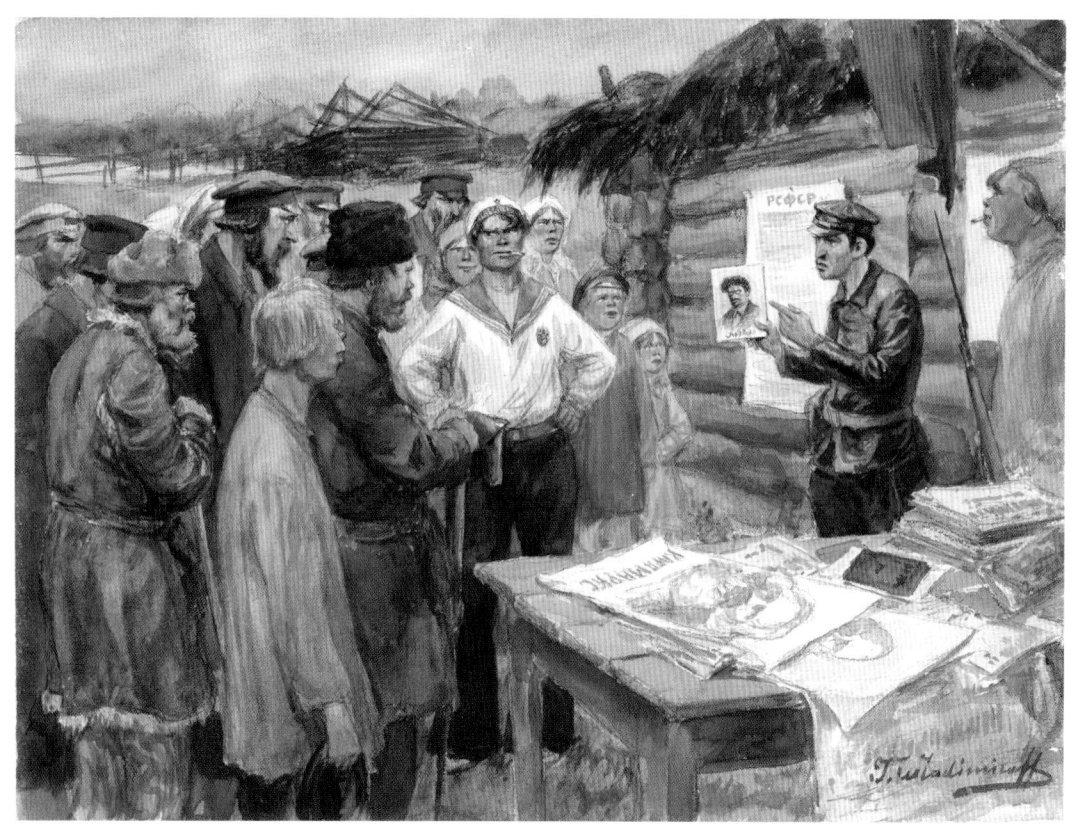

A lesson on communism for the russian peasants. (1922).

Lecture on Communism for Russian Peasants – 1922

watercolour on paper 29.2 x 39.4cm
signed bottom right: *J.Wladimiroff*
artist's inscription on back: *A lesson on communism for the Russian peasants. (1922).*
HILA

6.

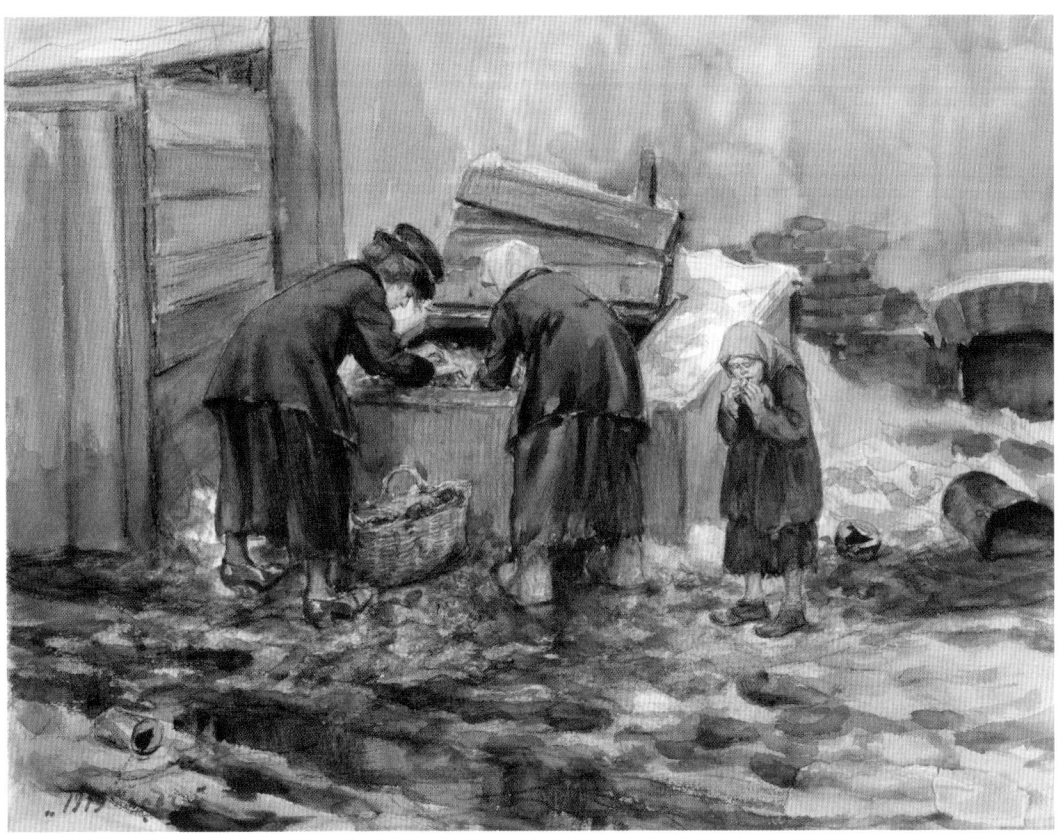

Famine in Petrograd – 1919

pencil & watercolour on paper 29.2 x 39.4cm
artist's signature bottom right masked by paper strip
inscribed bottom left: *"1919 год"*
artist's inscription on back: *Hungry times in Petrograd*
HILA

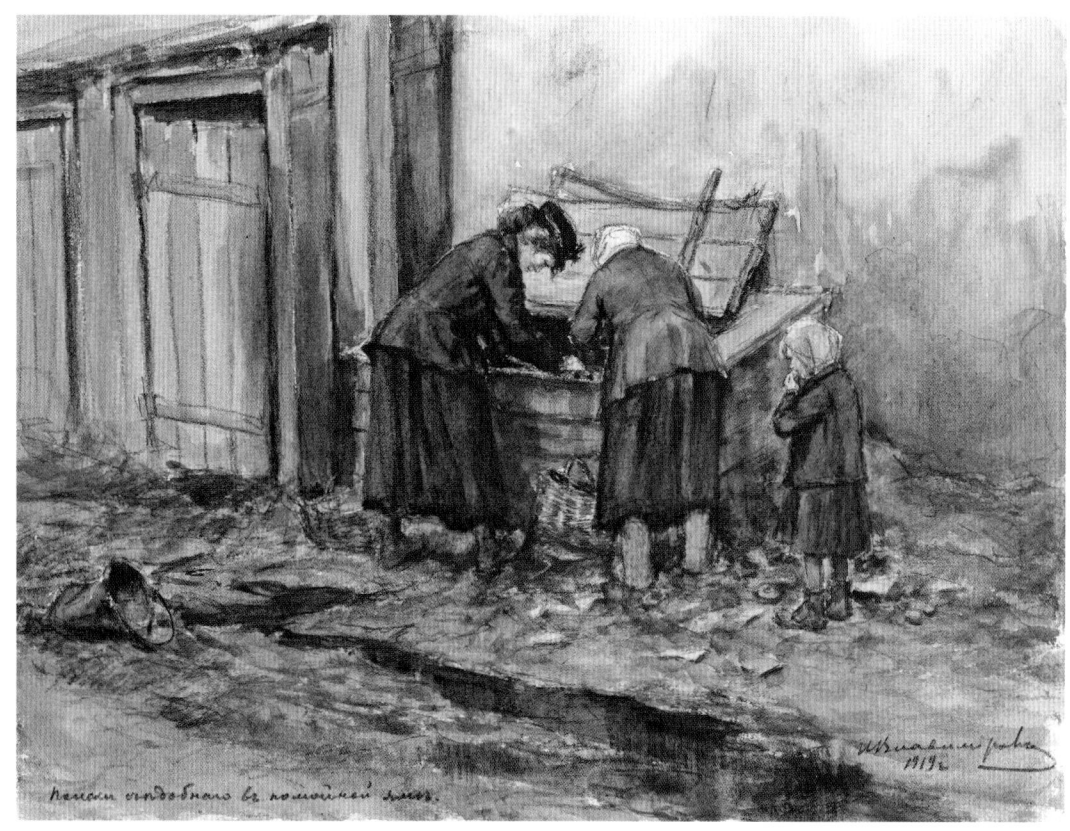

Searching the Rubbish for Something to Eat (1919)

pencil & watercolour on paper 25.8 x 34.5cm
signed bottom right: *ИВладиміровъ 1919 г.*
signed bottom left: *Поиски съедобнаго въ помойной яме.*
BMC

7.

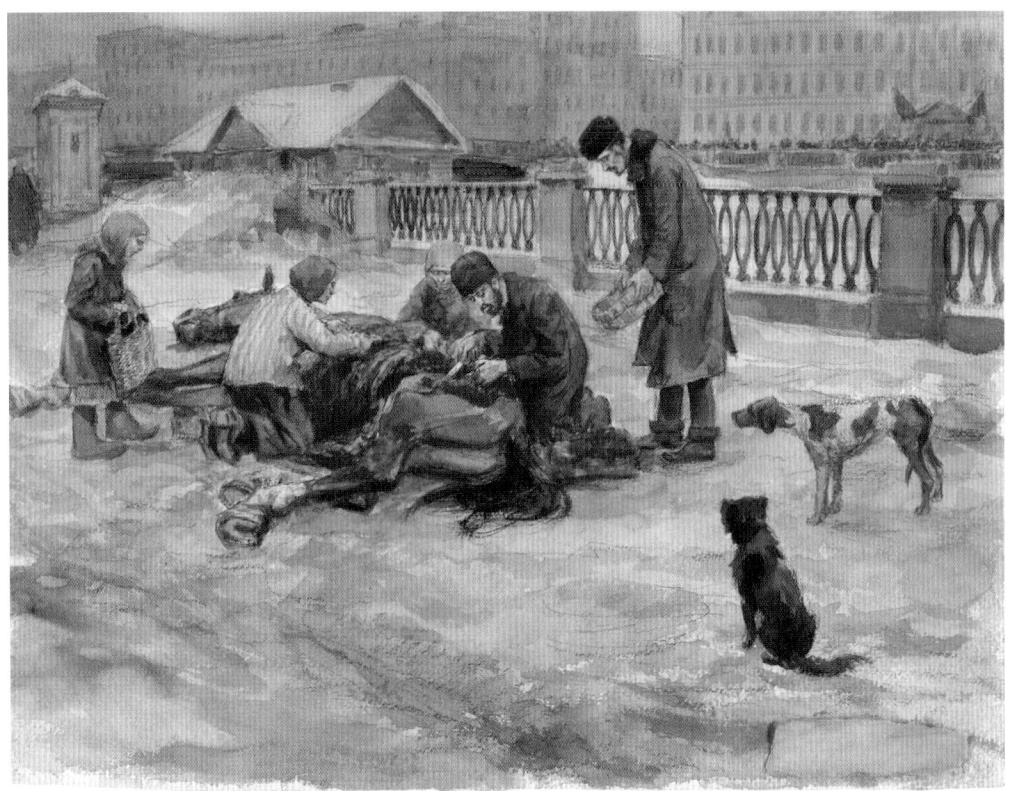

Hungry in Petrograd dividing a dead horse in the streets (1919)

The Hungry Cutting up a Dead Horse on a Street in Petrograd – 1919

pencil & watercolour on paper 29.2 x 39.4cm
signature bottom right masked by paper strip
artist's inscription on back: *Hungry in Petrograd dividing a dead horse in the streets (1919)*
HILA

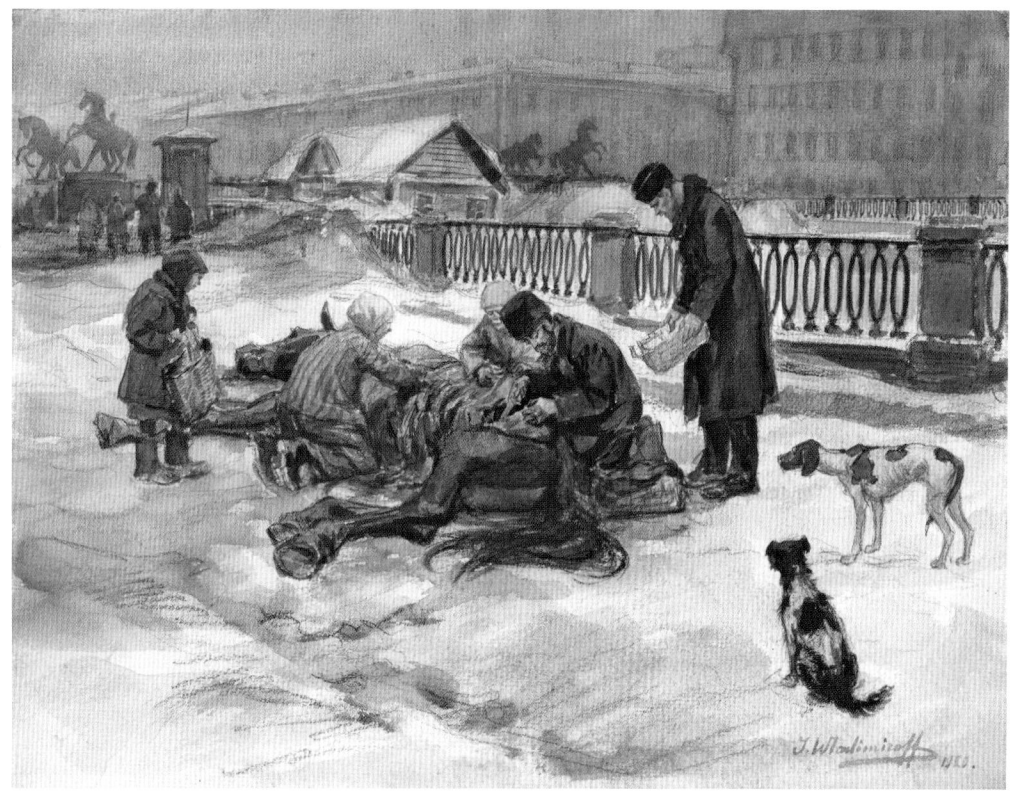

Cutting Up a Dead Horse for Food on the Fontanka in 1919 (1920)

pencil & watercolour on paper 25.7 x 34.2cm
signed bottom right: *J.Wladimiroff 1920*
artist's inscription on back: *Разделъ павшей лошади для еды (на Фонтанке въ 1919 году)*
Ruzhnikov Coll.

8.

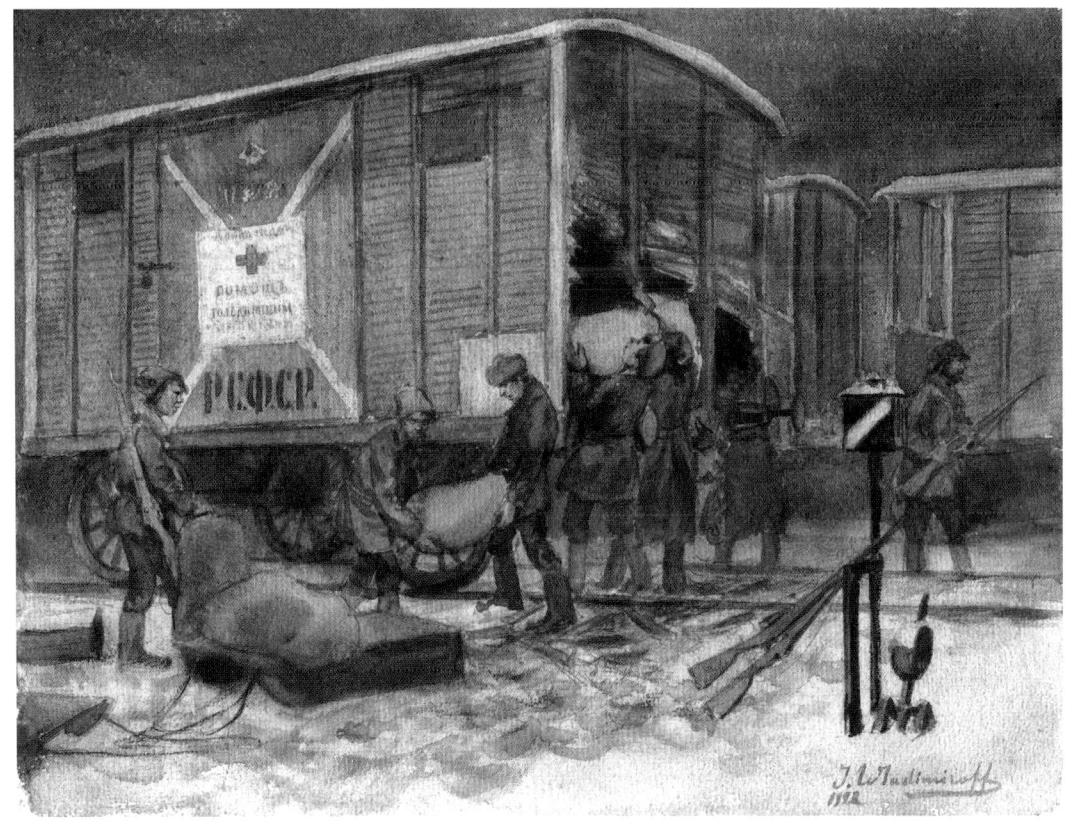

Robbing a Goods Truck (1922)

pencil & watercolour on paper 25.8 x 34.1cm
signed bottom right: *J.Wladimiroff 1922*
BMC

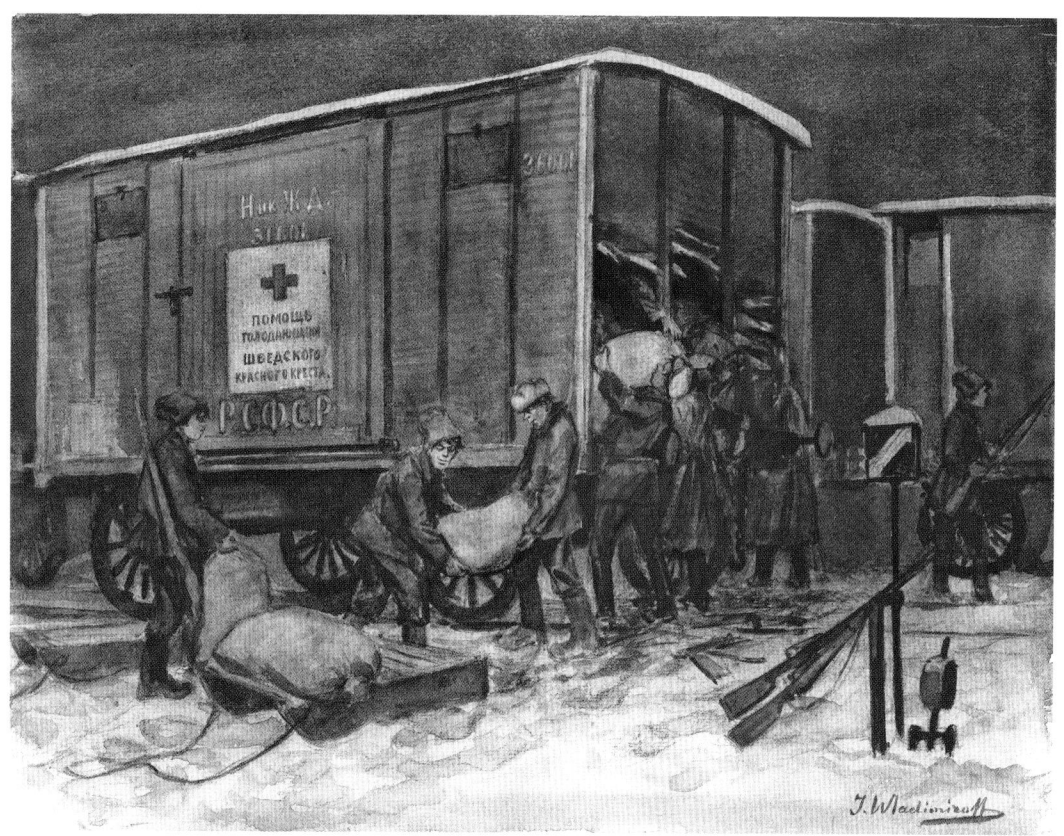

Огравление товарнаго вагона (12 февр, 1922 гв.)

Robbing a Goods Truck – 12 February 1922

pencil & watercolour on paper 25.5 x 34.5cm
signed bottom right: *J.Wladimiroff*
artist's inscription on back: *Ограбление товарнаго вагона (12 февр. 1922 года)*
Ruzhnikov Coll.

9.

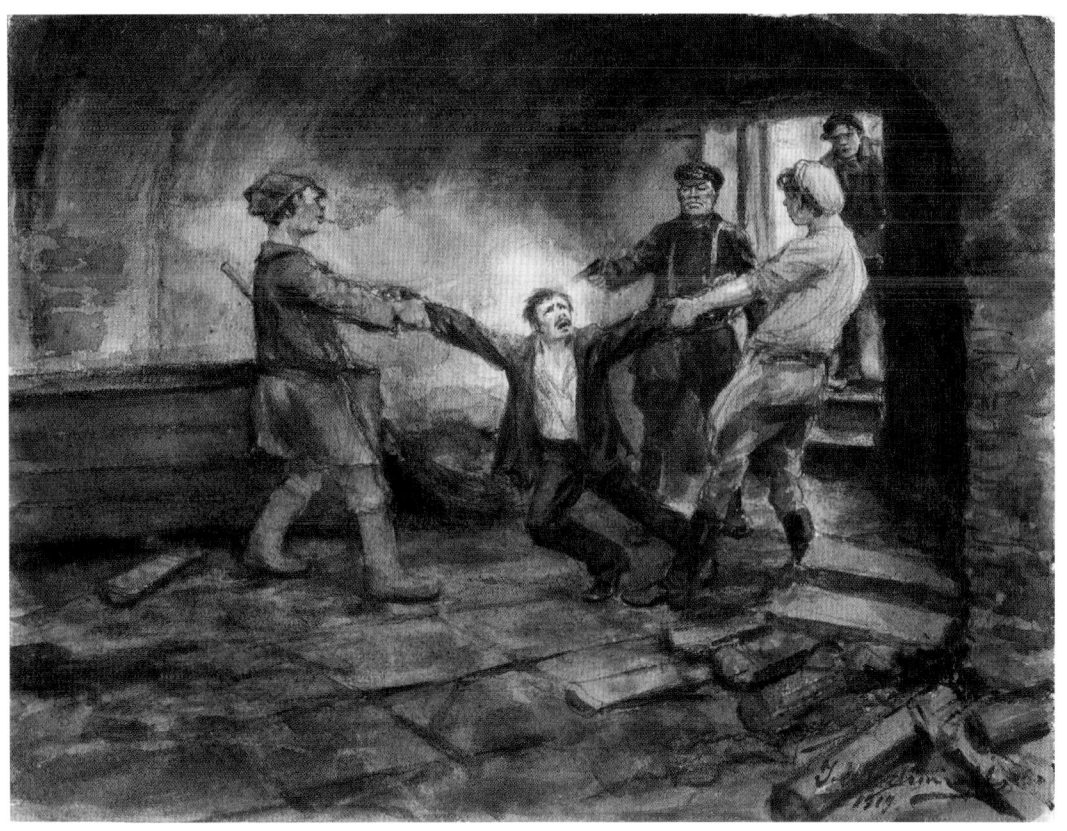

The Execution (1919)

pencil & watercolour on paper 25.7 x 34.5cm
signed bottom right: *J.Wladimiroff 1919*
BMC

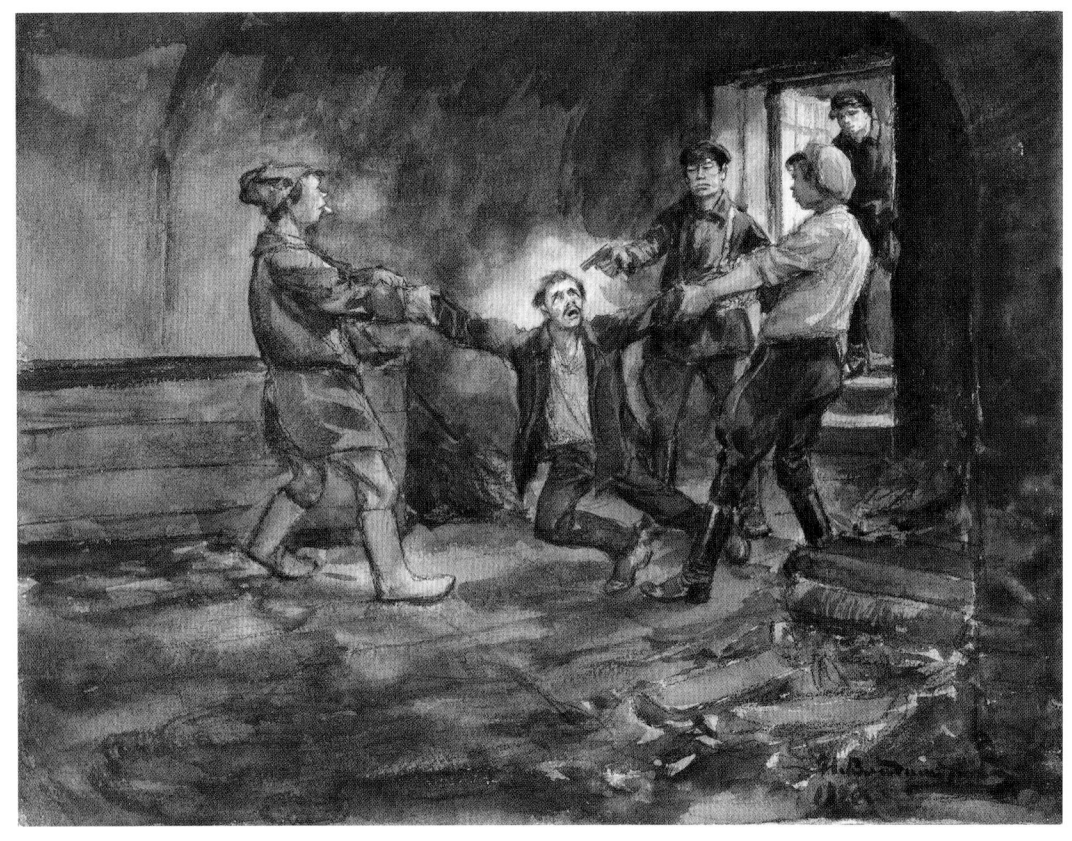

Execution at Dno Railway Station – 1919 (1920)

ink & watercolour on paper mounted on board 25 x 34cm
signed bottom right: *И.Владимиров 1920 г.*
Ruzhnikov Coll.

10.

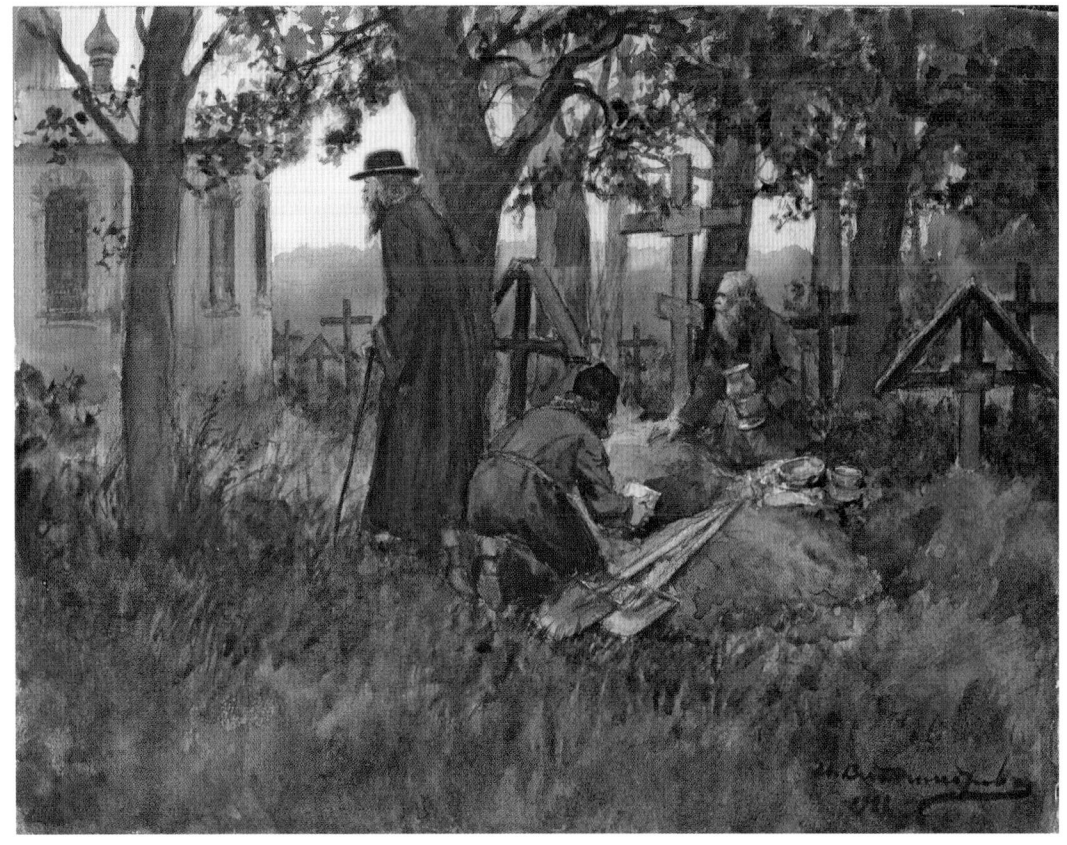

Priests Burying Church Valuables in a Cemetery near Luga (1922)

watercolour on paper 25.7 x 34.2cm
signed bottom right: *И.Владиміровъ 1922*
Ruzhnikov Coll.

Russian clergymen hiding church treasures in a new grave on a cementry. (near Luga) (1922).

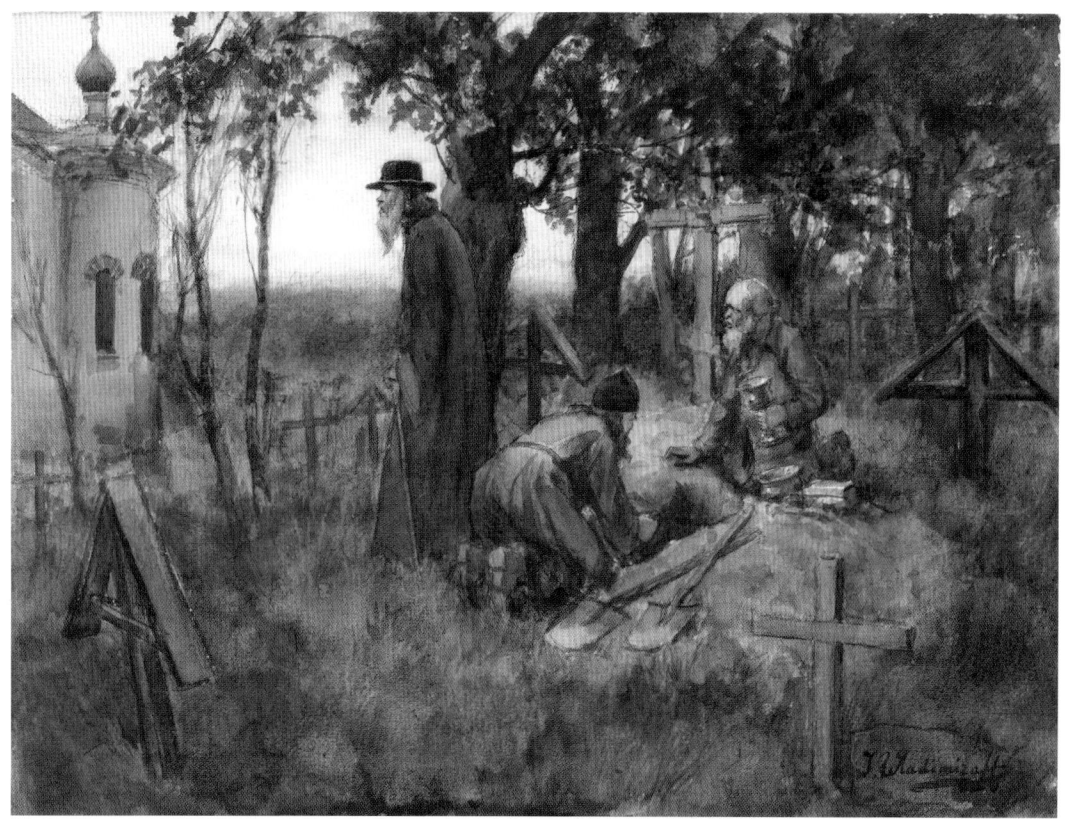

Russian Clergymen Hiding Church Treasure in a Cemetery near Luga – 1922

watercolour on paper 29.2 x 39.4cm
signed bottom right: *J.Wladimiroff*
artist's inscription on back: *Russian clergymen hiding church treasures in a new grave on a cementry. (near Luga) (1922).*
HILA

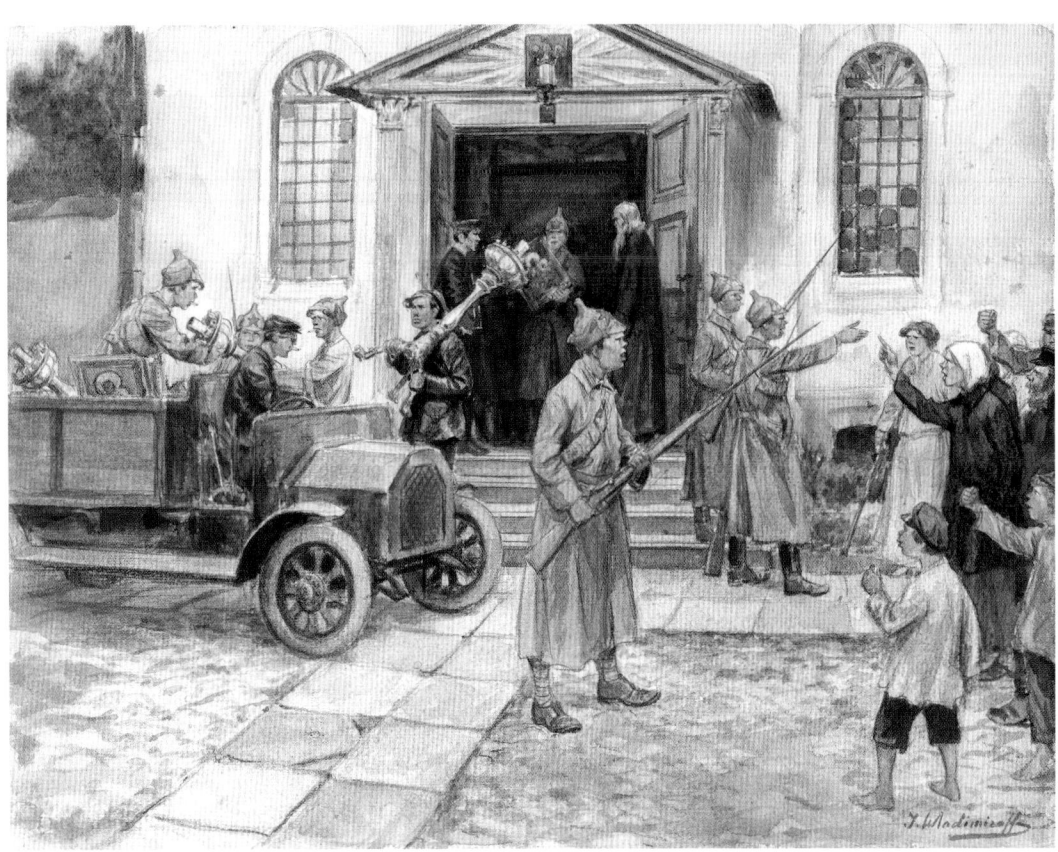

11.

Реквизиція церковнаго имущества церкви Введенія на Пет сторон

**Requisitioning Ecclesiastical Property from the Church of the Presentation –
Petrograd Side**

ink & watercolour on paper 25.7 x 34.2cm
signed bottom right: *J. Wladimiroff*
artist's inscription on back: *Реквизиція церковнаго имущества церкви Введенія на Пет сторонe*
Ruzhnikov Coll.

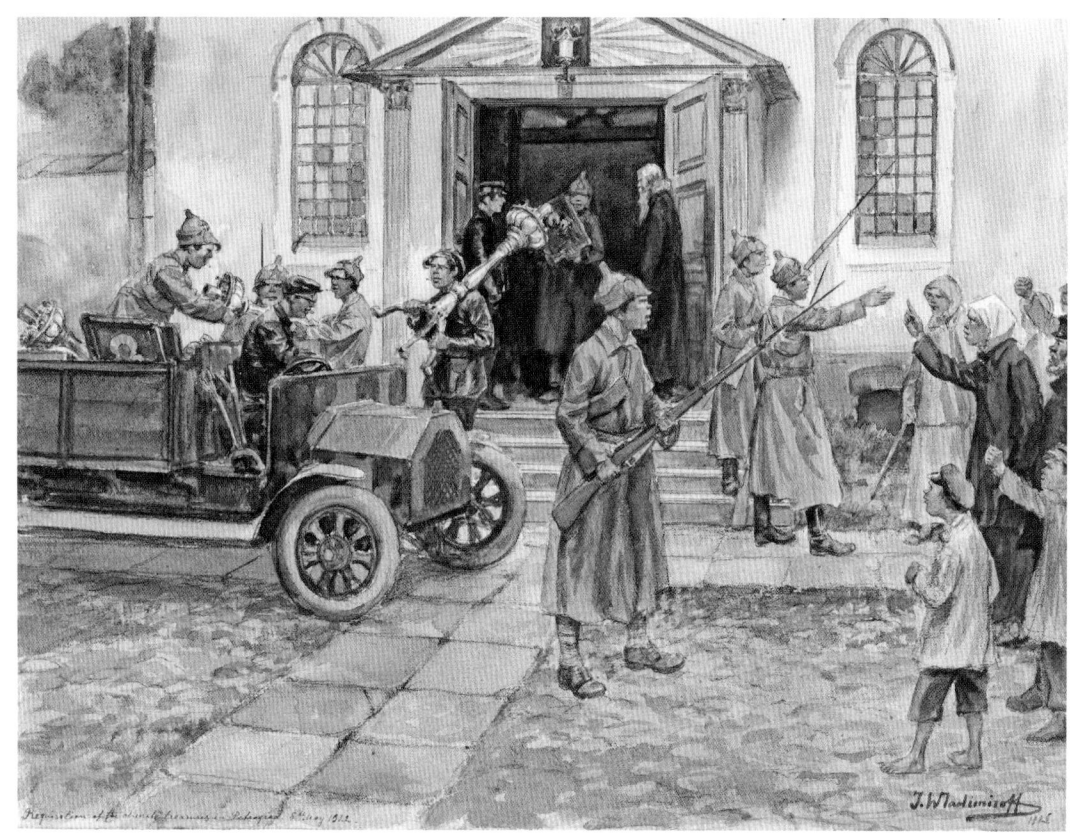

Requisitioning Church Treasure in Petrograd – 5 May 1922 (1922)

pencil & watercolour on paper 25.5 x 34.3cm
signed bottom right: *J.Wladimiroff 1922*
artist's inscription bottom left: *Requisition of the church treasures in Petrograd. 5th May 1922.*
BMC

12.

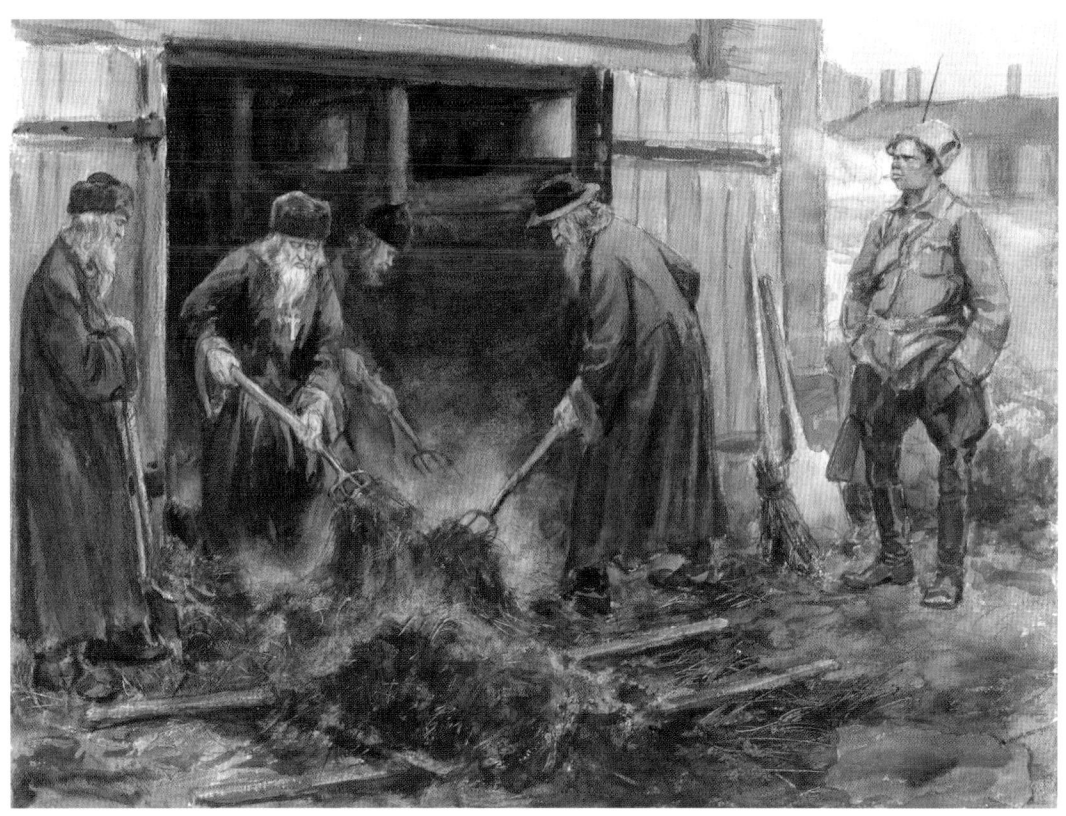

**Group of Russian Priests Forced to Clean Out the Stables in Barracks –
17th Line, Vasily Ostrov – 22 December 1918**

watercolour on paper 29.2 x 39.4cm
artist's signature bottom right masked by paper strip
artist's inscription on back: *Hard-work for russian clergymen (a group of russian priests forced to clear the barrack stables. Vasili ostroff 17 line) 22 December 1918.*.
HILA

Russian Clergy Forced to Clean Out the Stables – 1918 (1922)

ink & watercolour on paper
25.8 x 34.3cm
signed bottom right: *J.Wladimiroff 1922*
artist's inscription bottom left:
*Russian clergymen forced to clean
the stables. 5 Oct.[?] 1918*
BMC

Priests Forced to Clean Out the Stables

ink & watercolour on paper mounted on
board 25.7 x 34.5cm
signed bottom right: *J.Wladimiroff*
artist's inscription on back: *Принудительная
очистка конюшен священнослужителями*
Ruzhnikov Coll.

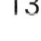

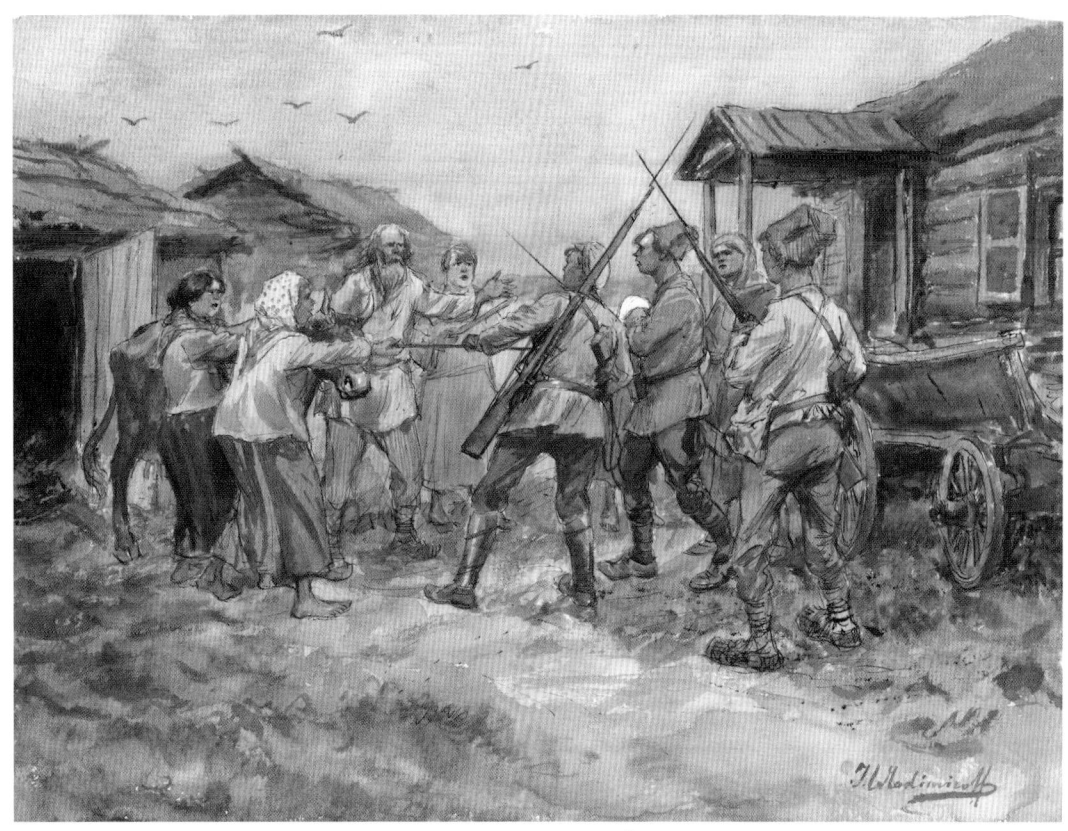

Requisitioning Livestock for the Red Army in a Village near Luga (June 1920)

ink & watercolour on paper 29.2 x 39.4cm
signed bottom right: *J.Wladimiroff*
artist's inscription on back: *Requisition of cattle for the red army in a village near Luga. June 1920.*
HILA

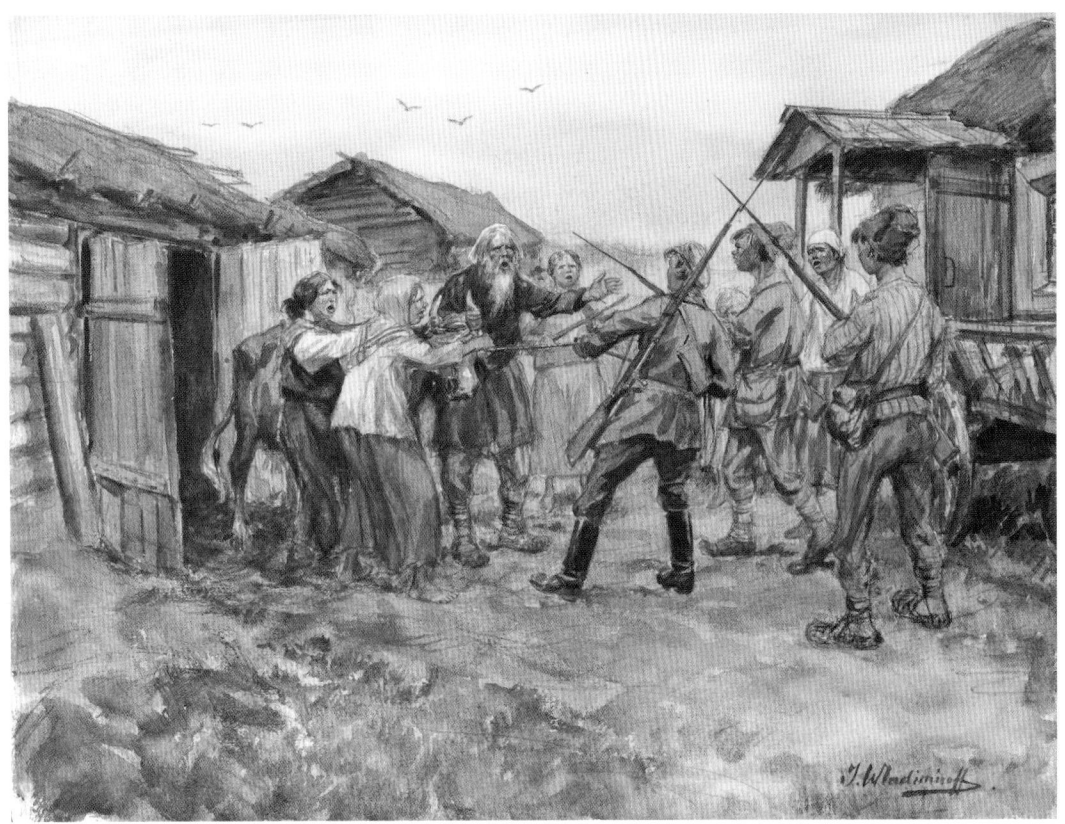

Requisitioning the Peasant's Last Cow – 1919

pencil & watercolour on paper 25.5 x 34.5cm
signed bottom right: *J.Wladimiroff*
artist's inscription on back: *Реквизиція последней коровы у крестьянина. 1919 год*
Ruzhnikov Coll.

14.

Moving Out – Remains of a Wealthy Home – 1919

ink & watercolour on paper 29.2 x 39.4cm
signature bottom right masked by paper strip
artist's inscription on back: *Переѣздъ на новую квартиру в 1919 году сценка съ натуры /
ИВладимiровъ / Remains of a wealthy home*
HILA

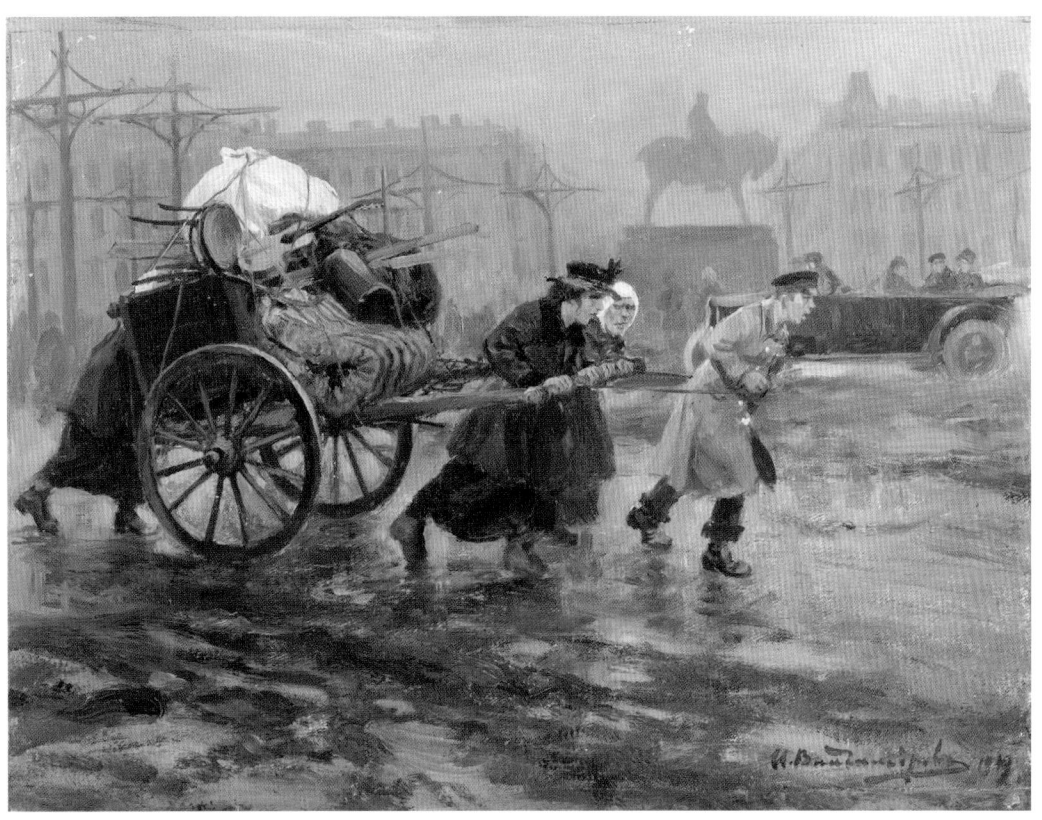

Moving to a New Apartment (1919)

oil on canvas mounted on board 24.5 x 32.5cm
signed bottom right: *И.Владиміровъ 1919 г.*
Ruzhnikov Coll.

Family of a Wealthy Merchant Moving Their Furniture – 25 March 1919

pencil & watercolour on paper 25.9 x 34.3cm
signed bottom right: *J.Wladimiroff*
artist's inscription bottom left: *Family of a rich merchant conveying their furniture. 25 March 1919*
BMC

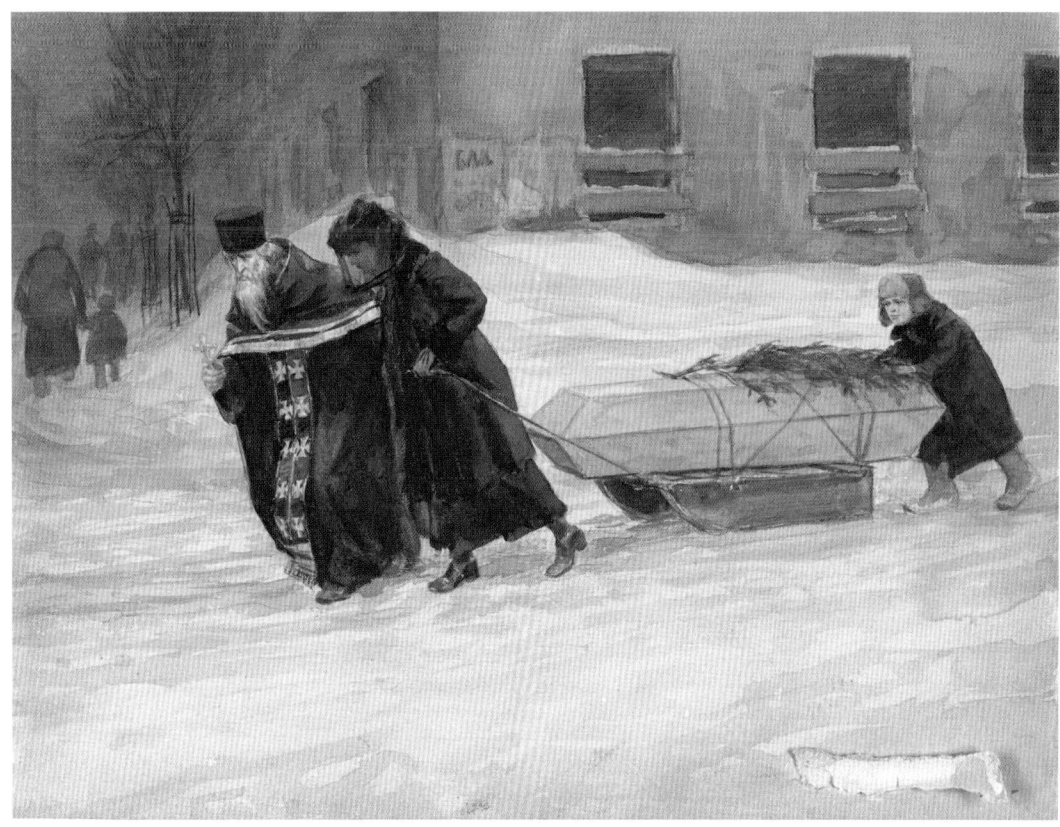

Funeral in 1919 – scene from nature (Father's Funeral)

pencil & watercolour on paper 29.2 x 39.4cm
signature bottom right: *ИВладимировъ 1919* masked by paper strip
artist's inscription on back: *Похороны въ 1919 году Сцена съ натуры / ИВладимiров / The father's funeral.*
HILA

A Funeral in 1919

ink & watercolour on paper 26 x 34.2cm
signed bottom right: *J. Wladimiroff*
artist's inscription on back: *Похороны в 1919
году*
Ruzhnikov Coll.

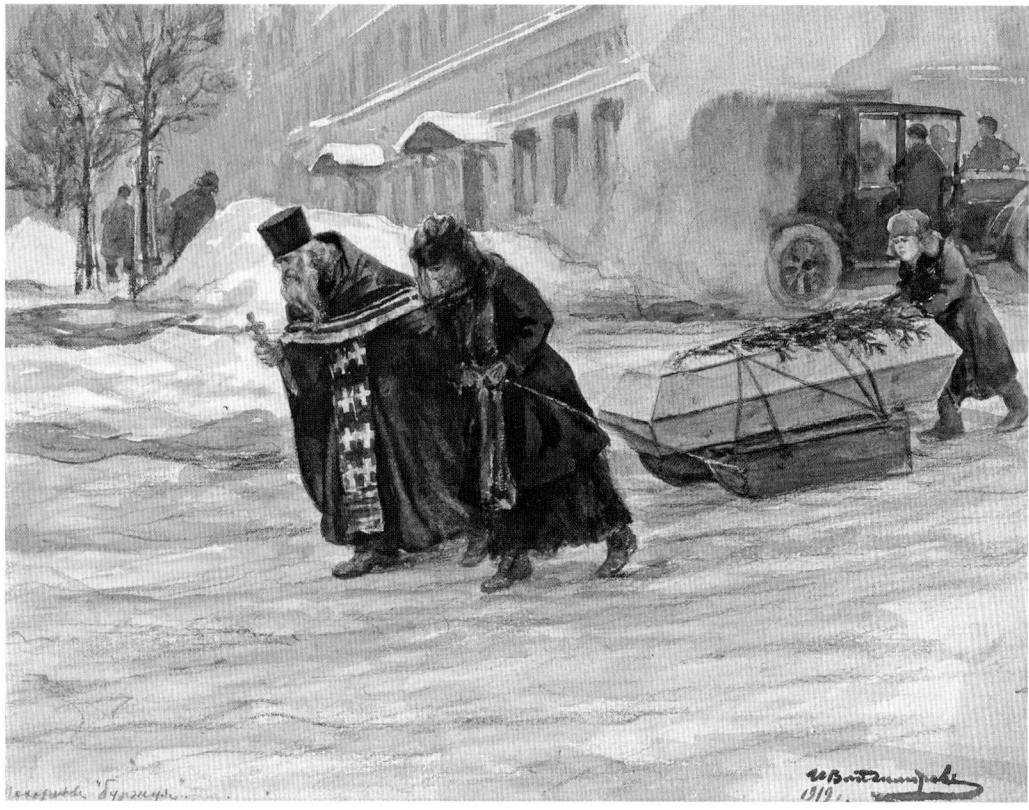

A 'Bourgeois' Funeral (1919)

watercolour on paper 25.5 x 33.5cm
signed bottom right: *ИВладиміров 1919 г.*
artist's inscription bottom left: *Похороны
"буржуя"*
Ruzhnikov Coll.

16.

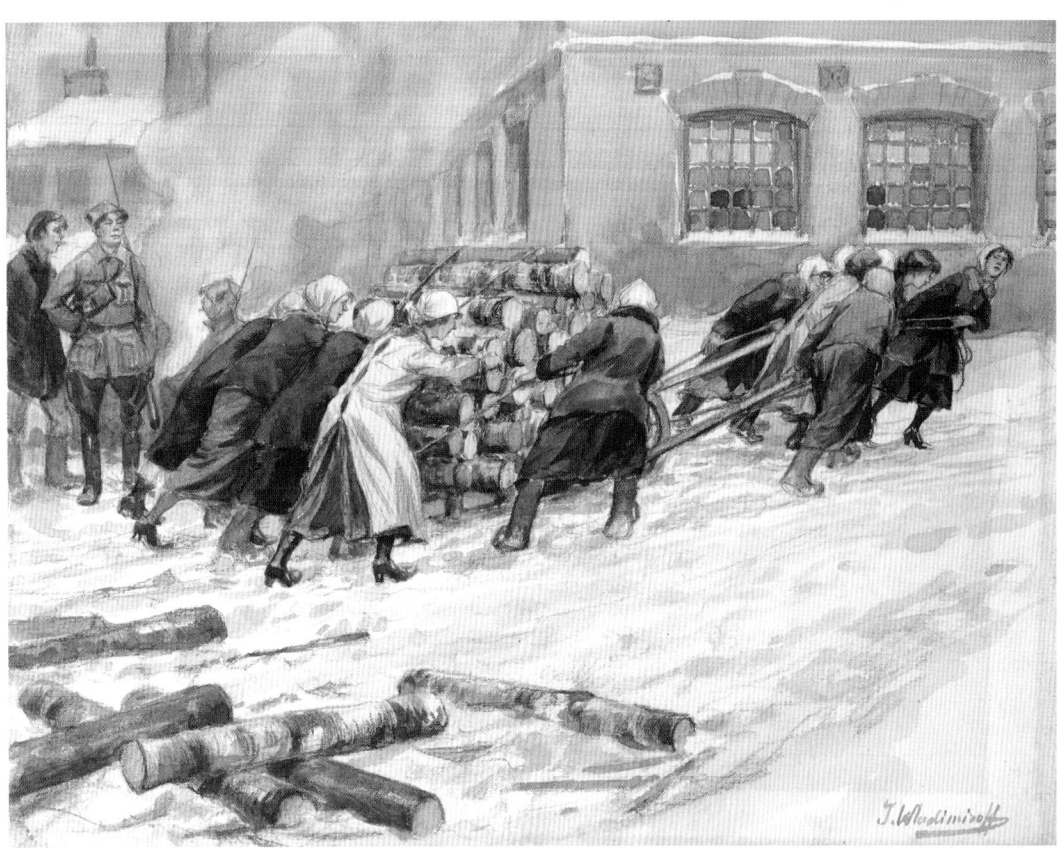

Firewood Commandeered for the Kersten Factory

pencil & watercolour on paper 25.3 x 34.5cm
signed bottom right: *J. Wladimiroff*
artist's inscription on back: *Принудительная заготовка дровъ
для фабрики Керстен*
Ruzhnikov Coll.

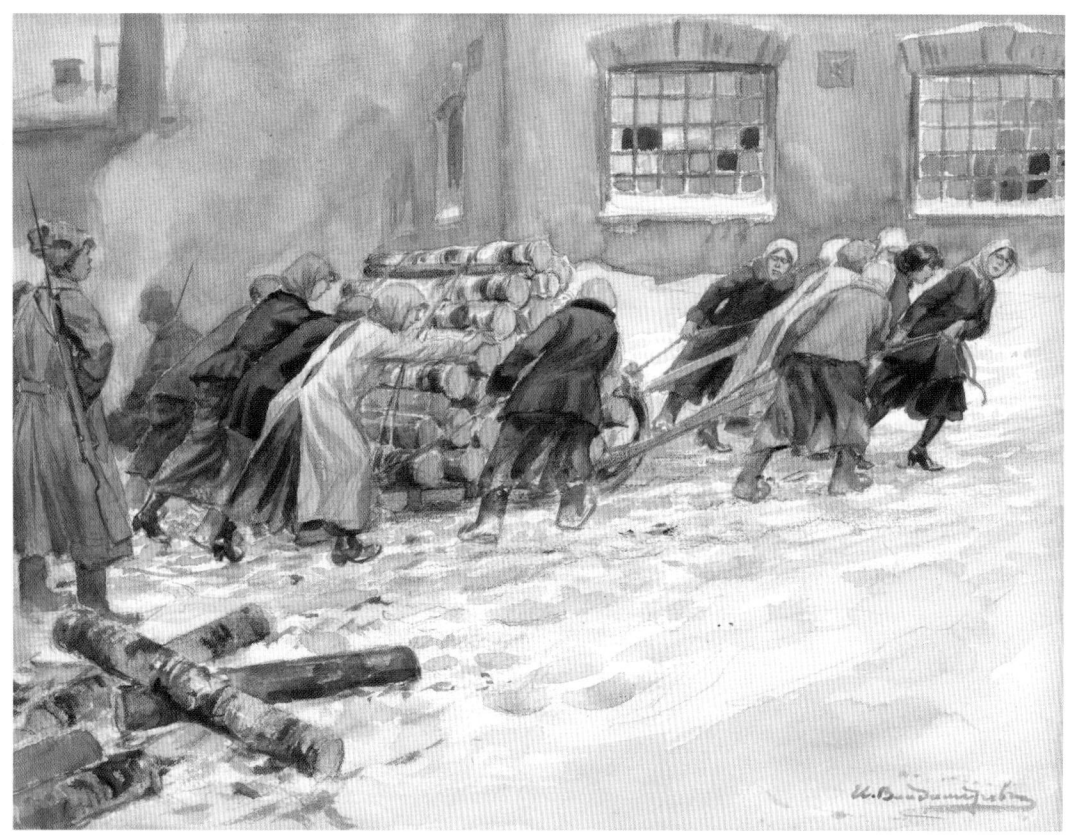

Requisition of fire wood

Requisitioning Firewood

watercolour on paper 29.2 x 39.4cm
signed bottom right: *И.Владимировъ*
inscription on back: *Requisition of fire wood*
HILA

17.

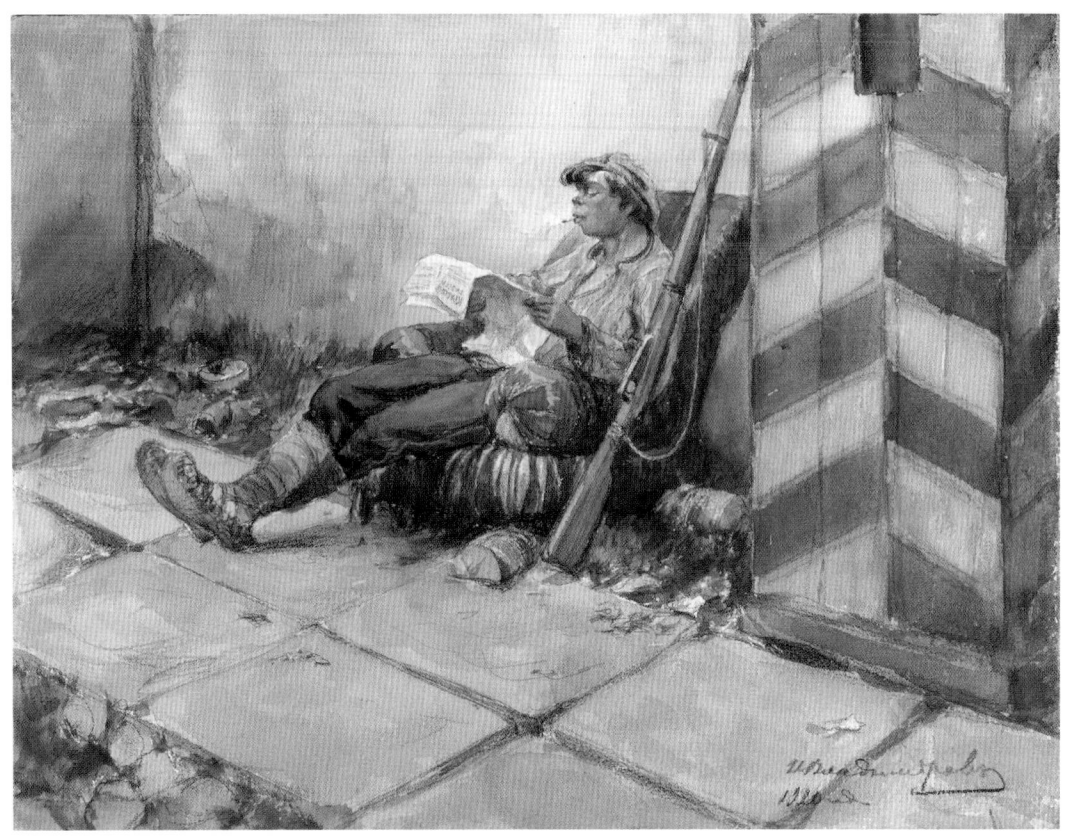

'On Duty' – Scene Outside the Barracks (1920)

ink & watercolour on paper 26.4 x 36.5cm
signed bottom right: *ИВладиміровъ 1920 год*
Ruzhnikov Coll.

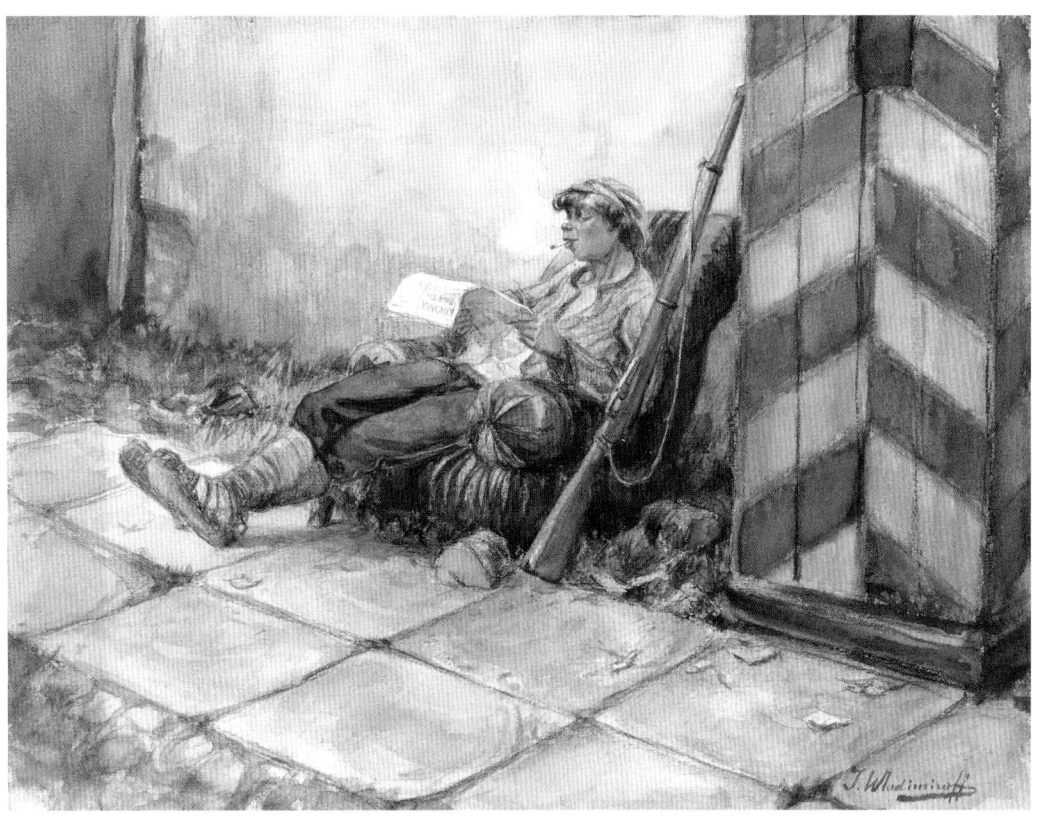

'On Duty' – Scene Outside the Barracks

ink & watercolour on paper
25.7 x 34.2cm
signed bottom right: *J.Wladimiroff*
artist's inscription on back: *"На посту" сцена у ворот казармы*
Ruzhnikov Coll.

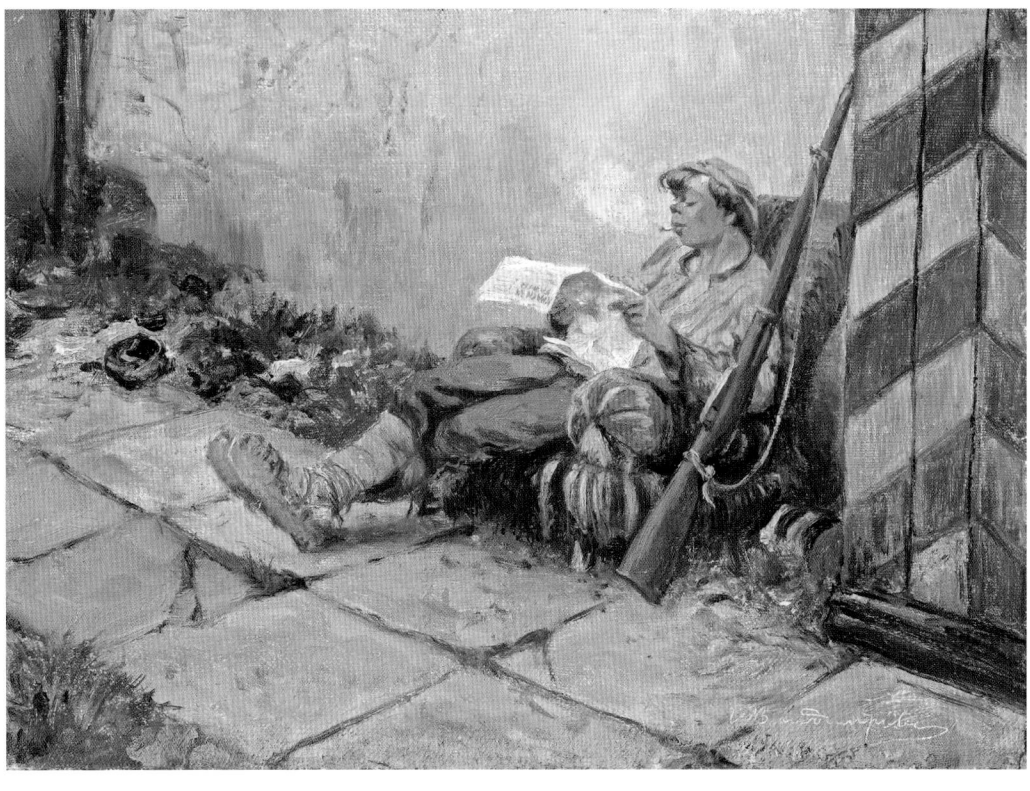

'On Duty' – Scene Outside the Barracks

oil on canvas mounted on board
23.8 x 33.7cm
signed bottom right: *И.Владиміровъ*
Ruga Coll.

18.

Sports Contest in the Imperial Garden in Petrograd – July 1921 (1922)

pencil & watercolour on paper 25.8 x 34.5cm
signed bottom right: *J.Wladimiroff 1922*
signed bottom left: *Sporting competition in the Imperial garden in Petrograd. July 1921.*
BMC

Sports Contest in the Summer Garden

ink, pencil & watercolour on paper 25.7 x 34.5cm
signed bottom right: *J.Wladimiroff*
artist's inscription on back: *Спортивныя состязанія в Летнем саду*
Ruzhnikov Coll.

19.

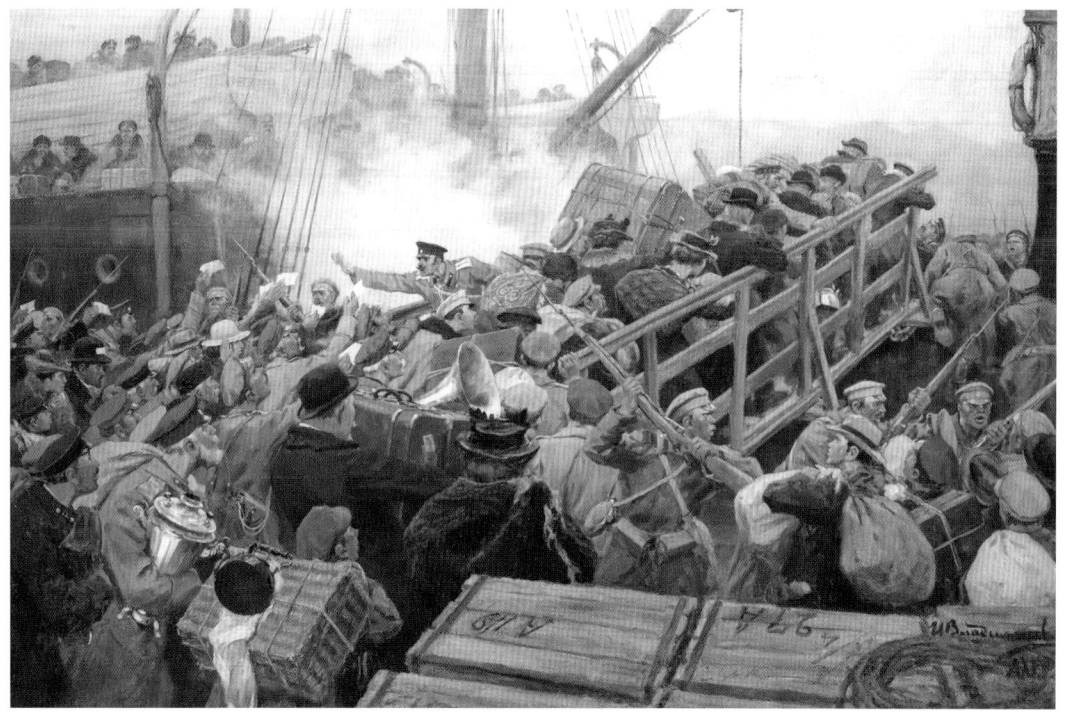

Flight of the Bourgeoisie from Novorossiysk (1926)

oil on canvas 138 x 212cm
signed bottom right: *ИВладимиров / АХРР*
CSMRMH

Sketch for the Painting Flight of the Bourgeoisie

ink & watercolour on paper 26.4 x 36.5cm
signed bottom right: *ИВладиміровъ*
artist's inscription bottom left: *Частичный эскиз картины "Бегство буржуазии"*
Ruzhnikov Coll.

20.

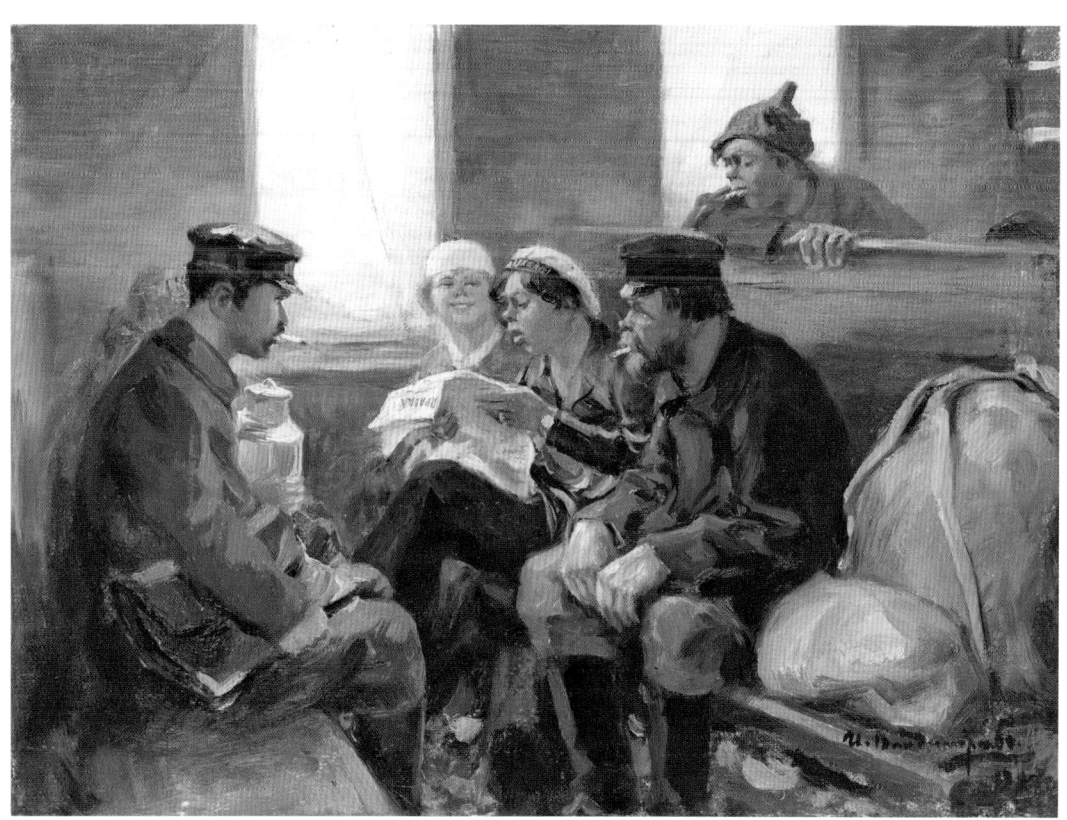

Political News (1920)

oil on canvas mounted on board 20.5 x 28cm
signed bottom right: *И.Владиміровъ 1920*
artist's inscription on back: *"Политическія новости" ИВладиміровъ*
Ruzhnikov Coll.

Political News

oil on canvas mounted on board 27.2 x 38.8cm
signed bottom right: *ИВладимировъ*
artist's inscription on back: *"Политическія новости" ИВладимировъ*
HILA

21.

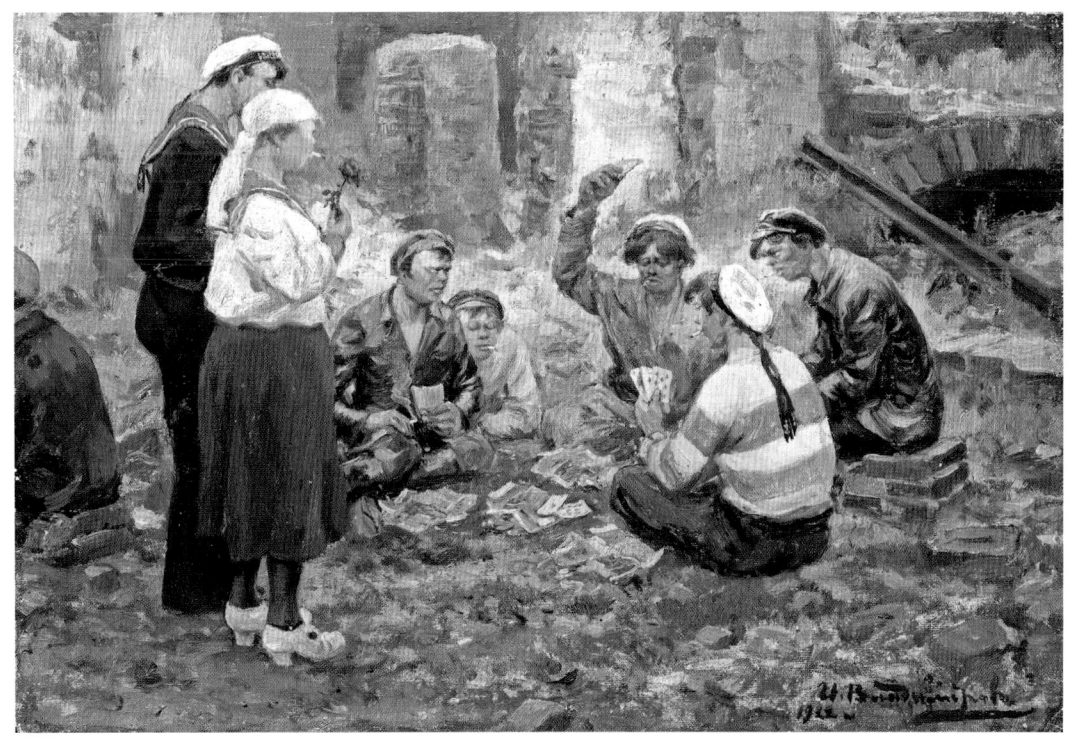

Playing Cards Amidst the Ruins (1922)

oil on canvas mounted on board 28 x 41.8cm
signed bottom right: *И.Владимировъ 1922*
Ruga Coll.

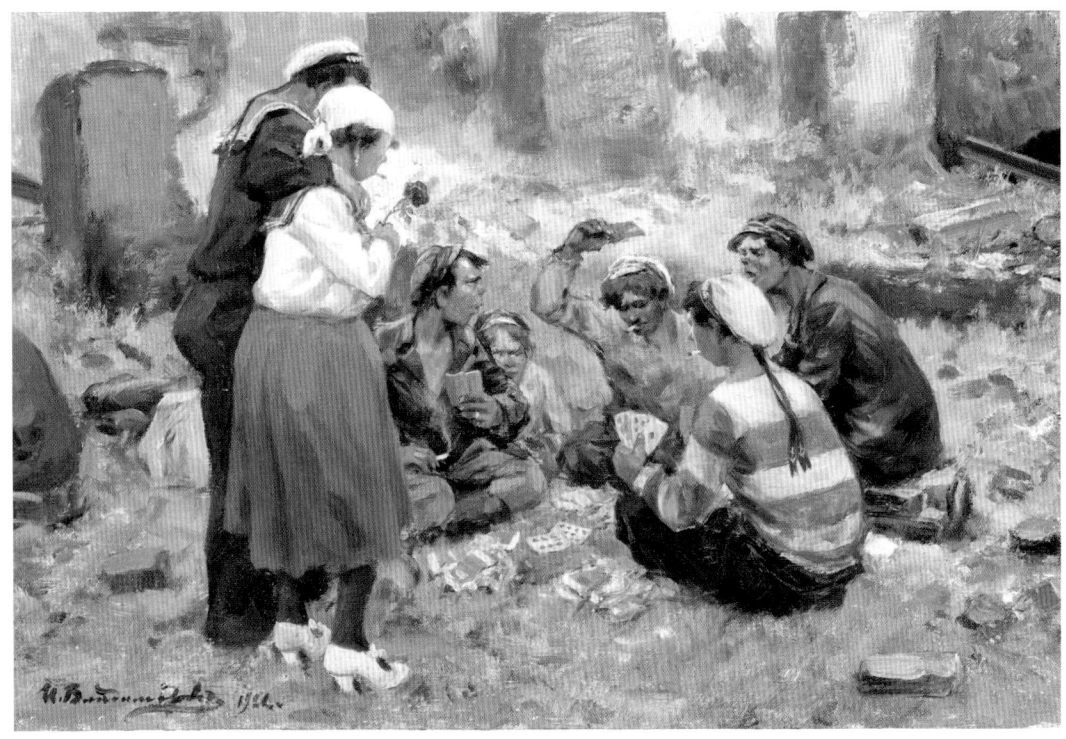

Playing Cards Amidst the Ruins

oil on canvas mounted on plywood 29.4 x 49.7cm
signed bottom left: *И.Владиміровъ 1922 г.*
HILA

22.

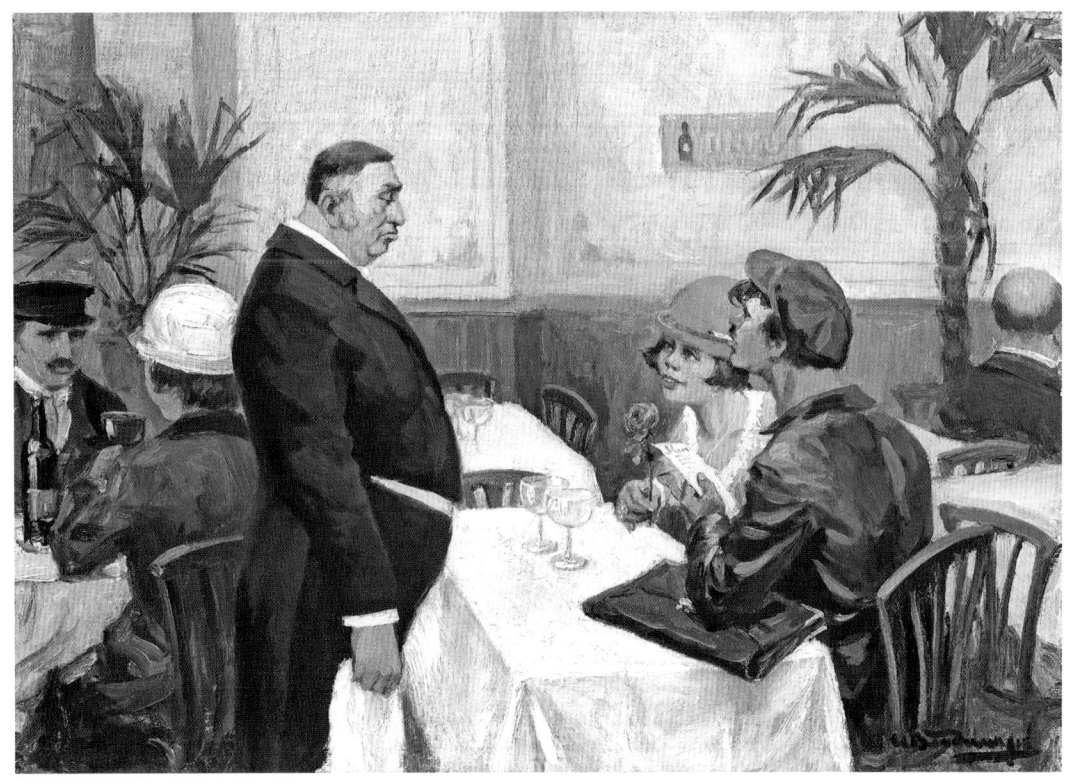

Grand Hotel Europa (1923)
oil on canvas mounted on plywood 29 x 41cm
signed bottom right: *ИВладимиров*
Ruga Coll.

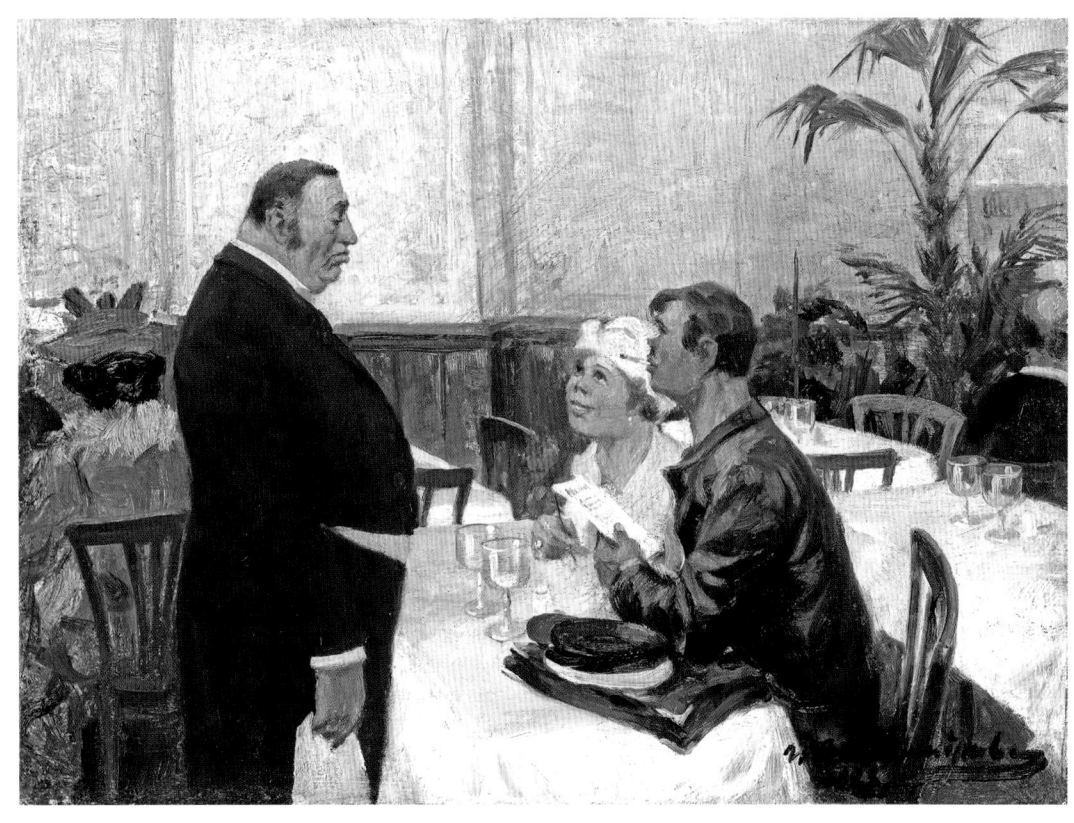

Grand Hotel Europa (1923)

oil on canvas mounted on board 26.8 x 36.7cm

signed bottom right: *ИВладимировъ 1923*

Ruga Coll.

Photographic Illustrations[1]

p. 23 *Ivan Vladimirov* (1946) – LenTASS (Anon.)

p. 39 *Ivan Vladimirov Sketching Captured Japanese Officers* (c.1904) – Anon.

p. 67 *'Unity of the Soviet People'* (Moscow 1 May 1980) – Valentin Khukhlayev © Valentin Khukhlayev Archives

p. 68 *Nikita Khrushchov Visiting a Contemporary Art Exhibition at the Manège* (Moscow 1 December 1962) – Alexander Ustinov © Alexander Ustinov / Union of Russian Photographers

p. 71 *In the Office of Political Education* (3 June 1963) – Valentin Khukhlayev © Valentin Khukhlayev Archives

p. 73 *Yuri Gautier* (c.1940) – Anon. (Archive of Russian Academy of Sciences)

p. 84 *Barricade on Liteiny Prospekt during the 1917 February Revolution* – Carl Bulla

p. 94 *Double-Headed Eagles After Removal* (1917) – Anon.

p. 98 *Front-page of Utro Rossii ('Russian Morning')* – 4/17 March 1917 – State Central Museum of Russian Modern History

pp 104/5 *Winter Palace Ransacked during October Revolution* – 26 October (8 November) 1917 – Anon. (State Hermitage Museum)

pp 108/9 *Building at them Nikitsky Gate damaged by Artillery Fire* – Moscow November 1917 – Alexander Dorn © ITAR-TASS Archives

pp 110/11 *Lesser Nikolayevsky Palace in the Kremlin damaged by Artillery Fire* (November 1917) – Anon.

p. 112 *Commission for Selecting Items for the Auction of Russian State Jewels at Christie's London in 1927* – Anon. (Russian State Film & Photography Archives)

p. 114 *Foreign Visitor to Gokhran trying on the Great Imperial Crown* (1923) – Anon. (Russian State Film & Photography Archives)

..

1 all materials in the public domain unless otherwise indicated

pp 118/19 *Crowd outside a State Liquor Store in Nizhny Novgorod* (c.1900-10) – Maxim Dmitriev

p. 132 *Demonstration Backing Red Terror* (1918) – Anon.

p. 137 *Felix Dzerzhinsky with Red Army Troops on Red Square* (1920) – Anon. (Multimedia Art Museum, Moscow)

p. 140 *Cheka Command at Lubyanka Prison* (1920) – Anon.

pp 148/19 *Troops from Budyonny's First Cavalry Army* (January 1920) – Piotr Otsup © Central State Film & Photography Archives, St Petersburg

p. 150 *Bolshevik Agitation in the Countryside* (1919) – Anon.

pp 152/53 *Lenin at the Vsevobuch Parade in Moscow on 25 May 1919* – N. Smirnov (?) – Russian State Socio-Political History Archives

p. 156 *Queueing in Petrograd* – Winter 1916/7 – Anon.

p. 158 *Foreign Aid for Famine Victims* – Volga Region (1922) – Anon.

p. 166 *Liteiny Prospekt on the Morning of 3 July 1917* – Anon. (Russian State Archives)

pp 172 *ARA Food Depot in Moscow* (c.1921) – Anon. (American Relief Administration Russian Operational Records, Box 395, Folder M – Hoover Institution Archives)

pp 176/77 *ARA Soup Kitchen in Former Palace of Grand Duchess Olga Alexandrova* (1922) – Anon. (American Relief Administration Russian Operational Records, Box 397, Folder 2 – Hoover Institution Archives)

p. 178 *Confiscating Church Property* (1922) – Anon.

p. 182 *Red Army Troops Removing Icons & Church Artefacts from Simonov Monastery* (1923) – Anon. (Sergei Burasovsky Collection), *Confiscated Mitres* (1921)– Anon.

pp. 186/87 *Destruction of Church Property* (1920s) – Anon.

p. 188 *Harvesting at Gunpoint* (1919 ?) – Anon. (Central State Film & Photography Archives, St Petersburg)

pp. 192/93 *Requisitioning Products in a Village near Samara* (c.1919) – Anon. (Alabin Regional Museum of Local Lore, Samara)

p. 196 *Dekulakization in the Village of Udachnoe, Donetsk Region* (1931) – Anon.

p. 198 *Forced Labour: Cleaning the Streets* (Petrograd 1919) – Anon. (Central State Museum of Russian Modern History)

p. 205 *Delivering Firewood* (1918) – Anon.

pp 212/13 *Lenin, Krupskaya & Lenin's Sister Maria in the Tsar's Renault 40 CV after the Red Army Parade on Khodynka Field – Moscow 1 May 1918* – Peter Novitsky (Multimedia Art Museum, Moscow)

p. 216 *Red Guards Keeping Warm on Smolny Prospekt (November 1917)* – Jacob Steinberg (Multimedia Art Museum, Moscow)

p. 220 *Inhabitants of Petrograd Dismantling Homes for Firewood* (1920) – Anon.

p. 227 *Street Trade under War Communism* – Petrograd *1920* – Anon.

p. 233 *Street Urchins on the corner of Arbat & Starokonyushenny Pereulok* (1922) – Georgiy Soshalsky (Multimedia Art Museum © Georgiy Soshalsky Archives)

p. 234 *Lenin at a Parade on Red Square – 7 November 1919* – Nikolai Alexeyev © RIA Novosti

p. 241 *Food Queue on the Corner of Nikitskaya/ Tverskoy Boulevard* (1920) – Anon.

RUSSIA *ACCURSED*

IVAN VLADIMIROV

RED TERROR
THROUGH THE EYES OF AN ARTIST

ISBN 978-1-9160484-1-6

2020
Ruzhnikov Publishing, London
ruzhnikov.com

Typesetting & Printing:
Latitude Press Ltd